THEMES AND FOUNDATIONS OF ART

ELIZABETH L. KATZ
WHITEHALL CITY SCHOOLS
WHITEHALL, OHIO

✦

E. LOUIS LANKFORD
THE OHIO STATE UNIVERSITY
COLUMBUS, OHIO

✦

JANICE D. PLANK
WHITEHALL CITY SCHOOLS
WHITEHALL, OHIO

WEST PUBLISHING COMPANY
MINNEAPOLIS/ST. PAUL NEW YORK SAN FRANCISCO LOS ANGELES

Copyedit: Nancy Palmer-Jones
Art: Miyake Illustration
Index: Terry Casey
Composition: Parkwood Composition
Cover Image: Miriam Schapiro, *Pas de Deux,* 1986. Acrylic and fabric on canvas. 90" × 96". Courtesy Bernice Steinbaum Gallery, New York. ©1994 Miriam Schapiro. (Study for Figure 9-63, *Anna and David,* seen on page 554.)
Student Activity photographs and other images featuring students at work in classroom situations © Keith Rittenhouse, 1994: 41, 86, 135, 140, 148, 183, 188, 189, 193, 194, 219, 223, 281, 349, 431, 501, 528, 539, 577, 585.

WEST'S COMMITMENT TO THE ENVIRONMENT

In 1906, West Publishing Company began recycling materials left over from the production of books. This began a tradition of efficient and responsible use of resources. Today, up to 95 percent of our legal books and 70 percent of our college and school texts are printed on recycled, acid-free stock. West also recycles nearly 22 million pounds of scrap paper annually— the equivalent of 181,717 trees. Since the 1960s, West has devised ways to capture and recycle waste inks, solvents, oils, and vapors created in the printing process. We also recycle plastics of all kinds, wood, glass, corrugated cardboard, and batteries, and have eliminated the use of Styrofoam book packaging. We at West are proud of the longevity and the scope of our commitment to the environment.

Production, Prepress, Printing and Binding by West Publishing Company.

COPYRIGHT ©1995 By WEST PUBLISHING COMPANY
 610 Opperman Drive
 P.O. Box 64526
 St. Paul, MN 55164-0526

Printed in the United States of America

02 01 00 99 98 97 96 95 8 7 6 5 4 3 2

Library of Congress Cataloging-in-Publication Data

Katz, Elizabeth L.
 Themes and foundations of art / Elizabeth L. Katz, E. Louis
 Lankford, Janice D. Plank.
 p. cm.
 Includes index.
 ISBN 0-314-02945-1 (Student Edition)
 ISBN 0-314-02946-X (Teacher's Annotated Edition)
 1. Art. I. Lankford, E. Louis. II. Plank, Janice D.
 III. Title.
N7438.K28 1995
70--dc20 93-38676
 CIP

About the Authors

Elizabeth L. Katz is an Art Education Specialist with the Whitehall City Schools in Whitehall, Ohio, and is currently serving an appointment as a Clinical Educator in the Department of Art Education at The Ohio State University. She received her Bachelor of Science degree in Education from Ohio State University, and her Master of Arts degree from The Ohio State University. Elizabeth has enjoyed 24 years of classroom teaching experience, and is a member of Phi Kappa Phi academic honorary and Phi Delta Kappa research honorary. She has been awarded the Educator of the Year award from the Whitehall Education Association, Outstanding Art Teacher of the Year—Central Region by the Ohio Art Education Association, and most recently, the Honoring Excellence in the Teaching Profession award from the College of Education, The Ohio State University.

E. Louis Lankford is a Professor of Art Education at The Ohio State University, where his dedication and verve have been acknowledged with an Alumni Award for Distinguished Teaching. He has devoted much of the last ten years to working with teachers in developing high-quality, integrated art curricula designed to meet the needs of today's complex, multicultural classrooms. He earned his Ph.D. in Art Education at Florida State University, and has since contributed to his field with over forty book chapters and articles in professional journals, and numerous lectures and workshops delivered to local, regional, and national audiences. His popular course, "Learning to Look at Art," has been a staple at the Columbus Museum of Art for several years, and his book, *Aesthetics: Issues and Inquiry*, has been a best seller for the National Art Education Association since its publication in 1992.

Janice D. Plank received an Associate of Arts degree from Vermont College, a Bachelor of Science degree in Art Education from Indiana University, and a Master of Arts degree in Art Education from The Ohio State University. She is currently an Art Specialist in the Whitehall City School District, Whitehall, Ohio where she has taught both elementary and high school art since 1976. Ms. Plank has received the 1982 Educator of the Year Award, Whitehall City Schools, the 1987 Ohio Art Education Association Outstanding Art Teacher Award for the Central Region, and the 1992 National Art Education Association Secondary Art Educator of the Year Award from the state of Ohio.

Ms. Plank along with Ms. Katz was involved in the J. Paul Getty Center for Education in the Arts 1982 study of discipline-based art programs in the United States (*Beyond Creating: A Look at Art in America's Schools*). Additionally, Ms. Plank has served as a consultant to numerous school districts concerning discipline-based art education and art education for the artistically gifted. She was a contributing author for the textbook series *Understanding and Creating Art*. Ms. Plank is also a member of the Phi Kappa Phi Scholastic Honorary Society, The Ohio State University.

Acknowledgements

The authors wish to thank, for their dedication, spirit of cooperation, and perseverance through an enormously complex process, editor Bob Cassel, production editor Carole Balach, senior developmental editor Theresa O'Dell, intrepid image-trackers Bette Darwin and Elaine Arthur, and the rest of the capable team at West Educational Publishing. Thanks also goes to Charlie Pepper, who helped us launch this project. We also wish to express our appreciation for the many art students—and their teachers—whose works are represented in this text, and special gratitude for the assistance of students at Whitehall-Yearling High School, Whitehall, Ohio. In addition:

From Elizabeth L. Katz: I wish to acknowledge, for their generous donation of time, effort, and expertise, Diane Robinson, Jerry Tollifson, and especially Renee Hartshorn. And, for their faith, support, and inspiration: Robert O. Stith, Sally Stith, Randall R. Stith, Douglas M. Stith, and especially Benjamin R. Katz.

From E. Louis Lankford: I wish to thank Dr. Sandra Kay Mims for her invaluable professional advice and assistance, and personal support; her unflagging faith in me heartened and renewed my efforts countless times.

From Janice D. Plank: I am grateful to Lindsay Ann Hollister and Ken Hollister for their constant support and encouragement. Many thanks to my brothers, sisters, and extended family for their belief in me. I also wish to thank Marilyn M. Plank for sharing her wisdom, for her continual support and for being the first art teacher in my life.

We would also like to acknowledge the following teachers who helped obtain the student art featured in this text:

Georgianna "Sam" Short
Shelley Howard
Jim Neiberger
Joyce Gilfillan
Overland High School
Aurora, CO

Emily Ruch
Overton High School
Memphis, TN

Kim Shipek
Buena High School
Sierra Vista, AZ

Carolyn Burtt
North Dallas High School
Dallas, TX

Rick Cuprys
Hilliard High School
Hilliard, OH

Sherry Woods
Sunset High School
Dallas, TX

Betty Burton
Whitehaven High School
Memphis, TN

Linda Stilley
Andy Zaller
Booker T. Washington High School
Tulsa, OK

Rosalinda Champion
Edinburg High School
Edinburg, TX

Beverly Norman
Cooper High School
Abilene, TX

Judy Smith
Logan High School
Logan, UT

Lisa Wilson
L. C. Mohr High School
South Haven, MI

Cheryl Niehaus
Terry Thomure
Pattonville High School
Maryland Heights, MO

Denise Jennings
Milton High School
Atlanta, GA

Kevin Cole
Tri Cities High School
East Point, GA

Wendy Thornley
Bristol Eastern High School
Bristol, CT

Holly Ring
March Mountain High School
Moreno Valley, CA

Geraldine Schilling-Nordal
Agawam High School
Agawam, MA

Steven Schneider
Sherwood Middle School
Columbus, OH

Jean Black
Jill Williams
George Washington High School
Denver, CO

Elaine Gauthier
Smithfield High School
Esmond, RI

CONTENTS IN BRIEF

TABLE OF CONTENTS

Chapter 7 The Human Image in Art 334

Part Three History of Art 387

Chapter 8 Treasures from History: Art from Ancient and Remote Worlds 388

Chapter 9 Art in Transition: Modern to Postmodern Art 482

Part Four Careers in Art 559

Chapter 10 Preparing for a Career in the Visual Arts 560

Appendices

Glossary

Glosario

Index

Looking Closer: Comparing Works of Art

The Artist as Young Adult

Technology Milestones

Student Activities

INTRODUCTION

Welcome to *Themes and Foundations of Art!* This book has been written for you and people like you who enjoy experiencing art and want to know more about it. Each of the ten chapters has been well researched to provide you with in-depth information about how and why people make art. You will view many high-quality reproductions of artworks made by artists from various cultures of the world from remote time periods to the present day.

You will see artworks made in the United States by artists who have challenged traditional ideas about art and beauty. Some of these pieces may cause you to rethink your own ideas, values, and feelings about art. You will also see art made by students like you. As you explore the pages of this book, you are encouraged to stretch your imagination, exercise and develop your skills, increase your knowledge, and improve your critical thinking and creative problem-solving abilities. Most importantly, this book invites you to become an active participant in the world of the visual arts, today and in your future.

Themes and Foundations of Art will do more than provide you with facts and information. It will guide you through various activities designed to help you gain more meaning and enjoyment from your experience with art. Much of what you will learn will be gained from an inquiry (IN-kwah-ree) approach to art, which means that *you will have the opportunity to investigate topics, techniques, and issues by applying your knowledge, judgment, and skills.* For example, there will be plenty of opportunities for you to express yourself by making art. You will need to make some of the same kinds of decisions that artists make concerning choices of color and form. You will have to consider alternative ways of expressing ideas and feelings effectively. When you have finished, you'll also look carefully at what you have accomplished, and think about what you have learned that you might apply to future projects.

Special questions posed throughout the book are designed to arouse your curiosity and get you to think about important topics and issues that challenge people in the world of art. For example, you will discover that art history is more than a collection of facts. Art historians must sift through countless fragments of artworks and pieces of evidence in order to arrive at their conclusions. You will learn what some of their questions and puzzles are, and you will be given the opportunity to ponder these yourself. If you spend some time with this book, reading, looking at the pictures, and doing the activities, you may find that your understanding and appreciation of art has increased a great deal through inquiry.

The term *themes* used in the title of this book refers to topics that have been explored by many artists over time and across cultures. Themes in the visual arts represent ideas, events, and relationships that are important to individuals and societies. Birth, death, conflict, the environment, faith, family, and love are examples of themes found in art. Throughout this book you will be introduced to many themes. Three chapters—Chapters Five through Seven respectively—are especially devoted to themes: Nature and Art, Cities and Art, and The Human Image in Art.

The term *foundations* used in the title of the book refers to ideas and processes that are basic to making and understanding art. This book is designed to help you learn about materials and methods for making art, the history of art, and techniques for looking carefully at artworks. Information in the text will introduce basic concepts about art, and questions will guide you as you delve into fundamental issues. Developing knowledge and skills in foundations of art can build your confidence and make your experience with art more fulfilling.

Themes and foundations of art are closely related. It would be difficult to study foundations of art without encountering themes. This is because so many artists have expressed thematic ideas. On the other hand, it would be difficult to explore themes in art without having some knowledge of art foundations. Familiarity with foundations of art makes it easier to understand and appreciate the ways artists have expressed thematic ideas. By imaginatively applying foundations of art, you can explore themes in artwork that you make.

SPECIAL FEATURES

We want you to know about the many special features of this book so that you can take full advantage of the opportunities it provides. Here is a brief description of features you will encounter:

- Each chapter opens with a set of learning objectives and a brief summary of each section of the chapter. You are also provided with a list of terms that will be defined in the text, so you can watch for them as you read. Making use of these features before you begin reading a chapter will enhance your understanding and retention of the key ideas in the chapter.

- At the beginning of each chapter is a special section titled *Art in Your Life*. It is designed to help you recognize art as something that can have personal meaning for you. It will explain relationships between art and the world in which you live.

- Each chapter contains *Student Activities* that can get you involved in art-making and discussions related to art. There are approximately 70 different activities in the text.

- You will find distinctive colored boxes containing questions to help you approach art in special ways. For example, you might be asked to view an artwork from the standpoint of an art critic. Or you might be asked to imagine yourself as part of an archeological expedition that discovers ruins of an ancient civilization. These boxes focus on the different approaches to studying art and are entitled *Thinking About Aesthetics, Developing Skills for Art Criticism,* and *Exploring History and Cultures*. You should think of these features as fun, as well as thought-provoking.

- Most chapters contain features titled *Looking Closer: Comparing Works of Art*. In each feature, two works of art are shown side by side, and you get to examine the style and meaning of each in comparison with the other. You will also learn about the different backgrounds of the artists and social conditions that influenced the creation of each artwork.

- *Technology Milestones*, located throughout the book, tell the stories of technological innovations that have had an impact on the way art has been made, from prehistoric cave art to modern computers.

- Features titled *Artist as Young Adult*, located in each chapter, introduce you to the lives of women and men whose artworks have been shown and discussed in the text. You will learn details about each artist's upbringing, how he or she got involved with art during the teenage years, and the artist's major achievements later in life. Perhaps you'll find these stories inspiring!

- *Quote Boxes* highlight ideas about art exactly as they've been expressed by artists and critics throughout the history of art. As much as possible, direct quotes from the artists being discussed have also been integrated into the text.

- *Section Reviews* provide review and enrichment exercises for the major sections within the chapters.

- At the end of each chapter, in the *Chapter Review*, you can find questions and suggestions for activities to reinforce and extend your learning about art as discussed in that chapter.

Again, welcome to *Themes and Foundations of Art*. We hope that this book will help to launch you on a lifetime voyage of discovery and enjoyment of art!

Building Your Process Portfolio

As you become involved with activities and readings in this book you may want to keep a record of your progress and involvement. A process portfolio can help you to do that in an organized way. A **process portfolio** *is a collection of sketches, artworks, writing, and other materials that document your thoughts, activities, and accomplishments as you develop as an artist and scholar.* You can organize your collection in a large envelope, folder, or other container which you may wish to decorate in your own unique way. Here are some of the items you may want to keep in your process portfolio:

- Save some of your initial sketches along with finished products you do in art class.

- After you have finished an artwork, describe in writing the process you used to make it, such as the decisions you made, and the effects you were trying to achieve. Make an honest judgment of how well you think you succeeded.

- Note your thoughts and observations about artworks pictured in the book. Are some of them unfamiliar, strange, or puzzling to you? Are there things you'd like to know about them, and the people who made them? Are some especially interesting to you?

- If you could meet the artists who made the works pictured in this book, what would you like to say to them? What would you ask them? Write your thoughts and questions on a piece of paper. Note the page number where you found their artworks pictured.

- Write answers to questions posed in the book, and put them in a special folder in your portfolio.

- As you think of other questions, topics for inquiry, or new ideas for artworks, jot these down and add them to a special folder.

- Save newspaper and magazine clippings about art. Write in the margins or on sheets of paper why the article was interesting or important to you.

- Save art postcards or other small reproductions that you like, and some you don't like. You might include sketches and descriptions you have made of other artworks you've seen. Write down why you think each artwork was, or was not, effective or appealing.

- Keep a journal with weekly entries summarizing what you've accomplished and learned in art class during the week. Note highlights of class activities and your successes. Also note problems you may have encountered as you worked on projects and assignments. Tell how you worked to overcome and solve those problems.

- Compose a statement summarizing why art is important to you, and why it has importance on a global scale. Rewrite your statement in your best handwriting on a piece of drawing or parchment paper and create a special decorative border.

- If you have the opportunity to interview artists or other people working in the arts, record in writing or on audio tape the content of those interviews.

- Depending on your work habits, assignments, and materials available, your portfolio might also include videotapes, photographs, and computer disks.

You may wonder why you are being asked to save so many materials. There are several reasons. As you learn more about art, you can return again and again to the same questions, problems, and activities and apply to them your new insights and skills. You may return to early sketches and decide to develop them into full-blown works of art.

A process portfolio can also help you and your art teacher assess your learning and achievements in art class. The portfolio will exhibit your strengths as well as reveal areas where you should try to improve. The portfolio will indicate how hard you have been working and how much thought and effort you have put into projects and assignments. It will provide evidence of extra study and work you have done outside of class.

Since you are saving written and visual work over an extended period of time, the process portfolio will allow you and your art teacher to compare earlier with more recent work. In this way the portfolio can help to demonstrate progress and changes in your thinking and art-making abilities. If you study the material in this book, you should notice that your written and spoken comments about art are becoming more knowledgeable and sophisticated, reflecting broader and deeper levels of understanding. The art that you made should be more meaningful and satisfying to you than ever before. You may be surprised to see how much you have changed over the course of a year!

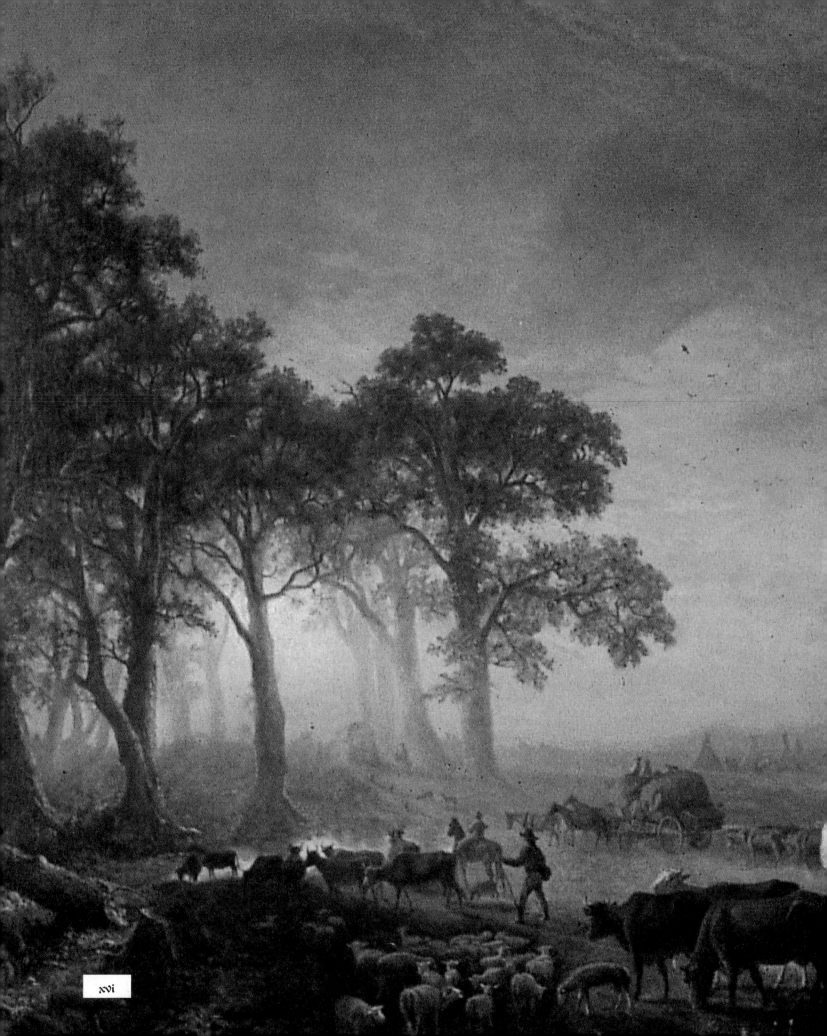

PART ONE

Foundations of Art

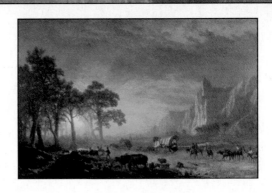

CHAPTERS

Albert J. Bierstadt (American, b. Germany, 1830–1902), *The Oregon Trail*, c. 1800. Oil on canvas. 31" × 49". The Butler Institute of American Art, Youngstown, OH.

1

What Is Art?

Figure 1-1 Artists throughout history have depicted themes reflecting important human experiences and concerns. This artist has visually portrayed love, caring, and responsibility in family relationships.

Romare Bearden, *The Family*, 1948. Watercolor and gouache on paper. The Evans-Tibbs Collection, Washington, D.C. Courtesy Estate of Romare Bearden.

Contents

Terms to look for

abstract	art criticism	expressive	perceive
aesthetics	art history	firing	scenario
aesthetic value	art theory	interpretation	studio production
allegory	calligraphy	monument	symbol
art	expression	mural	

Objectives

- You will learn that art can express ideas, values, and feelings that are important to individuals and society.

- You will discover the rich diversity of art forms that have been made throughout history and around the world.

- You will recognize that art can be understood and appreciated in many ways and from many points of view.

- You will be introduced to foundations and themes of art that you will encounter in the rest of this book.

Art in Your Life

It's likely that everyone you know uses the word *art* from time to time in ordinary conversation. But how many people have paused to think about what it really means and why it's important? Probably not many. Yet *art* is one of the most meaningful words in our vocabulary. When we make or study our own art, we often come to a fuller understanding of our personal thoughts, feelings, and values. When we study works of art made by other people, we are better able to see how each of us is unique but at the same time connected with other people and other cultures through similar human concerns and experiences. When we are engaged in artistic activities, we are developing technical skills, creativity, and problem-solving abilities that we can carry with us throughout our lives.

How can this chapter help you? It will open your eyes to what people (like you!) can accomplish when they apply their creative imaginations. It can help you to understand, enjoy, and create works of art that reflect deep human feelings and profound ideas and beliefs. It can set you on a path of unending discovery and personal enrichment as you enter and explore the world of art.

Section I

What Is Art?

The word *art* may mean many different things to different people. Some people use this word to refer to the "fine arts," including classical and established forms of dance, music, theater, and visual art, such as painting and sculpture. Some people use the word to refer to anything well made. For example, someone might look at a beautifully decorated cake and exclaim, "That is no ordinary cake—it's a work of art!" What the person means is that it is a beautiful cake, that it is skillfully done. The person paying the compliment may not intend to be taken literally.

It's not always obvious or easy to tell whether or not something should be called a work of art. Few would question whether the painting shown in Figure 1-2, *Still Life: Flowers and Fruit*, is a work of art. Most of us are familiar with the subject matter, an arrangement of flowers and fruit. You have probably seen pictures like this many times and are used to thinking of them as art. You might even have a picture similar to this one framed and hanging over your sofa at home. Most of

us would also associate this painting's manner of construction with art: it is made of oil paints brushed on a rectangular canvas panel. Learning that the painting

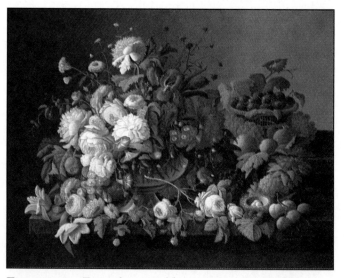

Figure 1-2 Few of us would question whether this painting is a work of art.

Severin Roesen, *Still Life: Flowers and Fruit*, c. 1850–1855. 40" × 50". The Metropolitan Museum of Art, purchase, bequest of Charles Allen Munn, by exchange; Fosburgh Fund, Inc. and Mr. and Mrs. J. William Middendorf II gifts; and Henry G. Keasbey Bequest, 1967. (67.111)

is part of a major art museum's collection reinforces our opinion that the painting is art.

Now look at the flag in Figure 1-3. Constructed of wood, iron, brass, and paint, it was designed to be used as a fence gate on a farm in Jefferson County, New York. It shows the signs of weathering and age that we would expect of an outdoor gate. We do not know who made it—a farmer, carpenter, or blacksmith, perhaps. Whoever made it possessed considerable imagination and skill, and had obviously studied carefully the movement of a flag flying in the wind. The undulating stripes of the gate make it appear as though it is fluttering in a stiff breeze. This sense of movement is enhanced by the spaces between the red and white stripes, which cause wavy shadows across the surface. The crisscrossing spacers add strength to the gate's framework, ensuring that the gate will serve a practical function as well as a decorative one.

Do you think that the *Flag Gate* is a work of art? The answer is not as obvious as it was for the painting of flowers, is it? It is unlikely that the person who made the *Flag Gate* was an artist by trade. The materials with which it was made are not as commonly found in art museums as oil on canvas. We don't usually think of fence gates as art. Still, this is no ordinary gate. It's extraordinary in terms of its visual design. It's also extraordinary because it does something gates seldom do: it expresses ideas, feelings, and values held by the person who made it and the persons who used it.

This *Flag Gate* was created around 1876. Americans were celebrating the centennial, or hundredth anniversary, of this country's struggle for independence. The person who made it created something special for the people of rural New York in the 1870s. What's more, the form of the gate—the American flag—is a visual symbol that is significant to millions of Americans today.

What, then, is art? **Art** *is the special expression of ideas, feelings, and values in perceptible form.* If something is *perceptible*, it means that we are able to *perceive* it. To **perceive** *means to be aware of things through our senses—seeing, hearing, tasting, smelling, touching. To perceive also means to have the ability to recognize and understand things we experience in our environment.* Using this definition, both the still-life painting and the *Flag Gate* can be considered art. In fact, this definition

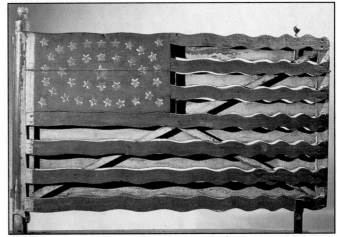

Figure 1-3 This *Flag Gate* is an effective expression of patriotism.

Flag Gate, Artist unknown, Jefferson County, New York, c. 1876. Polychromed wood, iron, brass, 39½" × 57" × ¾" deep. Collection of the Museum of American Folk Art, New York. Gift of Herbert Waide Hemphill, Jr. 1962.1.1.

allows a wide range of objects and performances to be considered works of art. A work of art doesn't have to be a painting hanging on a gallery wall or a sculpture resting on a museum pedestal. But a work of art will have special qualities and meanings that people value.

Locate the word *special* in a dictionary. What does it mean? It means that something is distinctive, exceptional, extraordinary, or highly valued. Now look up the word **expression.** *When we express ourselves artistically, we picture—or visually represent—our ideas, feelings, and values.* For example, we can show surprise, anger, sadness, and happiness quickly and effectively by "making faces" or by drawing facial expressions. We can convey our attitudes toward war and peace, or love and hate, through the use of visual images and symbols. Referring to a work of visual art as **expressive** *means that it effectively conveys or communicates feelings and ideas in visual form.*

It is impossible to describe with absolute precision what constitutes a "special expression." What is special for one person may not be special for another. But in general, a work of art is something that can make us think or feel more deeply than we normally would. Artistic expression is a way for people to reveal and to share their most important values and beliefs, their

Student Activity 1

Expressing Feelings in Pictures

Goals

1. You will increase your understanding of art as a means to express ideas and feelings.
2. You will improve your ability to express your ideas and feelings through art.
3. You will notice that a single idea or feeling can be visually portrayed in more than one way.

Materials

1. White drawing paper, one sheet
2. Pencil
3. Black felt marker

Directions

1. On your sheet of paper, quickly sketch, in pencil, six faces bearing the following expressions:

 surprise fear
 happiness anger
 suspicion sadness

 Do not label your drawings. Keep your drawings *as simple as possible,* using only a few lines to indicate the position of the eyes, nose, and mouth. You are not drawing a portrait but trying to discover how expressive a few lines can be. (See the example on this page.)

Keep your drawing simple. Can you guess which expression on the list in Student Activity 1 is portrayed above?

6

2. Using your marker, ink over your lines so your drawings will be easier to see.

3. On a tabletop or bulletin board, place your drawings alongside those of the other students in class. Through discussion, try to determine which expression (sadness, fear, and so on) each drawing represents. Then, answer the following questions:
 a. How easy was it to match the words with the drawings?
 b. How much do the drawings have in common?
 c. What differences do you notice?
 d. What features of the drawings tipped you off as to the emotion or state of mind represented?
 e. Are there any drawings that you think are particularly effective in conveying an emotion or state of mind? If so, what makes them successful?
 f. Did you have to *feel* the emotion or experience the state of mind that you were trying to portray *as you drew it*? Or was it enough to be able to remember having such feelings in the past or to have in mind an *idea* of these feelings as you drew?

Evaluation

1. Were your drawings of facial expressions as simple as you could make them? If not, how might you simplify them further?
2. Did your drawings express your ideas as well as you had hoped? If not, what might you do to strengthen them?
3. Did you participate constructively in the class discussions about the drawings? What are some of the main ideas that emerged from the discussion?
4. Did you notice similarities and differences among the drawings? Would you be able to point these out to others?

deepest concerns, and their most profound thoughts and emotions.

Let's look at four more examples: a Chi Wara (chee WAH-rah) headdress from Mali's Bambara culture (Figure 1-4); *Watts Towers*, built by Simon Rodia (Figure 1-5); *Out of Work*, by artist Käthe Kollwitz (KAY-tuh COAL-vitz) (Figure 1-6); and *Sunflowers in a Windstorm*, by Emil Nolde (NOHL-duh) (Figure 1-7). The first two, the headdress and *Watts Towers*, might not fit traditional conceptions of art because of their unusual forms, materials, or the purposes for which they were made. Yet we can think of each as a work of art because each is a meaningful expression of ideas, feelings, and values in visual form. The artworks by Kollwitz and Nolde illustrate how visual images can powerfully express deeply felt individual and social concerns.

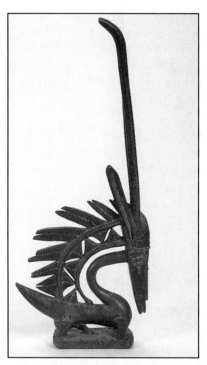

Figure 1-4 The person who made this headdress probably did not refer to it as "art." But for us, the word *art* might be the best way to express our admiration for it.

Antelope headdress. Late 19th–early 20th century. Chi Wara dance headdress with antelope figure; Africa, Mali, Bambara people. Wood, brass tacks, string, cowrie shells, iron, quills. H: 97.8 cm. ©1994 The Art Institute of Chicago, Ada Turnbull Hertle Fund. Photo by Robert Hashimoto. 1965. 6–7.

Art as Cultural Expression

The Chi Wara headdress in Figure 1-4 is part of a whole costume worn by the Bambara people of Mali in western Africa. The carved wooden figure represents a spirit who takes the form of an antelope; the Bambara people call this spirit "Chi Wara." According to their tradition, Chi Wara introduced agricultural cultivation to humankind. The headdress was carved by a Bambara blacksmith. It attaches to a wicker cap, which has a veil that masks the face of the dancer who wears it. Red cloth is tied to the headdress, which is worn with a body costume of fibers dyed black. At planting and harvest times, young Bambara farmers put on these costumes and perform dances that imitate leaping antelope.

For the Bambara, the Chi Wara headdress has a special ceremonial and symbolic significance. It is meant to ensure a bountiful harvest. It is unlikely that the Bambara would consider this headdress an art object in the same sense that most Americans would. Americans would be more likely to display it for viewing than to use it in ceremonial dances.

Understanding the significance of the headdress for the Bambara people can help us to recognize how special it is. All people can value the headdress for its artistic merit, the patterns and design, and for the skill of the carver. It can also be valued because it represents part of the artistic and cultural heritage of a people. It can be valued as art because it is a demonstration of the richness and diversity of human thought, values, and expression.

Monument to a Nation

Throughout history, individuals and societies have created objects that have special significance and visual appeal both for the people who first made and viewed them and for succeeding generations. Carvings, paintings, jewelry, medallions, temples, and monuments are only some of the world's art forms that we can admire in ancient and modern versions. Let's take a closer look at one of these art forms—monuments.

A **monument** *is a visual reminder of an important person, event, or idea in history.* The Great Pyramids of Egypt were monuments to the pharaohs and to the

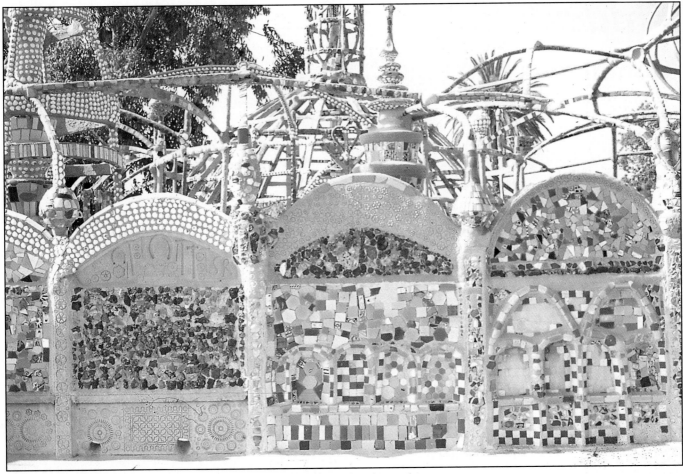

Figure 1–5 Rodia worked on his monument to America for thirty-three years.

Simon Rodia, *Watts Towers*, 1921–1954. Pipe, wire, mortar, found objects. Photo by E. Louis Lankford.

glory of Egyptian civilization. They were marvels to people of the ancient world, and we still marvel at them today. A more recent example is the Statue of Liberty in New York Harbor, which has been recognized around the world for over one hundred years as a monument to freedom.

Although less well known than the Statue of Liberty, *Watts Towers*, pictured in Figure 1-5, is another extraordinary visual monument to America. Constructed in the Watts area of Los Angeles, *Watts Towers* consists of an elaborate network of arches, gateways, and lacy spires pointing skyward. Virtually every inch

is encrusted with glittering pieces of broken glass, colored tile, seashells, and other fragments gathered by the artist, Simon Rodia.

Rodia (1879–1965) was a tile setter who immigrated to the United States from Italy. He wanted to make something lasting and special for his new homeland. Rodia worked on this project for over thirty years. He used no power tools, and he worked alone. Like a fantastic visionary cathedral, the towers rose from Rodia's backyard high above the small houses in his neighborhood. *Watts Towers* is one individual's remarkable artistic legacy to a nation.

Student Activity 2

Monuments in Your Community

Goals

1. You will learn more about the function of monuments in society, particularly in your community.
2. You will develop your skills in perceiving, describing, and interpreting works of art.
3. You will design a monument memorializing some person, idea, or event that you want to remember and honor.

Materials

1. Sketching paper
2. Writing paper
3. Heavyweight drawing paper
4. Pencil
5. Black felt marker
6. *Optional:* watercolors, cardboard, mat knife, tape, glue, found objects and materials

Directions

1. What ideas, persons, or events are honored and remembered by the Great Pyramids of Egypt, the Statue of Liberty (see Figure A), and *Watts Towers* (Figure 1-5)? Can you think of other famous monuments in the United States or other countries?
2. Try to identify some monuments in your community. Perhaps your parents, teachers, and friends can help you to identify some monuments you haven't seen or noticed before. If possible, visit one or more of these monuments on your own, with your family, or with your class. Make notes about each monument, using these questions and activities as your guide:
 a. Where is the monument? Is it in a location where lots of people are likely to see it?
 b. What person, idea, event, or combination of these is honored or remembered by this monument?
 c. How effectively does it function as a monument? Can you tell what it is trying to express?

 d. Do you think this monument is located in an appropriate place? Why or why not?

 e. Try to describe the monument in words. Write down what it looks like, what you think it means, and how successful you think it is.

 f. Draw a sketch of the monument.

3. Sketch a design for a monument to be placed in your community. What person, idea, or event in your community deserves to be honored by your monument? It can be a monument related to the present or the past.

4. Make a more detailed, finished drawing of your final design in black marker on heavyweight drawing paper.

5. Write a description of your monument to accompany your drawing. Include the following in your description:

 a. Where would it go?

 b. How big would it be?

 c. What would it be made of?

 d. What does it mean?

 e. Why would this be a good monument for your community?

6. Share your design with the class.

7. *Optional:* use watercolors to paint a view of your proposed monument in full color. Don't forget to include any landscaping or nearby buildings that would also be visible around your monument. If you want to take your plans a step further, build a scale model of your proposed monument, using cardboard, mat knife, tape, glue, and other materials that will help you represent your plan in three dimensions.

Evaluation

1. Have you deepened your understanding of the significance of monuments to society? Tell some of what you have learned.

2. Identify some monuments in your community and tell what they mean.

3. Have you made a written record of a monument in your community? Add it to your portfolio.

4. Have you completed a design for a monument and supported your design with a clearly written description of your plan? Add these to your portfolio.

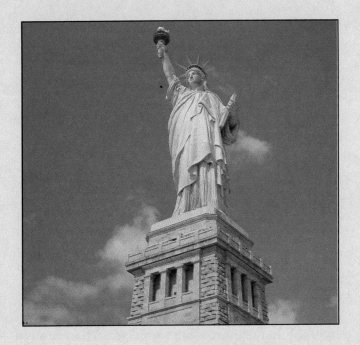

Figure A

Frédéric-Auguste Bartholdi (French sculptor, 1834–1904), *Liberty Enlightening the World*, 1876–1886. Copper. Height: 305'6" on pedestal. Liberty Island, New York Harbor. Photo ©1994 J. E. Stevenson/FPG International.

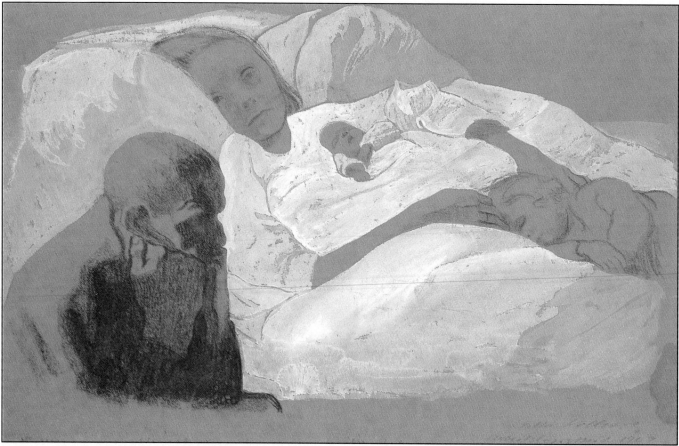

Figure 1-6 Art does not always portray the beautiful or happy aspects of life, as this grimly moving drawing demonstrates.

Käthe Kollwitz, (German, 1867–1945), *Out of Work*, 1909. Charcoal and whitewash over graphite on dark brown wove paper. 11½" × 17½". Rosenwald Collection, National Gallery of Art, Washington, D.C. ©1994 Artists Rights Society (ARS), NY/VG Bild-Kunst, Bonn. 1943.3.5218. (B-7714)/DR.

Sometimes Art Is Disturbing

Käthe Kollwitz (1867–1945) was a German artist who witnessed the horror of war and the desperation of people who lived under political oppression. These subjects frequently formed the themes of her art. *Out of Work* (Figure 1-6) grimly depicts one family's desperation. The mother and children look weak and undernourished. The father, with a dark shadow over his face, sits in a gesture of hopeless despair. Such a stark image of human suffering and frustration is not what we would ordinarily call "beautiful." Yet it is powerfully moving. A work of art like this one reveals problems of human existence and history that some people would prefer to forget or ignore. Art is not always pretty or easy to look at; it can sometimes make us feel uncomfortable.

Art Can Have Hidden Meanings

As the Kollwitz drawing illustrates, a work of art can be meaningful for its subject matter and for the ideas and feelings it conveys. On the surface, the painting

Sunflowers in the Windstorm (Figure 1-7) by Emil Nolde (1867–1956) seems to be a strong contrast to the Kollwitz work. Kollwitz has confronted us directly with the face of human suffering. Nolde's painting, at first glance, might be dismissed as just another rendition of flowers. Closer inspection, however, reveals a more troubling image. Notice the ominous mood of the sky. Heavy, dark clouds painted in black, purple, orange, and green almost fill the canvas. This clearly is no ordinary storm but is an eerie, terrifying one.

Set against this backdrop and pushed into the foreground are three sunflowers. They strain against fierce winds. The fact that the artist chose sunflowers is important. They are struggling to survive in a world with very little sunlight.

Sunflowers in the Windstorm was painted during World War II in Germany. Nolde had been forbidden by the Nazis to work as an artist. The Nazis considered his

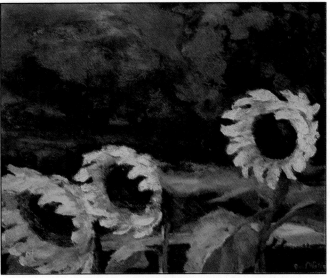

Figure 1-7 What do the sunflowers represent? What does the storm represent?

Emil Nolde, *Sunflowers in the Windstorm*, (*Sonnenblumen im Sturwind*), 1943. Oil on board. 28⅝ × 34⅝ in. (72.6 × 88.1 cm.) Gift of Howard D. and Babette L. Sirak, donors to the Campaign for Enduring Excellence and the Derby Fund. Columbus Museum of Art, Columbus, Ohio. ©Nolde-Stiftung Seebüll.

TECHNOLOGY MILESTONES IN ART

Oil on Canvas

Painting today is much easier than it used to be. Now we can purchase ready-to-use paints and canvases at neighborhood art supply stores. Prior to the nineteenth century, the preparation of paints was one of the most difficult tasks in the painter's studio. Artists had to manually crush and grind pigments into fine powders. Pigments were made from minerals, coal tar, and dyes made from plant, fish, and animal by-products. After grinding, the powders were mixed into a paste with strong-smelling turpentine and nut or seed oils and thinned to a workable consistency just before using.

By the late 1700s, paints were commercially available in Europe and America. But it was not until the 1840s that manufacturers prepared paints in tubes similar to those we use today. Modern paints contain *pigments* for color, *binders* to keep the pigments and other elements of the paint together and to help them adhere to a painting surface, a *vehicle* to keep the paint fluid, a *preservative* to extend the shelf life of the product, and a *dryer* or chemical to facilitate the even drying of the paint once it is applied.

Painting on canvas didn't appear in Europe until the 1500s. Prior to that, artists painted directly on prepared walls or wooden panels. The light weight of canvas made paintings more portable and easy to hang. Artists had to adjust to the texture of the cotton and the "give" of the surface. Also, painting on untreated canvas was unacceptable because it would absorb the paints quickly, making them dull and unworkable. Another problem was that canvas fabric would rot over time. To compensate for these unfavorable characteristics, artists would *prime*, or prepare, their canvases for painting by coating them with glues, *gesso*—a fluid form of plaster of paris, and a lead-based paint (which is now known to be toxic). Once it was primed, the canvas provided a stable, smooth surface for painting. Most artists still prefer to work on primed canvas and modern acrylic gesso is much safer and easier to use.

paintings too modern, which to them meant "decadent." (Decadent means immoral, corrupt, and setting a bad example.) They believed his art was a threat to the narrowly defined "correct" social order they were trying to establish. Nolde had to paint *Sunflowers in the Windstorm* in secret. By doing this, he was defying the Nazi regime at great personal risk. Perhaps this painting is a visual allegory for his experience. An **allegory** *is a story in which characters, things, and events have hidden meanings.* Usually an allegory relies on symbols to convey messages. A **symbol** *is something that stands for or represents another thing.* In this case, Nolde's sunflowers may be representing art and beauty. The storm clouds may represent tyranny, oppression, and war. The painting is rich with possible meanings.

As Nolde's painting demonstrates, the meaning of a work of art may not be fully evident by looking at the work by itself. We might not have attached allegorical meaning to *Sunflowers in the Windstorm* had we not learned something about the history of the artist and the social conditions under which he worked. Similarly, knowledge of Bambara ceremonial traditions helped us to understand the significance of the Chi Wara headdress. Very often, the meaning and value of a work of art only becomes clear after we have studied it carefully. Searching for the meanings of artworks we are attracted to, but don't fully understand, can be a rewarding and satisfying experience. This is one of the reasons that people value art.

Student Work

Gary Montoya, 16
Cooper High School; Abilene, TX

Section ❶ Review

Answer the following questions on a sheet of paper.

Learn the Vocabulary

Vocabulary terms for this section are *art, perceive, expression, expressive, monument, allegory,* and *symbol.*

1. Match the following description to the appropriate vocabulary term:
 a. A visual reminder of an important person, event, or idea in history
 b. Term to describe a work of art that effectively communicates feelings and ideas in a visual form
 c. A story in which characters, things, and events have hidden meanings

Check Your Knowledge

2. What characteristics make the *Flag Gate* a work of art?
3. What kinds of things can you learn about a culture by studying its monuments?
4. How does knowing about Emil Nolde's background help you understand his painting, *Sunflowers in the Windstorm?*

For Further Thought

5. What could someone who is unfamiliar with our culture learn about American society by looking at Simon Rodia's *Watts Towers?* What ideas, concerns, values, and beliefs does it convey?

Section II

How Art Is Valued

Why do people bother with art at all? Why do people collect it, preserve it, protect it, and study it? It's because we value art. When we value something, it means that we find it desirable, worthwhile, and important. A work of art may be valuable to us in several different ways.

Aesthetic Value

One type of value often associated with art is *aesthetic* (es-THEH-tic) value. **Aesthetic value** *is the impact a work of art has on our senses, intellect, and emotions.* We are figuring out the aesthetic value of a work of art when we concentrate on the extent to which it stimulates our vision, thoughts, and feelings. For example, we can value the Nolde painting (Figure 1-7) aesthetically because it is powerful in its ability to express courage in the face of overwhelming odds. We may be moved in a very different way by the still life painted by Severin Roesen (Figure 1-2). In *Still Life: Flowers and Fruit*, the artist has expressed his love for the beauty and bounty of nature. Clearly, Roesen has lavished a great deal of attention on this painting so that we might share in his wonder and appreciation of the natural world. Although the Nolde and the Roesen paintings contrast with each other—one is grim; the other, glorious—each can provide a meaningful and memorable experience.

Art can be admired and valued for its beauty alone. But art that is not beautiful can be just as expressive. Just looking at such artworks and allowing ourselves to think and feel in response to them is a rewarding experience. Valuing a work of art aesthetically means that we value it for its ability to touch our hearts and minds. It means that we value the work of art for its own sake rather than for any practical purpose it may serve.

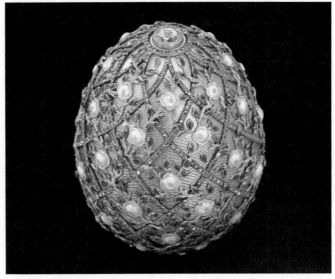

Figure 1-8 Fabergé's eggs are valued for their beauty of design and craftsmanship more than for their precious materials.

Rose Trellis Egg, Workshop of Fabergé. Walters Art Gallery. Baltimore, Maryland.

Economic Value

Another type of value people often think of is *economic* value. Some works of art have sold for enormous sums of money—tens of millions of dollars. Sometimes many museums and private art collectors will want to own the same work of art. When that happens, the price of the work will go up as the collectors bid against each other. The highest bid sets the "market value" of the artwork and affects the value of other works of art made by the same artist. It also affects the cost of insuring artworks produced by that artist. The market value of a work of art can change from day to day.

Art is seldom purchased just as an investment, however. Most people acquire art because they like it and because it is meaningful to them. For such people, art is "priceless," no matter what a work of art costs.

Look at Figure 1-8, the *Rose Trellis Egg* created by a jewelry firm known as the House of Fabergé (fa-ber-ZHAY). This firm, managed by Peter Carl Fabergé (1846–1920), created luxurious jewelry, table silver, and precious decorative objects for the imperial families of Czarist Russia. The *Rose Trellis Egg* is one

of several Easter eggs that the House of Fabergé fashioned from colored enamels, precious metals, and precious stones such as diamonds, rubies, sapphires, and emeralds. Although small in scale—only a few inches high—each egg is incredibly detailed. Most of the eggs open to reveal a tiny surprise inside, such as a miniature golden palace or portrait of an empress. All of these eggs are remarkable for their beauty, elegance of proportion, and exquisite craftsmanship.

We might wonder what such artworks are worth in terms of money. They're worth a lot. But Fabergé's eggs are valued even more for their beauty and craftsmanship than for the value of the precious materials used to make them. The *aesthetic* value of the *Rose Trellis Egg* is the chief reason that people preserve, protect, and cherish it.

Historical Value

An artwork created by the House of Fabergé has *historical* value as well as aesthetic and economic value. Russia is one of the largest and most politically important nations on earth. The era during which the czars ruled Russia is an important chapter in that country's history. Objects from Fabergé provide us with glimpses into the tastes, values, and life-styles of the imperial families of that time. Similarly, works of art from other nations and time periods are valued for their ability to reveal ideas, beliefs, customs, and technologies of people in history.

Social Value

Another type of value is *social* value. A work of art can represent important social ideals or focus attention on important social issues. Remember the *Flag Gate* (Figure 1-3)? It was an expression of one person's love for American liberty. You might also want to refer back to *Out of Work* (Figure 1-6). The artist, Käthe Kollwitz, provided us with a moving portrait of an unfortunate social condition and its unhappy results. Artists can use their art to express concern for virtually any social issue, from poverty, political oppression, injustice, and homelessness to personal relationships, work-related

stress, and war. Let's look in detail at one example of a work of art that is notable for its social value.

Figure 1-9, *Guernica* (GUAIR-nee-kuh), is a large-scale painting by Pablo Picasso. Picasso (1881–1973) created *Guernica* for the Pavilion of the Spanish Republic at the 1937 Paris International Exposition. The artist had been outraged by the senseless bombing of the village of Guernica in northern Spain during the Spanish Civil War. Although Picasso had moved to France in 1904 to pursue his career as an artist, Spain was his homeland. *Guernica* was his response to tragic events in his native land. But more than that, *Guernica* is a vivid and powerful condemnation of the brutality of war.

Picasso's painting, in addressing an important social issue, illustrates how art can have social value for viewers. But *Guernica* is also historically and aesthetically valuable. From an aesthetic standpoint, we value this work of art because it conveys strong emotions and makes us think. From a historical standpoint, we value it for reminding us of a moment that might have been forgotten were it not for Picasso's moving record of the terrible event.

Guernica is also important to art history. Picasso's style of painting was daring for its day, and it influenced many other artists, helping to shape the history of art in the twentieth century. Picasso chose to work in an **abstract** style, which means that he *purposefully invented, distorted, and rearranged forms and colors rather than trying to present them "realistically"* (the way we might ordinarily see things in our environment). By employing an abstract style and limiting his colors to black, white, gray, and a little yellow, Picasso was able to create in *Guernica* an image whose stark contrasts are jarring. He was able to exaggerate the expressiveness of his cast of symbolic characters. Let's identify some of the symbols in *Guernica*.

A fallen warrior, still clutching his broken sword, lies beneath the hooves of a terrified, dying horse. In the 1930s, few warriors fought with swords from horseback. This warrior symbolizes all fallen warriors throughout history. To one side, a figure with flailing arms is trapped in fiery debris. On the other side, a mother wails while clutching her limp child. These figures represent all people, young and old, who have suffered or died as victims of war. Amid all this chaos and

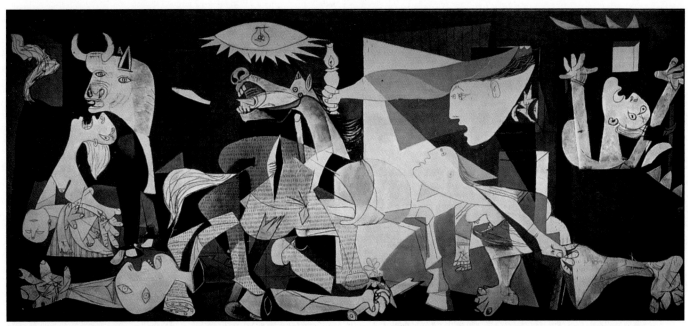

Figure 1-9 The powerful expressiveness of this painting is the main reason that it has become one of the most highly regarded and valued works of art in the world.

Pablo Ruiz Picasso, *Guernica*, 1937. Mural. Oil on canvas, approx. 11'6" × 25'8". Centro de Arte Reina Sofia, Madrid, Spain. ©1993 Artists Rights Society (ARS), NY. Giraudon/Art Resource, NY.

horror stands a bull, appearing strong and menacing. Overhead, a lamp bearer hovers in the air and seems to offer only a glimmer of light. Through these symbols, Picasso has managed to draw us into the scene in order to make us think and feel deeply.

Religious Value

A final type of value to be considered is *religious* value. For centuries, cultures throughout the world have used art to express their most profound beliefs. From vast temples and cathedrals to delicate paintings and carvings, religious art has helped people glorify and interpret the object of their faith.

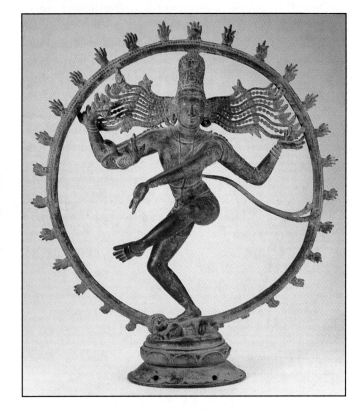

Figure 1-10 The ancient figure of dancing Shiva is rich with symbolism and has deep religious value for Hindus.

Shiva Nataraja, Indian, Tamil Nadu, bronze, 10th–11th century, Chola period. Ht.: 71.1 cm. Kate S. Buckingham Collection. 1965.1130. Photograph ©1993, The Art Institute of Chicago. All rights reserved.

Religious art tends to be symbolic. Look, for example, at Figure 1-10 on the previous page, called *Shiva Nataraja* (SHE-vah nah-tah-RAH-jah). This sculpture represents Shiva, an important sacred figure in Hinduism. Shiva is depicted dancing. Each gesture of the dance is symbolic. In one hand burns the flame of destruction. In another is a small drum, representing the rhythms of life. Another of the *Shiva Nataraja's* four hands is raised in a comforting gesture, as if to indicate "Fear not." The fourth hand points to a leg raised in dance, symbolizing liberation from profane ignorance. One of Shiva's feet stands on the back of a demon-dwarf, who symbolizes ignorance; this reinforces the idea that Shiva has conquered ignorance. The waters of the holy rivers in India are represented by Shiva's flowing hair. The most sacred river, the Ganges, is personified by a tiny figure in Shiva's hair near the top of the circle of fire. This ring of fire surrounding the dancing Shiva represents the cosmos, or universe.

It is remarkable how a single sculpture can be charged with so much meaning. These meanings are not evident to the untrained eye. In order to understand the work well, we must learn how to interpret its symbols.

We can appreciate the grace and elegance of the dancing figure and the superb artistry of its maker. We do not know who made this sculpture, but the artist was following a long tradition. There are many versions of *Shiva Nataraja*, which vary in size and in the materials with which they have been made. But they all share the same basic forms, gestures, and symbols. Other religions have their own rich and complex traditions of symbolic art.

TECHNOLOGY MILESTONES IN ART

Bronze

Bronze is an *alloy*, or mixture, of copper and tin. It has been favored by metalsmiths and sculptors since ancient times for its beautiful golden-brown color, strength, versatility, and durability. Jars and other vessels made of bronze have been dated by historians to at least 2500 B.C. Bronze artifacts have been found among the remains of ancient civilizations in Africa, China, Europe, India, and elsewhere.

The earliest pieces were shaped and hammered by hand from sheets of bronze, with rivets holding them together. By the sixth century B.C., Greeks and Romans had mastered the art of casting statues by pouring molten bronze into carefully prepared molds, a process still used today. Such statues range in size from small to quite large. After the bronze has cooled, the surface of the statue must be smoothed and detailed by the artist using hand tools.

After bronze has been cast and cooled, the statue must be smoothed, cleaned, and detailed by hand. Bronze will darken over time as it is exposed to weather and other environmental conditions.
Photo by E. Louis Lankford.

Student Activity 3

Looking in Depth at *Guernica*

Goals

1. You will further develop your ability to interpret visual symbols.
2. You will get a better idea of why Pablo Picasso's *Guernica* is revered as one of the world's greatest works of art.
3. You will get a sense of the massive scale of *Guernica* that you cannot get from looking at a reproduction in a book.

Materials

1. Availability of a large room, such as a gymnasium, or an open outdoor field or lawn
2. Tape measure

Directions

1. Look carefully at the reproduction of Picasso's *Guernica* in Figure 1-9. Read the corresponding portion of the text. In a class discussion, try to answer these questions:
 a. What do you think the bull symbolizes in the painting?
 b. What do you think the lamp bearer symbolizes?
 c. Why do you think Picasso chose to paint *Guernica* with so few colors? How did that decision affect the overall impact of the painting?
 d. Although the painting was titled after one town that was victimized by war, *Guernica* has come to symbolize war in general. Why do you think this is so?
2. Move to a large room uncluttered by furniture or to a flat open space outdoors. Take with you a long tape measure and the dimensions of *Guernica*, which are printed by the reproduction in this book.
3. Measure out the dimensions of *Guernica* on the floor or ground, and mark the perimeter by standing with your classmates along the edge.
4. Imagine walking into a room in which *Guernica* is exhibited. Discuss how you think the size of *Guernica* must affect its visual impact.

Evaluation

1. Did you think seriously about what *Guernica* and its symbols mean? What were some of your interpretations?
2. How well did you articulate your thoughts to others? What are some steps you can take to try to ensure that others will understand, or have understood you?
3. Did you participate constructively in the class discussion and activity? In what ways?
4. Do you think that you have grown in your ability to find meaning in works of art? Does this give you more confidence about "looking in depth" at other works of art in the future? Practice by interpreting another work of art.

19

Pablo Picasso

Pablo Ruiz y Picasso (PAH-blow roo-EES ee pea-KAH-so) was born on October 25, 1881, in the town of Málaga (MAH-lah-gah), Spain. He was the first of three children born to Doña Maria Picasso y López (DOAN-yah mah-REE-ah pea-KAH-so ee LO-pehz) and her husband, Don José Ruiz Blasco (doan ho-SAY roo-EES BLAHS-ko). Don José was a painter and teacher at the School of Fine Arts and Crafts, and he also worked at the local museum. Throughout Pablo Picasso's young life, Don José provided art instruction and encouragement to his eldest son. Some of Pablo's earliest surviving drawings depict bullfights that Pablo saw with his father.

At age eleven, Pablo was enrolled by his father in the School of Fine Arts in La Coruña (lah koh-ROON-yah), Spain. He amazed both his father and his teachers with his extraordinary artistic talent. He drew and painted portraits, landscapes, and battle scenes. In his early teens, he began keeping personal journals illustrated with his own pen-and-ink drawings and caricatures of people he knew and met.

In 1895, Pablo traveled with his family to Madrid, where he visited the famous Prado (PRAH-doh) Museum. There he saw for the first time paintings by some of the most admired Spanish artists, including Velásquez (veh-LAHS-kehz) and Goya. That same year Pablo's family moved to Barcelona, where Pablo was allowed to skip the entry-level classes at Barcelona's School of Fine Arts and enroll directly in advanced courses. The following year, at age fourteen, he completed and exhibited his first large-scale oil on canvas, *First Communion* (Figure 1-11).

By the time he was seventeen, Pablo was determined to create a style of art different from what he had learned in school. With a friend, he lived for a while in a cave near the little town of Horta (hor-TAH) and sketched the surrounding countryside. He then returned to Barcelona and moved from there, at age nineteen, to Paris, France. For the next ten years he lived in poverty as he worked to win success as an artist. Eventually his talent, hard work, and dedication to art were recognized worldwide. He became one of the most wealthy and well-known artists of the twentieth century. His innovative artistic styles have influenced countless other artists. Picasso continued to paint prolifically right up until his death, on April 8, 1973, at the age of ninety-one.

In an interview in 1935, Picasso shared some of his observations about his own artistic processes and works of art:

"A picture is not thought out and settled beforehand. While it is being done, it changes as one's thoughts change. And when it is finished, it goes on changing according to the state of mind of whoever is looking at it."

Figure 1-11 Pablo Picasso, *First Communion*, 1896. Barcelona, Museo Picasso. Giraudon/Art Resource, NY. ©1994 Artists Rights Society (ARS), NY/SPADEM, Paris.

> "In reality one works with few colors. What gives the illusion of their being many is simply the fact that they have been put in the right place."
>
> Pablo Picasso

Section II Review

Answer the following questions on a sheet of paper.

Learn the Vocabulary

Vocabulary terms for this section are *aesthetic value* and *abstract*.

1. Imagine you are explaining to a younger person what each of these terms means. What would you tell her?

Check Your Knowledge

2. Name some reasons that Easter eggs made by the House of Fabergé are highly valued.
3. How does Pablo Picasso's use of an abstract style affect the aesthetic value of his painting *Guernica*?

For Further Thought

4. Think of an idea, belief, or concern that is important to you. Imagine how you might express it artistically through either painting or sculpture. Can you think of some symbols you would use to help convey your meaning? For which reason would you like your work of art to be valued—aesthetic, economic, historical, social, religious, or some combination of these? Why?

Section III

Approaches to the Study of Art

Lots of people make, admire, and study art. Many people enjoy painting as a leisure-time activity. It is an excellent way to exercise the imagination and apply one's knowledge and skill creatively and constructively. Other people enjoy looking at and studying art in their spare time. Art museums across the country and around the world welcome millions of visitors each year. Large numbers of adults enroll in evening and weekend art appreciation classes. A person does not have to be a professional artist or critic to recognize and reap the benefits from art's special qualities, meanings, and values. There are many avenues for *you* to follow in order to enjoy and participate in the world of art!

There are four areas of study that are potentially useful to anyone who wishes to understand and appreciate art beyond a surface level. Those areas of study are *aesthetics*, *art criticism*, *art history*, and *studio production*. These four areas overlap considerably. Together, they can add both breadth and depth to your experience of art by making art more meaningful.

Aesthetics

Aesthetics *is an area of study aimed at understanding the nature of art. By the "nature of art," we mean its essential characteristics, including why art is made, what forms it takes, and how people respond to it. Aesthetic inquiry poses questions about the nature of art, such as what is the definition of art? What roles does art play in culture and society? How is art valued? How can we go about understanding art better?* By now, you've probably figured out that this chapter is devoted primarily to aesthetics.

THINKING ABOUT

AESTHETICS

Some artists prefer to work with traditional materials, like oil paint and marble. Other artists prefer more contemporary, "high-tech" materials, such as lasers and computers.

1. How might you justify the use of traditional art materials to someone who thinks these materials are hopelessly "old-fashioned" and "out-of-date"?

2. How might you justify the use of contemporary, high-tech materials to someone who thinks such materials shouldn't be used to make art? (Someone might argue, for example, that high-tech materials are "too gimmicky" and "too far removed from human hands.")

ALL THINGS ARE DELICATELY INTERCONNECTED

•

ABUSE OF POWER COMES AS NO SURPRISE

•

SOMETIMES SCIENCE ADVANCES FASTER THAN IT SHOULD

•

SELFISHNESS IS THE MOST BASIC MOTIVATION

•

SELFLESSNESS IS THE HIGHEST ACHIEVEMENT

•

SLOPPY THINKING GETS WORSE OVER TIME

•

MONEY CREATES TASTE

Artists Challenge Our Thinking. Contemporary art and artists have made the field of aesthetics challenging and exciting. For example, what would you think of a visual artist who conveys ideas with words rather than pictures? Is this person an artist in the same sense as someone who paints with oils on canvas or sculpts in marble? Do words and phrases in written presentations belong as visual artworks on the walls of museums and galleries, alongside paintings and drawings? Are we expected to respond to and value a presentation of words in the same way as we do pictures in an art gallery?

Words are the primary form of expression for an artist named Jenny Holzer (born 1950). Holzer uses light-emitting diode (LED) signs to transmit to others what she calls *Truisms*—brief sayings designed to make us think about the way the world is. She adds emphasis to her *Truisms* by presenting them in all capital letters. See the examples at the top of the next column.

Although Holzer's work has appeared in art galleries and museums, she often prefers to exhibit in more public places, where people might not expect to encounter thought-provoking signs. Her *Truisms* have appeared at Candlestick Park in San Francisco, outside Caesars Palace Hotel in Las Vegas, and above Times Square in New York City. *Truisms* have been printed on T-shirts, benches, and the sides of pencils. Internationally acclaimed, Holzer has captured the imagination and the social conscience of countless people around the world.

Holzer's *Truisms* make a powerful visual impact as well as deliver a message. The LED signs are often as large as billboards, and they appear in various vivid colors. Sometimes they flash off and on or move in horizontal or vertical patterns.

One of Holzer's most visually stunning installations was in the Solomon R. Guggenheim Museum in New York. The famous interior of the Guggenheim Museum, designed by architect Frank Lloyd Wright (1867–1959), features a central rotunda. A ramp spirals around the edge of the vast circular space. In Figure 1-14 on page 26, you can see how Holzer's *Truisms* followed that spiral, the words winding slowly and evenly upward in a 535-foot electronic sign. Such work is a far cry from what most people expect to see in an art museum!

Variations of Beauty

Works of art reflect the ideas and values of the culture in which they are made. Artists cannot help but be influenced by the social environment in which they live and work. The habits, customs, and beliefs of a culture are often mirrored in the form and content of works of art. Although in the twentieth century artists have often consciously tried to "go against the grain" in order to confront viewers with controversial points of view, most works of art throughout history have echoed the values of their cultural origins. Let's consider two visually contrasting examples of works that reflect certain cultural values.

Figure 1-12 shows a teacup manufactured in Sèvres (SEH-vrah), France, in the 1700s. It is made of porcelain, a specially formulated clay that produces a hard, smooth, pure white, slightly translucent ceramic. The porcelain has been evenly glazed and delicately decorated in rich colors. Its shape and weight have been carefully formed and balanced.

When this teacup was produced, porcelain had been imported to France from China for a long time.

(People still use the term *china* to refer to porcelain dishes.) But around 1700, after much research and testing, the French produced a new form of porcelain that had the light yet sturdy qualities they desired. This allowed them to produce dishes designed and decorated to match the tastes of the day. Although porcelain was produced to fit the incomes of various economic levels of society, the most lavishly decorated dishes, vases, and other items were reserved for the wealthiest—mostly royal—citizens. So important was porcelain to privileged French society that the Marquise de Pompadour (mar-KEEZ duh PAWN-pah-door), one of the most influential members of the French court of King Louis XV, established a royal apartment at Sèvres and provided support to the porcelain factory there.

Art in France at this time was highly decorative and refined. Care would have been taken to produce a cup and saucer that were lightweight and well balanced in the hand. Careful attention to small details in the form and decoration invited close inspection and admiration by those who used these dishes.

The controlled formality of the dishes was perfectly suited to the social occasions when they were used. The preparation and presentation of food and drink demanded careful attention, for food not only had to smell and taste good but it also had to be vi-

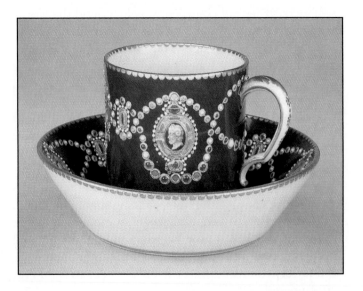

Figure 1-12 Antoine Capelle (porcelain painter, French, active 1746–1800) and Etienne-Henri Le Guay père (porcelain gilder, French, active 1771, 1778–1781 and 1783–1785), *Cup and Saucer (Gobelet Litron et Soucoupe)*. Sèvres Porcelain Manufactory. Collection of the J. Paul Getty Museum, Malibu, California.

sually beautiful as well. Dining or sipping tea at social gatherings required that strict rules of etiquette be obeyed. Men and women dressed in their finest attire for these occasions.

Now let's move our attention to Figure 1-13, a Japanese tea bowl. This tea bowl is stoneware, made of a darker, heavier, more grainy clay than porcelain. The tea bowl is designed to fit comfortably in the palm of the hand. Its form is very uneven when compared with the cup pictured in Figure 1-12. Little attempt was made to hide the hand of the maker. We can see indentations and bulges where the artist pushed, pulled, and shaped the clay by hand. The rim of the tea bowl is not uniformly level. The coloring, too, is uneven; the glaze has been allowed to run down from the rim and pool near the bottom of the bowl. Such effects are not only the result of the artist's choice of glazes but also result from the method of *firing* the vessel. **Firing** *is a process of heating clay at very high temperatures, then allowing it to cool gradually, which results in making the clay and glazes hard and impervious to water.* The tea bowl pictured in Figure 1-13 is an example of Raku ware, which results from a process of firing developed by the Japanese in the sixteenth century. Raku firing involves very rapid heating of ceramic pieces, then plunging them while still hot into leaves or other natural combustible materials that burn and smoke. This process yields unpredictable results and is quite different from the carefully controlled and predictable processes utilized in Sèvres, France.

This tea bowl was designed for use in traditional Japanese tea ceremonies. These ceremonies, associated with Zen Buddhism, are deeply rooted in Japanese culture. Although special teas and a light meal are served, the principal purpose of the ceremony is to honor the virtues of peace, harmony, respect, purity, and tranquillity. The ceremony itself is quiet, disciplined, and carefully paced. Guests remove their

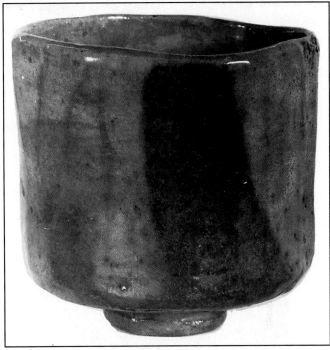

Figure 1-13 Yamasho, *Tea Bowl*, Japanese, mid-19th century. Raku ware. 4⅛" diameter. Museum of Art, Rhode Island School of Design. Gift of Isaac C. Bates. 09.027.

shoes and put on slippers before entering the ceremonial space. Sitting on a mat or small cushion on the floor, guests enjoy looking at carefully arranged flowers and engaging in quiet conversation with the host. Tea bowls used in the ceremony are highly prized possessions, and it is customary for honored guests to examine and admire the tea bowls offered them.

To many people, beauty resides in the sort of precise form and elaborate ornamentation seen on the French porcelain. To others, beauty lies in simplicity. Although each of these vessels is meant to serve tea, they are cultural expressions from very different ways of life.

Expanding the Boundaries of Art. As Holzer's work demonstrates, artists are constantly expanding the boundaries of what counts as art, what artists express and how they do it, and how viewers respond to art. Aesthetics can help us come to grips with these concerns so that the art we make and the art we encounter will be meaningful for us.

Artists are not the only source of challenge to our thinking about art. Art historians, art critics, museum curators, art educators, and a host of other people may present ideas that change the way we think about art. Sometimes circumstances or events force us to rethink our position on a work of art or issue in the world of art. You might enjoy pondering the aesthetic issues raised in "Student Activity 4: The P.M.A.M. Decision."

Aesthetic issues will emerge in other portions of this book. Although this chapter has introduced many basic ideas and issues of aesthetics, you may want to learn more about particular theories of art. An **art theory** *attempts to explain why certain objects or events are called*

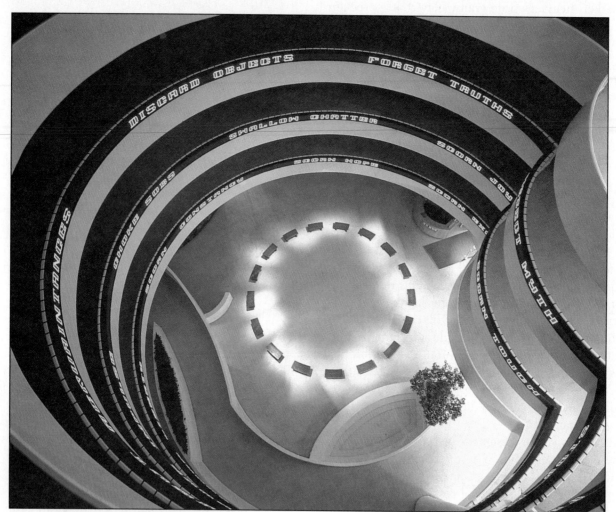

Figure 1-14 Work such as this challenges us to think about the nature of art even as we think about the artist's message.

Jenny Holzer, *Selections from Truisms, Inflammatory Essays, The Living Series, The Survival Series, Under a Rock, Laments* and a new writing, 1989. Extended helical tricolor L.E.D. electronic display signboard. 11" × 162" × 4" (27.9 × 411.5 × 10.2 cm). Solomon R. Guggenheim Museum, N.Y., partial gift of the artist, 1989. Photo: David Heald ©The Solomon R. Guggenheim Foundation, N.Y. FN89.3626.

art. Many art theories identify important features or characteristics shared by works of art. Appendix A contains a description of six art theories that have influenced the way people have recognized, understood, and appreciated visual art.

Chapters Two, Three, and Four of this book will focus on aspects of art criticism, art history, and studio production. Let's take a brief introductory look at each of these approaches to the study of art.

Art Criticism

Art criticism is *a process of asking questions about a work of art through which we may discover many of the work's meanings.* It is concentrated looking. It is looking with a purpose. Its aim is to get the maximum enjoyment and meaning from an encounter with a work of art. Although you may not aspire to be an art critic, you can learn to get more meaning and satisfaction from art by approaching it as a critic might. You will find in Chapter Two that being a "critic" takes a lot of work.

Some people have the mistaken idea that an art critic is a person expressing a hastily formed opinion— usually a negative one—about the value of a work of art. In reality, critics who take their work seriously put a great deal of time, research, and thought into their critical accounts. They look for what is good and successful in a work of art. Critics do much more than pass judgment. They have certain goals in mind when they write or speak critically about art. Two goals that critics usually have are *to educate the public* and *to search for meaning* in works of art.

Educating the Public. When we say that a critic wants to educate the public, this does not mean that the critic wants to teach classes in schools or colleges (although some do teach in that way, too). Critics educate the public by reporting their observations and thoughts about art in published reviews. Critics who write for newspapers and magazines alert their readers to worthwhile opportunities for viewing art in their communities. Readers who are able to attend exhibitions that have been reviewed may find the critic's observations helpful in guiding their own study of the artworks on display. Critics will often point out the highlights of an exhibition or provide background information about the artists, artistic materials and techniques, or the thematic content of the works of art. Readers who are unable to attend an exhibition may still be able to learn about it and from it by reading a critic's account.

Searching for Meaning. Another goal of the critic is to search for meaning in works of art. This will help the critic understand and evaluate the works exhibited. It will also help the critic in educating the public, as interpretations can be passed on to the public via reviews. An **interpretation** is *an informed explanation of the meaning of a work of art.* To do this, a critic will study the artwork carefully. Often, the critic will use additional information that comes from outside the work of art itself to aid in the interpretation. Such information may include biographical data about the artist and facts about the conditions present at the time and place where the work of art was produced. These ideas will be more fully explored in Chapter Two, "Criticism: The Quest for Meaning."

DEVELOPING SKILLS FOR

ART CRITICISM

Art criticism can help you get more meaning and enjoyment from works of art. It can help you to recognize how artists have achieved certain effects. Return to Figure 1-1, a work of art by Romare Bearden.

1. What scene has the artist depicted? Describe the characters and activities pictured.

2. Describe how the artist has arranged the various parts of the picture. What makes his arrangement special—different from the way we might see it in "ordinary life"?

3. Is this scene one that many people can relate to? In what way? What social values are represented?

Student Activity 4

The P.M.A.M. Decision

Goals

1. You will get to practice aesthetic inquiry by discussing a fictional scenario.
2. You will learn more about the kinds of decisions people other than artists have to make in the world of art.
3. You will develop your ability to think through difficult issues in art, on your own and through dialogue with others.

Materials

1. Writing paper

Directions

1. Read through the fictional scenario entitled "The P.M.A.M. Decision" printed after these instructions. A **scenario** *is a short summary of a real or imagined series of events.*
2. After you have read the scenario *but before you discuss it with anyone,* jot down on a piece of paper your answers to the questions at the end of the story. This will allow you to formulate your own ideas before you are influenced by anyone else.
3. Your teacher will break up the class into three or four discussion groups. Members of each group should take turns expressing their individual responses to the questions. After that, let the discussion flow naturally, being careful to listen and respect the points of view of your classmates.
4. Each group should provide an oral summary of their discussion to the class as a whole. It is *not* necessary for a group to come to an agreement, or consensus, on its members' answers to the questions. If there are differing points of view, report them fairly.
5. Answer the following related questions after completing items 1–4:
 a. How would you compare thinking about the questions that accompanied "The P.M.A.M. Decision" on your own and in a group discussion? Was it easier for you to think more clearly in one situation than in the other? Did you find one way more stimulating or thought provoking than the other?
 b. Did you change your mind or develop and refine your ideas as a result of the group discussion? Did it help to "bounce your ideas off someone else" or to hear someone else's opinions?

The P.M.A.M. Decision

Since 1908, the Petersburg Municipal Art Museum (P.M.A.M.) has housed an oil-on-canvas painting titled *Jacob's Ladder*. Although the painting is not signed, experts have attributed it to the famous Dutch artist Rembrandt van Rijn (van RHINE) (1606–1669). The painting, one of the museum's showpieces, was a gift from the estate of a wealthy collector. It was attributed to Rembrandt because of its biblical content, bold brush strokes, dark shadows, and luminous highlights, all of which were characteristic of Rembrandt's later paintings.

On March 4, a madman entered the museum and, to the horror of museum visitors, produced a carving knife. He managed to cut several long slits through *Jacob's Ladder* before he could be stopped by museum guards. The damage to the painting was extensive. *Jacob's Ladder* was immediately transferred to the museum's restoration division.

On March 21, chief restorer Dr. Sonya Pierre entered the museum director's office looking somewhat distraught and closed the door behind her. Then she gave her preliminary report:

"We've run tests on the pigments and primers of the slashed painting in order to know which materials to use to repair it properly. To be certain of our results, we ran the tests twice and had the university lab conduct its own chemical analysis. Test results were identical. There can be no doubt about it . . ." She paused.

The museum director's face showed deep concern. "There can be no doubt about what?"

Dr. Pierre continued, "*Jacob's Ladder* is not by Rembrandt. Some of the materials used to paint *Jacob's Ladder* were not available until 100 years after Rembrandt's death. It has been misattributed. Shall I proceed with the restoration?"

Questions for Discussion

1. If you were the museum director, what would be your decision: to restore or not to restore? Consider the following as you ponder your decision:
 a. Would you want other people to help you make the decision? Whose advice would you seek?
 b. Are there questions you would like to have answered before you would feel comfortable making your decision? List the questions, and explain why they are important to your decision.
2. Do you think the *economic value* of the painting has changed due to Dr. Pierre's discovery? Also consider these other questions related to the painting's value (you might first want to review the section in this chapter titled "How Art Is Valued"):
 a. Has the *aesthetic value* of the painting changed?
 b. Has the *historical value* of the painting changed?
3. Who suffers when a work of art has been vandalized or stolen?
4. One painting has been vandalized. What measures do you think should be taken to protect the other works of art in the museum's collections? Keep in mind that sophisticated electronic security systems and salaries for museum guards are very costly. The cheapest course of action might be to close the museum to the public. Do you think that would be a good decision? Why or why not?

Evaluation

1. Did you consider the issues in the scenario carefully and try your best to explain your point of view to others?

2. Did you listen carefully to others' points of view? Were you open-minded in considering the merits of arguments that differed from your own opinions?

3. Do you recognize that there are many different roles that people play in the world of art and that each role has its own challenges and responsibilities?

Footnotes to "The P.M.A.M. Decision"

1. Although "The P.M.A.M. Decision" is fictional, it was inspired by a combination of real events. For over twenty years, a panel in the Netherlands called the Rembrandt Research Group has been methodically studying the more than 500 works of art that have been attributed to Rembrandt van Rijn. So far, they have claimed that over 100 of them have been wrongly attributed! The group's findings have been controversial among art experts.

 It's also interesting to note that works of art in the world's museums have been vandalized. One of them, Rembrandt's famous *The Nightwatch*, Figure 1-15 on the opposite page, was slashed with a knife. It was restored and returned to its exhibition area for public viewing. Years later, another vandal damaged it with a spray of sulfuric acid. It has once again been restored and returned to the museum's viewing gallery. *The Nightwatch* is in the Rijksmuseum (RICKS-museum) in Amsterdam. This is a world-famous museum housing priceless collections, and it is open to the public. There is no doubt that *The Nightwatch* is a genuine Rembrandt painting.

2. A version of "The P.M.A.M. Decision" appeared in the book, *Aesthetics: Issues and Inquiry*, by E. Louis Lankford (Reston, VA: National Art Education Association, 1992).

Figure 1-15

Rembrandt van Rijn (Dutch, 1606–1669), *The Nightwatch*. Rijksmuseum, Amsterdam, The Netherlands. Art Resource, NY.

The White Clown. As an example of how interpreting a work of art can deepen our understanding of its meaning, let's look closely at Figure 1-16, *The White Clown*, a painting by American artist Walt Kuhn (KOON). *The White Clown* is a simple but powerful composition. A lone, large man sits squarely in the foreground. He is leaning forward, toward the viewer, his elbows resting on his thighs. He so completely fills the picture that little else is visible around him, except for the modest chair on which he sits. The artist's use of shading makes the man's figure appear solid and three-dimensional. The man wears a form-fitting costume of plain white. A white cap covers his hair, and white stage makeup covers his face. His form is set in stark contrast against a dark, mottled-brown background. His eyes, emphasized with black outlines, stare penetratingly out of the picture, as if gazing at something beyond the viewer's left shoulder.

The title indicates that this man is a clown, yet there is nothing here, beyond the costume, that suggests the act of clowning or gaiety. He looks weary and bored. The artist reminds us that behind the mask of hilarity that the clown shows the public, there are ordinary human concerns. Perhaps most of us wear masks of one kind or another. In this painting, Kuhn succeeds in helping us look beyond the surface of things; perhaps he even helps us to see ourselves more clearly. But we might not have noticed all this had we not studied the painting very carefully, the way a critic would.

Figure 1-16 Kuhn's many portraits of circus performers have psychological depth. But we must interpret his art in order to understand its meaning.

Walt Kuhn, *The White Clown*, 1929. Oil on canvas, 1.023 × .769 m. (40¼" × 30¼"). National Gallery of Art, Washington, D.C. Gift of the W. Averell Harriman Foundation in memory of Marie N. Harriman. Photo by Richard Carafelli.

Art History

Another approach to the study of art is art history. **Art history** *provides us with broad social, cultural, and historical contexts for understanding and appreciating artworks*. Art historians recognize that artists live and work within certain social circumstances and historical periods. These affect what a work of art looks like, how and why it came to be made, and its importance to the people who originally came in contact with it. Art historians seek answers to such questions as who made the artwork? When? Where? For whom was it made? What ideas, values, and beliefs influenced the form and meaning of the artwork? What art-making technologies were available to the artist? How was the artist influenced by earlier artists? Did the artist or the artist's works influence the work of artists to follow? Has the meaning of the artwork changed since it was produced?

Unlocking Mysteries. Art history is always limited by what records and evidence of previous periods are available. It is also limited by the ability of art historians to interpret that evidence. For example, historians and archaeologists have struggled for years to "read" or interpret accurately the surviving records of the ancient Maya. The Mayan civilization flourished

in parts of Central and South America for many centuries before Columbus landed in the West Indies in 1492. By A.D. 300, the Maya had perfected a set of pictorial symbols, or hieroglyphs, with which to record their knowledge, history, and beliefs. They had developed an accurate calendar based on their knowledge of astronomy and mathematics. They had learned how to build great temples, pyramids, and other structures in the midst of dense jungles (See Figure 1-17).

Unfortunately, almost all of the Mayan books of hieroglyphs were destroyed by invaders and missionaries during the sixteenth century. Over time, the hot, damp climate caused severe deterioration of Mayan murals, carvings, and architecture. After years of meticulous study, modern researchers have learned to recognize the distinct artistic style of the Maya. However, much more work remains to be done in the effort to know more about this fascinating civilization.

Art History Today. Art historians are not just concerned with ancient art forms. Art historians study and record who and what influences whom. They also study the extent to which art forms are similar and

Figure 1-17 Historians are still piecing together evidence of the art and culture of the Maya.

View of Palenque, Mexico. Photo by E. Louis Lankford

different, and what works of art mean to artists and to society yesterday and today. You will learn more about art history in Chapter Three, "Art History: Assembling the Pieces."

Studio Production

The study of art would be incomplete without **studio production,** or *the processes people engage in to make art.* Without studio production, there would be no art to study! Today, art is made from a host of materials, from paper and paint, to tree limbs and twine, to automobile tires and dirt. If there ever were any rules about what art should look like or what art should be made out of, those rules no longer seem to apply!

Surrounded Islands. One work that might challenge our usual thinking about art is *Surrounded Islands* (Figure 1-18 on the next page), an innovative and ambitious artwork created by the artist Christo (KRISS-toh) (born 1935). *Surrounded Islands* was a project that developed over a two-year period. It involved hundreds of people and cost the artist more than 3 million dollars. The project culminated in 1983 with a two-week installation on Florida's Biscayne Bay that captured worldwide attention. Christo had surrounded eleven is-

EXPLORING

HISTORY AND CULTURES

Imagine that the family of a friend of yours has recently purchased a farmhouse in Virginia. The farmhouse is at least 160 years old, and has been in the same family passed down from generation to generation until your friend's parents bought it. While exploring the house, your friend discovered a dusty old painting tucked half-hidden in a dark corner of the attic. Your friend has come to you for advice.

1. How might you go about finding out who painted this picture, and how old it is?

2. How might you find out what materials it's made of?

3. Who do you think the painting should belong to? What would your answer depend on?

Figure 1-18 Christo's work expands the boundaries of how artists can work and what art can be.

Christo, *Surrounded Islands*; Biscayne Bay, Greater Miami, Florida, 1980–1983. ©1983 Christo. Photo by Wolfgang Volz.

lands with rings of floating, flamingo-pink fabric. The colorful spectacle stretched for more than seven miles. The work made people think about the importance of the relationship between themselves and the natural environment. It also caused people to rethink their concepts of art. It was an artwork without edges or boundaries. The brushy green islands, the water sparkling in the bright Florida sunlight, the distant sandy shore, and even the Miami skyline set against a blue sky were as much a part of the artwork as the pink fabric.

All that remains of *Surrounded Islands* are the memories of millions of people who saw and read about it in 1983, Christo's preliminary drawings, an extensive written and photographic documentation, and a film. These records, though, are also part of the work of art. In this case, then, the artwork is not a single, unchanging object.

Cooperative and Anonymous Artists. To complete his project, Christo required the assistance of many people. Sometimes people who make art work alone, and sometimes they work cooperatively with others. For example, a sculptor may work alone on one piece but work with structural engineers and metal fabricators to make another. Printmakers may have apprentices and assistants who help them complete the steps necessary to producing the finished work.

Although many times we know the name of the artists or persons involved in the creation of a work of art, sometimes the artist remains anonymous. This may be because there is simply no surviving record of who made the artwork. Or the artist may have chosen to remain anonymous, considering the artwork to be a contribution to his or her family, faith, or community. For example, many beautiful quilts that have become family heirlooms are unsigned. And we know the names of only a few of the many people who built and carved the great cathedrals of Europe centuries ago.

A Mural Within a Mural. Let's look at an unusual work (Figure 1-19) that shows us an artist's involvement with others in studio production. The Mexican artist

Diego Rivera (dee-A-go ree-VEH-rah) (1886–1957) has created a unique self-portrait in which he is depicted making a mural. A **mural** is a work of art, *usually large in scale, painted on or attached to a wall or ceiling.* In the center of this mural sits Rivera, his back turned toward the viewer. Sitting with him on the scaffold before the mural are his assistants. Two are marking lines, while one applies the plaster surface on which Rivera will paint. As for the rest of the scene, Rivera has purposely made it difficult for us to tell the difference between the background mural-within-a-mural and those who are working on it. Rivera's murals often depict people hard at work. Here, he has placed himself in the middle of the action. Perhaps this is his way of telling us that he, too, works hard in pursuit of his ideals.

Why Make Art? There are many motivations for engaging in studio production. For some, it is an enjoyable leisure-time hobby. Others, such as Rivera, approach it with great passion, working long hours each day. Some wish to produce objects of great beauty. Others need to express their views about pressing social issues. Still others seek to represent something of the essence of human existence.

It is easier to understand and appreciate artistic motivations, efforts, and accomplishments if we have experienced studio production ourselves. *Everyone* can benefit from making art, whether or not he or she plans to become a professional artist. Making art lets us appreciate more fully artworks that we encounter because we can understand the processes used to make them.

Figure 1-19 Rivera painted murals because they could be seen by many people, not just a privileged few.

Diego Rivera, *The Making of a Fresco Showing the Building of a City,* 1931. San Francisco Art Institute, San Francisco, California. Photo by D. Wakely. Reproduction authorized by the National Institute of Arts and Literature of Mexico.

But even more important is the fact that making art allows us to express our ideas, feelings, and values in unique and powerful ways. Those of us who are able to express ourselves through art are truly fortunate.

The Artist's Tools. Artists utilize many different tools to accomplish their goals. Some work with traditional tools that date back thousands of years, like mallets and chisels for carving, or brushes and pigments for painting. Other artists work with "high-tech" tools, like computers and lasers. Artists choose the tools they think will best fit with their artistic visions.

Like anyone who takes pride in his or her work, artists must respect their tools. Carelessness during certain printmaking, sculpting, or painting procedures may spoil a work of art in progress or even result in injury to the artist. Artists will usually buy the best materials that they can afford and care for them well. That way, they not only get the best results in their artistic products but they also get the most from their financial investment in materials.

Look at the writing box in Figure 1-20. It was created in Japan more than a century ago to hold ink, brushes, and other writing implements. In Japan, **calligraphy,** or *beautiful handwriting,* is considered an art form. It takes years of practice to master Japanese calligraphy. Clearly, a person who would use such a special box to hold writing implements would value the art of calligraphy and the tools used by the calligrapher.

Section (III) Review

Answer the following questions on a sheet of paper.

Learn the Vocabulary

Vocabulary terms for this section are *aesthetics, art theory, firing, scenario, art criticism, interpretation, art history, studio production, mural,* and *calligraphy.*

1. Fill in the blank with the appropriate vocabulary term.
 a. A work of art, usually large in scale, that is painted on or attached to a wall or ceiling is called a _____ .
 b. _____ _____ describes the processes in which people engage in order to make art.
 c. The area of study aimed at understanding the nature of art, including why art is made, what forms it takes, and how people respond to it is _____ .

Check Your Knowledge

2. How do Jenny Holzer's *Truisms* expand the boundaries of what counts as art?
3. How do art critics educate the public?
4. List at least three materials with which art is made today.

For Further Thought

5. You are the art critic for your school newspaper. You are assigned to review an exhibition at the local art museum entitled "Georgia O'Keeffe and the American West." What kind of information will you need to obtain in order to aid in your interpretation?

Figure 1-20 This writing box was made to hold the valued tools of an artist.

Izuku Toyo, *Stationery Box,* 1775, Edo period (1615–1867). Japanese. Various lacquer techniques on wood. 8½" × 13¾" × 8¼" (21.5 × 35.0 × 21.0 cm.). The Nelson-Atkins Museum of Art, Kansas City, Missouri. (Purchase: Nelson Trust). F78-23. ©1993 The Nelson Gallery Foundation. All reproduction rights reserved.

Section IV

Three Themes of Art

The four approaches to the study of art outlined in the previous section—aesthetics, art criticism, art history, and studio production—can be used to help us gain a better understanding of themes that are found in art. Themes are subjects that have been explored in different ways by many artists over time. Such themes represent ideas, events, and relationships that are important to individuals and societies. Some of the themes thus far touched on in this chapter are patriotism (*Flag Gate*, Figure 1-3), natural beauty (*Still Life: Flowers and Fruit*, Figure 1-2), and war (*Guernica*, Figure 1-9). Three themes especially rich in images and meanings are nature, cities, and the human image. These themes, outlined here, will be explored in greater depth in Part Two of this book.

Nature and Art

Artists have been inspired by nature since ancient times. Many works of art represent the beauty and grandeur of nature. Other artworks express the artist's awe and fear of such destructive forces of nature as raging storms.

People around the world have used natural materials such as seashells, reeds, bark, and stone to make their art. Nature has also been harnessed in landscape and garden design.

Artist Joseph Stella was obviously inspired by nature when he painted *Flowers, Italy* (Figure 1-21). Colorful and exotic flowers bloom in wild profusion in Stella's painting. Water lilies and lotus blossoms float beneath tall plantlike columns and arches. Stella's imaginary landscape may have been influenced by European gardens that combine plants with architectural elements.

Figure 1-21 Stella's exuberant landscape imaginatively combines natural and contructed forms.

Joseph Stella, *Flowers, Italy*, 1931. 75" × 75". Oil on canvas. Phoenix Art Museum, Phoenix, Arizona. Gift of Mr. and Mrs. Jonathon Marshall.

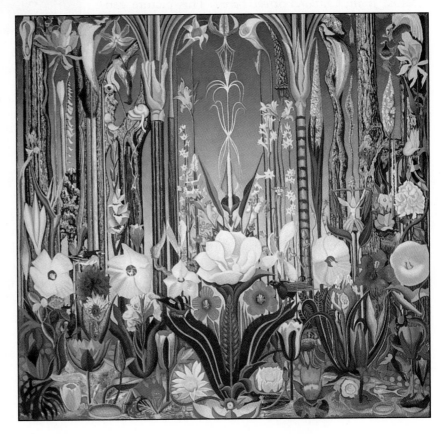

Nature can provide the inspiration, subject matter, or artistic material for artists. Small wonder that it is one of the most frequently found themes in the world of art.

Cities and Art

Mention the word *city* and listeners may have all sorts of associations. Some might picture towering skyscrapers, others a huddle of adobe dwellings on a windswept mesa. Some people may think of the hustle and bustle of a thriving center of commerce. Other people may think of grime, poverty, overcrowding, and unemployment. Families have moved to cities to be "where the action is," and they have moved away from cities to escape urban conditions. Cities are places of opportunity and despair. It is only natural that artists have taken an interest in cities, since artists have long been keen observers of human life-styles.

Figure 1-22 shows us an interesting view of a modern city. Created by artist Joseph Pennell (1857–1926), it is titled *From Cortland Street Ferry*. This picture can fill us with mixed emotions. On the one hand, the glow of the distant city invites us to enter its world of excitement and activity. Skyscrapers loom like great monuments to a mighty civilization. On the other hand, there is a moody and threatening quality about this picture. The night seems shadowy; everything is shrouded in mist and smoke. If the artist was trying to show us two sides of the city, he has succeeded admirably.

The Human Image and Art

The human image finds its way into virtually every theme found in art. Humans are depicted in natural environments and in city environments. Like people everywhere, artists laugh, cry, celebrate, suffer, love, work, play, and dream. Artists express such experiences in their art. When we look at artworks, we can, in a special way, share these experiences with the artists. That is one reason why art is so important. It helps us to see ourselves as part of a larger human community.

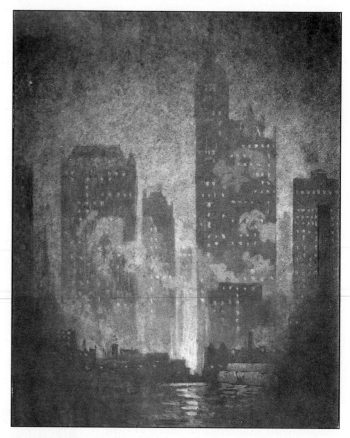

Figure 1-22 Do you think this picture shows the city as an inviting place?

Joseph Pennell, 1860–1925, *From Cortland Street Ferry*. Etching with acquatint. The Metropolitan Museum of Art, New York. Harris Brisbane Dick Fund, 1917. (17.3.799).

Look at Figure 1-23, a sculpture by artist Elizabeth Catlett entitled *Tired*. This is a portrait of quiet dignity. The woman portrayed wears a simple dress. She has on no jewelry, ribbons, or even shoes. She looks like a woman who has experienced hard work and hard times. She looks tired. Yet her head is not bowed. She does not look weak. She sits upright, strong in stature and strong in spirit. She gives the impression of being a knowing observer of her world.

Tired is a simple and effective portrayal of human feeling. We sense that Catlett has felt the way this woman feels. In this way, a work of art can connect us with the life of the artist. A work of art can also make us more aware of our own thoughts and feelings.

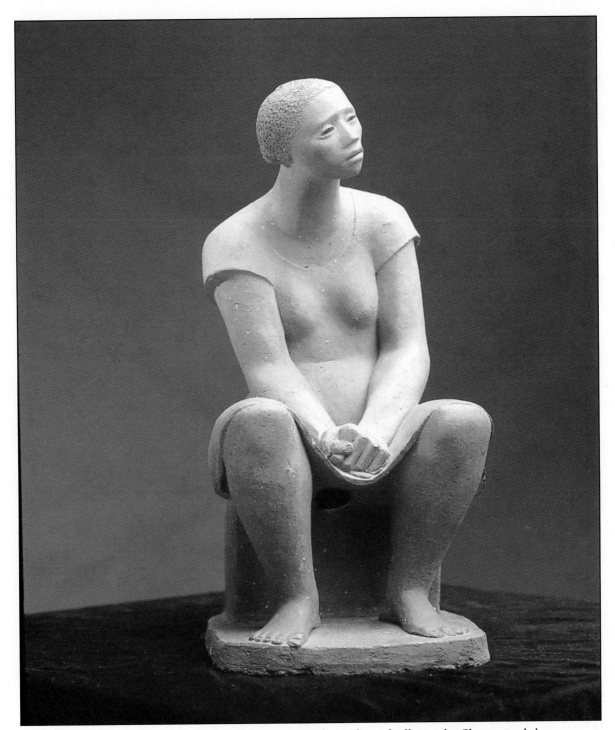

Figure 1-23 This woman has been portrayed simply and effectively. She is tired, but she is strong.

Elizabeth Catlett, *Tired*, 1946. Terra cotta. The Howard University Gallery of Art, permanent collection. Washington, D.C. Photo by Jarvis Grant.

Student Activity 5

Personalized Art Supply Box

Goals

1. You will transform an ordinary cardboard box into a special container for your art supplies.
2. You will develop your skills at working with art materials.
3. You will exercise your creative imagination by personalizing your box to reflect your own ideas, feelings, and values.

Materials

1. Corrugated cardboard box, with lid, about fourteen inches long by eight inches wide by four inches tall (A shoe box will work, but it must be *very sturdy*.)
2. Acrylic gesso
3. Sketching paper and pencils (#2 and #4)
4. Fine sandpaper
5. Acrylic paints
6. Acrylic gloss medium and varnish
7. Brushes
8. Cans to hold water for cleaning brushes
9. *Optional:* magazines to cut up, scissors, glue

Directions

1. Apply a smooth and even coat of acrylic gesso to the top and sides of the box. Let dry.
2. While the gesso on your box dries, work up some sketches using your #2 pencil, designing the surface decoration for your finished box. There are infinite possibilities. Remember that the function of the box is to hold your valued art supplies, such as pens, drawing pencils, erasers, scissors, ruler, and brushes. You may choose to decorate the box in a realistic or abstract style. *Think about including images and symbols that reflect your thoughts and feelings about the value of art in your life.*
3. Check your box. If a lot of the original surface of the box still shows, apply a second coat of gesso. After the second coat dries, if the gessoed surface of the box is a little rough, *gently* sand it using *fine* sandpaper.

4. Using a #4 pencil, *lightly* sketch your design on the sides and top of the box.

5. Paint your box using acrylic paints. If your box has a removable lid, you may want to paint the top and bottom portions of the box separately. Thin your paints to a workable consistency by mixing in a little acrylic medium and varnish. Keep your brush hairs damp as you paint; this will help the paint to flow more easily and also make cleaning the brushes easier when you've finished painting.

6. *Optional:* if you wish, you may incorporate magazine pictures into your design. Pictures clipped from magazines can be glued onto the box either before or after you paint. Don't be afraid to let strokes of paint overlap the edges of the magazine clippings. This will help to unify the cutout and painted portions of your design.

7. After the paint and glue have dried, apply two coats of acrylic medium and varnish, full strength (undiluted). Let the first coat dry before applying the second coat.

8. After the varnish has dried, depending on what kind of box you have, you may find that the lid has stuck shut. Simply take a mat knife and carefully cut the lid free. Make sure to sign your name to the bottom of the box. Also, put the date you finished it so that in the distant future you will be sure to remember when you made your special box for holding and protecting your valued art supplies.

Evaluation

1. Did you experiment with several designs on your sketch paper before you settled on one design? Include some of your preliminary sketches in your portfolio.

2. Did you work to improve and refine your final design before you put it on the box? Point out some of the changes you made.

3. Did your work habits demonstrate fine craftsmanship? Did you try to create the best box you could that expressed your ideas, feelings, and values? Write a paragraph explaining the significance of the design of the box to you. Also describe any technical challenges you faced in decorating your box. How did you overcome these challenges?

4. Did you respect your tools and materials during this activity? Did you try to conserve and not waste paint? Check to see that brushes have been thoroughly cleaned and properly stored.

"**I** don't have anything against men but since I am a woman, I know more about women and I know how they feel. . . . Artists do work with women, with the beauty of their bodies and the refinement of middle-class women, but I think there is a need to express something about the working-class black woman, and that's what I do."

Elizabeth Catlett

Section IV Review

Answer the following questions on a sheet of paper.

Check Your Knowledge

1. What are some natural materials that artists have used to make art?
2. Why are cities interesting to artists?
3. What can Elizabeth Catlett's sculpture, *Tired,* tell us about the artist?
4. What can Catlett's sculpture tell us about humanity in general?

For Further Thought

5. Throughout history, artists have portrayed humans and nature as either harmonious or full of conflict. How do you think the current societal emphasis on environmentalism will affect contemporary art?

SUMMARY

In this chapter we have explored the concept of art. We have discovered that art can be found in cultures all over the world and throughout history. Art is not limited to the expression of only a few ideas and feelings but cuts across the range of human knowledge, emotions, and values. Artists apply their skills and imaginations to express their experiences of the social world and the natural universe.

In order to understand and appreciate art fully, we need to grasp some of the foundations of art. These foundations include the concepts and methods of aesthetics, art criticism, art history, and studio production. Finally, it is useful to explore the great themes of art in order to appreciate how art can provide a panorama of society or express an individual vision.

CHAPTER ① REVIEW

VOCABULARY TERMS

Define the vocabulary terms by using each one correctly in a sentence.

abstract	art criticism	expressive	perceive
aesthetics	art history	firing	scenario
aesthetic value	art theory	interpretation	studio production
allegory	calligraphy	monument	symbol
art	expression	mural	

Applying What You've Learned

1. Why is it difficult to define art?

2. Does something have to be beautiful to be considered a work of art? Explain your answer.

3. What are five ways that works of art may be valued?

4. What are three themes found in art?

5. What are two goals that art critics usually have in mind as they write their reviews?

Exploration

1. Identify a sculpture, monument, or historic building in your community that you think is special. Tell why you think it is valuable. Can you think of other reasons that people might value this object?

2. Look through some art books at a nearby library, and try to find some examples of artworks that are made from unusual materials—that is, materials that we might not automatically associate with art. A good place to begin would be books about modern and contemporary art, as well as current art magazines. If you can check these resources out of the library, bring them to class. Otherwise, describe these artworks in class. Tell what you have learned about the artwork and the artist.

Building Your Process Portfolio

In this chapter you have been introduced to some key ideas and issues in the visual arts. You have had the opportunity to study and discuss several works of art, and to make some art on your own. Here is a list of some items that you might want to include in your process portfolio:

- Sketches and other preliminary notes for your artwork

- Your finished artwork

- Written summaries and reflections of class discussions

- Answers to questions asked in the Section Reviews and Chapter Review

- A list of questions that occurred to you as you were reading, making art, or participating in class discussions

- A written summary of any extra work or reading you did outside of class

- Written comments about any works of art that you saw and that interested you outside of class

Chapter 2

Criticism: The Quest for Meaning

Figure 2-A Do you see all thirty-six poets?

Sakai Hoitsu (Japanese, 1761–1828), *Thirty-six Immortal Poets,* early 19th century. Japan, Edo period. Ink and colors on paper. 150.9 × 163.0 cm. Courtesy of the Freer Gallery of Art, Smithsonian Institution, Washington, D.C. 70.22.

Contents

Section I The Goals of Art Criticism

This section describes some of the different reasons that people engage in art criticism and shows how setting goals influences the viewer's encounter with a work of art.

Section II Approaches to Art Criticism

This section introduces you to the intrinsic and contextual approaches to art criticism.

Section III A Critical Method

Section Three presents the steps in a critical method that will help you organize your critical encounters, and it presents sample criticisms written by high school students.

Section IV Establishing a Visual Vocabulary

The fourth section introduces you to the elements, or essential visual components, of a work of art. In addition, you will have an opportunity to explore the expressive properties of the elements while making works of art.

Section V The Principles of Art

Section Five introduces you to principles of art that give a work its expressive qualities. In addition, you will have an opportunity to explore the expressive qualities of the principles while making works of art.

Section VI Perspective: The Illusion of Depth

Section Six introduces you to the historical beginnings of linear perspective and the vocabulary and drawing techniques associated with its use. You will also explore several works of art that demonstrate the different ways in which linear perspective may be used successfully.

Terms to look for

actual texture	emphasis	movement	real lines	three-point
atmospheric	eye level	negative space	relief	perspective
perspective	form	one-point	rhythm	tint
balance	geometric shapes	perspective	secondary colors	two-point
bird's eye view	high relief	organic shapes	shade	perspective
closure	horizon line	perspective	shape	unity
color	implied forms	picture plane	simulated	value
contextual criticism	implied lines	pigment	texture	vanishing
contour lines	intrinsic criticism	positive space	space	point
critical method	invented texture	primary colors	spectrum	variety
curator	line	principle	tertiary colors	worm's eye
draftsman's net	low relief	proportion	texture	view
element	monochromatic	real forms		

Objectives

- You will discover that setting goals for art criticism is an important part of a successful critical experience.

- You will learn that effective criticism can help you discover meanings in works of art.

- You will become familiar with the elements and principles of art.

- You will explore the basic drawing steps of linear perspective, and several ways in which the illusion of depth has been created in two-dimensional works of art.

Section I

The Goals of Art Criticism

To many of us, the word *criticism* means finding fault or being dissatisfied with something or someone. When used in reference to a work of art, however, art criticism is a process of asking questions about a work of art through which we may discover many of the work's meanings. In addition, searching for answers to these questions will also help us make informed judgments about works of art.

When looking at works of art, most of us tend to perform some kind of critical activity quite naturally. Often, we are unaware that we are doing this. Although responding to works of art can be a spontaneous experience, effective art criticism is a highly organized process. It involves an intense, focused encounter with a work of art. We will call this process a "critical encounter." The purpose of such an encounter is to help you develop informed opinions about a work of art. These opinions are based on the careful study of what you see in the work and, sometimes, outside information about the work.

Although this may sound rather involved, art criticism is not meant to stifle or lessen your enjoyment of a work of art. Instead, it will actually intensify your enjoyment. Imagine sharing a wild and desperate adventure on the high seas, participating in futuristic flights of fantasy, or exploring the mysteries of cultures from other lands. Careful study of a work of art can give you the experience of such adventures, help you imagine the future, and provide insight into the beliefs and values of people from different cultures and different periods of time.

You probably have already had at least one critical encounter with a work of art. During this encounter, you and a friend or a group of classmates may have engaged in a heated argument over your different interpretations or judgments of a painting or a piece of music. Regardless of the outcome, your conversation got your emotions flowing, your senses in gear, and your opinions expressed. The fact that a work of art may have many meanings and interpretations is precisely what makes art criticism so intriguing.

Specific Goals for Critical Encounters

The overall purpose of art criticism, then, is to help the viewer evaluate and interpret a work of art. The goals that we set for our critical encounters help us stay focused during this process. Goals help us identify the amount and type of information we get from a

work, and give us direction for using that information. Specific goals of any critical encounter will vary depending on the viewer's needs.

Art Teachers. For example, an art teacher might want her class to study an artist's extraordinary use of color in a particular work of art. Their focus would then be on the work of art itself and the artist's use of color to convey meaning. Later, the teacher might wish to examine the same work for its impact on society. In this case, the teacher would look for historical information that would reveal the artwork's social relevance.

Art Dealers and Auctioneers. Art dealers or auctioneers might have an entirely different set of goals. Since it is their business to buy and sell works of art, the goals of their critical encounters would include evaluating artworks to determine their authenticity and market value. To determine this, they might study trends in sales of works of art by the same artist, noting the price paid for each work. In addition, they would need to carefully examine the work to determine its condition, verify the artist's signature, and pay close attention to the subject matter and how the medium has been applied or worked. Although studying trends in sales of an artist's work, verifying an artist's signature, and determining the condition of a particular work are skills that are not necessarily related to performing criticism, judging the successfulness of an artist's portrayal of subject, and use of media, is.

This type of criticism would not center as heavily around determining meanings, as it would around making some form of judgment about a particular work.

It is important to note that there is no one set of standards or form of judgment that an art dealer or auctioneer might use while making their judgments. These standards and forms of judgments are determined by the individuals using them, and as such, may vary greatly. Often, the judgments made by art dealers and auctioneers have consequences in the marketplace. Acting on a dealer's advice, a client may unknowingly purchase a work of art in poor condition, and perhaps considered by critics to be of lesser aesthetic quality. Poorly given advice of this nature may put the reputation of an art dealer or auctioneer in jeopardy.

Goals such as these often lead art dealers and auctioneers to become experts on works of art or on artists from one or more periods. Some are experts on contemporary art, while others prefer to focus on works from previous periods. Such expertise allows them to make informed choices in the buying and selling of art, and these skills are crucial in today's market, where prices can go sky-high. For example, a Japanese dealer, Hideto Kobyashi (hi-deh-toe koe-bee-AH-SHE) acting for a well-known Japanese collector spent $160.6 million of his client's money in three days for one painting by van Gogh and one by Renoir. The collector, considering Kobyashi's recommendations, agreed to pay $82.5 million for the van Gogh alone! This was the greatest sum paid to date at an auction for a single work of art.

Look carefully at the reproduction of van Gogh's *Portrait of Dr. Gachet* in Fig. 2-1. Let's put ourselves in Kobyashi's place hypothetically for a moment and see if we can determine why our client might be willing to pay such a large sum for this van Gogh. As an art dealer, with what information might we influence a client to purchase a work of art? What might we tell him or her about this work in particular that would make it seem worth its $82.5 million purchase price?

Curators. A curator (KYOO-ray-ter) of a museum might have another set of goals to guide his or her critical encounter. A **curator** *is a caretaker of a portion of a museum collection.* A museum frequently has several curators each specializing in works of art from a particular period. It is part of a curator's job to occasionally recommend the purchase of certain works of art and to discover as much information as possible about some of the works of art in a museum's collection. For example, a curator needs to understand how a particular work fits into the overall scope of an artist's body of work. This means that the curator must study a number of works from different periods of the artist's life and note the subtle or obvious changes in style and subject matter that occur. Some of these changes may already be documented. The curator would know to look for this information in previously published criticisms about that artist's work. He or she would also look for this information by engaging in many direct critical encounters with the artist's work. Information

Figure 2-1 Japanese collector Ryoei Saito purchased this painting by van Gogh for 82.5 million dollars for his private collection.

Vincent van Gogh, *Portrait of Dr. Gachet,* 1890. Oil on canvas. 26⅜" × 22". Christie's, New York, New York.

gathered during these critical encounters would allow the curator to add newfound perceptions to the way in which he or she understands a particular artist's work. (See pages 599–602 museum project).

Artists. Artists engage in critical encounters with their own works both before and after completion in order to help them in the creative process. In such encounters, artists assess how well they have communicated their meanings by looking closely at the ways in which they have used the chosen media. For example, if you were trying to express great anger in a particular work, you may feel, after critically analyzing that work, that the colors you have chosen do not communicate this anger as well as you had hoped. Crit-

ically analyzing your work has helped you to see that you should choose different colors in order to express this meaning more effectively. Often artists have given new direction to their work after they have analyzed their past efforts. You will find that critically assessing your own art may help you make better choices in the future when selecting materials with which to work, or may influence the ways in which you express your meanings.

Art Critics. As we discussed in Chapter One, the art critic engages in critical encounters with the goals of educating the public and searching for meanings. People learn a lot about a work from what critics have to say and how they say it. Look at the following crit-

ical statements by two art critics. These statements are about two different works of art:

"The surfaces of her paintings are 'worried' or fractured, having been scratched with a palette knife, to give a sense of age or organic decay, which allows the more brightly hued under-painting to be revealed."

> *Lesley Constable*, art critic for the *Columbus Dispatch*, Columbus, Ohio, Sunday, May 21, 1989 on the subject of a display of paintings by artist Sarah Slavick.

"Raymond handles color with superb mastery, whether it is on his sculptures or in his paintings. The dominance of black is deceptive in both. What is there is really a layering of pigments—reds, blues, and greens, which create the illusion of black. The red touches, for instance are not added, but rather the red layer left uncovered . . . In the paintings, the layering creates feelings of mysterious depth and untangible volume. . . ."

> *Jacqueline Hall*, art critic, the *Columbus Dispatch*, Columbus, Ohio, Sunday, May 21, 1989 on the subject of paintings and sculptures by artist Jeff Raymond.

Through their analyses, both critics make us aware of how the artists have skillfully used painting techniques to achieve special effects and enhance meanings in their works of art.

Because of the assessments critics make, museums and galleries may even gain new insights into their collections. For some people, the art critic's statements may serve as guidelines for their own critical goals and methods. In this case, the critic's insights are welcome enlightenment for untrained eyes.

When we go to exhibits or museums, critical goals help us approach works of art with confidence and get the most out of our encounters with them. For example, you might be doing a report in your government class on the outcomes of war. In your local museum are several works of art that deal with the destruction and agony of war. Critically analyzing these works will help you gain insight into the pain and suffering that comes with this destruction. However, pain and suffering may not be the only outcomes of war. Sticking with your thematic goals may also lead you to a number of paintings about the prosperity that rebuilding a city or even an entire country after a war may bring. These works of art may communicate a sense of great national pride and the tremendous perseverance of that nation's peoples.

As the result of your critical encounters, your report will reflect an understanding you may not have received from only reading about the disastrous effects of war. Good critical skills can be learned and improved with practice. Sections Two and Three in this chapter describe ways to approach a work of art and will teach you the critical skills you need in order to get maximum enjoyment out of your encounters with works of art.

> "The fascinating thing is not to show the source of light, but the effect of light."
>
> **Edgar Degas**

Section ① Review

Answer the following questions on a sheet of paper.

Learn the Vocabulary

The vocabulary term for this section is *curator*.

1. Define the vocabulary term by using it correctly in a sentence.

Check Your Knowledge

2. How might the goals of art criticism differ between an art teacher and an art dealer?
3. What aspects of a work of art does an art dealer consider when determining a particular work's market value?
4. Describe the research a museum curator does to understand a particular work of art.
5. How does an art critic help and guide the public?

For Further Thought

6. Your boss has asked you to select a painting for her office. What are some goals you will have as you consider different works? What are some possible difficulties you may encounter in selecting a work for someone else?

Section II

Approaches to Art Criticism

Practicing art criticism in your classroom can be your ticket to great adventures. These adventures will be especially exciting because you will share them with your classmates. You will do this through dialogues that allow you to exchange information, ideas, and opinions with others.

Considering several different points of view about a work of art through dialogue can help you clarify your own thoughts about what you are experiencing. It can also help you see the artwork in a new way. Such discussions show us that a single work of art can possess many meanings.

Art criticism focuses on the work of art itself. Often, outside information about the period in history in which the work was created, personal information about the life of the artist, or speculation about the social and political climate of the time add greatly to our understanding of a work. However, does the outside information *about* a work of art become more important than what the work may express to us on its own?

The answer to this question depends on which approach to art criticism you choose, and that choice, in turn, is related to goals for the critical encounter. Let's examine two approaches to art criticism.

Intrinsic Criticism

The word *intrinsic* means "to come from within." **Intrinsic criticism,** then, *focuses on the properties or qualities of a work of art that exist within the work itself and the meanings that are derived from what confronts the senses.* Intrinsic criticism involves a complete experience of the work without consideration of any information that might come from outside the work itself. You would not consider information about the artist or the circumstances under which the work was created when you do intrinsic criticism.

Intrinsic dialogue *would* include the recognition of the visual components that exist within the work, their expressiveness, and their relationships to one another. (These issues are discussed later in this chapter.) In addition, and perhaps most important, the dialogue should include a discussion of how the work affects us. Does it have the same meanings for everyone? Are there specific components of the work that seem to dominate, conflict, or create mystery?

Let's apply intrinsic criticism to a work of art. Look at Figure 2-2, which shows an intriguing still life by Cornelis de Heem. Resist the temptation to judge what you see right away. First consider how the work makes you feel. Is it a humorous painting? Is it powerful or mysterious? Does its complexity confuse you or invite you to explore the work further?

Next, consider the vast array of items spread on the richly draped table. Take a detailed inventory with your eyes. What types of items do you see? What is their condition, arrangement, and size? Is there a predominant object on the table? Is your eye drawn to one object more than to others? What about color? What colors do you see?

How has the artist represented the objects on the table—realistically or in some other manner? How has he applied the paint (with a brush, a palette knife, etc.)? And what of the objects' relationships to one another? Does there seem to be a particular pattern to their display?

Now that you are aware of what is *in* the painting, consider answering this question: what does this painting mean? Since we are only considering information that may be gathered from within the painting itself, how would we go about determining the possible meanings of this work of art?

A work of art may stimulate a variety of interpretations from different viewers. This is because we each bring to any critical encounter the knowledge and attitudes we have gained from past experiences, and we base our interpretations on this knowledge and these attitudes. Because we are all individuals and our experiences vary, our interpretations will vary, too. This does not mean that we are adding outside information to our assessment, rather that the way in which we

Figure 2-2 Does the condition of the food help you determine what has happened here?

Cornelis de Heem, *Still Life*. Oil on canvas. 53⅜" × 72". Columbus Museum of Art. Columbus, Ohio. Purchase: Derby Fund. 61.003.

interpret what we see is referenced to what we already know and understand about the world. We will interpret what we see from within our own frame of reference.

With this in mind, take a moment to consider all you have observed about this painting. Perhaps it would help if we think of the components of this work in symbolic terms. In other words, what symbolic meanings might the objects or elements in the work have? For example, you may have noticed that a good portion of the food on the table is only half-eaten, and

that some of it has begun to decay. What could this mean? There are many possible symbolic meanings we might apply to this. What are some of them? Then, think about how the decaying food has been coupled with the open songbook and the delicate butterfly floating in the sunlight. How does your interpretation change when you consider these components together?

Let us take these ideas one step further. Try putting all your observations together to determine what has happened in this scene and what the artist might be telling us about this kind of life-style. Is there a theme

Cornelis de Heem

Cornelis de Heem (core-NEE-liss da-HEE-m) was born in Holland in 1631. He came from a large family of painters. His father, Jan Davidsz de Heem (Yohn-da-VIDZ da-HEE-m), was the most well known.

As a teen, Cornelis spent long hours in his father's studio learning to paint. Father and son were both painters of still-life, and their styles, like their tastes, were remarkably similar. In fact, their works are often confused for each other's. Look at the two still-lifes in Figure 2-2 on the preceding page and Figure 2-3 on the next page. Cornelis painted Figure 2-2 and his father painted Figure 2-3. If you did not know that Cornelis painted only one of these, would you say that these two paintings might have been done by the same artist? Some critics feel that Cornelis's paintings tend to be more peaceful and orderly in arrangement than his father's. From what you can see, do you agree?

Their favorite paintings to create were of opulent arrangements of fruits and worldly goods. These items made extraordinary subjects for their paintings. The de Heem family even chose to live near the large seaport of Antwerp because of the variety of foods and goods from around the world that was available to them. When painting, Cornelis's father taught him to pay special attention to the careful compositional arrangement of these goods, and the techniques with which he painted them. Cornelis is said to have represented the objects in his paintings with "full sensual appreciation." This means that he showed in his painting of the objects the pleasure that he got when he touched or ate them.

Cornelis and his father continued to paint together through much of Cornelis's young life. Together, they were considered to have painted a rather large number of paintings. As you will read later in this chapter, Cornelis was given to moralizing in his paintings about the decadent and wasteful lifestyles of Antwerp's high society. And yet, he and his family enjoyed many of the pleasures of that kind of lifestyle themselves.

The latter part of his life was spent in the Hague, where he became a member of the artist's guild. After a long, creative, and prosperous life, Cornelis died in 1695 at the age of sixty-four.

Figure 2-3 What do you see in this painting that would help you identify it as belonging to Jan Davidsz de Heem, father and teacher of Cornelis?

Jan Davidsz de Heem, *Still Life with Lobster,* late 1640s. Oil on canvas. 25" × 33¼" (63.5 × 84.5 cm.). The Toledo Museum of Art, Toledo, Ohio. Purchased with funds from the Libbey Endowment, gift of Edward Drummond Libbey.

or moral that presents itself to the viewer? List all the possibilities you can think of. Are the clues to these themes hidden, or has the artist presented his opinions openly?

About the Artist and This Work. You have just experienced intrinsic criticism with de Heem's *Still Life*. In doing so, you have found that you can discover a lot of information about a work of art by just observing it very carefully. See how well you have done by considering the following information about the artist and this particular work. Note that it was not necessary for you to know this information beforehand in order to have fun with this critical encounter. In fact, much of this information you were able to discover through your own careful observation of this work.

Cornelis de Heem (1631–1695) was one of the leading masters of Dutch Baroque still-life painting. He was particularly given to moralizing and providing social commentary about the opulent life-styles of the wealthy. This still life is a wonderful example of both the artist's proficiency at his craft and his desire to moralize. In this work, we see a large, brocade-draped buffet arrayed almost to overflowing with fruit, seafood, and other delicacies. Interspersed among the refreshments are musical instruments and an open songbook. Fine china and glass and metal goblets contain half-eaten food and half-finished beverages. Perhaps the most dominant object in this painting is the large red lobster that overhangs the tilted edge of the large bowl in which it sits. In the upper left-hand corner is a small window through which a soft light falls, illuminating the background and balancing the brighter section in the lower right corner of the painting. Centrally located in the work is a dish on a pedestal; the dish holds flowers whose blooms have opened and are starting to wilt. The objects on the table look as if they are about to fall off, as if someone had hastily grabbed for them and then thrown them back. It's as though the feast had been started and then abandoned. Still, above all this decaying decadence floats a tiny, delicate butterfly, bright and fresh, the only unspoiled object in the work. Of the many morals this combination of images could represent, which would you choose?

The de Heem painting is a good subject for intrinsic criticism because a great deal of information about the painting's meaning may be discovered just by examining the work carefully. Additional research might be enlightening, but information about the artist or the work from outside sources is not really necessary in order to have a fulfilling critical encounter. This is true of many works of art. Sometimes, however, additional information may actually be essential for a full appreciation of the work.

Contextual Criticism

The term *context* refers to the events or conditions that surround a work of art and help to give it meaning. These conditions or events might include the life of the artist who created the work, the political climate at the time the work was created, or historical events that may have inspired the artist to create the work. They may also include the conditions under which the work of art has been exhibited since it was created. These conditions can often influence the way in which a work of art is interpreted. **Contextual criticism,** then, *focuses on understanding a work of art in relationship to personal, social, or historical information that cannot be gathered simply from observing the work of art itself.*

As you will see in Section Three, "A Critical Method," both intrinsic and contextual criticism start with the same steps. Both approaches require you to begin by describing the initial impact of the work: is it powerful, joyful, scary, and so on? Then, both approaches ask you to notice in detail what is in the work of art. But at this point the two approaches begin to differ.

An intrinsic encounter would continue to analyze only the information that could be seen and understood within the work of art itself. In other words, if you can see it and point to it, you may include it.

A contextual encounter, on the other hand, would go on to uncover information about the persons and events that might clarify aspects of the work that would not be perceivable by simply looking at it.

Both intrinsic and contextual criticism usually conclude with a judgment or a putting together of all the facts.

The contextual approach to criticism raises an important question. If you spend time considering information that comes from outside the work of art, will you lose sight of the actual work and its meanings altogether? Some critics worry that considering too much outside information may lead viewers away from appreciating the existing properties of a work of art. Others claim that information about the artist or about the social or historical conditions during which a work of art was created will provide insights that will enrich viewers' interpretations of a work.

For example, to determine a work's significance, we may need to know if it was considered revolutionary when it was created. Did it have a profound impact on society during that time? Does it still have the same impact today? Contextual information may also clarify the meanings of symbols or other components in a work of art.

In general, however, you can decide whether contextual information is appropriate based on the goals you have set for your critical encounter. If your goal is to gain a better understanding of an historical period through the examination of works of art created during that period, then contextual information about the life of the artist will be useful.

Sometimes an artist is trying to tell a story through his or her art. But can we understand the whole story through the work of art alone? As an example, let us look at the painting entitled *Watson and the Shark* by John Singleton Copley (Figure 2-4).

Figure 2-4 Many artists try to tell a story which will involve the viewer with their works. How many stories can you imagine in this painting by Copley?

John Singleton Copley (American, 1738–1815), *Watson and the Shark*, 1778. Oil on canvas. 72" × 90¼" (182.9 × 229.2 cm.). Courtesy the Museum of Fine Arts, Boston; Gift of Mrs. George von Lengerke Meyer.

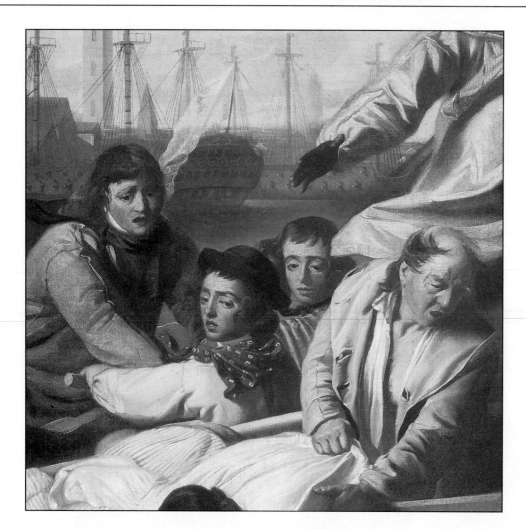

Figure 2-4A Examining a painting section by section can give new clues to its meaning.

Detail: John Singleton Copley, *Watson and the Shark*, 1778.

Before you begin to think about the story this painting tells, take a full account of what is in the picture. What do you see? How many men are in the boat? What do they have in their hands? How many people do you see in danger? Is there more than one shark in the water? Don't forget to look in the background.

Copley has created an intense drama here. What do you think is happening? Are we joining the story in the middle of the action, or has this young boy just fallen out of the boat? Does the artist give us any clues as to the pace of the action or what the outcome might be? How would you characterize the expressions on the faces of the men in the boat? Are they all similar, or do some of the men seem more in control of the situation than others? How are some of the men trying to rescue the boy?

After you have answered the previous questions, consider how this painting has affected you. Do you think the artist meant to scare you, or was this painting intended to be a portrait of bravery? Were you caught up in trying to figure out what has happened to the boy and what may happen next? Were you provided with any visual clues in the painting? Was the artist successful in holding your attention?

About the Artist and This Work. Copley captures our attention with this painting of a frantic life-or-death struggle. Young Brook Watson has been attacked by a shark, shown here as a huge gray "bullet" of death. Copley has created an extraordinary amount

of tension in the images, just as a scene in a movie can be edited to prolong the action, provide suspense, and document each of the character's reactions to what is happening. The shark is closing in at an incredible speed to finish off Watson. Watson, his body a deathly pale, looks his last upon the beast, while his nine shipmates are trying desperately to snatch his body from the jaws of a gruesome death! Who will be faster, the sailors or the shark?

Copley presents some clues in the rope that crosses Watson's arm and in the apparent forcefulness with which one of the sailors is about to hurl a harpoon. But does the artist stop short of answering our questions about the outcome of this drama? Does he do this deliberately?

Perhaps we can find the answers in the history that lies behind the creation of this work. As it happened, a fourteen-year-old boy by the name of Brook Watson became bored while waiting on one of his father's merchant ships on a hot day in Havana Harbor. He decided to take a swim. After a short while, he was attacked by a huge shark. He screamed for help, and within minutes help was frantically on its way. With the bottom half of his right leg severed in the attack, Watson, almost dead and deeply in shock, raised his arm to his friends. The shark was circling for the last time to finish off its prey!

Although accounts do not tell us all the details of the rescue, we may breathe easy to learn that young Brook Watson did indeed survive the attack. Much later, when he had become lord mayor of London, Watson commissioned John Singleton Copley to commemorate this incident in his life. Copley had never seen a shark. His portrait of this menacing beast with razor-sharp teeth is not anatomically correct; instead, he used Watson's vivid and horrifying recollection of the incident to create this face of death.

On occasion, an artist may not answer all the questions raised by a work of art. Sometimes this is deliberate; at other times it is not. What is your opinion in this case? Did Copley purposefully leave you wondering? Did you find the historical account of the story helpful in reaching a deeper appreciation of the painting?

John Singleton Copley (1738–1815) was considered to be one of the greatest American painters of the eighteenth century. His works were noted for their vivid characterizations, splendid composition, and skilled handling of his brush and paint. In 1774, after a short period of travel throughout Europe, Copley settled in England permanently.

Copley was a master of large-scale composition, and his most famous work, *Watson and the Shark,* hangs in the Boston Museum of Fine Arts. Copley's painting of Brook Watson's ordeal is important because it was one of the first paintings of a heroic event that carried no moral or historical importance. It just told a good story.

Section Ⅱ Review

Answer the following questions on a sheet of paper.

Learn the Vocabulary

The vocabulary terms for this section are *intrinsic criticism* and *contextual criticism.*
1. Match the following definitions to the appropriate vocabulary term:
 a. Analysis of a work of art that includes personal, social, or historical information that cannot be gathered simply from the work itself
 b. Analysis of a work of art that focuses on the qualities and components visible in the work itself

Check Your Knowledge

2. What information may be included in an intrinsic dialogue?
3. Why is de Heem's *Still Life* a good subject for intrinsic criticism?
4. Why does Copley's shark appear to be anatomically incorrect?
5. What is one possible drawback to looking at too much outside information about a work of art?

For Further Thought

6. As an artist, you want to create a work of art that expresses the thought "Honesty is the best policy." What objects would you use to symbolize this thought? Give a short description of the entire piece.

Section III

A Critical Method

In the beginning of this chapter, you learned that art criticism is a method of asking questions about a work of art that assists us in discovering the meaning and significance of the work. A **critical method** *is a means of organizing or structuring those questions so that goals may be met and the dialogue kept relevant.*

The following comprise the five steps of the critical method we will present here: preparation, impressions, descriptive exploration, construction of meaning, and judgment. Although this is not the only critical method that exists, it is a good one to start with. The steps follow an important sequence for critically analyzing a work of art successfully.

1. **Preparation:** When you approach a work of art, you should try to be as open-minded as possible; resist any tendency to form a hasty judgment. Try to eliminate distractions. Place yourself where you can see the work; try looking at it from up close and from a distance. You may find it helpful to work with someone else so that you can compare observations.

2. **Impressions:** What is the initial impact of the work of art? Is it powerful? Subtle? Joyful or gloomy? How does it make you feel?

3. **Descriptive exploration:** Provide a detailed account of what is visible to the eye, such as the subject matter, colors, arrangement of objects, dominant objects, and so on. Is there a story taking place? If so, what are the events? Are there people present at the event?

 What is the material the artist has used, such as oil on canvas or bronze? Is the artist's brushwork broad and loose or blended?

 If it is a realistic image, analyze the lighting. Is there a sense of depth? Does it have a foreground, middle ground, and background?

If it is a sculpture, are there open areas to let air pass through? Is it light or heavy in appearance? Does it hug the ground or reach skyward?

4. **Constructing meanings:** Try to recognize and interpret the symbols and themes in the work. Then ask yourself: what does this work of art mean? It may be meaningful on several different levels. For example, it may have a special message that we can relate to today, but it may have meant something different for people who were living at the time and place of its origin. It may be a record of a historical event, but it may also have a broader significance, as we saw with Picasso's *Guernica* in Chapter One. Try to get at all of these meanings. Your study of the work of art may include:
 a. Your own careful analysis and speculation based on your past experience and present knowledge
 b. Information provided by the museum or gallery exhibiting the work, such as wall labels and signs or guided tours
 c. "Deep research" in the library to find out more about the artist, the society in which he or she lived, or the history of the work's artistic style.

5. **Judgment** (optional): While judging the merits of a work of art can certainly be one outcome of both intrinsic and contextual criticism, judgment is not the only option for concluding a critical encounter. The other choice may simply be to bring together or clarify the facts or meanings you have perceived in the work of art.

 Which option you choose will depend on the goals you have set for the encounter. If your goals include determining whether you think a work of art is well done, a judgment would be called for. In this case, you would need to provide good reasons for your assessment. For example, you might say that the artist's use of light and shadow is particularly sensitive, or that a particular painting's composition is exciting as well as challenging.

 On the other hand, if your goal is to examine a work of art in order to learn about an artist's use of color or the way in which a particular subject has been expressed, then a judgment would not be necessary. Instead, you may wish to apply what you have learned from the encounter as you make your own art.

You will notice that with the exception of preparation and judgment, each step consists of asking questions about a specific aspect of the work of art. It is this "quest"—this search for the answers to these questions—that helps us understand what we are seeing and experiencing. You have already practiced this process with two works of art earlier in this chapter (Figures 2–2 and 2–4). Each work offered a variety of interpretations, one in its subtle moralizing and the other in its terrifying drama. As you could see, it is up to the viewer to make the most of a critical experience by continuing to ask questions and search for answers.

Student Examples

You are about to read some examples of student art criticism. The painting these high school students are using is George Tooker's *Government Bureau*, shown in Figure 2–5 below. See if you can determine the types of questions the students have asked themselves as they wrote. The student criticisms begin on the next page.

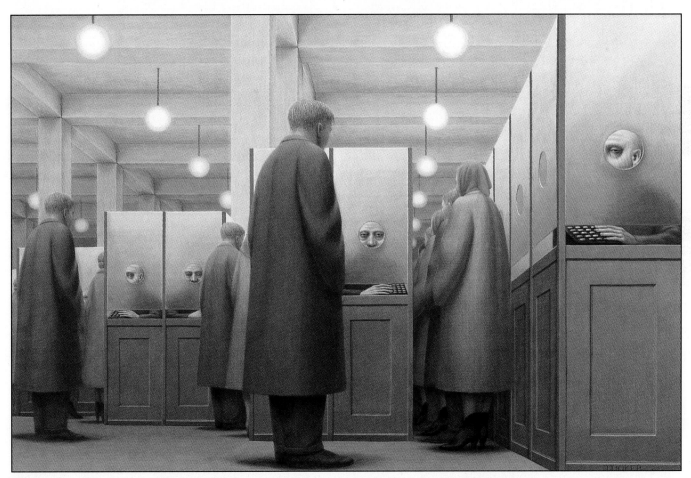

Figure 2-5 Reactions to Tooker's *Government Bureau* are as varied as the people viewing it.

George Tooker, *Government Bureau*, 1956. Egg tempera on gesso panel. 19⅝" × 29⅝". Collection of the Metropolitan Museum of Art, New York, N.Y. George A. Hearn Fund, 1956. 56.78. Courtesy of Marisa del Re Gallery, New York.

My first impression of the work is a sort of calming feeling. The colors are very soft, and not any one aspect of the painting is really eye catching or extremely bright. The browns, off-whites, and sort of faded shades are relaxing. While it is relaxing, it is depressing in a way because it sort of makes me feel like I want to go to sleep or start daydreaming.

The only disturbing thing to me are the bald-headed men in the windows. They are mysterious and frightening. They are ugly and look kind of old. The scene appears to be in a bank or something where you have to wait in line at a booth. Along with the bald men, the customers are repeated throughout the work. The people look depressed and as if they have no will to live. The work is symmetrical in that if the work was divided at the immediate left of the man in the foreground, both pieces would look the same. The work was made with egg tempera on wood, which is what gives it the soft, fluid look it has.

To me, the meaning is that in the government, the people are just numbers, or nonfeeling figures on a page in Washington—that we have become part of a system where person-to-person doesn't exist and we are being robbed of our identities. This is emphasized by the repetition of the characters and their dull appearance. They look lifeless and have no extraordinary features. They have become each other until they die, and have been brainwashed into a sad, depressing state which would drive me nuts. They all have the same characteristics, from the men with straight, brown hair and brown suits and shoes to the women with identical black boots and purplish overcoats and red hair. [This symbolizes] that governments are turning their people and personalities into hopeless beings [held] under mental and physical bondage by an oppressive, cold, all-powerful federal government.

At first, I didn't like the work, I thought it was boring, but I grew accustomed to it. Then I was disturbed by the realization of people stripped of their identities and helped [to do so] by the heartless government. I appreciate how this work made me think and feel, and personally, I like it and enjoyed viewing it.

Jesse Cononico, 17

As I first glanced at this work of art, I was puzzled. To have six dark, sunken-in eyes looking at me was a bit cold. The artist George Tooker has an interesting way of expressing and projecting a simple scene. It just gives you a peculiar feeling that someone is watching you at all times.

In this painting, I see a big case of repetition. The big dark grotesque eye is in every booth throughout this space. The form of the man is shown front and center in this work, but it is repeated again throughout the middle ground. Going off into space is a row of bright lights that are placed between rows of panels that are going in the opposite direction.

The man who is placed behind a toll booth and is busy pushing buttons symbolizes the pattern that person has gotten into. The painting *Government Bureau* shows what happens to people when they do the same thing day in and day out, with no interruption between. The people that are standing in line give you the idea that they have been doing this very same thing for quite some time now.

My judgment on this painting is neutral. I like the way Tooker took the objects and projected them in a way that draws some questions. But yet at the same time it's not all that pleasing to the eye. I do like this painting because it has a subject matter that changes interpretation from person to person.

Stacey Hallowes, 16

The work of art makes me feel as though I'm in front of the painting, yet at the end of the line. The repetition of the man in an overcoat is interesting. To see two men in the exact same wardrobe, exact same stance, and every other feature the same is almost unnatural-natural. One man in the foreground in a line and the same in the background give me the feeling that it keeps going diagonally away from me. The scene gives me a claustrophobic feeling since I'm stuck here in line at knee level like a little child. Although the name *Government Bureau* explains where this is, I assumed some sort of prison-like bulk financial institution.

It is depressing and disturbing to feel the government apathy toward society by having a very nonefficient system to do business. The left and middle workers seem to all be staring right at me. They are all bald, white zombies. They have no personality due to the repetition of their job day in and day out. Better stop—I'm going crazy!

Duane Rinehart, 17

This work of art is eerily subtle. The scene seems sort of dreary. The painting looks as though it is trying to get some strong point across. It is very interesting. It leaves me with an extreme sense of curiosity to find the true meaning.

Upon further observation, I found the title to be *Government Bureau*. I thought maybe the title would reveal more of the work's secrets. All the title did was force me to think more.

The light colors in the work give it that subtle feeling, along with the overpowering shades of tan that seem to dominate the painting. The artist's use of straight lines and repetition gives the painting organ-ization! Every window is identical. All the tellers have the same emotionless expression. Even the people, who seem to be customers, are repeated. They are all identical except for the color of their clothes.

All this seems to symbolize how everyone is the same. No one dares to be different. The tellers look dead. They are all old. They are not living life, they are just punching a time card and typing on the machines. They are robots or zombies.

This is a good work of art because of the thought it produces. It looks as though the artist had some real painting talent as well as some philosophical visions.

Brian Darby, 17

After studying the reproduction, do you understand how these students may have reached their conclusions? Do you agree or disagree with them?

Section III Review

Answer the following questions on a sheet of paper.

Learn the Vocabulary

The vocabulary term for this section is *critical method*.

1. Define the vocabulary term by using it correctly in a sentence.

Check Your Knowledge

2. What five steps comprise the critical method presented in the text?

3. What can your study of an artwork include as you try to construct meaning?
4. What goals of examining a work of art would require you to use judgment as part of the critical method?

For Further Thought

5. Choose a full-page advertisement from your favorite magazine. Give a short description of the ad. Apply steps three and four of the critical method to this advertisement. What are some symbols used? What is the meaning of the advertisement?

Section IV

Establishing a Visual Vocabulary

Art criticism has a special language. This section and the next introduce you to some of its major terms and concepts which you can then use to analyze and describe a work of art. Knowing these terms will deepen your appreciation of the artist's work and will have an impact on your own artwork. Many of these terms are already in your vocabulary.

Besides the words we use to describe the emotional impact of a work of art or the inspiration an artist has expressed, we can discuss art in terms of its basic components—the elements and principles that govern its creation. These elements and principles are common to all forms of expression in the visual arts. It is the artist's unique, inventive, and creative imagination that governs the use of the elements and principles and how they are used together in any specific work. In other words, when artists create works of art, they make intentional choices concerning how they use the elements and principles. These choices help artists to convey particular moods, feelings, and visual messages. When you describe and analyze the way in which the elements and principles interact, you are using the language of a critic.

It is important to note that not all artists of every culture and time period have utilized the elements and principles of art about to be listed in the same way. Some cultures do not have a visual art vocabulary that corresponds with ours. Because of this, while we might draw on our knowledge of elements and principles to help us analyze visual artworks, and to help us design our own, we probably wouldn't want to base our interpreations and judgments solely on the use of elements and principles.

Sections Four and Five of this chapter will introduce you to the elements and principles of a work of art, and help you understand how artists use them as well as how you might use them in creating your own art.

The Elements of Art

An **element** *is a basic component or essential "part" of a work of art.* The elements are necessary, for without them there would be no work of art. They are the visual instruments with which artists orchestrate their compositions. They are common to all works of art. The elements of art are line, shape/form/space, texture, and color/value.

These elements can function independently or in conjunction with one another. Some artists choose to use variations on only one element to create their work of art. Other artists may use several elements at the same time. Let's look at the following elements in detail.

Line

A **line** *is a moving point on the surface of a canvas, a paper, a slab of clay, or a metal printing plate. It forms shapes, gives direction, and creates rhythm and movement within a work of art.* Lines can direct our eyes around and through a composition. The artist may also manipulate lines to express moods or feelings, such as anger, joy, excitement, or sadness. An angry line, for example, might be jagged or irregular. A line that shows excitement might possess great swells and dips. A straight horizontal line may seem lifeless and sad.

A line may have thickness as well as length. An artist may use a line of varying thickness to express mood, create rhythm or establish patterns. Although a line may have thickness, it is usually considered relatively one-dimensional. Lines, when clustered, may be used by the artist to create either light or dark tones in a composition. Clusters of lines may also suggest texture.

Some lines define contours, and others form shapes. *Lines that show the edge of a shape are* **contour lines.** Pablo Picasso seems to capture the gentle nature of Igor Stravinsky in this simple contour line drawing. (See Figure 2-6).

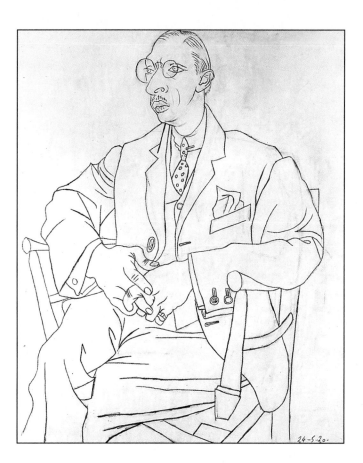

Figure 2-6 Contour line drawings should quickly capture the nature of the subject. After viewing this image, what type of person do you think Stravinsky was?

Pablo Ruiz Picasso, *Portrait d'Igor Stravinsky*, 1920. Giraudon/ Art Resource, NY. ©1993 Artists Rights Society (ARS), New York/SPADEM, Paris.

Lines can be either real or implied. **Real lines** *exist within a work of art.* They have been placed there by the artist as an integral part of the composition. **Implied Lines** *are lines that are recognized by the brain and the eye but are not really present.* They are created by the arrangement of shapes within a composition, including the spaces between shapes. Implied lines are even suggested by a familiar arrangement of points. **Closure** *occurs when the "mind's eye" forms the lines connecting the points even though no lines actually exist.* Ben Shahn demonstrates this process in his painting entitled *Still Music.* We mentally group or connect the points, lines, angles, and shapes into various patterns. (See Figure 2-7).

Shape, Form, and Space

A **shape** *is a two-dimensional area defined by a boundary.* Sometimes that boundary is a line; at other times, the boundary is created by the location of additional shapes.

Figure 2-7 Below The way Shahn has represented the music stands here suggests that there are more music stands in this painting than those we can actually see.

Ben Shahn (1898–1969), *Still Music*, 1948. Casein on fabric mounted on plywood panel. 48" × 83½" (121.9 × 212.0 cm). Signed. Acquired 1949. The Phillips Collection. ©Estate of Ben Shahn/VAGA. New York, NY, 1994.

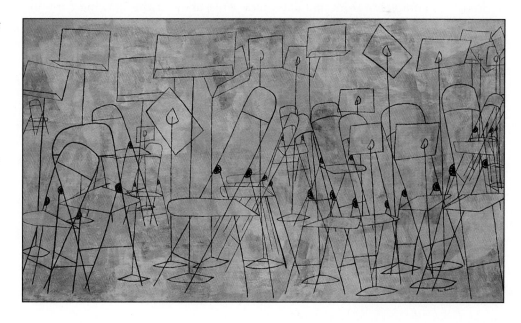

Student Activity 1

Lines over Shapes

Goals

1. You will create a contour-line drawing of a still-life with a variety of simple and detailed objects.
2. You will practice shading shapes to look three-dimensional.
3. You will combine the contour-line still-life drawing with shapes you have shaded.
4. You will develop a sensitivity to line detail and direction.

Materials

1. White drawing paper, approximately 18" × 24" or larger
2. Construction paper in assorted colors
3. Glue
4. Pencils, drawing and colored
5. Markers
6. Still-life objects: plants, shoes, fruit, bottles, and so on

Directions

1. Begin by tearing organic shapes from the construction paper. Three or four shapes will do. Use different colored paper for each shape.
2. Glue the shapes you have torn from the construction paper anywhere you wish on the surface of the white drawing paper.
3. On your white drawing paper draw the still-life contour lines only. The contour lines will overlap the shapes you have just glued down. Vary the thickness of the line from object to object. Attend to the detail of each form, using line only.
4. Study the completed work and determine what areas of the drawing contain the most interesting shapes created by contour lines.
5. Using colored pencils, shade the items of your still-life drawing that fall within the organic paper shapes so that your composition will appear to be more three-dimensional.

Evaluation

1. Did you successfully create a contour-line still-life drawing in which you varied the thickness of your lines and paid close attention to the details of the objects in the still-life? How does varying the thickness of the lines add interest to your composition?
2. Have you shaded the objects that fall within the torn paper shapes? Did your shading of these objects help them to appear to be more three-dimensional? In what ways?
3. Look at your finished work. With some areas of the composition more heavily shaded than others, do you feel that all the areas of the drawing seem to pull together into one unified work?

Student Work

with the space around them. **Space** *is the area between or around objects that defines shapes and forms.* There are two types of space associated with composition. **Negative space** *is the unused area between, within, and surrounding shapes and forms in a composition.* **Positive space** *refers to the shapes and forms themselves.*

In some two-dimensional works of art (such as paintings or drawings) the artist has created the illusion of three-dimensional forms. These are known as implied forms. **Implied forms** *are forms that give the illusion of being three-dimensional but are represented on a flat two-dimensional surface like drawing paper or canvas.* **Real forms** *are three-dimensional forms that actually exist in space* (such as trees, mountains, or buildings). By adjusting our line of sight, we may see the front, back, sides, top, and bottom of a real form.

Like shapes, forms may be geometric or organic. When an artist uses real forms to create a work of art, he is creating *sculpture.* Some sculpture is freestanding, which means that you can see it from every side. Other types of sculpture are only partially visible. For example, the ancient Greeks used a form of sculpture called *relief* to decorate parts of their temples. Medieval ca-

All shapes are *two-dimensional*—that is, they have *width* and *height.* Artists use two types of shapes in their works: geometric and organic. **Geometric shapes**—*circles, squares, rectangles, and triangles—are mathematical in proportion.* **Organic shapes** *are irregular, and curvilinear.* They are usually derived from nature. When the two types of shapes are used together, they add great variety to a composition.

Forms *are three-dimensional shapes.* Forms have height and width, as do shapes. They also have a third dimension—depth. Both shapes and forms interact

Student Work

thedrals were also decorated with this type of sculpture. See Figure 2-8 for an example. **Relief** *is comprised of sculptural forms that protrude from a flat surface.* Those that protrude significantly are called **high relief.** Those forms that protrude only a little are called **low relief.** Relief forms may appear in many other types of artistic expressions, such as ceramics, jewelry, weaving, and fashion design.

There are other forms that do not exist in real space but give the illusion that they do. These forms involve the use of technology in order to create them. They are not permanently rendered on a two-dimensional surface and are part of the visual repertoire of the artist who produces computer images, holography, video, or films.

Texture

Texture *refers to the surface qualities of a particular object or work of art.* Texture is the way things feel or appear to feel. We perceive and respond to texture in many different ways. Texture influences the enjoyment of the food we eat, the clothes we wear, and the objects with which we surround ourselves.

Artists are aware of many ways in which textures may influence their work. The ancient Greeks and Romans, as well as sculptors like Michelangelo, were skilled at creating a sense of the softness and flexibility of flesh in a medium as rigid as stone or marble. Cornelis de Heem created the illusion of food ripe enough to decay (Figure 2-2). Vincent van Gogh painted objects and atmospheres so intense with thicknesses of

Maggie Garcia, 17
North Dallas High School; Dallas, TX

Figure 2-8 This lively Greek carving is an example of relief sculpture.

Parthenon Freize: Group of Horsemen (Fregio del Partenone: Gruppo di Cavalieri). British Museum. London, Great Britain. Scala/Art Resource, NY.

Student Activity 2

Negative Space and Pattern Composition

Goals

1. You will draw the negative space of a still-life, then create pattern within that space.
2. You will become aware of what is negative space and what is positive space within a composition.
3. You will learn to see negative space within an object.
4. You will experiment with patterns consisting of lines and shapes.

Materials

1. Objects such as a chair, or a bicycle wheel, and so on that have negative space
2. Drawing paper
3. Pencils, markers
4. Pen and ink if desired

Directions

1. As a class, create an interesting still-life arrangement with the objects you have collected.
2. On your drawing paper, draw only the negative space of your still-life, using a light pencil line. Pay particular attention to the small negative spaces within each object.
3. Using pencils, markers, or pen and ink, develop a pattern in each of the negative-space sections in your drawing. Pattern is created by repeating units or motifs made up of lines and shapes. The pattern will unify and organize the negative space. Be consistent with the patterns you create in each space.

Evaluation

1. Did you carefully select objects that contained interesting negative spaces within? Did you combine them in a still life so that there were a variety of negative spaces created between each object? Which type of negative space seemed most dominant?
2. Were you successful in combining both types of negative spaces in your composition? Do the negative shapes seem to overpower the positive shapes in your work? How have you established good contrast between the negative and positive shapes in your composition?
3. Were you consistent with the patterns you created in each of the spaces? If you were to vary the patterns you used, how do you think it would affect your composition?

paint that one could literally feel the texture as well as see it.

There are three types of texture that artists use when they create their works of art. **Simulated texture** *is the recreation of a manufactured or natural texture.* Although such textures are seen in photographs, paintings, and

Carlene Brown, 17
Smithfield High School; Smithfield, RI

Figure 2-9 Dürer's rabbit looks so real, you can feel the softness of its fur.

Albrecht Dürer, *Junger Feldhase (Rabbit)*, 1502. Graphische Sammlung Albertina, Vienna, Austria.

Figure 2-10 A multitude of different textures adds interest to this composition.

Josef Albers, *Untitled (Fenster-Bild)*, 1921. Light box. Glass, wire, painted metal, nails, mesh, imitation pearls, brush and ink on painted wood light box. 23" × 21¾" × 8⅜" (58.4 × 55.2 × 21.2 cm.). Hirshhorn Museum and Sculpture Garden, Smithsonian Institution. Washington, D.C. Gift of Joseph H. Hirshhorn. ©1994 Artists Rights Society (ARS), NY/ VG Bild-Kunst, Bonn. Photo by Lee Stalsworth. 72.6.

computer images, they cannot be touched by the viewer.

Look at Figure 2-9, *Rabbit* by Albrecht Dürer (1471–1528) (see Section Six). Although the fur on this rabbit cannot be touched by the viewer, its softness is communicated visually. Similarly, a photograph of stones clustered at the bottom of a creek bed can communicate the feel of their cool, wet, smooth surfaces. We are *aware* of their texture without having to touch them.

Student Activity 3

Texture Sandwiches

Goals

1. You will design a "sandwich" composed of layers of simulated, invented, and actual textures.
2. You will learn how to create the illusion of texture on a two-dimensional surface.
3. You will be able to discern between simulated, invented, and actual textures.

Materials

1. Illustrations or photographs of textured objects within their environments, such as buildings, roads, trees, and so on
2. White drawing paper, 12" × 18"
3. Glue
4. Materials with actual textures, such as foil, sandpaper, fur, handmade paper, glitter
5. Tempera or acrylic paint
6. Colored pencils
7. Pastels

Directions

1. Start by reading the following scenario:

 You have suddenly been transported back to medieval times. You are now the chef for a rich and powerful king.

 The king has recently heard from a passing knight about a new gastronomical treat known as a sandwich. He is so curious about this new delicacy that he commands you to prepare one for his dinner.

 Knowing little about the appearance or ingredients of a sandwich, the king insists that it is made of two slices of bread and no fewer than six ingredients. Anything is possible! Use your imagination and a variety of actual, invented, or simulated textures for each of the six layers.

Student Activity 3 continued on next page

2. Place your drawing paper vertically on your work space. Create a slice of bread or a bun at the bottom of your paper with tempera or acrylic paint.

3. Alternate layers of simulated, actual, and invented texture. Use the illustrations and photographs for suggestions.

4. Glue the texture samples to the paper surface. Build up a minimum of six layers of texture or "food items."

5. Complete your sandwich by painting another slice of bread on top. Add a pickle and a toothpick!

6. Serve it to the king! Prepare a feast in which each class member presents his or her sandwich to the king. Be creative with your presentation. Convince the king that your textures taste best!

Evaluation

1. Were you able to differentiate between and experiment with actual, invented, and simulated textures? How have you done this?

2. Did you use a variety of textures and resources to create your sandwich? What made them so different? How would you make a choice among the three types of texture for future works of art?

3. Were you successful in presenting your texture sandwich to the king in a creative and convincing way?

Invented texture *is made up by the artist using lines and shapes.* Often these textures are referred to as *pattern.* These textures are not recreations of already existing textures, they are newly developed by the artist. When artists apply real textures from natural or man-made objects, they are called actual textures. **Actual textures** *can be felt when touched.* Some artists create actual textures with paintbrushes or palette knives. Other artists create actual textures by adding to their works materials that have textures of their own.

Figure 2-10 on page 68 provides examples of the different types of texture.

Color

Color is one of the most important elements for artists. It is used to create a mood, express certain feelings, create patterns, and give a sense of movement or balance in a composition.

Color *is what is perceived when waves of light strike the retina of the eye.* We perceive color in much the same way as a camera does. Light reflects off an object, passes through our eyes, and registers in our brains. We see the color of an object because of the type of light it reflects.

Light is made up of colors called a **spectrum.** When white light is passed through a triangular-shaped piece of clear glass called a prism, it separates into the colors of the spectrum. These are the same colors we see in a rainbow. Objects in our world reflect and absorb different spectral colors. The colors that are absorbed are the ones we do not see. The colors that are reflected are the ones we do see. For example, if a vase appears blue to us, that is because it is reflecting blue light and absorbing all the other colors. Objects that appear multicolored are reflecting more than one color of light at the same time (see Figure 2-11).

Because of the special properties of light, color theory concerning light is very different from color theory concerning pigments. A **pigment** *is matter that gives color to materials such as paints, dyes, crayons, or inks.* Pigments come from the earth or from animal or plant sources. Pigments that come from the earth produce shades of brown and red. Pigments that come from animal or plant sources produce shades of blue, green, yellow, violet, and orange.

With light, the process of mixing colors is an *additive* process. If you mixed all of the colors of the spectrum together, the result would be white light. This is not the case with pigment. The process of mixing pigments is said to be *subtractive.* When you mix all of the colors of pigment together, the result is black.

People who are lighting directors for theater productions, television shows, and films must be specially

Light Source

Figure 2-11 Color Spectrum Light passing through a prism separates into the colors of the spectrum.

Student Activity 4

Primary and Secondary Colors

Goals

1. You will experiment with primary and secondary colors by using them in a geometric and in an organic composition.
2. You will practice mixing primary colors to make secondary colors.
3. You will construct a color wheel that may be used as a reference for future critical dialogue, aesthetic dialogue, or art making.

Materials

1. Reproductions of works by Henri Matisse and Piet Mondrian
2. White drawing paper, 12" × 18"
3. Ruler
4. Pencils
5. Tempera or acrylic paint

Directions

1. Discuss the works of art by Matisse and Mondrian. Pay particular attention to how the artists have used primary or secondary colors to add interest to their works.
2. Discuss the design of a color wheel with respect to the placement of the primary, secondary, and tertiary colors.
3. Divide the drawing paper in half horizontally so that each half measures 9" × 12". On the bottom half, create a color wheel.
4. Place the primary colors on the wheel first.
5. Mix equal amounts of two primary colors to create a secondary color.
6. Place each secondary color on your color wheel halfway between the two primaries you mixed to create it.
7. Complete your color wheel by mixing equal amounts of a primary and a secondary color to create a tertiary color.
8. Place the tertiary colors on the wheel between the primary and secondary colors you mixed to create them.
9. Divide the top half of your paper into two equal portions. On the left half, create a design using only geometric shapes. On the right, create a design using only organic shapes.
10. Color one design with primary colors and the other with secondary colors.

Evaluation

1. Did you discover how Matisse and Mondrian used primary and secondary colors to add interest to their paintings? List some of the ways.
2. Did you construct your color wheel properly? How did you know where to place the colors?
3. Were you able to mix both secondary and tertiary colors successfully? What was the relationship between their placement on the color wheel and the amount of each color you needed to mix them?
4. Did you create and color designs using primary and secondary colors and geometric and organic shapes? What was your response to the different groupings of colors and how their use influenced the overall look of the composition?

trained to use light artistically, mixing different colors to produce a certain effect. Similarly, artists must be trained to use and combine pigments in order to produce the effects they want.

Since we are primarily concerned with using pigments, we will start by learning how to mix them. The mixing of pigments starts with the primary colors. The **primary colors** *are red, yellow, and blue,* and are *colors that cannot be made by the artist.* That is because they are pigments that occur naturally and cannot be mixed by combining other pigments. They are the basis for mixing all of the other colors. During the Middle Ages and the Renaissance, artists acquired these pigments by crushing such natural sources as coral, gemstones, and plant material.

Mixing two primary colors in equal amounts will produce what is known as a **secondary color.** The secondary colors are orange, green, and violet. *Mixing varying amounts of a primary and a secondary color produces a third grouping of colors called* **tertiary colors.** Varying the mixture of primary and secondary colors produces an infinite number of tertiary colors. Yellow-green, for example, is a mixture of yellow (primary color) and green (secondary color). Its title (yellow-green) indicates that it will be placed closer to the yellow on the color wheel because the mixture contains more yellow than green.

The relationship of these colors can best be understood by looking at a color wheel (see Figure 2-12). The primary colors are placed at equal distances from each other on the color wheel. Located exactly halfway between any two primary colors is a secondary color. This secondary color is located there to indicate that it can be produced by mixing equal amounts of the two primary colors on either side of it. The tertiary colors are located between the secondary and primary colors and arranged according to the amount of each color used in the mixture.

The color wheel is a helpful tool for artists in choosing and creating (mixing) colors for a work of art. An artist may use the wheel to help locate a color that will sharply contrast with another. *Complementary col-*

Figure 2-12 Color Wheel

Figure 2-13 Using Cool and Warm Colors. How do the different color schemes affect you? How do the terms cool and warm apply?

ors are those that are located directly opposite each other on the color wheel. When used together in a composition, they provide the highest degree of contrast.

Just as a color can appear to be happy or sad, so may a color seem to have a warmth or coolness about it. The *cool* colors are blue, green, and violet. The *warm* colors are red, yellow, and orange. Can you think of instances where an artist might make use of the warm or cool nature of a particular color? (See Figure 2-13.) What are some other moods or feelings we might associate with certain colors?

TECHNOLOGY MILESTONES IN ART

Color Comes to the Movies

In the early 1900s, chemical engineer Herbert T. Calmus patented the process known as Technicolor. This is a process for making motion pictures in color. The first motion picture to be made with this process is entitled "The Gulf Between". It played in theaters in 1917.

Originally, the Technicolor process was a two color process, but in 1932, a third color was added. This process consists of taking three separate black and white negatives of a scene being shot. The negatives are then exposed to one of the three primary colors of light—red, blue, or green.

The negatives are then developed in the positive on another piece of film. Then the positives are dyed by technicians (separately in red, blue, and green), to produce the colored areas indicated by the negatives. All three positives are then printed together on one piece of film to produce a color image.

This process was very costly and was replaced by less expensive methods after the 1940s.

Value

Value *refers to the amount of lightness or darkness a color possesses.* The value of a color may be changed by adding some black or white to the color. **Tints** *are colors to which a lighter color or white has been added.* **Shades** *are colors to which a darker color or black has been added.*

A color's intensity may also be changed by mixing it with varying amounts of its color complement. A color in its pure state has maximum intensity. The more complementary color you mix with it, the duller the first color will become. If you mix enough of any two complementary colors together, you get gray.

White, black, and gray are *neutral* colors. If you add them to any color, only the color's *value* will change. *A work of art that is done using only one color and its different values is said to be* **monochromatic.**

Photographer Ansel Adams produced images that were devoid of any color. His colorless compositions were fascinating because of their range of black, white, and gray contrasts he achieved. Do you become more acutely aware of the other elements in compositions because of the lack of color? If so, in what way?

DEVELOPING SKILLS FOR

ART CRITICISM

Most of us have a favorite room in our home, a room in which we feel most comfortable and relaxed. If you could choose one work of art from the list below to place in that special room, which one would you pick?

a. Cornelis de Heem, *Still Life*, Figure 2-2.

b. John Singleton Copley, *Watson and the Shark*, Figure 2-4.

c. Thomas Hart Benton, *Engineer's Dream*, Figure 2-14.

d. Wayne Thiebaud, *French Pastries*, Figure 2-22.

e. René Magritte, *Personal Values*, Figure 2-25.

1. On what criteria would you base your decision?

2. What qualities of the work you have chosen make it your *best* choice?

Student Activity 5

Monochromatic Self-Portraits

Goals

1. You will look at and discuss photographs by Ansel Adams and Margaret Bourke-White, and self-portraits by painters Paul Cézanne, Andy Warhol, and Rembrandt van Rijn.
2. You will learn how to mix black and white paint to acquire a variety of values and how to use these values to create the planes and features of the face.
3. You will create a self-portrait using black, white, and values of both.

Materials

1. Reproductions of photographs by Ansel Adams (Figure 5-24) or Margaret Bourke-White
2. Examples of self-portraits of the following artists (see Chapter Seven, "The Human Image in Art"): Paul Cézanne and Rembrandt van Rijn
3. Paper or canvas, 12" × 18"
4. Black and white tempera or acrylic paint
5. Brushes
6. Mirror
7. Sketching paper
8. Pencils
9. Palette or other mixing surface

Directions

1. Discuss how Adams and Bourke-White used black and white photography to capture subtle values and contrasts in a landscape or portrait. Then look at the self-portrait styles of Cézanne, Warhol, and Rembrandt. Select a style from among the painted examples that you feel best suits your facial qualities and personality.
2. Create a preliminary drawing of your face using sketching paper, pencil, and mirror.

Student Activity 5 continued on next page

3. Divide your portrait into planes where the eyes, cheekbones, and chin are located.

4. Transfer your drawing to canvas.

5. Indicate with pencil on your canvas where the planes of the face begin and end.

6. Place black and white paint on your palette. Mix a variety of black and white values.

7. Use this monochromatic palette to paint your portrait, changing the values from plane to plane and within each feature.

Evaluation

1. Did you understand how black and white and values of each could be used to create a work of art?

2. Did you demonstrate this understanding by creating a monochromatic portrait of yourself? How might the lack of color in your work affect the overall mood it projects?

3. Each of the portraits you looked at earlier expressed something of the subject's personality. Were you satisfied that your completed self-portrait did the same? In what ways?

4. Were you able to mix a variety of values from black and white paint? Did the values change from plane to plane in your self-portrait? How have you used different values of black and white to make your work seem three-dimensional?

Section IV Review

Answer the following questions on a sheet of paper.

Learn the Vocabulary

The vocabulary terms for this section are *actual texture, closure, color, contour lines, element, form, geometric shapes, relief, high relief, implied forms, implied lines, invented textures, line, low relief, monochromatic, negative space, organic shapes, pigment, positive space, primary colors, real forms, real lines, secondary colors, shape, space, simulated texture, shade, spectrum, tertiary colors, texture, tint,* and *value.*

1. Fill in the blank with the appropriate vocabulary term.
 a. An _____ is a basic component of a work of art.
 b. _____ refers to the surface qualities of an object or work of art.
 c. A _____ is a three-dimensional shape.
 d. Red, yellow, and blue are _____ _____ .
 e. Lines that show the edge of a shape are called _____ lines.
 f. The unused area between, within, and surrounding shapes and forms in a composition is called _____ _____ .
 g. Sculpture that protrudes from a flat surface is called _____ .
 h. _____ is the amount of lightness or darkness a color possesses.
 i. Matter that gives color to materials such as paints, dyes, crayons, or inks is called _____ .

Check Your Knowledge

2. What is the difference between real lines and implied lines?
3. What are the two types of space associated with composition?
4. List at least two purposes color can serve in a composition.
5. What type of color is produced by mixing primary colors?
6. How can the value of a color be changed?

For Further Thought

7. Colors can affect our moods. Some colors help to relax us while others make us feel more energetic. With this in mind, which colors would you use to decorate a dentist's waiting room? An elegant restaurant? A dance club? Give reasons for your color choices.

Section V

The Principles of Art

The **principles** of a work of art *are movement and rhythm, unity, variety, emphasis, proportion, and balance. They are the essential qualities of a work that produce a desired expressive effect.* As with the elements, an artist may use these principles independently or in conjunction with one another. Analyzing the effective use of the elements and principles together helps us, both as creators and viewers of art, to understand better the powerful messages a work of art may communicate.

Student Work

Christopher Montecalvo, 18
Smithfield High School; Smithfield, RI

Movement and Rhythm

Movement *is the visual suggestion of action created by the placement of the elements in a work of art.* **Rhythm** *is the regular repetition of elements, patterns, or movements in a work of art.* When certain elements, such as lines or shapes, are repeated throughout a composition or are arranged or clustered into repeated patterns, they give a work of art the illusion of movement.

It is not uncommon for one work of art to possess many types of rhythms. For example, in *Engineer's Dream,* Thomas Hart Benton (1889–1975) has created several different sensations of rhythmic movement (see Figure 2-14). How many different examples can you find? What has Benton done to create these rhythms?

In the bottom right corner of the painting, Benton has placed his aging engineer draped comfortably across a bed. The engineer's face is angular and rugged; it is the face of an experienced railroad man. His brow is wrinkled only slightly. While his body is made up of soft, distorted curves, its placement on the diagonally positioned bed creates one of many jutting, forceful triangles that cut back and forth across the picture.

Benton, however, breaks up this acute angular rhythm by sending the irregular swells and dips of the landscape, water, and smoke across the picture's jagged planes. In addition, he adds to the complexity of the composition by repeating strong diagonal and almost vertical lines, in the form of telephone poles and bedposts, throughout the painting.

There is another rhythm here, too, established by the sense of forward movement in the runaway locomotive. We can almost hear the rhythmic pounding of metal on metal and the screeching of the emergency brakes as the engine nears the edge. In a split second, our eyes leap from speeding locomotive, to flag-waving lineman, to the engineer jumping from the doomed train at the last moment, to the sleeping engineer who will surely be jolted from this nightmare as the disaster occurs.

Figure 2-14 Is this a "dream" or is it a "nightmare"?

Thomas Hart Benton, *Engineer's Dream,* 1931. Oil on panel, unframed: 29" × 41¾", framed: 35⅝" × 50¾". Memphis Brooks Museum of Art. Memphis, Tennessee. Eugenia Buxton Whitnel Funds. ©1994 T. H. Benton and Rita P. Benton Testamentary Trusts/VAGA, New York.

Student Activity 6

Action Through Rhythm and Movement

Goals

1. You will create a drawing or painting that tells an action story.
2. You will use the principles of rhythm and movement to intensify the drama and set the pace of the story's action.

Materials

1. White poster board, one sheet
2. Markers
3. Drawing pencil
4. Watercolors
5. Masking tape

Directions

1. Using your drawing pencil, create an action story containing great drama on your poster board. This may be a story about a daring rescue or some event about to happen. Make your story suspenseful.
2. Recall the paintings of Thomas Hart Benton and Edward Hopper in this chapter (Figures 2-14 and 2-21), and try to use the principles of rhythm and movement as they have to intensify the story in your drawing.
3. When your drawing is complete, consider what colors you might use to suggest the tone of your story. If the story is a daring rescue, does it take place at night or in broad daylight? If it takes place at night, you might use more blues, grays, and black. If it takes place in the daylight, is the sun searingly hot? What colors would suggest such heat?
4. Use markers or watercolors to color your work. If you choose watercolors, be sure to tape the edges of your poster board to your work surface so they won't warp.
5. Use a dark-colored marker to outline and add emphasis to the details in the composition.

Evaluation

1. Do you feel that you have created a drawing that tells an interesting action story? What is most intriguing about it?
2. Have you effectively used rhythm and movement in your drawing to intensify your story? In what ways?
3. Does your drawing tell the story from beginning to end, or do you leave your viewers guessing about the conclusion? What would be some good reasons for keeping your viewers unsure about the outcome of your story? What might be some good reasons why your story should have a visible conclusion?

The artist's use of rhythm and movement in a painting like this one can leave our hearts pounding and our imaginations racing. But there are also times when artists may wish to present more pastoral rhythms. Figure 2-15 provides an example. The artist, Grant Wood, is probably best known for his portrait of austere farm life in *American Gothic*.

When we first glance at *Spring Turning*, our eyes glide across the rolling surface of fertile farmland—over the first hill, into the valley, up the next hill, off to the left, and into the distance past the farmhouse and haystacks. We barely notice the farmer with the horses and plow at the bottom center of the painting. Once we do, we anticipate their forward movement, finishing row after neatly plowed row until the land is ready for planting. Wood's vibrant greens and deep browns suggest that the land is rich and fertile. The rhythmic rolling of the land's contours makes the ground seem to rise and fall as though it were breathing.

In sharp contrast to the soft undulating rhythms of Wood's idyllic farmland is the out-of-control swerving of the cars and truck about to collide in his work entitled *Death on the Ridge Road* (see Figure 2-16). Here Wood distorts his images to surreal proportions in order to emphasize the frantic movements of the vehicles just moments before the inevitable crash. Even the land seems to stretch under the weight of the vehicles to give more emphasis to the jerking movements of the cars. The action seems to build to an almost intolerable tension. The fence posts and telephone poles sway and weave, held in place only by the wires and cables that link them. The pattern created by these diminishing vertical lines leads our eyes to the horizon,

Figure 2-16 Using the same painting style as he did in *Spring Turning*, but changing the rhythms and movement in his composition, Grant Wood jolts us to attention in *Death on the Ridge Road*.

Grant Wood, *Death on the Ridge Road*, 1935. Oil on masonite. 32" × 39". Williams College Museum of Art. Williamstown, Massachusetts. Gift of Cole Porter. 47.1.3.

where over the top of the hill leaps the emissary of doom! Wood represents the power of the truck's forward momentum by raising the front wheels of this massive vehicle off the road's surface. With this violent sense of movement, Wood sends the drama's players to their impending end.

Figure 2-15 The soft curves and rolling surfaces of this painting give you a peaceful and pleasant feeling.

Grant Wood, *Spring Turning*, 1936. Oil on masonite. 18⅛" × 40". Reynolda House Museum of American Art. Winston-Salem, North Carolina.

These examples have shown us the powerful messages artists can create through the use of flowing rhythmic movements. But not all rhythms and movement are represented in this manner. Some rhythms and movements are represented when the artist uses static placements of the elements. This means that patterns may still exist to create the illusion of movement, but that arrangement of these patterns may be irregular. Look carefully at Figures 2-17 and 2-18 by Piet Mondrian (Peet MOHN-dree-ahn) and Joseph Stella.

The examples we have seen so far have been two dimensional, and the visual sensations of rhythms and movement have been illusionary. In some three-dimensional works of art, rhythm and movement are created when parts of the work actually move. The mobiles of Alexander Calder (1898–1976) are good examples (see Figure 2-19). Calder's works can only be fully appreciated when you see them move as the artist intended.

Figure 2-18 In this work, Joseph Stella has a different way of portraying the excitement and confusion of New York City's busy theater district. Diagonal flashes of light and repeating curvilinear lines capture the bright sights and wonderful sounds that greet theater crowds on "The Great White Way."

Joseph Stella, *Voice of the City of New York Interpreted (White Way I)*, 1922. Oil and tempera on canvas. Collection of the Newark Museum. Purchase 1937, Felix Fuld Bequest Fund.

Figure 2-17 Mondrian has used lines to establish grid-like streets for his rhythmically unpredictable procession of tiny square vehicles.

Piet Mondrian, *Broadway Boogie-Woogie*, 1942-43. Oil on canvas. 50" × 50". Collection, The Museum of Modern Art, New York. Given anonymously. Courtesy the Mondrian Estate/Holtzman Trust.

Figure 2-19　Imagine how many patterns these few pieces might form as the wind blows or light reflects off its parts.

Alexander Calder, *Red Gongs*. Mobile. Sheet aluminum, sheet brass, steel rod and wire, red paint. Overall length approximately 12 feet. The Metropolitan Museum of Art, New York. Fletcher Fund, 1955. ©1994 Artists Rights Society (ARS), NY/ADAGP, Paris.

With Calder's mobiles, we first notice the repetitive placement of similar shapes along the wire arms; then, a different kind of rhythm and movement arise when a slight breath of air begins to move the arms and rearrange the composition as we watch. One of the great pleasures of viewing mobiles is that the arrangement of all the arms and their shapes seldom stays the same. The placement and interaction of shapes within the entire work changes as the air currents lift and propel them. Calder himself expressed this pleasure clearly:

"A mobile? It's wind, freedom of movement, the joy of ceaseless recombination of shapes."

Unity

Works of art consist of many parts, elements that work together to create a composition. We tend not to separate a successful work of art into its parts but rather to appreciate how well those parts work together. This principle is called unity.

Unity *is a principle that helps us see the components of a work of art as a whole.* Unity in a work of art can be achieved in several ways. One of these ways is placement. The elements or subjects in a composition may appear to be unified because they have been clustered or placed close together (Figure 2-20 on page 87).

Student Activity 7

Shapes in Motion

Goals

1. You will create a free-hanging mobile that consists of seven shapes. The arrangement of these shapes will constantly change to create new compositions.
2. You will experiment with designing your mobile to become aware of composition in three-dimensional space.

Materials

1. Pictures of Calder mobiles
2. Drawing pencil
3. Markers or crayons
4. Foam board
5. X-acto knife
6. Wire hangers
7. Glue
8. Construction paper
9. Thread or fishing line

Directions

1. Study and discuss the way in which Calder has used shapes in his mobiles.
2. On white drawing paper, create seven shapes that you wish to use in your mobile. Keep in mind how these shapes will look when hanging near each other.
3. Cut out the shapes and trace them onto the foam board.
4. Cut the shapes out of the foam board.
5. On one side of each foam-board shape, create a texture. On the other side, create a pattern. Use crayons, markers, or construction paper to create your textures and patterns.
6. Cut the wire from the hangers into pieces. Vary the length of each piece.
7. Lay out the wire pieces and the colored shapes on the table, with the pattern side up, and arrange them in the order in which you intend to hang them.
8. Slide the foam-board shapes onto the ends of the hanger wire. Keep in mind that you do not need to put a shape on every wire end.

Student Activity 7 continued on next page

Student Activity 7, continued

9. Using thread or fishing line, suspend one wire section from another until all are assembled. Make sure that you are maintaining the arrangement of shapes you planned.

10. Hang your mobile from the ceiling or a stand you have created to hold it.

Evaluation

1. What did you learn from discussing Calder's use of shapes in space?

2. Have you successfully created seven interesting shapes and decorated their surfaces? List some of the different surface decorations you used.

3. Did you experiment with ways to combine and arrange the shapes? What did you find?

4. Were you successful in arranging and hanging the shapes you created? How did you decide upon the arrangement of your shapes?

5. Did you hang your mobile and take time to observe it in action? Is the recombining of shapes due to the mobile's movement interesting? In what ways?

Objects or elements that have a great deal of space between them can seem distant or alienated. Placing objects in close proximity or even overlapping them tends to suggest cohesiveness. This is the technique that Edward Hopper uses in *Nighthawks* (Figure 2-21). The scene is a desolate city street. The left half of the painting portrays a cold and empty environment. Nothing in the windows or doorways indicates that there is life outside the diner.

Figure 2-20 (at right) Chambers has clustered these fall trees in order to unify his composition.

Thomas Chambers, *The Connecticut Valley*, mid-19th century. Canvas. 18" × 24" (0.457 × 0.610 m.). National Gallery of Art, Washington, D.C. Gift of Edgar William and Bernice Chrysler Garbisch. 1956.13.2.

Figure 2-21 The brightness of Phillie's has invited these people in off the deserted street.

Edward Hopper, *Nighthawks*, 1942. Oil on canvas. 76.2 × 144 cm. Photograph ©1993, the Art Institute of Chicago. All rights reserved. Friends of American Art Collection. 1942.51.

Hopper has unified this part of the painting by establishing patterns of similar shapes. The rectangular windows, doorways, and buildings are neatly organized in rows.

Similarly, within the diner, unity is created by the grouping of the similar shapes and patterns of the empty seats and coffee urns that are grouped together or lined up with regularity.

The people in the diner appear to be unified by virtue of their *proximity*. But what about the lone figure who sits by himself? He is integrated with the other figures because he is in the diner with them. Hopper has added interest to the overall composition, without losing the sense of unity, by varying the spaces between the figures.

Another way in which an artist may create unity is by adding variety. Variety in anything tends to add interest. Hopper shows us that it is possible to have variety in placement and arrangement of the same or similar figures and still maintain unity. On the other hand, it is also possible to achieve unity when the shapes in a composition are different but they are ar-

ranged in a similar fashion. Take, for example, the painting by Wayne Thiebaud shown in Figure 2-22. The luscious pastries are each unique in shape, but they are similarly arranged around the cheesecake in the center. Thiebaud, like Hopper, has given us unity with variety.

Student Work

Tess Heydorn, 17
Buena High School; Sierra Vista, AZ

Figure 2-22 The arrangement of delicious-looking pastries gives unity to this image.

Wayne Thiebaud, *French Pastries,* 1963. Oil on canvas. 16⅛" × 24⅛" (41.1 × 61.3 cm.). Hirshhorn Museum and Sculpture Garden, Smithsonian Institution. Washington, D.C. Gift of Joseph H. Hirshhorn, 1966. Photo by Lee Stalsworth. HMSG 66.4909. Courtesy Allan Stone Gallery, N.Y.

Student Activity 8

Creating Unity Through Repetition

Goals

1. You will demonstrate an understanding of the principle of unity by creating a repetitive pattern.
2. You will draw a room on your paper in which you will apply this pattern creatively.

Materials

1. White drawing paper, 12" × 18"
2. Rulers
3. Drawing pencil
4. Colored pencils or fine-point markers
5. Copy paper, 8½" × 11"
6. Access to a copy machine

Directions

1. *Scenario:* you have been given the opportunity to decorate the house of your favorite celebrity. Given what you know about this person and his or her work, design a pattern that may be applied to the walls, furniture, or floors of the celebrity's mansion.
2. Using your drawing pencil and ruler, draw a grid of one-inch squares that covers an 8½"-×-11" sheet of paper. Fill the squares with shapes that create an interesting pattern when repeated side by side.
3. Before you color this page, make three or four photocopies of it.
4. Color the first page so that the shapes appear to be unified by color as well as by pattern. To do this, you may wish to limit your color choices to three or four colors that you would repeat in a certain order.
5. Color the other sheets similarly or with different colors.
6. On the large sheet of drawing paper, draw a room (as you would imagine it) from your celebrity's home.
7. Decorate the walls, furnishings, or floor with your patterned paper. Do this by cutting pieces of patterned paper to fit the walls, furnishings, and objects previously mentioned.

Evaluation

1. Were you pleased with the patterns you created using shapes and colors? What aspect pleased you most?
2. Did you find that changing the order of the colors gave you a greater variety of patterns to choose from? Explain how this worked.
3. Did you find that some patterns were more pleasing and better suited to the purpose than others? If so, in what ways?
4. Were you able to use your patterns to selectively and tastefully decorate the room you created for your celebrity's home? What were some of the successful ways in which you used these patterns?

Student Activity 9

Telling a Story Through Unity

Goals

1. You will practice the principle of unity by creating your own visual story inside Edward Hopper's diner.
2. You will choose five people of personal significance to use in your story.
3. You may change the time, period of history, arrangement of figures, and circumstances of the story taking place.

Materials

1. White drawing paper, 12" × 18"
2. Drawing pencil
3. Colored pencils or markers
4. A reproduction of Hopper's *Nighthawks* (see Figure 2-21)

Directions

1. Take a look at the structure of Hopper's diner. Recreate the diner and its window in any style or from any time period you wish.
2. Add interest to your composition by creating a sense of location outside the diner.
3. Choose interesting people to place in your diner window. These people should be important to you in some way; for example, a group of relatives, political figures, or friends.
4. Make your placement of them tell a story. Don't forget that the focus of this lesson is unity, so the people must appear to be unified in some way. Refer to the text (pp 84–88) for some ideas.
5. Use dramatic lighting in your composition. Vary the amount of light and dark areas.
6. Use colors that represent the mood or tone of your drawing.

Evaluation

1. Are you satisfied that the people in your diner look unified? How did you accomplish this unity?
2. Did your choice of people and location create an interesting visual story inside your diner? What made this story different than Hopper's?
3. Did your use of light and shadow heighten the sense of drama in your picture? How?

Variety

Variety *is a principle that focuses on differences and diversities in a work of art.* The old adage that "variety is the spice of life" holds true especially for works of art. As a general rule, adding variety to a work of art helps to hold the viewer's interest.

Variety refers to the differences in things, such as smooth versus rough textures or bold versus delicate forms. Variety can enliven a composition by adding conflict between elements, such as colors, shapes, and lines. When this conflict is intentional, a work of art can communicate great tension. For example, in Figure 2-23, the jagged yellow lines create incredible tension between the upper and lower sections of the painting. Color complements, purple and yellow, add additional tension when placed next to the large bright red area. Artists must be careful how they make use of these sharp contrasts because variety that is not controlled can destroy a composition.

Creating variety in a composition may be as simple as combining different materials, textures, colors, or subjects. For example a symphony is written in several movements, and each movement is built around one or more musical themes that are usually repeated throughout the movement. But the composer varies the tempo, volume, and tone of these themes each time they occur in order to add interest to the composition. In the same way, a visual artist will vary the presentation of the different elements in a work of art in order to add interest to the overall composition. Figures 2-27 through 2-30 later in this chapter illustrate the effective use of the principle of variety.

Figure 2-23 Intentional conflict creates great tension in this colorful work by Krushenick.

Nicolas Krushenick, *Measure of Red*, 1971. Synthetic polymer on canvas. 90" × 70". Hirshhorn Museum and Sculpture Garden, Smithsonian Institution. Gift of Joseph H. Hirshhorn, 1972. Photo by Lee Stalsworth. HMSG 72.166.

Emphasis and Proportion

When an element or a subject appears to be more important than anything else in a composition, it is said to be dominant. If something is dominant, it commands our attention. Artists use this concept to emphasize meanings or messages in their works.

Emphasis *is used by an artist to place special importance on an element, subject, or other aspect of a work of art.* There are many ways in which an artist may show emphasis in his or her work. Sometimes it is as simple as where an artist places an important object in a painting. For example, look at William H. Johnson's *Cafe* in Figure 2-24 on the next page.

At first glance, we see a couple sitting at a table in a cafe. The colors are bright and appealing. What is Johnson emphasizing here? The woman wears red gloves that draw our attention to large hands. She has on a purple hat. The man's suit is a bold, large plaid. He also wears a brightly-colored hat the same color as the lines in his suit. His hands, like the woman's are large in proportion to his body. Could it be that Johnson meant to emphasize the couple?

Figure 2-24 What has the artist chosen to emphasize in this painting?

William H. Johnson (American), *Cafe*, c. 1939–40. National Museum of American Art, Washington D.C./Art Resource, NY. Photo by M. Fischer. 1967.59.669.

Student Work

Eric Rangel, 18
March Mountain High School; Moreno Valley, CA

Look again. As we know from the title, the couple is in a restaurant, yet there are no other patrons. He has emphasized only this one couple, pulling our attention to them by placing them directly over the point where the green and beige walls join the blue floor. They dominate the middle foreground of the painting. The couple and the fine clothes they wear are the most important elements of the work.

Another way in which an artist might give emphasis to something is by drastically altering its size. This is called proportion. **Proportion** *refers to the relationship in size of one component of a work of art to another.* Artist René Magritte (1898–1967) carries this idea to extremes in *Personal Values* and *The Listening Chamber* (Figures 2-25 and 2-26). As with many of his paintings, Magritte chooses to have the proportion and placement of his subject matter command our attention. He presents us with visual puzzles.

In *Personal Values*, you see simple objects such as a comb, a glass, a shaving brush, a match, and a bar of soap, gigantically disproportionate to the other objects in the room. The oversized objects rest against other objects that appear to be realistic in size. Which objects are, in fact, the correct size? Is it important to solve this riddle, or has the artist made it unsolvable on purpose? And what do you make of the strange wallpaper? Is it wallpaper or reality? Does the size of the objects give you any clues? Interestingly enough, Magritte's first title for this work was *The Clear Field*. Knowing this, can you tell if the objects are in realistic proportion to the seemingly wide-open expanse of the sky?

Equally as puzzling is *The Listening Chamber*. In this work, Magritte has chosen to emphasize an apple by making it greatly disproportionate to its surroundings. He inflates this ordinary object until it fills the space that contains it. Why? Does he wish us to be more aware of the apple or of the room?

The answer may lie in Magritte's desire to confront his viewers with reality. He hoped that his work would bring to his viewers a better understanding of the "realness" of things. He had a collection of horticultural catalogs that he kept as references. He chose to paint objects from these catalogs because they always pictured the most perfect specimens of fruit and vegetables. Here, he wishes the viewer to see an apple in its most perfect state.

Figure 2-25 What do you think is important to Magritte from looking at this painting titled *Personal Values*?

René Magritte, (Belgian, 1898–1967), *Personal Values*, 1952. Oil on canvas. 31½" × 39½" (80 × 100 cm.). Harry Torczyner Collection, New York. Photograph: D. James Dee. ©1994 C. Herscovici/ Artists Rights Society (ARS), New York.

Figure 2-26 Magritte certainly emphasizes the apple by making it fill an entire room!

René Magritte, (Belgian, 1898–1967), *The Listening Chamber*. Oil on Canvas, 17½" × 21½" (45 × 55 cm.). Private collection. ©1994 C. Herscovici/Artists Rights Society (ARS), New York/ Art Resource, N.Y.

Student Activity 10

Variety

Goals

1. You will experiment with the principle of variety by working with different arrangements of the same shape.
2. You will apply these arrangements to the sides of a cube.
3. As a class, you will experiment with unity and variety by combining your cubes in a group composition.

Materials

1. One sheet of poster board (white or colored)
2. Assorted colors of construction paper
3. Scissors
4. Glue
5. Masking tape
6. Yardstick

Directions

1. Create a cube using your pencil, yardstick, and poster board. Looking at diagram 1, use your yardstick and pencil to measure and mark your poster board with the same pattern.

To make cube: Measure 30" x 40" poster board as shown. Cut on solid lines, fold on dashed lines.

Diagram 1

2. Cut out the shape you have just measured and drawn.

3. With your scissors, score the dotted lines indicated in diagram 1. Scoring is done by running one of your scissor points over the dotted line with a gentle, even pressure. Be careful not to cut through the poster board.

4. Do not assemble your cube yet. It will be much easier to work on the sides of your cube while they are flat.

5. Select a simple geometric shape and cut six of the same shape from each of four colors of construction paper. Your total number of shapes will equal twenty-four.

6. Arrange six of your twenty-four shapes in a composition. When you are satisfied with the arrangement of your shapes, glue that arrangement down to one of the four cube sides. Do not glue anything to the top or bottom of the cube. Repeat this process, changing the arrangement of shapes each time, until you have filled four sides of your cube. Then assemble your cube. See diagram 2.

7. When everyone in the class has completed a cube, the class, as a group, will stack or arrange them in one composition to demonstrate unity with variety. As a class, discuss how unity with variety has been achieved.

Evaluation

1. Did you successfully complete your cube? What was the best way to seal the edges of your cube?

2. Did you create four different unified compositions with the same shape, one on each of the four sides of the cube? How are you sure they are unified?

3. Were you and the members of the class successful in arranging all of the cubes to show unity with variety? What problems did you encounter? What do you most like about your group arrangement?

Diagram 2

William H. Johnson, a famous painter of the Harlem Renaissance (see Chapters Six and Nine), uses emphasis and proportion to express mood. In the painting in Figure 2-27, Johnson gives us more than just a portrait of a stylish young man. In fact, what he is wearing seems almost secondary to his disproportionate arms and hands. The young man's youthfulness is contradicted by deep-set eyes that appear to have seen their share of hard times and by hair that is prematurely gray.

Johnson sets the tone of this painting by emphasizing various bodily attributes of the young man. These attributes help to give us insight into this young man's character. Although there are no deep wrinkles on his face, there are hollows and recesses that give Johnson's figure a sense of character. His large eyes may be soul-

Figure 2-27 Disproportionately large hands and facial features give emphasis to this portrait.

William H. Johnson, *Man in a Vest*. 1939–1940. Oil on canvas. 30" × 24" (76.2 × 61.0 cm.). National Museum of American Art, Smithsonian Institution. Washington, D.C. Art Resource, N.Y. Gift of the Harmon Foundation. 1967.59.1118.

Student Work

Ricardo Sanchez, 18
Edinburg High School; Edinburg, TX

ful, but the arch in his eyebrows seems to express hope.

As for the young man's hands, Johnson has chosen to enlarge them and place them in the forefront of his composition. Why? What is he trying to tell us about this young man? Are his hands clenched? Is he wringing them? Or do they just appear to be strong? Perhaps Johnson is trying to tell us that this young man's strength lies in his character and in the hard work that those powerful hands have done.

Proportion and placement are not the only ways in which an artist may direct your attention or place emphasis on a subject. Contrasting some of the other elements, such as texture or color, can be equally as effective (see Figures 2-28 and 2-29).

A rough object among smooth ones will stand out by means of textural contrast.

Figure 2-28 How Texture Adds Emphasis

Although these are all rectangles, emphasis is achieved by means of color contrast.

Figure 2-29 How Color Adds Emphasis

Balance

Balance in a work of art *refers to the equal or unequal distribution or arrangement of the elements within that work.* Compositions that are balanced seem complete to the eye (see Figure 2-30).

There are three types of balance from which an artist may choose when creating a work of art: symmetrical balance, asymmetrical balance, and radial balance.

Figure 2-30 In this composition, Picasso has evenly distributed colors, shapes, lines, and textures.

Pablo Picasso, *Night Fishing at Antibes*, August 1939. Oil on canvas. 6'9" × 11'4". The Museum of Modern Art, New York. Mrs. Simon Guggenheim Fund. ©1994 Artists Rights Society (ARS), New York/SPADEM, Paris.

Symmetrical balance is established when there is equal distribution of the elements on both sides of the work. In other words, if you draw an imaginary line or axis down the center of a symmetrically balanced work of art, the elements that fall on either side of this line should be the same or similar and should be evenly spaced.

Student Activity 11

Emphasis

Goals

1. You will create a painting in which you experiment with the principle of emphasis.
2. You will emphasize objects in your composition by means of manipulating their color, position, or size.

Materials

1. Acrylic
2. A canvas (not too small)
3. Assorted brushes
4. Palette or mixing surface
5. Drawing pencil

Directions

1. In your painting, choose a room of your house in which you enjoy spending a lot of time, and emphasize a few objects in that room that are of particular value to you.
2. Emphasize these objects by enlarging them, by coloring them with wild colors, or by placing them in a conspicuous part of the room.

Evaluation

1. Did you select a room in your house that offered an interesting background for your composition? What made it so interesting?
2. Did you select an interesting variety of objects to use in your composition? Do these objects reflect some of your values? In what ways?
3. Do you feel you have successfully shown emphasis in your work by the way in which you have colored, enlarged, and positioned your objects?
4. Did you emphasize any of your objects more than others? What could this mean?
5. Discuss how you and your classmates have used the principle of emphasis to make a strong statement in your works.

A good example of symmetrical balance is Joseph Stella's *Brooklyn Bridge: Variations on an Old Theme* (Figure 2-31). Stella presents us with the view we would have of the bridge if we were standing on one side looking through one row of gothic arches toward the other. This painting is divided in half compositionally by the light blue line that falls between the

arches. In this case, the "imaginary axis" is actually present in the painting. One half of the painting appears to mirror the other, although if you look closely, you will see that the two sides are slightly different. Of the three types of balance, symmetrical balance is the least complex and the easiest to recognize.

Figure 2-31 Imagine "folding" this work in half vertically. If you could, you would find that one side almost mirrors the other, an excellent example of symmetrical balance.

Joseph Stella, *Brooklyn Bridge, Variations on an Old Theme*, 1917–1918. Oil on canvas. 84" × 76". Yale University Art Gallery, New Haven, Connecticut. Gift of Societé Anonyme.

Student Activity 12

Proportion

Goals

1. You will create a diorama (a three-dimensional picture) in which you will explore the relationship of one object to another with respect to size and proportion in a composition.
2. You will select objects that represent some aspect of your personal values.

Materials

1. Tag board or poster board
2. Drawing pencil
3. Scissors
4. Glue
5. White drawing paper
6. Markers or colored pencils
7. Assorted magazines
8. A large shoe box

Directions

1. Look again at the painting by René Magritte entitled *Personal Values* (Figure 2-25). In this painting, Magritte has chosen to make some objects disproportionate to others. His title implies that the objects that appear larger than others have some special value.
2. Look through the magazines that you and other members of your class have brought in, and cut out pictures of enlarged objects that may have some special meaning to you.
3. Glue these pictures to the tag board or poster board, and trim the excess board away, leaving some excess board at the bottom of the objects to form a tab. This will be used to glue the objects to the floor of your room.
4. Cut the white drawing paper to fit the bottom and short sides of the shoe box. Do not glue the paper inside the box yet (see diagrams 1 and 2).
5. Lay the white paper flat again, and create an environment or background for the objects on it. When you are done with the background, glue the drawing to the bottom and short sides of the box (see diagram 2).
6. When the background is in place, turn the box on its side so that the background is in the right place.
7. Glue the cutout objects into the diorama, placing some of them closer to the back, some in the middle of the box, and some in the foreground. This will give the composition a sense of spatial depth (see diagram 4).

Diorama

1. Start with box on its bottom. Measure bottom and sides.

2. Then, cut white paper to cover the bottom and the short sides of the box. Keep the paper in one piece. Fold paper to fit bottom and short sides.

▼ fold ▼ fold

side bottom side

3. Check paper for fit, do not glue down yet.

4. Glue these objects in your diorama.

8. On a sheet of drawing paper, draw other objects to fill in the composition. Make them smaller in size than the magazine cutouts. Cut them out, mount them to tag board and place them in the diorama.

Evaluation

1. Did you take time to locate interesting objects to include in your diorama? Did the objects represent some aspect of your personal values? In what ways?

2. Did the size and placement of your objects help to place emphasis on them? How did you accomplish this?

3. Were you successful in creating an interesting background or environment in which to place your objects? What made it an interesting choice?

4. Did you successfully create a sense of spatial depth in your diorama by placing your objects appropriately? How was the size of the objects important to this concept?

With *asymmetrical balance*, the elements on each side of a work may not be distributed evenly, but they still pull the composition together as a whole. For instance, the painting by Max Weber in Figure 2-32 entitled *Chinese Restaurant*, is an asymmetrical stir-fry of textures, patterns, and shapes. The composition bustles with the kaleidoscopic activity of the restaurant. If you envision an axis down the middle of this painting you will see that although the painting appears to be balanced, the artist has given a different treatment to the elements on one side of the work than to those on the other. On one side, some shapes are larger and appear to take up more space, but they are balanced by shapes on the other side that have been intensified with tiny patterns. In other words, a large, plain shape can carry the same visual weight as a smaller shape that consists of an intense pattern.

The differences between symmetrical and asymmetrical balance can be seen clearly when we compare Joseph Stella's *Battle of Lights, Coney Island, Mardi Gras* (Figure 2-33) to his *Brooklyn Bridge*, which we looked at earlier. In the first work, Stella has deliberately used a

Figure 2-32 *Chinese Restaurant* shows that large, plain shapes can be balanced by smaller, more intricately patterned ones.

Max Weber, *Chinese Restaurant*, 1915. Oil on Canvas. 40" × 48" (101.6 × 121.9 cm.). Collection of Whitney Museum of American Art, New York. Purchase. Photo by Geoffrey Clements.

Figure 2-33 Can you imagine the thrill of riding the giant roller coaster and enjoying the other attractions at Coney Island when you experience this colorful image?

Joseph Stella, *Battle of Lights, Coney Island, Mardi Gras,* 1913. Yale University Art Gallery, New Haven, Connecticut. Bequest of Dorothea Dreier to the Collection Societé Anonyme. 1941. 689.

state of symmetrical balance to create great tension. The Brooklyn Bridge stood alone, solid, dark, concrete. *Battle of Lights,* however, jerks and twists with the frantic motion of roller coasters and other amusement rides. When you look at this painting, you have no trouble imagining the deafening rumble of the rides and the shrieks of the riders, having the time of their lives. But is there balance here or just chaos?

Examine the work carefully. Does there seem to be an order to the arrangement of shapes and colors? Although your first answer might be no, look again. Stella has been very careful to balance his painting by evenly distributing the colors, lines, and textures. While the movement in this work may appear to be chaotic, the visual weight of the elements is surprisingly equal.

Student Work

Dung Tran, 18
Booker T. Washington High School; Tulsa, OK.

Student Activity 13

Symmetrical Balance

Goal

1. You will explore the principle of symmetrical balance by creating and drawing a symmetrically balanced still life.

Materials

1. Objects of interesting variety to arrange for your still life: baskets, bicycle wheel, umbrella, cloth, a vase, some rope, an article of clothing, and so on
2. White drawing paper, 12" × 18"
3. Any combination of crayons, markers, oil pastels, or chalk

Directions

1. Select a number of objects and place them in a symmetrically balanced arrangement. Keep in mind the imaginary axis that would be located through the center of your composition.
2. Using your choice of medium or combination of media, draw the still life. Remember that balance is not just a matter of the placement of objects in your composition. Balance may also be achieved through the use of colors, lines, and textures.

Evaluation

1. Did you select a variety of interesting objects for your still life? How do they vary?
2. Did you successfully position the objects in a symmetrically balanced arrangement? How were you sure your arrangement was symmetrical?
3. Were you able to use color, line, and/or texture to help achieve symmetrical balance in your composition? How did you accomplish this?

Student Activity 14

Asymmetrical Balance

Goals

1. You will explore the principle of asymmetrical balance by creating an asymmetrical composition that tells the story of an adventure or activity in which you participated.
2. You will use the elements of line, color, and shape to help you achieve asymmetrical balance.

Materials

1. Large sheet of drawing paper, 18" × 24"
2. Oil pastels
3. Drawing pencil

Directions

1. Look again at *Battle of the Lights: Coney Island,* in Figure 2-33. In this painting, Stella takes us on a wild roller-coaster ride at an amusement park at night. The bright colors and expressive lines recreate the frantic pace of the rides, the flashes of bright lights, and the confusion of sounds you would hear at an amusement park. If you follow the lines of his composition with your finger, you can feel the motion of the roller coaster moving back and forth throughout the composition. This motion does not feel exactly the same on both sides of the painting. That is because the composition is asymmetrically balanced.
2. Think of an adventure you've had in which there was great excitement and drama.
3. Create a composition that expresses that excitement using an asymmetrical arrangement of lines, shapes, and colors.

Evaluation

1. Did you give some thought to selecting an adventure from your experiences that was exciting and full of drama? Did your asymmetrical composition communicate these qualities successfully? How did you accomplish this?
2. Were you creative with your use of lines, shapes, and colors to achieve asymmetrical balance in your composition? In what ways?

Figure 2-34 The asymmetrical balance in Johnson's *Postman* is created by the diagonal slant of his shoulders.

Malvin Gray Johnson, *Postman*, 1934. Oil on canvas. 37.5" × 30". Schomburg Center for Research in Black Culture, Art & Artifacts Division, The New York Public Library. Astor, Lexon and Tilden Foundations. Photo: Lee White.

A much more quiet example of asymmetrical balance can be seen in Figure 2-34, Malvin Gray Johnson's *Postman*. The asymmetrical balance in this work is more easily identified than in the works by Weber and Stella. Everything in the composition is organized in a vertical or horizontal fashion with the exception of the strong diagonal line created by the postman's slanted shoulders. If this man were seated with his body facing straight forward, the composition would be almost completely symmetrical. The imaginary axis would fall right down the middle of his body. What would be on one side of the axis would be repeated on the other.

But Johnson chose to create balance *and* add interest to this portrait by positioning the postman at an angle. The strong diagonal line of the shoulders leads our eyes down the right arm, over to the left, and back up the other arm to the top of the shoulder. This positioning of the arms on the left side of the painting balances the table with the books on the right.

Be sure that you do not confuse asymmetrical balance with a lack of balance. Although the elements of an asymmetrical composition are not evenly spaced, they are not "out of balance." A work of art that is asymmetrically balanced is still balanced as a whole.

The third type of balance an artist may use is called *radial balance*. Radial balance occurs when the elements of a composition appear to radiate from a centrally located point. Radial balance is seen quite frequently in architecture and in such crafts as basket weaving and pottery (see Figure 2-35). Look again at Figure 2-22. Does this painting by Thiebaud have radial balance?

Figure 2-35 This dome at St. Peter's Basilica in Rome is a good example of radial balance in architecture.

St. Peter's Basilica, Vatican City. ©K. Reinhard, 1991. FPG International.

Section Ⓥ Review

Answer the following questions on a sheet of paper.

Learn the Vocabulary

The vocabulary terms for this section are *principle, movement, rhythm, unity, variety, emphasis, proportion,* and *balance.*

1. What is the difference between unity and balance?
2. How might emphasis and proportion work together in a composition?

Check Your Knowledge

3. Compare the different types of rhythm and movement that Grant Wood depicts in his two paintings, *Spring Turning* and *Death on the Ridge Road.*
4. Name a kind of art that has rhythm and movement.
5. Using placement within a composition, how does the artist achieve unity?

For Further Thought

6. Think of the objects that are currently in your backpack or locker. Using the techniques of placement and proportion, describe a painting of the backpack or locker that emphasizes the objects most important to you. Using the same techniques, describe a portrait of one of your best friends that emphasizes his or her most important qualities.

Section VI

Perspective: The Illusion of Space

Linear Perspective

Most of us are acquainted with the word perspective in respect to expressing a point of view, or formulating

Student Work

Lisa Brumfiel, 17
Overland High School; Aurora, CO

an opinion about something, as in the sentence, "The way I see it . . .". When applied to works of art, however, the word **perspective** *refers to a system for representing the illusion of three-dimensional space on a flat or two-dimensional surface.*

Perspective in works of art has concerned artists for centuries. To the ancient Egyptians, a sense of perspective meant representing in their paintings and sculpture, different views of the body at the same time, faces turned one way and bodies turned another (see Chapters Seven and Eight). The Romans painted representations of architecture using what they called an "optical system." This system was close to its counterpart developed later in the Renaissance (see Chapters Six and Eight), but lacked the mathematical foundation that helped produce a sense of convincing depth. This made the Roman efforts approximate (see Chapter Six). In other words, while some of the buildings came close to looking as they should, parts of others fell short of being correctly represented. These parts then, kept the overall illusion of spatial depth from working. Medieval attempts at portraying realistic spatial depth were equally awkward. It was not until the revival and further exploration of classical artistic and

architectural theories during the Renaissance in the 1400's (see Chapters Six and Eight), that an actual system for perspective (or linear perspective as it is sometimes called) was developed.

It was in Florence, Italy, during this great time of scholars and intellectuals, that architect, writer, artist, and historian Leon Battista Alberti (1404–1472) and Filippo Brunelleschi (fah-LEE-po brun-el-LES-kee) (1377–1446), artist and architect, developed the mathematically based rules for linear perspective.

The process of incorporating these rules successfully into works of art was a difficult and perplexing one. Just how to use this new discovery artistically was a challenge accepted by many artists. Among them was The Master of Flémalle (identified by some as Robert Campin, active 1406–1444, see Chapter Six), and Masaccio (1401–1428).

In Figure 2-36, we see St. Joseph pictured as a medieval carpenter. Do your eyes sense strong diagonal lines in this composition? Flémalle has used diagonal lines to enhance the feeling of depth in this room. Above St. Joseph's head is a part of the bench, upon which he sits, that has been made of criss-crossed diagonal wooden pieces. His gaze is cast downward so that his head and shoulders appear to be diagonally placed. The diagonal slant of his carpenter's drill also reinforces a sense of depth in this work. Perhaps most interesting is the table strewn with nails and tools. This is not an organized display of tools. The artist has cleverly placed them one on top of another, starting at the far end of the table and ending right in front of the viewer. Even the table that the tools rest upon slants unnaturally toward the viewer. Although Flémalle is close to establishing convincing depth in this work, there still seems to be something a bit awkward about the way in which the artist has attempted to use perspective. To help us better understand what isn't working in this painting, let's look at some of the rules and terms established by Alberti and Brunelleschi that make it possible to create the successful illusion of depth.

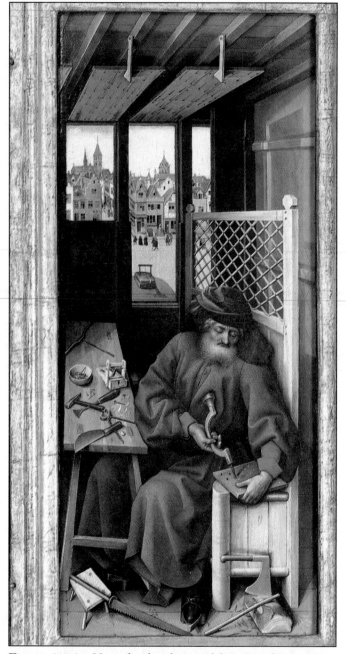

Figure 2-36 How do the diagonal lines in this composition affect your perception of this artwork?

Robert Campin, identified as the "Master of Flémalle" (c.1378–1444), *Joseph in His Workshop.* Right wing of the *Triptych of the Annunciation,* from the Mérode Altarpiece, 1425–28. Oil on wood. Right wing: H: 25⅜" × W: 10¾" (64.5 × 27.3 cm.). The Metropolitan Museum of Art, The Cloisters Collection, 1956. 56.70.

The underlying principles behind creating a picture with convincing depth are that all things seem to get smaller as they recede into the distance and that they seem to disappear or converge to a point in the distance. *This point to which all objects and lines seem to recede is called a* **vanishing point.** It is possible to have more than one vanishing point in a single work of art. *A work in which the artist has used only one vanishing point is referred to as* **one-point perspective.** This one point needs to be located on what is known as a picture plane. **A picture plane** *is the flat surface on which the work of art is made.*

In Figure 2-37A we see a picture plane with a vanishing point placed on it. But, for the illusion to work,

this vanishing point needs to be in relationship to something. That something is called a horizon line. A **horizon line** *is a line drawn across the picture plane where the earth appears to meet the sky.* This line is always drawn at the viewer's eye level. **Eye level** *refers to the point of view held by the viewer of a work.* In Figure 2-37B, we see that the vanishing point has been placed on the horizon line. Where it is placed on the horizon line is a decision made with the work's overall composition in mind. There are some instances in which the artist has established the horizon line and the vanishing point outside of the picture plane as in Figure 2-37C. This technique is used when the work of art pictures something fairly close-up.

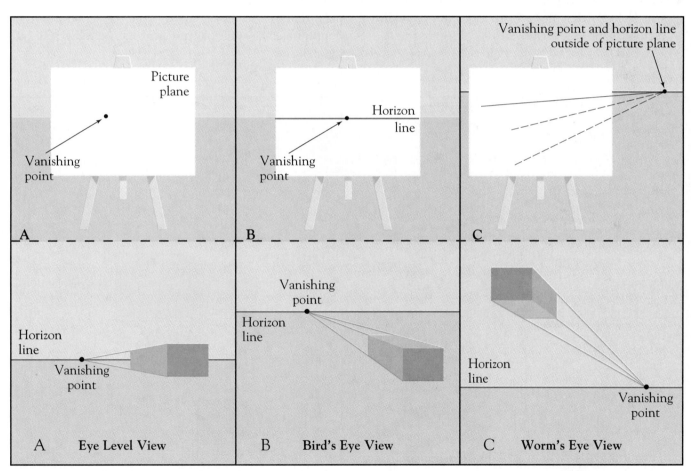

Figure 2-37 Identifying the Picture Plane, Vanishing Point, Horizon Line, Bird's Eye View, and Worm's Eye View

But, what is the relationship of the vanishing point and the horizon line to the subject? Earlier we stated that in a successful perspective illusion the objects in a picture plane seem to recede into the distance. How do we, then, establish the size, form, and position of these objects? The answer to this lies in the use of a series of lines that recede to the vanishing point. Figure 2-38 shows you how to draw a simple box using one-point perspective. In one point perspective, the box will be placed so that the sides are either parallel to the picture plane or perpendicular to it.

Two-point perspective *refers to the use of two vanishing points when creating a work.* In two-point perspective the sides of the box are positioned so that they are at an angle to the artist's line of sight. Figure 2-39 illustrates two-point perspective.

Three-point perspective *includes the use of three vanishing points.* In three-point perspective, the box would be positioned so that none of its sides are parallel to the picture plane (see Figure 2-40).

Making the choice of one-, two-, or three-point perspective for a work of art depends on the viewing point that the artist wishes his viewers to have. For example, in the diagrams you have just seen, you will notice that with some of the boxes, you appear to be looking up at them. In this view, you can see both the side and the bottom of the box. Positioning the box in this manner gives us a **worm's eye view.** It is called this because *it is the view you would have if you were lying on the ground looking up at the box.* In a worm's eye view, the object to be drawn lies *above* the horizon line. *If the object to be drawn lies below the horizon line, then the view we get is called a* **bird's eye view.** This makes sense because we will be able to see the top and the sides of the box as if we were flying above it. If the object to be drawn rests on the horizon line, then it is said to be at eye level. An artist's choice of one of these viewpoints is very important. The artist can add considerable drama or impact to a work by choosing the appropriate viewpoint to use. Let us see these rules of

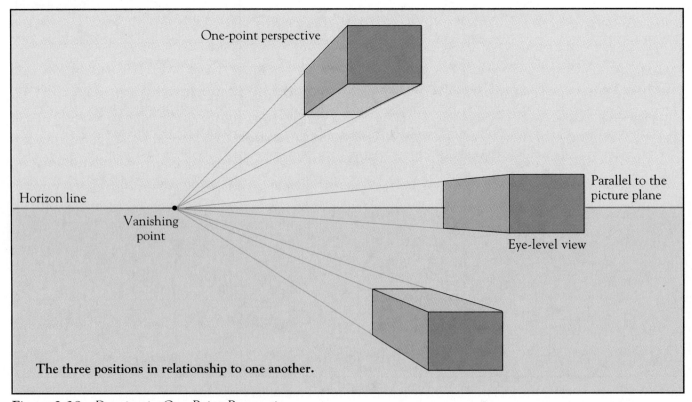

Figure 2-38 Drawing in One-Point Perspective

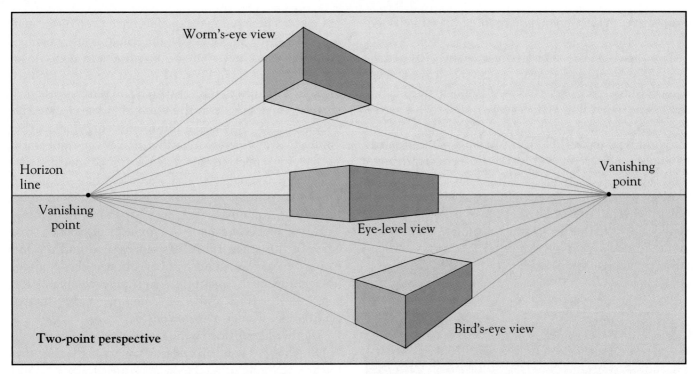

Figure 2-39 Drawing in Two-Point Perspective

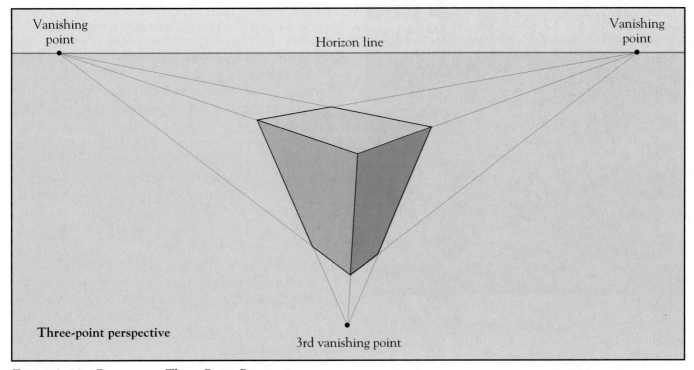

Figure 2-40 Drawing in Three-Point Perspective

perspective put to good use in the following works of art.

The first of the Renaissance artists to perfect Brunelleschi's rules of linear perspective was an artist named Masaccio (1401–1428). Although he did not live to be very old, Masaccio was said to be a true master of perspective technique. In Figure 2-41, we see his painting *Trinita* (holy trinity). This painting, with its barrel vault (see Chapter 6), and perfect architectural framework mystified its Renaissance viewers. The illusion of depth is so convincing that people said that the wall appeared to "have a hole in it." As you look at the work, you will notice that at two points in the painting the illusion of space is particularly persuasive. Look carefully at the crucifixion

Figure 2-41 In Masaccio's *Trinita*, we can see his masterful use of the principles of linear perspective set forth by Brunelleschi.

Masaccio (Italian, 1401–1428), *Trinita (Trinity)*. Early 1400s. S. Maria Novella, Florence, Italy. Scala/Art Resource, N.Y.

of Christ. The way the two figures have been integrated into the space provided by the vault is astonishing. Although we know that the painting was done on a flat surface, what our eyes tell us that we see is hard to dispute. The other point at which the illusion of space is most convincing is in the tomb of Adam, located at the bottom of Masaccio's illusionary chapel. It is the masterful use of perspective that makes the tomb with its skeleton appear to jut out into the space that lies in front of the upper chapel. Masaccio has added further to the illusion of depth by adding figures in front of various columns within the structure. Masaccio's Trinity is a good example of symmetrical balance. Because of this it should be easy for you to find the location of the vanishing point. Although the point is not present in the painting, you should be able to locate it on the basis of the receding lines of the vaulted ceiling. Use a ruler to help you.

Another Florentine by the name of Sandro Botticelli (1445–1510) was also concerned with perfecting the linear style of painting. His work entitled *The Wedding Feast* (see Figure 2-42) is a grand example of his ability to masterfully combine subject with technique.

In this painting, we see the wedding party and their guests being served a richly prepared meal. Men were seated on one side of the outdoor space and women on the other. The bride is from a wealthy family, as evidenced by the table of serving vessels displayed in the center foreground of the work.

This painting, like Masaccio's, is a wonderful example of perspective and symmetrical balance. What he has placed on one side of the composition, he has practically mirrored on the other. He has made the picture plane seem broad and expansive by establishing the vanishing point in the middle of the composition and having the columns and tables start to recede from the very front of the scene. This gives the viewer an overwhelming feeling of being drawn into the inner space of the feasting area.

Both Masaccio's and Botticelli's work truly excited the artists of their time. This excitement over the discovery and challenge of using linear perspective drew artists from other countries to Florence to learn and work. Among them was a German painter and printmaker named Albrecht Dürer.

Dürer was fascinated by the creative prospects of this innovation known as linear perspective. He skillfully

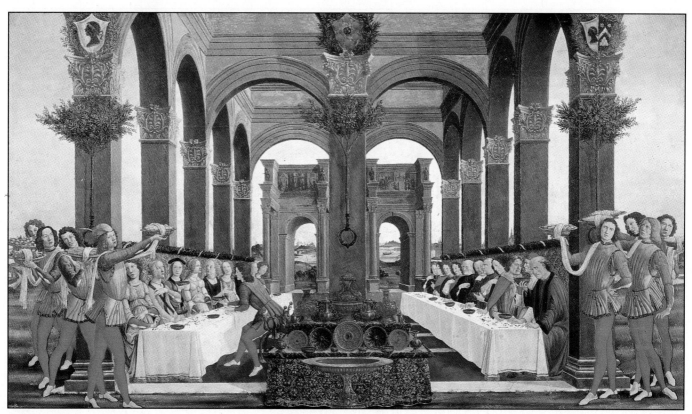

Figure 2-42 The one-point perspective in *The Wedding Feast* draws the viewer into the banquet.

Sandro Botticelli, *The Wedding Feast*. Private Collection. The Bridgeman Art Library, London, England/Art Resource, N.Y.

DEVELOPING SKILLS FOR

ART CRITICISM

The occasion of a wedding is supposed to be a happy one. In Sandro Botticelli's *The Wedding Feast* (Figure 2-42), all of the people except for one seem to be unhappy. Study the painting carefully and see if you can tell more about this story.

1. Look carefully at the faces and positions of the guests and servants. What can you tell about who they might be?
2. Can you identify the bride and the groom?
3. What activity is taking place in this scene?
4. You may wish to research the wedding practices of the 1400's.

applied the rules of perspective to many of the woodcuts he was so famous for. A woodcut is a print that gets its name from the way in which its printing plate is made. An image is cut from the surface of a flat piece of wood, then the wooden piece is rolled with ink, and then it is placed on a piece of paper to print the image.

One of Dürer's areas of experimentation lead him to revive and improve upon several devices to aid with his perspective drawing that were first designed by Leonardo da Vinci (1452–1519).

One such device was called a draftsman's net, similar to the drawing in Figure 2-43. Dürer's **draftsman's net** *consisted of a wooden frame with a net of black threads stretched across the opening, and a movable eyepiece to help the artist fix a line of sight*. Dürer would view his subject through the hole in the eyepiece and the grid of stretched threads at the same time. He would then paint or draw the outline of his subject onto a piece

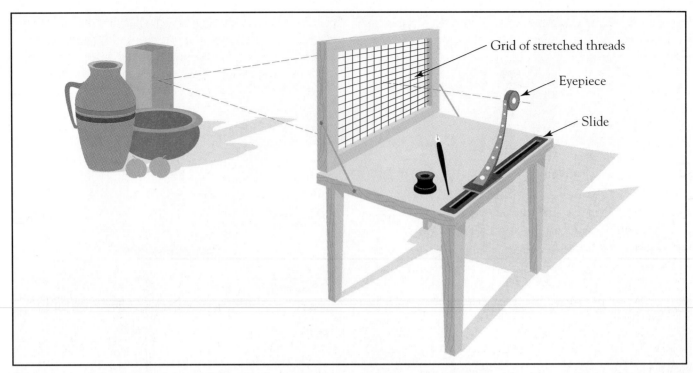

Grid of stretched threads

Eyepiece

Slide

Figure 2-43 Dürer's Draftsman's Net

of paper or canvas that had a similar squared pattern on it, using the net of threads to help him keep the sense of proportion and depth in his finished work accurate. Dürer would be only one of many to carry what he had discovered about linear perspective to other parts of Europe. These discoveries would change the face of the visual arts forever.

One of the last of the great Florentines to perfect the use of linear perspective in his work was Raphael Sanzio (1483–1520). At an early age, Raphael showed signs of great talent. His father gave him his first instruction in art, but it was the work of Leonardo da Vinci that intrigued him most. He would later paint a tribute to him in one of his most well known works, *The School of Athens* (1510–11), (Figure 2-44). During the later years of the Renaissance, Raphael immersed

"Treat nature in terms of the cylinder, the sphere, the cone, all in perspective."

Paul Cézanne

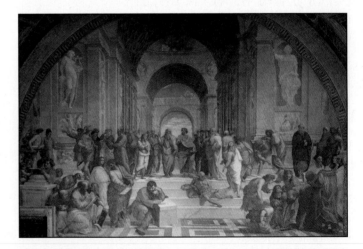

Figure 2-44 *The School of Athens* is Raphael's tribute to Leonardo da Vinci.

Raphael, *The School of Athens*, 1509–1511. Fresco. Stanza di Raffaelo, Vatican Palace, Rome. Scala/Art Resource, NY.

himself in the artistic climate of Florence. Unlike his fellow painters, Leonardo and Michelangelo, whom you shall read about later in this book, Raphael enjoyed the social side of life and he was well known for his social courtesy and charm. He was, however, aware of the genius of both Leonardo and Michelangelo, and learned much from studying their efforts. In his work, *The School of Athens*, Raphael demonstrates his incredible talent. He uses several means of achieving convincing depth. Like Masaccio, he uses linear perspective to center his work with a classical arch and a vault (see Chapter Six), and then pushes the feeling of depth even farther by adding another vault, and then another arch. His figures spill into the foreground, filling the steps of the structure and adding to the feeling of depth.

The artists of many non-Western cultures do not use linear perspective in their work. These artists utilized other methods for representing distance. Let's look, for example, at a painting done in 1590 by Indian artists Kesu Kalan and Dharmadas (see Figure 2-45), entitled *Birth of Prince Salim*. The artists have relied upon other compositional aspects to help provide this spatial illusion. They have layered the picture plane first with a crowd of people, then a wall, then another crowd of people and so on, until our eyes establish the fact that there needs to be room or space in which all of this action may take place. This painting shows the viewer a great deal of activity.

Kesu Kalan and Dharmadas were extremely talented and accomplished artists. The fact that they did not use the technique of linear perspective is not a reflection upon their abilities as artists. Instead, it merely shows that while European artists were developing the technique of linear perspective, artists in other cultures were experimenting with different methods of creating depth.

Atmospheric and Non-linear Perspective

When painting landscapes, some Renaissance artists knew that linear perspective was not as effective without some consideration being given to the effects of light and air on what they saw. It was Leonardo da Vinci that explored the effects of what he called "the perspective of disappearance," that later became known as atmospheric perspective. **Atmospheric per-** **spective** *refers to the effects of the layers of atmosphere and light, between artist and object, that influence the artist's perception of distance.* Leonardo's theories were based on the idea that as an object in the distance, such as a hillside or a group of trees, got farther and farther away from the artist it became more blue with atmospheric haze. The blue color comes from the optical effect created by the reflection and absorption of light in the atmosphere. Leonardo also observed that the farther away an object got, the less detail could be seen. Renaissance artists used these principles of at-

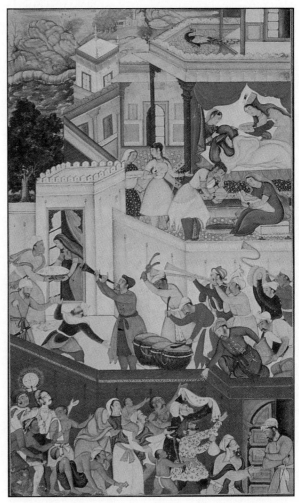

Figure 2-45 The layers in *Birth of Prince Salim* give "approximate" perspective. Note that these Indian artists did not use the rules of linear perspective that other artists were using at this time.

Kesu Kalan and Dharmadas, *Birth of Prince Salim*, c. 1590. Watercolor. Victoria and Albert Museum, London, England.

mospheric perspective in their paintings to add to the illusion of depth, as well as incorporate the soft blue tones this type of perspective created.

We can see the use of atmospheric perspective in Leonardo's famous portrait of the Mona Lisa (see Chapter Seven, Figure 7-23), and in this work by Domenico Ghirlandajo (1449–1494) entitled *Portrait of an Old Man and His Grandson* (Figure 2-46). Ghirlandajo, another Florentine and contemporary of Leonardo, gives us a touching portrait of an old man lovingly holding his grandson. The bright red used on the clothing of both figures is in sharp contrast to the dark and muted colors of the background. Through the open window we see the principles of atmospheric perspective at work. Ghirlandajo's blues are not as luminous as Leonardo's. In fact, they are more gray than blue. However, we can still recognize the representation of Leonardo's theories. The landscape in the foreground is green and full of detail, while the large hill that falls about middle ground reflects atmospheric haze. Some details are still visible on its rocky face. The farther back into the distance we look, the more obscured the land and its details become. Both the middle ground and the background of this work reflect the color of the sky above,

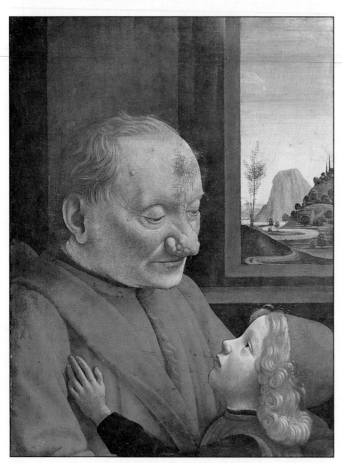

Figure 2-46 Notice how detailed the foreground in this painting is compared to the hazy images seen through the window. Ghirlandajo has successfully used atmospheric perspective to create the illusion of depth.

Domenico Ghirlandajo, *Portrait of an Old Man and His Grandson*. Louvre, Paris, France. Scala/Art Resource, N.Y.

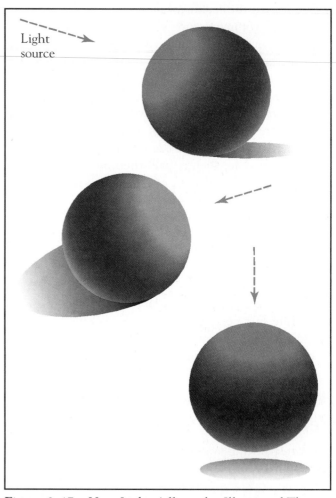

Light source

Figure 2-47 How Light Affects the Illusion of Three Dimensions

reinforcing the optical effect mentioned earlier.

Manipulating the use of light and shadow on a subject is another way in which artists can add the illusion of three-dimension to the flat surfaces of their canvases and drawings. Look at the drawings of three spheres in Figure 2-47. In each case the direction of the light source is indicated. The side of the object that is closest to the light source will reflect the most light. The side that is farthest from the light source will reflect the least amount of light. If the sphere is shaded to indicate its light and dark areas, it begins to look less flat. Add a shadow cast by the object as it blocks the light, and the illusion of three-dimension or depth is achieved. Nowhere is this technique put to better use than in the paintings of Rembrandt van Rijn (1606–1669). See *Aristotle with a Bust of Homer*, (Chapter Seven, Figure 7-26); and Rembrandt's *Self Portrait* (Chapter Seven, Figure 7-27). Rembrandt skillfully uses light and shadow to model his forms and create the illusion that they are solid. His use of dark backgrounds allows the lighter portions of his forms to appear to emerge from unlimited space.

Creating Depth With Placement

Some artists create the illusion of depth or space in their works by virtue of where they place objects in their compositions, and by carefully controlling the size of those objects.

The work in Figure 2-48, entitled *The Portrait of Giovanni Arnolfini and Giovanna Cenami,* is a good example of this technique. Although the artist has created a room with convincing depth, he has not relied solely on linear perspective to do so. Here, Jan van Eyck (1390–1441) establishes the illusion of depth in the room in a number of ways. One of these ways is by using receding lines in the floor boards, the bed, and the window frame. Another is by carefully placing the light source. Still another is in the size and placement of some of the objects in the room. If you look carefully, you will see a pair of shoes belonging to Arnolfini in the foreground, to the left of where he is standing. These shoes appear to be rather large in comparison to the tiny pair of red slippers, belonging to Arnolfini's

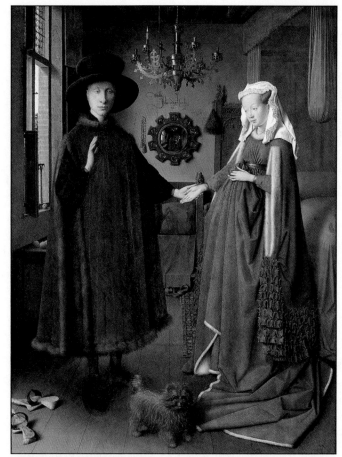

Figure 2-48 The placement and size of objects in this painting by van Eyck give depth and meaning to the work.

Jan van Eyck, *The Portrait of Giovanni Arnolfini and Giovanna Cenami*. The National Gallery. London, England.

wife, placed to the back of the room, at the far end of the bed. While it is true that the size of the shoes could bear some relationship to the fact that men's feet are quite often larger than women's feet, it is unlikely that Mrs. Arnolfini's feet could be that tiny. By drastically changing the size of the wife's shoes and placing them in the back of the room, van Eyck has suggested great depth to this wedding chamber.

For centuries after the Florence discoveries, artists continued to explore representing the illusions of space in art. Principles established in the early 1400s continued to be used, but with some variations. Impressionist Edgar Degas (1834–1917) (ed-gar day-GAH) was

a French painter and sculptor who lived for awhile in Italy. While there, he spent a great deal of time intensively studying the works of the old masters of the Renaissance.

Degas was very concerned with depicting movement in his works, and chose to use unusual viewpoints to heighten the viewer's sense of this movement.

In his work entitled *Miss La La at the Cirque Fernando, Paris* (see Figure 2–49), we see a good example of Degas' use of dramatic viewpoints to heighten a sense of perspective and movement. Daredevil La La hangs by her teeth as she is pulled to dizzying heights. The use of this extreme viewpoint forces the viewer to feel the danger in her performance. The way in which Degas has used the architecture, although it is somewhat distorted, adds to the feeling that La La is many feet above the audience. Degas has shown us a new way in which to integrate his figures into space.

As you continue to look at works of art in this text, pay close attention to the ways in which the artists have represented space and the illusion of depth in their two-dimensional works of art. See if you can identify which method or rule they have used, or perhaps you will discover a new method that was not presented here.

Figure 2-49 Carefully choosing the viewpoint can add great drama to your pieces. Degas adds tension to this painting by showing Miss La La as the circus audience would view her.

Hilaire-Germain-Edgar Degas, *Miss La La at the Cirque Fernando, Paris*. The National Gallery, London, England.

Section VI Review

Answer the following questions on a sheet of paper.

Learn the Vocabulary

Vocabulary terms for this section are *atmospheric perspective, bird's eye view, draftsman's net, eye level, horizon line, one-point perspective, perspective, picture plane, three-point perspective, two-point perspective, vanishing point,* and *worm's eye view.*

1. Fill in the blank with the appropriate vocabulary term.

 a. The device used by Albrecht Dürer to help him with his perspective drawing is called a

 _____ _____ .

 b. A view that has the viewer looking down on an object would be called a _____ _____ .

 c. A view that has the viewer looking up at the bottom of an object is called a _____ _____ .

 d. Perspective drawing that uses two vanishing points is called _____ _____ .

 e. According to Leonardo da Vinci, an object that becomes more blue with haze is an example of

 _____ _____ .

Check your Knowledge

2. What is so unusual about Edgar Degas' use of perspective in his painting *Miss La La at the Cirque Fernando, Paris?*

3. Why didn't the Roman "optical system" work as well as Brunelleschi's rules of linear perspective?

4. What are two ways an artist may show depth in a painting besides using linear perspective?
5. Why would an artist choose to use a bird's eye view in a particular work?
6. How does the use of light and shadow in a composition make an object look more three-dimensional?

For Further Thought

7. You have been commissioned to paint a mural on the wall of an office building. The owner of the building states that the lobby where the wall is seems cramped and small. He would like you to paint a mural that would visually open up the lobby space. Which method for creating the illusion of depth will you use, and what will the subject of your mural be?

SUMMARY

In this chapter, we have seen that art criticism is the process of asking questions by which we can discover the meanings in a work of art. Often, more than one critical encounter with a work of art is necessary in order to understand that work's many meanings.

We have also discussed how specific goals for art criticism help to focus critical inquiry. These goals are based on the particular needs of the individual engaging in critical activity. Curators and art dealers will have very different goals from art students as they examine a work of art.

There are two major approaches to art criticism. Intrinsic criticism focuses on the information found within the work of art itself in order to grasp its meaning. Contextual criticism adds outside information about the artist or the social context of the work of art to the critical encounter.

To be able to talk about works of art, we need to be familiar with the elements and principles. The elements are the essential components of a work of art. They include line, shape, form, texture, color, and value. The principles are the essential qualities of a work that produce desired expressive effects. They include rhythm and movement, variety, unity, emphasis, proportion, and balance. When the elements and principles are used together effectively, the resulting work of art can express moods, feelings, and visual messages.

The discovery of linear perspective in the 1400s opened up new frontiers for artists attempting to represent spatial depth in their works of art. This discovery led to the creation of works of art that exemplified the underlying principles of linear perspective in new and astounding ways.

Critical encounters with works of art can stimulate a variety of creative ideas that may later be applied to the making of art. Many artists critique their own works at various stages in order to improve the quality of their art.

It is important to remember that critical skills improve with practice.

How Techniques Convey Messages: Critical Clues

To Cornelis de Heem, plump fresh fruits were essential components of his opulent still-life arrangements. In many of his works, the arrangement and condition of fruits and other types of foods and objects of leisure suggested that these items had provided someone with enjoyable moments. Half-eaten fruits and glasses still half-full sug-

Figure 2-50

gest that these wonderful items might even have been taken for granted. In any case, we see these items in de Heem's work after they have been handled. Since the subjects of de Heem's works are the still-lifes that he creates, he does not show us the faces or actions of those who partake of these abundant buffets. Perhaps if we could catch them in the act of taking the food, we could tell a lot about the people who leave such wonderful foods half-eaten.

In these two works by John Singleton Copley and Yasuo Kuniyoshi (ya-SOO-oh KOO-nee-yo-she), we catch the participants in the act of reaching for the fruit dish. Figure 2-50, is a portrait of Mrs. Ezekial Goldthwait, painted in 1771 by John Singleton Copley. He has skillfully captured Mrs. Goldthwait in a realistic image and controlled the lighting in a manner that highlights her features. More importantly, Copley has managed to tell the viewer something about her personality and stature in the community. Mrs. Goldthwait was a prosperous and respected Bostonian. She is modestly but fashionably dressed in the style of colonial New England. She has a virtuous and dignified air about her. What do you think gives her this air? She sits straight, with a self-disciplined posture. Her expression is serene and confident. She looks directly out of the picture at us. It is as if she has nothing to hide and nothing to be ashamed of. Mrs. Goldthwait is a mature woman in full command of her decision-making abilities, her surroundings, and her behaviors. She reaches for an apple in the fruit dish before her. There is nothing and no one to stop her from doing so, nor is there any reason to stop her. Does she appear to value the apple enough to eat it all, or does she seem the type to take a few bites to satisfy her curiosity about its taste, and then discard it?

Comparing Works of Art

Figure 2-51

Yasuo Kuniyoshi, *Boy Stealing Fruit*, 1923. American. Oil on canvas, 20" × 30". Columbus Museum of Art, Columbus, Ohio. Gift of Ferdinand Howald. 31.194. ©1994 Estate of Yasuo Kuniyoshi/VAGA, New York.

Now shift your attention to Figure 2-51. It is a painting by artist Yasuo Kuniyoshi entitled *Boy Stealing Fruit*. The artist was born in Japan and immigrated to the United States when he was thirteen. He developed an abstract style of painting (see Chapter Nine) in which human figures and their surroundings were somewhat angular and distorted. In addition, he would combine different points of view. For example, some of the objects in a room might be pictured from above, some from below, and some in profile. His color schemes were often muted rather than bright. This put emphasis on form rather than color.

Boy Stealing Fruit tells a piece of a story. You can probably guess from studying this picture what happened just before and shortly after this scene. A boy, hungry, spies a dish on a table with a few pieces of fruit in it. He glances around to see if anyone is watching. Who do you think he might be afraid of seeing? Still looking nervously over his shoulder, he reaches for the fruit. He grabs it, and dashes for a hiding place where he hopes to eat it unnoticed.

Do you think someone is likely to notice that the fruit is missing? There aren't many pieces of fruit in the dish to begin with. Do you think the boy believes it is acceptable behavior for him to take the fruit from the dish? His actions are very different from those of Mrs. Goldthwait. How would you compare his facial expression and gestures with those of Mrs. Goldthwait? Is there any similarity between Mrs. Goldthwait's self-assured, virtuous posture and the boy's? Does the boy look like he would waste the fruit, or treasure the eating of it?

CHAPTER ②REVIEW

VOCABULARY TERMS

Describe any work of art depicted in the text, using at least ten of the vocabulary terms.

actual texture	form	organic shapes	shape
atmospheric	geometric shapes	perspective	simulated texture
perspective	high relief	picture plane	space
balance	horizon line	pigment	spectrum
bird's eye view	implied forms	positive space	tertiary colors
closure	implied lines	principle	texture
color	intrinsic criticism	primary colors	three-point perspective
contextual criticism	invented texture	proportion	tint
contour lines	line	real forms	two-point perspective
critical method	low relief	real lines	unity
curator	monochromatic	relief	value
draftsman's net	movement	rhythm	vanishing point
element	negative space	secondary colors	variety
emphasis	one-point perspective	shade	worm's eye view
eye level			

Applying What You've Learned

1. List some of the critical goals specific to the following:
 a. An art critic
 b. A museum curator
 c. An art dealer or auctioneer

2. Give a brief explanation of the differences between intrinsic and contextual criticism.

3. What is the significance of the chapter title, "Criticism: The Quest for Meaning"?

4. List the steps in the critical method described in this chapter. Briefly explain the relationship of one to the other.

5. Why would it be important for an artist to understand the relationship between the elements and principles of art?

6. Explain why someone might need more than one critical encounter with a particular work of art.

7. What impact did the discovery of the rules of linear perspective have upon the artists of Renaissance Florence?

Exploration

1. Establish an interactive criticism bulletin board in your school hallway. Through research, find works of art that you think would receive enthusiastic responses. Display critical questions with each of the works. Invite students from your class or other classes to submit written criticism about the works you have chosen. Display some of the written criticism on the bulletin board next to the appropriate work.

2. Invite students to respond to the written criticism displayed on your criticism bulletin board. Do they agree or disagree with what has been written?

3. Set up a critical debate. Choose a controversial work of art and have teams adopt opposing points of view about the work's interpretation or judgments about the work's merits. Each team should support its point of view with evidence found either intrinsically or through contextual research.

4. Design a wall mural for a wall in your school in which you create an illusion of false depth. Paint the illusion of a classroom, or a series of windows with landscapes of convincing depth.

Building Your Process Portfolio

In this chapter, you have learned about setting goals for your critical encounters, the importance of choosing the proper approach to art criticism, and the elements and principles of art that represent the language of criticism. You have also had some opportunities to engage in critical encounters with several of the works of art. By now you have discovered the importance of good critical skills, and how they can help you reach a deeper understanding of the meanings a work of art may express. You have also had an opportunity to make works of art that represent the exploration and application of the elements and principles of art. Here are some things you may wish to include in your process portfolio:

- Critical writings you may have done, including examples of both intrinsic and contextual criticism

- Works of art you may have created that demonstrate a knowledge of the application of the elements and principles

- Newspaper articles by professional critics that you have collected

- A vocabulary list of additional terms you have generated that will help you express your critical opinions

- For your sketch book: You may wish to include in your sketch book a pencil sketch in which you focus on rendering several objects monochromatically. Pay particular attention to where the light and dark areas appear.

- Written responses to any critical or aesthetic special feature boxes

Art History: Assembling the Pieces

Figure 3-1 *Las Meninas* is a visual history of the society it portrays. Velázquez even includes a self-portrait.

Diego Velázquez (Spanish, 1599–1660), *Las Meninas*. 1656. Oil on canvas. 10′5″ × 9′. Museo del Prado, Madrid, Spain. Erich Lessing/Art Resource, NY.

Contents

Section I What Is Art History?

Art history is a process of discovery. In this section you will look at ways to discover your own family history and learn how this process is similar to assembling the history of art.

Section II The Art Historian

The second section looks at the people who devote their professional lives to recording information about the art from around the world. You will also discover the different ways in which art historians share with others their knowledge about artists and the time in which the artists lived.

Section III The Windows of Art History

Each culture has its own story of art. This section explains how art is sequenced according to dates, time periods, or styles. You will also learn how periods in art history have been labeled with a name.

Section IV Assembling the History of Art

The fourth section explores how and where art historians look for information about art and the people who make art. You will learn about the contributions that anthropologists and archaeologists make to the history of art.

Section V Voyages Through Time

You, too, can be an art historian! In the final section in this chapter, you will learn the different methods through which you can research an artist, a period in art history, or a culture. Descriptions of one painting by three historians will illustrate the importance of using a variety of sources when writing about art history.

Terms to look for

academies	B.C.	excavation	oral history
A.D.	cadastres	Fauves	photoscreen
anthropology	catacombs	griot	radiocarbon dating
archaeology	chartography	iconography	ready-mades
art historian	chronology	icons	serigraph
art history	Dada	mosaic	

Objectives

- You will gain an understanding of how researching the history of art is similar to researching your own family history.

- You will demonstrate your understanding of how a chronology of art is assembled by developing a chronology of an art theme.

- You will begin to acquire an understanding of how the meaning of time is different among cultures.

- You will learn about the different areas of exploration and communication on which the art historian depends during the research process.

Art in Your Life

Do you know how historical knowledge about art is gathered, analyzed, and ordered in a logical sequence? How does this information about artists, styles, and periods in art history pass from generation to generation? In this chapter you will discover how art history is recorded. Some sources used during the process, such as archaeology and anthropology, may be of interest to you as a future career.

In addition, the study of art history is linked to other subjects studied in high school. Some of these subjects are world history, literature, science, and music. For example, art history often parallels major political events in a nation. Changes in governments and wars between nations have historically launched new directions in the way art has been made. Often, new art forms are artists' responses to social or political changes in their environments.

This chapter will also introduce you to research skills for obtaining information about artists and their art. These procedures can be applied to other areas of study in this book. They will also prepare you for advanced research skills you will need in college or in a career.

Section I

What Is Art History?

When you hear the word *history*, what images do you see in your mind? Do you see herds of buffalo or cattle surrounded by men on horseback? How about Cleopatra reclining on a barge and floating down the Nile? Perhaps you remember portraits of American presidents on the walls of your classroom, or a picture of a Chinese emperor in an elaborately embroidered robe. The word *history* might simply remind you of taking a class about events that happened centuries before you were born. In any case, the images that you see might also be a part of the history of art.

You have probably studied history through written accounts of events, descriptions of historical figures, or geographic information. How has this historical information been assembled from various sources and put into written words? One way of understanding how history is recorded through the years is to research your own family history. Mementos, such as clothing, photographs, jewelry, or old letters, are links between you and your ancestors. These items are usually preserved by family members and passed down from generation to generation. They temporarily remain with you until you pass them on to your own children, a relative, or a friend. Sometimes, older family members can help you understand the significance of each object by explaining its value to the family.

What would you do if you wanted to discover more about your heritage but could not locate any family records in your home? You might begin by researching court records that show the dates of your ancestors' births and deaths and any land purchases they made. The library can also provide you with information about countries from which your family came. Investigating your cultural heritage in this way may help explain some of your own characteristics, such as your preferences in food, clothing, music, art, and holiday traditions.

Interview family members about how their career decisions are part of the family history. Discover why they chose their professions. For example, did anyone inherit a family-owned business? Why did the family decide to pass the business from generation to generation? This information might also help you understand how your own hobby or career interests might be influenced by family professions. You may also dis-

cover that you live in a certain city or state because of the types of jobs your parents or relatives selected. Once you have gathered information about your ancestry from different sources, you can assemble your own history. Your personality, interests, likes, and dislikes might be a reflection of your heritage and family traditions.

Document your discoveries by making notes and by drawing family crests or the flags of the foreign countries from which your family came.

Assembling art history is similar to the process of assembling your family history. You may recall reading in Chapter One that art history provides us with broad social, cultural, and historical contexts for understanding and appreciating artworks. We can extend and clarify the definition by saying that **art history** *is an account of how, why, and when people around the world have made art.* It is a record of the different styles of art, artists who influenced these styles, and the place art has in the lives of people from around the world. Works of art have been preserved for future generations by groups of interested people just as family members might preserve a special quilt or photograph belonging to a relative.

The history of art, like the history of a family, tells a story. In art, this story is about people who have used their ideas, skills, and values to make an object that reflects the time and culture in which they live. Changes in art forms, media, and attitudes toward making art are the result of the creative growth of an artist or of an entire society. Making a record of these changes is similar to recording the changes throughout the generations of a family.

Section ① Review

Answer the following questions on a sheet of paper.

Learn the Vocabulary

The vocabulary term for this section is *art history.*

1. Define the vocabulary term by using it correctly in a sentence.

Check Your Knowledge

2. What kind of family mementos can help you learn about your heritage? What makes these mementos like works of art?
3. How can assembling art history be like researching your family heritage?
4. How does knowing about the countries your family has come from enable you to understand your own personal characteristics, interests, and preferences?

For Further Thought

5. During the great Western expansion of the 1800s, paintings of nature were popular. Since art often mirrors the time and culture in which the artist lives, what type of art do you predict will be produced during your high school years?

Section II

The Art Historian

The people who assemble accounts of how, why, and when people around the world have created art are called **art historians.** The earliest known art historian, Pliny (PLI-nee) the Elder, was a Roman who recorded the history of first-century Greece. His writings included descriptions of how functional objects such as furniture and pottery were made. The history of art would not be documented again until the sixteenth century. It was during this time that Georgio Vasari (JOR-jo va-ZAH-ree) wrote about the art and artists of Italy. When **academies,** or *schools of art,* were established in France during the seventeenth century, art history became part of the curriculum. This stimulated an interest in students to devote their lives to recording the development of art, past and present.

Some art historians concentrate on the art of a particular country, a special population of people, or a specific media. Other historians focus on the art of a certain period in time.

Art historians share their knowledge with us in a variety of ways. Some write books or develop educational materials about their special topic, artist, or period in time. This information can then be used by other historians or by students, teachers, and people

who are interested in the same areas. Sometimes art historians pass their knowledge on to students through teaching at a college or university. For example, an art history professor may teach a survey course on European art or teach a more specific topic such as "Court Painters of Fifteenth-Century Europe." Others travel throughout the world lecturing on their field of expertise at museums, colleges, or art events.

Museums rely on art historians for advice about works of art the museum may acquire. Historians sometimes record information concerning the existing collection of a museum. Art dealers and auctioneers mentioned in Chapter Two will often ask the art historian to assist in the appraisal of art work.

Movie producers will call on art historians to help recreate an historical set or period clothing for a film. They may also be asked to assist in developing an image of an historical figure to be portrayed by an actor. Often art historians are paid to remain on the production set of a film as consultants to guarantee historical accuracy. These methods of passing information on to others keep art history alive!

Section II Review

Answer the following questions on a sheet of paper.

Learn the Vocabulary

The vocabulary terms for this section are *art historian* and *academies*.

1. Define the vocabulary terms using each one correctly in a sentence.

Check Your Knowledge

2. List two areas in which an art historian may concentrate.
3. How do art historians share their special knowledge with us?
4. How might a museum use the services of an art historian? How might a movie producer?

For Further Thought

5. You have been asked to help design the costumes for your school's production of *Gone with the Wind* which is set during the American Civil War. What resources could you use to gain information on the clothing styles of that era? The hairstyles?

Section III

The Windows of Art History

There is no one history that can describe the development of art. This is because many different cultures from around the world make up the history of art. Each of these cultures has its own story about how, when, and why its people have made art. This story then forms an individual time line or "window" in art history. Art historians sequence the time line (Figure 3-2) or **chronology** *which tells the story of the development of art according to dates*. Chronologies of art are arranged by historians in different ways. Some chronologies may cover a significant time period such as the development of a particular art movement by a group of artists. Others might focus on a particular subject such as sculpture, portraits, or religious artifacts.

The dates that are used in most chronologies were established centuries ago. They were ordered according to European Christian religion. Time, as established by the Europeans, was divided into two groups. The first group refers to dates *before the birth of Christ* and are labeled **B.C.** The second set of dates are known as **A.D.,** *an abbreviation of Anno Domini, which is Latin for in the year of our Lord. This set of dates refers to time after the birth of Christ.* The B.C. dates span from the highest numbers such as 32,000 B.C. to lower numbers as they progress towards the date of Christ and the beginning of A.D. For example, from 60 B.C. to 30 A.D. would be a total of ninety years. Since the majority of art history has been assembled by Western historians, the non-Western civilizations such as Japan and Africa are sometimes referenced according to the B.C.–A.D. time line.

Why have art historians bothered to put art in a sequence according to dates, or to label styles of art? First, it is human nature to try to classify things any time we have vast amounts of information. Establish-

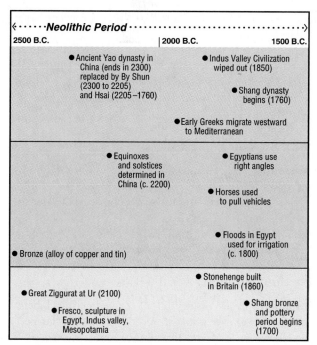

Figure 3-2 An Example of a Time Line.

ing an order provides a way to reference the art world. Using a title or name to refer to a style of art makes it easier to talk about it or refer to it.

Divisions of time, however, are as individual as each culture. For example, the United States, Canada, and Japan celebrate the beginning of a new year on the first day of January. The Chinese, however, celebrate the beginning of a year just before the spring planting begins, in order to ensure good luck for the harvest.

The chronologies of art from cultures around the world parallel one another. Different movements, styles of art, and techniques of making art have occurred at the same time but in different settings. For example, during the late 1800s, French artists were capturing the effect of sunlight on objects. At the same time, visual artists in the United States were recording the westward expansion. Meanwhile, Japanese art was moving away from the decorative painting of landscapes, birds, and trees, to paintings of people busy at daily tasks.

How Periods in Art History Get Their Labels

The labels that art historians give to different time periods have many different sources. The labels may refer to political, religious, or social issues of the time period. For example, art historians categorize the art of China under the name of the emperor on the throne when the art was made. Many art movements receive a label from historians after the period is over. For example, the Renaissance (REN-uh-sahns) period occurred in Italy during the 1400s and 1500s. It was a period in European history that saw a renewed interest in art, music, and literature. Some of the greatest artists in history such as Michelangelo (1475–1564), Raphael (1483–1520), and da Vinci (1452–1519) are Renaissance artists. However, it was the art critics in France who later gave the period its name in reference to a French word meaning "rebirth."

A group of French artists, the Fauves (FOHVS), obtained their label for a different reason. Henri Matisse and Raoul Dufy exhibited their new approach to painting in 1905. The public reacted with horror. Instead of the genteel painted landscapes and portraits that society was used to seeing, these paintings included distorted forms, bold colors, and emotional subject matter. The critics quickly proclaimed that these works of art must have been created by **Fauves,** which is French for *wild beasts.* You will meet the Fauves again later in this book.

Some artists have labeled their own style of making art. Often, the label has been prompted by conditions or events in society. This was the case with a group of artists and writers who protested the destruction caused by World War I. They believed that as a result of the war, Europeans were lacking in values and direction for the growth of their society. The artists also felt that the traditional art styles no longer served as models for the rest of the art world. Writers began to compose nonsensical poetry and stories. Artists conducted an anti-art movement by making ready-mades. **Ready-mades** *were objects, such as bicycle wheels and hat racks, that fulfilled an everyday function and that the artist proclaimed to be works of art.* These artists, knowing that the critics would react negatively to what they saw, labeled their style of art Dada. **Dada** *was a nonsensical name invented by the artists to reflect their philosophies.* Ready-mades shocked a society not conditioned to seeing familiar objects used in radical ways. Marcel Duchamp (mar-SELL doo-SHAHN) (1887–1968) used an ordinary bicycle wheel for his sculpture in Figure 3-3 on the next page. Viewers were simultaneously con-

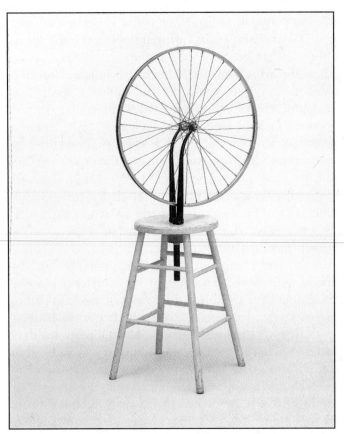

Figure 3-3 This work by Marcel Duchamp is an example of ready-made art of the Dada movement.

Marcel Duchamp (French, 1887–1968), *Bicycle Wheel*, 1951 (Third version, after lost original of 1913). Assemblage: metal wheel, 25½" diameter, mounted on painted wood stool 23¾" high; overall, 50½" × 25½" × 16⅝". The Museum of Modern Art, New York. The Sidney and Harriet Janis Collection. ©1994, Artists Rights Society (ARS), New York/ ADAGP, Paris.

fused and angered by the art of Duchamp and the other Dada artists. As World War I ended, so did the Dada movement. However, the style named by its creators would give birth to new art forms, some which would embrace its artistic beliefs.

Section III Review

Answer the following questions on a sheet of paper.

Learn the Vocabulary

Vocabulary terms for this section are: *chronology*, B.C., A.D., *Fauves*, *ready-mades*, and *Dada*.

1. Match the following description to the appropriate vocabulary term:
 a. The French word meaning "wild beasts" that critics used to describe Henri Matisse and Raoul Dufy
 b. A story of the development of art according to dates
 c. Abbreviation for the Latin term meaning "in the year of our Lord"

Check Your Knowledge

2. In Western civilization, what is the ordering of dates based on?
3. What are two reasons art historians put art in sequence according to dates?
4. Name a type of art that received its label not for political or religious reasons, but rather for the art itself.

For Further Thought

5. Time periods in art history have received certain labels for many different reasons. In recent years, film has become a popular art form. If you were an art historian, how would you label the current time period based on the style and content of contemporary movies?
6. Marcel Duchamp claimed that a bicycle wheel was a work of art. Do you agree? Based on your answer, what qualities of art does a bicycle wheel have or lack?

Section IV

Assembling the History of Art

The art historian assembles information about an artist, culture, or time period through extensive study and research. Where do art historians look for the in-

formation they need? What if they are looking for information about art that was created centuries ago?

Archaeology is one field of study that art historians depend on (see Figure 3-4). **Archaeology** *is the study of the physical remains of a culture.* These remains may include art and artifacts. Artifacts are objects that are used for daily living made by people in a culture. After pieces of artifacts are unearthed during an excavation, they are reassembled by the archaeologist. **Excavation** *is the act of digging through layers of earth to locate the physical remains of a culture.* During this process, the archaeologist looks for clues as to how people made the artifacts. Some clues can be discovered in the type of tools and natural materials, such as shells, seeds, and bones, discovered in the excavated area. *A scientific process called* **radiocarbon dating** *can be used to determine the age of an object through testing these materials.* Radiocarbon exists in all living matter and its rate of decay can be measured to determine the age of the artifact. Radiocarbon dating is further explained in the *Technology Milestone.*

The art historian also depends on anthropological research. **Anthropology** *is the study of people and the culture of which they are a part.* Anthropology began as a science during the early 1800s. Anthropologists interpret the written word and art of a society. They research the customs, celebrations, and holidays of a group of people. The roles of people in the society are also studied. This would include the importance of the

Figure 3-4 Archaeological excavations such as the one seen in this photograph are sources of information for the art historian.

Bone excavation, Piazza de la Signoria, Florence, Italy. Photo ©1992, Nancy Cataldi, FPG International.

artist or craftsperson to the community. Anthropologists can often discover the reasons *why* objects were produced. The art historian uses the anthropologist's research on the government, religion, and social structure of a society to draw conclusions about the art that society produced.

Let's look at the clay horse from China in Figure 3-5 as an example of how the art historian relies on information from both the archaeologist and the anthropologist. The archaeologist discovers the horse in a

TECHNOLOGY MILESTONES IN ART

Radiocarbon Dating

Radiocarbon dating was invented in 1947 by Willard Libby, an American chemist. This technological discovery allows archaeologists to determine the dates of ancient objects. This, in turn, has helped art historians to identify and place the objects in accurate chronological order.

Radiocarbon (or carbon 14) is absorbed from the air by green vegetation and is passed on to animals who eat the plants. It takes a long time for radiocarbon to

decay in a living animal. What radiocarbon is lost is replaced as long as the animal lives. Once the animal dies, however, the radiocarbon decays at a steady rate. The radiocarbon can be measured to determine how long ago the animal lived. Since many artifacts of the past have contained living organisms while being crafted, they too can be dated. One example would be small snails or other organisms found in clay along river banks and used to make containers.

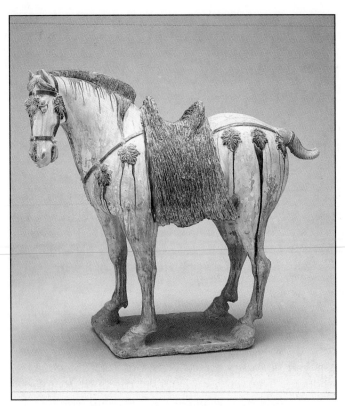

Figure 3-5 Clay horses were buried in underground tombs along with the emperor upon his death.

Bactrian Horse, A.D. 618–906. China, Tang Dynasty. Polychrome lead-glazed pottery. H: 28" × W: 31" (71.1 × 78.7 cm.). Los Angeles County Museum of Art. Gift of Hedwig Worch and Henry Trubner. ©1993 Museum Associates, Los Angeles County Museum of Art. All Rights Reserved. M.90.140.1.

Tang dynasty (618–906) tomb near Xi'an (SHE-ahn). The horse is carefully removed from the tomb while information about the surrounding area is recorded. This information would include the location of the horse in the excavated site. This information would be valuable to the anthropologist in determining the importance of the horse to the deceased royalty.

The archaeologist would also analyze the composition of the clay soil of northwest China where the Tang tombs are located. The clay, known to the Chinese as "yellow earth," is a fine powder. It was mixed with water, and poured into a mold to make the horse form. After the clay horse was released from the mold, a glaze, or decorative paint, was applied to the surface. This glaze would also be tested by the archaeologist to discover that the pigment (pure paint) was mixed with

a type of food gelatin to hold the pigment together. The glaze was applied to the horse as decoration.

The anthropologist then studies the reasons why the Chinese buried clay horses in the royal tombs. Research from previous excavations has revealed the ancient practice of placing live horses and warriors in the tomb before sealing it. It was hoped that the deceased would go to the afterworld guarded by an army of horses and men. This practice was discontinued during the Han Dynasty (206 B.C.–220 A.D.) and clay horses and clay warriors were substituted. If the horse was located in the burial chamber, the anthropologist would probably conclude that the horse was used as transportation. The hallway outside of the tomb was called the "Spirit Way" where the royal body would travel to its resting place. Some horses were located in the hall to protect the deceased. It has also been discovered by anthropologists that the horse was important to the Tang dynasty for another reason. Emperor Tang Taizong (626–649) was a strong military leader. His royal army commanded several military victories over Tibet and neighboring lands. Through researching the military structure of the society and the archaeological re-

EXPLORING

HISTORY AND CULTURES

Horses are symbols for cultures other than the Tang Dynasty but for different reasons. The horse may represent a source of survival, helping to provide work, food, or protection. To others, the horse represents recreation or sport.

1. Historically, what symbols have been used to represent the United States of America? Are any of these symbols viewed differently by other countries?

2. What symbols represent your school? Locate these symbols around the school, such as at the entrance, in the cafeteria or gymnasium, or on school jackets.

3. Are there symbols that are specific to the community in which you live?

mains, the anthropologist discovers that the Chinese armies used chariots drawn by horses during war.

The anthropologist would also look for signs of recreation or leisure activities used by the Chinese of the Tang dynasty. Upon analyzing the writings and objects in the tomb, it would be discovered that polo was a popular sport during this period. Horses were used to transport both males and females as they galloped down the playing field. When the anthropologist studies how the Chinese culture established dates or time, it would be discovered that the horse was also an important sign of the Chinese calendar. The calendar consists of a twelve-year cycle of dates with each year represented by an animal. It is believed that persons born in a particular year would assume the characteristics of the animal assigned to that year. The Chinese calendar was also used to plan important events such as marriages or celebrations.

The art historian then might study the discoveries by the anthropologist and archaeologist and assemble the information in writing. This information is typically presented in art history books, educational resources, or lectures. Where else does the art historian locate information about works of art? What can historians learn from the visual images and written words artists have left for society? Let's look at some other ways art historians discover information about art around the world.

Other Ways in which Art Historians Assemble the Pieces

The art historian may use iconography as a way of decoding the significance of a work of art or artifact. **Iconography** *is the interpreting of an artifact or work of art through studying its subject matter, theme, or symbols.* These *symbols* are referred to as **icons.**

One of the oldest examples of iconography is found in the religious art of the Early Christian (4th century) and Byzantine (BIZ-an-teen) (527 A.D.) cultures. The art was in the form of a **mosaic,** *which means that it is constructed from many small pieces of colored tile.* During the first part of the fourth century, Christians were persecuted by the Romans for their religious beliefs. In an attempt to avoid this suppression, the Christians built

underground tunnels called **catacombs** outside of Rome. The catacombs were used as a burial ground for the deceased and as a place of worship. The ceilings of the catacombs were painted with religious figures and symbols. The symbols were a form of communication for the Christians that only they could read. Circles represented heaven and peacocks stood for immortality. The human figures stretching up to the circles were members of the Christian Church.

The Byzantine mosaics were made from brilliant pieces of colored glass embedded in plaster to create a picture. The symbol of the cross, representing the presence of Christ in the church, was widely used in Christian Byzantine mosaics (see Figure 3-6). When a cross

Figure 3-6 Symbols, such as the cross in the dome of this Byzantine church, are "read" by art historians for their historic significance.

Apse mosaic from Sant' Apollinare in Classe, c. A.D. 549. Ravenna, Italy. Scala/Art Resource, NY.

Student Activity 1

Thematic Time Line

Goals

1. You will learn how to develop a chronological time line using dates to show artists from different periods in art history.
2. You will learn how to research a theme for key events and changes in subject and technique of the theme.

Materials

1. Art history textbooks, encyclopedias, periodicals
2. Poster board cut into lengthwise strips approximately 5" in width
3. Colored paper (optional) and white drawing paper 3" × 4" pieces. (You may change the dimensions of the paper if you desire.)
4. Markers and colored pencils

Directions

1. You are going to assemble a special chronological time line with information from several periods in history. The time line will be a chronology of an art theme. The theme could focus on the use of still lifes in painting, the house in art, or portraits of the twentieth century. Begin by selecting the theme—perhaps from the suggestions below. Be specific and keep your theme informative.

Themes

Children in Art	Cities in Art	Sports in Art
Self-Portraits	Motion in Art	Music Represented in Art
Nature in Art	Work and Play	War in Art
Sports in Art	Hidden Symbols	Fantasy Images

Then select a time period that your chronology will cover. Also, decide what cultures will be included in your chronology.

2. Using the resources and references in your classroom and library, research how artists have used your theme during the time period you selected.

3. Select ten to fifteen examples for your chronology. Try to include different types of art in your selection such as sculpture, watercolor, or printmaking.

4. Mark the poster board strip with the dates of your theme selections in chronological order. Leave some space between each date. It may be necessary to use more than one strip for your chronology.

5. Use the assorted paper to write a description of each major development of your theme. Glue the descriptions onto the poster board next to the appropriate date.

6. On 4"×3" paper, draw or paint examples of different styles of art that use your theme. Glue them to their appropriate place on the time line (see Evaluation #3).

Evaluation

1. Did you thoroughly research your theme, for the time period you chose?

2. Did you research a diversity of cultures and artists who influenced the theme? What periods on your time line could possibly be researched for additional examples?

3. Is your chronology in the correct order? Make necessary corrections by switching the images before glueing them to the poster board.

4. Did you make examples of different styles of art represented on your time line? Go back to at least two periods and add a small example of the styles to the time line.

Your school library is a good place to start your time line research.

also appears in functional or decorative objects from this period in history, the historian views it as an icon of Christ.

As we mentioned, the art historian depends on the writings of other historians for clues to a history puzzle. But how do we know about the art of a culture that existed before the written word? One way is through oral history. **Oral history** *is the passing of information from generation to generation through the spoken word.* This information could be about events, celebrations, battles, or the social structure of a culture. Techniques for making functional or decorative objects were also passed from person to person by word of mouth.

In ancient Africa, for example, the **griot** (GREE-oh), or *storyteller*, was an important person in each village. The griot memorized narratives about the life and traditions of the people, then trained younger men to do the same. This verbal chain of information was passed down through the generations until written communication was developed.

Written information about art has taken many different forms. Autobiographies, diaries, and the letters of an artist provide information about the individual's life-style, creative thoughts, and technical approaches to creating art. Vincent van Gogh (van-GO) frequently recorded his thoughts by writing letters to his brother, Theo. In one letter, van Gogh passionately described how it felt to be an artist:

"I feel a strength within me that I must develop, a fire I can't put out, but must stir up, though I don't know where it will lead me and I shouldn't be surprised if it brought me to a bad end."

In another letter to his brother, van Gogh shared technical information about the painting process:

"Here's another landscape, sunset or moonrise, but summer sun anyhow. Violet town, yellow star, bluish green sky. All the cornfields have tones of old copper, gold-green or red, golden-yellow, bronze-yellow, greenish red. A no. 30 square canvas. I painted it in a strong mistral [wind] with my easel plugged into the ground with iron pegs, a tip I can recommend. You push the feet of the easel into the ground with iron pegs twenty inches long beside them. Tie the whole thing up with string. Then you can work in the wind."

Letters, like van Gogh's, and diaries are usually passed down among family members through generations. They are often sold to collectors or given to libraries where the art historian can access the written information.

Chartography, *the science of drawing land or sea maps,* provides additional resources for the art historian. Information about cultural and trade centers, land boundaries, and exchanges of art and goods between countries, have been provided on maps throughout history. This information was recorded through the drawing and painting of symbols and pictures on various surfaces. The earliest maps were etched into stones and were used to locate food and water sources for traveling groups of ancient people. One example of land maps were ancient Egyptian **cadastres,** *slabs of clay and papyrus into which land boundaries and fertile areas for crop planting were drawn with a sharp tool.*

As people began to form countries, maps were made to describe events such as military battles and exploration routes. Sea captains traveling throughout the Orient in search of silks and spices were protective of maps that might tell others how to find these riches. Often, captains would attach lead weights to their maps in case they were attacked by the enemy and needed to throw the maps overboard!

Ancient chartography was a blend of science, geography, and astrology. Claudius Ptolemy (TOLL-uh-me) (150 A.D.) one of history's first chartographers, divided the earth into latitudes and longitudes in his drawings. He used mathematical tools he invented to measure objects based on the horizon line of the earth. Ptolemy also used astrology to line up the earth with the "heavens." However, it would be thousands of years later before people would read the chartographer's original maps or writings again. During the Middle Ages, people were forbidden to read Ptolemy's scientific writings.

Since Christian religion was central to the lives of people during this time, only religious symbols could be drawn on their maps. The maps of the Middle Ages served two purposes. They taught people through illustrations about the Bible and how to travel to the Holy Land. Not all maps during the Middle Ages were truthful, however. Some artists invented people and animals whom they believed inhabited far away lands as decoration for the borders of their maps.

Figure 3-7 Many of van Gogh's letters to his brother give us information about how van Gogh created his works.

Vincent van Gogh (Dutch, 1853–1890), *Wheat Field and Cypress Trees*. The National Gallery, London.

During the late 1600s, map-making schools were established throughout Europe. The maps during this period were elaborate, showing detailed cities and colorful mountain ranges. Chartographers invented their own symbols for rivers, roads, and the weather. The maps were also filled with miniature paintings and detailed writings giving direction to travelers. Artists established "rules" for making the maps beautiful. Different colors were used on the maps for specific purposes. Water was painted with light blue pigment, and each tree in a forest was to have green applied to every branch. Cities and towns were red in order for them to be visible and property boundaries were outlined in green. Gold was applied to special areas on a map and black soot was used for accents or lettering (See Figure 3-8 on the next page).

Figure 3-8 Early maps used detailed symbols for invented and natural elements.
©1994 Bettmann Archives.

Chartography would continue to bridge art and science for some time to come. Some map makers wanted to make maps beautiful with detailed portraits of explorers, royalty, or miniature castles. Some countries were even mapped into the shape of an animal! Other chartographers wished to eliminate all drawings and paintings and concentrate on lines and numbers as descriptions. Maps are an illustration of technical skills while providing information about the society and time period in which the artists lived.

Section IV Review

Answer the following questions on a sheet of paper.

Learn the Vocabulary

Vocabulary terms for this section are *archaeology, excavation, radiocarbon dating, anthropology, iconography, icons, catacombs, oral history, griot, chartography,* and *cadastres.*

1. Explain the difference between the following pairs of vocabulary terms:
 a. Anthropology and archaeology
 b. Iconography and chartography
 c. Griot and icon

Check Your Knowledge

2. What is one of the oldest examples of the use of iconography in history?
3. What could an art historian learn about Vincent van Gogh's art from reading his letters to his brother?
4. Which was one of the first cultures to use chartography?

For Further Thought

5. Hundreds of years from now, archaeologists may discover objects from our time. What items and icons that are in use today could inform future archaeologists and art historians about our culture?

Student Activity 2

Creative Chartography

Goals

1. You will design a map of the city or town where you live based on the art of chartography.
2. You will learn how to create symbols that will represent places, landmarks, and roads in your environment.

Materials

1. World maps and historical charts with symbols, to use as references while you work
2. Maps of your city or town
3. Large sheets of drawing or craft paper
4. Tempera, acrylic, watercolor paints and colored inks
5. Brushes
6. Markers, pencils, chalk

Directions

1. Enjoy designing a map of your city or town in a creative way! Begin by analyzing old maps obtained from the library or your school's history department. Look specifically at the decorative borders and the symbols used for special landmarks, people, buildings, trees, and so on.

Student Activity 2 continued on next page

2. Now analyze the map of your city or town. Where are schools, places of worship, recreational centers, malls, and public transportation located? Are there public parks or areas of undeveloped land? Study the borders of your city or town to determine its shape.

3. Design an image or symbol that will represent each landmark on the map. For example, what image would best represent your school? Private homes? The local mall? Remember . . . you are making a map of your environment without using words.

4. Begin making your map. Draw the borders of your city or town to define its shape. Lightly sketch the symbols or images in their proper place on the map. Roads, streets, and highways should also be represented. Landscape elements such as trees, hills, rocky areas, or water should be indicated by drawing them representationally or symbolically. Apply watercolor, tempera, or ink to your drawing for color emphasis.

5. *Optional:* antique your map by tearing the edge around your paper. Brush light brown watercolor over the torn edge to give the map an aged appearance.

Evaluation

1. Did you research and develop symbols specific to your city or town? What makes them unique to your environment?

2. Is your map readable? Can the viewer acquire an understanding of the type of community in which you live through your drawings and symbols? Which symbols do you need to improve on and why?

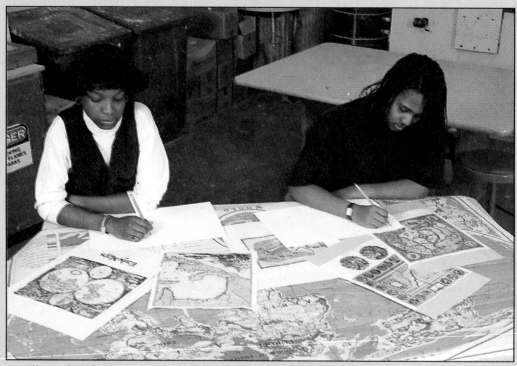

You'll need to look at many maps before you design your own.

140

Section V

Voyages Through Time

When you begin to discover the world of art history, it is like going on a fascinating journey through time. The search for information about a work of art or an artist can be a challenging and rewarding experience. You have been reading about the ways in which art historians assemble information about artists and periods in history. But how can a high school student gather information when the expertise of scholars in other fields may not be readily accessible? Where would you begin to learn about the historical significance of a work of art in your textbook, classroom, or local museum? How do you look for clues to the history puzzle?

Begin with the Work of Art

Sometimes you can find clues about the artist who created the work, the media used, and the time period in which it was completed by simply *looking* at the work. Some of the questions that an historian would think about that you might ask yourself include:

- What subject matter did the artist choose for the work? Do you think that the theme is a contemporary view of life or one perhaps from ancient times? Is it possible that the artist has chosen a theme from a different time period as a statement about contemporary social conditions?

- Was the work designed for ceremonial or religious purposes?

- What type of materials did the artist use to create the work of art? Are the materials only available in a particular country or specific region of a country?

Jan Joest van Kalkar (attributed)

Flemish, 1459-1519

VIRGIN AND CHILD WITH ST. ANNE, CA. 1510

Oil on panel

Columbus Museum of Art, Ohio; Bequest of Frederick W. Schumacher

57.14

Elijah Pierce

American, 1892-1984

CROCODILE, 1973

Wood, polychrome, small stones

Columbus Museum of Art, Ohio; Gift of Mrs. Ursel White Lewis

76.4.3

Figure 3-9 We can learn a great deal of basic information from the labels that the museum supplies.

Wall labels. Courtesy Columbus Museum of Art, Ohio.

- Has the artist used methods for making the artwork that appear to be from a particular culture or period in history?

- Does the artist's style remind you of any other work you have studied?

Sometimes the information you are searching for is on a label placed on or near the work of art (see Figure 3-9). For example, when you are looking at art reproductions in class or in this book, you will find the artist's name, title of work, date of completion, and

where it is located. When you visit a museum or gallery, this information is usually located on a plaque next to the artwork. Sometimes, in place of the artist's name, the label may state that the work is "attributed to" a particular artist, culture, or period. This means that although art historians have not been able to determine exactly who created the art, the style and subject matter of the work have provided clues. When the style and subject matter are similar enough to those of a known artist or period, art historians will attribute it to (guess that it comes from) that artist or period.

Looking Outside the Work of Art

Looking at the work of art and reading labels is the first step in discovering its historical significance. From there, the way in which you look for information about the work of art depends on your own curiosity. Do you want to know more about the artist, the entire period in history, other artists who work in a similar style, or the social influences on the art of the period?

Once you have decided what to focus on, your next step would be to obtain resources that will give you more pieces to the puzzle. Some questions to ask before beginning this adventure include:

- What resources are within your reach? Will the materials, textbooks, or visual aids in your classroom provide information about the style, the artist's background, or the time period in which the work was made?

- What reference books and magazines are available to you through your school and local libraries?

- Do you live close to a museum or gallery? Is there information about your subject in its educational department or museum bookstore? Are there other works of art from the same time period in the museum's collection that you can use for comparison?

- Are there special documentaries about artists on videotape or television that may be used for your research?

- What museums could you write to for information about the work of art that you are studying? A list

of museums and their addresses is provided in the back of this book.

Collecting Information

Let's look at the painting in Figure 3-10 as an example of how you might find an answer to these questions. Next to the reproduction you will find the name of the artist, Théodore Géricault, (TAY-o-door zhay-ree-KOH), and the title of the painting, *Raft of the Medusa.* You will also see that the painting was completed in 1818–19. It is now located in the Louvre Museum in Paris, France. Perhaps you could write to the museum for additional information or locate reference books on the Louvre collection.

The next step might be to discover more information about the time period in which the painting was created. Using the date and a chronological time line for European art during the 1800s, you can determine that the painting is an example of *Romanticism.* Turn to Chapter Eight and read about this time in which artists wanted to "return to nature" in their paintings. The visual art of the period was also an emotional retelling of dramatic events. Géricault's painting appears to fit this category!

Now that you know the name of the period, you may want to research Romanticism and other key artists of the time, such as Eugène Delacroix and Francisco de Goya, whom you will meet in Chapter Eight. You can also look at areas other than the visual arts. The literature, music, and drama of this period can help explain why this particular style of painting was popular during the 1800s.

You might also be curious as to why Géricault decided to paint *Raft of the Medusa.* Who are these desperate people clinging to life on a makeshift raft? How did they end up in this dangerous situation in the first place? Reading several accounts of the scene might give you answers to these questions. When you compare several historians' writings about the painting, keep the following questions in mind:

- Which description provides information about how the French government influenced Géricault's painting of the historical event?

- What preparation did the artist complete before beginning the painting?

Figure 3-10 Write down your reactions to this painting before you read the art historians' accounts below and on the next page. Then, read the accounts. Did your feelings about the painting change after learning why Géricault painted it?

Théodore Géricault (French, 1791–1824), *Raft of the Medusa,* 1818–19. Oil on canvas. Approx. 16′ × 23′. The Louvre, Paris, France. Giraudon/Art Resource, NY.

- Which historian provides the most complete description of events? Which one provides the least complete description?

- Can you gather from any of the accounts why the artist decided to paint this particular event?

Sometimes when you are assembling the pieces of the history puzzle, you will need to formulate your own description of the event, based on several accounts. Let's read three writings about *Raft of the Medusa:*

Art Historian A

"A government ship, the *Medusa,* was wrecked on the way from France to Senegal in 1816. The captain, who had obtained his office as a political favor, abandoned ship first, along with his crew, and the 149 passengers were crowded onto a raft to be towed by the lifeboat. The raft was eventually cut adrift, and after suffering extreme torments of starvation and thirst, only fifteen survivors made it to the African coast. It was a national scandal that shook the entire country. Géricault, always interested in humanity's struggle with nature,

jumped into the subject with great enthusiasm. He interviewed the survivors, read the newspaper accounts, and made sketches and paintings of corpses and bodies at the morgue. He even had himself lashed to the mast of a small ship in a storm so he could feel the movement of the swells and the wind."

Compare the account of Art Historian A with the next description of the same painting:

Art Historian B

"In a scandalous incident, the seamen of the wrecked transport *Medusa* had been set adrift on a raft in the Mediterranean. Géricault was involved with pamphlets that rocked France in protest to the government, and he carefully prepared a painted memorial to the cause. He constructed his history painting by the most exacting study: questioning survivors, drawing corpses, studying atmosphere, and launching a trial raft on the sea. There followed a long series of compositional sketches in line [only lines, no shading] and wash

Presidential Portraits

Artists throughout history have recorded historical events and political leaders through drawings and paintings. The image that you have of one of our early presidents, such as George Wash-

Figure 3-11 Healy's original portrait was lost. This is a copy by Healy painted in 1859. Tyler left office in 1845.

George Peter Alexander Healy (American, 1813–1894), *Portrait of John Tyler* (Tenth President of the United States), 1859. Oil on canvas. 36⅛" × 29⅛" (91.2 × 74 cm.). Transfer from the National Museum of American Art; Gift of Friends of the National Institute, 1859. National Portrait Gallery, Smithsonian Institution/Art Resource, NY. NPG.70.23.

ington or Abraham Lincoln, probably comes from an artist's portrait. Let's take a look at two artists who created portraits of American presidents.

George Peter Alexander Healy (1813–1894) was born in Boston, Massachusetts. His family was an influential part of Boston aristocracy. Healy traveled throughout Europe painting many members of royalty. On returning to the United States, he was in demand as the personal portrait artist to a succession of presidents.

In Figure 3-11, you will see a portrait created by Healy. Healy was noted for presenting the human side of the people he painted. One of his favorite subjects was the tenth president of the United States, John Tyler. In this portrait, President Tyler appears to be resting momentarily from reading the newspaper. The newspaper is gripped firmly in his left hand, signifying the strength and determination necessary to be the leader of the country. Gazing to his left, Tyler seems deep in thought, probably pondering weighty issues. The newspaper cannot divert his attention. Although Tyler is painted in the midst of a routine task, his formal clothing, chiseled face, and thoughtful gaze speak of strong leadership qualities.

The leader represented in Figure 3-12 is John Fitzgerald Kennedy, the thirty-fifth president of the United States. The artist of this work, Andy Warhol (1928–1987), is a "Pop artist." *Pop art* is artwork that reflects popular images of society. These images may include movie stars, commercial products, and television news clips. Warhol's portrait of Kennedy is created in the same style that he used for "popular images," such as soup cans and movie stars, in the 1960s. Warhol had a photoscreen made from a photograph of President Kennedy. A **photoscreen** *is a stencil of an image produced in a printing shop.* Warhol then placed the stencil on his canvas and pushed paint or ink through the openings of the screen. This

Comparing Works of Art

Figure 3-12 The title of this portrait of President Kennedy is the date of his assassination.

Andy Warhol (American, 1928–1987), *Flash—November 22, 1963.* Screenprinted on paper in 1968. Courtesy The Andy Warhol Foundation for the Visual Arts, Inc. ©1994 The Andy Warhol Foundation.

transferred the image to the canvas. Using a photoscreen allows the artist to print the same image multiple times, as Warhol has done here. He preferred the photoscreen process explaining that he wanted to be a machine, and that anyone should be able to execute his canvases. (You will read about printmaking processes in Chapter Four.)

Warhol created a different type of presidential portrait than Healy's. Rather than one image of the president in a traditional pose, Warhol chose to create a **serigraph,** or *a silkscreen color print* from the photoscreen. This portrait is from a series of prints Warhol made to document Kennedy's assassination. The portrait of President Kennedy resembles a negative of a photographic image. Warhol has used a different color for each of the three portraits. Repeating the same image, yet changing the color, is perhaps

Warhol's way of representing the emotional impact of the assassination.

Andy Warhol was born in a coal-mining town in Pennsylvania in 1928. Warhol's father was a miner who died when Andy was only twelve years old. Warhol, perhaps in reaction to the death of his father, was ill during most of his teenage years. He passed the time by reading movie magazines and tabloids. Perhaps these influenced his choice of images as a professional artist.

Warhol attended the Carnegie Institute of Technology. He later moved to New York City where he worked as a commercial artist creating advertisements for companies. He eventually began his painting career developing his unique style. Warhol was extremely influential in the direction that art took during the 1960s and 1970s.

[thinned ink or watercolor] evolving finally into the rocking pyramid which he used . . . , Official circles were not too pleased, however, and Géricault was persuaded to send the canvas to England where it earned him considerable money as a traveling exhibit."

Now read a third account of Géricault's painting of the disaster. Keep in mind that you should be looking for information that was not stated in the previous two accounts. Also be aware of information that Historian C leaves out.

Art Historian C

"In July of 1816, the French ship *Medusa* was wrecked in a storm off the west coast of Africa. When it was certain that the ship was sinking, 149 passengers and crew members were placed on a large raft made from parts of the ship. The raft was then towed by officers aboard a lifeboat. Later, it was claimed that the officers, concerned with their own survival, cut the raft adrift. By the time they were rescued, only 15 men on the raft remained alive."

Now that you have read the accounts, consider once again the questions posed at the beginning of this section. It is important that you study several sources when researching a painting, artist, period or culture.

DEVELOPING SKILLS FOR

ART CRITICISM

Study Théodore Géricault's painting *Raft of the Medusa*.

1. How does Géricault's use of color affect the dramatic impact of the scene?

2. How did Géricault use *lines* to direct the viewer's eyes to the person waving the white cloth?

3. Why did the artist devote most of the space on the canvas to the raft and the desperate people?

This will make your account of a specific topic as accurate as possible. To complete your study of *Raft of the Medusa*, you might want to find additional information on Théordore Géricault. Some question for exploration might include:

- Did he paint other historically significant works?

- What other roles did Géricault play in the French politics of the time?

- What type of art training did Géricault receive at the beginning of his career?

- Did he influence the artwork of other artists during this period in history, or afterward?

As you explore the themes of art in this book, you may find an artist, work of art, or period in history that you will want to investigate further. Rely on the different areas of research that you have read about in this chapter for assistance.

Section Ⓥ Review

Answer the following questions on a sheet of paper.

Learn the Vocabulary

The vocabulary terms for this section are *photoscreen* and *serigraph*.

1. Define the vocabulary terms by using each one correctly in a sentence.

Check Your Knowledge

2. Where is the best place to begin searching for information about a work of art? Why?

3. List some resources available to you that could provide answers to your questions about a work of art?

4. Théodore Géricault's painting, *Raft of the Medusa*, is an example of Romanticism. How could researching the work of other Romantic artists, writers, and musicians help you learn more about Géricault's painting?

For Further Thought

5. Do you think that understanding a work of art created during an earlier time period can provide insight into your own point in history? Why or why not?

Student Activity 3

Researching Historical Accounts

Goals

1. You will learn how to research different historians' accounts of one topic, artist, event, or period in art history.
2. You will become aware of how different accounts can provide a range of information.

Materials

1. Reference books, art history books, encyclopedias, periodicals
2. Writing materials

Directions

1. Your teacher will divide the class into groups of two or three students each.
2. Your group should select a topic, artist, period in art history, or work of art. You may want to select one of the following topics:

- Grant Wood's *American Gothic*

- Andy Warhol's early career

- Rembrandt's *Nightwatch*

- Landscapes of the Impressionist artists

- The image of Buddha in India

- The meaning behind Hopi kachina dolls

3. Research the topic. All group members should take notes on similarities and differences among the historical accounts. Record the references you use during your research such as the title of the book, author, or critic.
4. Write a short paper on the subject. Refer to your notes as you assemble the information.
5. Exchange your paper with others in your group. Read the papers, then record on paper the similarities and differences in the information each person discovered about the topic. Compare your research to others in the group. Each group should write one collective report based upon the preliminary research reports. Decide as a group what information is important to understanding the topic and what should be eliminated. Turn your final report in to your teacher or share it with the rest of the class.

Student Activity 3 continued on next page

Evaluation

1. Did you find a variety of resources on the topic? List on paper your references, date of publication, author's name, and publisher. Keep these references for future use.

2. Did you accurately record information on the topic? What areas of your notetaking could be improved?

3. Were you able to recognize the differences and similarities among your group's accounts? If not, check a second time or ask your teacher to assist you in identifying them.

THE ARTIST AS A YOUNG ADULT

Théodore Géricault

Théodore Géricault (1791–1824) was born in Paris, France. He began his formal art training at seventeen years of age with Carle Vernet (1758–1836), a French painter of battle scenes and sporting events for Napoleon I and King Louis XVIII. Under Vernet's guidance, young Géricault developed the ability to capture animal movements and the human figure in his paintings. He studied the works of master artists displayed in the Louvre Museum in Paris. Géricault would copy the paintings onto his own canvas as was the practice among beginning artists during this time.

During his late teen years, Géricault traveled throughout Europe supporting social causes such as the rights of common laborers. While in Florence and Rome, Italy, he was introduced to Michelangelo's paintings and Baroque art. Géricault spent hours copying Michelangelo's human images. His dedication to perfecting human form would be evident ten years later in *Raft of the Medusa*.

At the age of twenty-one, Géricault's painting *Officer of the Imperial Guard* was accepted for exhibition at the prestigious Salon of the Academy in Paris. Eventually, that painting and *Raft of the Medusa* would be a part of the Louvre's collection—in the very place where Géricault began his career.

SUMMARY

This chapter has explored the different ways art history comes alive through research by the art historian. The research is dependent upon the contributions of archaeologists, anthropologists, and other historians. Historical knowledge is also passed down through the generations in a variety of ways by the written and spoken word.

Student historians can learn to question how art history has been recorded throughout the centuries.

Learning how to ask questions, comparing written accounts of historic events, and researching an artist or time period are skills that can be developed through practice. In addition, taking time to sequence large amounts of historical information into a chronological time line creates an order to the study of art history.

CHAPTER ③ REVIEW

VOCABULARY TERMS

Using at least five of the vocabulary terms, write a paragraph about the work of an art historian.

academies	B.C.	excavation	oral history
A.D.	cadastres	Fauves	photoscreen
anthropology	catacombs	griot	radiocarbon dating
archaeology	chartography	iconography	ready-mades
art historian	chronology	icons	serigraph
art history	Dada	mosaic	

Applying What You've Learned

1. What type of information about your ancestors and the time period in which they lived can be gathered from their personal memorabilia?

2. For what reasons might an art historian want to research a particular culture or period in history?

3. Can you think of any other way of putting art in sequence besides according to the date when the work was made?

4. Can you think of any examples of contemporary griots, or storytellers, who pass on historical information to younger generations?

5. Why is it important that we understand the reasons *why* an artist created a work of art?

6. Why might historians' explanations of the historical significance of a work of art differ?

Exploration

1. Visit the library and locate books on archaeology. On a piece of paper, list some major discoveries that archaeologists have made about the art and artifacts of civilizations. (One example would be the art found in the tombs of Chinese emperors.) Select one archaeological discovery from your list for further research and study. Write a two-page paper about the importance of the discovery for our understanding of that culture.

2. Locate different historians' accounts of the life of your favorite artist. Select three of the biographical accounts. Compare and contrast the accounts in one report about the artist's birth, life as an artist, and influence on the art world.

 Optional: create a video presentation based on your report. You may want to dress in the style of your artist or of the time period in which the artist lived.

3. Research your own family history. Discuss with family members what works of art, photographs, crafts, or mementos are a vital part of your heritage. List them on paper along with their origin. Answer the following questions:
 a. Are the objects still in existence? Where are they located in your home or in the home of a relative? Be specific.
 b. Were any of the items made by family members?
 c. What family members, past and present, are involved in art-related hobbies or careers? Interview them to discover why they enjoy making art.

Building Your Process Portfolio

This chapter provided different avenues for exploring art history. It will hopefully be of use to you as you study the art of the past and present throughout this book and after you complete this course. In order to have references at your fingertips, include the following items in your process portfolio:

- The research paper completed in Student Activity 3

- Notes on your study of *Raft of the Medusa* as well as comments about how you plan to gather information for future research

- A folder in which you keep a file of articles about artists and critical reviews of recent exhibitions so that information can then be readily available as you assemble the pieces to an art history puzzle

THINKING ABOUT

AESTHETICS

The painting *Raft of the Medusa* by Théodore Géricault is the artist's interpretation of an historical event in 1816.

1. After reading the historians' accounts of the tragedy, do you think that Géricault captured the drama of the event?

2. How close to the actual scene is Géricault's version? How have you arrived at your answer?

"At last I could work with complete independence without concerning myself with the eventual judgment of a jury. I admired Manet, Courbet, and Degas. I hated conventional art. I began to live."

Mary Cassatt

How Is Art Created?

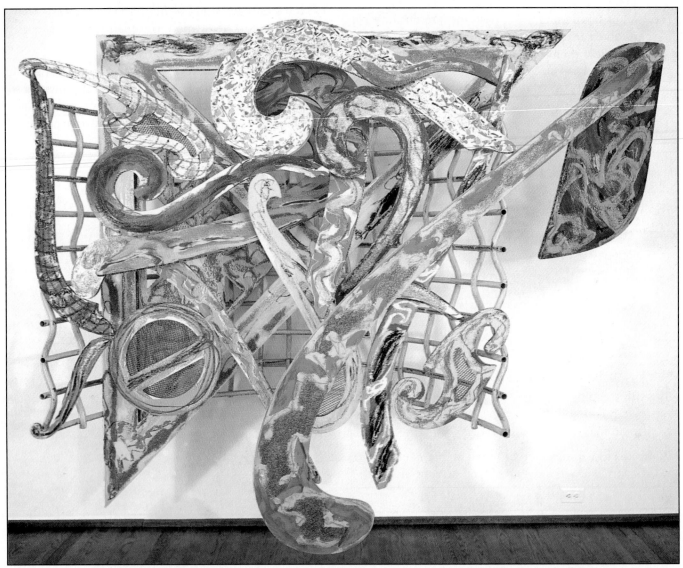

Figure 4-A Frank Stella "created" this mixed media piece in a far different style from his paintings.

Frank Stella, *Jungli-Kowwa*, 1978. Mixed media on metal relief. 86" × 102" × 38". ©1993, Frank Stella/Artists Rights Society (ARS), New York. Joseph H. Hirshhorn Collection, Leo Castelli Gallery, New York.

Contents

Section I Creating Art Is Meaningful

In this section, you will discover the ways in which making a work of art is meaningful for different people. You will also learn about how some people become artists and develop different styles of making art. Enter the world of two different artists by exploring their backgrounds and motivations for making art.

Section II Media and Methods for Making Art

The second section of this chapter will discuss the different materials available to you as a student artist.

You will become acquainted with the variety of ways in which these materials can be used to make works of art. You will explore the history and development of materials and the art-making processes.

Section III Safety in the Art Room

In this section you will be introduced to the importance of using safety skills in the art room. You will also become aware of the importance of manufacturer labeling of the supplies you may use on a daily basis.

Terms to look for

acrylic paint	drawing	method	scumbling
architectural drawing	enameling	modeling	sketchbook
armature	etching	monoprint	smudging
artists	found-object prints	mouse	software
assemblage sculpture	frescoes	naturalistic style	stippling
batik	gesso	nib	style
canvas	gesture drawing	pastels	template
carving	glaze	photography	tie-dye
casting	gouache	porcelain	tjanting needle
ceramics	hardware	printmaking	tooth
cloisonne	hatching	realistic drawing	warp threads
collagraph	kiln	representational	weaving
contour drawing	loom	drawing	weft threads
cross-hatching	mechanical drawing	screen	wire sculpture
curved lines	media	sculpture	wrapping

Objectives

- You will become aware of how personal differences affect the making of works of art.

- You will explore the history, use, and creative possibilities of different media.

- You will learn about and practice safe working procedures and ways of handling materials during the art-making process.

Art in Your Life

Until now, you have explored the many ways in which you may discover meanings in works of art. But how about the process of making art itself? Many of the materials artists use to make works of art are freely handled and lend themselves to wonderful experimentation. Others require some knowledge of techniques and limitations. You will be able to apply your knowledge of materials and the ways in which to use them to your own work. This chapter will provide you with terms and definitions of art forms and the specific materials used for each. Since the vocabulary remains the same for both student and professional artists, you will also be preparing for a future career in art if you so choose.

As you make art, you will learn to draw upon your skills and knowledge to solve problems, follow procedures, and develop technical skills. These experiences will hopefully spur you on to new levels of exploration and creativeness.

Section I

Creating Art Is Meaningful

Making art is meaningful in different ways to different people. For some, making art is a pleasant and constructive way to use leisure time. For others, making art is central to their way of life. **Artists** *are people who apply their knowledge, feelings, imagination, values, and skills to create extraordinary objects or events that we call art.* Usually in this society, the label *artist* as a professional designation is reserved for those who have dedicated their working lives to making art. In the United States, artists usually try to exhibit and sell their work, and try to gain the recognition of art critics, curators, and collectors. But not all people who make art seek such recognition. Some people whom we call artists may not think of themselves in that way. For example, in certain cultures, people who make special objects for ceremonial, decorative, or practical purposes, may not consider themselves artists.

It is almost certain that the Mayan woman depicted in Figure 4-1 did not consider herself an artist. Portrayed in ceramic over 1,100 years ago, she is shown sitting cross-legged, weaving on a loom. One end of the loom is attached to her waist, the other end to a tree trunk on which a bird perches. Today, we recognize the Maya as highly skilled and artistic weavers. They created textiles that were sturdy enough to withstand harsh natural conditions, yet ornamental enough to be worn by high officials during important ceremonial events. Mayan weavers added special elements of color and pattern to their work, and those enriched their communities visually.

Many communities around the world include people who have made art without ever giving much thought to becoming "artists." Mask makers, sand painters, doll carvers, lace makers, tinsmiths, quilters, potters, and a host of others have applied their knowledge, imagination, values, and skills to create special objects that have been enjoyed by members of their communities. Perhaps all of us are capable of being artists in some way.

There is no defined route to becoming an artist. Some people develop their concepts and skills in art school, studying with artists and scholars to learn art history, theories, and artistic processes. Others learn from their parents or other family members. Still others are essentially self-taught. What all visual artists have in common is a desire to express their thoughts and feelings in

Figure 4-1 Weaving, as depicted here, is a very natural process for this Mayan woman.

Figurine of a woman weaving. Mayan sculpture from Island of Jaina. Terra cotta. Dr. Kurt Stavenhagen Collection, Mexico City. Werner Forman Archive/Art Resource, NY.

visual form, to bring into the world a record of their values and perceptions. An artist's perceptions are reflected in his or her style. **Style** *refers to a characteristic manner of presenting ideas and feelings in visual form.* A style may be characterized by the materials and the way in which an artist chooses to work with them, by the use of color, texture, light and shadow, scale, or choice of subject matter. One artist may choose to paint realistically, another abstractly. One artist may choose to use muted colors and broad brush strokes, another to paint in brightly colored dots. Adopting a particular style as an artist is a matter of personal choice. Similarly, the viewer may have a favorite style of art that he or she most enjoys. By being open to many different styles, however, we increase our chances of getting the most out of our encounters with art.

Art production is meaningful, then, because it provides us with unique and powerful ways of expressing and exchanging our thoughts, feelings, and experiences in life. Although the making of art has taken a multitude of forms throughout history and across cultures, its ability to enrich our lives has never waned.

Section I Review

Answer the following questions on a sheet of paper.

Learn the Vocabulary

Vocabulary terms for this section are *artist, style,* and *naturalistic style* (see *Looking Closer* on the next page).

1. Write a short paragraph using these vocabulary terms.

Check Your Knowledge

2. Why can the Mayan woman depicted in Figure 4-1 be considered an artist?
3. What do all artists have in common?
4. What elements may characterize an artist's style?

For Further Thought

5. An object designed to be used, rather than to be displayed and viewed, can still be a work of art. Can you think of any objects in your current environment that fit this description?

LOOKING CLOSER:

The Alligator and the Crocodile

Let's compare the artistic styles of two artists represented in Figures 4-2 and 4-3. Figure 4-2 depicts an alligator in a **naturalistic style,** *meaning that the artist tried to make the sculpture as life-like and true to nature as possible.* The artist, Anna Hyatt Huntington (1876–1973), specialized in creating sculptures of animals that appear frozen in motion. In Figure 4-2, she "captured" an alligator in the act of thrashing its tail and snapping its jaws. It is a powerful and menacing creature. The rough texture of its hide accentuates its fierceness.

Figure 4-3 presents a very different image stylistically. This carved crocodile has been simplified in form. The artist, Elijah Pierce (1892–1984), has placed the emphasis on the two rows of sharp teeth, gleaming white against red gums. The red and white glare out from a hide of flat, neutral gray. Movement

is suggested by the opposing direction of the legs. The rough back, which was detailed on Huntington's sculpture, has been simplified by Pierce into a rhythmic pattern of triangles. Each sculpture is visually striking and effective in showing the animal's essential characteristics, yet each expresses the artist's unique perception.

Anna Hyatt Huntington and Elijah Pierce also represent the dramatically different routes people take in becoming artists. Huntington was born in Cambridge, Massachusetts, and began her career as a violinist. She took up sculpting in clay as a hobby, but it soon became her passion. She studied at the Art Students League in New York, and for a time was taught by Gutzon Borglum (GUT-san BOR-glam), the creator of the monument to the U.S. presidents carved on Mount Rushmore. She practiced drawing

Figure 4-2

Anna Hyatt Huntington, *Alligator,* 1937. Bronze. 49 × 28 × 54 cm. Brookgreen Gardens, Murrells Inlet, South Carolina. S.1972.003.

Comparing Works of Art

Figure 4-3

Elijah Pierce, *Crocodile*, 1973. Wood, polychrome, small stones. 4⅛" × 2⅝" × 12⅜". Columbus Museum of Art, Ohio. Gift of Mrs. Ursel White Lewis.

at the New York Zoological Park, and became an expert in animal anatomy and behaviors. Her bronze sculptures are to be found in various collections and in public parks throughout the United States and abroad. In 1931, she and her husband, Archer Milton Huntington, founded Brookgreen Gardens on a large tract of land in South Carolina. This became a garden showcase for modern sculptures, including the works of many women artists. She received numerous awards and honorary degrees throughout her lifetime, including becoming a "chevalier of the French Legion of Honor" for creating a heroic equestrian monument to Joan of Arc.

Elijah Pierce was born in Mississippi, where his father, a former slave, owned a farm. As a youth, Pierce did not want to be a farmer, and he left home to wander the railroad routes as a hobo, working when he could on railroad construction gangs. Eventually he settled in Columbus, Ohio, where he opened a barbershop. Even as a boy, Pierce enjoyed carving in wood, although he never received any formal training as a woodcarver. Over time, his freestanding carvings and wooden panels depicted a wide range of his interests, including many animals, figures in sports, biblical parables, and other religious subjects. In the last several years of his life, Pierce used his barbershop as a gallery for his carvings, and he and his wife, Estelle Pierce, welcomed thousands of visitors. His work has been exhibited in museums around the country.

Section

II

Media and Methods for Making Art

Since the beginning of time, people have searched for different ways to make a mark on a surface. Prehistoric people discovered that eggs, animal blood, and ground rocks could serve as a type of paint for their cave paintings. Weaving techniques were developed by ancient Indian, Chinese, and Japanese civilizations. The Greeks invented methods and tools to carve beautiful sculptures from monumental blocks of marble. Drawing and painting materials have been invented and improved over the centuries.

Today, art supply manufacturers produce hundreds of products that make it possible for everyone to create art. The sophisticated products on the market today are the result of centuries of trial, error, and improvement. *These materials, such as paint, clay, wood, drawing tools, and textiles, are referred to as* **media.** *The way in which the artist uses the media is called a* **method.** Each art form such as drawing, painting, and sculpture, utilizes a variety of media or methods.

Drawing

Drawing *is the process of creating an image on a surface with a drawing tool.* Sometimes this is referred to as *rendering.* Drawing is one art form discussed in this chapter that might be familiar to you. You have probably spent hours as a child drawing your favorite images with pencils or crayons. Now that you are in high school, you might want to improve your drawing skills and learn new and varied techniques.

There are several reasons why artists learn how to draw. First, drawing helps the artist plan a work of art.

Student Work

Derrick Weaver, 19
Whitehaven High School; Memphis, TN

The artist can make artistic decisions on paper rather than wasting materials or time later in the creative process. Second, the artist uses drawing to practice a particular skill, such as creating the illusion of depth or texture. Finally, some artists draw in order to create a finished work of art.

Types of Drawings

There are several types of drawing that an artist uses during practice or when beginning a final work.

Contour Drawing. Contour drawings *are renderings of an object's edges and interior lines through a continuous movement of a drawing tool.* When working on a contour drawing, the movement of the drawing tool must coordinate with eyes and hand while scanning across, through, and around an object. A contour drawing might appear to be slightly distorted in some areas because the edges of the object are the focus of the drawing rather than on shading or proportion. The lines in a contour drawing are made only once without corrections.

Student Activity 1

Contour Drawing of Shoes

Goals

1. You will learn how to draw the edges and lines of an object by coordinating the movement of your eyes and the drawing material.
2. You will learn how to use your entire work surface when doing a contour drawing.
3. You will learn to recognize the form and interior spaces of an object.

Materials

1. Pencils and markers
2. Large sheets of drawing paper (minimum 12" × 18")

Directions

1. Place several shoes of different designs and sizes on your work surface at interesting angles. Arrange the shoes so that they touch one another.
2. Determine with your eyes at what point you will begin your drawing.
3. Draw the lines that make up the outer and inner edges of the shoes. Try not to lift your drawing tool from the paper surface. Coordinate your hands, eyes, and drawing tool as you render the shoes and connect all lines to each other. Include the seams, shoelaces, and designs on the shoes.
4. Periodically check your progress to see if you have attended to the details of the edges of the shoes. If you return to an area of your drawing, begin with an existing line and draw from that point.

Evaluation

1. Did you draw all of the edges and lines of the shoes?
2. Were you able to coordinate your eyes with the movement of your pencil on the paper?
3. Can you identify contour lines in other objects in the art room?

Student Work

Edwin McSwine, 18
Whitehaven High School; Memphis, TN

multiple lines that suggest the motion created by the subject as it changes positions.

Mechanical or Architectural Drawings. Mechanical and **architectural drawings** *are detailed renderings of plans for the assembling of an object, building, or environment.* The lines used for these types of drawings are very controlled and precise. Special tools, such as compass, rulers, and templates are used for mechanical and architectural drawings. **Templates** *are manufactured geometric and amorphic shapes which the artist traces to achieve a precise image.* Often, mathematical measuring and calculation processes are necessary in mechanical drawings.

Representational Drawing. Representational or **realistic drawings** *look like the object or image the artist is viewing or imagining.* Perspective, shading, proportion, and modeling techniques are typically used in order to produce a realistic appearance.

Media Used for Drawing

There are many different materials that can be used while drawing. The type of medium that is selected depends on the subject being drawn, the purpose of

Gesture Drawing. Gesture drawings *are loose, quick renderings of a person, animal, or object that capture them in the act of moving.* Gesture drawings often have

TECHNOLOGY MILESTONES IN ART

Pens and Pencils

The pen is one of the oldest tools for making marks on a surface. The word pen comes from the Latin word *penne* which means quill. People discovered that a sharpened feather or quill could be dipped in ink and used as a writing tool. For example, a quill pen was used to sign the Declaration of Independence.

The steel pen was invented in 1820 and soon replaced the quill. Making a steel pen involved several processes. The steel rod was heated and rolled in iron and sawdust to give it a polished surface. The tip was then ground to make a smooth writing point. In 1884, Lewis Edson Waterman of the United States, invented the first fountain pen (ink contained inside of the pen case).

Pencils were first made from graphite around the early 1500s. They were made in Europe until the 16th century. The process of making a pencil was designed by Nicolas Jacques Conté in 1795. When English graphite was unavailable due to the French Revolution, Conté invented a mixture of clay and graphite from local materials. Graphite and clay were placed in a wooden casing. (Please note that conte crayons described in the drawing section of this chapter were named after the inventor of the manufactured pencil). In 1856, the first pencil factory was built in Yonkers, New York by a German pencil manufacturer. Like they do with pens, today's consumers have an assortment of pencil colors, shapes, and styles to choose from.

Student Activity 2

Five-Step Exercise

Goals

1. You will learn how to apply paint to a canvas with a brush.
2. You will improve your observational skills.
3. You will gain an awareness of the Impressionist artist's painting techniques.

Materials

1. Canvas, 12" × 18" or larger
2. Acrylic paint
3. Brushes
4. Palettes
5. Water pans
6. Slide projector and screen

Directions

1. Look at the work of Impressionist artists (located in Chapter Nine), and discuss how they applied paint to the surface of their paintings. Since the Impressionists were concerned with the way light reflected off an object, each brush stroke contained high intensity colors. By layering the paint and applying quick strokes to the canvas, they were able to capture the effect of light on objects in a landscape (see Chapter Five). You will have an opportunity to strengthen your observational skills while you learn how to apply paint to the canvas.
2. Set up your canvas and work space so that you are facing the image of a landscape, projected on a screen. Focus the slide so that it is a blurred image of the landscape. Only masses of light and dark should be visible at this stage of your work.
3. Underpaint your canvas with light yellow acrylic. Begin your painting by transferring what you see in the image to your canvas. At this stage, only large areas of color will be applied since the image is blurred. Keep in mind that you should paint only what you see on the screen.
4. When you have applied the first layer of paint to the surface, focus the slide one step and continue to paint only what is visible. Use quick brushstrokes to paint directly into your first layer of paint.
5. Repeat the process, focusing the slide for each step. As the image becomes clearer, your painting should become more detailed. Work new colors and textures into the existing colors and textures on the canvas. Your final step should include adding details and developing certain areas of your painting for emphasis.

Evaluation

1. Did you understand the Impressionist artists' theory of paint application and the use of light in their work?
2. Were you able to transfer what you viewed in the slide to your painting?
3. Did you analyze each step as you focused the landscape, and paint only what was visible?

the drawing, and the type of visual expression the work is to have.

Pencil. The word *pencil* is derived from the Latin word *pencillium,* which means "little tail" (representing a small tail of an animal). There are two basic categories of pencils: drawing pencils and mechanical pencils. Drawing pencils have softer graphite for shading and blending images. Mechanical pencils, the type used for mechanical or architectural drawings, contain hard graphite in order to produce a precise line that will not smudge.

Pencils are identified by numbers and letters. Although the 2B or school pencil is the most commonly used drawing pencil, it is wise to experiment with different grades of graphite. A 9H pencil has the hardest graphite. It will make a light mark. A 9B pencil will produce a dark, soft mark on the surface.

In addition to graphite pencils, there are colored pencils. Colored pencils consist of a wooden casing around a mixture of wax and pigment. *Pigment* is what gives the pencil its color. Pigments are obtained from a variety of ground substances, such as clay, minerals, and synthetic materials. Colored pencils, like graphite pencils, vary in degree of softness and can be used on a variety of paper and cloth surfaces.

Charcoal. Charcoal is one of the oldest known art media. Prehistoric cave dwellers are believed to have drawn images on the walls of their caves with charcoal made out of pieces of charred wood. Charcoal is now manufactured in several ways:

- Stick charcoal is produced by burning sticks and twigs during the manufacturing process, leaving only carbon. This is the softest charcoal and is fragile when used on surfaces.

- Pressed charcoal consists of charcoal particles that have been formed into sticks by pressure. Pressed charcoal is more durable than stick charcoal. Sometimes the side or edge of a piece of pressed charcoal is used by artists to cover a large area in a drawing.

- Charcoal pencils are made of pressed charcoal that has been encased in wood for easier handling during drawing.

Figure 4-4 Leonardo da Vinci did hundreds of drawings throughout his lifetime. His subjects included detailed studies of the human anatomy and his inventions.

Leonardo da Vinci, *Volto grottesco (Grotesque head).* Gabinetto Disegni e Stampe, Florence, Italy. Scala/Art Resource, NY.

A completed charcoal drawing is usually sprayed with a clear fixative. *Fixative* sets the charcoal and prevents the work from smudging.

Chalk. Chalk is made from ground pigment, oil, and clay. Chalk as a medium also dates to prehistoric times when materials from the earth, such as clay and soft rocks, were used for cave drawings. At the beginning of the Renaissance, in the 1400s, artists developed methods of forming these materials into sticks for easier handling while drawing. Chalk is easily blended. Like charcoal drawings, chalk drawings must be sprayed with a fixative once the drawing is finished. Chalks, when dipped in liquid starch before drawing eliminates the need for fixative and creates a fluid drawing media.

Wax Crayons. Although you may consider crayons to be a child's medium, many professional artists use crayons alone or mixed with other media. Crayons are composed of pigment and *paraffin,* which is a refined wax.

Crayons are manufactured in a variety of sizes and colors, from primary colors to fluorescents. Crayons can be used in combination with inks, watercolors, and tempera. (These media are described in the "Painting" section.) The wax resists these liquid materials in areas of a drawing resulting in a special visual effect. Crayons are also an excellent media for texture rubbings or melted on paper for special drawing effects.

Oil Crayons. Oil crayons are made of oil and pigment, instead of wax and pigment. Oil crayons are rich in color and are easily blended on a surface. Strokes of color may be applied on top of one another to create a rich texture in a drawing. However, oil crayons tend to smear and care must be given to the completed work until the color dries on the work surface.

Conté Crayons. Conté crayons are composed of a pigment, clay, and oil mixture. Conté crayons adhere to a paper surface because they contain less oil which makes them a versatile drawing tool. They are manufactured in pencil and short stick form. They come in shades of black, white, brown, and pastel colors. Only three grades—hard, medium, and soft—are available.

Markers. Markers or felt-tip pens were first introduced as an art medium in the early 1950s. They are now used in elementary- through college-level art classes and by professional artists. Markers are pigment and water contained in a plastic tube; the pigment flows from a felt point onto a paper surface.

Markers come in a variety of sizes and nibs. A **nib** *is the point of a marker or pen.* Some marker nibs are flexible and can be used like a paintbrush. Markers are also produced in dozens of colors, from primary to metallic, such as gold, silver, and copper.

Markers are excellent for line drawings and sketching because they are easily controlled and dry quickly. However, care must be given to keeping the markers capped as the nib dries quickly.

Student Work

Diane Dorfer, 17
Milton High School, Atlanta, GA

Ink. The inks used during the thirteenth to fifteenth centuries were made from natural materials. Some of these materials included tree roots, iron, ashes, and black soot. These materials were combined with water to produce a liquid drawing medium. The inks of today are made of refined pigment and water. They come in an assortment of colors, as well as in black and white. Inks can be applied to most surfaces with a brush, pen point (nib), or natural materials such as sticks and twigs. Drawing ink is permanent and will not wash off a surface.

The earliest pens were quills of birds' feathers carved to a sharp point at the end. During the eighteenth century in Europe, metal points for pens were developed. Today, steel pen points come in a variety of sizes for drawing and lettering. These nibs slide into the end of a pen holder and can be changed during the drawing process to produce different sizes and shapes of lines.

Drawing Surfaces. Artists draw on the traditional paper surface and non-traditional surfaces such as brick, glass, and cloth. However, the most commonly used drawing surface is paper. There are a variety of papers available which may be selected according to the media being used. For example, charcoal should be applied to paper that has a **tooth** or *slightly rough surface*. This type of paper is referred to as *cold press paper* due to the light amount of pressure used to manufacture it. A rough surface will retain a greater amount of charcoal.

Ink drawings need to be applied to a smooth or *hot press* paper so that the ink flows more easily across the surface. During the manufacturing process, heat and pressure are applied to the paper resulting in a smooth surface. However, there are few rules concerning the correct choice of drawing surfaces. Experimentation with media on a variety of materials can lead to exciting visual effects.

Methods of Shading or Modeling in Drawing. Artists use certain techniques when they want to create an illusion of volume, or depth in objects in a drawing (see the discussion of perspective, in Chapter Two, pages 107–118). The techniques typically involve shading the side, edge, or bottom of an object. The six basic shading techniques shown in Figure 4–5 include:

1. **Stippling:** *using the point of the drawing tool to make small dots in order to create an area of dark or light*

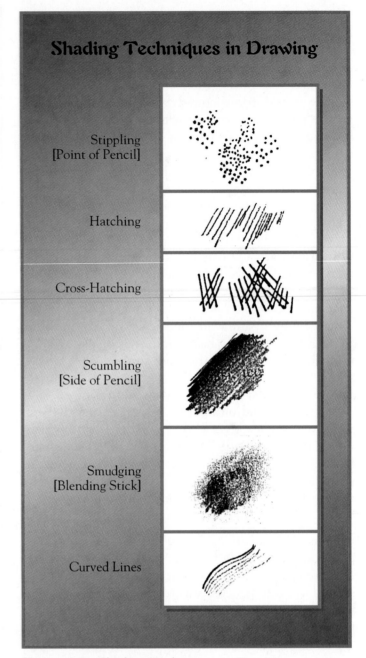

Shading Techniques in Drawing

Stippling
[Point of Pencil]

Hatching

Cross-Hatching

Scumbling
[Side of Pencil]

Smudging
[Blending Stick]

Curved Lines

Figure 4-5 Shading Techniques in Drawing

2. **Hatching:** *drawing a series of parallel lines that are placed close together for dark areas and farther apart for light shading*

3. **Cross-hatching:** *using two sets of hatching lines (parallel lines) that cross one another to create dark and light areas*

4. **Scumbling:** *using the side of the tool in a back-and-forth motion to create a solid area of shading*

5. **Smudging:** *using a finger or blending stick (compressed paper) to spread the medium on the surface*

6. **Curved lines:** *using a set of curved lines with equal spacing between them to create shading of a curved object.*

Keeping a Sketchbook for Your Process Portfolio. Have you ever maintained a written record of your daily activities? How about an account of the details of a special trip or school event? Perhaps you have kept a written diary about a special person in your life. When you later read what you have written, the words help you recall significant events.

Artists use a sketchbook in a similar way. A **sketchbook** *is a visual diary of your artistic thoughts.* The sketchbook can be a personal record of drawings of people, animals, buildings, objects, and fantasy images. These images may be used later to inspire new works of art.

Sketchbooks can also be used to record ideas and to keep brief notes about what colors you might use in an artwork or how you might improve your techniques. Remember, the purpose of a sketchbook is to experiment with subjects and drawing media rather than to complete a finished work of art!

Maintain a sketchbook throughout this class. There are many activities in each chapter. Use the sketchbook to plan your artwork or to practice a skill. Your teacher may assign sketching activities periodically in preparation for some of the activities in this book or for your process portfolio. Always put the date at the bottom of the page so you can evaluate your progress at the conclusion of the course. Keep your sketchbook with the rest of your process portfolio materials. If you decide to apply to a college or art school, your sketchbook can become part of your *admissions portfolio.* The procedure for putting together an admissions portfolio will be explained in Chapter Ten, "Preparing for a Career in the Visual Arts."

Student Work

Jessica Buttermore, 17
Overton High School; Memphis, TN

Painting

Painting is one of the most common forms of visual artistic expression. As far back as 32,000 B.C., humans were intrigued by the discovery of ways to apply paint to a surface.

There are many different types of paint and ways in which to use them. Oil, tempera, acrylic, and watercolor are the most commonly used paints. Paints can be applied to a variety of surfaces, such as canvas, wood, plaster, paper, glass, ceramics, and fabric. While some application techniques may require no tools at all, others need specific tools to obtain a desired effect. Paint can be applied with fingers, a palette knife (a flat tool that applies a thick layer of paint), sponges, natural objects such as twigs, and manufactured brushes. Paint can be carefully applied to the surface or dribbled, splashed, sprayed, and rolled. Although there are many different types of paint, all paint has three ingredients:

1. Pigment: a fine powder of color

2. Binder: a liquid or powdered material that binds or holds the pigments together

3. Solvent: a liquid that thins the binder (not used in powdered tempera).

Varying the type and amount of these three ingredients can make the paint more pliable, thin it, affect the drying time, or change the texture of the paint.

Let's examine the different types of paint available to artists today.

Tempera. The use of tempera (TEM-puh-ruh) paint by artists dates back to prehistoric times and was used exclusively throughout the Renaissance in paintings and **frescoes,** *tempera applied to the wet plaster surface of building walls.* The tempera used during this period was composed of pigment mixed with egg yolk or egg white and water.

You are probably familiar with today's manufactured tempera paint, composed of pigment, powdered binder, and water, because it is widely used in school art programs. However, like crayons, professional artists also use it in their work. Tempera dries quickly, and is easily cleaned with water. Tempera colors are characteristically *opaque.* Opaque means that light does not pass through the color. Typically, thick, soft brushes are used to apply tempera to paper, cardboard, or wood surfaces.

Watercolor. Watercolor was first used by early artists such as Leonardo da Vinci for sketching. Today, watercolor is a widely used versatile painting medium. Watercolor is composed of pigment blended with *gum arabic,* a sticky binder. The mixture is then thinned with water during use to make it fluid enough to be applied. Watercolors are slightly *transparent.* Transparent means that light passes through the color. Watercolor is produced in cake, or solid, form and in small tubes. Brushes used for watercolor painting are soft with long bristles that hold a large amount of pigment. This allows the artist to make wide, flowing strokes across the paper surface.

Issac Evans, 18
Tri-Cities High School; Eastpoint, GA

Oil Paint. The ancient Egyptians first used oil paint to color and varnish cloth. However, it would not be used as a painting medium until the 1400s. During this period a renewed interest in painting the human portrait demanded a slower drying medium.

Because oil paints are made of pigment mixed with linseed oil, they take longer to dry. This gives the artist more time to develop a painting and attend to details in the work. Linseed oil is also added in small amounts to the oil paint to slow the drying process as the artist works. Turpentine is used as the solvent for oil paints.

Typically, oil paint is applied to wood or canvas surfaces. **Canvas,** *a cotton or linen cloth stretched over a wood or cardboard frame* is the most commonly used surface. It is first primed, or prepared, with **gesso,** *a white, acrylic-base paint.* Brushes used for oil painting have short stiff bristles in order to hold the thick consistency of the paint.

Figure 4-6 Diego Rivera applied tempera to wet plaster to complete this mural at the National Palace in Mexico City.

Diego Rivera, *History of Mexico*, 1935. Fresco. Mural in the Presidential Palace, National Palace, Mexico City. Bryant/Art Resource, NY. Reproduction authorized by the National Institute of Arts and Literature of Mexico.

Acrylic Paint. Acrylic paints were developed as a painting medium during the 1940s and soon became a popular medium for contemporary artists. **Acrylic paint** *is pigment mixed with synthetic or plastic binders.* Unlike oils, acrylics are thinned with water or a clear acrylic binder. This clear acrylic binder is also used to keep the quick drying paint moist during the painting process. However, the artist must give special care to brushes and work surfaces as exposure to air will adhere the acrylic to them.

Figure 4-7 Although Degas created this work with pastel, it is considered to be a painting due to the way the medium was applied.

Edgar Degas, *The Star: Dancer on Point,* c. 1877–78. French. Gouache and pastel on paper. 22¼" × 29¾". The Norton Simon Foundation. F.1969.40.P.

Acrylics are available in a wide range of hues from primary colors to fluorescent and metallic colors. They can be applied to and will adhere to most surfaces including canvas, plastic, wood, and glass. As with oil paint, acrylics require brushes with short stiff bristles to contain the weight of the paint. Some artists thin acrylics with water to achieve the consistency of watercolors. In this case of acrylics used as watercolor paint traditional watercolor brushes can be used.

Because acrylics dry so quickly, the artist must give special care to the painting tools, brushes, and work surfaces. Acrylics will stick, or adhere, to most surfaces.

Gouache and Pastels. Gouache (gwash) and pastels are often used as painting media. **Gouache** *is opaque paint used with watercolor techniques.* It is made from pigment, ground chalk, gum arabic binder (a natural material that comes from the Acacia tree) and water.

Rachael Bailey, 18
Booker T. Washington High School; Tulsa, OK

yellows, and beiges. Pastels can be dipped into turpentine and linseed oil and used as paint. They are typically applied to paper surfaces that have a tooth but can also be used on canvas (see Figure 4-7 on the previous page).

Sculpture

Sculpture *is the making of works of art that possess height, width, and depth.* Artists must consider all angles and viewpoints of a sculpture throughout the work process.

David Hooper, 19
Overton High School; Memphis, TN

Gouache is used frequently by illustrators and fashion designers who require a non-transparent medium for their work. Gouache is manufactured in a variety of colors and is applied to paper surfaces with watercolor brushes.

Pastels *are sticks of ground pigment* held together with gum arabic binder. They are available in a wide range of colors from reds, blues, and greens to soft pinks,

Student Activity 3

Wash-Off Painting

Goals

1. You will increase your painting skills and brush control.
2. You will learn how to create a painting using more than one media in a multiple-step process.

Materials

1. Poster board, 12" × 18" or 18" × 24"
2. Pencils
3. Acrylic paints
4. Yellow chalk
5. Brushes
6. Black ink

Directions

1. Assemble a group of different plants in a still-life on a worktable.
2. Begin by sketching the plants on paper. Keep the shapes simple by concentrating on the contour lines. When you have completed the sketch, transfer your sketch to the poster board using lines only.
3. Trace over the pencil lines with yellow chalk. Be sure to create a thick application of chalk as you trace the lines.
4. Apply a thick layer (select a group of colors) of acrylic paint to all of the spaces in between the chalk lines. Craftsmanship is important in this step as so not to cover the chalk.
5. Allow to dry, then cover the entire painting with black ink with a watercolor brush. Allow ink to dry.
6. This next step is an important one and must be carefully done. Place the painting under water and gently rub the surface with a sponge. The ink will wash away from the acrylic areas because the polymer surface will not absorb the ink. However, the ink will cover the chalk lines.
7. Brush a coat of gloss polymer over the entire painting after it is thoroughly dry. Gloss polymer is a clear shiny acrylic.

Evaluation

1. Were you able to control the chalk areas and acrylic spaces on the paper surface?
2. Did this exercise inspire you to combine several media in one composition for special effects?

DEVELOPING SKILLS FOR

ART CRITICISM

Emanuel Leutze provides us with this humanistic portrait of Washington during his career as a military man and statesman.

1. Look closely and see if you can figure out what the artist is telling us about George Washington, the man.

2. How would you characterize the expression on Washington's face?

3. Does the size of this painting help create a particular impression of Washington?

4. Where would be a good place to display a painting like this one?

Figure 4-8 George Washington has been depicted heroically and humanistically in this work.

Emanuel Leutze, *Washington Crossing the Delaware*, 1855. Oil on canvas. 14′ × 20′. The Metropolitan Museum of Art, New York. Gift of John S. Kennedy, 1897.

Sculpture dates to pre-historic times when nomadic peoples made small sculpted figures from stone that could easily be transported. Sculpture has been used as decorative art and as a way to honor our world leaders and heroic deeds of our military forces.

Sculpture may be made out of a variety of media, such as clay, bronze, plaster, wire, cardboard, aluminum, glass, plastic, neon tubes, wood, and even mounds of earth and rock. There are four basic methods from which an artist may choose when making a sculpture. These methods are carving, casting, assembling, and modeling. Figure 4-9 is an example of bronze sculpture.

Figure 4-9 This bronze temple statue from Thailand is representative of sculpture used to honor the person depicted.

Wat Suthat, Bangkok, Thailand. Bronze. Photo ©Jean Kugler, 1991, FPG International.

Carving. **Carving** *is the removal of portions of sculpting material in order to create a form.* Because some of the material is removed, carving is referred to as a *subtractive* method of sculpting. Clay, plaster, stone, and wax may be carved, chipped, filed, or manipulated into a sculpture. Files, chisels, knives, mallets, and saws are examples of tools that an artist might use in carving a sculpture.

Many of the tools used today for carving are much the same as they were in the fifteenth and sixteenth centuries. For example, Michelangelo, one of the finest and most accomplished stonecutters of the Renaissance, used metal hammers, wooden mallets, and chisels to create some of the most breathtaking sculptures in the Vatican. He would start his sculptures by striking off the edges of a block of stone with a metal hammer and a flat-headed chisel called a pitcher. A pointed metal chisel would then be used to "rough out" the main forms. In the final stages, Michelangelo would use a wooden mallet, a claw chisel that lifts away layers of stone in powdered form, and a small, flat-headed chisel for smoothing and finishing his sculpture (see Figure 4-10).

The sculpture shown in Figure 4-10, the Bruges *Madonna*, illustrates Michelangelo's genius. Although he was working in a medium as rigid and difficult as stone, the artist managed to create the radiant faces of a loving mother and child. He made the stone seem soft and pliable. Michelangelo's sculptures might be cool to the touch, but they look as if they possess an almost human warmth.

Carving did not have its beginnings in the Renaissance, however. As far back as the Stone Age, people were expressing themselves by carving. Some of the earliest tools used for carving were made out of sharpened stone, bones, and wood. The carvings of prehistoric humans were simple ones. The ancient Egyptians, Greeks, and Romans were able to refine the art of carving through the development of metal tools. Even so, many of their early carvings lacked the refinements of the stonecutters of the Renaissance.

Relief sculpture was mentioned briefly in Chapter Two. This is a type of carving in which material is removed from only one side of the sculpture. The back of a relief sculpture is flat. Most relief sculpture is de-

Figure 4-10 Michelangelo's Bruges *Madonna* is crafted in hard stone, but looks humanly soft and warm.

Michelangelo, *Madonna col bambino (Madonna and Child)*. Church of Our Lady, Bruges, Belgium. Scala/Art Resource, NY.

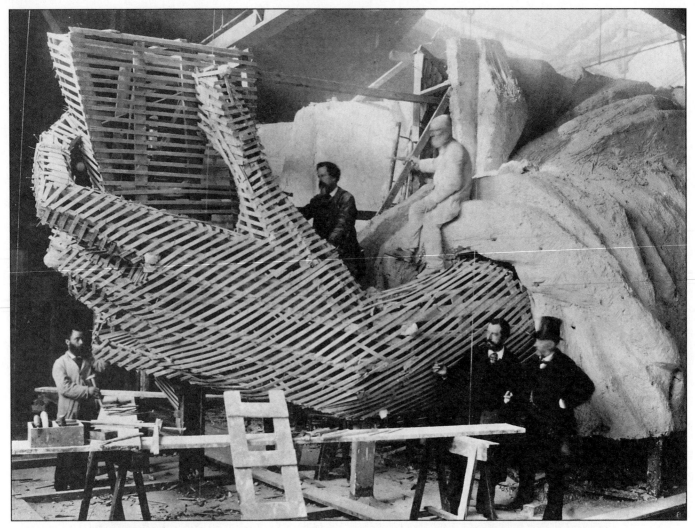

Figure 4-11 The armature needed to support the Statue of Liberty's left arm dwarfs the artisans working on it.

Construction of the Statue of Liberty, c. 1883. Photo ©1989, FPG International.

signed to be viewed from the front. It is most often seen on the surfaces of buildings, over doorways, or on the doors themselves.

Casting. Casting *involves the pouring of liquid materials, such as clay, bronze, or plaster, into a mold designed by the artist.* When the liquid metals cool, they harden into a solid form.

The creation of a mold begins with the artist creating a sculpture in a modeling material, such as plaster or clay, from which an impression can be taken. Im-

pressions may be made by pressing the sculpture in wet sand, plaster, or soft wax. The indentation left in the material by the sculpture forms the mold. A finished piece of large proportions, such as the Statue of Liberty, will require the sculpture to be cast in sections, using many molds (see Figure 4-11). When the casting is complete, the pieces will need to be assembled. Some molds are destroyed during the casting process, while others may be used over and over.

Of the casting materials mentioned, one of the most popular is bronze. Bronze is a composition of copper

and tin. Although there are other choices for the artist, such as gold or silver, bronze offers the sculptor a more affordable media. In addition, the surface of bronze is flexible. It may be polished, filed, or treated to bring out a variety of interesting surface textures and colors. Examine Figure 4-12 for this variety.

One of the most difficult forms of casting is called the "lost-wax" method. The principle of the method is easy to understand. A sculpture is first created in wax. It is then surrounded with a heat-resistant material like clay or plaster. The encased wax sculpture is then baked to dry the casing and melt out the wax. When the wax melts and runs out of the mold, it leaves an impression in the casing, and this now becomes the mold. Since the mold is made of heat-resistant material, it will be able to withstand the very high temperatures of molten metals.

When the metal has been poured and allowed to cool, it will harden into the shape of the impression inside the mold. The mold is then cracked open, and the cast metal sculpture is cleaned and polished.

Assemblage. Assemblage (a-SEM-blij or as-am-BLAGH) **sculpture** *is the bonding together of shapes or objects by gluing, soldering, pasting, or nailing.* Because materials are added together to make these sculptural forms, assemblage is considered to be an *additive* method of sculpting. This sculptural technique is relatively new to the history of art; it was made popular by artists in the twentieth century. Since an odd assortment of materials may be used to create these sculptures, artists may choose from unconventional materials, setting new boundaries and exploring new creative possibilities.

Figure 4-12 Giacometti's (JAH-kuh-MET-ee) *Annette IV* is an exemplary bronze sculpture.

Alberto Giacometti (Swiss, 1901–1966), *Annette IV*. Bronze. Tate Gallery, London, Great Britain/ Art Resource, NY.

One assemblage artist of note is Red Grooms. Grooms creates warehouse-size installations documenting some of the larger cities in the United States. Of special interest is his work entitled *Ruckus Manhattan Subway*, shown in Figure 4-13. This walk-through monument to New York City is loaded with cartoon-

THINKING ABOUT

AESTHETICS

George Horner uses Silly Putty to create his sculptures. He forms the putty into reproductions of famous works of art. One of his copies of a Constantin Brancusi sculpture sold for $1,250.00.

He also makes his own sculptures based on social issues. *Designer Babies* is Horner's version of a cigarette commercial complete with "cancerous" Silly Putty blobs. The artist's intent is to warn women of the dangers of smoking while pregnant. Horner's sculptures have been exhibited in galleries located in Chicago and New York.

1. What are your memories of Silly Putty? What was special about the material? Did you ever attempt to create a sculpture from the putty?

2. What makes Silly Putty different from other clay? What are its limitations?

3. Is Silly Putty the type of material you think artists should use as a medium? Why or why not?

4. Why do you think galleries would exhibit Horner's sculptures? What would the public find interesting about sculptures made entirely from Silly Putty?

5. Why would someone pay $1,250.00 for a copy of a famous sculpture created from Silly Putty? If Horner had used another medium such as clay or plaster would your opinion be any different?

6. Which sculpture might be more interesting to you—the Brancusi copy or Horner's anti-smoking commentary? Why?

Leigh Mason, 18
Milton High School; Atlanta, GA

like landscape elements and city dwellers. Each building, alley, and landmark in the piece provides a comment or joke about city life.

Modeling. **Modeling** *is the shaping of a sculpture by the artist into a desired form.* Methods of modeling can be said to be both additive and subtractive. Clay, wax, and plastic-based media are best suited for modeling.

Perhaps the most widely used modeling medium is clay. Clay is inexpensive and found in a natural state near riverbanks and bodies of water all over the world. Clay is extremely flexible, and can be fired to the hardness of stone. Modeling with clay allows the artist to leave a record of his or her personal touch. Since its surface is soft, it can capture the slightest impression of the artist's fingers. Clay also provides the artist with the opportunity to work and rework the shape and composition of the sculpture.

Some sculptures become too large or heavy for the medium and may require the use of an armature. An **armature** *is a supporting structure, usually made of wire or wood (or both), that eventually becomes covered with the modeling medium.* It may become a permanent part

Figure 4-13 Does this assemblage work give you a clear picture of what riding on a Manhattan subway can be like?

Red Grooms, *Ruckus Manhattan Subway* (detail), 1975–76. Mixed media, 9′ × 18′7″ × 37½′. ©1993 Red Grooms/ARS, New York. Courtesy Marlborough Gallery, Inc., New York.

of the sculpture, or be removed when the modeling material has hardened and is capable of supporting its own weight. See Figure 4-11 on page 174.

With contemporary modeling media such as fiberglass and soft plastics, modeled forms can take on new dimensions. Plastics in vivid colors inspire grand-scale abstract forms.

Wire Sculpture. **Wire sculpture** *is the process of bending and twisting wire into a desired shape.* Heavy gauge (thickness) wire is typically used for the base of the sculpture. The armature wires are joined by soldering, using a strong adhesive, or wrapping thinner wire around the joints. Wire of various gauges is then wrapped around the armature to form the sculpture such as a human figure, animal, or abstract design. The sculpture can then be attached to a base made from wood, foam board, or plaster.

Student Work

Eric Cyr, 18
Bristol Eastern High School; Bristol, CT

Student Activity 4

Assemblage Sculpture

Goals

1. You will work together in a group to assemble a sculpture.
2. You will decide upon one object that best represents your group for the sculpture.

Materials

1. One object from each member of the group
2. Large cardboard box
3. Glue
4. Acrylic or tempera paint
5. Brushes and water pans

Directions

1. Each object in Red Grooms' assemblage sculpture was carefully selected to comment on city life. Your sculpture will be a reflection of the personalities and interests of the group you work with.
2. The class should divide into groups of five or six. Each student should list on paper several objects that would represent his or her hobbies, interests, or personality. For example, a tennis shoe might represent the basketball player in the group. A pair of glasses (old) might be used to represent someone who wears glasses. A paperback book would stand for the person who enjoys reading. Each person in your group should bring in one object that they want to represent themselves for the assemblage sculpture.
3. As a group, decide how the cardboard box should be altered before starting the assemblage. Should the box be turned on one side: Perhaps your group would like to cut out a shape from the side of the box as a "viewing hole" into the sculpture.
4. Arrange all of the objects inside the box. Decide as a group where each object should go. Perhaps several objects could be located outside of the box as well. Additional shapes cut from poster board could be added to the assemblage for interest and to join objects together.
5. Paint the entire assemblage sculpture with one color of acrylic (optional: spray paint) paint. Be sure to cover all of the objects from each angle.

Evaluation

1. Did you work well as a group?
2. Did each person bring to the assemblage sculpture at least one item that represented his or her personality?
3. Did the group balance the objects inside the box and arrange them to create an aesthetically pleasing composition?

Student Activity 5

Sculptured Chairs

Goals

1. You will explore the possibilities of the chair as a sculptural form.
2. You will become familiar with artists who have used chairs as themes for their art.
3. You will be introduced to designers who have created functional chairs that are also considered to be works of art.
4. You will work with clay to make a three-dimensional form.

Materials

1. Clay
2. Glaze or acrylics
3. Clay tools
4. Assorted media, such as cloth, buttons, glitter, and so on

Directions

1. Look at the work of artists who have used chairs as subjects for their artwork, either in paintings or three-dimensional form (suggestions: David Hockney or Lucas Samarus). How have these artists changed or exaggerated the chair's properties in order to express their feelings about the chair as an art form? Would you like to own any of these chairs? Why? Are any of the chairs functional? Does that make a difference in your opinion about the chair?
2. Design your chair on paper, showing at least three viewpoints. You may want to create a "play-on-words" such as a "love seat" or a "reclining chair." Perhaps your chair may be fashioned after a piece of sports equipment or a musical instrument. Use clay to construct your chair using the proper techniques for working with clay. (Consider how much kiln space you have for firing when you decide on the dimensions of your sculpture.) Fire and glaze your chair. *Optional:* Add found objects to the chair to create special effects after the glazing process such as lace, buttons, or natural objects.

Evaluation

1. Were you able to make a connection between the chair as a functional object and the chair as an art object?
2. Were you able to manipulate the clay to fulfill your plans for your chair and follow the proper clay techniques?

Young Artists of Today

In the manner of the medieval and Renaissance cathedral builders, the art of stonecutting is still being preserved in the United States today. The Cathedral of Saint John the Divine, near New York City's Harlem district, is the oldest gothic cathedral in the United States. After 100 years, it is still under construction. The cathedral's stonecutting yard is unique in this day and age. In this yard, the stonecutter's art is being practiced in much the same way it was during the Renaissance.

The stonecutters training and working at Saint John's are members of the Manhattan Valley Youth Outreach Program. Members of the program are being counseled for a variety of problems, but at the same time they are finding great expressive opportunities through learning to carve stone.

Because these young stonecutters live in a different time than the sculptors of the Renaissance, the images that they cut into the stone are those of contemporary heroes, and other world figures. The stonecutters have gained such a reputation for excellence that they have been sought out to help restore the facades of some of New York's landmark buildings. In fact, the stonecutting yard at Saint John's has attracted interest from around the world. Stonecutters from Russia, France, and Colombia have come to Saint John's to share their ideas and learn more about the art of stonecutting.

Figure 4-14A Two cutters preparing to strike the first cut in a clean slab. (Stonecutters should always wear protective eye covering.)

Stonecutters at work. The Stoneyard Institute of The Cathedral Church of St. John the Divine, New York, NY. Photo ©Deborah Doerflein.

Figure 4-14B Detail work is completed with smaller tools. (Stonecutters should always wear protective eye covering.)

Woman stonecutter carving detail onto a column. The Stoneyard Institute of The Cathedral Church of St. John the Divine, New York, NY. Photo ©Robert Rodriguez.

Maria Martinez

Maria Martinez was a Pueblo Indian. She was born in San Ildefonso, New Mexico in 1892 and died in 1980. Maria remained in San Ildefonso throughout her lifetime, studying and practicing her ancestral ceremonies and crafts. Where most young adults move on to careers away from their childhood home, Maria chose to become actively involved in the Pueblo community.

Maria learned how to make Pueblo pottery at age nine by observing the technique from the elder family members. Throughout her teen years, she perfected the technique of making coil pottery passed down through the generations. Martinez and her husband Julian invented the "black-on-black" method of making pottery by "smothering" the pottery with manure during the firing process. They would fire their pottery outdoors in a pit dug into the earth using wood for fuel. The manure caused the pottery to turn black. Maria's dedication to her craft continued throughout her lifetime as she trained other young Pueblo teens to continue her legacy.

Figure 4-14C The vase was first polished, then painted to leave some areas a dull black.

Maria Martinez, *Long-Neck Pot*, 1961. Black on black, feather design. H: 11¾", W: 7⅞". Clay. Courtesy the Wheelwright Museum of the American Indian. Photo: Hawthorne Studio, Santa Fe. No. 40/234.

Imogen Cunningham

Imogen Cunningham spent seventy-five years photographing people. Cunningham, one of ten children, was born in Portland, Oregon, in 1883 and died at the age of ninety-three in 1976. When Imogen was in high school, her family moved to Seattle, Washington. It was in Seattle that Cunningham became interested in photography. Her father purchased a camera for her and built a darkroom in the family home. (A darkroom is where the process of developing photographs takes place. Chemicals and developing solutions used for the development of prints from the film negative are also stored in a dark room. Since natural or artificial light can ruin the developing process, windows are typically not found in a darkroom.)

Imogen spent numerous hours in her darkroom as a teen, perfecting her process of photographing and processing film of her school friends and family. She completed a photography correspondence course before graduating from high school. Cunningham went on to graduate from college, then studied in Germany on a photography scholarship.

Figure 4-14D This image depicts the love and care Imogen Cunningham lavished on her photographs.

Imogen Cunningham. *John Roeder*, 1961. Photograph. Courtesy the Imogen Cunningham Trust. ©1993, Imogen Cunningham.

181

Printmaking

Printmaking *is the process of creating one or more images from a single prepared surface.* Some common printmaking techniques are in the paragraphs that follow.

Monoprinting. A **monoprint** (*mono* means "one") *is a process in which only one image can be lifted from a flat printing plate such as a sheet of plastic or linoleum.* The image may be drawn or painted on a surface. A paper is then placed over the image, rubbed with fingers or the back of a spoon, and then pulled away to reveal the print.

Linoleum- and Wood-Block Printing. A linoleum- or wood-block print is created by carving a design into a sheet of linoleum or a piece of wood. Water- or oil-based printing ink is then rolled over the surface. The tool used to apply the ink is called a *brayer.* A piece of paper is placed on the block, rubbed with fingers or a flat tool, and then pulled away. It picks up ink from the raised areas of the block, and this makes the print.

Since the surface of the printing plate is hard, a single plate may be inked again and used many times. The image may be altered by removing parts of the printing surface during the process or by applying another color. A variety of papers including foils and tissue papers can be used for the printed surface.

Student Work

Ryan Grigsby, 18
Booker T. Washington High School; Tulsa, OK

TECHNOLOGY MILESTONES IN ART

The Printing Press

Johannes Gutenberg was a German printer who invented movable type in 1440. Movable type allows for the printing of different pages of a book by reusing the same pieces of type. Gutenberg also invented a printing press which used the movable type. It is believed that he used an old wooden press formerly used to make cheese. Gutenberg was the first printmaker to introduce colored ink for printmaking.

Printing plants soon spread across Europe and America. Benjamin Franklin was America's first renowned printer who wrote and published newspapers, books, and magazines. Today's printing presses are designed after an all-metal press invented in 1880 by the Earl of Stanhope. This press was not only more durable, but also required less pressure in order to make a print. This technology has allowed for the mass reproduction of books and art prints.

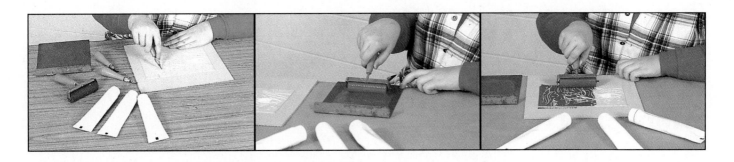

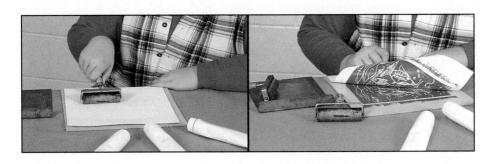

Figure 4-15 Linoleum Block Printing

EXPLORING

HISTORY AND CULTURES

The process of printmaking was invented by the Chinese some 2,000 years ago. It was the Japanese, however, who turned printmaking into a profitable means of distributing art at a low cost. Their prints were so affordable that when trade routes between Japan and Europe were established during the early 1800s, paper prints were used as packing material around articles being shipped. This shipping practice first brought Japanese art and culture to the United States.

Select Mexico, India, China, or Africa and research how the art media and methods of the culture were brought to the United States.

Student Work

Kevin Shive, 17
Overland High School; Aurora, CO

Student Activity 6

Monoprints

Goals

1. You will be introduced to the printmaking process through a monoprinting technique.
2. You will learn how to work with paint on a printing surface to create a design.
3. You will learn the technique of "pulling" a print from an inked plate.

Materials

1. Newsprint or drawing paper, 12" × 18"
2. Plexiglas or table surfaces
3. Water-based printing ink
4. Brayers
5. Wooden sticks or wooden clay tools

Directions

1. Plan a design or image for your print on paper. As you plan, draw thick lines and simple shapes.
2. Apply printing ink to a flat surface, such as a sheet of Plexiglas or tabletop with a brayer. Check to see if the application of paint is even on the surface.
3. Transfer your drawing into the ink by using the tools or your fingers. Be sure to push through the ink to the surface. You will need to wipe the ink off of your tools periodically as you work.
4. Place a sheet of drawing paper or newsprint over the ink, and rub the paper with your fingers or the back of a spoon. You need to apply pressure to all areas of your paper for an even transfer of ink.
5. Peel your paper from the work surface to reveal the design.
6. Clean your plexiglas or table surfaces immediately after you make your print. Repeat the entire process if you wish to make a second print.

Evaluation

1. Were you able to transfer your planned image to your ink plate with the tools?
2. Can you think of any other examples of how *one* print is made in art or nature? (A footprint in the sand or a thumbprint in clay?)

Student Work

Alex Schultz, 17
Overland High School; Aurora, CO

Collagraph. A **collagraph** *is a print made with cardboard and textured materials.* Shapes are cut from cardboard or thick poster board and glued to another sheet of cardboard. Objects such as pieces of screen, netting, toothpicks, strings, and buttons can also be glued to the cardboard. Ink is rolled across the surface with a brayer. Paper is placed on top of the ink, rubbed with the hand or rolled with a clean brayer, and pulled away to reveal the print. Several collagraph printing plates may be assembled to make one print of many colors and textures.

Found-Object Printing. **Found-object prints** *are made by using one or many miscellaneous items to make a mark or pattern on a surface with ink or paint.* Some examples of the items used for the process are forks, vegetables, whole fish, small blocks of wood, small toys, bottle caps, and empty spools of thread. The objects are pressed into a thin layer of paint or printing ink that has been placed on a tray. Then they are stamped onto a paper surface into the desired image or design. The paint may also be applied to the object with a paintbrush. A variety of textures and patterns can be built up on the paper surface for special effects.

Silkscreen Printing. A silkscreen print is produced by applying a design to a screen. A **screen** *is a fine-mesh fabric stretched across a wooden frame.* The design may be applied by painting directly on the screen with *blocking fluid,* or by using a stencil made of lacquered film that can be attached to the screen.

Paper is then placed under the screen and the ink is then forced through the areas of screen left uncovered using a squeegee. A *squeegee* is a rubber blade with a handle attached. Once the squeegee has been "pulled" across the screen, the screen is lifted, and the image appears on the paper. This process may be repeated numerous times. Sometimes several screens may be used to make multiple parts of one print and different colors.

Etching. **Etching** *is the process of engraving or incising a design into a metal plate with a pointed tool called a stylus.* A metal plate made of copper or zinc is covered with a heavy acid-resistant waxy coating. The artist uses the stylus to scratch fine lines through the wax coating, exposing the metal plate. When the artist has finished the image, the back of the metal plate is painted with a protective varnish and then immersed in an acid bath. The acid eats away at the metal on the face of the plate where the wax has been scratched off. The wax coating is then removed, and the plate is ready for inking.

Ink is rolled on the etched plate with a brayer. A soft cloth is used to wipe the surface of the plate clean, forcing ink down into the etched lines. The plate is then placed in a press. Damp paper is carefully laid on top of the plate and pressure from the press is applied, forcing the ink left in the lines onto the paper.

Printed effects similar to etching a metal plate can be achieved by pressing lines into a Styrofoam plate with a ballpoint pen. However, the Styrofoam is not rigid like a metal plate and will not last indefinitely. Therefore, the number of prints you may be able to pull from the Styrofoam plate will be considerably fewer than the number you would be able to pull from a metal plate.

Photography

Photography *is the making of fine art, commercial, and educational pictures by capturing the light of an object with a camera.* Photographs are made when objects reflect

Student Activity 7

Photomontage

Goals

1. You will be introduced to the technique of photomontage.
2. You will learn how to utilize and manipulate photographic images to create one unified composition.

Materials

1. Black-and-white and color prints
2. Glue
3. Paper
4. Marker
5. Pencils
6. Found objects

Directions

1. Collect a variety of photographs (black and white or color photographs) from home that can be used in your composition. If you have access to a camera, take a series of photographs of objects that are similar in subject to be used for a possible theme.
2. Cut or tear some of the photographs for collage pieces.
3. Arrange the photos and glue on a piece of paper to create a thematic collage. Suggestions for themes include celebration, school, anger, peace, age, time, birth, death, conflict.
4. Think about subject, color, and texture when combining the photographs. Add pencil, paint, or paper to emphasize an object or area of the work. Permanent markers, acrylics, or oil crayons can be applied to the glossy surface of the photograph to highlight an area. You may want to remove color from a photograph in certain areas with a cotton swab and bleach. Use extreme caution if you use bleach.

Evaluation

1. Did you understand the concept of photomontage?
2. Did your choice of photographic images support your theme?
3. Did you experiment with other media in combination with the photographs?

Robin Wyant, 17
Overland High School; Aurora, CO

tion too rapid for the human eye to perceive, and inside the human body. They document family life, breathtaking scenery, and people. Sometimes photographs can help the police solve a crime or locate missing persons. Photographs have been used in advertising to reach vast numbers of consumers. The creative use of photographs has sold many products because of the impact the images have on viewers.

The first photograph is believed to have been made in 1826. Since then, pioneers in photography have succeeded in bringing their artistic talents to the public. Gaspard Felix Tournachon—or Nadar, as he preferred to be called—was one of the first to focus on the feelings and expressions of his subjects. His claim to fame, however, was the first aerial photograph, taken during a balloon ride over Paris. Julia M. Cameron, Ansel Adams, Man Ray, Alfred Stieglitz, Imogen Cunningham, and Dorothea Lange stirred the public interest in the photograph as art.

Today, photographers may seek exciting careers in advertising, photojournalism, scientific photography, and the motion picture industry.

Ceramics

Ceramics *is the process of creating containers, dishware, or decorative and functional objects from clay.* Clay is one of the oldest and most universal media throughout history. People such as the ancient Greeks used clay to make vases to hold water, grain, and oils for daily use. In other cultures, such as some in South America, clay was used to create death masks for burial rituals. Clay, as it was centuries ago, is found along river banks. Today, clay is processed and refined with machinery rather than by hand to remove foreign materials such as small stones and twigs.

There are several different types of clay. **Porcelain** *is a white fine clay used in the production of high-quality dishes or decorative objects.* The most commonly used clay in art classrooms is stoneware or earthenware clay. Stoneware is easiest to handle and comes in both brown and gray. Earthenware has a lot of minerals in the clay mixture and is typically red. It is used both for pottery and sculpture.

Clay is porous; this means that it can absorb water. Because it is porous and fragile, clay objects must be

light onto material (such as film) coated with light-sensitive materials. The material is then treated chemically and processed into a photograph. The photographed image is considered to be the finished work of art. Sometimes the image is manipulated or altered creatively by artists in a variety of ways. These techniques include drawing or painting on the photograph, chemically altering the image, or processing two images as one.

Photographs are important to us for a number of reasons. We may learn about people, places, or times we cannot visit. We may view historical events as they happened. Photographs help us see what our own eyes cannot: images from outer space, microorganisms, ac-

fired (baked) at extremely high temperatures in a *special oven called a* **kiln.** The first firing of a clay piece is called a bisque firing. A **glaze,** *or liquid glass,* is then painted onto the bisque-fired clay. The object is then returned to the kiln for a glaze firing. Glazes are not only used for decorative purposes but they also seal the clay so that the object can hold water.

There are two basic methods for working with clay: by hand or by potter's wheel.

Hand-Built Ceramics. Creating a piece of ceramic art by hand can involve several different techniques:

Pinch: Using fingers and thumbs, the artist forms the desired shape from a lump of clay. This is the simplest and oldest method of creating ceramic art.

Coil: The artist pinches a small amount of clay and rolls it into a long coil between the palms of the hands. The coil is wrapped around a slab of clay cut to the desired shape. Using a clay tool or his or her fingers, the artist "scores" or bonds the coil to the slab. This process is repeated as coil is placed on top of coil until the desired height is obtained. All the individual coils must be scored to each other.

Slab: To create a slab pot, the artist uses a clay rolling pin and "fettle" knife, which is a flexible knife used in ceramic work. A ball of clay is rolled into a flat slab, keeping an equal thickness across the slab. Using the fettle knife, a desired shape for the base of your pot is cut and removed from the excess clay. The process is repeated for the sides of the slab pot. Each piece is scored and attached with "slip," which is clay mixed with a small amount of water.

Wheel-Thrown Ceramics. The artist uses a potter's wheel to create pottery in large quantities or to produce a container with even, smooth sides. There are two types of potter's wheels: electric and kick wheel. The kick wheel is turned by sliding a metal bar back and forth with a foot.

To use a potter's wheel, the artist places a lump of clay in the middle of the wheel. Using his or her thumbs, the artist creates a small indentation in the

Figure 4-16 This student is "throwing" a pot on a pottery wheel.

Photo ©Keith Rittenhouse

middle of the clay and "pulls" or brings up the sides of the pot as the wheel is turning. When the pot has been formed, the artist removes it from the wheel with a piece of wire and uses a fettle knife to remove any excess clay. Figure 4-16 shows a student at the wheel.

Fiber and Fabrics

The art of making woven fabrics has appeared in every civilization for thousands of years. People have devised techniques to make clothing, shelter, and containers from natural and synthetic (manufactured) materials. Skills for quilting, hand dyeing, applique, and

Student Activity 8

Special Containers

Goals

1. You will learn how to assemble a box from clay with the slab method of hand-built pottery.
2. You will develop skills in adhering clay pieces to one another using slip and scoring techniques.
3. You will learn the proper use and handling of clay tools.
4. You will experiment with creating thematic images from clay in three-dimensional form.

Materials

1. Clay: terra cotta (red), or gray
2. Clay rolling pins, fettle knives, and clay tools
3. Small water pans for slip
4. Plastic bags
5. Plaster slab (bat) or flat work surface
6. A variety of books and magazines with photographs
7. Assorted glazes
8. Glaze brushes
9. Cardboard

Student Activity 8 continued on next page

Directions

1. Select a theme for your slab container. Some suggestions for your theme are sports, animals, flowers, the galaxy, faces, and hands. Look at reproductions of artist's works where they have made art from a theme. You may want to turn to Part Two in the book and study some of the illustrations found in the three thematic chapters. Your clay container will reflect your theme in the images that you sculpt into the clay and attach to the sides and top.

2. Draw your plans on paper for all four sides and top of your container. Will the slabs be square or rectangular? Will they all be even? What images will you select to represent your theme? How will they be applied to the sides of the container? Which images will be incised or cut into the clay and which will be in relief? Will you have any three-dimensional images attached to the top of your container?

3. Cut a template from poster board or cardboard for the sides, top, and bottom of your container. Begin your box by preparing approximately five pounds of clay. You may need to prepare more clay depending upon the size of your box and your theme. Wedge or strike the clay against a hard, flat surface to remove any air pockets (air pockets will cause the clay to explode during the firing process). Roll a large handful of clay out to approximately a ½" thick slab. Lay one of the templates on the slab. Using a fettle knife (a clay knife) cut around the template. Repeat the procedure until the sides, top, and bottom of the box are cut from the clay slabs. Cover the unused clay with a plastic bag while you work to prevent the clay from drying.

4. Place the top of the container on the work surface. You will construct the container upside-down so that the top will dry slightly, or become leather-hard. This will make placing clay objects on the top easier and prevent sagging of the clay once the container is right-side up. Add each slab to the container using plenty of slip and scoring (or making small cuts with a fettle knife) on the two pieces to be joined for greater adhesion.

5. Turn the container over. Roll another lump of clay into a slab and cut out the images that you have selected for your theme. For example, if you selected an animal theme, you can place animals cut from another slab onto the sides of the box, and a sculpted animal on the top. Cover the container with images of your theme. Letters can be cut from clay and worked into your design. Reminder: carefully adhere each piece with slip.

6. Use a fettle knife to cut around the top of the container to make a lid. Carefully lift the lid off the container and roll a thin coil from clay which you will attach to the underside. This will prevent the lid from slipping. You may need assistance with this step if your lid is elaborately decorated with images.

7. When dry, fire the container in the kiln, then glaze.

Evaluation

1. Were you able to select and create a variety of images that represented your theme? Now that you have completed your container, what, if any, images would you like to change if you repeated the project? Explain your answer.

2. Analyze your slab techniques. Are there any areas of your container where you could have improved the quality of the construction? Make notes for your process portfolio as to what skills you need to improve upon for your next ceramic project.

stitchery have been developed in different cultures for both utilitarian and decorative purposes. Some of the decorative uses for fibers and fabric include clothing, jewelry, wall hangings, and sculptures.

Fibers can be stitched, knotted, wrapped, twisted, frayed, woven, and glued to surfaces. Fabrics can be created by sewing fibers together, silkscreening designs, and making patterns with wax and dyes.

Weaving *is the process of making fabric by passing threads over and under each other in a given pattern.* Thread for weaving can be spun from a variety of materials. Some threads are made from natural materials such as cotton, flax, silk, and wool. Other fibers such as nylon or orlon are manufactured from synthetic materials. Weaving does not have to simply consist of making cloth to produce garments. Many fiber artists create sculptures and decorative or functional objects such as baskets or furniture.

Historians believe that prehistoric people first wove baskets and containers from grasses and reeds. The Egyptians, as early as 5000 B.C., are thought to have mastered the weaving of fabric or cloth, as evidenced in some of their ancient wall paintings. Textile weaving is thought to have reached parts of the Middle East, Pakistan, and Central Europe by 2500 B.C. The Chinese learned to weave the threads of the silkworm around 2000 B.C. The late 1700s and early 1800s saw the rise of weaving with machines during the Industrial Revolution in Europe. Today, high-speed looms in factories use shuttles called "darts" that hold the threads that travel back and forth through the mechanical looms faster than the eye can follow.

Woven cloth consists of two types of threads. **Warp threads** *are vertical threads* and **weft threads** *are horizontal threads.* Warp threads are placed first on a **loom,** *the frame that holds the threads during the weaving process.*

Figure 4-17 Perhaps the most famous weavers in the United States are the Navaho Indians. They have handed down centuries of weaving techniques and patterns from one generation to the next. Their weavings are some of the most prized examples of the art; they are owned and displayed by museums, collectors and family members.

Navaho rug weavers in Monument Valley, Arizona. Photo ©Jack Zehrt, FPG International, NY.

There are several different types of weaving looms:

- Free form loom: This type of loom is made from an object such as a tree branch or a wire frame. The loom usually remains as part of the finished work of art. Warp threads are stretched across the object and weft threads are woven by hand in an over and under pattern (see Figure 4-17 on the preceding page).

- Table top or floor loom: This loom is manufactured with wood and comes in a variety of sizes. Table top looms are operated entirely by hand. Floor looms are larger and have treadles that are operated with the feet. The treadles separate the warp threads during the weaving process creating different patterns as the weft threads pass over the warp.

 Both types of looms have a shuttle which holds the weft threads during the weaving process. A beater, a long bar with slots through which the warp is strung, is pushed back and forth by the artist pressing the weft threads together.

- Power looms: This type of loom is found in a textile factory and is used to produce large quantities of woven cloth. They are usually powered by electricity and can automatically refill the shuttles with thread.

Wrapping. **Wrapping** *is the binding of cords or fibers together by wrapping them with other fibers.* Wrapped cords can then be assembled into baskets or sculptures by wrapping or stitching them to one another with additional fibers.

Batik. **Batik** *is the making of decorative fabric using wax and dyes.* Hot wax is used as a resist to the dyes. The wax is applied to the fabric with brushes as an image or decorative pattern. The fabric is then submerged in dye. The wax resists the dye and then it is removed by sandwiching it between paper and ironing with a hot iron. Variations on batik include brushing the dye directly on the fabric or applying melted crayons to the surface. Although brushes are the most common tool for applying wax, tjanting needles are also used. A **tjanting (CHAN-ting) needle** *is a hollow handled tool with a spout through which the wax flows as it is applied to the fabric.*

Tie-Dye. **Tie-dye** *is a resist technique of folding or twisting fabric then placing it in dye.* Waxed string or rubber bands are used to secure the fabric during the process. The tied areas resist the dye from penetrating the fabric. More than one color of dye may be used beginning with the lightest and moving to the darkest colors.

Jewelry

Throughout history and in every culture, people have adorned their bodies with jewelry for religious or decorative purposes. In societies where people lived nomadic lives (continually moving from one place to another) people had to wear all of their possessions such as belts, medallions, bracelets, and earrings on their body at one time. The ownership of jewelry often

This stunning piece of jewelry was created by an art instructor at The Ohio State University.

©Jim Loomis

Student Activity 9

Coil Weaving

Goals

1. You will create a coil basket using a wrapping and figure eight method.
2. You will explore the expressive qualities of color and texture by adding them to your basket.

Materials

1. Core materials: Core materials are the foundational materials that you wrap the yarn around and should be at least ¼" or more in thickness. Core materials should be pliable, sucyh as cotton cord, jute, raffia, or twisted craft paper. The thicker the core material, the larger the coils on your basket.
2. An assortment of yarns in different colors and textures.
3. A large-eye blunt needle (metal or plastic). You must be able to thread the yarn through the eye of the needle.
4. Scissors.

Directions

1. Start by cutting a piece of your core material six feet long. The ends should be cut diagonally.
2. You will need to cut long pieces of yarn for wrapping (about six or eight feet long). Plan to use yarns that are varied in color and texture to add interest to your basket. You may develop patterns with the textured and colored yarns by planning certain intervals at which you will add them. You may also add interest to your basket by decorating the outside with yarns after the basket has been finished.
3. At one end, wrap two inches of the core material tightly with yarn.

Student Activity 9 continued on next page

4. Fold the core material over and attach it by wrapping the end tightly against the rest of the cord. This will form the center of the basket base.

5. Moving further down the core material, wrap another inch with yarn. With the yarn threaded through the needle, join the inch you just wrapped to the coil that lies just below it by passing the yarn in a figure eight manner, over the top coil, down between the coils, under the bottom coil, back between the two coils, and back up over the top. Do this only once.

6. You are now ready to wrap another inch, and then repeat the figure eight process.

7. Continue these steps until your basket is the size and shape you want. Note about shaping the basket: A coil basket can be shaped very easily by positioning the coils carefully. If you stack the coils slightly to the outside of each other, your basket will open outward. If you stack the coils slightly to the inside of each other, your basket will curve inward. By changing the direction of the coils, you can manipulate the shape of the basket very easily.

Evaluation

1. Were you able to create a coil basket with a pleasing shape? Where did you get the idea for the shape that you chose?

2. Were you experimental with the colors and textures that you applied to your basket? How did you select which colors and textures you would use? What do you think is particularly nice about the way you have used them?

indicated wealth and status in the community. Precious stones and gems have been coveted by heads of states, European royalty and merchants for thousands of years.

Jewlery can be made from a variety of materials and through a diversity of methods. Advanced classes in jewelry include casting techniques, wax carving (for making models of jewelry), metalsmithing, and working with gold, silver, and platinum. Jewelry can also be made from plaster, glass, fibers, clay, wire, plastic, paper, and found objects. Materials such as pin and earring backings, glues, plastics, feathers, beads and sequins can be purchased in local craft supply stores. These materials are usually easier to work with and more affordable for high school art programs. Let's look at several types of jewelry making that you can explore.

Wire Jewelry. Wire is a versatile medium for jewelry design. It is available in a variety of colors such as copper, brass, or silver. Manipulating and shaping wire can be accomplished in several ways. First, it may be wrapped around a dowel rod, craft stick, or nails. The wire can then be easily removed by sliding it off the object. Secondly, pliers of various sizes can be used to bend the wire into angular or gently curving shapes. Delicate, lacy designs can be created with fine gauge

Student Work

Katherine Trapp, 16
Overland High School; Aurora, CO

wire by twisting, braiding, weaving, or tying it. Plastic, glass, or ceramic beads can be integrated into the jewelry by sliding them onto the wires. Wire can also be gently hammered into flat shapes and textures.

Enameling. *Enameling is a process where metal is covered with finely ground glass in a pattern.* The glass is fused onto the metal by heating it in an enamel kiln. Copper is typically used in high school art rooms because it is affordable. The following steps are usually followed to make enamel jewelry:

1. *Forming Copper:* The copper is cut into a shape with metal scissors or a jewelry saw.

2. *Finishing:* The rough edges of the copper are smoothed with jewelry files.

3. *Cleaning:* The copper must be thoroughly cleaned with steel wool then dipped into commercial solution or nitric acid.

4. *Applying Gum:* Gum arabic (refer to the drawing and painting section) is applied to the copper with a brush. This will act as a "glue" assisting the enamel in adhering to the copper.

5. *Applying Enamel:* The enamel colors are in powdered form. They are gently sifted onto the surface in an even layer. Threads, small beads, stenciling, painting, or metal foils can be added for decoration to the enamel during firing. **Cloisonne** *is enamel jewelry created by the use of wire to separate the enamel into intricate patterns before firing.*

6. *Firing:* The gum arabic and enamel should dry before firing. Once the firing process has begun, the enamel will turn black, a slightly bumpy texture will appear, then a bright red color will appear during the final stage.

7. *Finishing:* The enamel is finished by filing any rough edges with steel wool or jewelry files. Wash the piece in water, dry, and glue a pin or earring backing on the back of the enamel.

Ceramic Jewelry. Jewelry can be made from clay and combined with other materials such as fibers or plastics. Shapes can be cut from slabs of clay to form earrings or necklaces. These shapes can be decorated

TECHNOLOGY MILESTONES IN ART

Computer Graphics

The term "computer graphics" is used to refer to works of art created with the aid of a computer. The term itself was coined by a researcher named William A. Fetter, who in 1960 used it to describe his computer-assisted drawings of an airline cockpit.

Many of the earliest computer graphics were created by researchers whose knowledge of computer programming far exceeded that of average computer users. In the 1960s and '70s, a lot of pioneering work in computer graphics was geared toward military, scientific, and technological applications. By the early 1980s the world of computer graphics had greatly expanded, and was being used more and more in business, and also in the entertainment industry to achieve spectacular special effects. The development and availability of "user friendly" computers and interactive paint software packages had enabled artists to create with a freedom approaching that of working with traditional media. With the spread of personal computers into schools and homes, computer graphics is becoming an increasingly accessible medium that can be used by young, aspiring artists such as yourself!

by incising the clay or adding textures and details to them. A hole must be pierced through the top of the clay in order for yarn, cloth, or wire to be placed through it. Beads can also be made from clay by rolling small pieces of clay with the palms of the hands and piercing a hole through the bead. The beads can also be incised with decorations or patterns before firing on a special wire rack that fits into the ceramic kiln.

Computers and Art

Throughout history, artists have experimented with and relied on technological advances. Prehistoric cave painters must have experimented with different combinations of natural materials to create paints that would adhere to cold rock walls. Sculptors have explored various ways of casting molten bronze in order to achieve the size, detail, and durability they desired in their monuments. Nineteenth-century artists were the first to benefit from the manufacture of premixed paints made available in portable lightweight tubes.

The twentieth century has been marked by rapid and dramatic technological changes that have had a profound impact on art and society. Artists today are able to purchase materials that artists even fifty years ago might only have dreamed of. Today's sculptors are as likely to work in stainless steel, plastics, neon, and lasers as they are to work in stone, wood, clay, and bronze. Electronics have allowed artists to add movement and sound to their artworks. Some artists who were trained to use watercolors and oils have put down their paintbrushes and picked up a "mouse"! A **mouse** *is a hand-held device that artists may use to help them create images on a computer screen. It is used to select commands or options visible on the screen.*

More and more artists and designers are turning to computers as their medium of choice (see Figure

Student Work

Michael Collins, 15
Sherwood Middle School; Columbus, OH

Figure 4-18 In this bug's eye view of an imaginary glade of lilies, the artist has explored the computer's capabilities in capturing the organic forms of nature.

Marsha McDevitt, *Sundays*, 1985. Computer-generated image. ©Marsha McDevitt, The Ohio State University.

4-18). Although computers come in various shapes and sizes, the most familiar unit is a personal computer, which consists of a monitor (a screen for viewing words, data, and images), a keyboard for typing messages and commands to the computer, and a disk drive for disks, which are used to store and retrieve information and instructions. A mouse is sometimes wired to the unit, allowing a computer operator to perform some tasks without using a keyboard. Another device similar in size and function to a mouse is the joystick. A printer is used to copy the images on the screen onto paper. *The monitor, keyboard, disk drive, mouse or joystick, and printer are all equipment referred to as computer* **hardware.**

Another piece of equipment often used in making images with a computer is a *digitizer*. A digitizer allows a computer to be connected to a video camera. The picture transmitted from the camera can be stored on a disk and called up as a still image on the computer screen. Once on the screen, the shapes, colors, and textures of the image can be altered, or other images can be added to the foreground and background.

Student Activity 10

Computer "Custom Brush" Landscapes

Goals

1. You will compare and contrast computer-assisted and traditionally painted landscapes.
2. You will practice using the brush selector tool in a software program, to create an abstract landscape.

Materials

1. Deluxe paint IV software manufactured by Electronic Arts
2. A hardware system that is compatible with the software (Apple Macintosh, Commodore Amiga, IBM)

Directions

1. Look at the two painted landscapes pictured in Figure 4-19 (below) and Figure 4-19A (on the next page). *Wivenhoe Park, Essex*, by English artist John Constable (1776–1837), was painted using the traditional medium, oil on canvas. Constable was interested in capturing a *realistic* picture of the outdoors. This calm scene shows the rolling, grassy hills and wooded knolls of the English countryside. Shadows from passing clouds dapple the meadow in the foreground. The computer image was created by student artist Jason Clifton (see Figure 4-19A on the next page) and is a more *abstract* landscape. Remembering what you

Figure 4-19 Constable's landscape uses traditional techniques.

John Constable, *Wivenhoe Park, Essex*, 1816. British. Oil on canvas. .561 × 1.012 m. (22⅛″ × 39⅞″). National Gallery of Art, Washington, D.C. Widener Collection. 1942.9.10.(606)/PA.

have learned about abstraction, tell why you think the computer landscape is more abstract than Constable's. What moods have been conveyed by these paintings, and how have the artists achieved these moods? Look for things the two pictures have in common. How have both used overlapping to achieve a sense of visual depth?

2. If appropriate computer hardware and software are available, have your teacher demonstrate the "brush selector" tool. This tool lets you capture a portion of your computer screen and manipulate it as you would a paintbrush. Work along with your teacher, if possible, or follow instructions. First, using the "spare page," or practice area, on your computer screen, lay down various colors that you would find in a landscape that you remember. You might want to use the "airbrush tool" to do this. Next, use the "brush selector" tool to cut out a portion of the colored area you have made. Cut out an abstract shape that reflects the forms you remember seeing in a landscape—use an organic shape for trees and bushes, or a geometric shape for rugged mountains or buildings in the landscape.

3. Switch from the "spare page" to the "drawing page," where you will create your finished artwork. Using the custom brush you created on the spare page, begin painting the landscape you remember, or invent one using your imagination. Don't try to make your landscape realistic. In this activity you are experimenting with abstraction! Make sure you save your drawing page if you leave your computer for any length of time.

4. You will need to make more than one custom brush to create your landscape. Each element in the landscape may need a different color, texture, or shape. Before you make a new brush, make sure you save your old one on disk, in case you want to use it again later. As you make your landscape, use overlapping shapes to show visual depth.

5. If you have access to a camera, take a photo of your completed landscape.

6. Write a brief critical analysis of your experience with this activity. What are the strongest parts of your landscape? How is working with a "custom brush" different than working with a traditional paintbrush? How is it similar? Which do you like working with more?

Evaluation

1. Did you make an abstract landscape using custom brushes (instead of using built-in brushes)?
2. Did you use overlapping to achieve a sense of depth?
3. Did you seriously reflect on the activity in the written portion?

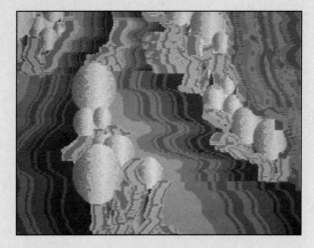

Figure 4-19A Student artist Jason Clifton created this more abstract landscape using a computer program.

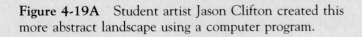

Photo ©Steven Schneider

Student Work

Robin Wyant, 17
Overland High School; Aurora, CO

Which functions a particular computer can perform depends on many factors. Some computers have more *memory* capability than others, so they can store and retrieve more information. Some computers are able to perform only one function at a time, while more sophisticated computers can handle many functions at once. Some screens have a *higher resolution* than others, meaning that images on the screen can be much more detailed and precise. Some computers are able to produce only simple geometric black-and-white diagrams, while others can produce overlapping forms in thousands of possible color combinations. A computer's capabilities depend in part on the power and sophistication of the computer hardware, but also in part on the computer software. Computer **software,** which is usually stored on disks, *contains information (or programs) and instructions that help computer operators meet their needs.* Although some computer experts create their own programs, most people use software that is commercially available. New and improved software is always entering the marketplace.

Sophisticated computer hardware and software provide artists with valuable tools for experimenting with form and color. An artist who used to spend hours or days with conventional media exploring the effects of light and shadow, various color schemes, different points of view, textures, proportions, and compositions can now manipulate and view the same elements in minutes by giving a computer a few commands through a keyboard. Computer artists seldom, however, give up traditional media entirely. Often, they will sketch their ideas on paper before beginning a project on the computer. (Figures 4-20A–C show how an image can be manipulated.)

Computer art is a term that can be applied to any visual expression created with a computer. Some people prefer to use the term *computer graphics* when referring to functional or scientific applications of computer imaging. Architects and interior designers now utilize computers to help them design the spaces in which we live and work. Product designers, industrial designers, and engineers utilize computers to help

them design everything from space shuttles to automobiles to shoes, toys, and beverage containers. People in business and finance use computer graphics in the form of charts, graphs, and diagrams. The publishing industry uses computers to design page layouts and to retouch magazine photographs. Researchers in sports and medicine use computer graphics to help them visualize and study the human body in motion. Archaeologists have even used computers to help them reconstruct the dwellings, palaces, and temples of ancient civilizations.

Some computer artists specialize in computer animation, or the creation of images that, when viewed in rapid succession, present the illusion of movement.

The television and film industries are increasingly dependent on computer artists/animators to produce cartoons, commercials, opening segments for news broadcasts and sporting events, and special effects. Because animation can be very complex and time consuming, it is common for the work to be divided among members of a team of computer artists.

As artistic tools go, computers are still relatively expensive, but their rising popularity, and competition among computer manufacturers, are making them more affordable, accessible, and easy to use.

When artists first began to experiment with computers, some people thought that no art—or, at least, no good art—could come of it. Computers, after all,

Figure 4-20A A "true" image of the person is first scanned into the computer.

Photos 4-20A, B, & C, Courtesy Steven Schneider.

Figure 4-20B The image is transformed by the computer into a line drawing.

Figure 4-20C The image can then be manipulated into an almost limitless arrangement of colors and patterns to create an abstract composition.

are machines, these people pointed out, and true art must spring from the hands, hearts, and minds of human beings. Although there are still individuals who are unwilling to accept computer imaging as art, many others have embraced this new technology as an exciting artistic frontier.

Computer art, while unique in many ways, has many of the same characteristics as other art forms. Computer images are the result of the imagination and creativity of the computer artist. The artist must have special knowledge and skills in order to work with the medium. Computer art, like any art, can be beautiful or ugly, novel or trite, symbolic or straightforward, profound or trivial. It can be boldly abstract, or it can echo the soft lines and colors of nature. In the final analysis, each artist must choose his or her own means of expression. But in the years ahead, we can all expect to see more and more artistic applications for computers.

Section II Review

Answer the following questions on a sheet of paper.

Learn the Vocabulary

Vocabulary terms for this section are *media, method, drawing, contour drawing, gesture drawing, mechanical or architectural drawing, representational or realistic drawing, templates, nib, tooth, stippling, hatching, cross-hatching, scumbling, curved lines, sketchbook, canvas, gouache, sculpture, carving, casting, assemblage sculpture, modeling, armature, printmaking, monoprint, screen, etching, photography, ceramics, porcelain, kiln, glaze, loom, weaving, warp threads, weft threads, mouse, hardware, acrylic paint, gesso, frescoes, pastels, batik, cloisonne, enameling, found-object prints, collagraph, tjanting needle, tie-dye, wire sculpture,* and *wrapping.*

1. Write a one-page short story about an artist at work, using at least ten of the vocabulary terms.

Check Your Knowledge

2. What are the differences among contour, gesture, mechanical, and representational drawing?
3. Name five surfaces to which paint can be applied.
4. What kind of paint would you use if you wanted to achieve a transparent effect?
5. Give an example of a subtractive method of sculpting and of an additive method of sculpting.

Section II Review, continued

6. Name three reasons photographs are important.
7. Who were the earliest people in history to master the art of weaving?
8. How do computers aid artists in experimenting with form and color?

For Further Thought

9. Do you think that the numerous stylistic techniques computers make available to artists will eventually make other art media obsolete? Why or why not?

Section III

Safety in the Art Room

Creating a work of art can be a personally rewarding experience. Experimenting with both new and familiar media can produce visually exciting works of art that can become part of your portfolio. However, some art supplies can pose a serious health threat if used improperly. You need to be aware of the properties that make up the media that you use in order to minimize the risk of health problems or accidents.

There are several ways in which the human body is susceptible to potentially harmful materials. First, inhaling clay or plaster dust, spray paint, and adhesives over a period of time can cause respiratory problems. Chalks, pastels, and charcoals can also irritate your lungs if the art room does not have proper ventilation. Brush cleaners are also toxic if the vapors are inhaled.

Skin contact with certain materials can be harmful to the artist. Spray paint, clay glazes, turpentine, and glue can be absorbed through the skin into the bloodstream. If you are allergic to these materials, skin rashes may develop. Printmaking inks and cloth or paper dyes should be handled with rubber gloves. It is a good idea

to protect your eyes with safety glasses and your nose with a safety mask when working with sculpture materials such as plaster or plastics.

Although we tend to think of elementary school children as the likely candidates to swallow paint or glue, ingesting these supplies can happen in high school, too. Chewing on paintbrushes or colored pencils can be toxic. Be sure not to rub your eyes or place your fingers in your mouth while working in the art room. Protect any cuts or blisters you may have with clean bandages. Art students must respect all equipment and tools. Listen to the instructions of your teacher as to the proper handling of tools, such as knives, paper cutters, drills, potter's wheels, and linoleum cutters. Proper use of the equipment should minimize any risk to you. However, always remain alert and aware of the movements you make while working on an assignment.

Labels on Supplies

The Art and Craft Materials Institute, Inc. (ACMI) is a group of art supply manufacturers who have established standards for labeling art supplies. The group was originally formed in 1940 with the purpose of creating a safe environment for artists and students in their work places. The ACMI works with a toxicologist (a person who analyzes products for toxic or harmful contents) in providing one of three labels for supplies currently on the market. These labels are CP (Certified Product), AP (Approved Product) and Health Label (Non-Toxic). The difference between CP and AP Certifications is that CP products have met additional requirements by the ACMI such as color quality, and consistency of the material while being used. It is wise to use only products that carry one of the three labels.

Section III Review

Answer the following questions on a sheet of paper.

Check Your Knowledge

1. List the four ways in which the body is susceptible to potentially harmful materials that are used to make art.
2. Give examples of ways you can minimize the risk of injury while working on an art project.
3. What do CP and AP stand for on art-supply labels?

For Further Thought

4. If you were an art teacher, what would you do to ensure a safe environment in the art room?

SUMMARY

• *Creating works of art is important to different people for different reasons. People make art as a way to spend leisure time or to earn a living. Art is made by some people to provide visual enjoyment for others.*

• *There are many different forms of art. They include drawing, painting, sculpture, and ceramics. There are also a variety of media that can be used while creating art such as clay, paper, pencil, acrylic paint, or computers. There are specific techniques that are used when working with the media.*

These techniques have been designed to allow the artist to experiment, yet be successful in reaching artistic goals.

• *While making works of art, students and professional artists must use safety precautions when in the art studio. Being aware of the labeling on products indicating toxic free materials is one way of providing a safe environment. The proper use of tools should be understood before beginning an art project. In addition, it is wise to protect your body against harmful vapors, paints, or dust.*

CHAPTER ④ REVIEW

VOCABULARY TERMS

Think of two different artworks (a painting and a decorative bowl, for example). Using a total of eight vocabulary words, write a paragraph about how each would be made.

acrylic paint	gesture drawing	realistic drawing
architectural drawing	glaze	representational drawing
armature	gouache	screen
artists	hardware	sculpture
assemblage sculpture	hatching	scumbling
batik	kiln	sketchbook
canvas	loom	smudging
carving	mechanical drawing	software
casting	media	stippling
ceramics	method	style
cloisonne	modeling	template
collagraph	monoprint	tie-dye
contour drawing	mouse	tjanting needle
cross-hatching	naturalistic style	tooth
drawing	nib	warp threads
enameling	pastels	weaving
found-object prints	photography	weft threads
frescoes	porcelain	wire sculpture
etching	printmaking	wrapping
gesso		

Applying What You've Learned

1. What were some of the stylistic differences between Anna Hyatt Huntington and Elijah Pierce?

2. What were some of the events in the lives of Anna Hyatt Huntington and Elijah Pierce that led them to be artists?

3. What is the difference between a contour drawing and a mechanical drawing?

4. List four types of shading techniques.

5. Name three tools used to apply paint to a surface.

6. What is the relationship between a pigment and a binder?

7. Explain how the sculpting process may be additive or subtractive.

8. Name two types of media that can be modeled.

9. List at least three materials threads for weaving can be made from.

10. List three techniques a photographer may use to creatively alter a photograph.

11. List the seven steps involved in making a piece of enameled jewelry.

12. Unlike art created on a canvas, computer art is made to move. What are some of the valuable applications of movable computer images?

Exploration

13. Select one of the art forms described in the chapter. Research how the art form was important in the art of ancient Japan, Africa, and Greece.

14. Trace the development of the camera from its beginning to contemporary photographic equipment.

15. Make your own egg tempera from egg whites mixed with a small amount of powdered tempera. Mix and pour plaster into a shallow aluminum pan. Allow the plaster to dry, then paint a picture on the plaster as did the early artists.

Building Your Process Portfolio

Throughout this chapter you have been introduced to a variety of media and methods for making art. If you completed all of the student activities, then you are well on your way to building the studio portion of your portfolio. You may have also decided that you enjoy working in one particular medium. Keep examples of your progress experimenting with media in one section of your portfolio. In addition, the following items can be placed in your process portfolio:

- One example from each student activity, or a selection of your work from the activities

- Lists of definitions found at the end of each chapter section for reference

- A drawing sketchbook which was suggested in the chapter

- Additional information your teacher may give you concerning methods for making art, including any notes you have taken during demonstrations of techniques (It is a good idea to keep your notes in a folder so that they are quickly accessible.)

PART TWO

Themes of Art

CHAPTERS

Ralph Albert Blakelock, *Moonlight Indian Encampment*, 1885–1889. National Museum of American Art/Art Resource, NY.

Nature and Art

Figure 5-1 The rich colors and organic shapes of nature have been captured in this contemporary glass sculpture.

Dale Chihuly, *Cobalt Blue and Chrome Green Macchia Set* (8 pieces) 1986. Blown glass using optic mold (except for largest piece), applied color decoration; lip wrap. The Toledo Museum of Art, Ohio. Partial gift of the artist and partial purchase with funds from anonymous donors and from the Libbey Endowment, Gift of Edward Drummond Libbey. ©1986 Dale Chihuly. 1991.12 a-h.

Contents

Section I Nature in Art Around the World

The first section opens with a look at nature as a theme in art dating back to the Stone Age. Then you will have the opportunity to look at and learn more about art from many different corners of the world. A special subsection is devoted to the rich legacy of art from the Far East.

Section II Reawakening to Nature Through Art

The second section shows how artists point out through their work the wondrous beauty and details of nature. Through art, we'll explore the American wilderness and experience the terror of raging storms. We will also take a close look at the work of one of the world's most beloved artists, Claude Monet.

Section III Nature and the Built Environment

This section takes you into the tranquil, yet complex world of gardens and landscape design. It may change the way you think about your neighborhood park! We'll also visit one of the world's most famous houses, called Fallingwater, and learn how it got its name.

Section IV Unconventional Interpretations of Nature

Section Four describes a number of unique and unusual artistic perspectives on nature. You may be challenged to rethink your ideas about art when you learn about earthworks.

Terms to look for

album quilt
anthropomorphism
aquatint
baren
botanical illustration
bustle
caricature

earthworks
effigy
gold leaf
Impressionism
motif
Mogul
Paleolithic

pointillism
stone pictures
stylized
topiary
tumulus
ukiyo-e

Objectives

- You will discover that artists throughout history and around the world have interpreted nature in many ways.

- You will learn more about how cultural ideas and values are reflected in art.

- You will expand your thinking about art by studying unconventional art forms, media, and methods.

Art in Your Life

It is impossible to overestimate the importance of the relationship of humankind to the natural world. Our very existence depends on our access to air, water, and soil. We constantly interact with the earth's plant and animal kingdoms. Yet sometimes, especially in urban areas, we forget about the importance of these relationships, or we take them for granted. We think of food as something that comes from supermarkets rather than from the earth. We think that water comes from faucets rather than from rivers and streams. In cities, the natural world has often been covered by concrete or controlled and contained in parks and backyards.

Sometimes, though, nature reminds us of its presence with storms, floods, earthquakes, volcanoes, and other natural calamities. But nature also shows us its benign and beautiful side, when the flowers bloom in springtime, or when the sun sets, crimson and gold, on the horizon.

We live in an age when environmental concerns are making headlines. Air and water pollution, toxic waste dumps, urban sprawl, and overflowing garbage landfills threaten our quality of life. Some scientists say that our actions to control these problems today could save the planet for tomorrow.

Art is one important way in which people throughout history have expressed their ideas and feelings about nature. Art can help us rediscover the wonder and beauty of nature. It can remind us of the awesome power of natural forces. By looking at, thinking about, and making art, you can heighten your awareness of nature and what it means to be alive on the planet Earth.

Section I

Nature in Art Around the World

The relationship of art to nature is as old as art itself. Stone Age artists depicted animals such as bison and reindeer in their paintings. These images were painted during the **Paleolithic** period. *This was a period 10,000 to 30,000 years ago, when people fashioned tools from stone, and lived by hunting, fishing, and gathering berries, nuts, and roots to eat.*

Paleolithic paintings were created in the dark, remote recesses of caves. Stone Age artists had to grope their way into the caves through narrow, twisting passages. They carried flickering torches that dimly lit their path. While we cannot be certain, it is unlikely that they painted these pictures just for decoration. Instead, these paintings were probably part of sacred or magic rituals associated with the hunt. Most of the animals pictured provided food and warm furs for the people of those times. Some of the animals have what appear to be spears painted in or near them. All of them have been carefully and skillfully drawn.

Altamira (al-tah-MIH-rah), in Spain, is the name of one of the first painted caves discovered (Figure 5-2), and it remains artistically one of the finest. A young girl discovered the drawings in 1879 while accompanying her father as he explored the cave. Pointing up, she cried, "*Papa, toros pintados!*" (painted bulls). So sophisticated were these images that it was years before the scientific community accepted them as authentic rather than a modern hoax.

The ancient artists carefully studied the anatomy and the habits of animals. To appreciate the skill of these artists fully, consider how closely they had to observe their subjects. They had no pencils, sketch

Figure 5-2 These remarkable paintings were hidden, unseen, for 10,000 years.

Prehistoric cave painting: detail of a bison. Altamira, Spain. Scala/Art Resource, NY.

pads, or cameras to carry into the countryside. It took a disciplined eye and a keen memory to record so accurately the animals' forms and colors on the cave walls.

In certain examples, we see the beginnings of perspective drawing. The nearer legs of some animals overlap and partially hide the farther legs. In addition, in some paintings, the nearer legs are rendered in more

TECHNOLOGY MILESTONES IN ART

The Earliest Paintings

Stone Age artists were ingenious in developing painting techniques. These prehistoric artists used sharp stones to cut the outlines of their subjects, usually animals, into the cave walls. They next applied animal fat to the etched outlines to form an adhesive surface. Powdered charcoal, used to color large dark areas, was blown onto the adhesive through a hollowed-out bone. Berries, red clay, and other natural materials were ground and mixed into colored pastes that were also rubbed onto cave walls where color was desired.

detail, and in more vivid color.

Altamira and some other locations are now closed to the public. Entrance is by special permission only. Unfortunately, some visitors marred the walls with graffiti. Even well-behaved crowds caused damage without meaning to. Human breath and body heat altered the temperatures and levels of humidity in the caves. Bacteria from the outside were introduced from the soles of people's shoes. Mold and deterioration resulted and threatened to destroy the art. Art and science experts have attempted to save the cave paintings and stabilize the delicate cave environment.

THINKING ABOUT

AESTHETICS

Some caves containing prehistoric art have been closed to the general public. Although vandalism has accounted for some damage to these caves, most of the damage has been accidental. Visitors unwittingly introduced harmful mold spores tracked in on the bottoms of their shoes. Crowds of people raised temperatures of the cave with their body heat. Such occurrences created unstable conditions and the cave paintings began to deteriorate. Now access to many caves is by special permission.

Some of the cave paintings from Altamira have been recreated by contemporary artists in an artificially constructed cave on the grounds of the National Anthropology Museum in Madrid, Spain, where the public is welcome to visit.

1. If you had the authority to close the caves or keep them open, and you knew the cave art was deteriorating, what would your decision have been?

2. If you were told that a few visitors each year would not endanger the cave art, how would you go about deciding who should be allowed to enter from among the many requests to gain entry?

A Sampler of Nature in Art

Decorative and symbolic images drawn from nature have been used by artists throughout the world since ancient times. The following describes some examples.

Undersea Life. Undersea life is shown on ancient pottery vessels discovered on the Mediterranean island of Crete. The vessel in Figure 5-3 was created by a potter of the Minoan culture in about 1900–1700 B.C. The Minoans were a seafaring people who often referred to undersea life in their art.

An Egyptian Garden. Lotus blossoms and papyrus plants are depicted alongside the Pharoahs in ancient Egyptian tomb paintings. Figure 5-4 shows a fragment of a wall painting from ancient Egypt. It reveals that the Egyptians were designing landscapes as early as 1400 B.C. The artist has pictured a carefully planned garden, with neat rows of fruit trees and a pond stocked with fish, waterfowl, and lotus blossoms. Each part of the garden is shown to advantage: the trees are painted in profile, while the pond is viewed from above. The artist had no qualms in this picture about turning trees on their side or raising fish out of the water in order to give people looking at the painting the best view.

Figure 5-3 The Minoans who made this vessel depended on the Mediterranean Sea for their livelihood.

Large vase with octopus design, 1900–1700 B.C. Minoan. Archaeological Museum, Herakleion, Crete, Greece. ©Erich Lessing/Art Resource, NY.

Figure 5-4 This mural, discovered in an Egyptian tomb near Thebes, shows an ancient garden.

Pond (Garden of a private estate with ornamental water). Wall painting from the tomb of Nebamum, Thebes, c. 1400. B.C. The British Museum, London, Great Britain. Bridgeman/Art Resource, NY.

Figure 5-5 How many plants and animals can you identify in this 2,000-year-old mural?

Landscape of the Nile. Artist unknown, from Pompeii. c. 50 A.D. Mosaic. National Museum of Naples, Italy.

Ancient Wildlife. A hippopotamus, cobra, crocodile, and other animals and birds are shown along the banks of the Nile River in an ancient Roman mural (Figure 5-5). This mural is a mosaic constructed of many small pieces of colored tile. The Nile River is in Egypt. At the time this mosaic was made, Egypt was part of the Roman Empire. The artist who designed this mural must have visited Egypt and studied its

Figure 5-6 Animal forms frequently appear in patterns of native North and South American art.

Double-spout vessel depicting lizards in the desert. c. 180 B.C.–500 A.D. South America, South Coast, Peruvian, Nazca Culture. Ceramic. 16.5 × 17 cm. The Art Institute of Chicago. Buckingham Fund. 1955.2096. Photo ©1993, The Art Institute of Chicago. All Rights Reserved.

plants and animals. This mosaic landscape was discovered at Pompeii, the city in southern Italy devastated by the volcanic eruption of Mount Vesuvius in 79 A.D.

Lizards of Clay.　Lizards of clay and reed adorn the pottery and baskets of native cultures of the United States and South America (see Figure 5-6). Animals were frequently used to identify a particular clan; to symbolize particular attributes, like wisdom or bravery; or to signify the unity of the earth and its creatures.

An Unusual Tree House.　Figure 5-7 shows us an interesting storytelling image that reveals something of the relationship of a culture to the natural environment. The **Mogul** (MOH-gull) *dynasty was a culture that flourished in Northern India from the mid 1500s through the early 1700s.* Originally Persian invaders to India, the Islamic Moguls adopted many of the ways of Indian culture, but they also developed their own distinctive styles of art. The Mogul dynasty was marked by war and political intrigue, but it was also a period in which architecture, poetry, garden design, and many other art forms flourished. Mogul palaces were designed with many garden courtyards, pools, and

Student Work

Gray Morgan, 18
Overton High School; Memphis, TN

bubbling fountains. During India's long, hot summers, these architectural elements provided a welcoming oasis. Artists painted garden scenes populated with people enjoying the cool shade of trees. Gardens were also common motifs in handwoven carpets and other textiles. A **motif** *is a visual theme or repeated pattern in a design* (see Figure 5-8).

Figure 5-8 This fabric design features a luxuriant floral motif.

Bedspread from India, c. 1690–1720. Painted and resist-dyed cotton and linen. Courtesy, Winterthur Museum, Delaware. 57.1290.

Figure 5-7 Note how the tree appears to grow beyond the edge of the pictorial space.

Anvari Entertains in the Summer House, from a Divan of Anvari. Attributed to Basawan. Indian, Mogul, 16th century. Opaque watercolor and gold on paper. Approx. 13.8 × 7.5 cm. Courtesy of the Arthur M. Sackler Museum, Harvard University Art Museums. Gift of John Goelet (formerly Collection of Louis Carter). 1960.117.2.

Student Work

Effie Mansell, 17
George Washington High School; Denver, CO

TECHNOLOGY MILESTONES IN ART

Papermaking

In our world, paper is plentiful. We can go to art supply stores and select from dozens of different papers for drawing and watercolor. But once, paper was a rare and treasured commodity.

Ancient Egyptian, Greek, and Roman scribes wrote on a paperlike surface made of the dried, pressed fibers of papyrus plants. Paper similar to the kind we use today was invented in China in 105 A.D. by a man named Ts'ai Lun. He was searching for a use for scraps of woven cloth made from natural materials. He pounded the rags until they were shredded into tiny fibers, and mixed the fibers with water. The mixture was poured through a flat, fine screen so that the water would drain away and the fibers would dry matted together, forming a thin, flat surface. This basic method

of making paper has continued to this day, only today sophisticated mechanical manufacturing processes usually take the place of laborious hand-made papermaking.

Over time, the art of papermaking spread to the rest of the world. Paper was made by hand for centuries, and skilled papermakers were much sought after by artists. Some people experimented with different materials and processes in efforts to make paper tougher and more durable, and to produce it more economically. One of the strangest experiments, conducted in the nineteenth century, used the cloth wrappings from ancient Egyptian mummies in place of rags to make wrapping paper! Today, hand-made paper is considered an art form in itself, and many artists experiment with different materials to create variously colored and textured papers.

Figure 5-7 provides us with a glimpse of sixteenth-century Mogul life during the reign of Emperor Akbar (1556–1605). It depicts two gentlemen reading and dining in a tree house. A cook, kneeling at left, is roasting meat. The fan blows away the smoke and keeps the coals hot. The setting is a lush flowering garden complete with a duck pond. Tree houses in Mogul India were not for children's play: from an elevated position on a platform in a tree, aristocrats could escape the heat at ground level and enjoy the benefits of shade and breezes, while literally maintaining their social stature "above" their subjects.

Mogul painting is characterized by carefully outlined forms that are all in focus. Objects in the distance appear as sharp as objects in the foreground. Often there are central characters surrounded by minor characters. Each one is engaged in a separate activity, but together they tell a story. Faces and gestures are expressive, and patterns are colorful and detailed. Portraits are meant to be accurate visual representations.

Many Persian and Mogul paintings, such as *Anvari Entertains in the Summer House,* are miniatures, ranging in dimension from a few inches down to the size

of a postage stamp. Miniatures were most often the creation of several people: one might cut, prime, and smooth the surface of the paper (smoothing was accomplished by rubbing the surface with an egg-shaped, polished agate stone), and one or more persons would draw and paint the image, according to their specialized skills. Fine brushes of kitten or squirrel hairs would be dipped in clam shells filled with paint. Pigments were made of natural materials such as clays, finely ground lapis lazuli (LAP-is LAZ-oo-lee)—which is a semi-precious stone colored a rich blue with golden flecks—gold, and crushed beetles. The final surface of the painting would be polished and sometimes further decorated with precious stones. Neatness and attention to detail were the order of the day. One miniature could take weeks to produce.

As members of the royal court, artists were rewarded for outstanding service, receiving wealth, property, or perhaps a prized elephant.

Nature's Bounty in a Quilt. The items shown in Figures 5-9 and 5-10 on the next page further illustrate how nature has functioned as a theme in virtually

every form of visual art. The fruits, vegetables, and cornucopias pictured on the quilt in Figure 5-9 are symbolic of the bounties of the earth, and of planting and harvesting seasons. Quilts like this one were highly valued in eighteenth- and nineteenth-century America, just as they are today. Quilts provided warmth to family members, and made the home a more visually pleasing place. Quilts also reflected the love of caring family and friends. The quilt in Figure 5-9 is an **album quilt,** *which is a fabric bedcovering of individually designed and stitched squares assembled into an overall pattern.* The patterned "quilt top" would be layered over a plain piece of fabric of identical size, and the two layers would be "quilted" or stitched together with a warm layer of wool, cotton, or goose down (soft feathers) between them. An album quilt is the result of a group effort.

Figure 5-10 Can you see the "cobwebs" on this lamp?

Tiffany Studios (New York, 1900–1938), *Cobweb Lamp,* c. 1904. Unsigned. American. Leaded glass, glass mosaic tiles, bronze. H.: 29½" × Dia.: 20" (74.9 × 50.8 cm.). Virginia Museum of Fine Arts, Gift of Sydney and Frances Lewis. Photo by Katherine Wetzel. 85.164 a/b.

Figure 5-9 This quilt reflects the love of family and friends as well as the bounty of nature. The building on the right is the nation's capitol.

Sarah Anne Whittington Lankford, et al., *Baltimore Album Quilt.* Abby Aldrich Rockefeller Folk Art Center, Williamsburg, Virginia. 79.609.14; T89–276.

Several persons, usually friends and family of the person who is to receive the quilt, each contribute one or more "blocks" or squares to make up the finished product, and several people worked on the quilting.

The Cobweb Lamp. Figure 5-10 shows a decorative and imaginative lamp designed by the Tiffany Studios of New York. This company is famous for its stained glass. The *Cobweb Lamp* in Figure 5-10 is an elegant and functional interpretation of natural forms. A complex pattern of flowers, stems, leaves, and spiderwebs has been skillfully incorporated into the design.

Student Activity 1

Album Quilt Design

Goals

1. You will have the opportunity to work together with friends and classmates to make a work of art.
2. You will develop your designing and art-making skills as you work with the medium of cut paper.
3. You will learn more about quilt designs and quilts as an art form.
4. If you choose the optional extension, you will learn quilting skills as they have been practiced for 200 years in America.

Materials

1. Lots of paper scraps—colored paper, wallpaper samples, white paper, painted paper, and so on
2. Glue, scissors, pencil
3. Heavyweight paper or lightweight poster board, cut into 12" squares, all the same color
4. *Optional:* fabric scraps, batting, thread, quilt frame, and other materials needed to make a real quilt

Directions

1. Visit a library and see if you can find books about quilts. Study the pictures and discuss the patterns. Pay special attention to patterns that include motifs from nature, like leaves, flowers, or fruit.
2. Each student in class gets one twelve-inch square of heavyweight paper or lightweight poster board. Measure and mark with pencil a border that is one and a half inches wide all the way around.
3. Sketch a design inspired by nature in the space within the border. It could be a floral pattern, seashell, fruit or vegetable, fish, bird, and so on. Discuss with your classmates whether you want the overall finished quilt design to represent just *anything* about nature, or to follow a more particular theme.
4. Following your sketch, use cut paper to create your design. You will probably want to use several pieces of different colored and patterned paper. Glue them securely to your square, making certain that the edges and corners are flat.
5. When everyone's squares are complete, arrange them on a wall or floor. Try several arrangements until you agree on one that looks good. You may need to add some more squares, either plain or decorated, in order to make the overall arrangement form a square or rectangle.

6. Overlap the squares one and a half inches on each side, and glue them together. Display the finished product in a prominent place.

7. *Optional:* quilting is an old and well-established art form in America. It is also very time-consuming, as it requires a lot of skilled measuring, cutting, and meticulous sewing by hand. It requires a lot of fabric, too. If you and some of your friends and classmates like sewing, or are willing to learn, you might want to try making an album quilt. Each person would be responsible for one or more squares or blocks that will form the overall design of the quilt. Ask your teacher, librarian, or local crafts or quilt shopkeeper to help you find books, patterns, and other resources to get you started and see you through the project. Remember that album quilts are made by many to be presented as a special gift to one person. To whom will you present your quilt?

Evaluation

1. Did you develop your research skills when finding out more about quilts? What are some resources someone might use to learn more about quilts?

2. Did you find working together cooperatively to be a rewarding experience? Explain your answer. Did you do your part to the best of your ability? Tell what you did.

3. Did you try several design ideas for your square and for the finished overall pattern before settling on one? Why did you settle on the one you did?

Figure 5-11 The top of this architectural column is decorated with a carved floral motif. You can probably find similar carvings on buildings near you.

A capital on a column. Photo ©1994 E. Louis Lankford.

Inside and Outside Our Buildings and Homes.

Today, we needn't look far to find examples of nature in the art around us. Carved leaves curl decoratively atop the columns on the front of courthouses, banks, and other large older buildings (see Figure 5-11). Wallpaper, furniture upholstery, and fabric for curtains, clothing, and bed linens frequently utilize motifs from nature (see Figure 5-12). Even our dishes and eating utensils are often ornamented with fruits, flowers, and other natural designs.

Natural Objects in Ceremonial Artworks.

Natural objects have often been put to artistic use. Seashells, feathers, fur, hide, quills, bones, grasses, and other natural materials are frequently part of ceremonial dress, masks, and other special objects. We see examples in Figures 5-13 and 5-14. Our knowledge of the history of such ceremonial art forms is often limited to the few old pieces that have withstood the natural processes of decay. Some ceremonial art forms, such as Navaho sand paintings, were intentionally destroyed when their ritual functions (such as blessing or heal-

ing) had been completed. Sometimes we can learn about art history by studying the traditions that still survive within a culture.

African masks, such as that shown in Figure 5-14, play an important role in the lives of people who make and wear them. They are intended to be part of a larger costume, and to be viewed in ceremonial movements or dances. They inspire awe, fear, joy, or other moods appropriate to the occasion.

It is understandable that many people who make and use such artifacts have been reluctant to part with their most prized possessions—the ones they consider the handsomest or most powerful. Collectors must often settle for damaged or inferior items, or those that have been "stripped down" by the removal of sacred or magic parts considered too valuable to sell.

The Native American ceremonial war shield pictured in Figure 5-13 utilizes important symbols drawn from nature. Golden eagle feathers cascade from one side of the hide that forms the round shield. Eagle feathers are associated with high social standing, nobility, honor, and wisdom.

The fur of a weasel is also attached to the shield. Native American warriors believed that each animal possessed special powers which could be imparted to humans who understood and respected these animals. The warrior who used this shield may have felt he shared certain qualities with the weasels who are swift runners, good climbers, and ferocious attackers against prey much larger than themselves.

Figure 5-12 This elaborate design was used for fabrics and wallpapers.

William Morris (English, 1834–1896), *Strawberry Thief*, detail. Textile design, painted and printed cotton. Whole: L. 108", W: 37". The Metropolitan Museum of Art, Purchase, Edward C. Moore, Jr., Gift, 1923. 23.163.11.

Figure 5-13 Pictured above are examples of what a warrior might need to know how to make.

Crow shield, c. 1880, Montana. Buffalo hide with owl and eagle feathers and ermine pelt. *Blackfeet Bow with bow case and quiver*, c. 1875. Montana. *Crow miniature shield*, c. 1850, Montana. Adorned with owl feathers and a plait of human hair. *Crow knife and knife sheath*, c. 1880, Eastern Montana. *Crow arrow*, c. 1870–1890, Montana. *Sioux arrow*, c. 1870–1910. South Dakota. ©1994 Colter Bay Indian Arts Museum, Grand Teton National Park, Wyoming. Photo by John Oldenkamp and Cynthia Sabransky.

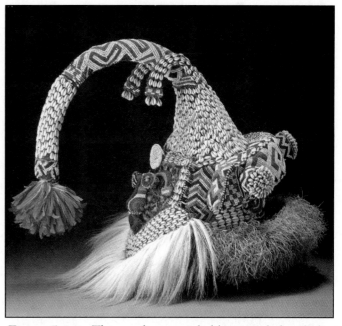

Figure 5-14 This mask was probably intended to help gain the favor of ancestral spirits.

Mask of a mythic royal ancestor (Mukyeem or Moshambooy). Africa, Zaire, Western Kasai Province, Mweka Zone, Kuba People, late 19th–early 20th century. Wood, beads, cowrie shells, feathers, hair, fiber, skin, metal. 5.1 × 7.6 × 7.6 cm. The Art Institute of Chicago. Laura T. Magnuson Fund; X-Hautelet Collection. Photograph by Robert Hashimoto, ©1993, The Art Institute of Chicago. All Rights Reserved. 1982.1504.

Young warriors had to learn how to craft their own weapons. Symbolic as well as practical features had to be considered. Weapons had to be sturdy; arrows had to fly straight and true. Beads, paint, bear claws, feathers, rattlesnake skins, and other natural objects and ornaments were added to ensure spiritual protection and to increase inner strength and courage. The tiny shield pictured here, with the braided human hair, beads, and owl feathers attached is a *talisman*—a sort of sacred good luck charm intended to invoke the protection of guardian spirits.

Nature in Far Eastern Art

The art of the Far East is as diverse as its people. The cultures in and around the Asian regions of China, Japan, and Korea developed art forms and artistic traditions over centuries of history that are as

EXPLORING

HISTORY AND CULTURES

Some ceremonial works of art, such as masks, are acquired for museums by anthropologists through trade. If people value an object highly, they may be unwilling to part with it at any price.

1. Would you give up your most prized possession to a collector or museum in exchange for money? Why or why not?

2. Would you consider donating your prized possessions to a museum, even if it was to a far-off museum? Explain your answer.

Student Activity 2

Miniature Painting

Goals

1. You will develop your ability to paint small details.
2. You will practice looking closely in order to render accurately.
3. You will gain a fuller appreciation for the skill and craftsmanship of artists who paint in miniature.

Materials

1. Extra-heavyweight drawing paper cut into 8" × 7" pieces
2. Acrylic matte medium and varnish
3. Number 4 pencil, eraser, ruler
4. Acrylic gloss medium and varnish
5. Acrylic paints
6. 1" flat brush
7. Selection of fine-point brushes (such as a number 1 round)
8. Water containers, rags, palettes, palette knives
9. Drawing board, plus thumbtacks or tape
10. White and colored mat board cut into 9" × 8" pieces, mat knife, tape

Directions

1. You are going to produce a miniature painting depicting *either* a single flower *or* your house pet. If you choose to paint a flower, bring one to class from your garden or a neighborhood shop or market. If you choose to paint a portrait of your dog, cat, parakeet, goldfish, or other pet, bring in sketches you have drawn.
2. Tack or tape the drawing paper to your drawing board.
3. Measure and draw a two-inch border around the edge of the paper, leaving a four-inch-by-three-inch rectangle in the center.
4. With your pencil, lightly draw your flower or pet within the four-inch-by-three-inch rectangle on your paper. You may use either a horizontal or vertical format.
5. Using a one-inch flat brush, apply a thin, even coat of *undiluted* acrylic matte medium and varnish over the four-inch-by-three-inch area of your paper. You don't need to worry about staying in the lines. Apply

Carlene Brown, 17
Smithfield High School; Smith-
field, RI

the varnish directly over your drawing. This step will help prevent your pencil marks from blending with your paints.

6. Use acrylics to paint the image you have drawn. You do not have to worry about staying within the rectangle. Any brush strokes beyond the lines will be covered when your finished painting is framed with a mat. As you paint, refer often to your flower or sketch for color and detail information.
Clean your brushes often with water, and gently wipe them dry with a soft rag. Then form a point at the tip of each brush with your fingers.

7. Put a thin, even coat of gloss varnish over the finished, *dry* painting.

8. Your finished painting will look even better with a mat to frame it. Tape your painted eight-inch-by-seven-inch paper onto the center of a nine-inch-by-eight-inch piece of white mat board. Use small pieces of tape just in the corners, as you may have to adjust its position later. Select a second piece of mat board to serve as your frame; it could be white, or you may select a color to complement the colors of your painting. Cut a nine-inch-by-eight-inch piece from the second piece of mat board, and then carefully measure and cut a four-inch-by-three-inch window in the center of it. Line up the edges of your two pieces of mat board, making sure the window aligns with your painting. If it doesn't, loosen the tape holding the painting, and move it around until it's framed in the window; then retape it onto the board. Attach the two pieces of mat board together with double-stick tape or a thin bead of glue around the inside edges.

Evaluation

1. This assignment required careful, detailed work habits. What are some of the things you did to make certain the assignment was carried out successfully?

2. Has this assignment changed your opinion of the artistic skills necessary to accomplish small scale work? Has it changed your level of appreciation for small-scale artworks? Explain your answers.

223

lively and sophisticated as any on earth. To those trained in the traditions of European art, art from these regions might at first appear strange and mysterious, because the artistic traditions of the Far East differ from those of the Western world. Yet, even to the Western eye, Asian artworks are undeniably beautiful and obviously created with great skill. Throughout history, artists in the Far East have shared with Western artists an attraction to the beauty of nature. But there have been significant differences in their artistic approaches to the subject.

Since the early Renaissance, Western artists have sought to recreate, as accurately as possible, what is visible to the eye. Artists in China and Japan have taken a different approach. They have created images that reveal the essence of the subject, rather than a one-time visual impression. What does this mean? Their drawings and paintings are not intended to give an accurate picture of a particular place at a particular time. Instead, Asian artists study the natural elements of a site very closely over a period of time. After noting the seasonal changes, as well as the atmospheric changes at various times of day and in various kinds of weather, the artists recreate a generalized visual image.

A Serene Forest

The work in Figures 5-15 and 5-16 provides a good example. It shows us the essence of a forest of trees. Entitled *Trees*, this forest of treetops has been painted on a twelve-panel folding screen. When it was painted in Japan in the middle of the seventeenth century, it was common for people to put large folding screens in their homes. These screens could be used instead of walls to separate living areas, and they functioned as decorative backdrops. Often, as in *Trees*, gold leaf was applied to the screen along with paints and inks. **Gold leaf** is a very thin sheet of gold applied to a surface with adhesive. The resulting shiny golden surface brightened the room and

Figure 5-15 The first section of this twelve-panel seventeenth-century Japanese screen leads the eye into the second part pictured below.

Master of the I-nen Seals, *Trees*, 17th century. Japanese, Early Edo. 12-panel screen; ink and colors on paper. Courtesy of the Freer Gallery of Art, Smithsonian Institution, Washington, D.C. 62.30 and 62.31.

Figure 5-16 The second section of the screen completes the picture intended to provide viewers with a sense of serenity and spiritual refreshment.

added visual richness to both the artwork and the room itself.

Trees exhibits many of the attitudes toward art and nature held by the Japanese. One is that experiences with nature, either in the outdoors or through art, should provide solace and refreshment. Another is that subtle differences in forms and colors can be as satisfying, if not more satisfying, to the senses as contrasting forms and colors. This attitude is evident in Figure 5-16. Similarly, Japanese gardens often blend plants that bear few flowers, but offer a variety of different textures and shades of green. Such a garden is a place where visitors can contemplate nature serenely and quietly.

Asian artists often make good use of uncluttered space. Look again at Figure 5-15. Notice how the foliage-filled areas are skillfully balanced by unpainted areas. In fact, some panels are unadorned gold leaf. The contemplation of a work of art, like the contemplation of a serene garden, can relax and refresh the mind. In *Trees*, the artist has provided plenty of room for our imagination to roam.

The artist of *Trees* is referred to as the "Master of the I-nen Seal" because no certain record exists of the artist's name. However, the artist's style is distinctive, and works by the same artist can be identified by the stamped impression of the artist's seal. A *seal* is a small, specially designed block of wood, metal, or stone into which has been carved a picture or monogram. When inked and pressed against a smooth surface, it leaves an impression of its design. Such impressions were sometimes used instead of, or in addition to, the artist's signature.

"The Floating World"

Trees was created during the Edo-Tokugawa (E-doh toh-koo-GAH-wah) period in Japan, which spanned the years 1600 to 1853. Edo was a cultural and political center whose name later changed to Tokyo. Tokugawa was an emperor who took over Japan in 1615. The Edo-Tokugawa period was an era of relative peace and prosperity in Japan. One literary art form that you may be familiar with that developed during this time is a type of poetry called haiku.

Figure 5-17 Ukiyo-e pictures depict a way of life in the Edo-Tokugawa period.

Eishosai Choki, *Catching Fireflies*. ©The British Museum, London.

A popular form of visual art that emerged during the Edo-Tokugawa period is known as **ukiyo-e** (you-KEE-yoh-ay), *which means "pictures of the floating world."* What does the "floating world" refer to? It refers to a special way of life characterized by attention to elegance, beauty, social refinement, the arts, and high fashion. Women were frequently depicted in ukiyo-e, displaying the latest hairstyles and dressed in fashionable silk garments called kimonos. Other subjects included children playing, elderly sages or wise men, characters from the theater, and the infinite beauty of nature. A good example of ukiyo-e is pictured in Figure 5-17. While the artistic style and fashions displayed in this picture may be unfamiliar, the child's activity is a common one in many parts of the world. Can you guess what the woman is carrying in her left hand?

Making a Wood-Block Print

Most ukiyo-e artworks were wood-block prints. Making a print required the efforts of several people. An artist would make a drawing or painting on paper. Another person would trace the design onto a flat block of wood. Someone else would carve out the design. Each color needed for the picture required a separate block. A full-color print could require twenty or more carved blocks. Printing presses were not used; a piece of paper was placed on top of an inked woodblock and rubbed with a disk-shaped **baren,** *or rounded, smooth, flat pad.* After printing was completed, the artist or a calligrapher would often write the title of the artwork on the surface of the picture, or include a piece of prose or poetry related to the scene depicted. Finally, the seal of the artist was stamped on the print, and usually the seal of the publisher who would sell the print as part of a set. Some prints also bear the seal of approval of an official censor appointed by the government.

Contrasting Traditions

Catching Fireflies (Figure 5-17) may be used to illustrate some other differences between traditions of Asian art and European art. One difference can be seen in the way that the artist, named Choki (cho-kee), has created a sense of space and distance in this picture. In European art, a landscape is usually pictured from one point of view. In other words, the picture looks to us as though we were standing at a particular place, looking in a particular direction, from a particular height—usually the eye-level height of a standing adult. Choki, on the other hand, has used more than one vantage point. We see the woman and child from normal eye level, as if we were looking straight ahead. But we are looking downward and at an angle at the brook. Interestingly, we see the iris plants as if they,

too, were at eye level, and we were looking straight ahead. These plants are in an artificially neat row along the horizon line. The flowers are drawn with a degree of detail we wouldn't expect to see on objects viewed from a distance. Choki's treatment of the flowering plants gives them special importance in the picture, although they do not dominate the scene.

Another difference between Asian and European traditions is the indication of light and shadow in a landscape. In Western painting, it is common for the artist to settle on a single light source, such as the sun or a campfire, to illuminate a scene. All of the highlights and shadows conform to that light source: surfaces facing the light are brighter and more detailed than those in shadow. In Choki's picture, however, there is no obvious dominant source of light. Although the sky is dark enough that the fireflies are surrounded by glowing halos of their own making, the woman and child are fully illuminated. The lack of shading on their figures makes them look more flat than three-dimensional. The artist has chosen to accentuate shape, color, pattern, and line rather than to create the illusion of three-dimensional form.

It would be impossible to surpass the keen observation, creativity, and imagination demonstrated by Asian artists. Fine examples of these attributes can be seen in Figures 5-18 and 5-19. These are works of art called **stone pictures,** *which literally are pictures discovered in stones, the way we might "discover" or imagine the shapes of people and animals when we gaze at clouds.* Small inscriptions have been carved into the corners of each polished slab of stone. These describe the scene the artist wants us to see in the forms and colors of the rock. Figure 5-18 suggests *Many Wonders of Summer Clouds,* and Figure 5-19 presents a landscape titled *Winter Peaks Hoard the Snow.* Can you see these images? Do you think you would have noticed them in the stone without the titles provided by the artist?

Figure 5-18 This work of art is called a *stone picture*.

The Four Seasons: Many Wonders of Summer Clouds, 18th century, Chinese, Ch'ing Dynasty (1644–1911). Ta-li marble mounted in wood frame. 20½" × 27" (framed), 19½" × 25" (unframed). ©1994 The Nelson Gallery Foundation. All Reproduction Rights Reserved. The Nelson-Atkins Museum of Art, Kansas City, Missouri. Purchase: Nelson Trust. 59-76/1.

Figure 5-19 It requires an equal measure of observation and imagination to see the pictures in these stones.

The Four Seasons: Winter Peaks Hoard the Snow, 18th century. Chinese, Ch'ing Dynasty (1644–1911). Ta-li marble mounted in wood frame. 20½" × 27" (framed), 19½" × 25" (unframed). ©1994 The Nelson Gallery Foundation. All Reproduction Rights Reserved. The Nelson-Atkins Museum of Art, Kansas City, Missouri. Purchase: Nelson Trust. 59-76/2.

Section ① Review

Answer the following questions on a sheet of paper.

Learn the Vocabulary

The vocabulary terms for this section are *Paleolithic, gold leaf, Mogul, motif, album quilt, ukiyo-e, baren,* and *stone pictures.*

1. Match the following descriptions to the correct vocabulary term:
 a. Means "pictures of the floating world"
 b. A time period 10,000 to 30,000 years ago when people lived by hunting, fishing, and gathering berries, nuts, and roots to eat
 c. A visual theme or repeated pattern in a design

Check Your Knowledge

2. What was one of the first and artistically one of the finest of the painted caves to be discovered?
3. What was a common motif found in the paintings and textiles of the Mogul dynasty in India?
4. Name two types of artists' materials used in the creation of a Persian or Mogul miniature painting.
5. List at least three natural objects used artistically as parts of ceremonial dress, masks, shields, and other special objects.
6. Describe the difference between Western art and Asian art regarding use of one of the following: point of view, shadow, or shading.

For Further Thought

7. In ancient cultures, artists included in their works plants and animals that were important to them as sources of food or shelter. Now that the world is more urban and further removed from nature, what parts of nature are important to society? How might today's art reflect the changes in attitudes toward nature?

Section II

Reawakening to Nature Through Art

Some artists have sharpened people's awareness of the glories of nature by focusing on subtle features and details of the natural world. For example, Jan van Kessel (1626–1679) combined a keen respect for nature with scientific curiosity to create life-size renditions of flowers, butterflies, and insects, as shown in Figure 5-20. Van Kessel's small paintings are rendered with obvious concern for accuracy of color, form, and minute detail. As a result, they make us marvel at natural wonders that we might normally overlook.

Botanical Illustration

A special type of art form is called *botanical illustration.* **Botanical illustration** *is the art of drawing and painting plant forms with extreme accuracy and detail.* Such illustrations can be used to study plants from a scientific perspective. Before the invention of photography, books of botanical illustrations were useful references for botanists and horticulturists, providing information about fruits, flowers, vegetables, herbs, and other common and exotic plants. But the artistry of these volumes also appealed to art collectors and appreciators. Even today, it is not unusual to find botanical illustrations on note cards or framed as works of art.

Cantaloupe, shown in Figure 5-21, is a botanical illustration from a book titled *Pomona Britannica,* created between 1804 and 1812. The artist, Englishman George Brookshaw (1768–1829), began by making highly detailed drawings and paintings. These images

Figure 5-20 A great artist can reveal the complex beauty of even the simplest subjects.

Jan van Kessel, *Butterflies, Other Insects, and Flowers*, and *Butterflies, Caterpillars, Other Insects and Flowers*, 1659. Flemish. Oil on copper. Each approx. 4½" × 5¾" Collection of the High Museum of Art, Atlanta, Georgia. Purchase in memory of Dr. and Mrs. De Los Lemuel Hill. 58.19, 58.20.

were painstakingly transferred to printing plates by a skilled engraver using an *aquatint* technique. **Aquatint** *is a printmaking process that involves etching, but while most etchings show only the lines of a drawing, aquatint permits broad areas of black and gray tones as well.* Brookshaw would then hand-color each print.

Figure 5-21 Botanical illustration is notable for having both scientific and artistic value.

George Brookshaw, *Cantaloupe*, 1812. Plate LXX from *Pomona Britannica*, London. Hand-painted aquatint, 24" × 19". Rare Books Room, The Astor, Lenox and Tilden Collections, The New York Public Library.

Every Detail Is Worth Seeing

Some twentieth-century artists have continued the tradition of capturing the exquisite details of nature in their art. Georgia O'Keeffe (1887–1986) created many paintings that invite viewers to observe nature closely. A pile of leaves, a sun-bleached animal bone, or a single flower might fill a canvas by O'Keeffe (see Figure 5-22). She marveled at the infinite variety of forms and colors of nature, and her paintings convey that special sense of wonder. So close is her view of the red canna flower in Figure 5-23 that the forms actually become undulating, abstract streams of color.

> "I was trained by men to be an artist, but I learned from women how to be expressive."
>
> **Miriam Schapiro**

Figure 5-22　O'Keeffe helps us to appreciate the delicate beauty in even the simplest of natural subjects.

Georgia O'Keeffe, *Autumn Leaves, Lake George, New York*, 1924. Oil on canvas, 20¼" × 16¼" (51.4 × 41.3 cm.). Columbus Museum of Art, Ohio. Museum Purchase: Howald Fund II. ©1994 The Georgia O'Keeffe Foundation/Artists Rights Society (ARS), New York.

Figure 5-23　This close-up of a single flower becomes an abstract symphony of color.

Georgia O'Keeffe, *Red Canna*, c. 1923. American. Oil on canvas mounted on masonite. 36" × 29⅞" (91.4 × 76.0 cm.). Collection of The University of Arizona Museum of Art, Tucson, Gift of Oliver James. ©1994 The Georgia O'Keeffe Foundation/Artists Rights Society (ARS), New York. 50.1.4.

Georgia O'Keeffe

From the time she was very young, Georgia O'Keeffe was always engaged in creative activities. Once, as a little girl, she designed a dollhouse for her dolls to live in. "In the summer I took the dollhouse outdoors to a shady place between some hemlock and apple trees," she wrote as an adult, remembering her childhood. She arranged a park to go with the house. "I cut the grass with scissors, left weeds tall for trees, made walks with sand and little stones, and had a large pan of water for a lake with moss on the edge of it." Her dolls did not take well to water sports, however: "One of the little girls was ruined trying out a bathing suit in the water. Her arms and legs and hair all came off when I let her go bathing."

Young Georgia took drawing and painting lessons from local art teachers on Saturdays. At home, she diligently practiced her art-making skills. Her mother admired her artwork, and framed some of Georgia's pictures to hang on the wall.

> "Everyone has many associations with a flower—the idea of flowers Still, in a way, nobody sees a flower—really—it is so small—we haven't time—and to see takes time, like to have a friend takes time. If I could paint the flower exactly as I see it no one would see what I see because I would paint it small like the flower is small.
>
> So I said to myself—I'll paint what I see—what the flower is to me but I'll paint it big and they will be surprised into taking time to look at it—I will make even busy New Yorkers take time to see what I see of flowers."
>
> **Georgia O'Keeffe**

When she was in the eighth grade, Georgia announced to a friend that she intended to become an artist. She later admitted that, at the time, she didn't really know much about what artists actually did. At thirteen, she was sent to a boarding school where she took art classes taught by a nun. On the first day in class, Georgia thought she had made a very nice drawing, until the teacher scolded her for drawing too small. Georgia was embarrassed and had to struggle to hold back tears. Secretly she thought that most of her teacher's suggested "improvements" made her drawing worse.

In high school, Georgia had a teacher who really helped her to examine things with the goal of making more detailed drawings. She learned to use watercolor with more confidence and expressiveness. But she preferred roaming the countryside, enjoying beautiful vistas, to being in school.

Georgia O'Keeffe went on to attend the Art Institute of Chicago, and the Art Students League in New York. For a while she taught school. On her own, she followed her creative impulses and experimented with different media and methods. She sought effective new ways to express her ideas and insights about life and the world around her. While still young, O'Keeffe was well on her way to becoming one of the most respected and important American artists of the twentieth century.

Student Activity 3

Botanical Illustration

Goals

1. You will develop your skills of drawing accurately and realistically.
2. You will practice your ability to perceive form, color, light, and shadow.

Materials

1. White drawing paper
2. Pencil, eraser
3. Colored pencils or oil pastels
4. Fruit or vegetable

Directions

1. Botanical illustration is a good way to sharpen your perception and develop your drawing skills (see Figure 5-21). Select a piece of fruit or a vegetable you would like to draw in detail. Set it down on the table in front of you, making certain that it is in a good light. You may need to sit next to a window, or place a lamp at the end of the table.
2. Inspect the fruit or vegetable closely. Draw an outline of it as close to life size as you can. Be as accurate as possible. Look carefully to see where to add shading to the form of your drawing. Try to capture any surface details. Use colored pencils or oil pastels to reproduce the colors that you see. Watch for subtle changes in color—there may be dark greens, bright greens, olive greens, and yellow greens on a single stem of broccoli or a pear, for example.
3. Ask your teacher to help you slice your fruit or vegetable in two. Make a color drawing of a cross-section. You may do this on the same piece of paper as your first drawing, or on a separate sheet of the same size and type of paper.

Evaluation

1. Did you look carefully and draw carefully? Point out some details in your drawing that serve as evidence that you did.
2. Are you satisfied with your finished drawing? What do you think are its best features? Are there any aspects you think could be improved if you made another botanical illustration? Explain what you might do differently.

Wilderness Photography

Photographs can also be used to make us aware of the mystery and fragility of our environment. One master of wilderness photography was Ansel Adams (1902–1984). Before taking a photograph, Adams would patiently explore a landscape, searching for the best viewpoint and experiencing its various atmo-spheric conditions. His pictures provide more than an accurate record of the locations. They convey a sense of awe and reverence. Adams' photograph, *Mount Williamson, the Sierra Nevada, from Manzanar, California, 1945* (see Figure 5-24) effectively captures these feelings.

Figure 5-24 Adams pioneered a system of capturing and controlling a wide range of tonal values in black and white photography. His skill is evident in this majestic scene.

Student Activity 4

Photographing the Environment

Goals

1. You will use photography as a means to express important ideas about the environment.
2. You will explore visual contrast as a way of examining dramatically different concepts or circumstances.
3. You will look closely and critically at visual elements in your environment.

Materials

1. Cameras, any type
2. Print film, either color or black and white
3. Access to photo development equipment and supplies or photo printing services
4. Cardboard, glue or tape, scissors
5. *Alternate assignment:* Magazines with plenty of pictures of natural and built environments.

Directions

1. If you have access to a camera, try to capture some images around these contrasting themes: *Nature in the Human Environment: In Harmony,* and *Nature in the Human Environment: In Disharmony.* The *In Harmony* photos would show examples of human planning, design, and construction that demonstrate sensitivity to the natural environment. For example, you might photograph an office building that is surrounded by attractive landscaping. Or you might photograph a pretty tree-lined street, or an old stone wall supporting a rambling rosebush.

 The *In Disharmony* photographs would show places where nature and the human environment clash. Photographs might show such things as litter, vandalism to park benches, a weedy and unused parking lot, or other evidence of disregard for the environment.

2. Depending on your access to and knowledge about photography equipment, you will need to develop and print your pictures yourself, or have a photo service do it for you.

3. After your pictures have been printed, use glue or tape to mount your favorites carefully and neatly on cardboard. You may want to use scissors to trim some of them in order to improve your presentation.

4. Exhibit your photographs alongside those of your classmates. Discuss each photograph in terms of how effectively the composition and subject matter express harmony or disharmony in the landscape. Talk about whether or not this assignment caused you to pay closer attention than you normally do to visual elements in your surroundings. Also ask yourself if this assignment has in any way changed the way you think or feel about your environment.

5. *Alternate assignment:* Proceed through steps one through four as described above. Instead of taking your own photographs, locate, clip, and paste up environmental photographs available in magazines.

Evaluation

1. Did you study your environment closely and critically before selecting what to photograph? Describe some of the things you noticed in the environment.

2. Did you compose your photograph carefully? Describe how you went about composing your picture.

3. Did you thoughtfully choose which photographs to exhibit, and mount them neatly on cardboard? Why did you make the choices you made?

4. Did you contribute to the discussion about the photographs and the assignment?

Art and the American Landscape

Photographs like Adams' (Figure 5-24) can serve as visual reminders of how precious our natural environments are. Many people today are deeply concerned about the earth's shrinking wilderness areas. Yet over a hundred years ago, artists were already exploring, documenting, and working, through their art, to preserve the landscapes of the American wilderness.

The public has long been captivated by the strange tales that adventurers tell of their travels. Explorers experience the vastness of oceans and the blazing heat of deserts; they come across previously undiscovered natural wonders, and they encounter exotic, sometimes dangerous plant and animal life. In the eighteenth and nineteenth centuries, it was not unusual for artists to accompany people setting out on voyages of exploration and scientific discovery. The artists' mission was to record the exotic landscapes and new species of plant and animal life. One noted American wildlife artist, John James Audubon (1785–1851), led his own expeditions into wilderness areas to record the birds and animals of North America.

Audubon's Birds

Figure 5-25 is one of many aquatints from Audubon's massive four-volume set, *The Birds of North America*. The birds in this aquatint are Carolina parakeets, the only known native parrots of North America. These colorful birds enjoyed eating cockleburs, as we see in the illustration. They were social creatures, living close together in huge flocks. They lived throughout most of the eastern portion of the United States. By 1918 they were extinct, as a result of ruthless hunting and the destruction of their natural habitat by human settlers.

While Audubon was searching the wilderness for birds and various animals, other artists were concentrating their talents and energy upon capturing the majesty of the land itself.

The Hudson River School

In mid-nineteenth-century America, a group of artists in New York began to create landscapes that were

Figure 5-25 Now extinct, the Carolina Parrot, ranged from New York State to the Gulf of Mexico in the 19th Century.

John James Audubon, *Carolina Parrot*, 1827. American. Hand-colored engraving with aquatint, from *The Birds of America*, Plate XXVI. (Robert Havell, Engraver). National Gallery of Art, Washington, D.C. Gift of Mrs. Walter B. James. Photo by Dean Beasom. 1945.8.26. (PR).

uniquely American. This group of artists became known as the "Hudson River School." They recorded the exploration and settlement of remote areas of the Hudson River Valley. The enormous popularity of their paintings encouraged them to journey into the vast western regions of the North American continent.

"The picture that looks as if it were done without an effort may have been a perfect battlefield in its making."

Robert Henri

Americans who lived in established communities in the East were endlessly curious about the vast territory that stretched to the continent's opposite shore. The Hudson River School artists gained fame and fortune by providing vivid pictures of America's natural splendors.

America's First National Park. Many of the artists who accompanied expeditions to the West were concerned about the exploitation and careless destruction of the wilderness. One of these artists was Thomas Moran (1837–1926). Moran joined surveying expeditions to the West, and returned with many sketches. From these, he created huge landscape paintings. When Moran first saw the grand canyon of the Yellowstone River, he said that it was a scene no artist could duplicate. Still, he tried to capture some of the grandeur he experienced there (see Figure 5-26). This expansive painting, which measures about seven feet by twelve feet, was purchased by the U.S. Department

Figure 5-26 This viewpoint of Yellowstone Canyon is now known as "Artist's Point." It is still frequently depicted by artists.

Thomas Moran, *The Grand Canyon of the Yellowstone*, 1872. Oil on canvas. 84" × 144½". National Museum of American Art, Smithsonian Institution. Lent by the U.S. Department of the Interior, Office of the Secretary. National Museum of American Art, Washington, D.C./Art Resource, NY.

Student Work

Chyvorn Se, 18
Logan High School; Logan, UT

of the Interior. It was hung in the lobby of the U.S. Senate chambers. So impressive was the scene that it helped influence the congressional decision to establish Yellowstone as the first national park in America. The painting is now part of the collection at the Smithsonian Institute.

So artists journeyed westward, ever deeper into the wilderness. One of the most prolific of these artists was Albert Bierstadt (BEER-stat) (1830–1902), who traveled and painted for ten years in the American West. Figure 5-27 is Bierstadt's *The Oregon Trail*. It displays the characteristics for which Bierstadt became famous:

- A panoramic view, overlooking many miles

- A foreground rich with minute detail

- A peaceful stream and broad valley bounded by towering jagged peaks

- Dramatic effects of light and shadow

- A visually balanced and meticulously executed composition.

DEVELOPING SKILLS FOR

ART CRITICISM

Look closely at Albert Bierstadt's painting, *The Oregon Trail* (Figure 5-27). At first glance, the beautiful scenery and lovely sunset seem to indicate that the pioneers have reached a paradise on earth. But look closer. Can you see anything that takes away from the perfection? The grandeur of the unspoiled wilderness contrasts with the relentless encroachment of settlers. Thick dust rises from wagons and oxen to cloud the sun. A tree has toppled to one side. Broken and abandoned debris litters the trampled grasses of the meadow.

1. Do you think the artist is trying to show both good and bad sides of pioneer settlements? Explain your answer.

2. Huddling in the center of the valley is an encampment of Native Americans. What might they be thinking about the approach of these people from the East?

3. Is the wilderness as pictured by this artist a tough place to travel and settle? Does it have its hardships *and* rewards? Explain your answers.

Bierstadt and other artists of the Hudson River School excelled in the use of atmospheric perspective, which, as we learned in Chapter Two, is the achievement of a sense of spacial depth in a painting through two methods:

1. Objects in the foreground are larger and more detailed than similar objects in the background.

2. Colors, light, and shadow are more intense and contrasting in the foreground than in the background. By using softer tones, the background appears hazier and more distant.

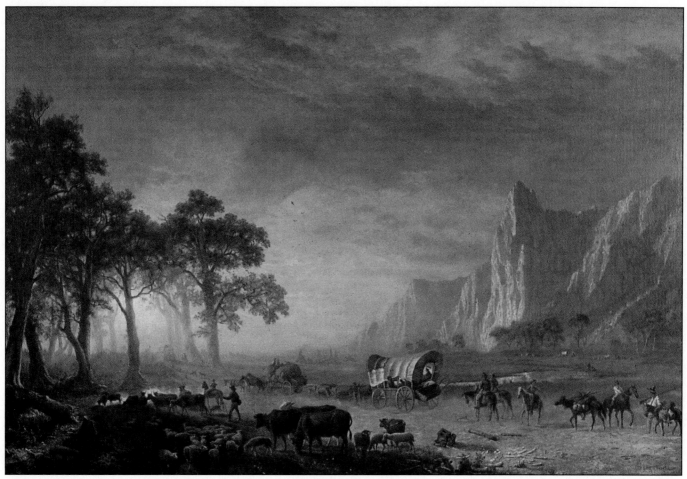

Figure 5-27 Wagon trains roll west into a romantic lavender and gold sunset on the famous Oregon Trail. The artist has shown us a vanishing wilderness.

Albert J. Bierstadt, *The Oregon Trail*, c. 1800. Oil on canvas. 31" × 49". The Butler Institute of American Art, Youngstown, Ohio.

Frederic Edwin Church. Some Hudson River School artists roamed the entire Western Hemisphere. Frederic Edwin Church (1826–1900) first made a name for himself with his dramatic painting of Niagara Falls on the border between New York and Canada. He then traveled north to paint icebergs in Labrador, and south to paint volcanoes and waterfalls in the Andes Mountains of South America. Church took liberties with his landscapes. He often combined various pictorial elements of a region in one panoramic composition. Church's reputation in his time was tremendous. Many of his contemporaries considered him to be the finest living American artist. His paintings, such as *Rainy Season in the Tropics* (Figure 5-28, on the next page) were taken on tour throughout Europe and North America. Sometimes a single-picture exhibition would be presented. People flocked to these exhibitions, paying admission to admire just one breathtaking image of nature.

Tornado Over Kansas. Thus far in this section, we have seen examples of art that captures the quiet beauty and delicate details of nature. We have seen paintings and photographs that reflect nature's awesome gran-

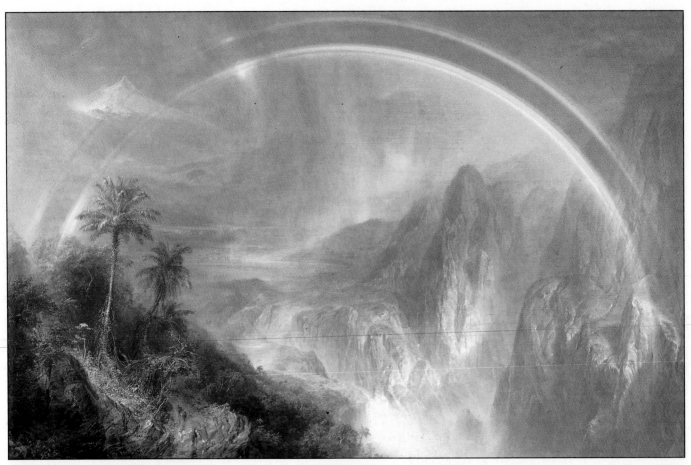

Figure 5-28 What characteristics does this painting share with Figures 5-26 and 5-27?

Frederic Edwin Church, *Rainy Season in the Tropics*, 1866. American. Oil on canvas. 56¼" × 84 ¼". The Fine Arts Museums of San Francisco, Mildred Anna Williams Collection. 1970.9.

deur. But nature also has frightening, destructive power. Cultures that have celebrated the bounty of the earth have also suffered the natural disasters of drought, floods, earthquakes, and terrible storms.

There may be nothing more terrifying than the destructive energy of a tornado. The greenish sky and eerie calm that often foreshadow these dark funnels are dreaded omens to people living in rural midwestern United States. In Figure 5-29, artist John Steuart Curry has dramatically captured the grim approach of a tornado toward a farm family in *Tornado Over Kansas*.

Curry (1897–1946) grew up on a farm in Kansas, where he rose before dawn to help with chores before heading to school. He understood the hardships that farmers had to endure, such as the loss of crops due to

drought or flood. He knew that tornadoes posed a serious threat to life and property. In *Tornado Over Kansas*, Curry has depicted the frantic moments before a tornado strikes. A farmer directs his family into the safety of a cyclone cellar. Children run for cover, clutching the family pets. One holds a cat, another carries an armload of puppies, while the pups' mother looks up protectively from below. The woman holds her baby securely as she enters the cellar, and throws a concerned glance over her shoulder, no doubt checking to make sure that all of her children will follow her. In the background, horses run about in terror. The entire scene is lit with an eerie glow. Curry has accentuated the fearsomeness of the approaching funnel through his dramatic use of perspective: the lines of

the farmhouse, steps, barn, and even a distant fence all lead our eyes directly to the funnel, and form a visual path for the tornado to follow as it surges menacingly toward the farm.

Curry's paintings of farm life depicted people of modest means who displayed strength, courage, and compassion in the face of hardships of daily living. Curry was one of a group of artists who came to be known as the "American Scene" painters, or "Regionalists." These artists rejected both abstract art and overly idealized portrayals of America, choosing instead to show ordinary citizens struggling and rejoicing in their homeland. Curry was also a crusader for soil conservation during the period when much of the Midwest had been labeled the Dust Bowl. He believed that people should work to conserve and protect natural resources for future generations.

While many American artists sought to capture the drama and majesty of their land and its natural environment, other artists here and abroad chose to depict quiet gardens and gently rolling countrysides. One of the greatest of these was Claude Monet (moh-NAY), whose paintings have reawakened many people to the beauty and wonder of nature.

Figure 5-29 The artist has chillingly captured a dramatic moment.

John Steuart Curry, *Tornado Over Kansas*, 1929. American. Oil on canvas. 46¼" × 60⅜".
Courtesy, The Muskegon Museum of Art, Michigan. Hackley Picture Fund. 35.4.

LOOKING CLOSER:

Pet Dogs

For centuries humans have domesticated dogs. Wild dogs have become hunting dogs, shepherd dogs, guard dogs, and lovable pets. Let's compare two paintings depicting dogs with their owners, one from the sixteenth century, and one from the 1980s.

Figure 5-30 shows a *Portrait of a Noblewoman*, by Italian Renaissance artist Lavinia Fontana. Fontana became a successful artist in an era when few women in Europe were encouraged to be artists. She received many commissions to paint portraits of wealthy citizens and nobility. The woman pictured in Figure 5-30 certainly has the bearing of a noblewoman. She is standing straight, dressed in finery that only the ruling class could afford. In her left hand, she holds the fur of a marten, which has been decorated with gemstones. She wears pearls and rubies. She does not look toward us, but gazes calmly and coolly to one side. Her unruffled demeanor contrasts with the liveliness of her little dog. At the time this painting was made, it was fashionable for members of the nobility to own small dogs as pets. These pets were called "lapdogs" because they could easily nestle in their owners' laps. The noblewoman is paying little attention to her dog, although her right hand is lifted as if to pat or stroke its back. The dog, on the other hand, appears playful, desperately trying to get its owner's attention. Have you ever seen a dog behave this way? The artist has depicted the woman unnaturally stiff, as was customary in portraits of the time. The dog, however, is shown acting quite naturally.

Now turn your attention to Figure 5-31, a painting titled *Feeding the Dogs*, by American artist David Bates (born 1952). This picture convincingly portrays the special and loving relationship between a man and his six dogs. The artist has chosen to depict his subject in a lighthearted rather than a sentimental way. The figures have been slightly abstracted and simplified, as compared with the highly realistic approach Fontana employed in the other painting. In Fontana's day, such abstraction was unheard of.

Figure 5-30 Even the dog is dressed up for this picture, wearing a tiny silver bell on its collar.

Lavinia Fontana (Italian, 1552–1614), *Portrait of a Noblewoman*, c. 1580. Oil on canvas. 45¼" × 35¼". The National Museum of Women in the Arts. Gift of Wallace and Wilhelmina Holladay.

Comparing Works of Art

Figure 5-31 In this picture, as in the other, it seems easier to pose the dog owner than the dogs.

David Bates, *Feeding the Dogs*, 1986. Oil on canvas. 90.0" × 66.969". ©1994 Phoenix Art Museum. Museum Purchase. Photo by Craig Smith. 87.3.

The man in Figure 5-31 looks like an ordinary man. His clothes are not special, except for the big brass belt buckle emblazoned with an image of a dog. He wears that belt with pride, and obviously enjoys showing off his dogs to the artist and to people who will view this painting. His boots, the setting, and the vehicle and boat in the background all suggest that this is someone who likes to be outdoors. The man seems unaware and unconcerned about muddy paw prints left on his clothes by the frisky dogs. One dog is trying to get its owner's attention, striking a pose similar to the one of the lapdog in Figure 5-30. This spotted dog, however, is clearly not a lapdog.

Do you think the noblewoman would have been unconcerned about muddy paw prints on her dress of velvet and lace, with its gold and silver embroidery?

Why might one person choose to dress up for a portrait, and another choose not to? If you were going to have a well-known artist paint your portrait, how would you like to be dressed?

Why might one artist choose to simplify the background behind the main figures, as Fontana has done, and another artist choose to fill the background with objects and details?

As these two portraits demonstrate, pets in art—like pets in life—can capture our attention and our hearts. Very different artistic styles can express similar messages about people and their pets.

Painting in the Open Air: Claude Monet

France has been home to many artists who have provided unique visual interpretations of nature. One of the most beloved French artists is Claude Monet (1840–1926), whose paintings of gardens and landscapes are much sought after by collectors for their enduring beauty. Crowds have flocked to art museums, waiting in long lines, to gaze at special exhibitions of Monet's artworks.

Monet was a founder of **Impressionism.** *Impressionism is a style of painting that tries to represent forms, colors, and space as they are perceived by the eye.* The Impressionists realized that not everything in our field of vision is in focus all the time. Also, in nature, things are often in movement: waves, clouds, trees all move in the wind, changing the way they look from moment to moment. In addition, the Impressionists observed that sunlight changes in intensity throughout the day, and that shadows change in shape and depth. The intensity of the light affects the way we perceive color. You can see how this works if you take a square of bright red paper into bright sunlight and look at it. Next, carry it into a shaded area. Notice how the intensity of color changes? We know that the actual color of the paper does not change, but its *appearance* to our eyes does.

Impressionists tried to capture their impressions of the constantly changing landscape by applying colors to the canvas in small brush strokes. The viewer's eyes blend the side-by-side colors when the viewer stands back from the work. Black was used very sparingly by Impressionists, because they realized that deep shadows are actually composed of the colors of the surrounding objects and atmosphere. The Impressionists also softened the outlines of forms, which added to the effect of shimmering light by eliminating hard, sharp edges.

A fairly early work from Monet's long career as an artist is shown in Figure 5-32. Titled *Terrace at Sainte-Adresse* (sant ah-DRESS), it depicts Monet's father and other relatives and friends enjoying a sunny day on a patio overlooking the Atlantic Ocean. One would hardly call this a portrait painting, however. Monet has directed his attention to the natural surroundings: the

> "I advise you to paint the best way you can as much as you can without being afraid to paint bad pictures."
>
> **Claude Oscar Monet**

luxurious flower garden, the gentle roll of ocean waves, the play of sunlight and shadow, and the wind curling and snapping the flags. By directing his attention in this way, he can raise *our* awareness of the natural environment through his painting.

Water Lilies. In 1883, Monet settled in a small village named Giverny (gee-vair-NEE), northwest of Paris. There he cultivated fruit trees, vegetables, and a large flower garden. Rose arbors arched over a path leading to a pond filled with water lilies. Flowers bloomed in profusion from early spring until the first frost. The rich, varied colors and the textures and forms of his garden and pond became the dominant subjects of his late work.

Monet's paintings of his water lily pond, one of which is shown in Figure 5-33, are among the most lyrical images of nature ever produced. The subject presented the painter with a great challenge. He was faced with capturing on his canvas many natural elements. In this work, he makes us aware of both the solidity of the shoreline and the liquidity of the water. He has captured the gentle movement of the willow branches overhead and the swaying of the underwater grasses that are just barely visible beneath the pond's surface. The trees, clouds, and blue sky are reflected on the glassy ripples of the water's surface. The pastel-colored water lilies float on the surface, between water and sky. Perceptive viewers marvel at Monet's ability to manipulate colors of paint. From your own experience mixing

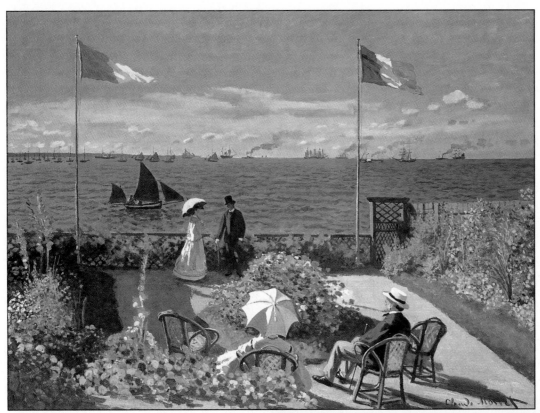

Figure 5-32 In Impressionist style, the artist has lavished as much attention upon the effects of outdoor color and light as on portraying people.

Claude Monet (French, 1840–1926), *Terrace at Sainte-Adresse*. Oil on canvas. H: 38⅝" × W: 51⅛" (98.1 × 129.9 cm.). The Metropolitan Museum of Art, New York, Purchased with special contributions and purchase funds given or bequeathed by friends of the Museum, 1967. 67.241.

Figure 5-33 This is one of many canvases Monet devoted to this complex subject.

Claude Monet, *Waterlily Pond*, 1904. Oil on canvas. 35⅛" × 36⅜". The Denver Art Museum, Colorado. 1935.14.

Student Activity 5

A Closer Look at *Terrace at Sainte-Adresse*

Goals

1. You will practice analyzing a work of art to learn more about its visual qualities and meanings.
2. You will engage in a critical activity that will allow you both to teach and to learn from your peers.

Materials

1. Color reproduction of Claude Monet's painting, *Terrace at Sainte-Adresse*

Directions

1. The class should divide up into four groups. Each group should elect a spokesperson to represent the group in making an oral report.
2. Each group should refer to Monet's painting, *Terrace at Sainte-Adresse* (Figure 5-32).
3. Each group is responsible for doing a visual analysis of one aspect of the painting:
 - Group One: *Describe the space and atmospheric conditions.* For example, is it sunny? In which direction is the sun? Is it windy? How windy? What season of the year is it? What evidence do you have to support your answers? How has the artist created the illusion of space and distance?
 - Group Two: *Describe the color and technique.* What colors has Monet used to cover large areas of the painting? How has Monet distributed colors in order to help achieve visual unity? Which colors are the brightest and most intense? Where are the areas of strongest contrast, light against dark? Can you distinguish the artist's individual brush strokes? Has the artist provided a lot of detail in the objects represented?

- Group Three: *Describe the subject matter*. Try to describe the scene in one sentence. Where are these people? What are they doing? How are they dressed? Why are the women carrying parasols (umbrellas)? Do you think flowers are valued by these people? What type of boats are on the water? Are there any clues (other than knowledge of the artist, title, and date of the painting) that would help someone identify this scene as being set in France in the late 1860s?

- Group Four: *Describe the mood and value of the painting*. What feeling do you get when you look at this painting? Do you think many people would enjoy looking at this painting? Why? In what ways do you think people might value this painting? (You might want to refer back to Section Two of Chapter One, "How Art Is Valued.") Does this painting have aesthetic value? Historical value? Economic value? Explain your answers.

4. After a few minutes in group discussion, get back together with the whole class. Each group's spokesperson should give a brief report on his or her group's findings, trying to be as detailed and descriptive as possible. Help the rest of the class to see what your group saw.

Evaluation

1. Did you participate constructively in your group's discussion?

2. Did you notice things about the painting that you hadn't noticed before? Tell what some of these are.

3. Do you think that you could apply the categories you used to analyze Monet's painting to analyze other landscape paintings? Give it a try! Select another landscape painting from this book, or at a local art museum, and repeat the process.

Claude Monet

Do you ever doodle in your notebook while sitting in class? As a teenager, Claude Monet did. In fact, he spent quite a bit of time drawing cartoons as a way of avoiding the schoolwork he hated. By the time he was fifteen in 1855, his caricatures of the teachers and other inhabitants of the small French seaport town where he lived had become so popular that he was able to sell them for a few francs each. A **caricature** *is a drawing of someone in which certain features have been distorted to achieve a humorous or satirical effect.* Claude's caricatures were drawn in pencil and typically showed a little body with a huge head and funny, exaggerated features, as in Figure 5-34.

Claude's parents didn't know much about art, but they allowed him to take art lessons because they were impressed by his success as a caricaturist. A local art supply and framing shop displayed Claude's artwork in its window, and by age sixteen he had quite a local reputation as an artist. He met painter Eugène Boudin (boo-DA[N]), who was the former owner of the frame shop. Boudin encouraged young Claude to develop his abilities as a painter, and the two of them traveled around the countryside, setting up their easels outdoors and working in the open air. This was truly an innovative approach to landscape painting, since, in the nineteenth century, most painters practiced their art in indoor studios.

By his late teens, Claude was entering his landscape paintings in local art exhibitions, and he was determined to embark on a lifelong career as an artist.

He moved to Paris at age nineteen to continue his training, where he met other young art students who had fresh ideas about painting. One of them, Pierre-Auguste Renoir (p-yair o-GOOST ren-WAHR), painted a portrait of Claude's working in the open air, painting a flower garden (Figure 5-35). Within a few years, Claude Monet would become a pivotal force in the important French Impressionist movement.

Figure 5-34

Claude Monet (French, 1840–1926), *Caricature of a Man with a Large Nose,* c. 1855–56. Graphite on tan wove paper. 24.9 × 15.2 cm. The Art Institute of Chicago, Gift of Carter H. Harrison. Photo ©1994, The Art Institute of Chicago. All Rights Reserved. 1933.895.

Figure 5-35

Pierre-Auguste Renoir (French, 1841–1919), *Monet Painting in His Garden at Argenteuil*, 1873. Oil on canvas. 18⅜" × 23½". Wadsworth Atheneum, Hartford. Bequest of Anne Parrish Titzell. ©1994 Wadsworth Atheneum.

colors, you can appreciate how difficult it was for Monet to create this range of color values without just ending up with a jumble of muddy grays and browns.

Monet was doing more than recording what he saw. He was reminding his viewers that nature, in its movement and change, richness of color, and diversity of form, is always extraordinary, never ordinary.

Section II Review

Answer the following questions on a sheet of paper.

Learn the Vocabulary

The vocabulary terms for this section are *botanical illustration, aquatint, Impressionism,* and *caricature.*

1. Fill in the blanks with the appropriate vocabulary term.
 a. _____ is a printmaking process that involves etching and that produces gray tones in addition to lines.
 b. _____ strived to represent forms, colors, and space as they are perceived by the eye.
 c. _____ _____ is the art of drawing and painting plant forms with extreme accuracy and detail.

Check Your Knowledge

2. Which artist was famous for creating visual reminders of natural environments with black-and-white photography?
3. What two methods are used in atmospheric perspective to achieve a sense of spacial depth?
4. Name two characteristics of the group of artists known as the American Scene artists or Regionalists.
5. What does Impressionism try to represent?
6. What is the subject of those paintings by Monet that are considered to be among the most lyrical images of nature ever produced?

For Further Thought

7. Monet's garden and pond were subjects of his later work. How do you think Monet's gardens influenced his paintings? What surroundings encourage creativity in you?

Section III

Nature and the Built Environment

The relationship of nature and art is found in environments created by human beings. Architects and city planners try to create a harmonious balance between natural and constructed elements of the environment. This tradition has ancient roots. The fabled hanging gardens of Babylon, from the sixth century B.C., are considered one of the seven ancient wonders of the world. A more recent example is Central Park in New York City, a haven of green plants and open sky in the midst of towers of steel, glass, and concrete. Central Park (Figure 5-36) was designed by Frederick Law Olmsted (1822–1903). Olmsted realized that people living in urban areas can tend to lose touch with the refreshing beauty and wonder of nature. His plans for Central Park had a tremendous influence on modern town planning and public park development.

Figure 5-36 Central Park provides city dwellers with places for outdoor activities and quiet reflection.

Photo ©1994 James Blank. FPG International.

A Water Garden

The Water Garden situated in downtown Fort Worth, Texas, is very different than Olmsted's Central Park. Yet in its own way, it is just as refreshing to the senses. In his design for the garden, architect Philip Johnson echoed the geometric forms and straight edges of nearby buildings. The Water Garden's dominant feature is a canyon constructed of broad sloping terraces (see Figure 5-37). Water flows in sheets across the terraces, and spills in torrents from its cliffs and down its gullies. Ever-changing patterns of light and shadow are created as the sun and moon pass overhead. In bright sunlight, the surface of the water sparkles like diamonds. Visitors to the garden in summer enjoy the cool mist that rises from the fountains. People also come to escape the noises of the city by listening to the soothing sounds of water in motion. It is easy to see, in an aesthetically pleasing environment such as this, why garden design is considered an art form by so many people.

Figure 5-37 The Water Garden is a unique environment combining natural and constructed forms.

Philip Johnson, *Water Garden*, 1976. Fort Worth, Texas. Photo ©1994, E. Louis Lankford.

Topiary Gardens

One of the most fanciful elements to be found in parks and gardens is called **topiary** (TOE-pea-airy). Topiary *is the practice of training and clipping shrubs to grow in specific shapes that they wouldn't take on their own*. Often, geometric shapes, such as cones or spheres, are created in topiary. Famous examples of this kind of topiary grow at the Palace of Versailles (vair-SIGH) in France (Figure 5-38). In the seventeenth century, King Louis XIV had a vast garden designed for his pleasure outside the palace. It included fountains, lakes, statuary, tree-lined avenues, millions of flowers, and carefully maintained rows of topiary.

Figure 5-38 Tourists now stand where royalty once stood to admire the gardens at Versailles.

Photo ©1994, E. Louis Lankford.

The creation of topiary requires great patience and attention to detail. It may take years of careful attention to get the desired results. Successful topiary is shaped slowly over time by pruning, and tying the limbs to wire frames.

Sometimes, topiary designs take the forms of people and animals. An ambitious topiary garden of this type was begun in Columbus, Ohio, in 1989. Sculptor James T. Mason set out to recreate a famous painting in topiary. The painting Mason chose was *A Sunday on La Grande Jatte* (grahnd-jhot) (see Figure 5-39 on the next page), by the French artist Georges Seurat (suh-RAH) (1859–1891).

Seurat's painting is notable for its harmoniously balanced composition. Notice how still and calm everything seems. Almost everyone faces toward the water. Only the little dog in the foreground and the girl in the middle ground seem really active. Seurat's painting

style is also remarkable. *A Sunday on La Grande Jatte* illustrates the painting style called **pointillism,** *which means that it is made up entirely of small dots, or points, of color.* (See Figure 5-40.)

Seurat's painting depicts fashionable Parisians strolling, playing musical instruments, boating, and otherwise enjoying a leisurely Sunday afternoon in a shaded waterside park. One woman, carrying a parasol (a small umbrella) to protect her from the sun, is walking a pet monkey. This woman, along with other women in the painting, is wearing a *bustle* (BUS'l). *A* **bustle** *is a framework or padding worn by women to puff out a skirt at the back.* Although it may look odd or even comical to today's viewers, in late-nineteenth-century France it was the height of fashion.

Mason's topiary garden (see Figure 5-41) recreates Seurat's work. It includes over forty people, boats in a pond, dogs, and, of course, the monkey. Since topiaries exist in three dimensions, Mason had the added challenge of figuring out what the far side of the figures looked like—the side Seurat's painting does not show. Just for fun, Mason added a pet not in Seurat's image: he put a topiary cat in the lap of one of the sitting figures whose back is turned toward us in the painting.

Although growing gardens is one way to tie nature in to the built environment, it's also possible to construct buildings that harmonize with wild, natural areas. Beginning on page 256 we will look at a famous example.

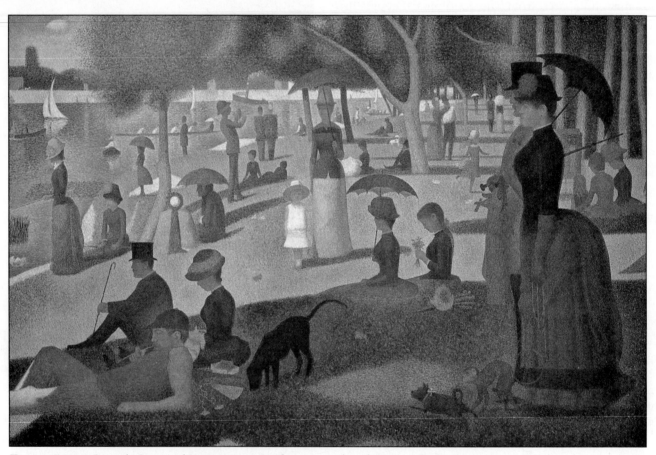

Figure 5-39 It took Seurat three years, using his unusual technique of painting, to depict a leisurely Sunday afternoon.

Georges Seurat, *A Sunday on La Grande Jatte,* 1884–86. French. Oil on canvas. 207.6 × 308 cm. The Art Institute of Chicago. Helen Birch Bartlett Memorial Collection, 1926.224. Photo ©1993, The Art Institute of Chicago. All Rights Reserved.

Figure 5-40 Seurat's meticulous painting technique, called *pointillism*, was very time-consuming.

Georges Seurat, *A Sunday on La Grande Jatte*, (detail).

"Nature has always been a source of inspiration to the artist, and the relationship between art and life is an ongoing concern. Seurat's painting, *A Sunday on La Grande Jatte*, is a work of art about these concerns—about people (life) in a natural setting (a park or garden). It is a timeless theme in Western art

If an artist can paint a picture of a landscape—art mimicking nature—then why not a sculptor creating a landscape of a work of art—nature mimicking art? The topiary garden is both a work of art and a work of nature. It plays on the relationship between nature, art, and life."

James T. Mason

Figure 5-41 Artist Mason refers to his garden as "a landscape of a painting."

James T. Mason, *Topiary Garden*. Photo ©1994, E. Louis Lankford.

Student Activity 6

Pointillist Topiary

Goals

1. You will get to experiment with pointillism as an artistic technique.
2. You will practice rendering areas of highlight and shadow in order to create the illusion of three-dimensional form.
3. You will exercise your imagination in the creation of a proposal for topiary.

Materials

1. Heavyweight white drawing paper
2. Number 4 pencil and eraser
3. Yellow, green, and dark blue or black medium-point markers.
4. *Optional:* Wire, sphagnum moss, small clay or plastic pot, lump of firm clay *or* plaster you can mix yourself, scissors

Directions

1. You might enjoy exercising your imagination in the design of a topiary. First, imagine a possible site in which to plant and grow your topiary. It could be a park, yard, schoolground, or elsewhere. Now imagine what sort of topiary would be good for that space. If you've chosen a park near a zoo, a topiary in the form of an animal would be fitting. If your site is near a library, a giant topiary in the form of an open book might be good. Near an art museum, a figure from one of the paintings or sculptures in the museum's collections could be perfect. You decide.
2. After you've decided what form you want your topiary to take, use your preliminary sketches, pictures or photographs to serve as references as you sketch the outline of your proposed topiary on your sheet of paper, in pencil.
3. This step is important! After you have drawn the outline of your topiary, decide where the light will be coming from to illuminate it. Imagine that your paper forms the face of a clock; a good place to position your light source would be at 10:00 or 2:00. Lightly draw a small circle on the paper where you want your light source to be. This will determine where the shadows will fall in your drawing (see Figure A).

Figure A

Figure B

4. Using your yellow marker, evenly fill in your outline with small dots. Also, add yellow dots to indicate a patch of ground under your topiary.

5. Now, use your green marker to fill in the outline with small points of color, only this time space your dots farther apart on the side facing the light, and closer together on the side away from the light. Also, add green dots to the ground under the topiary.

6. Next, take your dark blue or black marker and use dots to indicate shadows. Spacing the dots closer together as you move away from the light source will create a gradual change from light to dark. This will give your drawing the look of three-dimensional mass.

7. Add dots using your blue or black marker to indicate the shadow your topiary would cast on the ground. (See Figure B.)

8. Use your eraser lightly to remove any distracting pencil lines.

9. *Optional:* Create an actual three-dimensional scale model of your topiary using wire and sphagnum moss, which is available from gardening and craft supply stores. Start by forming a wire armature, or frame, in the shape of your topiary. Securely plant your wire frame in a lump of clay or in plaster poured into a small pot. Stuff the frame tightly with moss. Use scissors to trim off any untidy surfaces.

Evaluation

1. Did you succeed in achieving the look of three-dimensional mass in your drawing?

2. How would your drawing have been different if you had placed the light source in a different location?

3. Do you think that you could apply this shading technique when making other drawings or paintings?

Living in Harmony with Nature: Frank Lloyd Wright's Fallingwater

Imagine living in a house so artistically designed that it has been compared with sculpture—a house some have called the most architecturally significant private residence of the twentieth century. Now imagine living in a house where the sounds of a natural stream and the wind whispering through the trees lull you to sleep at night. Each of these descriptions fits a house built for Edgar Kaufmann and his family. Designed by architect Frank Lloyd Wright (1869–1959), this house is nestled in the wooded hills of Pennsylvania.

There are no formal gardens surrounding the Kaufmann house. Instead, Wright designed the house to take full advantage of its wooded hillside location. Huge trees form a leafy canopy over the broad balconies. At some points, the balconies and overhangs have openings that allow trees to grow up through them! Rock outcroppings on the hillside were left in place, and the living room was built around them. Boulders form part of the fireplace and floor. Large windows open onto splendid views of spring greens, autumn reds, and snowy winter whites. But the most dramatic and unique feature of the house is its relationship to Bear Run, a creek flowing through the property. Bear Run has a small but picturesque waterfall, and it is this feature that inspired the name of the house: Fallingwater (see Figure 5-42).

Wright did not choose to build the house *beside* the waterfall, as one might have expected. Instead, he incorporated the falls into the overall design of the house. The house is made up of a series of horizontal terraces that extend from the hillside. These terraces are suspended directly *above* the cascading water. The look and sound of the water, and the feel of its cool mist, are literally part of the life of the house and its occupants. Wright wanted Fallingwater to be more than a house built on a landscape. He wanted it to become part of the landscape, to complement the natural setting perfectly (see Figure 5-43).

The Kaufmann family no longer lives at Fallingwater. Realizing that the house was historically and aes-

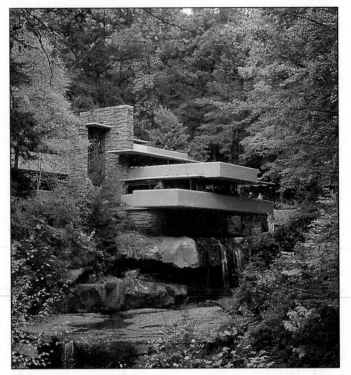

Figure 5-42 This famous woodland retreat is aptly named.

Frank Lloyd Wright, *Fallingwater*, built 1935–1937. Photo ©1994, E. Louis Lankford.

Figure 5-43 Wright's famous design perfectly complements the landscape.

Frank Lloyd Wright, *Fallingwater* (detail). Photo by E. Louis Lankford.

thetically important, Edgar Kaufmann, Jr., donated the house to the Western Pennsylvania Conservancy, an organization dedicated to the preservation of wilderness areas and endangered species. Today, visitors from all over the world come to see and tour this unique house.

> "No house should ever be on a hill or *on* anything. It should be *of* the hill. Belonging to it. Hill and house should live together, each the happier for the other."
>
> **Frank Lloyd Wright**

THE ARTIST AS A YOUNG ADULT

Frank Lloyd Wright

Frank Lloyd Wright always liked to say that his mother had decided, even before he was born, that he would become a great architect. It is true that Anna Wright was a determined, indulgent, and supportive mother who was convinced that her firstborn child was destined for greatness. She provided young Frank with blocks, colored paper, and cardboard to encourage his creative efforts. He loved to arrange these materials, making small furniture, buildings, and cities. As an adult, he maintained that these early experiences greatly affected the kind of architect he was to become.

As a teenager in the 1880s, Frank spent his summers at his uncle's farm near Madison, Wisconsin. Country life and the beauty of nature appealed to him. He was later to build his famous estate and design studio, called Taliesin (tah-lee-ES-en), in this countryside.

Young Frank enjoyed reading, which he did almost constantly. He was obviously very bright. His low marks in school did not reflect his abilities. Some biographers think that he was distressed about his parents' divorce, and that led to his poor performance in classes. He failed to graduate from high school. In spite of this, when he was eighteen he managed to gain admission to the University of Wisconsin as a special student. There he studied engineering briefly before setting out for Chicago. In Chicago he hoped to gain some practical experience in the field of architecture.

Frank could draw well, with precision, and that helped him land a job at age twenty in the prominent architectural firm of Louis Sullivan. Sullivan became a mentor for Frank, teaching, guiding, and inspiring him. In 1893, when he was in his midtwenties, Frank opened his own architecture firm in Chicago. He soon gained recognition for his innovative designs. Frank Lloyd Wright's plans for houses, hotels, office buildings, auditoriums, and churches made him the most renowned architect of the twentieth century.

> "It has served well as a home, yet has always been more than that: a work of art, beyond any ordinary measures of excellence . . . House and site together form the very image of man's desire to be at one with nature, equal and wedded to nature."

Edgar Kaufmann, Jr., an original occupant of Fallingwater

Section III Review

Answer the following questions on a sheet of paper.

Learn the Vocabulary

The vocabulary terms for this section are *topiary*, *bustle*, and *pointillism*.

1. Define the vocabulary terms by using each one correctly in a sentence.

Check Your Knowledge

2. What famous park did Frederick Law Olmsted design?
3. What pet did James Mason add to his topiary recreation of *A Sunday on La Grande Jatte*?
4. What inspired the name of Frank Lloyd Wright's architectural masterpiece, *Fallingwater*?

For Further Thought

5. While we can't all live in a house like Fallingwater, we can still enjoy nature in our homes. What inexpensive changes could you make in your bedroom to create a harmonious blend of natural and constructed elements? What changes could be made to the lawn and exterior of your family's home?

Section IV

Unconventional Interpretations of Nature

Some artists give us new ways of looking at nature. Their images may be quite different from the way most of us see the world. Dutch artist Vincent van Gogh was powerfully affected by the coarse textures and brilliant colors of the landscape of southern France. The style of painting that van Gogh developed was unique among his contemporaries. It was vigorous, with bold but controlled brush strokes, each one heavily laden with vibrant color. Van Gogh seemed to be trying desperately to convey the living presence of nature—the ever-changing sky, the movement of leaves and grasses,

Student Work

Jacob McNeil, 17
Logan High School; Logan, UT

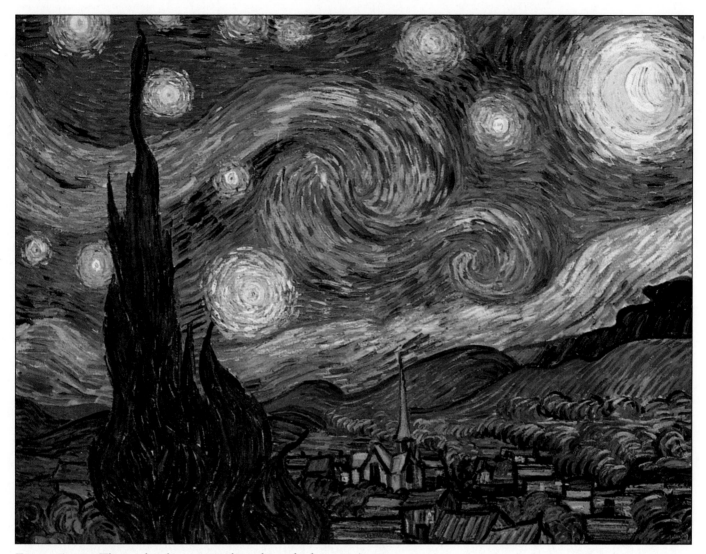

Figure 5-44 The night sky comes alive through the artist's vision.

Vincent van Gogh, *The Starry Night*, 1889. Oil on canvas, 29" × 36¼". The Museum of Modern Art, New York. Acquired through the Lillie P. Bliss Bequest.

the hard surfaces of rocks and mountains, the soft shapes of clouds. One of his most powerful images is shown in Figure 5-44. Titled *The Starry Night*, it features swirling masses of stars and constellations sweeping across the night sky. The cypress tree in the foreground echoes the twisting, turning movement of sky. In contrast to the natural environment stands a quiet little village, painted with neat and stable horizontal and vertical lines.

Even with pen and ink, van Gogh breathed life into his work. In *Grove of Cypresses*, Figure 5-45 on the next page, he represented the knotted, twisted growth of the trees with a cluster of tightly braided lines writhing upward to the sky. Beneath the trees, grasses bend and curl like breakers on a beach. Rocks and flowers appear to be scattered about like confetti. Nothing is entirely still in this picture. Even the clouds appear to dance.

It is hard for us today to imagine that van Gogh's genius was scarcely recognized in his lifetime. The remarkable vision and energy of his work must have seemed quite radical and strange to art patrons of the day. They were used to darker, more academic works

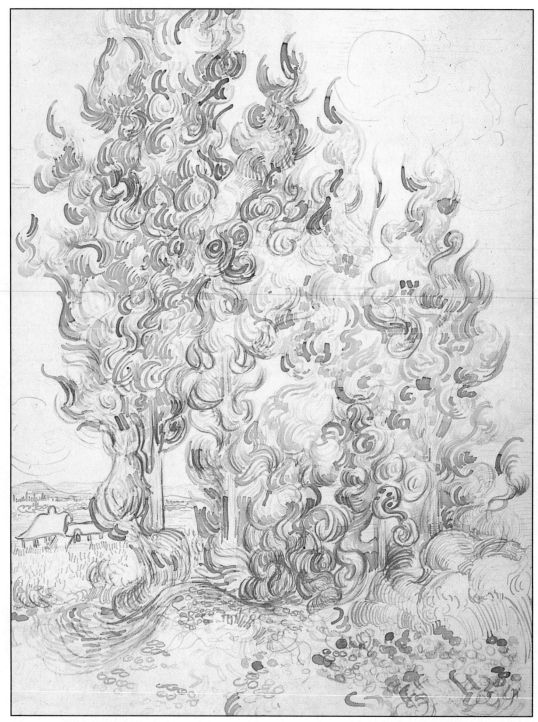

Figure 5-45 Compare the movement in this drawing with the painting by the same artist in Figure 5-44.

Vincent van Gogh, *Grove of Cypresses*, 1889. Dutch. Reed pen and ink over pencil on paper. 62.5 × 46.4 cm. The Art Institute of Chicago. Gift of Robert Allerton. 1927.543. Photo ©1993, The Art Institute of Chicago. All Rights Reserved.

Student Activity 7
Landscape Drawing

Goals

1. You will develop your line drawing skills.
2. You will exercise your perceptual skills when viewing a landscape.
3. You will study the drawing techniques used by a great artist.

Materials

1. Heavyweight white drawing paper
2. Number 4 pencil
3. Eraser
4. Crow quill pen and black ink, *or* black felt marker, fine point
5. Drawing board, thumbtacks or tape

Directions

1. Study closely the pen-and-ink drawing by Vincent van Gogh (see Figure 5-45). Notice how he has used short parallel lines to create form and texture. Sometimes he used small dots and circles. He has used bolder, heavier lines for many of the objects in the foreground, and finer, thinner lines to indicate objects farther away. These are techniques you should use in your landscape drawing.
2. Tack or tape your drawing paper to a flat, smooth drawing board. Carrying your drawing tools with you, find an outdoor setting you would like to draw. You don't need a broad vista, nor do you need to draw the entire panorama of a landscape. You may choose a clump of trees, a group of rocks and weeds, or a small garden.
3. Using the techniques we've discussed, lightly sketch your drawing on your paper with pencil. When you are satisfied with the proportions, ink over the pencil lines. The ink drawing should be much more carefully rendered and detailed than the pencil drawing. Use many small strokes, dots, circles, and squiggly lines to indicate textures.
4. When the ink has completely dried, lightly erase the excess pencil lines. It is not necessary to try to remove all indications of the pencil drawing. You can frequently see pencil sketches under the ink or watercolor pictures created by artists.

Evaluation

1. Have you created the illusion of form, texture, and space in your drawing by using only lines? Describe how you did so.
2. Did you study carefully the van Gogh drawing, and try to learn from his technique? What are some techniques you noticed in van Gogh's drawing that you tried to apply?
3. Did you look closely at the landscape, and do your best to reproduce its visual qualities in your drawing? What are some strong points in your drawing? What are some points you are less satisfied with?

which had smoother surfaces, carefully blended brush-strokes, and more traditional forms of realism.

Beasts of the Sea

Like van Gogh, Henri Matisse (o[n]-REE mah-TEESE) (1869–1954) was drawn to the south of France by the brilliant colors. Matisse was a sculptor, painter, and book illustrator who frequently included natural elements in his compositions. His many still lifes and paintings of room interiors often included fruit, flowers, and wallpaper and fabric printed with floral motifs. Frequently, an open window in the painting would offer a glimpse of sunny blue skies, palm trees, or the sea. Matisse wanted to create serene and joyous art. His work is unique, characterized by broad areas of flat, bright color punctuated by richly patterned design.

As he grew older, Matisse had difficulty standing at his easel. He began to create cut-paper designs. As he tried to take full advantage of this medium, his images grew more and more abstract. He explored color relationships, and simplified forms into silhouettes. Some of his cut-paper compositions were as large as a mural. *Beasts of the Sea*, Figure 5-46, is an example of his late style. Totally abandoning realistic representations, Matisse managed to capture the color harmonies of a blue-green sea, the bright pink and yellow accents of reefs, and the mysterious, fluid movements of fish, seaweed, and other tiny sea creatures. The depth of the water is emphasized by narrow, layered arrangements of form and color.

> "**W**hat I dream of is an art of balance, of purity and serenity, devoid of troubling or depressing subject matter . . . like a mental soother, something like a good armchair in which to rest from physical fatigue."
>
> **Henri Matisse**

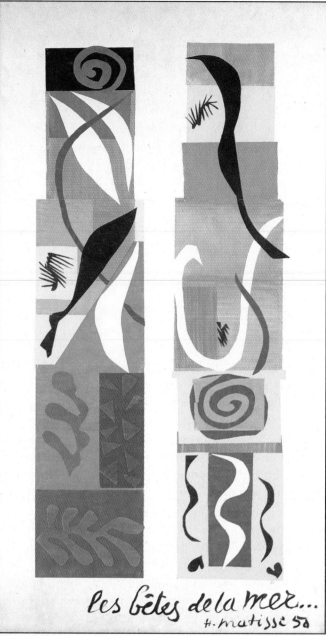

Figure 5-46 Matisse was remembering his visit to the South Seas as he made this picture. Do you see the sea snail?

Henri Matisse (French 1869–1954), *Beasts of the Sea*, 1950. Paper collage on canvas. 116⅜" × 60⅝" (2.955 × 1.540 cm.). ©1994, Succession H. Matisse/Artists Rights Society (ARS), New York. Courtesy, National Gallery of Art, Washington, D.C., Ailsa Mellon Bruce Fund. 1973.18.1(PA).

Playful Creatures

Another abstracted image of nature can be seen in Figure 5-47. The Spanish artist Joan Miró (zhuh-WAHN mee-ROH) (1893–1983) has presented us with a playful and imaginative study of birds. Little faces, stars, wiggly lines, and bright spots of primary colors form a lively and rhythmic composition. Miró wanted to keep his art simple. He wanted his art to express the wonder a child might feel toward his subjects. Often he would try to blend in his artworks a sense of the public, visible world and of his private, inner dreams. His birds demonstrate the ability of an artist to be spontaneous, yet controlled enough to achieve a well-organized and visually pleasing result.

Figure 5-47 In this composition, the artist has masterfully blended spontaneity and control in his technique.

Joan Miró, *Les Oiseaux (The Birds)*, n.d. Lithographic print. 21¼" × 29¼". Columbus Museum of Art, Ohio; Long-term Loan from Mrs. A.H. Thomas. ©1994 Artists Rights Society (ARS), New York/ADAGP, Paris.

Perhaps even more playful than Miró's birds are the lizards pictured in Figure 5-48. *Dancing Lizard Couple*, by Ann Hanson, is a whimsical portrait of two jolly reptiles kicking up their heels. Hanson's animals are *anthropomorphic*. **Anthropomorphism** *is the process of attributing human characteristics, movements, or behaviors to an animal.* Hanson has accomplished this with her lizards that appear to dance together like humans. Hanson (born 1959) has accentuated the liveliness of

Figure 5-48 To what kind of music do you think these whimsical creatures are dancing?

Ann Hanson (American, b. 1959), *Dancing Lizard Couple*, 1985. Celluclay. 16½" × 20½". The National Museum of Women in the Arts, Washington, D.C. On loan from the Wallace and Wilhelmina Holladay Collection.

her sculpture by covering its surface with intricate patterns of triangles and circles. The lizards gesture energetically. It's easy to imagine their curling tails swinging to the rhythm of dance music.

A Strange Jungle

Henri Rousseau (roo-SO) (1844–1910) was a French artist whose vivid imagination matched his careful study of nature. The results were beautiful, yet fantastic. In his lifetime, Rousseau could never afford to visit the tropical jungles he was so fond of painting. Instead, he became obsessed with stories, illustrations, and photographs of the steamy climates around the equator. Among Rousseau's favorite pleasures was visiting the zoo in Paris. There he spent countless hours sketching the animals that came from the jungle. In the Paris Botanical Garden, he painstakingly sketched tropical plants. These sketches, combined with pictures he saved from magazines and books, formed the basis of his work.

Figure 5-49 is one of Rousseau's most exciting images. As you can see, despite his constant study and careful sketching, Rousseau was not a realistic painter. He frequently combined animals and plants that do not appear together in nature. He shows us the jungle of his own vivid imagination, and an exciting place it is.

Rousseau invented a unique way of conveying a sense of depth in his paintings. Overlapping flat planes of carefully outlined shapes stretch across his canvases. The planes most hidden from view appear the most distant. This creative method of displaying perspective is especially impressive when we consider that Henri Rousseau could not afford formal artistic training.

His paintings often feature a moment of conflict in the jungle—a tiger attacking a buffalo, for example, or a gorilla wrestling with a hunter. In *Surpris!*, Figure 5-49, movement is evident in the leaves and branches as they bend in the wind of a violent rainstorm. Streaks of lightning flash across the darkened skies. The title of the work makes us think. What is the surprise? Is it the tiger who is surprised, perhaps by the lightning, or is the tiger about to surprise some unseen prey?

Figure 5-49 Who, or what, is the surprise?

Henri Rousseau, *Tropical Storm with a Tiger (Surpris!)*, 1891. Oil on canvas. 51⅛" × 63¾". Reproduced by courtesy of the Trustees, The National Gallery, London.

A Landscape in Steel

The next artist we'll consider is an American sculptor, David Smith (1906–1965). Trained as a metalworker in an automobile factory, Smith used this skill to create art out of welded iron and steel. He thought it was particularly appropriate to make contemporary art with modern materials and techniques. He even incorporated industrial metal scrap and cast-off hardware into his pieces.

Smith pioneered the creation of freestanding metal sculpture that has an open form—that is, sculpture that allows air to pass through it as well as around it. He considered gravity a force to be challenged in his work,

Student Activity 8

Dancing Creatures

Goals

1. You will develop your ability to imaginatively model a three-dimensional form.
2. You will practice working with paints and patterns.

Materials

1. Air-drying modeling clay or modeling compound
2. 9" square piece of Masonite or plywood
3. Ceramic tools, water bucket, plastic sheeting
4. Acrylic paints, brushes, medium, and varnish
5. Books, magazines with pictures of animals

Directions

1. You are going to create a dancing creature couple. Use as your inspiration Ann Hanson's whimsical *Dancing Lizard Couple* (Figure 5-48). First, decide what sort of animal or animals you'd like to represent. You will need to decide whether you want two of the same kind of animals dancing together, or two different kinds of animals. Find pictures of those animals to refer to. However, you are not going to try to make a realistic sculpture of your animals.

2. Prepare your modeling clay according to your teacher's directions or the directions on the package. You will need two lumps about the size of baseballs or oranges. You may have to knead the clay in your hands to soften it up and make it easier to work with.

3. Using your Masonite as a base, shape your dancing creatures by hand. Give them lively gestures. Use ceramic tools, if you have them, to help you shape the clay and add surface details and patterns.

4. If you have to leave your sculpture for a long period of time, wrap it in plastic to keep it from drying.

5. When you have finished modeling your creatures, let them dry in the air until they are hard.

6. Use acrylic paints to paint your creatures. You may want to give them colorful patterns. Finish with a coat of clear acrylic varnish.

7. When all the creatures in class are completed, create a dance-floor setting in a display case and arrange your sculptures in it.

Evaluation

1. Did you prepare your clay according to the directions?
2. Did you make your animals anthropomorphic, or human-like, in their gestures? Describe how.
3. Did you thoroughly clean up your work space after working with the clay and paints? Why is it important to do this?

266

and his piece *Hudson River Landscape* (Figure 5-50)—with its broad linear forms perched atop a narrow base—does seem to defy gravity. Smith shows us his landscape from multiple points of view. We can see a rolling hill against the horizon, and a pond is viewed from above. The curving contour lines look like a topographical map on which changes in elevation are indicated. Smith has allowed himself a great deal of freedom in representing the landscape. The sweeping lines and rhythmically placed angles work together to pay special homage to the wide-open spaces. What a difference from the landscapes produced by the Hudson River School (see Figures 5-26, 5-27, and 5-28)!

"This sculpture came in part from dozens of drawings made on a train between Albany and Poughkeepsie, a synthesis of ten trips over a 75 mile stretch . . . I want the viewer to travel by perception the path I travelled in creating it."

David Smith

Figure 5-50 This sculpture is a modern artist's interpretation of nature in steel.

David Smith (American, 1906–1965), *Hudson River Landscape*, 1951. Welded painted steel and stainless steel. 49¹⁵⁄₁₆" × 73¾" × 16⁹⁄₁₆" (126.8 × 187.3 × 42.1 cm). Collection of Whitney Museum of American Art, New York. Purchase. Photo by Jerry L. Thompson, New York. 54.14. ©1994 Estate of David Smith/VAGA, New York.

High-Tech Dragonfly

Many artists continue to create art by using the most modern materials and techniques available. In the past twenty-five years, computers have emerged as a popular medium for artists and designers. You might think that computers are an unlikely tool for relating art and nature, since the computer artist often spends long hours in a closed room, punching keys on a keyboard and gazing at an electronic screen. Indeed, computer artist Marsha McDevitt admits that sometimes she feels isolated from nature because of the time she spends in a technological environment. The urge to keep in touch with nature is partly what motivated her to create *Sundays* (see Figure 5-51), a vivid bug's-eye view of an imaginary glade of lilies. A dragonfly hovers in the air overhead, suspended by its rapidly beating wings. McDevitt, like artists throughout the ages, has provided us with an intimate portrait of nature. At the same time, she is trying, like other artists, to refine her control of a complex artistic medium.

Figure 5-51 Even computers have been used artistically to explore the organic forms of nature.

Marsha McDevitt, *Sundays*, 1985. Detail from computer-generated image. ©Marsha McDevitt, The Ohio State University. (See page 197 for full reproduction.)

Earthworks

This chapter has described a variety of approaches that artists have taken to nature. Some have chosen to represent nature through standard forms such as drawing, painting, and sculpting. Their images may be realistic, idealistic, or abstract. Others have worked with natural elements such as reeds, fur, and feathers. Landscape architects and garden designers alter natural spaces to complement the built environment.

But there is another aspect of the art-and-nature relationship that deserves our attention. This is the creation of artworks that actually become *part of the landscape*. These are called **earthworks.** An earthwork *is a site-specific work of art, which means that it is a work designed for a particular place. Earthworks depend on the natural environment for their existence, their impact, and their meaning.* Some artists have designed cavelike structures or tunnels with small windows that open to the sun, moon, and starry night sky. Some have dug shallow trenches that etch simple designs in sandy soil (see Figure 5-52). Some have placed rows of stones across hilly landscapes, as if marking mysterious paths that lead to no particular place.

Many earthworks are in remote areas, difficult to reach. Once there, visitors cannot view the entire work from any single position. They must walk around, over, and sometimes through it. Sometimes it is necessary to see it at different times of day in order to appreciate it fully, just as the view of any landscape will change with the passing hours and seasons. Like the natural environment, earthworks are subject to the effects of wind, rain, and other natural causes of erosion, deterioration, and destruction. In some cases, all that eventually remains are photographic and written records.

Michael Heizer (born 1944) is an artist who pioneered the creation of earthworks. Heizer wanted to express his feelings about the western American wilderness areas. The wilderness he saw was vast and barren—limitless miles of rocky plains with distant, hazy mountain ridges stretching across the horizon. He saw deep, wide canyons under a huge, intensely blue sky, perhaps punctuated by a lone circling vulture. The quietness, the stillness, seemed very powerful to Heizer.

As no museum or gallery could contain the works Heizer dreamed of, he chose to work directly *in the*

Figure 5-52 Earthworks are meant to be part of the landscape. This one is reminiscent of some mysterious prehistoric hieroglyph.

Michael Heizer, *Rift,* 1968 (deteriorated). #1 of "Nine Nevada Depressions." 1.5-ton displacement on playa surface. 75′ × 300′. Location: Jean Dry Lake, Nevada. Commissioned by Robert Scull. Photo ©1994, Michael Heizer.

landscape itself. Heizer wanted to convey, in a simple and direct way, the idea that both the whole and the particular are important. In other words, the vast landscape is a presence to be reckoned with, yet each pebble, each gnarled shrub also has its own significance.

Most of Heizer's early works were geometric forms. However, a project that he completed over a three-

year period (1983–1985) resulted in five representational, though abstract, shapes. Each shape is an **effigy,** *which is a likeness or representation of a person or other living thing.* Heizer's *Effigy Tumuli Sculptures* are five mounds of grass-covered earth in the shapes of a snake, a turtle, a frog, a catfish, and an insect called a water strider. This insect has the remarkable ability to walk

on the surface of pond water. The *Water Strider* sculpture is shown in Figure 5-53. It is fourteen feet high, and its legs sprawl over 685 feet of land.

The *Effigy Tumuli Sculptures* are part of the Buffalo Rock Reclamation Project near Ottawa, Illinois. This project was a cooperative effort of a corporation, a nonprofit organization, the state of Illinois, and the federal government. Its purpose was to reclaim a 200-acre site that had been a coal-mining facility. The site, on a bluff overlooking the Illinois River, had soil so toxic that it could support no vegetation. The runoff from rain showers was polluting the river. Creatures native to the area, such as those represented by the effigy mounds, were dying or leaving. Perhaps this is

why Heizer chose to call his earthworks *Tumuli Sculptures*. The word **tumulus** *refers to a mound over a burial site. Tumuli is the plural form.* Part of the reclamation project was to neutralize the toxicity in the area. Gradually, plants have reemerged and wildlife has returned.

Construction of these sculptures required heavy earth-moving equipment. The people who operated the machinery had previously constructed roads and dams. At first, they didn't seem to take the project of building earthworks seriously. However, after they viewed the work in progress from helicopters, they became excited about it, and proud of their contributions.

Figure 5-53 This huge sculpture is part of a landscape that has been reclaimed from pollution.

Michael Heizer, *Water Strider*, one of five "Effigy Tumuli Sculptures," 1983–85. Compacted earth. 770′ × 18′ × 280′. Location: Buffalo Rock State Park, Ottawa, Illinois. Commissioned by the State of Illinois. Photo ©1994, Michael Heizer.

Figure 5-54 The purpose of this ancient mound remains a mystery. Today, the serpent is encircled by pathways for visitors.

Great Serpent Mound. Probably built by the Adena culture, c. 100 B.C.–A.D. 700. Near Locust Grove, Ohio. Photo courtesy of the Ohio Historical Society.

Ancient Mound Builders

Heizer's earthworks are reminiscent of the work of the mysterious, prehistoric Mound Builders who lived in the eastern United States, from the Atlantic coast to the Great Plains, from about 1000 B.C. to A.D. 1000. Little is known of these people. Archaeologists have tried to reconstruct their way of life from surviving artifacts. The Mound Builders were, in fact, people from several cultures, who inhabited overlapping regions. They built huge mounds by using simple tools and by carefully layering clay, sand, and gravel collected from floodplains. Many of the mounds were burial sites. Some seem to have been forts, or meeting places. The mounds are in various shapes. Some are geometric: squares, circles, octagons, and spheres. Others, such as the one shown in Figure 5-54, are animal-like shapes that are not always easy to identify. They are highly **stylized** forms. This *means that the natural form has been changed or abstracted in order to fit the artistic traditions and styles of a culture.*

Figure 5-54 is one of the largest effigy mounds in the world, and among the most famous. Many archaeologists consider it to be the finest Native American effigy mound in North America. The *Great Serpent Mound* extends almost one-quarter of a mile in length across a ridgetop. It has an average width of twenty feet, and an average height of five feet, although these dimensions are smaller than they once were due to erosion. The mound's twists and turns are graceful and symmetrical. The serpent's tail is coiled in a perfect spiral. In the nineteenth century, people who studied this ancient mound thought that the oval at its head represented an egg in the serpent's mouth. Many experts

today think it represents the wide-open mouth of a snake. No evidence has been found to indicate that this mound was a burial site. Nor is there evidence to suggest that people lived at the mound site, although both burial mounds and habitation sites have been discovered nearby. Scientists are not even certain about which ancient culture built the mound. There is still much to be learned. But whoever built it, for whatever purpose, it remains an extraordinary and striking visual expression of a culture.

Spiral Jetty

The spiral shape of the tail of the *Great Serpent Mound* can be seen again in the contemporary earthwork titled *Spiral Jetty* (Figure 5-55). Designed by artist Robert Smithson (1938–1973), *Spiral Jetty* extends 1,500 feet out from the northeastern shore of Utah's Great Salt Lake. It ends in a concentric triple spiral. This shape was chosen to echo the spiraling form of salt crystals found on rocks surrounding the lake. Also, it recalls an old legend about a giant whirlpool in the lake's center caused by an underground channel that supposedly connected the lake with the sea. *Spiral Jetty* has often been underwater, as the water level of the Great Salt Lake may change significantly from year to year. Each time it reemerges part of it has eroded, and other parts have been encrusted with mineral deposits.

Figure 5-55 Smithson's jetty curves inward and disappears into the pink water of the Great Salt Lake.

Robert Smithson, *Spiral Jetty*, 1970. Photo ©1994, Gianfranco Gorgoni, Contact Press, New York.

THINKING ABOUT

AESTHETICS

Artist Robert Smithson, who created *Spiral Jetty* (Figure 5-55), wanted to reclaim abandoned mines and quarries and recycle them as art by constructing earthworks on the sites. This is a different approach to reclamation than attempting to restore an area to its natural wilderness state. Read all the questions below before answering any of them.

1. What do you think of the idea of earthworks used to reclaim polluted or spoiled landscapes? Do you think it's a good idea? Tell why or why not.

2. Should earthworks be used, in at least some cases, as monuments to remind people of our responsibility to protect the natural environment? Provide reasons to support your answer.

3. Do you believe that sites that have been devastated by human misuse should always be returned to their natural state, when possible? Explain your answer.

The Lightning Field

One of the most unusual and dramatic earthworks ever constructed was *The Lightning Field*, created in the 1970s by artist Walter De Maria (born 1935). De Maria was fascinated by the power and visual intensity of lightning, so he designed an earthwork to harness lightning bolts! *The Lightning Field* (Figure 5-56) consisted of 400 metal rods planted in a stretch of desert in New Mexico. The rods were evenly spaced in a grid pattern that was approximately one mile square. The average height of the rods was twenty feet.

It is ironic that *The Lightning Field* looked its best when it was unsafe to be near it—when lightning crackled from thunderheads and struck the desert floor. The artist situated this earthwork in a remote area. At

dusk each day, the stainless steel poles gleamed in the pink and golden sunlight, casting long shadows across the rough terrain. The rows of steel accentuated the vastness of the desert landscape. The grid pattern was meant to remind us of the artificial boundaries people have invented—boundaries that divide the natural world into property that can be "owned." *The Lightning Field*, like other unconventional interpretations of nature, surprises us with the artist's unique vision. Artists can heighten our appreciation of nature *and* art by providing new and meaningful visual experiences.

Figure 5-56 The awesome power of nature plays a starring role in this work of art.

Walter De Maria, *The Lightning Field*, 1974–1977. Stainless steel poles. Average height of poles: 20'7½"; overall dimensions: 5,280 feet by 3,300 feet. Near Quemado, New Mexico. Collection of the Dia Art Foundation. ©1994 Dia Center for the Arts. All reproduction rights reserved. Photo by John Cliett.

Section ⓘ Review

Answer the following questions on a sheet of paper.

Learn the Vocabulary

The vocabulary terms for this section are *anthropomorphism*, *earthwork*, *effigy*, *tumulus*, and *stylized*.

1. Match the following descriptions to the correct vocabulary term.
 a. When a natural form has been changed or abstracted from nature in order to fit the artistic styles and traditions of a culture
 b. A site-specific work of art that depends on the environment for its existence, impact, and meaning
 c. A mound over a burial site

Check Your Knowledge

2. Describe at least two characteristics of van Gogh's style of painting.
3. What setting did Henri Rousseau frequently use in his paintings?
4. What five shapes did Heizer use in his *Effigy Tumuli Sculptures?*

For Further Thought

5. Newer and unconventional art forms are often treated with skepticism at first. What are your feelings toward computer-generated art? Do you feel that these artists are the same kind of artists as Matisse and van Gogh? Why or why not?

Student Work

Edwin McSwine, 18
Whitehaven High School; Memphis, TN

SUMMARY

From architects to painters, mask makers to quilters, artists all over the world have recognized that we are not merely visitors here, we are part of the planet earth. Our relationship with the natural environment is one we cannot avoid and should not ignore or take for granted. Air and water, sunshine and storms are part of daily life. Our actions and attitudes toward the environment can affect the quality of life on earth today and in the future.

Throughout human history, artists have expressed in visual forms the many moods and aspects of the natural world. They have revealed nature's wonders, celebrated its beauty, and tried to capture its awesome power. In doing so, they have reflected society's attitudes and values toward nature, and influenced the way people think, feel, and act toward the environment. You can join artists and patrons of the arts in trying to understand, appreciate, enhance, and celebrate the relationship between nature and humankind.

CHAPTER 5 REVIEW

VOCABULARY TERMS

Choose a vocabulary term that refers to a type of artwork, and then write a short paragraph describing an example of that type of artwork.

album quilt	bustle	Impressionism	stone pictures
anthropomorphism	caricature	motif	stylized
aquatint	earthworks	Mogul	topiary
baren	effigy	Paleolithic	tumulus
botanical illustration	gold leaf	pointillism	ukiyo-e

Applying What You've Learned

1. When did humans begin depicting nature in art?

2. What subjects are the artists of the Hudson River School famous for painting?

3. Describe how any one of the following artists has given us a new way of looking at nature: Vincent van Gogh, Henri Matisse, Joan Miró, Henri Rousseau, David Smith, Marsha McDevitt, or Michael Heizer.

Exploration

1. Each culture provides a different artistic interpretation of nature. Research further the differences between Japanese ukiyo-e art, the Hudson River School, and French Impressionism. How are their interpretations similar? How are they different? Draw a scene of nature in the three different styles listed above.

Building Your Process Portfolio

In this chapter you have surveyed many works of art from different cultures around the world and across history. All of these were in some way related to nature. By now, you must have formed certain opinions about the relationship of nature to art and to humankind. You have also had the opportunity to write about, discuss, and make art by following the directions given in the Student Activities and other special feature boxes. Here are some things you may wish to include in your process portfolio:

- Preliminary notes and sketches, along with finished artwork (Mark the pages in your sketchbook you have filled while studying this chapter.)

- Written reflections or an essay expressing your own thoughts and feelings toward the environment; include some comments about how these thoughts and feelings have become important to your work in making art and in art criticism

- Responses to questions asked in the Section and Chapter Reviews, and in the *Aesthetics, Criticism, and Cultural-Historical* special feature boxes

- Newspaper and magazine clippings focusing on the environment, with your comments about how ideas or issues contained in these articles might be worked into your artworks

Cities and Art

Figure 6-1 Georgia O'Keeffe has captured the drama of the city at night.

Georgia O'Keeffe, *Radiator Building—Night, New York*, 1927.
Collection of Fisk University Galleries, Nashville, Tennessee.
©1994 The Georgia O'Keeffe Foundation/Artists Rights Society
(ARS), New York. Photo by Malcolm Varon, New York.

Contents

Section I The Beginnings

This section will offer information on how and why the first cities were formed.

Section II Rebirth and Innovation

In this section you will learn about the importance of cities to the innovative spirit of the Renaissance. You will also discover the importance of linear perspective to the art of the city. Finally, you will be introduced to the practice of patronage.

Section III The City as Social Environment

In this section you will explore how artists have portrayed the subject of everyday life and leisure in a city environment. You will discover architectural innovations that facilitated the bringing of art to the general public. You will also explore the city art of The Eight, The Ash Can School, the Social Realists, and the artists of the Harlem Renaissance.

Section IV One Man's Ceiling Is Another Man's Floor

In this section you will explore works of art that express the humorous side of city life, as well as works that respond to the unpleasant side of living in the city. In addition, you will become acquainted with the works of some twentieth-century artists whose portrayals of the city go beyond conventional boundaries.

Section V Unusual Places to Find City Faces

In this section you will discover the art of Soho and the significance of the galleries in the streets. You will also explore the motivation that leads Graffiti artists to "write."

Section VI Building the City: An Historical Look at Terms and Techniques

In this section you will be introduced to some of the basic elements of construction, and how those elements have been applied. You will also explore how these basic elements and techniques have been used and altered by different civilizations around the world. Finally, you will discover how new and versatile building materials have changed the face of cities.

Terms to look for

aqueduct	dome	Ionic column	pointed arch
arch	Doric column	keystone	post
architecture	embrasures	Kinetic art	ribbed vault
barrel vault	ephemeral	lintel	Social Realists
buttress	flying buttress	merlons	Soho
capital	Gothic	pagoda	The Eight
colonnade	Graffiti art	panorama	vault
Corinthian column	groined vault	patron	wall installation

Objectives

- You will learn that cities were built to meet the needs of the people who lived in them.

- You will discover that cities became the gathering places where people could exchange ideas and develop their art.

- You will recognize that artists have found life and lifestyles in cities to be great subjects for their art.

- You will recognize the importance of architectural planning and construction methods that made the building of the world's cities possible.

> "The multitudinous sky-scrapers were standing up to view from the water, like extravagant pins in a cushion already overplanted, and stuck in as in the dark, anywhere and anyhow."
>
> **Henry James**

Section I

The Beginnings

For centuries, artists have been drawn to the city as extraordinary subject matter for their works of art. The city is alive with people and their stories. Cities have provided places where scholars and artists could gather to exchange ideas and pursue creative exploration. Cities remain places where art may be expressed and experienced in many different ways.

From the master builders of ancient Greece and Rome to the boundary-breaking architects of the modern world, cities have provided artists with numerous opportunities to invent and construct the urban landscape.

In this chapter you will have an opportunity to explore the long relationship between the city and art: the city's mysteries, its realities, its humor, its sense of social conscience, and its technological triumphs.

Since the beginning of group living, people have continuously defined and redefined the physical and social structure of their living space. Influences on city life such as the need for shelter, commerce, philosophy, religion, wealth, society, politics, architecture, and growing urban populations have been recorded throughout time by artists with their unique visions and skills in a variety of media.

Archaeologists suggest that the first "citylike" communities occurred sometime in the New Stone Age or Neolithic period (7000 to 4000 B.C.). It was during this time that human beings moved out of natural shelters, and started to domesticate animals and to section off parcels of land on which to grow crops. In addition, people began to build structures that can be considered some of the first attempts at architecture. **Architecture** *is the art and profession of designing and constructing buildings*. A particular building reflects a certain style of

architecture. Many of these early buildings were for living in. Unlike caves, which were communal, these buildings were separate and private. Simple structures were also built in which to worship and perform rituals.

As a society's religious, commercial, social, and political needs developed and increased, so did the shape and size of their cities. It is important to remember that civilizations all over the world developed simultaneously. The cities in each of these civilizations developed specific characteristics that were related to the needs of their communities. The differences among these cities lasted as long as the cities continued to be isolated. Eventually, however, the opening of trade routes ended the isolation. Cities located on major trade routes drew merchants from many distant points. City inhabitants were exposed not only to new commercial products, but also to new techniques and forms of creative expression. The urban dweller developed a life-style far different from the rural dweller. Crowded conditions in cities led to some personal inconveniences and impersonal relationships. These conditions were accepted then, as they are today, in exchange for the intellectual and recreational resources of the city.

The Greeks and the Romans

Works of art depicting ancient cities are rare. That is because much of the artwork that concerned itself with the city consisted of building the cities themselves. Elements basic to Greek and Roman architecture have been used and refined for thousands of years. Up until the twentieth century, Greek theories of proportion still provided the scale by which many monumental buildings were built.

The refinement of architecture as an art form can be attributed to the Greeks and Romans. The Greeks were guided by a rich heritage. This heritage led the Athenians to develop the arts and study the human condition. Enlightened leadership made public funds available for the refinement of the arts. Among the most important of these refinements was the perfection of architecture.

The Romans were history's greatest builders. Many examples of Roman bridges, water channels, roads, and buildings still exist. Some are still in use.

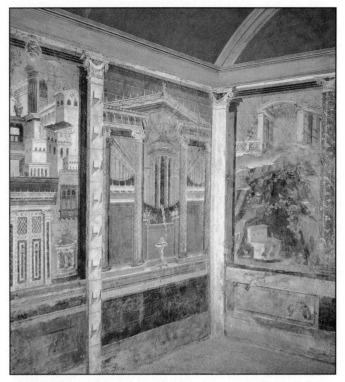

Figure 6-2 Were these buildings represented with convincing depth?

Anonymous Roman Artist, Wall Decoration in a Bedroom from the villa of P. Fannius Synistor in Boscoreale, Pompeii. Detail #7: northeast corner. c. first century B.C. Fresco on lime plaster. H: 8'. The Metropolitan Museum of Art, Rogers Fund, 1903. 03.14.13.

Most Greek and Roman cities were laid out in a neat orderly fashion known as a "grid system," with a forum or town square in the center where people could gather. Long promenades stretched through the center of town where goods could be sold, and where parades and processionals of political and religious significance could take place.

Rome was the site of one of the first attempts at actual urban planning. Over a period of time, an ancient city was built and rebuilt on the same ground. In doing so, the architects of Rome made a conscious effort to preserve time honored pathways of their past. We do the same thing today when we restore and preserve historic areas in our modern cities. Roman architects also tried to provide the city's inhabitants with stately views of the city's many fine buildings. In the fresco shown in Figure 6-2, you are treated to an im-

pressive view of Roman Architecture. Familiar elements include the arch and colonnade, as well as examples of post and lintel construction (see Section Six later in this chapter). Most important are the aspects of decoration.

Cliff Cities

In the southwestern United States, approximately 1000 A.D., the ancient Anasazi people built cliff cities in large openings in canyon walls and under huge rock overhangs. The most famous of these cliff dwellings is Mesa Verde (MAY sa VER dee), built from 1100–1275 A.D. as seen in Figure 6-3. Because of the sandstone-brick and mud-mortar construction of the buildings, and the large rock overhangs that have protected them from the elements, many of Mesa Verde's dwellings are still standing.

During the day, the cliff dwellers would farm the flat lands located in the canyons below their homes. At night they would return to the safety of their elevated cities in the canyon walls, hundreds of feet above their farm land. Some of the sheer rock walls reached staggering heights of three to four hundred feet! The Anasazi developed a system of natural and constructed trails with which to climb their way home. The constructed trails, known as "hand and toe hole trails," consisted of a series of small indentations chiseled out of the rock at intervals into which a person's hands and feet would fit. The Anasazi would use these indentations like the rungs of a ladder for climbing.

Their climbing didn't stop with the canyon walls. The houses that the Anasazi built contained several levels. In order to move from one level to another, a series of wooden ladders was placed between the openings on each level. This economic use of vertical space is the same theory that appealed to the builders of our modern skyscrapers.

Mesa Verde's inhabitants were primitive and were skilled only in basic crafts. However, the architectural feats they accomplished were astounding considering the natural barriers that they had to overcome. Simple in structure, and lacking the building materials and aesthetic refinements of Rome, Mesa Verde as an ancient city is still no less wonderful.

Contemporary artist, Charles Simonds, was inspired by cliff cities such as Mesa Verde when creating his own works of art. Figure 6-4 on page 283 is one of eight panels of a wall installation by Simonds in the Museum of Modern Art in Chicago. A **wall installation** *is a work of art that has been permanently installed into a wall in a museum, or another public or private building. The work cannot be moved without destroying it.* Simonds has hollowed out eight portions of a long wall. The hollows resemble the rock-like caves of Mesa Verde. He then inserted miniature brick and mortar buildings. Each of the eight installations is very tiny. Because they are small, it is possible to view all eight of the installation panels at the same time. Like the cliff houses of Mesa Verde, Simonds' dwellings seem dwarfed by the massive amounts of smooth surface that

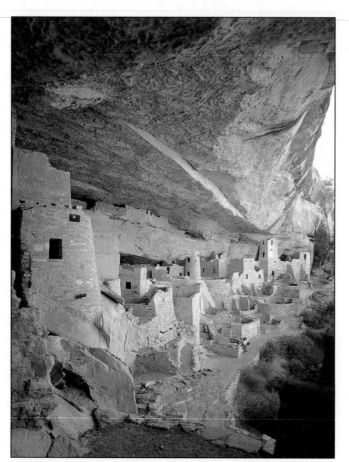

Figure 6-3 Mesa Verde is a lasting reminder of the architectural abilities of the Anasazi people.

Cliff Palace at Mesa Verde, Colorado, c. A.D. 1100. Photo ©1991, Wim Swaan, FPG International.

Student Activity 1
Constructed Cliff Dwellings

Goals

1. You will construct a piece of installation art that contains a stylized dwelling.
2. You will construct a dwelling made from clay bricks. This dwelling will be designed specifically to fit in the opening of your "wall" section.

Materials

1. One 4′ × 4′ piece of foam board
2. One x-acto knife
3. Tempera or acrylic paints
4. Tempera or acrylic brushes
5. One large shoe box or box of comparable size
6. One roll of 2″ wide masking tape
7. White school glue
8. One to 1½ lbs of red terra cotta clay
9. A rolling pin and assorted clay tools
10. A wide-mouth container with a lid such as a margarine tub
11. A brush to apply slip (a fluid mixture of water and clay)
12. Medium-sized cardboard scraps

Directions

1. Begin your installation piece by cutting an irregular opening in your foam board. This opening must not be larger than the size of your shoe box. The edges of this opening may be either jagged or gently curved.

2. When you have finished making the opening, turn your foam board around to the back. Position your shoe box so that it completely covers the opening you have just cut. Put a few small pieces of masking tape on each side to temporarily hold the box in place. Run a bit of glue completely around the edge of the box. This will form a complete seal. Let the glue dry. Then, using the 2″ wide masking tape, reinforce the glue seal by running tape completely around the box. This will help the box from becoming dislodged later when you place your dwelling in it.

3. When you have secured the shoe box in place, turn your foam board around to the front. It is now time to paint the inside of the box with an appropriate background. The background you invent will need to match the style of dwelling you intend to place in this opening. Think about where your

Student Activity 1 continued on next page

dwelling is located. What type of location is it? Be inventive with your colors and the way in which you apply the paint.

4. It is now time to concentrate on constructing your dwelling. Roll the clay out flat, using the method described in Chapter Four for slab building with clay. Roll the clay to approximately a ⅜" thickness. While the clay is still pliable, cut it into as many small bricks as you can. Separate them, and let them dry overnight. With the leftover clay, you will make a mortar called slip for your bricks. Slip is made by mixing clay with water (use your slip brush for mixing) until it reaches a "ketchup" consistency. This is most easily done by mixing powdered clay with water, but you may achieve this mixture by mixing water with your clay scraps. Add a small amount of glue to the mixture. This will help your slip to seal the bricks together permanently when it dries. Do this in your margarine tub with the plastic lid so it will be easy to store and re-use each time you need it.

5. When your bricks are dry, you may start to build your dwelling by gluing the first layer of bricks to a small piece of cardboard or poster board. Glue the first layer (the foundation) in the shape you wish your dwelling to take. From there you will begin building the sides of your dwelling by staggering the bricks in each row with the bricks in the row below it. Slip mortar must be placed on the bottom of and between each brick as you put it in place. The slip mortar will dry and hold your bricks in place.

6. Be creative with the shape of your dwelling. Experiment as Charles Simonds did (see Figure 6-4 on page 283) in his wall installation. When you are finished building your dwelling, put it aside to dry over-night.

7. Finally, place your dwelling into the opening you have created and glue it firmly in place (it will still be attached to the cardboard piece). Touch-up any spots that you see that don't blend with paint. Consider at this point, if the stark white surface of the foam board on the outside needs any painting to make the dwelling appear more integrated into the space created by the opening. Add any finishing touches you wish, and your installation piece is ready to be displayed.

Evaluation

1. Did you cut an interesting opening in your foam board for your dwelling? Where did you get the idea for the shape of this opening?

2. Were you satisfied with the brick dwelling that you created? What were some of the problems you encountered while building it?

3. Have you given any consideration to where you might display your installation piece? Where are some of the locations that might be most suitable? Why would they be good locations?

Figure 6-4 In some of his other works, Simonds has twisted and flattened the buildings in his compositions for variety and movement.

Charles Simonds (American, b. 1945), *Dwellings* (detail), 1981, Unfired clay wall relief, 96" × 528" overall. Collection of Museum of Contemporary Art, Chicago, Gift of Douglas and Carol Cohen. Photo ©1994 MCA, Chicago. 81.19.

surrounds them. Each of the tiny installations is connected by means of a narrow path. These tiny paths look as if they would be as challenging as the real ones that provide access to Mesa Verde's cliff cities.

Medieval Cities

Medieval cities in Europe were very different from the ancient cities of Rome or Mesa Verde. People of trade lived in cities because they had work to do. They provided goods and services to the ruler or land owner in exchange for wages and protection.

Homes or shops were clustered around a castle, but it was the church that became the focal point of medieval life. The church was where the people would gather for a pageant, royal wedding, or religious festival. Working-class people had little time for leisure activities, so they had to make do with these occasional

Figure 6-5 Churches were one of the first places in which the general public was exposed to the world of art and decoration.

Interior view of the nave of Saint Denis Church, near Paris, France. Mid-12th century A.D. Photo ©1989, Alan Hipwell, FPG International.

festivities. As the power and political clout of the clergy grew, churches became more and more decadent. The churches were supposed to represent the "heavenly city" on earth and as such, were decorated with rich carvings, stained glass windows, and many types of gilded objects used during the performance of worship services. It was in these elaborately decorated churches that the general public was first introduced to the world of art and decoration.

The architecture and lavish embellishments of these monumental cathedrals made important contributions to the development of cities and the art world. The elaborate system of braces known as flying buttresses (see Building the City) allowed the walls of these cathedrals to reach new heights. As a result, Gothic cathedrals were dramatically larger than earlier cathedrals. In addition, the ribbed and vaulted ceilings added greatly to the lavish look of these important buildings (see Figure 6-5).

In medieval art, cities do appear, but primarily as backgrounds for the action taking place in front of them. Some artists had the same problems in their depictions as did their forerunners in Rome. Their structures were shown true to form, but compositionally they lacked a proper sense of perspective.

"The history of art is the history of revivals."

Samuel Butler

Section ① Review

Answer the following questions on a sheet of paper.

Learn The Vocabulary

Vocabulary terms for this section are: *architecture* and *wall installation*.

1. Define the term *architecture* by using it correctly in a sentence.
2. Describe a wall installation.

Check Your Knowledge

3. When did the first "citylike" communities begin to form?
4. Who refined architecture as an art form?
5. What is distinctive about the ancient dwellings of Mesa Verde?
6. What was the focal point of medieval urban life?

For Further Thought

7. What areas within cities are the focus of urban life today?

Section II

Rebirth and Innovation

In some of the early works of the Renaissance, cities and building interiors became elaborate frames or stage settings for the figures in front of them. In Figure 6-6, we see some of the benefits of Renaissance stylistic developments. Among them are the use of linear perspective to achieve a sense of structural reality. The use of several vanishing points in this painting gives the viewer a variety of angles from which to view the city, heightening the sense of depth and spatial reality. Angelico's solid, simple, building forms and his tight clustering of them are reminiscent of medieval townships from earlier centuries. The protective town wall with its patterns of merlons and embrasures cuts across the composition diagonally and leads our eyes up the hill to the right toward the golden turreted castle. **Mer-**

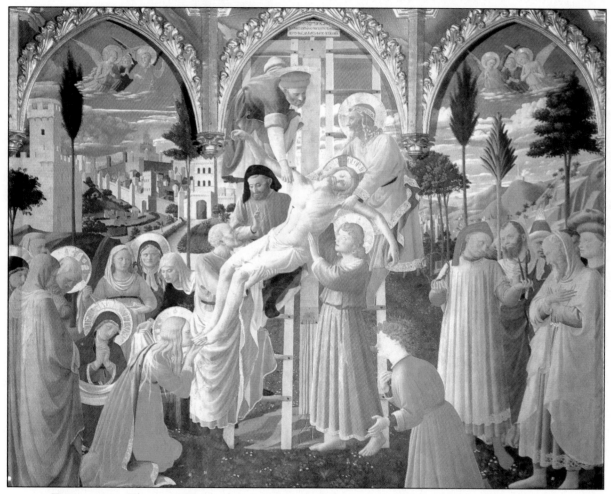

Figure 6-6 The city details that form the background of this work add to the sense of visual depth created by the artist.

Fra Angelico (Italian, Dominican monk, c. 1387–1455), *The Deposition*, 1436. Fresco. Museo di San Marco, Florence, Italy. Erich Lessing/Art Resource, NY.

lons *are the high segments of a castle or town wall that contain an arrow loop from which arrows could be shot.* **Embrasures** *are the low segments of a castle or town wall. They provided larger openings from which a variety of weaponry could be launched.*

Fra Angelico's colors are luminous and "jewel-like," because he actually used ground precious and semiprecious stones in his pigments. Many of these gems were provided to him by his patron Cosimo de' Medici. A **patron** *is a person of wealth and stature in the community that supports, most often, a specific artist by providing opportunities and funds that make it possible for the artist to do his or her work.* With de Medici's help, Fra Angelico enriched his pink and red hues by adding coral, blues by adding lapis lazuli (a favorite ornamental stone of the Egyptians), and by putting pearl dust in the beiges.

The very wealthy Medici (MED-uh-chee) family dominated Florence for most of the fourteenth and fifteenth centuries. They were, for the most part, enlightened leaders, and were patrons of the arts and scholarship on a scale not seen before nor since. Intellectual curiosity and artistic achievement were constantly encouraged by the Medici.

During the Renaissance, artists and architects were concerned with reviving principles in art, architecture, and literature learned from classical Greece and Rome. But it was not merely a time to copy what they learned. It was also, and most importantly, a time to improve on the past. Renaissance artists searched for ways in which to carry the principles of the past to even greater heights. These improvements were reflected in the architectural and artistic accomplishments of the period.

In Rome, during the early part of the Renaissance, another "city" was undergoing great renovation. Artists and architects were given an opportunity to test some of their innovative theories. The Vatican City, center of Roman Catholicism, is the smallest independent city-state in the world. It covers about 109 acres that all lie within the city of Rome. The Vatican was of great importance to the art world, then as it is now, because of its grand history of patronage by the popes, and because it has been termed by some as "the world's first and greatest museum" (Grisani, 1983). The Vatican's extensive collection represents the talents of many of the world's greatest artists. As important as

Student Work

Ruth Putman, 16
Buena High School; Sierra Vista, AZ

the works of art inside the Vatican's chapels and museums were the skills and visions of the many architects who worked on its renovation during this time.

One of the single most important concepts adopted from the classical world by artists and architects of the Renaissance was the theory of proportions. In this theory, the human body served as the scale by which all dimensions were measured. This affected the scale of actual buildings, as well as the size of the human form in painting and other art forms.

By the middle of the 1400s, the perfection of linear perspective in Renaissance art was apparent. Most of

Figure 6-7 Both perspective and detail help you see Saint Barbara as an integral part of the room.

Robert Campin, identified as the "Master of Flémalle" (c. 1378–1444), *Saint Barbara*. Museo del Prado, Madrid, Spain. Scala/Art Resource, NY.

the cities and building interiors that appeared in paintings no longer served as merely backgrounds or elaborate stages for the figures in front of them. As time progressed, works of art began to show figures that were more integrated into their surroundings.

Look carefully at the painting of Saint Barbara by the Master of Flémalle (see Figure 6–7). Here we see a radiant Saint Barbara tucked cozily away in her reading room. Her back is to the fire. Her body is seated gracefully on a cushioned bench. Notice the soft curves of the sides of the mantle. They seem to mirror the curves of the seated figure, and as a result, they help to balance the composition. There is little ornamentation in the room except for a few vases and a lone tea pot. Perhaps this suggests that the young woman does not need material possessions. She seems far more interested in her reading than mindful of her surrounding comforts. The influence of the church is strongly felt through the use of the Gothic arches in both the upper and lower ends of the bench, and the decorative carving on the chest near the window. As you look more closely, you will get a sense of the radiating lines in the composition of this painting. These are part of Campin's masterful use of perspective.

One of the most important aspects in creating the successful illusion of depth and space is the careful placement of a vanishing point. Can you tell how many vanishing points the Master of Flémalle has used in this painting? To help you, locate the radiating lines in this painting. Where do they all seem to come together? Does there seem to be more than one point at which these lines converge? Can you tell if the artist has used one-, two-, or three-point perspective? What visual clues would give you the answer? And what of the small table with the vase located just under the window? Does it suggest more than one vanishing point? Finally, would the vanishing point or points be located within the frame of the painting or outside it?

The painting of Saint Barbara represents a masterful integration of the human figure with the architecture of the room. Saint Barbara does not appear to be in front of the room posing or looking in. Rather, she is seated well within the heart of this warm and inviting atmosphere. It is the skillful use of perspective that creates this successful spatial relationship. Fra Angelico and the Master of Flémalle, as well as many other art-

ists of the Renaissance, were fortunate to have patrons whose commissions helped make their works of art possible. Patrons sometimes accumulated such vast collections of commissioned art that their houses and palaces became the equivalent of our modern museums. But, works of art are not all we have to thank these patrons for. It is to the wealth and leisure of these aristocrats that we owe the birth of cities as we know them today. Because these patrons needed to fill their leisure hours with many forms of entertainment, architects and city planners began to design and build the forerunners of town meeting halls, race courses, sports arenas, theater districts, malls, museums, and amusement parks.

Section III

The City as Social Environment

By the seventeenth and eighteenth centuries, art had become available to the general public. This happened as a result of the emergence in cities of what is known as "polite society." Its roots can be traced back to medieval times. Even though the common people in those days did not have much time to devote to

Section II Review

Answer the following questions on a sheet of paper.

Learn the Vocabulary

Vocabulary terms for this section are: *merlon, embrasures,* and *patron.*

1. Describe the purpose of merlons and embrasures.
2. Describe what patrons during the Renaissance were interested in.

Check Your Knowledge

3. What were artists and architects concerned with during the Renaissance?
4. What is one of the most important aspects of creating the successful illusion of depth in space?
5. What was the most important concept adopted from the classical world by artists of the Renaissance?
6. Why is the Vatican City of great importance to the art world?

For Further Thought

7. If you were a wealthy patron, what types of innovation would you support?

Student Work

Katie Schmidt, 17
Overland High School; Aurora, CO

leisure activities, they did have one thing in common with the ruling class: a "taste for enjoyment, and a certain skill for devising agreeable ways of passing time" (Mark Girouard, 1985).

Unlike medieval times, when class distinctions were very important, the 1600s and 1700s offered the average citizen a chance to join society. By now, the social classes did not distinguish among themselves when it came to amusement. All forms of entertainment were available to all types of people. The working class could enjoy the same amusements and cultural events that only the wealthy had previously enjoyed. "Society" became a "group" that many wished to join. The more fun and privilege that society offered its participants, the more people wanted to join.

Since the days of ancient Rome, it had been customary for the layout of a city to include one or more wide stretches of roadway, called a common or promenade. Promenades in the 1600s and 1700s were set up for kings, queens, and their courts along a grassy, flower-strewn park, garden, or picturesque waterway. But anyone who was well dressed and who owned a carriage could use the promenade. These outings became more like parades in which people came to "see and be seen," trade stories, exchange news, and let others know they were in town. Soon these processions called for entertainment. Among the diversions were bowling on the green, open-air theater, the selling of handcrafted goods, and buying refreshments. Frequent art exhibitions were among the most popular forms of entertainment. All of this took place out of doors. Unfortunately, the public could not rely on the "pleasure gardens," for amusement during bad weather.

People quickly demanded a solution to this problem, and they got it. At the beginning of the 1800s, people and their cities began to feel the effect of the Industrial Revolution, especially in the field of architecture. Astounding feats were accomplished in the field of engineering as well. This was due largely to the development of new technologies and building materials. Glass had never before been considered for use as anything other than windows. The public found the solutions to its weather problems in the construction of huge glass and iron buildings such as Joseph Paxton's Crystal Palace (see Figure 6-8). These grand, enclosed buildings could accommodate large crowds, and were

Figure 6-8 It is hard to imagine that this technologically advanced building was completed in 1857!

Crystal Palace, London, Great Britain, 1850–51. Joseph Paxton, architect. Photo courtesy Foto Marburg/Art Resource, NY.

used for a variety of social activities including art fairs and exhibits.

Camille Pissarro's (1831–1903) *The Crystal Palace*, (see Figure 6-9 on the next page) shows a typical long, wide promenade from the nineteenth century. Notice the gas lamps, which allowed the promenade to be lighted and used at night. Some people stroll while others in carriages ride up and down the boulevard, taking in the warm, sunny day. Pissarro's sky is as bright and translucent as the glass vault of the palace itself. Only an occasional cloud casts a brief shadow here and there on the palace glass.

The promenade seems to cut the painting in two. On the right, we see red brick homes with neatly kept gardens; on the left is Joseph Paxton's Crystal Palace, finished in 1857 for the great art exhibition of that year. So, on the right side of his painting, Pissarro seems to be making an architectural tribute to the past, and on the left side, he seems to be saluting the future. Paxton's palace literally dwarfs the buildings that surround it. It rises like a gigantic prism that announces its presence with periodic flashes of sunlight off its crystal facets. Pissarro captured the essence of an architectural innovation in his painting.

The pleasure gardens, as we have learned, were designed to offer as many leisurely diversions as one

Figure 6-9 How is the Crystal Palace like some of our large and elaborate malls today? Do you think you would have enjoyed the first indoor art exhibit held there?

Camille Pissarro (French, b. West Indies, 1830–1903), *The Crystal Palace*, 1871. Oil on canvas. 47.2 × 73.5 cm. Gift of Mr. and Mrs. B. E. Bensinger, 1972, The Art Institute of Chicago. Photo ©1994, The Art Institute of Chicago. All Rights Reserved. 1972.1164.

could think of—socializing, listening to music, dancing, and shopping. You might even say that buildings such as these were the forerunners of our modern shopping malls, providing all of that entertainment under one roof.

But what of the art exhibitions for which this particular structure was built? Because of the popularity of these pleasure gardens, art was now more accessible to the public than ever. The appreciation of art became fashionable as well as informative.

This was partly due to the political climate in Europe during the later half of the 1800s. People began to question class distinctions, and as a result, a series of revolutions broke out in many parts of western Europe. People's thoughts turned more to democracy, individual freedom, and the power of the working class.

Similarly, artists began to abandon the subject matter and the aesthetic principles of art that had been supported by the formal academies. Formal academies consisted of a group of learned members who established very strict rules about what the subject of a work of art may be, and how it may be created. Without the restrictions that the academies had placed on art, artists were free to choose new styles and subjects. Groups of artists who shared the same attitudes and philosophy about art formed new artistic movements. Women artists were finally included in these groups.

The City and Its People as Subject for Art

Artists now found working-class people and their daily activities fresh and exciting subjects for their art. It was at this point that cities, and the people who live

TECHNOLOGY MILESTONES IN ART

Sheet Glass

Between the years of 1908 and 1917, a machine for drawing sheet window glass was invented by I. W. Colburn and developed further by Libbey-Owens Sheet Glass Company in Charleston, West Virginia. Prior to this, sheet glass, primarily used for windows, was produced by casting or spinning, as in the making of crown glass. Window glass, known as crown glass in the early 1800s, was made by spinning a lump of molten glass until it flattened out, leaving only a small lump, or crown, in the middle.

Figure 6-10 Built in 1863, the St. Pancras Hotel in London, England was a masterpiece of Gothic revival architecture.

John O'Connor (1830–1889), *St. Pancras Hotel and Station from Pentonville Road*, Courtesy Museum of London. Bridgeman/Art Resource, NY.

in them, became frequent and celebrated subjects for artists' work. Some artists painted grand vistas of cities, highlighting architectural wonders.

One such wonder is the St. Pancras Hotel and train station built in 1863 by renowned architect W. H. Barlow. The train station had a vault of iron and glass with some Gothic touches in the interior. But it was the hotel that was the real architectural feat. The Saint Pancras Hotel was a masterpiece of Gothic revival with hundreds of rooms. In John O'Connor's painting, *St. Pancras Hotel and Station from Pentonville Road* (see Figure 6-10), the Saint Pancras's Gothic spires seem to reflect the heat of the sun. O'Connor's use of perspec-

tive draws us from the real to the fairy tale. At the end of his street, one may imagine a gateway leading to the entrance of this Gothic phoenix rising from the smoke-like mist to a rebirth amid a sky of flames.

Even though O'Connor seems to be paying homage in this painting to a monstrous Gothic wonder, the hotel is not the only subject of the painting. The title includes the hotel *and* Pentonville Road. Why did O'Connor choose to mention the road? It is the scene of active, everyday life. Is there a contrast between this active bustle and the romantic giant in the background? Does the hotel's mirage-like image suggest that perhaps it belongs to another time and place?

In addition to artists who chose to paint city vistas, there were others who preferred the inhabitants of cities and their daily routines as subjects. One such artist was John Singer Sargent (1856-1925). Sargent was an American-born artist who gained his reputation as a portrait painter. He studied art in schools in France and Italy. Sargent lived a good portion of his adult life in England, and as a result most of his important works were created in Europe.

In the painting entitled *In the Luxembourg Gardens* (see Figure 6-11), Sargent has chosen one of many beautiful formal city gardens as his subject. Here are the open areas needed for promenading and socializing that you learned about earlier. In the evening, however, Sargent's moonlit "garden" gives way to more private and romantic activities. As the lights come up on the promenade in the background, Sargent illuminates the pool with bits of their reflected light. Elegant floral bouquets make the setting more formal and balance the composition with touches of brightness. Sargent captures a romantic moment for the strolling couple in his painting. People sitting to the side or with their backs to the couple, as well as the emptiness of the open space, seem to provide a welcome moment of privacy.

Sargent's paintings were often characterized by broad

Figure 6-11 Many cities today are trying to establish "gardens" in their midsts to bring people back from the suburbs and recapture the city life of yesterday.

John Singer Sargent (American, 1856–1925), *In the Luxembourg Gardens*, 1879. Oil on canvas. 25½" × 36". Philadelphia Museum of Art: The John G. Johnson Collection. J#1080.

Figure 6-12 Not all images of the city are as appealing as this one. The Paris theater district of 1890 was a bustling, vibrant area.

Jean Béraud, *Le Boulevard des Capucins and the Théâtre de Vaudeville in 1889.* Musée Carnavalet, Paris, France. Giraudon/Art Resource, NY.

brush strokes and lack of detail, but not at the expense of his subjects. This technique is evident in the trees and structures of the background and middle ground of the painting, as well as in the foreground, in the soft chiffon of the woman's scarf and the lace-lined folds of her gown. This is a scene of contentment and pleasure, of romantic pastimes—a picturesque, moonlit dreamworld where love and fantasy are a wonderful part of the city.

Many artists associated all types of pleasurable experiences with city life. Some captured the glamorous nightlife of the social scene. Others preferred more private moments, catching people being themselves, preserving personal rituals and customs.

In this painting entitled *Le Boulevard des Capucins and the Théâtre de Vaudeville in 1889* (see Figure 6-12), artist Jean Béraud shows us the daily hustle and bustle of city life. The sky seems dreary. Perhaps it has rained recently as the streets appear wet and reflective. Even so, the activity in the streets seems lighthearted. The sidewalks are crowded. In the distance, groups of well-dressed gentlemen engage in conversations—business deals, the latest news, or talk of the performance at the Théâtre de Vaudeville. The people in the foreground rush across the street exchanging a word or two. Béraud counters the rush of motion toward the background by including a smartly dressed soldier walking in the opposite direction. Béraud uses the placement of the sol-

dier to help the viewer feel a part of the rush as the soldier appears to be walking right at us. The theatre itself seems a wonderful place. Its doors are open, the billboards on either side of the doors advertise the performances. It's a lovely place where life seems just a little more special.

By the late 1800s, the Impressionists had left their mark on the art world and the art of the city. They, too, recognized the city and its rush of life as compelling subject matter for their art. "Everywhere that people gathered, especially for amusement and pleasure, became a place that the Impressionists painted: streets and cabarets; views down boulevards and across rivers; people at work or at leisure" (Cole and Gealt, 1989).

The Impressionists' philosophies sent waves of creative change in every direction. And as the end of the nineteenth century drew near, these waves of change lapped at the shores of America.

American artists at the turn of the century, many of whom had studied abroad, were greatly influenced by the formal guidelines set forth by the European academies. The impact of the Impressionist movement on American art and artists was as profound as it was on their European counterparts. Subject matter shifted from classical themes to a celebration of everyday life.

While some American artists chose to hold true to the formal principles of the European academies, others preferred to break with tradition and seize the opportunity to explore new styles and subjects as their European counterparts did. One such group was "The Eight." **The Eight** *was a gathering of eight artists brought together in 1907 by artist Robert Henri.* The group consisted of Robert Henri (1865–1929), Arthur Bowen Davies (1862–1928), George Luks (1867–1933), Ernest Lawson (1873–1939), William Glackens (1870–1938), Maurice Pendergast (1859–1924), Everett Shinn (1876–1953), and John Sloan (1871–1951).

Henri gathered this group of rebel artists together, much as Monet and his Impressionist friends did, in order to oppose the restrictive exhibition policies of established art galleries. This meant specifically New York City's art galleries. Five members of this distinguished group would later form the body of the "Ash Can School."

Many European artists considered American cities to be crude and unsightly, lacking in certain European charms and refinements. But to the members of the Ash Can School who lived in cities like New York, Philadelphia, and Chicago, these were wonderful, exciting places to be. Members of this movement wanted to be known as American artists who painted American life. The term *Ash Can* came from their choice of subject matter. These artists often chose to focus on life in the slums and tenements or their impoverished inhabitants and social outcasts. They did, however, manage to avoid controversial issues in favor of painting their subjects in a more "picturesque" way.

The most famous exhibition of their works was the Armory Show in 1913. Held in a regimental armory in New York City, the exhibit was the primary vehicle for introducing modern art and Postimpressionist works to the United States. Smaller versions of this exhibition were later displayed in Chicago and Boston. Many of the works shown were European as well as American. Among the important outcomes of this show was the rethinking of American artists' attitudes toward their methods of painting. This happened primarily as a result of the stir caused by Marcel Duchamp's *Nude Descending a Staircase,* which is described in Chapter Seven.

Two of the most well-known Ash Can artists were William James Glackens and John Sloan. Glackens, like his other friends in the Eight, enjoyed a career as an illustrator for books, newspapers, and magazines as well as a painter. Although many of his works dealt with life in the tenements and streets, he preferred to paint the more "fashionable" side of city life.

In an urban environment where any space is at a premium, people feel strongly the loss of space in which to amuse themselves. Sometimes it seems as if all the "space" available already belongs to someone else. There are no spacious front yards, no grassy hills, or formal gardens—at least for individuals. In a city environment these spaces must be shared by many. In Glackens's world, this fact added to the charm of public parks. These gathering places teemed with life. In the middle of New York City's urban chaos, set aside by architectural boundaries, Glackens found a tranquil stretch of space that beckons to some to come and play.

Looking at his painting *Central Park in Winter* (see Figure 6-13 on the next page), we feel the delight and

hear the laughter of the children as they play, riding their sleds down the hill as primly dressed nannies and doting parents look on. Glackens captures a moment of anticipated excitement in the boy with his sled raised. One foot pushes off to begin his frenzied flight down the hill. Others have taken the ride before him. There was no need to make this landscape more amusing; it was pleasurable in and of itself.

But what of the two figures in the foreground? What are they looking at? The little girl dressed in white has stopped pulling her sled to turn and look at something. What could it be? Are there others in the painting who are also distracted? Whatever it is, the young woman leaning against the tree seems interested, too. One scarcely notices her at first, as Glackens has coyly propped her arm against a tree of similar hue, and has

Figure 6-13 Glackens shows us Central Park as it was in 1905.

William Glackens (1870–1938), *Central Park in Winter*, 1905. Oil on canvas. H: 25" × W: 30" (63.5 × 76.2 cm.). Signed (lower right): W. Glackens. The Metropolitan Museum of Art, George A. Hearn Fund, 1921. 21.164.

repeated her image in reverse in the segment of tree branches a few feet above her.

Glackens uses cool blues and pure whites to layer this small secluded valley with winter softness. Although it is not snowing now, it appears that it may again soon, covering the tracks of those who frolicked on this day.

Of a more personal and private nature were the works of another Ash Can artist, John Sloan. Sloan painted city life with humor and compassion. He was the master of the rooftop, the back alley, and the backyard. His works seemed to capture their subjects converting small spaces within the confines of the city into makeshift vacation spots or winter playgrounds. Equally as fascinating were his views of domestic chores being completed in an urban landscape of alleys and fire escapes.

In his painting entitled *Backyards, Greenwich Village* (see Figure 6–14), Sloan gives us a whimsical glimpse of life in one of these treasured spaces. On the rare occasion when people in New York City were lucky enough to have a backyard, they would fence it, plant it, and work or play in it. Sloan reminds us that children in the city are the same as children in the country when it comes to snow. Set against a backdrop of buildings, he uses crisp white laundry instead of clouds in the sky. Although we know it is cold enough to snow, Sloan paints sunlight to let us know that the temperature on this day is tolerable. Little sister giggles with delight at the idea of big brother being spied on by a couple of precocious alley cats. Of particular amusement to the little girl is that one of the cats has turned to howl at an intruder. Have the cats been sitting there for some time? Have they made the trip to the edge of the shed roof before?

Sloan's good friend and mentor Robert Henri had introduced him to the Impressionist works of Édouard Manet, among others. In Figure 6-14, we can see Manet's influence on Sloan's choice of the light colors in his palette.

Figure 6-14 Sloan chose to represent the city realistically. His paintings portray rooftops, alleys, and backyards.

John Sloan (American). *Backyards, Greenwich Village*, 1914. Oil on canvas. 26" × 32" (66 × 81.3 cm.). Collection of Whitney Museum of American Art. Purchase 36.153.

The Face of the City in the Twentieth Century

Because of the innovations and inventions of the latter half of the nineteenth century, the twentieth century became an era of exploration—exploration of ideas, philosophies, social awareness and artistic expression. The art world was giving birth to a multitude of new movements, and American cities were undergoing important renovations.

As we have just seen with artists like Sargent, Béraud, Glackens, and Sloan, many artists liked to focus on the glamour and friendliness of the city. Still others turned to a more personal side of life, choosing to paint scenes of social significance that focused on the poor and oppressed, the lonely and the paranoid.

In 1929, America was heading into the Great Depression. The bottom fell out of the economy, and as a result, businesses were forced to close or lay off thousands of people. Without jobs, many people could not pay their mortgages or put food on the table. They lost their homes and couldn't afford to buy medicine or clothing. Countless numbers of Americans were living in the streets or "Hoovervilles." Hoovervilles were small areas called "towns" consisting of a group of makeshift shacks sourly named after President Herbert Hoover to show the public's discontent with his economic policies.

These conditions contributed to the development of a movement of artists known as the **Social Realists.** Social Realism *dealt with themes like poverty, oppression, and social injustice.* Motivation for this movement in America first came from the Muralist works of Mexican artists Diego Rivera (1886–1957) and José Orozco (1883–1949). They were active in the struggle for Mexicans to gain political and economic equality in the late 1920s and early 1930s. Social Realism remains a popular subject for works of art even today, as we shall see later in this chapter.

The American Social Realists felt strongly about deteriorating social conditions during the Great Depression. They had strong opinions about what needed to be done, and tried to educate the public through their paintings.

Reginald Marsh. Reginald Marsh (1898–1954) was an American painter who belonged to the Social Re-

alist movement. During the 1920s, Marsh was a prolific illustrator and cartoonist for publications like *Harper's Bazaar, Vanity Fair,* and the *Daily News.* He took up painting seriously in 1923 and worked chiefly in tempera. His works were influenced by the drawings of Englishman William Hogarth (1697–1764). Hogarth won acclaim for his insightful drawings of eighteenth-century London's seamy side. Like Hogarth, Marsh chose to paint the grimy, depressing side of city life during the 1930s.

In *Why Not Use the "L"?* (see Figure 6-15 on the next page), Marsh gives us a look at the unfriendly side of urban life. On the right of the painting, we see a woman who appears to be dressed rather well. On the left of the painting we find another woman who has also chosen not to look at the vagrant. She has retreated behind a wall and is glancing through the fashion section of her newspaper.

As for the man on the bench, he appears desperately tired. He is so exhausted that he is sleeping through the roar of the subway cars as they speed by. It looks as if he has fallen asleep reading the paper, which now lies about his ankles. But what of the title of this painting? What does it tell?

Perhaps it is this element of storytelling that makes the Social Realists' paintings so compelling. They capture dramas of real life that cannot and should not be ignored.

"**M**exican mural painting celebrates the worker in the fields, the factories, the cities and the towns."

Diego Rivera

Jacob Lawrence. Social Realist Jacob Lawrence (born 1917) is another voice for freedom and social justice. He moved from Philadelphia to Harlem when he was about fourteen years old. His works were profound chronicles of African American history, culture

and life-styles. Lawrence is credited with six series of paintings, and some of these series included sixty or more individual works. In these series, he focuses on various aspects of African American life. His "*Migration*" series, which told of the migration of blacks from the South, contributed to the "Harlem Renaissance" as well as the black nationalism movement.

The only one of Lawrence's series that does not remain intact is the *Harlem* series. *Tombstones*, shown in Figure 6-16, is only one of the panels that originally made up the series. Its somber tones and elongated fig-

ures add to the message that the title implies: that contact with death is also a part of living in the city.

In the lower right corner of the painting, a mother grieves the loss of a child. The small lifeless body is shrouded in green; no limbs are visible. The woman sits alone, while neighbors share her pain from a distance. Their sad faces reflect her grief. The figures look almost unreal in their angularity (a characteristic Lawrence picked up from the works of Ben Shahn). The gravity of their situation seems to weigh them down, to stretch and tug at their arms and legs. Their

Figure 6-15 This image is representative of the Social Realist movement. What aspects of the painting make it typical of the Social Realists' works?

Reginald Marsh (American), *Why Not Use the "L"?*, 1930. Egg tempera on canvas. 36" × 48" (91.4 × 121.9 cm.). Collection of Whitney Museum of American Art, New York. Purchase 31.293. Photo by Geoffrey Clements, New York.

Figure 6-16 What type of script would you write for this painting? Lawrence's works often "act out" a story.

Jacob Lawrence (American, b. 1917), *Tombstones*, 1942, Gouache on paper. 28¾" × 20½" (73 × 52.1 cm.). Courtesy of the artist, via The Francine Seders Gallery, Seattle, Washington. Photo by Geoffrey Clements. Collection of Whitney Museum of American Art, New York. Purchase 43.14.

shoulders are already stooped from the burdens of everyday life—and now this: a child dies. People are frozen in their places. No one lifts a finger to help the crying child who has lost its doll. The tombstone shop is, appropriately, on the ground level of the building. How many times have these same people witnessed similar sorrow? From the looks of them, we would say many times. The depression hit Harlem much harder than other places, and as a result many more people died from hunger and disease.

For each of his paintings, Lawrence would take notes on what he observed and would then write scripts and scenarios for his dramas. The characters in his paintings would "act out" the stories. Lawrence painted Harlem just as Sloan painted New York: sympathetically, occasionally with humor, critically, and with a keen eye for reality. He had an intuitive feeling for

creating the illusion of depth.

Constance Coleman Richardson. During the same time that Marsh and Lawrence were painting, Constance Coleman Richardson (born 1905) was making her mark on the Midwest. Influenced by Thomas Eakins, she chose the following quotation by him to represent one of her exhibitions: "In a big picture, you can see what o'clock it is, morning or afternoon, if it is hot or cold . . . what kind of people are there, what they are doing, and why they are doing it."

Although life in midwestern cities and towns was thriving, life in Indianapolis was not on the same scale as life in the large cities of New York, Boston, and Chicago. It was a much more subdued existence, where warm summer nights could be enjoyed without the clamor and bustle of overcrowded streets.

Richardson captures just such a moment like this in her painting entitled *Street Light* (Figure 6-17). As the viewers, we watch from the shadows of the lawn as the soft geometric forms of a mother and her two daughters take a stroll down their neighborhood street after dinner. The landscape is reminiscent of the "Mother Earth" forms used by some of the Regionalists. For example, the grass is lush, and the trees are in full leaf.

Although we can identify the woman and her children, they are most intriguingly not the subject of this painting. It is the light cast by the street lamp that becomes the focal point. How dramatically it illuminates the people and landscape beneath it! Its high-

lights and shadows mold this street scene. We are uncertain about much that lies outside the bright glow, and drawn to that which lies within. The light that filters through the leaves creates a magical enclosure, a porthole in the darkness through which we may view these warm and loving figures. But Richardson has not left the quiet peacefulness of this street to the family alone. In the upper left corner of the painting, distinguishable by his white suit and the glow from his cigarette, Richardson has placed a man on the front steps of his home. He is not a menacing figure; rather he is a witness to this familial scene. Would he be more threatening if this scene were placed in a more de-

Figure 6-17 Richardson's *Street Light* gives us a glimpse at a quieter, simpler life than we've seen in some other works of art.

Constance Coleman Richardson (American), *Street Light*, 1930. Oil on canvas, 28" × 36".
©1993 Indianapolis Museum of Art, Gift of Mrs. James W. Fesler. IMA35.78.

Student Activity 2

Narrative Art: The Visual Reporter

Goals

1. You will select a section of your city to observe. You will record these observations on site by means of photographs, notes, sketches, and tape recordings of location sounds, or interviews with the people who live there.
2. You will create narrative works of art that reflect the information you have collected.
3. You will share your narrative works and some of your research documentation with your classmates.

Materials

1. Acrylic, tempera, or watercolor paints
2. Brushes
3. Conté crayons
4. Pen and Ink
5. Colored paper scraps
6. An assortment of magazines
7. Camera and film
8. A sketchbook
9. Scissors
10. Glue
11. Large white paper or canvas

Directions

You have read in this chapter about the narrative art of Reginald Marsh and Jacob Lawrence. Narrative art is art that tells a good story. Each of these artists was described as a visual reporter (through their art) of the adverse conditions brought about by the Great Depression. Marsh made a general statement about the plight of the poor; Lawrence a more personal statement about his particular neighborhood. The important thing to remember is that their paintings told a story about what had been observed.

Both Marsh and Lawrence spent time in the neighborhoods of New York City experiencing the nightlife, and cultures, and observing the poverty and oppression that existed there. In this lesson, you and your classmates will become visual reporters in your own communities, like Marsh and Lawrence did in theirs, and create works of art that tell the story of what you see.

Student Activity 2 continued on next page

1. You will need to start this activity by dividing yourselves into teams of three or four. It will be best to do your observations as a group. Study a map of your city. If you live in a big city, you may wish to confine your observations to your own community. Decide on an area where you will concentrate your observations. Try not to select an area that is either too small or too large.

2. When you have selected the area in which you will observe, plan times when you and the other members of your group can meet and spend time on location observing and recording. When you go to your location, stay together, and try to coordinate your recording efforts. Your recording should take the form of sketches, notes, photographs, and taped interviews. Always *use good judgment* on which is the best form to use. Set a time limit for your observations (a few days, or a weekend, etc.) and conclude your observations during that time.

3. When you return to your class the next day, meet with your team and discuss the important observations of the previous day. Keep a record of things you feel are especially interesting.

4. When the time you have agreed upon for your observations is up, meet for one final session with your observation team and share any materials that you have not already shared.

5. When you have had time to think about the information you have collected through your observations, use this information to create a work of art that tells a good story. You may select the appropriate media for your work from the list at the beginning of this lesson. Try to select a media that fits the expressive tone of your story. You may even wish to do as Lawrence did, and write scenarios or scripts for your narrative before you create it.

6. When you and your classmates have completed your narrative works, show them to each other, and discuss the value and importance of the story you have to tell. You may even decide to share some of your methods of documentation with the class.

7. Display your works prominently in your art room or building.

Evaluation

1. Were you pleased with the narrative work that you created? How well did you tell your story? What are some of the things you liked best about the work you created?

2. What were some of the methods you used to collect information while observing? Which method do you feel was particularly successful?

3. Do you feel that you gained a better understanding of the city you live in from the narrative works created by you and your classmates? In what ways?

pressing part of the city? How would the atmosphere change if this scene were a more crowded part of the city? Would we be as likely to notice the aura of the streetlight, or would our attention turn to the activity we might witness?

Edward Hopper. Many artists, like Richardson, have painted the city in response to the moods and feelings they have experienced, while observing city life. During the depression and shortly thereafter, life in the city was hard and, in some instances, lonely or even isolated. Some artists remained keenly aware of this depression of the *soul* as well as of the economy. One of the greatest American Realists, Edward Hopper (1882–1967), was drawn to the city and its inhabitants by virtue of these very conditions.

Born on July 22, 1882, in Nyack, New York, Hopper began his involvement with art by copying the pictures in children's books. His mother saw to it that Hopper

and his sister had many books to read. She also sparked their interest in theater—an interest that would later surface as the subject for several of Hopper's paintings. When Hopper graduated from high school, he received instruction from the Correspondence School of Illustrating in New York City. During this time, he became friends with Robert Henri and John Sloan.

In 1906 Hopper took a trip to Europe where he was influenced by the work of the Impressionists and others. When he returned to the United States a year later, he attended the New York School of Art, better known as the Chase School. While there, Hopper studied painting under Robert Henri, Kenneth Hayes Miller, and William Meritt Chase (1849–1916). Hopper felt that Henri's teaching was energetic and magnetic. Henri inspired Hopper's choice of technique as well as subject matter, for it was Henri and his Ash Can School that turned Hopper's attention to city life.

Figure 6-18 Hopper gives us a glimpse at the type of city life that only night owls usually see.

Edward Hopper (American), *Nighthawks*, 1942. Oil on canvas. 76.2 × 144 cm. The Art Institute of Chicago, Friends of American Art Collection. Photo ©1993, The Art Institute of Chicago. All Rights Reserved. 1942.51.

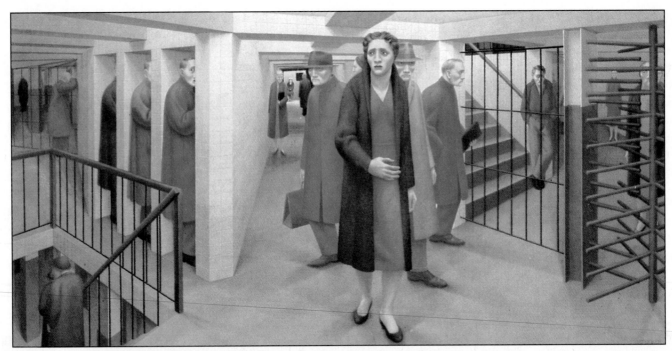

Figure 6-19 Have you ever been in a subway station and felt the way the people here seem to feel?

George Tooker, *The Subway*, 1950. Egg tempera on composition board. 18⅛" × 36⅛". Collection of Whitney Museum of American Art. Purchase with funds from the Juliana Force Purchase Award. 50.23. Courtesy of Marisa del Re Gallery, New York.

"You must not forget that I was, for a time, a student of Henri's," Hopper wrote, "who encouraged all his students to try to depict the familiar life about them."

Hopper's three mentors were vital to the way in which he painted his views of city life: Henri and his vision of back alleys and fire escapes; Chase for his use of the Impressionist palette; and Miller with his focus on urban realism. Hopper was lured to the city not only because he loved architecture, but also because he wanted to observe and paint the heart of the city as it worked and slept.

Loneliness, isolation, and quiet desperation were recurrent themes in Hopper's paintings. Nowhere were these themes more apparent than in *Nighthawks* (see Figure 6-18 on the preceding page). The setting is a restaurant on Greenwich Avenue where two streets come together. In a letter to his mother, Hopper wrote of this scene, "The picture was probably first suggested by many rides on the L train in New York City after dark and glimpses of office interiors that were so fleeting as to leave fresh and vivid impressions on my mind."

The bright fluorescent light from the restaurant spills softly onto the street outside. It is late; the streets are empty and quiet. Inside the restaurant, the same light seems harsh, intense, unforgiving. Our eyes are drawn to the four figures, wondering if they speak or just play out the scene anonymously. (Four figures in one of Hopper's paintings could be considered a crowd.) The curious arrangements of twos—two coffee cups, two people, two coffee urns on the far side of the counter— seem to heighten the sense of loneliness of the solitary figure with his back to us. Even the "soda jerk" appears to ignore him. The city can be a lonely place. Who are these people? How long will they stay? There are no clocks—we have no sense of time. They are "Nighthawks."

George Tooker. Another artist famous for his disturbing portraits of city life is George Tooker (born 1920). He is best known for his painting entitled *The Subway* (see Figure 6-19). In terms of composition, it is perhaps one of Tooker's most elaborate works. As we

George Tooker

On August 5, 1920, George Clair Tooker was born in Brooklyn, New York. As early as age seven, Tooker started taking painting lessons from a family friend. Although he learned a great deal about composition and ways in which to handle paint, Tooker was not pleased with the habit his teacher had of finishing his students' works for them so that the public would like the painting.

While attending high school, Tooker's parents became concerned that their son was not getting the type of rigid academic education that he should, so they sent him to Phillips Academy in Andover, Massachusetts. Tooker was not very happy there. His schooling at Phillips was cold and impersonal. In fact, he said that they trained the students to hide their emotions.

The one subject he liked at Phillips was English. But he also managed to spend considerable time in the school's art studio. His time there was spent making landscape drawings and watercolors.

While still in high school, Tooker was confronted with the effects of the great depression on the nearby mill towns. The fact that so many people were suffering because they were out of work angered Tooker. Perhaps it's the faces of these suffering souls that haunt his mysterious paintings produced later in his life.

In 1938, Tooker graduated from Phillips Academy and went on to attend college at Harvard. There he majored in English literature. Boston was the perfect setting for Tooker to continue his landscape drawing and painting. After a short membership in some radical organizations, which he ended because he found them boring, Tooker began to realize that it was through his art that he could express his desire for social change. He was particularly influenced by the strong social messages of the Mexican muralists, David Alfaro Siqueiros and José Clemente Orozco (see Chapter Nine).

Later in life, Tooker would spend a few short months in the United States Marine Corps before going on to art school. His reputation as an artist would grow. Selling some of his works to museums and private collections led him to numerous personal exhibitions. Tooker still lives and works in his studio at his home in Hartland, Vermont.

see in this painting, Tooker creates a labyrinth of passageways from which there seems to be no escape. These passageways, through the use of multiple vanishing points, sharp angles, and complex lighting, appear to hold these people captive. Strong repetitive vertical lines suggest prison bars.

The anguished expressions on the faces of the figures proclaim their fear. Will they ever find their way out? The figures seem unable to move. "I was thinking of the large modern city as a kind of limbo," Tooker wrote. "The subway seemed a good place to represent a denial of the senses and a negation of life itself. Its being underground with great weight overhead was important."

Section III Review

Answer the following questions on a sheet of paper.

Learn the Vocabulary

Vocabulary terms for this section are: *The Eight* and *Social Realists*.

1. Describe the difference between the works of the Ash Can artists and the Social Realists.

Check Your Knowledge

2. What aspect of the social classes changed during the seventeenth and eighteenth centuries?
3. In the 1800s, how did people solve the weather problems that often hampered the "pleasure gardens"?
4. How did the political climate in Europe during the late 1800s affect the art world?
5. What was the impact of Impressionism on American artists at the turn of the century?

For Further Thought

6. What aspect of modern city life would you explore as an artist? Why?

Section IV

One Man's Ceiling Is Another Man's Floor

While Tooker's *The Subway* expresses a fearful and claustrophobic existence, other artists, like Red Grooms, found humor in the midst of the city's confusion.

Charles Rogers ("Red") Grooms (born 1937) uses premade forms, such as cardboard boxes, tabletops, barrels, and odd pieces of plywood, in assembling his sculptures. He combines these things into a design in wire (an armature). Then he covers the armature with burlap and canvas, and paints his creations in brilliant colors. The complete Grooms work is a combination of additive sculpture and painting.

One of Grooms' most interesting and amusing works is titled *Ruckus Manhattan Subway*, a sculptural panorama. A **panorama** *is a view of what can be seen in many directions*. Grooms' panoramas were made up of scenes from various parts of the city combined into one. Figure 6-25 on page 312, *A Dozing Man in Miss Prim's Lap*, is part of that panorama (also see Figure 4-13). People on a subway often doze off, hypnotized by the rhythmical motion and clatter, as Miss Prim is discovering to her horror. What do you think she will do?

What is it like to live in crowded conditions in the middle of a big city? James Rizzi (born 1950) has a unique way of making us "feel" city life. He chooses titles carefully to fit the impact of his work. Consider the title of the example shown in Figure 6-20. How does the title enhance our appreciation of the work?

Three characters are about to cross the street in George Segal's *Walk, Don't Walk,* Figure 6-26 on page 313. Segal (born 1924) uses real people as models for his plaster-cast sculptures. He places plaster-soaked rags on his models to make the casts. After the plaster has hardened, the cast is cut away in sections and then reassembled using more plaster rags to cover the seams. The results are actual replicas of human beings in stark white plaster.

The prop in *Walk, Don't Walk* is a real street sign. The solid whiteness of the characters emphasizes their ordinariness, their lack of individuality. They are not perfectly formed figures engaged in heroic activities. They perform such everyday tasks as eating, crossing the street (and obeying traffic signals), or climbing aboard a bus.

Figure 6-20 James Rizzi gives us a view of a small but bustling portion of the city.

Detail. James Rizzi, *One Man's Ceiling Is Another Man's Floor,* 1987. Silkscreen with 3-D construction, edition of 99. 35¾" × 26". ©1994, James Rizzi. Courtesy of John Szoke Graphics, Inc.

DEVELOPING SKILLS FOR
ART CRITICISM

In the work by James Rizzi entitled *One Man's Ceiling is Another Man's Floor*, Figure 6-20, Rizzi shows us his impression of what it must be like for people to live in a big, congested city. It will take a lot of looking to see all that he has put before us. Study the work carefully and see if you can answer the following questions:

1. Why has Rizzi given some of his buildings human heads? How would you characterize some of the expressions on their faces?

2. What types of things do you see in the windows of the buildings? What do they tell us about the people that live there?

3. Has Rizzi included some objects in this work that seem strange to city life? What types of objects are they? Why do you suppose he put them in the work?

3. Why do you think he titled his work *One Man's Ceiling is Another Man's Floor*?

The City in Abstract Art. Crowded masses, honking horns, bright lights, the grittiness of the subway—these sights and sounds were ideal subjects for the abstract artist of the twentieth century.

Fernand Léger (Fair-NAHN lay-ZHAY) (1881–1955) was one such artist. He studied architecture in northwestern France before he began his career in painting. In the years just before the First World War (1910–1914) Léger was a Cubist (see Chapter Nine). After the war, he became fascinated with mechanical objects, and his works began to look machinelike. For Léger, the human figure had no more importance in his art than machines. We see the result of this attitude in his painting, *The City* (see Figure 6-21). Do you see the two human figures in this painting? Of what are they made? Léger said he kept his human figures "purposely inexpressive." He lived in the United States during the Second World War, discovered jazz music,

and loved what he called the "unbelievable vitality" of American cities.

In contrast to the bold images in Léger's *City* is the quiet Cubist work of Lyonel Feininger (FIE-ning-ur) (1871–1956), *Church of the Minorites II* (see Figure 6-22). Feininger has used the Cubist technique to emphasize the orderliness and peace of this haven in the city.

New York City I (see Figure 6-23 on page 310) was painted by the Dutch artist Piet Mondrian (peet MON-dree-ahn) (1872–1944). Prior to the Nazi occupation of France in 1940, Mondrian came to the United States from his home in Paris. His early work was less experimental, than his later work. By 1920, he had developed the style we see in Figure 6-23. From that time until his death in 1944, all of his paintings were rendered in vertical and horizontal lines, often with rectangular patches of color. His style is unique. Mondrian used the primary colors, plus white, and lines of black and gray.

Mondrian believed that balance and equilibrium are achieved, in his words, "through the balance of unequal but equivalent oppositions." If this seems a bit difficult to understand, imagine Mondrian in front of a blank canvas. Even within the limitations of color and shape that he imposed on himself, he had endless possible combinations of lines and shapes to consider. Any slight change would alter the compositional relationships between the lines and shapes and throw them out of balance. His sense of asymmetrical balance was nearly perfect.

The influence of Mondrian on artists who followed was great. He also had a major impact on fashion design, advertising layout, and architecture. Many of Mondrian's later works were simply compositions, not interpretations of a specific subject. Figure 6-23 is his interpretation of New York City, completed after living there about three years. He uses no black or gray lines or patches of color in this work. The painting is of monumental size. What do you think he is saying about the city?

Jean Tinguely (ten-GWEE) (born 1925), pondering the pace of modern society, observed, "The only stable thing is movement." Tinguely's sculptural pieces are known as Kinetic art because they include various forms of motion. **Kinetic art** then *is sculpture that moves.* During one year, 1959, Tinguely's automatic

painting machine ground out 40,000 Abstract Expressionist paintings. His *Homage to New York* (see Figure 6-24 on page 310) was a kinetic sculpture that contained, among other things, miscellaneous construction pieces, a broken-down player piano, drums, rickety motors, typewriters, soda bottles, and a weather balloon. The assembled sculpture made a variety of unintelligible noises, played out-of-tune music, issued typewritten reports about nothing, produced no usable weather information, burped periodic puffs of steam, and haphazardly painted canvases.

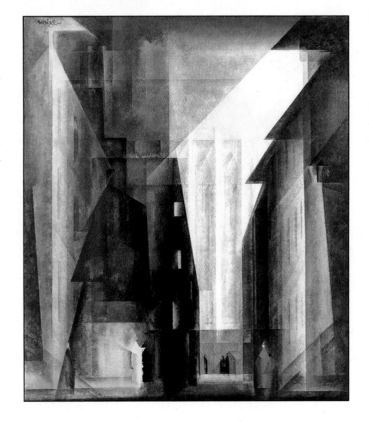

Figure 6-22 Feininger uses Cubism to express the serene qualities of this haven.

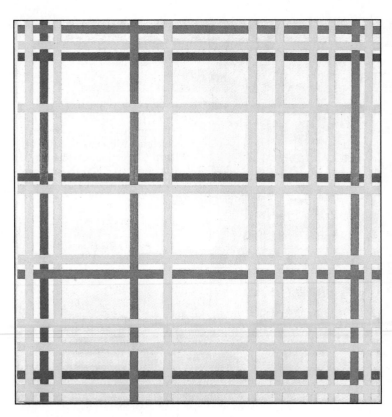

Figure 6-23 Notice the size of this work in the credit line following. Mondrian's sense of asymmetrical balance was nearly perfect.

Piet Mondrian (Dutch, 1872–1944), *New York City I*, 1942. Oil on canvas. 10′ × 12′. Sidney Janis Gallery. Courtesy of Mondrian Estate, Holtzman Trust. Giraudon/Art Resource, NY.

Figure 6-24 What does Tinguely's work really represent?

Jean Tinguely (b. 1925), Fragment from *Homage to New York*, 1960. Painted metal, wood, and cloth. 6′8¼″ × 29⅝″ × 8′3⅞″. The Museum of Modern Art, New York. Gift of the artist. Photo ©1994, Artists Rights Society (ARS), NY/ADAGP, Paris.

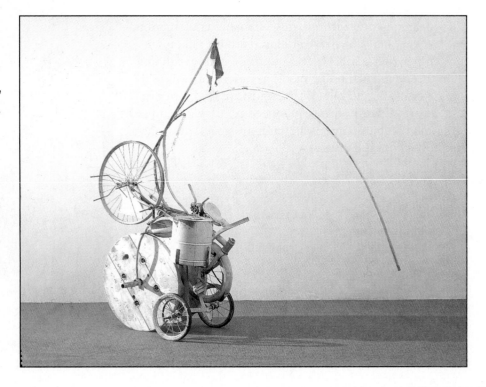

Notice that the work is referred to in the past tense. Within the work was a timed, built-in device for self-destruction. The sculpture destroyed itself on schedule before a distinguished audience in the garden of New York's Museum of Modern Art in 1960.

THINKING ABOUT
AESTHETICS

Most of us think of works of art as being pleasurable to look at. But is art always intended to be so? Can a "machine" like Jean Tinguely's *Homage to New York* (on the opposite page), which belches, performs no useful function, and self-destructs, be considered art? What kind of art would you call it? What was Tinguely trying to express? What was the point of his work?

Section IV Review

Answer the following questions on a sheet of paper.

Learn the Vocabulary

Vocabulary terms for this section are *panorama* and *Kinetic art*.

1. Define the vocabulary terms by using each one correctly in a sentence.

Check Your Knowledge

2. How were George Segal's sculptural forms made?
3. What types of materials did Red Grooms use to make his panoramas?
4. What did Piet Mondrian believe he was creating in his art?

For Further Thought

5. What kind of comment about city life is Jean Tinguely making by designing his kinetic art to self-destruct?

Section V

Unusual Places to Find City Faces

Many people believe that the only place to find art in the city is in a museum. In fact, nothing could be further from the truth. While art museums do provide the general public with opportunities to view vast collections of art, they are not the only places where city dwellers can find art. You need only look around as you walk or drive through many of our large cities to see sculptures of huge proportions or murals that decorate the entire side of a building.

Public art, as these works are called, is widely relied on by architects and urban planners to improve the metropolitan landscape. But look a little deeper, be a little more observant, and you will see the thoughts of the urban artist surface in the most unusual places and the most unusual ways.

The Art of Soho

The 1960s saw the transformation of the lower area of Manhattan, in New York City, from a failing manufacturing district to an innovative artistic center. This area became known as **Soho,** short for *south of Houston Street.* Artists were drawn to this area because of low rents and abundant work space. Many of the old warehouses and factory buildings provided large work areas for studios. Remarkably enough, though, much of the artwork that won Soho its audience was not created *in* a studio at all. Soho became famous for the **ephemeral** (ih-FEM-er-al), or *short-lived* art that emerged on the walls, windows, and doorways of the buildings that be-

It's People That Make the City

Both George Segal and Red Grooms were artists who drew the magic of the city and its people into their work. Perhaps even more than the bold structures of the city buildings, Grooms and Segal knew that the real magic of the city was in watching the people who live there. Look closely at the works in Figures 6-25 and 6-26.

Grooms' figures are cartoon-like and often have heads too large or too small for their bodies. By doing this, Grooms can emphasize character traits of his city dwellers. In the case of Miss Prim, Grooms has made her head larger than it would naturally be in order to accommodate the look of outrage and horror she expresses at what has happened to her. The dozing man looks peaceful enough; it is Miss Prim that

seems too uptight to handle the situation. Grooms has enlarged the head of the dozing man in order to make his intrusion seem that much greater. In this manner, Grooms seems to say that some people find life in the big city quite hard to handle.

Grooms' love of films and the theater is also evident in his sculptures. He creates elaborate stages or settings in his work, in which he casts his figures as players. Although we are momentarily unaware of the sensation of rapid movement in this subway car, the stage has been set and the drama has begun. Imagine the chaos when the rapidly moving subway comes to a jolting stop and all the passengers are thrown together in a jumble! This prospect must have given Red Grooms a good laugh.

Figure 6-25 Why do you think Red Grooms called the woman "Miss *Prim?*" Does she look that way to you?

Red Grooms, *A Dozing Man in Miss Prim's Lap,* detail from *Ruckus Manhattan Subway,* 1975–76. Mixed media. 9′ × 18′7″ × 37½″. ©1994 Red Grooms/ARS, New York. Courtesy Marlborough Gallery, Inc., New York.

Comparing Works of Art

In sharp contrast to the piece by Grooms, is George Segal's *Walk, Don't Walk*. Gone is the carnival atmosphere of Grooms' work, traded for a more stark contrast of white figure against dark background. It is easy to see why Segal might have enjoyed teacher Hans Hofmann's guidelines for representing the human figure. Segal's plaster figures are true to size and, in most cases, astonishingly real looking. Part of this is because of the casting method that Segal used, taking molds from live models. The other reason is because he places his figures in real-life surroundings, using props and familiar objects that are life-size.

In this work, we again see city people in the act of commuting. In this case, however, the commute is done on foot, which creates a much different atmosphere than Grooms' subway. Segal shows us that even though living in the city means that we must share space with others, the particular act of walking can remain somewhat a solitary venture. The figures are not crowded together cramped into a small space, forced to be a part of one another. Instead Segal has left space between them so they do not touch. The faces of Segal's figures are not alive and animated like those of Grooms' work. That is because Segal had a much simpler focus with these figures than Grooms had with his. Grooms wants us to know something about the characters in his little drama. Segal focuses not on the personalities of the figures, but on the gracefulness of the bodies as they stride down the sidewalk, near each other, but not touching. The figures in this work are frozen in a moment's time, waiting for the crossing sign to change so that they may continue their anonymous journey in silence.

Both artists, with similar subjects, have expressed their viewpoints in very different ways. Each artist has given us an important view of the heart and soul of the city—its people. The next time you are in a big city see if you can observe people similar to the characters from the works of Grooms and Segal hurrying to their jobs, or home to relax at the end of a busy day.

Figure 6-26 Segal's characters look so lifelike because he makes them from castings taken from living subjects.

George Segal, *Walk, Don't Walk*, 1976. Plaster, cement, metal, painted wood, and electric light. 104" × 72" × 72" (264.2 × 183.9 × 182.9 cm.). Collection of Whitney Museum of American Art. Purchase, with funds from the Louis and Bessie Adler Foundation, Inc.; Seymour M. Klein, President, the Gilman Foundation, Inc.; the Howard and Jean Lipman Foundation, Inc.; and the National Endowment for the Arts. Photo by Jerry L. Thompson, Amenia, NY. 79.4. ©1994 George Segal/VAGA, New York.

came Soho's galleries. David Robinson, a photographer and historian of Soho art says:

"What made Soho so special to me was the intensity of what was happening in that compact twenty-block area. Art was in the Soho air, its energy, palpable, spilling out of lofts onto the streets and into the world."

Soho wall art is described as ephemeral because many of the images would last only a short time before being altered in some way by people passing by. Some works may last only a few hours, others a month or even several years, before being changed. Once such a

Figure 6-28 SoHo Walls #112: Mona Lisa.

Photo © David Robinson, SoHo Walls: Beyond Graffiti.

Figure 6-27 Wall art changes as people pass by and leave their "marks" on what may first appear as a finished piece by a single hand.

SoHo Walls #14: *Pink Shirt*. Photo © David Robinson, SoHo Walls: Beyond Graffiti.

work has been changed, the original is lost forever. Wall art is worked and reworked by many different hands. It is often added to or covered over, but seldom erased altogether. Figures 6-27 and 6-28 are two examples of wall art.

Although some wall art appears to share characteristics with graffiti, the two things are not the same. Major differences between the two include the motivation of the creators and the media that are used. For the Soho artists, David Robinson states that: "the (artist's) motivation is not censorship but rather the participation of many voices in a kind of conversation, each struggling to be heard above the din—arguing, poking fun, making caustic, cynical comments."

Student Activity 3

Ephemeral Art: Soho Revisited

Goals

1. You will create works of art in the manner of the Soho artists of New York.
2. You will plan a display of these works along with photomontages that document the daily changes in the works.

Materials

1. Three or four 4′ × 4′ panel surfaces that may include: bulletin boards, plywood, heavy cardboard, old windows in the frames, a discarded door, or sheets of foam board.
2. Acrylic paints and brushes
3. Cans of spray paint (assorted colors)
4. Magazines
5. Chalk
6. Glue
7. Scissors
8. X-acto knife
9. Poster board

Directions

You have read in this chapter about the art found on the walls, windows, and doorways of buildings in an area of New York City called Soho. This art was usually initiated by a single artist painting an image, using a stencil, assembling a collage, or posting a photograph on any flat building surface that could easily be seen. Sometimes the images would be repeated on several surfaces. A stenciled image might be repeated many times in one location, or spread out over many buildings. The most interesting thing to remember about this kind of art is that it may only have lasted, in its original form, a few hours or a few days before someone came along and altered it in some way. Ultimately, these works of art may have made many statements as they were transformed. These messages may have been about the state of art, politics, love, or other personal issues. It is important that you keep in mind that this type of art was the product of many hands and many ideas and messages over a period of time.

1. To start this activity, you and the members of your class will need to prepare three or four surfaces on which your works will appear. You may choose from the list of recommended surfaces that appears in the materials list.

Student Activity 3 continued on next page

2. When the surfaces are prepared, divide into three or four groups. The number of groups will correspond to the number of surfaces you have prepared. Each group will be responsible for creating an original work of art on their panel using one of the following techniques (note that these techniques may be combined):
Collage
Stencil and spray paint
Direct application of paint with a brush
Chalk

3. When each group has finished an original work on their panel, the panels should be positioned around the room in order to invite alteration by other members of your class, or students from other art classes if you wish. This means that they should be easily accessible. Your art teacher should help you with the location of the panels as they should not interrupt the daily flow of class activity. Your class should decide things like how long will the works remain out for interaction, and whether or not you want students out of your class to be involved with altering the works.

4. An important aspect of this activity is that one member of your group will need to be in charge of photographing your panel at the end of each day in order to document the changes the panels undergo. When the time for active participation in altering the works is up, the photographs should be mounted chronologically on poster board and displayed with the finished panels. It will be fun for the students in your building to see the daily changes in the work from the beginning of the project to the end.

5. Before you display the panels for the whole building to see, take some time with your group and your class to try and interpret how the meanings of the artwork may have changed with each attempt to alter it. Write a critique of the work in its "finished" state.

Evaluation

1. Did you initially create a work that invited others to become involved with its alteration? What were some of the ways in which you hoped it would attract others?

2. Were you surprised at the artistic reaction that your panel received? In what ways?

3. Were you careful to photo-document your panel each day? Discuss your reactions to the ways in which your panel changed from day to day.

4. Did you mount an interesting display of your panels and photographs when the project was completed? What were some of the reactions to it?

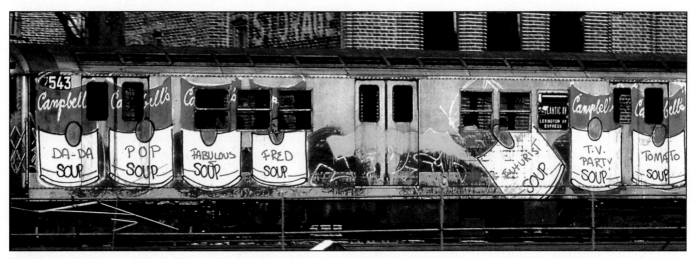

Figure 6-29 Do you think this train car is art in motion?

Martha Cooper, *Fred's Soup Can (after Warhol) Train*. Photograph, subway art. Photo ©1994,
Martha Cooper.

While most graffiti is done with cans of spray paint, Soho wall art may have been done using posters, photographs, collages, paint, stencils, or some form of sculpture. When Soho artists create, they rip, tear, obscure, write a new truth, and have a good laugh.

Unlike the graffiti artists, the artists who created Soho wall art did not sign their work. This is partially because what they were doing was illegal. Perhaps they wished to state merely the issues and not debate them. In addition, if wall art was the product of many artists, who should be the one to sign it? All?

With galleries now in the streets, people are flocking to Soho to immerse themselves in this cultural and artistic innovation—to look, to judge, perhaps to participate. The public's reverent attitudes toward art that hung in museums has been transferred, in part, to the ephemeral works of Soho's streets.

The Graffiti Artists

The 1970s saw the rise of large-scale mural art and the proliferation of graffiti in major cities in the eastern part of the United States. **Graffiti art** *consists of images, words, messages and writings, applied to subway walls and trains, buildings, and public fixtures.* Although a revival took place in the 1970s, graffiti first began to appear nearly a decade earlier. In the 1960s, teenagers marked neighborhood territory and established names for themselves with graffiti.

Unlike the anonymous artists of Soho, "writers," as these teenagers called themselves, enjoyed having their names become legendary. Because what they were doing was illegal, they chose names that reflected a "street identity." The more difficult-to-reach locations helped to create legends when decorated with the names of daring "writers." Their tags were recognized at a glance. A tag is a special signature specific to one particular artist. Past legends were remembered for their innovations, and their work constituted a collection of "graffiti folklore."

The 1990s have produced a whole new generation of writers. Constantly searching for bigger and better surfaces to paint, many Graffiti artists turned to subway cars as a means of transcending neighborhood boundaries. The trains circulate through neighborhood after neighborhood, spreading the messages of these "writer-artists" to a citywide audience. In a sense, these graffiti artists have taken the art of the Soho artists one step further since their galleries travel (see Figure 6-29).

Because what they are doing involves defacing or vandalizing city property, the graffiti artists work under cover of night. Completing a "top-to-bottom whole car" in one night is the ultimate challenge. Their me-

dia is spray paint and permanent markers, allowing fast application and vivid, striking, imagery. In order to claim their fame, artists make their names a bold and an instantly recognizable part of their designs. Finished works of art are referred to as a "piece," a shortened version of the word *masterpiece*.

Subway Graffiti art may be considered as ephemeral as Soho wall art. As quickly as the "pieces" are created, they are washed from the trains with solvent by transit authorities. Is this censorship? In any case, it is the public that pays for this clean-up. The New York transit authorities estimate that it costs taxpayers $300,000 a year and it takes 80,000 man-hours to restore the city's transit cars (Cooper 1984). Much of the Graffiti art is destroyed almost as quickly as it is created. This is accepted and expected by the artists as they anticipate an opportunity to fill their next "moving canvas."

Student Work

Ben Katz, 17
Gahanna-Lincoln High School; Gahanna, OH

Graffiti is discussed here because it is considered an art form by many artists, art critics, and art historians. This does not mean, however, that it is okay for you or anyone else to make graffiti. As you know, defacing public property is against the law. Making graffiti also creates expenses for businesspeople and for taxpayers who must pay to have the graffiti removed. Even if you are the "Michelangelo" of your neighborhood, you should not mark on public property or on private property that is not your own. When you feel the need to express yourself through the visual arts, use media and materials in a responsible way. Don't damage or destroy other people's property.

Section (V) Review

Answer the following questions on a sheet of paper.

Learn The Vocabulary

Vocabulary terms for this section are *Soho, ephemeral,* and *Graffiti art.*

1. Define the vocabulary terms by using each one correctly in a sentence.

Check Your Knowledge

2. Why was Soho art considered ephemeral?
3. How are Graffiti artists different from Soho artists?

For Further Thought

4. Write a paragraph that either defends or challenges the statement "Graffiti is art."

THINKING ABOUT
AESTHETICS

Is graffiti "art"? Are people who make graffiti "artists"? If an art gallery owner invites a "Graffiti artist" to paint on the gallery walls as an "exhibition," is it still graffiti? These are controversial questions. What do *you* think?

things in mind, you will find the story of architecture to be an evolutionary process.

Section VI

Building the City: An Historical Look at Terms and Techniques

There are so many beautiful examples of architecture in the world that it is almost impossible *not* to appreciate them. However, a basic knowledge of architectural terms and techniques can add to your understanding of how cities were built.

Architecture is unique because it is one of the fine arts, yet it is also a practical science. It addresses basic human needs—such as the need to support a roof for shelter, and the need to develop an aesthetically pleasing environment. The story of architecture is the story of solutions people have devised through the ages to meet these needs. Construction methods are always determined by the materials available to architects at a particular time. Results must be appreciated based on how successfully the available materials have been used. The work of medieval architects, whose materials were stone, wood, brick, and mortar, cannot be compared with the same standards used to judge the work of twentieth-century architects who have worked with steel and reinforced concrete. If you will keep these

> "**A**rchitecture is inhabited sculpture."
>
> **Constantin Brancusi**

Post and Lintel

The first step away from the construction of simple dwellings for cover was taken when people began to use *posts* and *lintels*. Post and lintel construction was used by the ancient Egyptians, the Greeks, and the Romans. Egyptian architecture spanned a great period, beginning in the 1500s B.C. and lasting about 500 years. The ancient Greeks were master builders. Architecturally, the most productive years fell between 1600 B.C. and 146 B.C. The Romans elaborated on Greek principles and added some innovations of their own in a glorious period of city building that lasted from 100 B.C. to A.D. 300. The **post** *is the upright (vertical) member.* Posts are also known as *columns* or *piers.* Their function is to support *the horizontal beam, which is known as the* **lintel.** The lintel lies across the top surface of the posts. Lintels are also commonly called *rafters,* or *girders.* The function of the lintel is to support the weight of the load placed on it without bending or breaking. This load may be a heavy roof or a second story (see Figure 6-30 on the next page).

Architects and builders must be careful to choose materials for lintels that can withstand these heavy loads. On occasion a lintel may fail to withstand the weight placed upon it.

What could cause this failure? One of two things:

1. A post or lintel may be too long for the job it is supposed to do.

2. A post or lintel may be made of material that is not strong enough to do its job.

Posts made of stone are quite strong. Stone posts can withstand a great deal of direct downward pressure caused by a heavy weight above. They may be short or very tall. They also may be made from a series of cylindrical blocks (called drums). The downward pressure from the weight of the drums actually helps bind the drums together. If you look closely at Figure 6-31, you will see that these posts are stacked columns of drums.

Columns, another word for posts, may be used for support as well as decoration. The Egyptians frequently

Figure 6-30 Post and Lintel Construction

used rows of columns in their temples and large buildings. Quite often these columns supported large terraces that surrounded the main building of a temple complex. Rows of columns were also used in the interiors of their large buildings. The Greeks integrated columns symbolically into their architecture as a means of expressing the sense of order and harmony they sought in life. Greek architects used **colonnades,** *long rows of similar columns set equal distance apart,* to represent order and balance in their architectural designs.

The top of a column, or **capital,** could be very simple in design or very elaborate. **Doric columns,** *were simple columns with no decoration on the capital.* **Ionic columns,** *have fluted shafts and scroll-like decorations on the capital.* **Corinthian columns** *are tall and slim, and have very ornate capitals.*

Lintels made of stone must be kept comparatively short. There are two reasons for this. The first is that

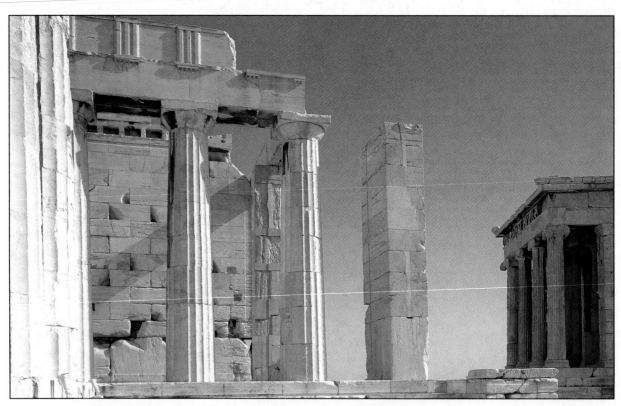

Figure 6-31 The Acropolis provides good examples of post and lintel construction and Doric capitals.

The Propylaea of the Acropolis, Athens, Greece. Photo ©1994, Eberhard E. Otto/FPG International.

builders are limited by the lengths of solid stone they can find. Unlike posts, lintels are laid horizontally, so the downward weight will not push joints together as it does with posts. Joints in lintels are potential weak spots.

The second reason why stone lintels must be kept short may surprise you. Stone, as we have noted, has the strength to hold great weight in the vertical position (a post). However, stone is somewhat weak in resistance to bending. Wood, composed of long, fibrous strands, is stronger than stone in resisting bending. Lintels must not bend or break, or the entire structure will collapse.

Egyptian architects used stone lintels exclusively. The result was that the rooms in Egyptian interiors looked like narrow boxes, or hallways. Interior open spaces were limited to the length of the stone lintels. Egyptian interiors without interior walls looked like a forest of columns. Stone lintels were also used in the interior chambers of the great pyramids. Although Egyptian architecture is most often remembered in terms of the great pyramids, Egyptian architects spent most of their time building temples.

Greek architects and builders utilized the superior resistance to bending of wood lintels in interior areas. Therefore, Grecian interiors had larger open areas than did the buildings of the Egyptians. The Greeks continued to use stone lintels on the exteriors of their buildings for the richness of the texture and the beauty of stone.

The Roman architects employed post and lintel construction as developed by the Egyptians and Greeks, but they added their own refinements. For example, they retained the posts, but replaced the lintel with arches and vaults, which you'll learn about next. Remember that these changes in construction were attempts to better utilize the materials available at the time. Much later in our story, posts and lintels made of iron and steel reappear as the framework of modern skyscrapers.

The Arch

An **arch** is *simply a curved replacement for a lintel.* It performs the same function the lintel does—it supports the load that rests on it. Roman architects used the rounded arch because it allowed much wider openings

Figure 6-32 Stone Arch Showing the Keystone

and because much smaller building blocks could be used. These building blocks were lighter and easier to transport.

You will notice in Figure 6-32 that the building blocks for the arch are wedge-shaped pieces. The *keystone* (shaded in Figure 6-32) is placed last. A **keystone** *is a wedge-shaped piece of stone at the top of an arch that locks all of the other stones in place.* The arch is not freestanding until the keystone is in place.

If no load is placed on a rounded arch, the tension of the wedge-shaped blocks creates outward (horizontal) pressure. However, when the arch supports an overhead load, the weight of the load exerts a pressure directly *downward.* Note the direction of the arrows in Figure 6-33 on the next page. They indicate the directions of the pressure on a load-bearing and non-load-bearing arch. The combination of these two pressures (one outward, the other downward) results in *diagonal* pressure. Diagonal pressure will cause an arch to collapse if it is not properly supported.

Pressure to these rounded arches may also come from the posts. The wider the arch is, the more outward pressure it exerts. The heavier the load placed on the arch, the stronger the downward pressure becomes. The stronger the resulting diagonal pressure becomes, the stronger the posts or columns must be to resist it. With the material available to Roman architects, "stronger" posts or columns meant *thicker.*

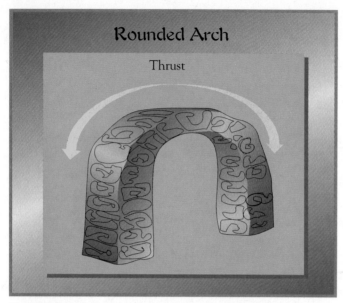

Figure 6-33 Rounded Arch Showing Thrust

A valuable Roman discovery was that arches could be successfully placed next to each other in rows, as we see in a drawing of a Roman aqueduct. An **aqueduct** *is a canal for carrying water from one location to another* (see Figure 6-34).

Why does this connected system of arches and canals work? Think of the downward and diagonal pres-

sure of each of these arches individually. (Look at Figure 6-34 again.) Envision the arrows that would indicate the direction of the pressure of each arch in the aqueduct. Can you see that the pressure of one arch would counteract, or work directly against, the pressure of its neighboring arches? The pressures of each arch actually work together to support the total structure. Such an arrangement of arches must, however, be thickly supported at each end as well. The arches in this drawing are supported by the earth. Water would then fill the canals and flow by means of gravity or pressure from one location to another. The Romans used this system of aqueducts to supply their cities and farm lands with water.

The Vault

The principle behind building a vault is closely related to building an arch. A **vault** *is just a combination of arches.* The simplest vault is the *barrel vault* (see Figure 6-35 on the next page). A **barrel vault** *is a series of arches joined together to enclose space, as in a tunnel.* A barrel vault must be supported by a system of posts or columns (which become a reinforced wall along its entire length). Wall openings must be quite limited in such a structure or the entire structure will collapse from the outward pressure.

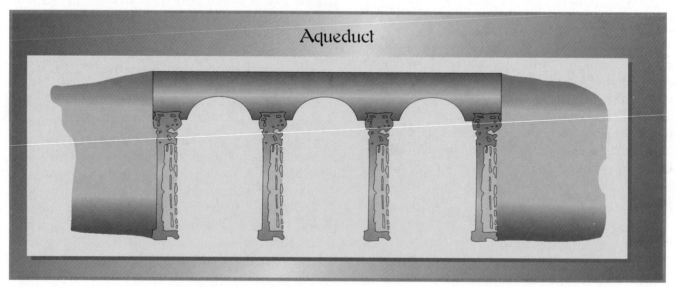

Figure 6-34 Aqueduct

The **groined vault,** another Roman invention, *is made by intersecting two barrel vaults at right angles,* as we see in Figure 6-36. This kind of vault gave the architect several advantages over post and lintel construction. First, the groined vault can enclose more open space. Second, it needs support only at the four corners of the square formed by the vault. Groined vaults could be repeated in a series (just as arches were repeated to make an aqueduct). The repetition of groined vaults allowed Roman architects to span areas of unlimited length (although the width was, of course, limited to the width of the square). This allowed them to create much larger interior spaces for living and for special gatherings. An example of this is seen in Figure 6-37.

Figure 6-35 Barrel Vault

Figure 6-36 Groined Vault

Figure 6-37 Locate the groined vaults in this French cathedral.

Bourges Cathedral, France. Photo ©1989, Alan Hipwell/FPG International.

The Dome

The **dome,** such as we see atop the Roman Pantheon (Figure 6-38), *is essentially a continuous series of rounded arches with a common center.* The diagonal pressure is exerted equally all around the dome. Consequently, the Pantheon required very heavy walls for support.

The only source of light for the interior was the "eye"—the circular opening in the center of the dome. Architects made dramatic use of the "eye" by placing the opening over an important part of a structure, and allowing the light that came through the opening to illuminate with great effect, altars, tombs, and other important parts of the building.

Figure 6-38 The Pantheon was dedicated to all Roman gods.

Giovanni Pannini (Italian, 18th century), *Interior of the Pantheon.* c. 1734. 47" × 39½". Photo courtesy The Bettman Archive.

Asian and Pre-Columbian Architecture

It is important to remember that the architectural discoveries going on in Europe did not represent the total architectural picture worldwide. Civilizations that existed in other parts of the world during the time of the Egyptians, Greeks, and Romans were busy inventing architectural styles of their own.

Asian architecture includes Chinese and Japanese architecture, as well as Indian and Islamic architecture. Indian architecture was heavily influenced by the Buddhist, Hindu, and Islamic religions. Islamic architecture includes buildings designed by people of the Muslim faith. Examples of this type of architecture can be found in areas of the Middle East, Spain, parts of northern Africa, and Asia.

Pre-Columbian architecture was devised by groups of people (ancestors of the Native Americans), that migrated from Asia to the American and South American continents about 20,000 years ago. Their architecture was considered as brilliant as it was beautiful. It is referred to as "Pre-Columbian" because it was designed and built prior to the coming of Christopher Columbus to the Americas in 1492.

Chinese Architecture. It is hard to put a date on the earliest of Chinese architecture because the Chinese culture dates back to very ancient times. The Chinese constructed many different types of buildings, but the most important ones were beautifully ornate Buddhist temples and pagodas. A **pagoda** *is a temple of several stories, each story having its own projecting roof* (see Figure 6-39). Perhaps as unique as the look of a pagoda, is the way in which they were built. Building these temple structures often times took thousands of workers. The first level of the pagoda would be built, and then earth would be mounded up around the sides so that the workers could build the next level. Then that level would also be buried so that the third level could be built, and so on. You can imagine how monumental a task it would be to unearth pagodas that reached nine or ten stories tall. The Chinese would often hang hundreds of bells on the outside of the pagoda. When the winds would blow, the entire structure became a huge musical instrument.

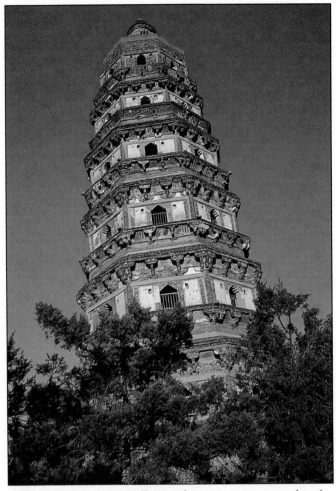

Figure 6-39 Tiger Hill Pagoda is a prime example of this style of ornate Chinese architecture.

Tiger Hill Pagoda. Suzhou, China. Photo ©1994. Haroldo de Faria Castro/FPG International.

Japanese Architecture. Japanese architecture reflected the structural influences of the Chinese. At the heart of traditional Japanese architecture is the use of posts and lintels. Some of the oldest examples of this concept are the Shinto shrines. (Shinto is an ancient Japanese religion.) Large posts would elevate the shrines above the ground, and bear the weight of the roof. Interior posts would not be load bearing, rather they would provide a framework for privacy walls.

Indian Architecture. Indian architecture dates back to at least the 200s B.C. Inspiration for this architectural style comes from the influences of three

major religions: Buddhism, Hinduism, and Islam. Buddhism gave rise to the development of the stupa, a dome-shaped building that houses Buddhist relics. Quite often Hindu temples would feature colonnades of elaborately carved columns, and vast open porches like the ones you saw in the Egyptian temples.

Islamic Architecture. Islamic architecture created unusual houses of worship called mosques. There are many different styles of mosques. In fact, the style of mosque will vary from country to country, but the purpose remains the same. General patterns for the building of a mosque includes a minaret, a very tall prayer tower, a large courtyard, a domed sanctuary, and four halls with arched entrances that surround the courtyard, the minaret, and the sanctuary. Each mosque contains a mihrab (ME-rahb), a niche in a wall oriented to the holy city, Mecca. Other Islamic buildings include religious schools, palaces, tombs, and private homes.

Pre-Columbian Architecture. Pre-Columbian architecture includes the buildings of the Aztec, the Toltec, the Maya, the Inca, and the cliff dwellers known as the Anasazi. Their empires were built in North and South America, Mexico, and Central America. The Anasazi as you have learned earlier in this chapter, built their cliff homes in the rocky walls of the canyons of the American Southwest. Among the impressive buildings of the South American peoples, were structures of mammoth proportion built as religious temples, fortresses, and public buildings. Many of these buildings took the form of step-sided pyramids, and temples built into the side of a mountain. The Anasazi built multi-level houses that resembled apartment buildings.

The Pointed Arch and Gothic Architecture

European Medieval and Gothic. In the twelfth century A.D., Gothic architecture was introduced in northern Europe. The term "Gothic" was applied to this style of architecture by writers and artists of the 1400s and 1500s who disapproved of the complex and irregular designs that were so different from the classical styles of architecture they thought should be revived and adhered to. The term **Gothic** refers to the *Goths, a fearsome German people who destroyed a great deal of classical art during the 400s.* Despite their disapproval, Gothic architecture was soon the dominant style of architecture in that region of the continent as well as in the British Isles. "Dominant" is an excellent word to use when we think of Gothic architecture, as the towering cathedrals constructed in this manner dominated the communities in which they were built (see Figure 6-41A and 6-41B on the next page).

 Gothic architecture was made possible after the **pointed arch** was introduced in Europe (Figure 6-40). *Its shape directs more of its weight downward, rather than outward* as with the round arch.

 The pointed arch formed the basis for the construction of the *ribbed vault* (see Figure 6-40 on the next page). A **ribbed vault** *is a vault consisting of a skeletal structure of self-supporting ribs (pointed arches), with plaster or other light masonry material filling the spaces between the ribs.* Such a skeleton (the ribbed vault) could cover rectangular areas as well as square areas. The weight of ribbed vaults was much less than that of the previous vaults.

EXPLORING

HISTORY AND CULTURES

The ancient Anasazi made dwellings that were different in most every respect from the huge Gothic cathedrals of the European medieval and Renaissance periods. What would happen if these historical cultures came together and combined their building practices? Imagine combining multi-level apartment homes with the soaring vaults and beautiful stained glass windows of a cathedral!

1. Form a group to discuss this concept. What would be some of the shared needs of the people that would live in such dwellings?

2. Have your group discuss and come up with several architectural drawings of what these dwellings might look like.

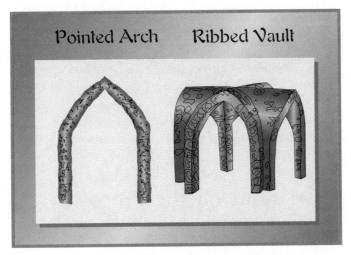

Figure 6-40 Pointed Arch and Ribbed Vault

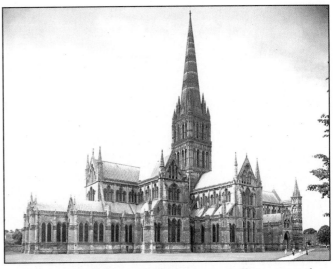

Figure 6-41B This cathedral is an excellent example of early English Gothic style.

Salisbury Cathedral, England. View from the northeast. Photo courtesy The Bettman Archive.

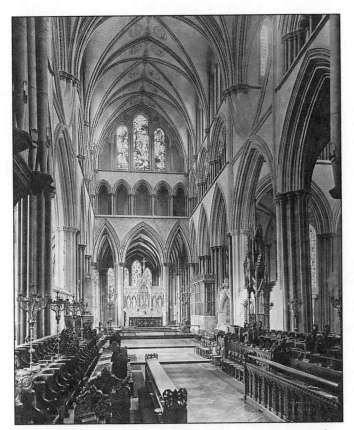

Figure 6-41A Gothic architectural innovations made large naves (interior spaces) possible.

Salisbury Cathedral, England; interior of choir looking east. c. 1220-1266. Stone and marble. Photo courtesy The Bettman Archive.

Gothic architects also invented the *buttress* and the *flying buttress*. A **buttress** *is a large support built against a wall to counteract the pressure exerted on the wall from the weight of an arch, vault, or roof.* A **flying buttress** *is an arched support that reaches from a column to the upper part of the wall to be supported.* Look at Figures 6-42A and 6-42B on the next page. Do you see that the high arch (the flying buttress) is placed exactly where the downward and outward pressure of the vault is concentrated? This flying arch takes the load and diverts the pressure from it down the post (on which it rests) *outside of,* and *away from,* the walls.

"I call architecture frozen music."

Johann Wolfgang von Goethe

This method of buttressing has distinct advantages. First, it allows huge interior spaces, since the buttresses that support the roof are outside the walls. Second, the

Figure 6-42A Flying Buttress

walls may be a mere skeleton (used only to enclose space), since they are freed from carrying the weight of the roof. To the devout people of the late Middle Ages, the new Gothic cathedrals seemed a miracle. Heavy dark walls had been replaced by walls of bright, intricate stained glass. Light entered these houses of worship for the first time. The vast interior spaces made the ceilings seem to soar, to be a part of heaven itself.

Variations on the Processes

During the early Renaissance at the beginning of the 1400s, important architects like Filippo Brunelleschi (1377–1446) created new buildings using old techniques in new ways. His building materials were still wood, stone, brick, and masonry, but his techniques were very experimental. Most of the buildings he designed were churches and cathedrals. His first project of great importance was the dome for the Cathedral of Florence. The dome of this important structure is the most recognizable structure on the Florence skyline to-

Figure 6-42B Notre Dame is perhaps the best-known Gothic cathedral.

Notre Dame Cathedral, Paris, France. Built A.D. 1163–1250. Photo ©1994, Dennis Hallinan/ FPG International.

day. What makes this dome such an architectural accomplishment is the way in which it was constructed. Brunelleschi designed this octagonal dome by combining the gothic style dome with the Roman concept of the vault. The result was an octagonal ribbed vault that was considered by the Italians to be one of the "greatest engineering accomplishments of their time."

During this time, other architects continued to revive the building principles and components of ancient Greece and Rome, and apply them to Renaissance buildings. The principles of geometric balance and harmony, along with the use of stylized columns could be seen in the work of many of the architects of the Renaissance. In the early 1500s the architectural concepts of the Italian Renaissance spread to France, and eventually England.

New Materials

We have reached a point in our story of architecture, at which the basic construction problems of working with stone, brick, wood, and masonry have been explored and conquered. The innovations of the Baroque and Rococo periods (about 1600 to 1750) were largely ornamental rather than structural. New advances in architecture would come from the utilization of new materials.

As you have learned earlier in this chapter, in the middle of the 1800s, a former builder of greenhouses named Joseph Paxton was to lead a breakthrough in construction methods using new materials. Paxton was chosen to build the largest building in the world. He constructed this building from iron and glass, materials not yet used together for building purposes, and it was popularly called the "Crystal Palace" (see Figure 6-8 on page 289). The strength of the iron, and the light weight of the glass, let Paxton use and design for the structure the material and methods he considered most appropriate. It is interesting that he chose the Roman barrel vault for the center portion of his building.

A similar building known as The Machine Hall was built in Paris for an exhibition of machinery in 1889. Designed by architect Ferdinand Dutert (Fer-di-nand DU-ter), this structure was made of steel girders and

glass panels. Like the Crystal Palace, this structure enclosed a vast amount of space.

> "The physician can bury his mistakes, but the architect can only advise his clients to plant vines."
>
> **Frank Lloyd Wright**

The Beginnings of Modern Architecture

The late 1700s to the late 1800s had seen architectural trends toward reviving the Greek and Gothic styles of architecture. But new generations of architects were looking for innovative styles that would reflect progress and modern times. In protest to the historical styles that had been revived in the mid-1800s, these turn-of-the-century architects set out to break the conventional boundaries of the architecture of the past. A great influence on these radical architects was Englishman William Morris. Trained as an architect, Morris traded designing the outside of buildings for designing the inside of them. His interest in interior design was fueled by a dislike for the poor quality goods turned out during the Industrial Revolution of the 1700s. This led him to produce original, superior quality designs for wallpaper, textiles, and furnishings. These new designs had a profound effect on those architects who sought to change the shapes and styles of modern buildings. Most of these modern architects initially worked in the Netherlands, Austria, and Germany. Eventually, however, modern architecture surfaced in the United States.

Perhaps the greatest opportunity for architects in the United States to try new designs was with the rebuilding of Chicago after the great fire in 1871. Much of the city was destroyed by the fire, and the

need for rebuilding was immediate. Much of the re-building of Chicago can be attributed to architect Henry Hobson Richardson. He is credited with the designing of such important Chicago landmarks as The Glessner House and the Marshall Field & Company Wholesale Warehouse.

Other notable architects that helped reshape the cities of America were Frank Lloyd Wright (see Chapter Five), Walter Gropius (1883–1969), and Ludwig Mies van der Rohe (1886–1969). It was van der Rohe that mastered the design and building of the modern sky-scrapers we see today. Steel and reinforced concrete provide the basis for framing and constructing these large buildings. The old post and lintel framing that we saw at the beginning of our story has come a long way to the twentieth century. In fact, post and lintel framing is so strong with today's materials that it doesn't matter if the exterior and interior walls of a tall building are added to the frame from the ground up or from the top down! How do you suppose this concept would seem to a builder or architect from the Middle Ages?

This brings us to the conclusion of our historical look at building terms and techniques. Perhaps we should leave some space for the inclusion of wonderful things to come. Who knows what materials will revolutionize the buildings and dwelling spaces of the future? Given the amazing history of architecture as a means of problem solving and expression, prospects for the future seem unlimited.

Section Ⓥ Review

Answer the following questions on a sheet of paper.

Learn the Vocabulary

Vocabulary terms for this section are *post, lintel, arch, keystone, vault, dome, Gothic, flying buttress, buttress, groined vault, pointed arch, pagoda, barrel vault, ribbed vault, aqueduct, colonnades, capital, Doric column, Ionic column,* and *Corinthian column.*

1. Match the following descriptions to the appropriate vocabulary term:
 a. A combination of arches
 b. Long rows of similar columns set equal distance apart
 c. The top of a column

Check Your Knowledge

2. Give one reason a lintel could fall.
3. Why did Grecian interiors have larger open areas than Egyptian buildings?
4. List the two reasons Roman architects developed the arch.
5. What are the two main advantages of the groined vault?
6. What type of arch made Gothic architecture possible?
7. What new combination of materials made buildings like the Crystal Palace possible?

For Further Thought

8. Can you identify a building in your city that has a vault? A dome? Any of the other architectural components discussed in this section?

SUMMARY

In this chapter, you have discovered that the first "citylike" communities began sometime in the New Stone Age or Neolithic period (5000 to 1500 B.C.) when humans moved out of caves and other natural shelters. As civilizations all over the world developed, their cities underwent great changes and refinements. Much of the art that concerned itself with the city consisted of building the cities themselves.

The ancient Greeks and Romans were master builders. They developed architectural standards that have been adhered to and refined for thousands of years. Some of their structures are still standing today.

With the coming of the Renaissance, great cities like Florence drew important scholars, architects, and artists together to share ideas and philosophies. This produced an explosion of experimentation that affected virtually all forms of artistic expression.

The rise of polite society in the seventeenth and eighteenth centuries afforded the general public opportunities to view art. Magnificent buildings made from the "New" lightweight materials (glass and steel), such as Joseph Paxton's Crystal Palace, were constructed to house public art exhibitions.

In the late 1800s, European cities provided gathering places for the exchange of ideas, as groups of artists, joined by a common philosophy, ignored traditional concepts of art and founded new artistic movements. Movements such as Cubism and Expressionism and Pop art would eventually rock the twentieth-century art world in America.

With the inception of the "Ash Can School," artists turned their attention toward the working class and the social environment in cities as subjects for their art. During the Great Depression, some city art made moral judgments about poverty, misfortune, and the overcrowded living conditions in America's larger cities.

As the depression ended, America began to see signs of prosperity once again, and "city" artists turned their attention toward more experimental ways of portraying the city and its inhabitants. Artists like Tooker, Segal, and Grooms saw the paranoia, isolation, and humor expressed by the city dweller.

By the 1960s, art had left the galleries and spilled out into the streets. Former manufacturing districts became centers for both studios and galleries. "Writers" expressed themselves with spray paint and markers on city trains and in back alleys; graffiti folklore became a tribute to their achievements. In cities around the world, customs, traditions, and world events have influenced structural decoration and the expression of personal values.

As in the past, the city will remain a sublime subject for the artist—a magnet for scholars' reflection on the social environments, the site of a changing and challenging architectural landscape, and a mystery that artists may strive to interpret.

CHAPTER 6 REVIEW

VOCABULARY TERMS

Imagine you are an architect and use at least five of the vocabulary terms to describe a structure you plan to build.

aqueduct	dome	Ionic column	pointed arch
arch	Doric column	keystone	post
architecture	embrasures	Kinetic art	ribbed vault
barrel vault	ephemeral	lintel	Social Realists
buttress	flying buttress	merlons	Soho
capital	Gothic	pagoda	The Eight
colonnade	Graffiti art	panorama	vault
Corinthian column	groined vault	patron	wall installation

Applying What You've Learned

1. What were some of the unique architectural forms developed by the ancient Greeks and Romans?

2. What impact did the development of linear perspective have on the city art of the Renaissance?

3. Why were magnificent structures like Joseph Paxton's Crystal Palace important to cities?

4. Why were patrons important to the art world?

5. What were some of the primary concerns of the Social Realists?

6. What was unique about the art of Soho?

7. Why did the Graffiti artists choose subway trains to paint?

Exploration

1. Get to know your own city better. Do some research about the city in which you live. Find out about its history, famous landmarks, and cultural traditions. Visit the local historical society, and look at old newspapers and photographs of the city. Photograph your city as it is today. Take pictures of all the different types of areas in your city (such as industrial, commercial, or residential districts; parks; and so on). Mount these photographs and create a comparative photo essay.

2. Construct a sculpture consisting of various architectural components (such as columns, arches, relief panels, different window shapes, and so on) drawn on heavy cardboard. Assemble the class's sculptures for a group display.

Building Your Process Portfolio

In this chapter you have discovered that a "city" may take many different forms. You have also learned that cities are places where scholars, scientists, and artists gather to fuel the spirit of exploration, exploration that often brings about great change. You have heard from voices that claim the streets as their galleries and vanish as quickly as they arrive.

As you have studied, you have had an opportunity to write about the city, photograph it, and make works of art in the spirit of its traditions, and its changes. Here are some of the things you may wish to place in your process portfolio:

1. Photographs you have taken of the city, or of the Soho wall art that your class has made

2. Photographs or videotapes of your wall installation piece

3. Answers to the critical, cultural/historical, or aesthetic boxes you have written

4. Any notes or taped interviews you took while you were the "Visual Reporter"

5. Photographs of your "dwellings" installation art

6. Any architectural drawings you might have made

7. Any notes you may have taken during critical discussions of the works in this chapter

8. In your sketchbook you may wish to do a detailed perspective drawing of yourself in a comfortable room like that of Saint Barbara. Be sure that you appear to be integrated into the room and not positioned outside the room.

Chapter 7

The Human Image in Art

Figure 7-1 Do you think Picasso liked this portrait done by his contemporary, Juan Gris?

Juan Gris (José Victoriano Gonzalez, Spanish, 1887–1927), *Portrait of Pablo Picasso*, 1912. Oil on canvas. 74.1 × 93 cm. The Art Institute of Chicago. Gift of Leigh B. Block. Photo ©1993, The Art Institute of Chicago. All Rights Reserved. 1958.525.

Contents

Section I The First Images

In this section, you will be introduced to the first human images created by people. You will also read about the first human images in art from Egypt, Rome, Greece, the Far East, Africa, and America.

Section II A Survey of Portraiture

This section features a brief history of portraits and self-portraits.

Section III Three Themes in the Use of the Human Image

Artists have used different themes in making the human image. In this section, we look at several of these themes: emotions and tensions, the family, the human image in action, and the human image in the twentieth century.

Terms to look for

Buddha	hieroglyphics	stylized
chiaroscuro	kachina	Superrealism
donor portraits	kachina-manas	Venuses
enigmatic	mudras	
foreshortening	self-portraits	

Objectives

- You will understand how certain people have created images of the human figure for decorative, religious, spiritual, and survival purposes.

- You will learn how the human image in art represents various traditions, life-styles, and customs from different civilizations and cultures.

- You will learn about artists who choose to experiment with the human image in their art.

- You will be introduced to several themes that artists have used in depicting the human image.

Art in Your Life

The human figure is probably one of the most important images we know. It is a common link between all cultures and civilizations. Studying the many reasons why the human image is one of the foundations of art around the world will broaden your understanding of humankind.

As an art student, you will be asked to draw, paint, and sculpt the human figure as a part of your studies. You might be asked to render a representational figure or abstract a portrait. Seeing how other artists have chosen to depict the human image will help you make decisions in your own work.

Section I

The First Images

The Human Image in Art from the Stone Age

The earliest significant images of the human figure that still exist date from the Stone Age. (about 32,000 B.C.) These images were carved by ancient artists using stone tools. *Each surviving figure is female. These figures have been named* **Venuses** by some archaeologists. The Venus in Figure 7-2 was carved approximately 20,000 years ago in southern France. The rotund characteristic of the figure is purposeful. Its form symbolizes fertility and bountiful supplies of food. With the presence of both in the lives of the people, human survival during this time was possible.

The most complete record of life during the Stone Age exists in the Sahara Desert in Africa. Over 30,000 paintings have been found on Saharan rocks. Some date from as far back as 6000 B.C.

The name *Sahara* now brings to mind a dry, sandy landscape. But the Sahara was actually green and fertile until around 4500 B.C. The change was gradual. It took thousands of years, and the drying process continues even today. Rock paintings not only give us glimpses of the beginnings of African art, but they also provide an invaluable record of the history of the Sa-

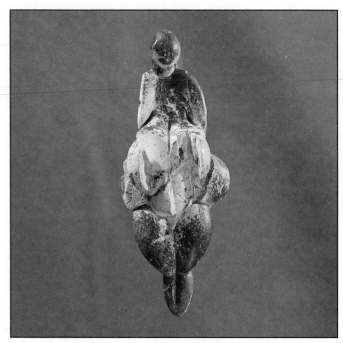

Figure 7-2 The earliest human figures were carved in the Stone Age.

Venus of Lespurgue. Musée de l'Homme, Paris, France. Scala/ Art Resource, NY.

hara. For example, early rock paintings depict water-loving animals such as the hippopotamus, elephant, giraffe, and antelope. As the Sahara dried, the animals and the people who lived there moved south to more moist areas. The paintings left behind are an indication that animals at one time existed in this area of the Sahara.

Figure 7-3 shows how the human image was stylized during this ancient period. In this case, **stylized** *means that the body parts of the figure have become more simplistic and reduced to their basic form.* In this rock painting located in Algeria, human images are rendered in various proportions. Cattle, which appear to be stacked on one another in an attempt to show depth, are being herded by the women and children. The three white circles to the right of the people represent the huts in which they live. The people, like their huts, look more like symbols than humans.

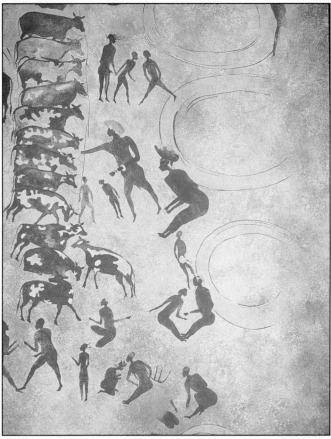

Figure 7-3 The Sahara contains more than 30,000 rock paintings.

Prehistoric fresco of women, children, and cattle. From Tassili n'Ajjer, Algeria. Henri Lhote Collection, Musée de l'Homme, Paris, France. Erich Lessing/Art Resource, NY.

The Human Image in Art from Ancient Egypt

In 1799, a rather small, irregularly shaped stone was found by workers who were restoring an old fort near the town of Rosetta on the Nile river. The stone was inscribed in three languages. One was Egyptian **hieroglyphics,** *or sacred-writing;* the second was a simplified version of hieroglyphics known as demotic (dih-MOT-ic) writing and the third was Greek. In each language, the text described a royal Egyptian event of the second century A.D. The Greek inscriptions on the Rosetta Stone provided the key to deciphering the hieroglyphic symbols. This unlocked 6,000 years of Egyptian history. The hieroglyphic language is very complex. The basic "alphabet" consists of twenty-five signs. In addition to the alphabet there are other symbols that are sounds or objects. Decoding the hieroglyphics has helped historians identify the people in ancient Egyptian art, as the pictures were not realistic portrayals. As seen in Figure 7-4 on the next page, parts of the human anatomy were represented with a picture as part of the original alphabet.

For 4,000 years, Egyptian artists obeyed rigid conventions when depicting the human figure in their art. In two-dimensional work, various parts of the figure were consistently rendered from the most easily recognizable viewpoint. For example, Egyptian artists depicted the head in profile, with the exception of one feature. Look at Figure 7-4 on the next page. What facial feature is not in profile? It is the eye that can be seen completely when viewed from the front.

The shoulders, chest, and upper torso are also rendered in a frontal view. This is because, from the front, it is clear to the viewer how the arms are attached to the shoulders. Also, from the front, anything held in either hand will be clearly visible. The lower torso, legs, and feet are rendered from a side view so that movement, such as walking, can be easily seen.

The figure seems stiff and unnatural to us. In your art classes, you are often asked to draw the human figure in a representational style. To appreciate Egyptian art, we need to understand the logic of their art style, and then study the artwork from that understanding. Differences among human beings were purposely ig-

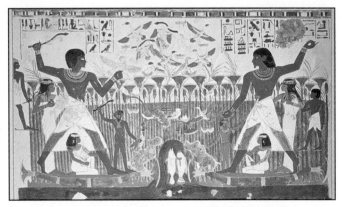

Figure 7-4 Hieroglyphics were added to tell the story of the painting.

Festival of Sekhtet, Fowling. Painted wall from the Tomb of Nakht, Thebes, c. 1410 B.C. The British Museum, London, Great Britain. Bridgeman/Art Resource, NY.

nored. An Egyptian artist did not dare change the system; this would have been considered disrespectful to the gods and would have caused a curse to be placed on the subject. If one part of the human image was not visible in a painting, the person would go onto the "afterlife" (or life after death) minus that part of their anatomy.

The Human Image in Classical Greece

The human figure dominated Greek art (1100–700 B.C.). Typical poses in early Greek art were similar to those of the Egyptians, whose art the Greeks had carefully studied. For example, the earliest Greek efforts were large, freestanding stone figures. Like the Egyptians, the Greeks carved many of their figures freestanding rather than in relief.

However, Greek artists were not forced to conform to rules as were the Egyptians. The stiff, wooden poses of early Greek art, from the Archaic Period (600–480 B.C.) such as that shown in Figure 7-5 developed into the graceful, natural poses we see in Figure 7-6.

Figure 7-5 (Far Left) Early poses appear stiff.

Hera from Samos, c. 560 B.C. Marble. Height approx. 6′4″ Louvre, Paris, France. Giraudon/Art Resource, NY.

Figure 7-6 (Near Left) The artist took full advantage of the marble block. You will read about *Nike of Samothrace* in Chapter Eight.

Nike of Samothrace, c. 190 B.C. Marble. Height approx. 8′. Louvre, Paris, France. Scala/Art Resource, NY.

Early works in marble (see Figure 7-5), resembled figures carved from tree trunks. But as the skills of Greek artists developed, they began to take advantage of the natural shapes of the marble blocks and used them as foundations for arms, legs, heads, and torsos.

In depicting the human form, Greek artists strived for perfection. Individual human distinctions were not considered important, and artists deliberately overlooked these differences. This resulted in the "ideal" image, as we see in the fragment of the statue of *Dionysus* (dy-uh-NY-sush) (see Figure 7-7). Dionysus was the god of wine in Greek mythology whose name was later changed to Bacchus by the Romans.

No complete Greek paintings have survived. Only a few fragments of murals remain. Instead, we can trace the use of the human image in two-dimensional work by looking at painted Greek vases. Greek artists slowly dropped the stylistic figures they had copied from the Egyptians, and began to paint more lifelike human images. An important breakthrough was the development of the technique of **foreshortening,** or *rendering the human form as if it were moving directly towards the viewer.* Greek art began to include foreshortening around 500 B.C. Look closely at the young hunter on the vase in

Figure 7-8. His head and body are rendered in typical Egyptian fashion, but the feet are different. One foot is shown in the traditional Egyptian side view, but the other is seen from the front, and is foreshortened. This way of painting of the human figure would change forever the way western artists represent the human image.

Figure 7-8 An Early Example of Foreshortening

The Pan Painter, *Young Hunter with Dog (Attic Red Figure Lekythos)*. 5th century B.C. Height: 0.392 m. (15½"). The Francis Bartlett Fund. ©1993, Museum of Fine Arts, Boston. All Rights Reserved. 13.198.

Figure 7-7 This fragment is among a few remaining original Greek sculptures.

Dionysus, from the east pediment of the Parthenon. Marble. Over life-size. ©The British Museum, London.

Student Activity 1

Creating a Cartouche

Goals

1. You will learn how to create an Egyptian cartouche.
2. You will draw a human figure the way the Egyptians did.
3. You will be introduced to the Egyptian alphabet.

Materials

1. Hieroglyphic chart
2. Paper
3. Pencils

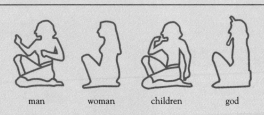

man woman children god

Directions

1. The ancient Egyptians used hieroglyphs, or picture writing. The word hieroglyphic means sacred writing in Greek. This picture writing depicts sounds or meanings in addition to the basic alphabet of twenty-five symbols. Some of the symbols have been designed to represent the human image.

2. Use the hieroglyphic chart to create your own cartouche. A cartouche is the hieroglyphic spelling of the name of Egyptian royalty. A cartouche is identifiable by the "rope" or line drawn around the hieroglyphics. Use your name or the name of a friend. Include an Egyptian-style human image somewhere in your cartouche design. If you cannot locate a hieroglyphic symbol to match a letter in your name, select a sound or image that is a close match.

3. Your cartouche can be in a vertical or horizontal position. Draw the royal ring, or rope, around the cartouche.

Evaluation

1. Were you able to match the letters of your name to the hieroglyphic alphabet? If not, what symbols did you choose and what significance do they have to your personality?

2. Did you include an Egyptian-style human image somewhere in your composition? Why did you select the specific placement in your cartouche for your human image?

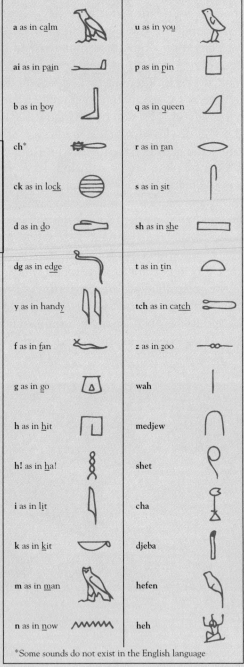

a as in c<u>a</u>lm		u as in yo<u>u</u>	
ai as in p<u>ai</u>n		p as in <u>p</u>in	
b as in <u>b</u>oy		q as in <u>q</u>ueen	
ch*		r as in <u>r</u>an	
ck as in lo<u>ck</u>		s as in <u>s</u>it	
d as in <u>d</u>o		sh as in <u>sh</u>e	
dg as in e<u>dg</u>e		t as in <u>t</u>in	
y as in hand<u>y</u>		tch as in ca<u>tch</u>	
f as in <u>f</u>an		z as in <u>z</u>oo	
g as in <u>g</u>o		wah	
h as in <u>h</u>it		medjew	
h! as in <u>h</u>a!		shet	
i as in l<u>i</u>t		cha	
k as in <u>k</u>it		djeba	
m as in <u>m</u>an		hefen	
n as in <u>n</u>ow		heh	

*Some sounds do not exist in the English language

The Human Image in Art from Imperial Rome

The rise of the Roman Empire and the development of art throughout the land is a story of political conquest. A group of people called Etruscans dominated Italy and developed Rome into the largest city in the country during the sixth century. However, the Romans banished the Etruscans from the city in 509 B.C. and established their own republic. This act instigated a battle between Rome and surrounding countries. Eventually, Rome controlled all of the lands throughout Europe and Africa during this period.

Many Greek statues were transported to Rome after the Roman conquest of the Greek islands in 146 B.C. Copies of the sculptures were made by Greek sculptors who went to Rome to work in the villas (homes) of wealthy Romans. Although Roman sculpture was based on Greek models, Roman artists gradually began to use a more realistic approach in making human figures by concentrating on the head and torso. As their skills increased, they produced close likenesses of Roman politicians and citizens who desired to be immortalized in stone. Bronze and marble sculptures of Roman emperors would tour the empire so that citizens could see what their leaders looked like! Gone were the idealized heads and bodies the Greeks had admired. Individual differences were portrayed realistically, as in Figure 7-9. This shift to making representational portrait sculptures left a legacy for the world to study and appreciate.

Many portrait sculptures would be mounted on decorative pedestals (or bases) which were often adorned with marble or bronze leaves. This decorative feature is exclusively a Roman characteristic and has helped archaeologists and historians to classify and date them.

The Image of Buddha in the Far East

Let's stop for a moment in our discussion of ancient human images in Western civilization and study the use of human images in the Far East. The earliest forms made to represent people were made for religious ceremonies or to honor spiritual leaders. The Islamic, Hindu, and Buddhist religions emerged in the ancient

Figure 7-9 Roman sculptors accurately depicted the features of their subjects.

Portrait Bust of a Man. Roman. Early 1st century B.C. Marble. H: 17½" (44.5 cm.). Metropolitan Museum of Art, New York, Fletcher Fund, 1926. 26.60.3.

cultures of Asia and Africa. Icons were created to signify nature, animals, and human spirits in religious practices.

One of the most universally recognized human images in the world comes from Buddhism. *The **Buddha,** meaning "enlightened one," was Siddhārtha Gautama, the spiritual leader of India during the sixth century* B.C. He was an Indian Prince who at age twenty-nine renounced his throne and family for a life devoted to religious teaching. It is Eastern belief that Buddha was sitting under a tree in meditation when he experienced an "enlightenment" or directions to guide the spiritual lives of the people.

Typical images depict Buddha seated, as in Figure 7-10 on the next page, although some are meditating, teaching, or reclining. The Buddha image usually has a knob on the top of his head, signifying wisdom. Long, distended earlobes indicate the spiritual leader's use of

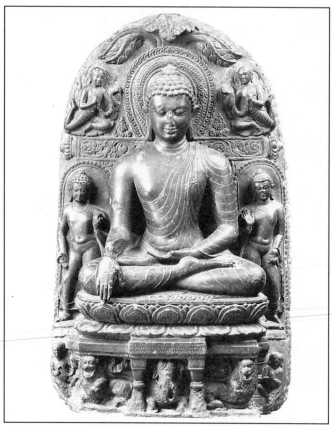

Figure 7-10 The Buddha is a human image representing Gautama Buddha, India's spiritual leader.

Buddha Calling on the Earth to Witness. India, Bengal Pala Period, 9th century. Black chlorite. H: 99.0 cm. ©The Cleveland Museum of Art, Dudley P. Allen Fund. 36.146.

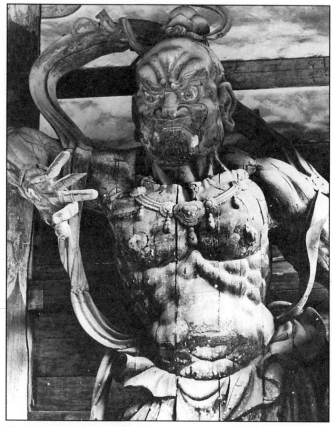

Figure 7-11 Guardian figures reassured the faithful and protected Buddha.

Guardian Figure at the Great South Gate of Todaiji Temple, Japan. Courtesy, Shashinka Photo Library, New York.

heavy ornate earrings. The position of Buddha's hands changes from image to image. *Hand gestures,* called **mudras** have specific meanings for blessings during prayer. Notice the parasol-like halo, which is another typical feature of these images.

As the Buddhist religion spread, images of Buddha grew larger. They were placed in temples called stupas (STOO-puhs) in India. Other forms of Buddhist temples developed in other parts of Asia. In Chinese and Japanese temples it was common to find guardian figures such as the one pictured in Figure 7–11.

The Human Image in African Art South of the Sahara Desert

The use of the human figure in southern African sculpture can be traced back for more than 2,000 years. The oldest known examples come from the Nok culture (located in what is now Nigeria). Nok human images were highly stylized, with distorted features, as we see in Figure 7-12 on the next page. Animals, in contrast, were depicted realistically. In other words, Nok artists were capable of rendering realistic images, but in the case of the human figure, they chose not to do so. Perhaps a realistic human image would have been considered unlucky for the person who was the model,

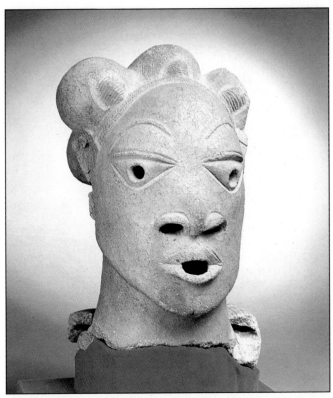

Figure 7-12 This head was found at the site of a tin mine in northern Nigeria.

Nok head. Nigerian, 500 B.C.–A.D. 200. National Museum, Lagos. ©1994 Dirk Bakker, The Detroit Institute of Arts, Michigan.

or the sculptor would have been accused of witchcraft if the resemblance had been close. Regardless of the reason, the tradition became a strong one, and the Nok style had a lasting effect on the art of West Africa. The stylized, abstract works of African artists later had a significant influence on the development of Cubist art in twentieth-century Europe and America (Chapter Nine). Masks were used during ceremonies to influence the spirit world. Some masks were created with geometric and amorphic shapes carefully placed in order to resemble a human portrait. Others became so abstract that recognizable features were non-existent.

Kongo is located in Central Africa, south of Nigeria. People of Kongo created unique ceremonial clay or wood figures (see Figure 7-13 on the next page). These figures are called *nail fetishes* by contemporary historians. The Kongo name for these ceremonial figures is nkisi n'kondi. *Nkisi* means the figure itself. *Kondi*

comes from *konda* which means *to hunt.* These figures were made in the image of a human form. The nkisi n'kondi belonged to the entire community, and were used for magic rituals. The Kongo people believed that the figure stopped famine, brought rain to dry crops, healed the sick, ensured honesty and peace, and resolved arguments. Village counselors who kept the figures in their possession listened to the problems of people seeking spiritual help. They would then apply various materials such as mud, grass, or mirrors to the surface of the figures in order to activate the magic.

As a person spoke of his or her problems, the counselor would hammer a nail or other sharp object into

Student Work

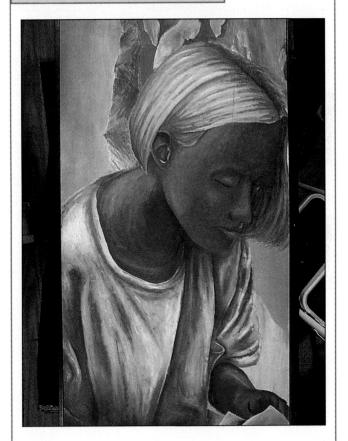

Ryan Grigsby, 18
Booker T. Washington High School; Tulsa, OK

the figure's body. This act signified the contract be-tween the person and the spirit of the nail figure. There were specific nails and blades for the various problems presented to the nail figure. Sometimes rope or cloth would be wrapped around the nail first to specify a special request to the spirit. If a problem was resolved, the nail or blade was removed from the figure.

Nail figures were carved from a living tree. The villagers believed that the tree's strength was transferred to the figure and enhanced the power of the spirits. The nail figure in Figure 7-13 stands with the left hand on the hip. The right hand, which once held a spear, is aggressively poised in the air. Nails and blades cover the torso. In the figure's abdomen, a small space is hollowed out to hold twigs, bones, mud, clay, or other items that were used during the ritual. A mirror has been placed in the abdomen over the objects to attract the spirits. The figure's eyes, nose, and open mouth are all expressive.

The symbolic image of a human figure used in India and African religious ceremonies would continue throughout the centuries. Although the Buddha and nkisi n'kondi assumed a variety of human forms, their spiritual significance remained the same.

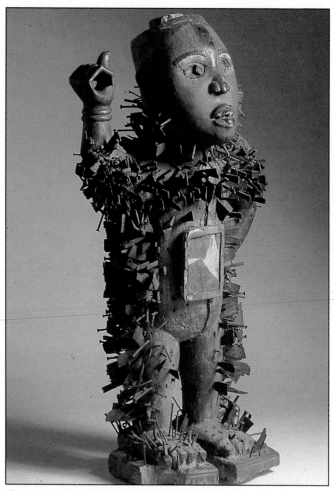

Figure 7-13 The piercing of the figure signified that the contract had been made.

Nkisi N'Kondi Nail Figure, male. Yombe, Zaire. The University Museum Archives, University of Pennsylvania, Philadelphia.

Student Work

Maria Lopez, 18
Sunset High School; Dallas, TX

"The head is the most expressive part of the human being, and that is why it has always been treated as an independent theme in art."

Henry Moore

Student Activity 2

Emotion Mask

Goals

1. You will learn how to express feelings, moods, and emotions through the use of colors, shapes, textures, and forms.
2. You will learn how to create a mask that conveys a specific feeling.

Materials

1. Photographs of African, New Guinean, or Native American masks located in books from the school library
2. Newspaper strips, wallpaper paste, or plaster and gauze strips
3. Mixed media (feathers, buttons, foil, sequins, and so on)
4. Tempera or acrylic paints
5. Brushes and water and paint pans

Directions

1. Masks have been used in various cultures during religious or ceremonial events. Masks express emotions or feelings designed to entertain or persuade religious spirits or important persons within the community. Study the examples of masks. How have shapes and textures been used to express feelings?
2. Select one emotion or feeling to express through your mask. This feeling could be angry, silly, sad, happy, calm, and so on. On a piece of paper, list the colors that you associate with that feeling. You may want to refer to the Activity 1 art you completed in Chapter One.
3. Use an inverted plastic bowl, or several papers that have been wadded into an oval, to form the base on which to mold the mask face.
4. Strips of papier-mâché or pariscraft should be placed across the top half of your form. Build up the layers until you have a one-quarter inch thickness. Features that stick out, such as the nose and chin, can be built up with extra layers of papier-mâché.
5. Allow to dry. Paint the mask with colors that express the emotion you have selected. For example, you might use red paint to express anger. Sharp angled lines may express excitement. Embellish the mask with a variety of textures, shapes, or found objects, such as sequins and feathers.

Evaluation

1. Were you able to manipulate the materials in order to form a mask with an expression? What steps during the construction of the mask were the most challenging? How did you overcome the obstacles?
2. Did you select colors, objects, textures, and shapes that represented the emotion you chose? What were your reasons for selecting them?

Hopi Kachinas: Sacred Spirits

Another interesting example of the ancient spiritual use of the human image in art can be found in the southwestern United States. For several centuries, the Hopi (HOH-pea), a population of Native American people, have lived throughout northern Arizona. They lived on mesa tops and farmed the dry yet fertile valleys below. It was the growing of maize (corn) and the need for water for the crops that laid the foundation of the Hopi religion. To obtain assistance in securing water in any form, the Hopis called upon spirit forces. They believed, as they do today, in a complex religious system that involved over two hundred and sixty *kachina* (kah-CHEE-nah) spirits. Each **kachina** *represents the spirit of an earthly object.* The Hopi believe some kachinas provide a plentiful harvest by bringing rain and sun. Others ensure long life, and happiness. Marriages and births are blessed by kachina spirits.

During Hopi ceremonies, the men of the tribe portray the kachina spirits. They wear elaborate symbolic costumes and decorative masks.

Hopi artists also create small replicas of the kachina spirits from wood, feathers, and other assorted materials. These kachina dolls are given to young boys at birth, and to young women before entering marriage.

Each doll represents one of the kachina spirits. The mask of the doll identifies a spirit with a symbol. Some of the major symbols are a cactus or corn for harvest, and sun, moon, and stars to worship the universe. Kachina "officials" or the most powerful kachinas are marked with an upsidedown "V" over the mouth. Often, the dolls hold objects in their hands such as rattles, bows and arrows, and knives. The many different *female kachinas*, **kachina-manas** can be identified by the different colors of corn attached to their hands. Some kachinas appear to be still, but most assume the typical pose that the kachina would strike during the dance.

The kachina dolls are made from the root of the cottonwood tree. Cottonwoods are found along streams and riverbanks and contain moisture. The Hopi carefully carves the doll from the root after it dries, then forms it by hammering the wood with a mallet. A coating of clay is sometimes applied to smooth the surface of the wood and prepare it for decoration.

> "**N**earness to nature . . . keeps the spirit sensitive to impressions not commonly felt, and in touch with the unseen powers."
>
> **Ohiyesa, Santee Dakota**

The paint colors chosen to decorate the kachina dolls represent the geographic location from which the kachina originates. White represents east; blue-green represents west; red, south; and yellow, north. Early Hopi artists used brushes made from the fiber of yucca plants. The paints were made from natural materials, such as copper, iron, and vegetable dyes. Foliage, such as leaves and moss were sometimes applied to the masks. Animal fur and feathers were applied for decoration. Each feather used by the Hopis is symbolic. Eagle feathers represent clouds and rain, while owl feathers ensure excellent night vision (see Figure 7-14). However, these feathers are now considered illegal for kachina use as the birds are protected by the government.

Although kachina dolls are designed for spiritual reasons, they are also made for commercial use today— a situation which has been controversial in the Hopi community. Regardless, the symbolism of the kachina and the techniques used to make them have been preserved from generation to generation.

EXPLORING

HISTORY AND CULTURES

The Hopi Native Americans use kachina images to represent their spiritual beliefs. Select one of the following countries and write a short research paper tracing the use of human images in the art of the people.

1. New Guinea
2. Brazil
3. Mexico

Figure 7-14 A Hopi Kachina Doll

Kwahu, Eagle Dancer Kachina Doll, 1973. Hand-carved by Herbert Quimayousie, member of the Hopi Spider Clan. Cottonwood root (obtained at Hopi Reservation near Hotevilla, Arizona) eagle feathers, acrylic paint. Photo ©1994 Denny Arthur.

Section ① Review

Answer the following questions on a sheet of paper.

Learn The Vocabulary

The vocabulary terms for this section are *Venuses, stylized, hieroglyphics, foreshortening, Buddha, mudras, kachina* and *kachina-manas.*

1. Match the following description to the appropriate vocabulary term:
 a. Reducing or distorting shapes to give the illusion of three-dimensional space as it is actually seen by the human eye

 b. The name archaeologists have given to the earliest significant images of the human figure, which date back to the Stone Age and are all female
 c. Represent the spirit of earthly objects, according to the Hopi people

Check Your Knowledge

2. What is the most complete record of life during the Stone Age?
3. Why was the discovery of the Rosetta Stone important?
4. What is the main difference between Greek and Roman sculptures of the human form?
5. What is the purpose of guardian figures in Buddhist sculpture?
6. Give two possible reasons why Nok human images are highly stylized.

For Further Thought

7. Think about various human images you see in your everyday environment (video-game figures, dolls, cartoon characters, and so on). What do their characteristics say about our contemporary culture?

Section II

A Survey of Portraiture

Portraiture is an important part of the human image in art. Artists have created drawings, paintings, and sculptures of other people throughout history. Works of art in which *artists have used their own images as subjects for their portraits* are called **self-portraits.** A portrait is more than an attempt to produce an exact likeness of an individual. It is often one person's interpretation of another. The portrait may bear a close resemblance to the subject or it may be rendered with-

out making a physical likeness. A self-portrait can reveal things other than the physical appearance of an artist. Sometimes we can guess what their personality might be like or how they view their role in society. We can tell what type of clothing they liked to wear or what the fashions of their period in history were like.

In Chapter Three you learned about how researching your family heritage is similar to studying art history. Photographs or paintings are a vital element to discovering what our ancestors looked like. The ancient Romans for example, would display ancestral portraits which were painted on wood on the walls of their homes. They arranged them in chronological order and drew lines on the walls behind the portraits linking each family member together. This method of displaying portraits was superior to a written record because a physical resemblance could not be disputed. However, the collapse of the Roman Empire in 395 A.D. changed the importance of portraiture in the Western world.

For approximately 900 years after the fall of Rome, social and governmental chaos prevailed and portraiture was almost nonexistent. The church became the only safe haven from the barbarians who roamed the European continent. During the Middle Ages, individual differences were considered of little importance compared to the holy subjects. However, in the thirteenth century, Saint Francis of Assisi and other religious leaders inspired a renewed appreciation for the natural world. This meant that artists were expected to use representational images, specifically portraits, in their art.

As communities in the fourteenth century grew, **donor portraits** became popular decorative works of art. Donor portraits *were paintings, sometimes in the form of murals, commissioned by wealthy persons and donated to their churches as visible signs of their faith.* The donor expected that his or her portrait, and perhaps that of the entire family, would be painted next to a saint or a biblical figure. This was to ensure their inclusion in the prayers of the congregation. This practice of incorporating portraits of donors in religious paintings continued into the seventeenth century.

Raphael. The Renaissance artist Raphael Sanzio (1483–1520) was commissioned in 1512 by a wealthy patron named Sigismondo de Conte (Sig-is-MON-do de CON-tee) to paint a donor portrait as part of an altarpiece. Sigismondo wanted to show his gratitude that his family had survived when their home was hit by a meteor. In the resulting work (see Figure 7-15 on page 350), Saint Francis and John the Baptist are lo-

Student Work

Amy Billharz, 18
Overton High School; Memphis, TN

Student Activity 3

Mirror Images

Goals

1. You will learn how to transform a mirror image into a self-portrait.

Materials

1. Mirrors
2. Drawing pencils
3. Watercolors
4. Brushes and water pans
5. White drawing paper or watercolor paper

Directions

1. Some artists use their own face to paint a portrait if another person is not available. If a mirror is used in the process, the image must be reversed in the drawing for accuracy. Look in a mirror and analyze your reflection. What is in reverse? Does the pattern on your clothing appear to be backward? Is the part in your hair on the opposite side of your head?

2. Make a list of the objects or facial features you would have to reverse in order to create a portrait from a reflection. Refer to the list as you create your self-portrait.

3. Begin sketching your self-portrait on paper while looking into the mirror. Reverse any objects or features that may be "backward" when you look in the mirror. This will require sharp observational skills!

4. Complete the self-portrait by applying watercolors to the drawing.

Evaluation

1. Does your self-portrait resemble your mirror image? What areas of your face are distorted or not in proportion?

2. Did you reverse any backward objects when you transferred your mirror image to paper? What challenges did you experience while reversing the image in your drawing?

cated on the left. Saint Jerome places his hand on the donor's head in blessing as they both gaze up at the figure of Mary. In the distance, the fireball is streaking through the atmosphere, headed for the de Conte home. Sigismondo's portrait in the scene is a sign of his gratitude for being spared certain death.

Van Eyck. The Flemish brothers Jan and Hubért van Eyck (IKE) were trained to capture the smallest detail of a scene or a face. Figure 7-16 on page 351 is believed to be a self-portrait of Jan. The work is particularly significant because it is the first portrait in a thousand years to show the subject looking directly at

Figure 7-15 The master Raphael included the donor as part of the scene.

Raphael Sanzio (Italian, 1483–1520), *Madonna di Foligno*. Vatican Museums, Vatican State. Scala/Art Resource, NY.

Figure 7-16 Even if the viewer moves, the eyes cannot be avoided.

Jan van Eyck (Flemish, 1390–1441), *Man in a Red Turban* (Self-Portrait?), 1433. Approx. 10¼" × 7½". Courtesy of the Trustees of the National Gallery, London. NG022.

the viewer. Jan lived from 1390–1441, and painted this portrait around 1433.

In the Middle Ages, artists depicted human beings looking toward heaven, at a saint, or at some other part of the picture. However, Jan's fifteenth-century man in the red turban looks directly at the world in front of him. His attitude and expression seem to signal a change in the way human figures would be used in the art of the future.

Michelangelo Buonarroti— Renaissance Genius

The Italian Renaissance artists and scholars studied classical literature and art from Greece and Rome for inspiration. Any relic that could be bought or traded in the two countries was brought to Florence and used as a model. This inspired the production of some of the greatest human images in the history of art through painting and sculpture. The theme of this chapter demands that we consider the works of the artist who, more than any other, defined the Renaissance attitude towards the human image—a man born in 1475 named Michelangelo Buonarroti.

In September 1508, Michelangelo's seventeen-foot-high statue of David was unveiled in Florence. From that moment, Michelangelo was considered the greatest sculptor of the human form during his time.

When Michelangelo was six years old his mother died. His father sent him to live with a stone quarry worker and his wife. Before he learned to read, Michelangelo could handle a hammer and chisel. From that time on he considered sculpture to be the greatest of all art forms.

At the age of thirteen, Michelangelo began studying the painters of the early Renaissance, and was most strongly attracted to the works of Masaccio. Masaccio's brilliant use of perspective and his foreshortening of the human figure technique appealed to the young artist. Michelangelo's early figure drawings appear to be studies for sculpture.

Michelangelo competed his first Pietà (pee-AY-tah') in 1498, at the age of twenty-three (see Figure 7-17 on the next page). A Pietà is an image of the Virgin Mary mourning the dead body of Christ. This Pietà was a radical departure from previous sculptural treatments of this subject. Most earlier Pietàs had been carved from wood. They were rather gruesome works designed to shock the viewer with the magnitude of Christ's sacrifice. Mary was typically pictured overcome with grief at the loss of her son, her features distorted in agony. In contrast, Michelangelo chose to emphasize her spiritual beauty. The outstretched hand solemnly and elegantly displays her sorrow. The Christ figure is life-size. Mary, if she were to stand, would be seven feet tall. Yet her head is the same size as that of

Christ. Why and how do these distorted proportions appear so "right?" In order for Mary to visually support Christ, Michelangelo had to make Mary larger than life. Her wide lap and flowing garments appear to adequately sustain the lifeless body.

In 1508, Pope Julius II decided that no other artist but Michelangelo would be suitable to decorate the huge ceiling of the Vatican's Sistine Chapel in Rome. The challenge was awesome. The area to be painted in fresco was almost 6,000 square feet. The ceiling height was sixty-eight feet. Michelangelo did not consider himself a painter; his major works up to that time had been in marble. He tried desperately to avoid this commission. However, Julius II was stubborn, and would not consider another artist. Michelangelo had no choice but to obey.

The plan for the ceiling originally called for a dozen human figures from the Bible in the center sections, with decorative work surrounding them. In the early stages, it was discovered that a moldy condition in the ceiling was destroying Michelangelo's efforts. He was forced to begin again. Five skilled artists were assigned to assist him. He dismissed them all, and destroyed the parts they had worked on.

Figure 7-17 No work of Michelangelo's has more attention to detail and fine finishing touches than this famous sculpture.

Michelangelo Buonarroti (Italian, 1475–1564), *Pietà*. St. Peter's Basilica, Vatican State. Scala/Art Resource, NY.

During the difficult four-year period when Michelangelo was painting the ceiling of the Sistine Chapel, he wrote his most famous sonnet. The last line reads, "The place is wrong, and no painter I." He adorned the sonnet with a sketch of himself. In the sketch we see him on his high, lonely scaffold. He says in the sonnet that his beard points to heaven, his scalp is on his shoulders, and his paintbrush drops "a rich mosaic" on his face. His pupil and biographer, Ascanio Condivi (con-DEE-vee) said that for months after completing the ceiling, Michelangelo could read only by holding the correspondence above his head. He had looked straight up at the Sistine ceiling all day, each day, for four years.

When the chapel was opened for public viewing in 1512, all the important artists and citizens of Rome came to see his work. Now it was obvious that Michelangelo had become the supreme master of the human image.

We see in Figure 7-18 that Michelangelo abandoned his original plan for twelve human figures. In the end, he included more than 300. Very few preliminary sketches remain. However, we can learn a lot from studying those that have survived time. For example,

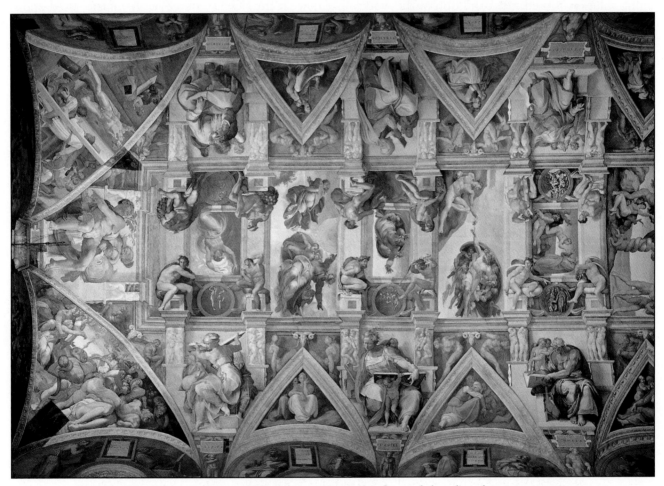

Figure 7-18 Imagine yourself looking up from the floor of the chapel as you examine this photograph.

Michelangelo, *The Sistine Ceiling*, 1509–1512. Fresco. Sistine Chapel, Vatican, Rome. Photo after restoration ©1994 Nippon Television Network Corporation, Tokyo.

TECHNOLOGY MILESTONES IN ART

Restoration of the Sistine Chapel

Paintings, sculptures, murals, and other art forms can deteriorate or yellow with age. They may darken due to dust and soot. They can crack, flake, break, warp, chip, tear, or otherwise suffer damage at the hands of humans and time (see Figure 7-19 below).

Restoring art to its original condition is a highly specialized and complex field. Artworks must be studied carefully before they can be restored. Restoration materials must be tested to ensure that they are perfectly suited to the artwork. If the wrong chemical or cleaning solution is used, the condition of the work of art could worsen. The artwork could even be damaged beyond repair.

It took over ten years to restore the Sistine Chapel ceiling. That's much longer than it took Michelangelo to paint it! The ceiling had suffered from five centuries of black smoke rising from burning candles, as well as from grease and grime, water damage, and dark varnishes and glues that had been used in earlier, less successful attempts to preserve the painting.

Beginning in 1979, Fabrizio Mancinelli and dozens of other restoration experts labored to return the Sistine Chapel's ceiling to its original glory. They used new technologies along with older, tried-and-true methods. For instance, a computerized map was made of every square inch of the ceiling. The map was used

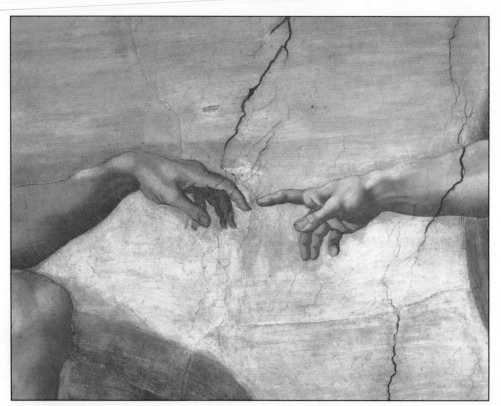

Figure 7-19 Notice the deterioration before the restoration. Severe damage is quite evident.

Michelangelo, *The Sistine Ceiling*, detail, *The Creation of Adam*, before the restoration. Scala/Art Resource, NY.

to identify and analyze cracks and other special problem areas. The composition of the painted ceiling was studied under a variety of light sources: daylight, quartz lamps, ultraviolet, infrared lights. These were used to detect and study foreign particles and substances on the painting.

Computerized infrared reflectoscopy (a microscope to look underneath a surface) allowed restorers to peer beneath the layers of varnish and paint to see Michelangelo's original drawings and brush strokes. Chemical tests were run to discover what the layers were made of. Cracks and flakes in the plaster ceiling were carefully repaired. Various cleaning materials were tested and retested to ensure that they would remove everything *except* Michelangelo's original painting.

Art historians around the world were astonished by the brilliance of the colors revealed by the restoration. This information has caused historians to rethink their opinions about Michelangelo's style of painting.

Finally, after the ceiling was restored, work began to stabilize the chapel environment in order to preserve the painting in the future. Sophisticated air filters and temperature, draft, light, and humidity controls were installed. Today, visitors to the Sistine Chapel in the Vatican City can enjoy the results of the labors of many dedicated art conservation and restoration specialists, as seen below in Figure 7-20.

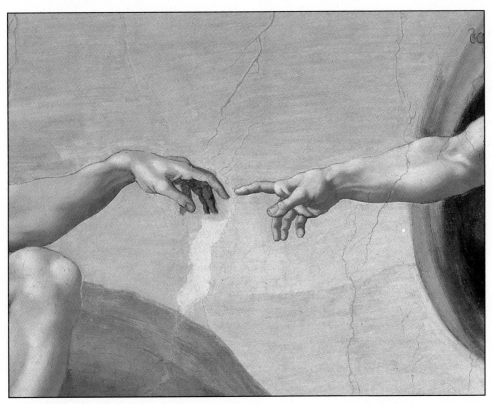

Figure 7-20 The image has now been restored to its original glory.

Michelangelo, *The Sistine Ceiling*, detail, *The Creation of Adam*, after the restoration. Photo ©1994 Nippon Television Network Corporation, Tokyo.

a sketch of a male model (see Figure 7-21) was translated into the study of female Libyan sibyl (SIB-ul, a female prophet) of Figure 7-22. On the sketch page, we can see the practice and the care taken by Michelangelo to render the foreshortened hand accurately.

> "Make your portrait at twilight or in clouds or mist. Works painted then have more insight, and *every* face becomes beautiful."
>
> **Leonardo da Vinci**

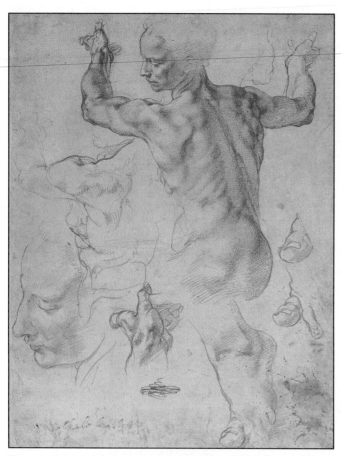

Figure 7-21 Michelangelo's sketch of a male model.

Michelangelo, *Studies for the Libyan Sibyl*, 1508–1512. Red chalk on paper. H: 11⅜" × W: 8⅜". The Metropolitan Museum of Art, Purchase, 1924, Joseph Pulitzer Bequest. 24.197.2.

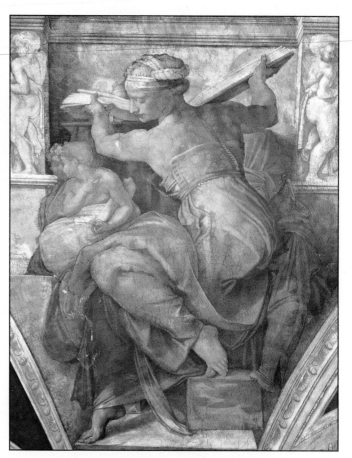

Figure 7-22 The finished female sibyl.

Michelangelo, The Libyan Sibyl, detail from the Sistine Chapel, Vatican State. Scala/Art Resource, NY.

Leonardo da Vinci. Leonardo da Vinci is also considered a Rennaissance genius because of his contributions to the world through his art and inventions. He has been credited with inventing the helicopter and military tank among others. However, he is probably best known for his portrait paintings.

Leonardo da Vinci's *Mona Lisa* (see Figure 7-23) is, perhaps, the most famous portrait ever painted. You have probably seen reproductions of this work. The image is now so common that you might be tempted to dismiss the study of it. For now, try to suspend any judgments you already have about it or any associations of this image with advertisements for computers or corn flakes.

The face of the *Mona Lisa* is often described as **enigmatic,** *which means puzzling or hard to understand.* While the figure's pose is somewhat aloof or regal, her clothing is quite simple. The subject's expression radiates an inner warmth, and her relaxed hands are graceful. Notice the artist's masterful detailing of the hands. It is often said that Leonardo was not painting a specific woman (she was actually a real person, the wife of a prominent banker) but an idealized being, in the classical Greek tradition.

Figure 7-23 Do you find her mysterious?

Leonardo da Vinci (Italian, 1452–1519), *La Giaconda (Mona Lisa)*. c. 1503–05. Oil on panel. 30¼" × 21". The Louvre, Paris, France. Scala/Art Resource, NY.

What do *you* think? How about the smile on her face? Through the centuries, viewers and critics have wondered about that smile, and what it may reveal about Mona Lisa's character. It certainly makes the subject all the more of a mystery.

The fantasy landscape behind the subject is rarely considered in discussions of this work, but it adds greatly to the overall impression. Da Vinci's landscape is an example of atmospheric perspective discussed in Chapter Two. The landscape is lighter and less-focused in the background which creates an illusion of depth. The dream-like landscape seems to be a world in itself

Student Work

Robert Wall, III, 19
Overton High School; Memphis, TN

Student Work

Cindy Bowler, 17
Pattonville High School; Maryland Heights, MO

invented by the artist. *Mona Lisa* has charmed and challenged the imagination of the public for almost 500 years.

Hans Holbein the Younger. Hans Holbein the Younger (1498–1543) was one of the most accomplished portrait artists in history. The Protestant Reformation during the 1500s influenced the way in which Holbein approached his work. The Reformation movement resulted in the creation of the Protestant Church in Europe. For a thousand years the Catholic Church had religious, economic, and social power over people. It was also the center of education and art. The Reformation, however, demanded a change in power away from the Holy Roman Empire.

The type of art made by artists during this period also changed. In many European countries, religious art was forbidden during the separation from the Catholic Church. Portraits commissioned by wealthy patrons soon became the only source of income for artists.

Holbein was born in Germany. However, he went to England during the Reformation and became the court painter for King Henry VIII. The king, widowed

and in search of a bride, sent Holbein off to paint portraits of eligible daughters of European aristocrats. The king intended to select prospective brides from Holbein's portrait paintings. The portrait of King Henry in Figure 7-24 shows him in an elaborate wedding robe, as a result of his search for the ideal bride! The detailed fabric, jewels, and ornate, decorative quality of the robe indicate the king's great wealth and power.

Portraiture During the Baroque Period

The Renaissance artists made art that was compositionally balanced and representational. Baroque art (1600–1780 A.D.), however, was dramatic, with strong

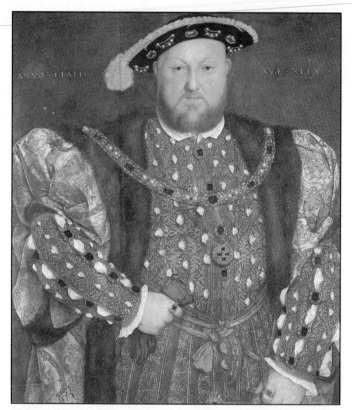

Figure 7-24 Hans Holbein the Younger was court painter for Henry VIII when he painted this detailed portrait of the monarch.

Hans Holbein, the Younger, *King Henry VIII*, c. 1540. Oil on panel. 34¾" × 29½". Courtesy of the Board of the National Museums and Galleries on Merseyside. Walker Art Gallery, Liverpool.

darks and lights, the illusion of motion, and asymmetrical balance. Dutch artist Frans Hals (HALLZ) (1580–1666) had few rivals in portraiture. He had the unique ability to capture the one particular, fleeting moment when a sitter's expression revealed the essence of his or her personality. In Figure 7-25, the sitter, Willem Coymans, seems to be relating to us personally, as if we were engaged in conversation. Today, when we look at Hals's portraits, we feel as if we have been transported back to the seventeenth century.

Rembrandt van Rijn. The Dutch master Rembrandt van Rijn (RINE) (1606–1669) used areas of darkness and light in his portraits in unique ways. He carefully placed the light values in his portraits so they would highlight the faces of his subjects. The rest of

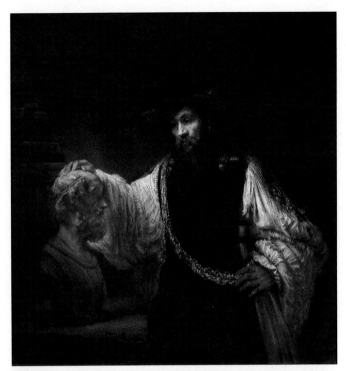

Figure 7-26 What do you imagine Aristotle is thinking?

Rembrandt van Rijn (Dutch, 1606–1669), *Aristotle with a Bust of Homer*, 1653. Oil on canvas. H: 56½", W: 53¾" (143.5 × 136.6 cm.). Signed and dated (on pedestal of bust): "Rembrandt. *f.*/1653". The Metropolitan Museum of Art, Purchased with special funds and gifts of friends of the Museum, 1961. 61.198.

the figure and the background were painted with deep shadows enhancing the brilliance of the white paint used on the face. Rembrandt would also add touches of white to buttons on clothing or jewelry belonging to the persons he painted. This *drastic change in dark and light in art is called* **chiaroscuro** (ki-ra-scuro). In Figure 7-26, we see Rembrandt's painting titled *Aristotle with a Bust of Homer*. The light enters from the upper left and strikes Aristotle's ring in such a way that its reflection seems to burn the eye and produce an afterimage, as it would in the sunlight. But it is not sunlight that is producing the effect here. It is Rembrandt's brilliant use of pigment.

However, his style of portraiture was not accepted by all of Holland's aristocracy. As Rembrandt's use of chiaroscuro became more pronounced, many prospective clients rejected his services. The artist resorted to

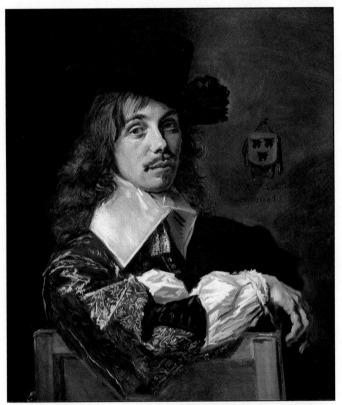

Figure 7-25 Hals captured the essence of the sitter's personality.

Frans Hals (Dutch, c. 1580–1666), *Willem Coymans*, 1645. Oil on canvas. 30¼" × 25" (.768 × .635 m.). Andrew W. Mellon Collection, ©1993 National Gallery of Art, Washington, D.C. 1937.1.69.

using his own face as a model. Rembrandt painted more than sixty self-portraits. These self-portraits are a remarkable record of his life. He was as honest in his portrayals of himself as he was with his other subjects. Figure 7-27 is a self-portrait that Rembrandt painted when he was fifty-four. You will read more about Rembrandt in Chapter Eight.

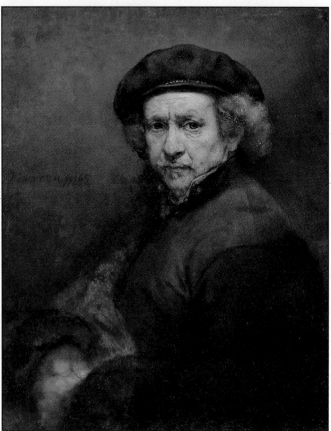

Figure 7-27 Rembrandt's extraordinary use of light and dark highlights the faces of his subjects.

Rembrandt van Rijn (Dutch, 1606–1669), *Self-Portrait*, 1659. Oil on canvas. 33¼" × 26" (.845 × .660 m.). Andrew W. Mellon Collection, ©1993 National Gallery of Art, Washington, D.C. 1937.1.72.(72)/PA.

George Catlin. One hundred and seventy-two years after the Baroque period, an American artist was painting portraits as honestly as Rembrandt did. George Catlin (1796–1872) practiced law for three years before beginning an art career. He soon became proficient in painting the portraits of governors, aristocrats, and a group portrait of one hundred delegates to the 1829 Virginia Constitutional Convention. However, Catlin was concerned about the procession of settlers who were flooding onto the immense prairie between the Mississippi River and the Rocky Mountains following the Civil War. The Native Americans were being driven away from their homeland. Catlin proclaimed that "the history and customs of such a people, preserved by pictorial illustrations, are themes worthy of the lifetime of one man, and nothing short of the loss of my life shall prevent me from visiting their country and becoming their historian."

While government officials and cavalry leaders saw the Native Americans as savages who needed to be eliminated, Catlin admired them. He often visited their land and recorded their life-styles in his paintings.

Student Work

Mary Feldman, 17
Overland High School; Aurora, CO

Traveling thousands of miles through uncharted wilderness, Catlin produced hundreds of portraits. His favorite subjects were the chiefs of each tribe, whom he compared to the ancient Greek and Roman gods in character, strength, and dignity.

In the portrait of Chief *Buffalo Bull's Back Fat* (Figure 7-28), Catlin took the classical approach to portrait painting. Pride, hope, and determination appear to be etched on the face of this leader. The symmetrical balance of the face is countered by the diagonal line made by the pipe and the feathers of the headdress.

Catlin took detailed notes about the Native Americans who posed for him. Of *Buffalo Bull's Back Fat*, Catlin wrote, "I have this day been painting a portrait of the head chief. . . . He is a good-looking and dignified Indian, about fifty years of age, and superbly dressed; whilst sitting for his picture, he has been surrounded by his own braves and warriors. . . . In his hand, he holds a very beautiful pipe, the stem of which is four or five feet long, and two inches wide, curiously wound with braids of porcupine quills of various colors."

The portraits in Western civilization to this point have been representational images. In the next subsection, we look at how some artists have redefined the art of portraiture.

Portraits in the Nineteenth and Twentieth Centuries

Portraiture underwent a change in the nineteenth and twentieth centuries. No longer were all artists concerned with creating realistic portraits. Rather, some artists chose to be expressive in a unique way. They elected to distort the facial features, use brilliant colors,

Figure 7-28 Catlin abandoned painting wealthy aristocrats and spent the remainder of his career painting Native Americans such as this Blackfoot chief.

George Catlin (American, 1796–1872), *Buffalo Bull's Back Fat, Head Chief, Blood Tribe*, 1832. Oil on canvas. 29" × 24". Gift of Mrs. Joseph Harrison, Jr., National Museum of American Art, Washington D.C./Art Resource, NY. 1985.66.149.

Student Work

Michael Louks, 15
Overland High School; Aurora, CO

LOOKING CLOSER:

Fantasy Portraits

We have looked at artists who have fragmented, distorted, or altered the human image. In Figure 7-29 and Figure 7-30 we see two artists who rather than distorting facial features in their portrait, substituted them for other objects from their environment. In *Summer* (1563), Archimboldo (1537–1593) has painted an organic portrait. The portrait has been constructed with fruits, vegetables, and wheat, the products of summer harvest in the Austrian countryside. In this portrait Archimboldo's figure appears to have the external skin stripped away, leaving the internal muscular structure. Each feature has been replaced with a vegetable or fruit similar in form to that feature. At the same time, flowers, fruits, and vegetables become clothing, and a string of plums is a necklace.

Archimboldo's style of portraiture would not be copied by another artist until the twentieth century.

Figure 7-29 Archimboldo's portrait represents a bountiful summer harvest.

Archimboldo, *Summer*. L'Estate Brescia, Pinacoteca Civica, Italy. Scala/Art Resource, NY.

362

Comparing Works of Art

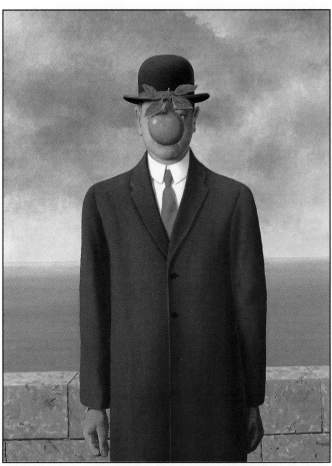

Figure 7-30 Magritte's haunting self-portraits are in response to a terrible personal tragedy.

René Magritte, *The Son of Man*, 1964. Oil on canvas. 116 × 89 cm. Courtesy, Harry Torczyner Collection. ©1994 C. Herscovici/Artists Rights Society (ARS), New York. Photo by D. James Dee.

Surrealist artist René Magritte (1898–1967) used substitution techniques similar to Archimboldo's. His portraits and self-portraits do not have eyes, noses, mouths, or other features. Instead, a single object such as an apple or dove covers the entire facial surface. The other option for Magritte was to paint the back of the figure's head leaving the viewer wondering who the person was. Some historians believe that Magritte's techniques were influenced by his mother's drowning death. When his mother's body was discovered, a portion of her nightgown was draped over her face. This event left a lasting impression on the artist as evident in his self-portrait *The Son of Man* (1964) (see Figure 7-30). A solitary apple covers the artist's face replacing all possible facial features.

The artists' portrait techniques are as similar as their backgrounds are different. Archimboldo was a self-taught artist. He perfected his painting techniques while he was being commissioned by wealthy aristocrats throughout Vienna. The artist was also retained by the Emperors of Austria to work for the royal courts. Archimboldo's harvest portraits (he painted one for each season) were viewed as visual entertainment for the government officials. They were amused and intrigued with the fantasy images.

Magritte was born in a small Belgian town. When he was eight years of age, he received his first oil painting lessons from a local artist. In 1916, Magritte entered the Academie Royal des Beaux-Arts in Brussels where he attended art classes for five years. However, his professional career did not begin until he was in his forties. Magritte and other Surrealist artists such as Salvador Dali rediscovered Archimboldo's portraiture and applied his fantasy techniques to their own work.

Figure 7-31 By including her artist's tools in the painting, Bailly shows us that art is a part of her identity.

Alice Bailly (Swiss, 1872–1938), *Self-Portrait*, 1917. Oil on canvas. 32" × 23½". The National Museum of Women in the Arts; on loan from the Wallace and Wilhelmina Holladay Collection.

shift the planes of the face, or replace facial features with functional objects.

Alice Bailly (1872–1938) also challenged the way in which traditional portraits were rendered. Bailly was born in Switzerland, where she worked and studied at the École des Beaux-Arts (the School of Fine Arts) before continuing her career in Paris. She embraced the Cubist techniques of fragmenting and shifting the planes of the face as well as the facial features. You will read more about the Cubists in Chapter Nine.

In the self-portrait shown in Figure 7-31, Bailly has used lines, shapes, and color to create almost a dual image of herself. Her colorful palette and the brush held in her fingertips provide the backdrop for her face.

The tools of her work are clearly part of her identity as she has provided them in her portrait.

Sometimes, an artist may create a portrait so unusual that it redefines what a portrait might be. American Jim Dine (born in 1935) is a sculptor, painter, and graphic artist. Dine, a leader of the Pop art movement you will read about in Chapter Nine, uses everyday objects such as tools and clothing in his work. Dine lithographed the image of eleven bathrobes as his self-portrait. Each of the eleven robes is a separate image, and portrays an aspect of Dine's view of his own personality.

Figure 7-32 shows one of the eleven. This bathrobe contains a landscape with tall grasses blowing in the wind near the hem of the robe. Clouds dot the arms and front of the garment. This landscape gives the portrait a dimension. In other "bathrobe" portraits, Dine has included chains hanging around the collar of the robe, and a log complete with a hatchet buried in it! Jim Dine is featured in *The Artist as a Young Adult* on page 384. Dine's portraits may be difficult to accept in

Figure 7-32 What aspect of Dine's personality do you think he was portraying with this bathrobe?

Jim Dine, *Self-Portrait: The Landscape*, 1969. Color lithograph. 53" × 38". Petersburg Press, New York. Courtesy Pace/Wildenstein.

Student Work

Josh Durden, 18
Overland High School; Aurora, CO

THINKING ABOUT

AESTHETICS

Carefully analyze Jim Dine's self-portrait in Figure 7-32, and answer the following questions:

1. Do you consider Dine's work to be a "legitimate" self-portrait? Defend your answer.

2. Do you believe that Dine is trying to change people's perceptions of what a self-portrait can be? Why might an artist want to do this?

Student Activity 4

Personality "Portraits"

Goals

1. You will express your own personality through objects and images that represent your interests, rather than through your facial features.

Materials

1. Paper
2. Colored pencils
3. Tempera or acrylic paints
4. Mixed media
5. Brushes and water pans
6. *Optional:* found objects and magazines

Directions

1. On paper, brainstorm one object, image, or color that would best represent your personality. For example, if you play basketball, a hoop or ball might be the central part of your self-portrait. If you enjoy riding horses, a horse might represent you as a person. Artist Jim Dine selected a bathrobe to represent his own human image.
2. Draw the one image you have selected on paper. Then add other objects or images around the main object. Select colors that will represent your personality when painting your image.
3. Place your "portrait" in an environment. This environment should be a place that you enjoy visiting, such as the beach, the mountains, a park, or recreational center. Use tempera or acrylics to make this environment.

Evaluation

1. Were you able to select one main image and several secondary images that represent your personality and interests? Why did you choose them?
2. Does the completed "self-portrait" reflect your personal tastes in outdoor atmospheres? Why did you select the landscape or outdoor environment illustrated in your portrait?

relation to what we already understand about self-portraits. However, to the artist the image is as representational of his physical appearance as a traditional portrait.

> **"I** found an ad for a red bathrobe in the Sunday magazine in 1963. It was headless and it seemed like my body was in it. I had searched for some time for a vehicle to label 'self-portrait'. The value of doing self-portraits for me has always been the reaffirmation that I do exist."
>
> **Jim Dine**

Section II Review

Answer the following questions on a sheet of paper.

Learn the Vocabulary

The vocabulary terms for this section are *self-portraits, donor portraits, enigmatic* and *chiaroscuro.*

1. Define the vocabulary terms by using each one correctly in a sentence.

Check Your Knowledge

2. Why is the self-portrait of Jan van Eyck (Figure 7-16) particularly significant?
3. Why was Michelangelo reluctant to paint the ceiling of the Sistine Chapel?
4. Who were George Catlin's favorite subjects?
5. How did the way in which artists render portraits change in the nineteenth and twentieth centuries?

For Further Thought

6. In his self-portraits Jim Dine chose eleven views of a bathrobe to represent the different aspects of his personality. In the same manner, what object might you choose to represent the different aspects of your personality? What would you surround the object with to distinguish between each aspect?

Section III

Three Themes in the Use of the Human Image

Now that we have studied the earliest human images and some of the different ways in which portraits have been made, let's look at three of the themes artists have used in rendering the human image.

Emotions, Tensions, and the Human Image

The social and political changes that occurred throughout Europe at the beginning of the twentieth century affected the art world. New inventions such as the telephone and radio made communication more accessible to the public. When transportation advanced with the debut of the automobile and airplane, people became more aware of life-styles other than their own. As cities and towns grew, so did social problems such as overcrowding and unemployment. The artists during this period in history illustrated the anxiety people felt through their art.

Edvard Munch. Norwegian artist Edvard Munch (MOONK) (1863–1944) wanted us to see the changing world the way he did. Munch once said, "For as long as I can remember I have experienced a deep feeling of anxiety, which I have tried to express in my art." He was interested in making portraits that expressed this anxiety rather than a likeness of an individual.

Critics were appalled at Munch's approach to painting. In *The Scream* (see Figure 7-33), Munch combined color, line, and shape into one emotional expression of human form that was different from pre-

vious images we have studied. The figure in this painting has unrecognizable features. A gaping hole represents the mouth, and smaller holes serve as eyes and a nose. These holes are the only clue that a human image is being represented by the artist. Hands appear to grasp the sides of the head as if to block out the sounds of a screaming landscape. The figure sways to a vibration of color and swirling pattern. It appears to be rising from the ground where it might possibly have originated. Munch's paintings made other artists aware that their art could be a vehicle for expressing emotions and tensions.

Figure 7-33 Does this image support Munch's statement that his art should exhibit his "deep feeling of anxiety"?

Edvard Munch (Norwegian, 1863–1944), *The Scream*, 1893. Tempera and oil pastel on cardboard. 91 × 73.5 cm. Nasjonalgalleriet, Oslo, Norway. ©1994 Munch-museet/Munch-Ellingsen/Artists Rights Society (ARS), NY. Photo by J. Lathion. NG.M.939.

AESTHETICS

On February 12, 1994, Edvard Munch's *The Scream* was stolen from the National Art Museum in Oslo, Norway. Thieves climbed through a window at 6:30 A.M. and used wire cutters to remove the painting from the wall. Although a security alarm signaled the theft, it did not prohibit the thieves from leaving the museum with the priceless work. "It's like someone stole the *Mona Lisa*," said Trygve Nergaard, professor of art at Oslo University. Fortunately, the painting was found undamaged three months later.

1. Selling a work of art such as *The Scream* to a collector or auction house is impossible because it would be quickly recognized as a stolen work. What, then, do you think motivates thieves to commit such an act?

2. Now that *The Scream* has been recovered, do you think that it should be put back on display at the museum? If so, what precautions would you take as a curator, to guard against another theft? After all, only wire held the work to the wall.

3. If the museum does not want to take another chance and put it back on display, should a copy be made and hung in its place? Explain your answer.

4. If the painting had not been recovered, should an artist have copied the work from books such as the one for this course, and displayed the work as Edvard Munch's *The Scream*? Why or why not?

5. Do you agree with Professor Nergaard that stealing *The Scream* was the same as stealing the *Mona Lisa*? Why do you agree? For what reasons do you disagree?

Student Work

Dale McNeil, 17
Overton High School; Memphis, TN

Ivan Albright. American artist Ivan Albright (1897–1983) was born in Chicago. He attended Northwestern University where he studied architecture. After one year at the university, he entered the army during World War II where he served as a medical illustrator. Albright later attended the Art Institute of Chicago and the Pennsylvania Academy of the Fine Arts. Albright also used color and texture to represent personal despair. In Figure 7-34, *The Farmer's*

Kitchen, all passion for living appears to have left this woman. The figure sits alone in a kitchen chair clutching a bunch of radishes. A knife and bowl have been readied for the preparation of yet another meal. The woman's body, sapped of strength from years of hard labor, is pressed into the corner of the kitchen. She stares with unseeing eyes, and her face, lined with grief and neglect, has assumed deathly shades of gray and blue.

The bulbous forms of the radishes, which are clutched in sausagelike fingers, have been repeated by the artist in the fabric of the woman's clothing, her knuckles and nose, and in the walls and floor of the kitchen. The textures in the painting visually create a claustrophobic atmosphere.

Figure 7-34 The repetition of confining patterns in this image add to the despair that Albright wanted to portray.

Ivan Le Lorraine Albright (American), *The Farmer's Kitchen*, c. 1933–34. Oil on canvas. 36" × 30⅛" (91.5 × 76.5 cm.). National Museum of American Art, Smithsonian Institution, Transfer from the U.S. Department of Labor. National Museum of American Art, Washington, D.C./Art Resource, NY. 1964.1.74.

Student Work

Robert Wall, III, 19
Overton High School; Memphis, TN

Willem de Kooning. Modern contemporary artist Willem de Kooning used lines, color, and texture to create tension in his portraits. De Kooning was born in Rotterdam in 1904. He came to the United States in 1926 and was soon working as a muralist and teaching at Yale University. De Kooning was part of the Abstract Expressionist movement that began in New York City and swept the United States after World War II. Artists experimented with media and techniques while simplifying images and forms in order to express moods and feelings. However, de Kooning's paintings are not totally abstracted. He was also intrigued with using the human figure in some form.

In *Woman I* (see Figure 7-35), de Kooning seems to have unleashed on the canvas a tirade of tension, anger, and expressions. At first glance, the portrait ap-

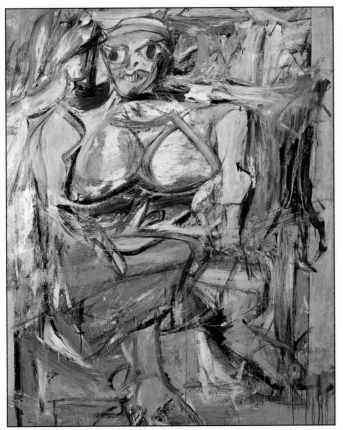

Figure 7-35 What emotions, tensions, and feelings are expressed in this work by de Kooning?

Willem de Kooning (American, b. Dutch, 1904), *Woman I*, 1950–52. Oil on canvas, 6'3⅞" × 58". Collection, The Museum of Modern Art, New York. Purchase. Photo ©1994, Willem de Kooning/Artists Rights Society (ARS), NY.

pears almost sinister due to the woman's bared teeth, wide eyes, and distorted limbs. Reds, oranges, and yellows were applied vigorously next to cool blues. These contrasts create additional tension, as do the black lines slashing their way through the figure.

Willem de Kooning painted a series of female figures like *Woman I*. Often, he would cut out the smiles from the faces of women in toothpaste advertisements and glue them directly to his painted figures! Critics of de-Kooning's work were shocked when he first unveiled his figures. They believed that the artist was poking fun at how women had been portrayed in traditional portraits throughout history. Others thought de Koo-

ning was commenting on the violence sometimes found in the cities of America.

Munch, Albright, and de Kooning represent many artists who have used the human image to express emotions, tensions, and feelings. Let's turn now to artists who have expressed feelings of unity and belonging through images of the family.

The Family in Art

If you were asked to write about your family, where would you begin? Who would you write about? Would you describe your grandmother, uncle, or a friend? Each family is different just as families in works of art are different. Sometimes families are in crisis because of divorce, illness, or a death of a family member. However, the art that we will experience in this section allows us to visually enjoy the unity between human beings as they celebrate their life-styles and traditions as a family. Let's look at several examples of the family in art.

Student Work

Jessica Buttermore, 17
Overton High School; Memphis, TN

Mary Cassatt. Mary Cassatt (cah-SAT) (1845–1926) was born in Philadelphia and studied art at the Pennsylvania Academy. Like other American artists during the nineteenth century, Cassatt moved to Paris where the art world was blooming. Cassatt was introduced to the Impressionist artists Claude Monet (mo-NAY) (Chapter Five) and Edgar Degas (day-GAH) (1834–1917). However, it was Degas who invited her to exhibit her work in the Salon des Independants. This event established Cassatt as an artist.

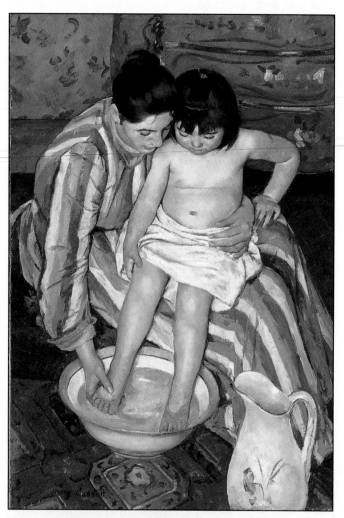

Figure 7-36 Mary Cassatt made over 1,200 paintings, watercolors, and pastels of people busy at daily tasks.

Mary Cassatt (American, 1845–1926), *The Bath*, 1891–92. Oil on canvas. 39½" × 26". The Art Institute of Chicago, the Robert A. Waller Fund. Photo ©1993, The Art Institute of Chicago. All Rights Reserved. 1910.2.

Another Parisian exhibit also influenced her style of painting. In 1890, a display of Japanese prints was unveiled for the Impressionist artists to see. Cassatt was intrigued with the rich detailed patterns, flat space, and human images cropped by the edge of the paper. She adopted the style of the Japanese artists for her own by blending their use of space and pattern with her subjects. The Impressionists painted people such as theatre performers, waitresses, and laborers. Cassatt chose mothers and children as a theme for her work. She produced over 1,200 paintings, watercolors, and pastels of adults and children busy at daily tasks.

In *The Bath* (see Figure 7-36), the scene is a tender moment between a mother and her child. The mother gently bathes the feet of the daughter from a basin placed on the floor. Cassatt has painted different patterns and textures in the clothing, background, and carpeting of the room. The patterns set off the two figures and are in contrast to the creamy, smooth skin of the child. In the style of the Japanese artists, our view of the bath is from above and the figures seem to be oblivious to our presence. This painting could be seen as a tribute to the mother for the continuous care she gives to the child.

Palmer Hayden. *The Janitor Who Paints* is the title of the 1940 work by Palmer Hayden (1890–1973), shown in Figure 7-37 on page 374. This is a warm family scene as the man, a janitor by profession, sits at his easel in a cleaning supply room turned art studio. His palette and brushes, the tools of his passion for creating art, are in his hand. His beret and tie are more typical of an artist than a janitor. The wife sits proudly with their child as her husband captures their image on canvas. Surrounding the man and his family are the tools of his livelihood. It is almost ironic that both palette and trash can lid become a visual echo of one another and the janitor's two lives. Painting by the illumination from a bare light bulb, the janitor paints with a large hand used to hours of hard labor, yet sensitive enough to capture the image of his family. Touches of red, in the man's tie, the woman's dress, in the cloth on the table, and on the broom handle tie the human images to the environment.

In all probability, this warm scene might have taken place. Hayden's art represented African American life during the 1940s through the 1970s. He preferred to

Student Activity 5

Family Portraits

Goals

1. You will discover that family groups sometimes constitute people other than biological family members.
2. You will create a family portrait of the people on whom you depend the most on a daily basis. These people could include a close friend, grandparent, neighbor, teacher, or minister.

Materials

1. Large mural or kraft paper
2. Tempera paints
3. Acrylic paints
4. Markers
5. *Optional:* pastels or oil crayons

Directions

1. Think about how the family unit can mean different things to different people. For example, the "family" may include single mothers or fathers, a grandparent, adoptive parents or children, friends, teachers, counselors, or ministers. Determine who it is that helps you on a daily basis with personal challenges. Who do you like to share your successes with?
2. Use a large sheet of mural paper for your painting. Sketch with pencil your family portrait including the persons discussed in the first step. Include activities, hobbies, favorite foods, and so on that your family enjoys. Arrange your composition so that family members are engaged in the activities or place the activities around the family portrait.
3. Use tempera or acrylic to paint your mural. Use pastels or oil crayons to accent certain areas of your composition.

Evaluation

1. Did you understand that different definitions of "family" exist? What were your reasons for selecting the people in your portrait?
2. Did you surround your family with scenes that show your family's interests? How did you determine what those interests are?

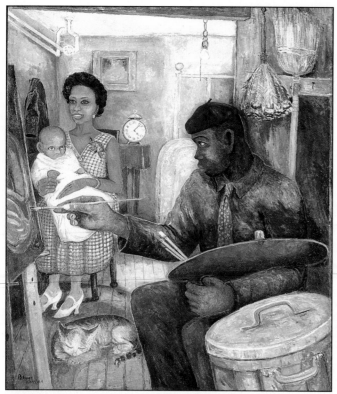

Figure 7-37 Hayden's touches of red integrate the human images with their environments.

Palmer Hayden (American), *The Janitor Who Paints*, 1939–40. Oil on canvas. 39⅛" × 33". National Museum of American Art, Washington, DC/Art Resource, NY.

paint scenes that reflected the customs as well as the myths of the people. Hayden, born in Wide Water, Virginia, attended West Point and served in the military. He went on to study art at Cooper Union. He received a $3,000 grant to study art in Paris at the École des Beaux-Arts. An exhibition of his work in 1931 was the first time Europeans saw African American images in paintings. However, it would not be Hayden's only exhibition. Returning to the United States, he displayed paintings at the Smithsonian Institution in Washington, D.C. and in numerous exhibitions throughout the United States.

Carmen Lomas Garza. San Francisco artist Carmen Lomas Garza has broadened her vision of the fam-

ily in human image to include all members of an extended family. Take a good look at all the things happening in Figure 7-38. We see a family busy preparing a traditional meal of tamales. This is a family event in which each member is expected to participate by working in team-like fashion. Around the large cloth-covered table in the kitchen, men, women, and children form an assembly line of tamale production. Although we are witnessing a group activity, each member has an important role to fulfill. A large tub filled with soaking corn husks is being tended by three family members. A young child plays on the floor near the grandmother. The grandmother is the one responsible for applying the finishing touches to the tamales, ensuring that they are properly wrapped and stored.

The kitchen becomes not only a place to prepare food, but also a social environment for the large family. Each figure has an identity; facial features are defined, and the clothing creates a pattern in the composition prompting our eyes to move around the painting.

Figure 7-38 What seems to be the specific job of each family member?

Carmen Lomas Garza, *La Tamalada*. ©1994 Carmen Lomas Garza. Photo by Wolfgang Dietze.

Henry Moore. The nontraditional sculpture of Henry Moore (1898–1986) is often controversial because of his abstraction of the human figure. Moore was born in Yorkshire to a coal miner and his wife. He began his art career by studying sculpture at London's Royal College of Art. From Moore's earliest work to the sculptures completed before his death, the human figure was his primary theme. Moore wanted the viewer to see the connection between the forms and shapes of plants, trees, flowers, the earth, and the human form. The results were stylized figures like those we see in Figure 7-39, a bronze sculpture, entitled *Family Group*. The mother and father sit on a bench and hold their child between them. Their legs and knees have been placed toward one another in a sign of unity. Their arms stretch horizontally across the group, linking them into one family.

The faces of the humans are indistinguishable. Moore has given them only suggestions of eyes, noses, and mouths. The shoulders of both adults are massive in proportion to their heads. Although the figures are not realistically rendered, they clearly are human forms. They cannot be categorized by nationality or ethnic characteristics. They represent all of us, and act as a universal symbol for the family unit.

Figure 7-39 In 1934 Moore said, "Beauty, in the later Greek or Renaissance sense, is not the aim of my sculpture."

Henry Moore (British, 1898–1986), *Family Group*, 1948–49. Bronze (cast 1960), 59¼" × 46½" × 29⅞", including base. The Museum of Modern Art, New York. A. Conger Goodyear Fund. Photo ©1993, The Museum of Modern Art.

The Human Figure in Action

Capturing the human image in motion has challenged artists throughout history. Techniques such as distorting the human form, overlapping or repeating images, or placing the figure in a diagonal position are some of the ways artists have created motion in their work.

Jacob Lawrence. Jacob Lawrence, whom you met in Chapter Six, made a series of well-known paintings of famous African Americans in the 1930s and 1940s. He developed a very unusual compositional style. Often, he distorted the human figure to emphasize one particular feature. The distortion helped to characterize

Figure 7-40 The distortions give a heightened sense of the runners' efforts.

Jacob Lawrence (American b. 1917), *Study for the Munich Olympic Games Poster*. Gouache. H: 30⅜" × W: 10⅝". The Seattle Art Museum, Purchase with Funds from P.O.N.C.H.O. Photo by Paul Macapia. Courtesy of the artist, via The Francine Seders Gallery, Seattle, Washington. 79.31.

the individual or emphasize what the subject was doing. The gouache study in Figure 7-40, created to commemorate the Olympic Games of 1972, is one example of this technique.

The track event Lawrence shows here is a relay, a race in which speed and stamina are essential, and teamwork a must. It is the last lap. Five racers are heading for the finish line. Their batons are grasped firmly in their hands. Lawrence has stretched the legs of his runners to almost twice their actual length, and emphasized the muscles. The runner on the left appears to have one long leg as wide as his torso while the other leg extends directly behind him, an unnatural position. However, this distortion gives the illusion of one long, continuous leg, and accentuates the runner's stretch for the finish line. With the aerial view of the track and the position of the curve, the figures appear

Figure 7-41 Bellows gives the viewer a ringside seat at Sharkey's.

George Bellows (American, 1882–1925), *Stag at Sharkey's*, 1907. Oil on canvas. 36¼" × 48¼"
(92 × 122.6 cm.). ©1994 The Cleveland Museum of Art, Hinman B. Hurlbut Collection.
1133.22.

almost flattened against the picture plane. The visual effect is a tribute to the speed required for such an event.

George Bellows. George Bellows (1882–1925) was a member of the group of artists known as the Ash Can School. As you may recall from Chapter Six, six Ash Can artists portrayed the stark, realistic side of city life. Typical subjects were children playing street games, crowded sidewalks and streets, slum buildings, social gatherings, and occasionally, sporting events. Bellows, who was himself a semi-professional baseball player during the weekends, is well known for his scenes of boxing matches in the private sports clubs of New York City. *Stag at Sharkey's* (see Figure 7-41) was painted by Bellows in 1909. At that time, public box-

ing was illegal in New York. Boxers who wished to practice their profession had to join private clubs. So did anyone who wanted to watch the matches.

Sharkey's was a notorious private boxing club in New York, and Bellows was a frequent visitor. He would gather ideas for his paintings or draw illustrations for the sports page of a local newspaper. In *Stag at Sharkey's*, Bellows combines the three figures into a triangle. The bent knees and raised elbows of the men suggest the action taking place. The fighter on the right has an elongated torso which is hunched over his opponent in a powerful curve. The viewer can feel the force with which these figures attack each other. The referee is on a different angle from the boxers. With outstretched arms he attempts to monitor the fight. Bellows used wide, quick brush strokes which adds to the action.

Student Activity 6

People in Motion

Goals

1. You will learn how to render a figure in action on a two-dimensional surface.

Materials

1. Large sheets of white paper
2. Acrylic, tempera paints or watercolors
3. Sets of cards with the following action words printed on them: *run, step, climb, catch, hit, squeeze, slide, hop, jump*

Directions

1. Form groups of four students each. Select one person from each group to pose in an action position chosen at random from the pile of cards. Some poses will need to represent an action just before it happens, such as *preparing* to jump or hop.
2. Repeat the process until a variety of action poses have been rendered, and all students have had an opportunity to draw.
3. Select five different poses from these sketches. Transfer the drawings to the white paper for the final arrangement. The figures should touch and slightly overlap at strategic points. They can all be the same size or several may be slightly smaller for variety.
4. Paint the figures with tempera, acrylic, or watercolor.
5. Apply a design or pattern behind the figures that complements the action theme. You may want to limit your colors to one hue and black or white.

Evaluation

1. Were you able to capture the essence of each action pose on paper? What could you have done to improve the positions of the figures on the paper?
2. Did you overlap portions of each figure when arranging the composition? In what ways could the composition be rearranged to create different movements across the compositional surface?

Figure 7-42 Consider the rhythmic pattern and compare it with other Cubist works in Chapter Nine.

Marcel Duchamp (American, 1887–1968), *Nude Descending a Staircase, No. 2*, 1912. Oil on canvas. 58" × 35". Philadelphia Museum of Art, Louise and Walter Arensberg Collection. ©1994 Artists Rights Society (ARS), New York/ADAGP, Paris. '50-134-58.

Marcel Duchamp. Jacob Lawrence and George Bellows created images of the human figure in motion by emphasizing and distorting body parts. This distortion adds to the expression of character, motion, and drama. Each of these artists, however, still kept body and facial features recognizable. In contrast, Marcel Duchamp, whom you met in Chapter Three, fragmented the human figure to show movement. In his revolutionary painting, *Nude Descending a Staircase, No. 2* (see Figure 7-42), the subject is transformed into geometric planes and multiple overlapping lines. Duchamp eliminated any emotional connection that the viewer might have had with a more realistically rendered human being. Here, movement is everything. Each shift of the body is visually frozen as the figure descends the staircase.

Nude Descending a Staircase, No. 2 was a landmark painting. It was first exhibited at the 1913 Armory Show in New York, itself a landmark exhibition of modern art. This period in history is also discussed in Chapter Nine. This painting of a human image was one of the most controversial works exhibited. It was generally ignored by the public while the critics didn't take the work seriously. Others seemed to feel that Duchamp was intentionally insulting their intelligence. Approximately eighty years have passed since the Armory Show. Most people who are seriously interested in art now feel quite differently about the work of pioneers such as Duchamp. Rather than insulting our intelligence, these artists are asking us to use it.

Section III Review

Answer the following questions on a sheet of paper.

Check Your Knowledge

1. What was Munch interested in, with regard to painting the human figure?
2. Which artistic movement did Willem de Kooning belong to?
3. What type of people was Mary Cassatt interested in portraying?
4. Why did Henry Moore make the faces of the figures in his sculpture *Family Group* (Figure 7-39) indistinguishable?
5. What is distinctive about Jacob Lawrence's compositional style?
6. List some typical subjects of Ash Can artists' work.

For Further Thought

7. Why is Marcel Duchamp's painting *Nude Descending a Staircase, No. 2* (Figure 7-42) considered revolutionary? Explain how it provides an intellectual challenge for its viewers.

Section IV

Modern Art Images

As a final theme, we will look at the human image of the twentieth century through the work of two sculptors. Duane Hanson (born 1925) creates life-size human sculpture so realistic that they are often mistaken for real people. His images portray ordinary figures in ordinary settings. Hanson uses real people to make plaster casts from which a polyvinyl acetate form will later be made. The plastic material gives the sculpture a life-like appearance. After Hanson casts the figure, he paints the skin and features, dresses them, and applies small details such as fingernails and eyelashes. Finally, the figures are arranged with ready-made props, such as shopping bags, suitcases, books, sunglasses, and purses.

Superrealism Through the Eyes of Duane Hanson

Duane Hanson's sculptures are an example of **Superrealism.** In other words, *the work is so realistic that the viewer is unable to distinguish between illusion and reality.* Why would an artist want to make a life-like figure from plastic? Many new forms of expression came from the Abstract Expressionist art of the twentieth century. During the 1970s artists were concerned that society was becoming just like the fictional shows on television or emulating electronic game characters. They believed that "reality" was becoming meaningless to some people. Thus, their response to the changing society was evident in their work. Hanson, and other artists of this time, wanted to shock people into recognizing what was real and what was not.

Hanson, born in Minnesota, attended a one-room school throughout his teen years. Later, he went on to study art in college. He worked in Germany, where he developed his method of casting superrealistic images. Hanson first makes a plaster mold from a live model he has carefully selected for stereotypical features. Of the selection process, Hanson states, "I usually portray heavyset, working-class people who have great dignity or are overburdened with despair and fatigue due to the complexities of our time." The next phase of the sculpting process is to photograph the model in various poses until one is selected. The arms, legs, and torso of the model are protected with petroleum jelly then covered with quick-drying silicone rubber. Then a coat of plaster of paris is applied to the mold. After the plaster has dried, the mold is removed from the body. The head of the model is cast in the same manner. Vinyl casting material, which has been tinted with oil paint to make it skin colored, is poured into the molds.

TECHNOLOGY MILESTONES IN ART

Art and Commercial Products Share Media

Sometimes artists have "borrowed" materials typically used to manufacture products. Artist Duane Hanson is one example of this sharing of technology.

Polyvinyl resins were invented during the late 1940s for the manufacturers of such products as floor coverings, records, raincoats, and shower curtains.

Used in liquid form, polyvinyl resins may be poured into a mold. When cool, the material is removed and the form is permanent. The resins may be dyed with color while still in the liquid state.

Artist Duane Hanson discovered the versatility of these plastics when used as a sculpting medium. His discovery led the way for other artists' exploration of media that could be borrowed from manufacturing processes.

Synthetic hair is applied to the scalp and eyebrows. The sculpted figure is then dressed in appropriate clothing for the human image.

In Figure 7-43 Hanson has depicted a couple on vacation. What do you know about each of them? What can you guess about their life together? What could they be looking at? Are they having fun on their vacation? Would you like to join them? Have you seen people like them before? Where? Hanson wants the viewer to immediately identify with the stereotypical couple.

Another View Through the Eyes of Ernest Trova

Duane Hanson has used the products of twentieth-century technology to create his works of art. Ernest Trova (born 1927), on the other hand, makes a statement through his art about modern human existence in a technological world. Trova's *Walking Man* (see Figure 7-44 on the next page) is a chrome, mechanical, subhuman creature. This work stands in sharp contrast to Hanson's heightened reality. It is also the opposite of most of the works in this chapter. This figure is devoid of feelings or emotions. The faceless, armless figure moves forward automatically to an undefined destination. Without eyes, the figure can have no vision of the future. Without arms, it can have no control. A mechanism that resembles a spraying device is attached to the figure's chest. Has the human image been reduced to a mechanical tool?

The shiny surface of the figure reflects the tiniest details of its surroundings. Perhaps the artist is telling us the figure is too dependent on its environment or perhaps a reflection of society. The form of the figure is neither strong nor elegant. The swayed back and protruding stomach symbolize a creature that has perhaps become lazy in an age in which machinery and technology have replaced human action.

Figure 7-43 Hanson's people look so realistic, you almost want to ask them how their vacation is going.

Duane Hanson, *Tourists*, 1970. National Galleries of Scotland Collection. Courtesy, Scottish National Gallery of Modern Art, Edinburgh. GMA.2132.

"When I look at them, my figures are hard to confront. They had a life of their own when I made them and now they have to go on, to face the world."

Duane Hanson

Figure 7-44 Trova presents a far different view of mankind than Hanson in this technological piece from his *Falling Man Series*.

Ernst Trova, *Study from Falling Man Series: Walking Man*, 1964. Chromium-plated bronze (cast 1965), 58⅝" × 11⅜" × 26½", on chrome base recessed in marble base 4" to 6" high × 20⅛" × 35⅛". The Museum of Modern Art, New York. Gift of Miss Viki Laura List. Photo ©1994 The Museum of Modern Art, NY.

ART CRITICISM

Look at the wedding portrait of Mexican artists Frida Kahlo and Diego Rivera (see Figure 7-45 below). It was painted by Kahlo (1907–1955).

1. What images indicate that a marriage has taken place?

2. Describe the expressions and positions of the couple's bodies in the portrait.

3. List the differences in proportion found in the portrait.

Figure 7-45 What does this portrait tell you about the relationship between Kahlo and Rivera?

Frida Kahlo, *Frieda and Diego Rivera*, 1931. Oil on canvas. 39⅜" × 31" (100.01 × 78.75 cm.). San Francisco Museum of Modern Art, Albert M. Bender Collection. Gift of Albert M. Bender. 36.6061. Reproduction authorized by the National Institute of Arts and Literature of Mexico.

Student Work

Kelly Hecker, 15
L. C. Mohr High School; South Haven, MI

Section IV Review

Answer the following questions on a sheet of paper.

Learn the Vocabulary

The vocabulary term for this section is *Superrealism*.

1. What is the primary intent of a Superrealist work of art?

Check Your Knowledge

2. How does Ernest Trova's *Walking Man* (see Figure 7-44) differ from most of the work in this chapter?

For Further Thought

3. Imagine and then describe a Superrealist human image that would comment on or reflect some aspect of today's society.

SUMMARY

This chapter has explored how artists have depicted the human image in art. We have discovered that the human image can teach us about the diversity of traditions, life-styles and customs of people around the world. We can share a victorious moment in sports, watch children at play, or observe adults at daily labor. The human image has been glorified through rendering perfect anatomical images. It has also been distorted and reduced to mechanical parts void of feelings or emotions.

In some civilizations the human image is a spiritual image created to ensure good health, bountiful crops, and physical safety. In others it is used to educate or transmit a cultural heritage to future generations. The human figure is an image that everyone can identify with regardless of their nationality. It is a powerful visual link between people of all nations.

Jim Dine

As you read about the bathrobe portraits created by Jim Dine, you may wonder why the artist would include tools such as a hatchet in his work. The inclusion of saws and work tools in his portraits are reflections of his childhood memories.

Jim Dine was born in 1935, in Cincinnati, Ohio. His grandfather enjoyed working with hardware tools in repairing objects or working with wood. The tools he used were always available to Dine to use as toys, rather than for practical purposes. Since his grandfather owned a hardware store, Dine would spend countless hours playing with and studying the variety of tools found there. Dine would later reflect on this experience. "It wasn't or isn't the craftsmanship that interests me, but the juxtaposition (next to) of tools to ground or air or the way a piece of galvanized pipe rolls down a flight of gray enamel steps." Dine's father also owned a hardware store that specialized in house paint, plumbing supplies, and tools. Paint charts displaying spectrums of every conceivable color intrigued the young boy. The tools to use the paint were also a constant source of interest to him.

In school, Dine enjoyed experimenting with crayons and paint, but sensed frustration in his inability to control the media as he wished. When he was a senior in high school, Dine began formal art classes in the evenings at the Cincinnati Art Academy. It was there that he experimented with painting techniques and subjects that laid the foundation for his future career.

CHAPTER 7 REVIEW

VOCABULARY TERMS

Explain how each of these words applies to the human image in art.

Buddha	foreshortening	mudras
chiaroscuro	hieroglyphics	self-portraits
donor portraits	kachina	stylized
enigmatic	kachina-manas	Superrealism
		Venuses

Applying What You've Learned

1. What is the earliest human image that has been discovered by archaeologists?

2. How did the Greeks differ from the Egyptians in their representations of the human image?

3. What sequence of events occurred during the painting of human images on the ceiling of the Sistine Chapel?

4. How did Jacob Lawrence, Marcel DuChamp, and Ernest Trova create motion in their human images?

5. What similarities and differences are there between the Greek and Roman approaches to creating the human figure in sculptural form?

Exploration

1. Look through current magazines and cut out examples of how the human image is used in contemporary society. Write several paragraphs about the different forms the human image assumes in advertising.

2. Research how artists have used the images of children in their artwork. You might study the paintings of Mary Cassatt or the sculptures of Henry Moore. Select several examples and discuss how the artist has used the children to establish a mood or feeling in the work.

Building Your Process Portfolio

The information and activities in this chapter about the human image in art will further develop your process portfolio. The ability to render the human figure is one skill you need to exhibit in your admissions portfolio if you apply to college. Keep this in mind as you select work from your process portfolio while compiling an admissions portfolio. For now, the following things might be included in your process portfolio:

- The finished artwork from the Student Activities, including photographs or slides of your mask
- Photographs or advertisements from magazines of the human image that can be used for future research and drawing exercises
- Responses to questions asked in the Section and Chapter Reviews, and the Aesthetics, Critical, and Cultural-Historical special feature boxes
- For your sketchbook you may want to complete several gesture drawings of the human figure. Sketch your friends at lunch, study hall, or participating in a sports activity. Complete several detailed studies of hands or feet. Draw several self-portrait studies reflecting different moods or emotions.

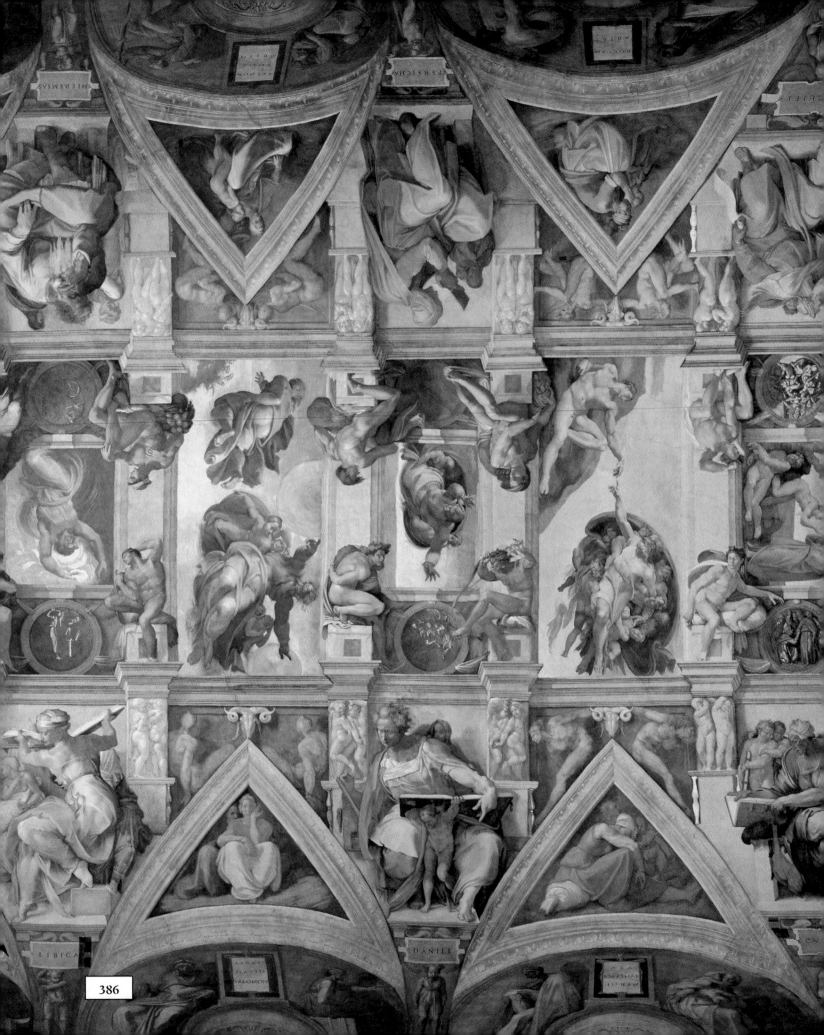

PART THREE

History of Art

CHAPTERS

Michelangelo, *The Sistine Ceiling,* after the resto-
ration. Photo ©1994 Nippon Television Net-
work Corporation, Tokyo.

Treasures from History: Art from Ancient and Remote Worlds

Figure 8-1 The brilliance and skill of artists throughout time and around the world have left a rich legacy of artistic treasures. Here superb artistry has transformed slabs of marble into lacy ornamental patterns to serve as an incredible window covering. Outside, the summer sun blazes on a courtyard of a centuries-old Mogul city.

Marble Fretwork. c. A.D. 1570–1580. Fatehpur Sikri, India. Photo, E. Louis Lankford.

Contents

Section I Ancient Worlds

In this section, we will examine some of the earliest known artistic expressions and art forms from ancient civilizations.

Section II Splendor and Allegiance

This section features art that glorifies royalty and religions around the world.

Section III Western Art in Transition

Important developments in European and American art are traced in this section.

Terms to look for

allegiance
apprentice
book of hours
codex
dynasty
embroidery
figurative painter
finial
fluted columns
folk art
gargoyle

illuminated manuscripts
itinerant artist
jali
Kabuki
kiosk
mastabas
minaret
mother-of-pearl
netsuke
pantheon

portrait bust
powwow
reliquary
Renaissance
rock art
rock-cut temple
rose window
scarification
scepter
scroll

serpentine
sikharas
step pyramid
striations
totem pole
trompe l'oeil
vellum
verticality
whirligig
ziggurat

Objectives

- You will learn that artistic production has occurred in various parts of the world ever since ancient times.

- You will observe diverse styles that have been used by artists from different time periods and places.

- You will recognize that works of art are as much an expression of a culture as they are of an individual.

- You will discover that periods and styles of history overlap and influence each other.

- You will gain an appreciation of the art forms of other cultures as well as those of your own.

Art in Your Life

Why is the study of art history worthwhile? One reason is that we can learn more about our personal and national heritage through the art of our ancestors. We can take pride in the achievements of those who have come before us. We can admire the contributions of our own and other cultures to the history of world civilizations.

By studying the social context of art, we can learn more about artistic motivations, cultural events, and human aspirations. In so doing, we are also learning more about the dynamics of our own families and communities. Such understanding can increase the level of mutual respect people have for one another. Our own self-esteem rises in the process.

A second reason that the study of art history is worthwhile is that, as young artists, you can find inspiration in the artistic traditions and innovations that have occurred throughout history. The world's art is available for you to learn from.

Themes, subject matter, media, techniques, styles, and forms of art are all available for you to explore, examine, duplicate, and extend. Being creative in art is more than just a matter of thinking up something entirely new. It's also important to understand, synthesize, and adapt historical ideas and methods to suit today's world.

A third reason art history is worthwhile is that it provides us with countless opportunities to have meaningful experiences. Each time we encounter an artwork, whether it is new to us or already familiar, we are invited to experience inner and outer worlds of ideas, feelings, and values. Some works may have a profound effect on us. We may be shocked, laugh, cry, get angry, or settle into a feeling of peacefulness and tranquillity. Artworks help us to get in touch with our feelings, and to think on higher planes. Art can cause us to question and renew our sense of values. In short, encounters with works of art from throughout history and around the world can help us to live life to the fullest.

Introduction: Treasures From History

No scholar, no textbook, no high school or college course can teach you a *complete* history of art. There is simply too much information and there are too many works of art for any one source to cover. Entire books have been devoted to a single artist or work of art. To make things more complicated, art historians are making new discoveries and offering new interpretations of historical evidence almost every day.

Throughout this textbook, we have provided historical and cultural information to help you understand and appreciate your experiences with art. What we are about to offer in this chapter and the next is a *con-*densed survey of the history of art. Think of the artworks that we will show you as a selection of *treasures from history*. A treasure is something we value highly, something we admire, protect, and cherish.

You probably have something that you consider to be a treasure. It could be something you've made with your own hands, or a gift from a loved one, or perhaps a special object you found or purchased. One thing treasures have in common is that stories lie hidden beneath their surfaces. For example, suppose someone painted your portrait, and that painting later became a treasure of a museum collection. (It could happen!) You know that the painting portrays only a tiny, but significant, portion of your life. You know that behind that portrait are many stories you could tell about your experiences, beliefs, ideas, and feelings. You could tell about the people who have influenced you. You could describe the natural and built environment that surrounds you. You could explain social customs, holidays, manners, and patterns of communication that you have observed. You could share your knowledge of lo-

"Art is derived when a single universal judgment springs from many ideas born of experience."

Aristotle

cal and international events. A portrait may reveal bits and pieces about you and your environment, but dig beneath the surface and there's a whole fascinating and complex world to explore.

So it is with any artwork; each one is a single entry in a vast catalog of human experiences and historical events. Beneath the surface, there are stories to tell about triumph and tragedy, war and peace, love and hate. You can learn about natural and built environments, social customs, trade routes, religious beliefs, technological innovations, political systems, group efforts, and individual genius. The more artworks you study, the broader and deeper will be your understanding of art and its vital place in world history.

What makes a work of art a treasure? It could be any number of things, or a combination of things. Remember that in Chapter One we explored reasons why art is valued. An artwork may have *aesthetic, economic, historical, social, religious, or other values* associated with it. Remember our definition of art, given early in Chapter One? *Art is the special expression of ideas, feelings, and values in visual form.* Art is special, and any work of art may be a treasure. Some people reserve the word *treasure* for objects they value above all others. Such objects may be rare, beautiful, well crafted, or influential. You must decide for yourself which works of art you will consider treasures and why.

We have tried to select treasures from different cultures in different parts of the world, so that you can gain a broad perspective on art. As much as possible, we have arranged them chronologically, from oldest to most recent. Naturally, there will be some overlap, since amazing things have happened at about the same time but in different parts of the globe.

You will see that there really is not just one world of art, but many worlds of art. Artists in different cultures and at different times have varied widely in terms of their artistic motivations and styles. For instance, the world of Ming Chinese art is far removed from the world of ancient Greek art, not just in terms of time period and geography but in how the artworks looked and what they meant to the people who made them. Despite these differences, it is still possible to find traits that these artworks have in common. Among these are some of the abiding themes discussed elsewhere in this book, such as the relationship of humans to the natural world discussed in Chapter Five. Other themes you might notice in this chapter include the glorification of rulers, reverence for religious beliefs, love of music, struggles among warriors, and mythological beasts.

Section I

Ancient Worlds

There is really no single, known beginning to the history of art. We must take as our starting point the earliest works that have survived. However, we suspect that these examples came after a long period of development, because the style and technique of these examples already show refinement.

Among the earliest works that survive today are cave paintings rendered by people of the Old Stone Age, between 30,000 and 10,000 B.C. Although not all are that old, *ancient images painted or carved on rock—sometimes referred to as* **rock art**—have been discovered in different parts of the world, including Africa, Australia, Europe, and North and South America. Many cave paintings depict animals, such as the one in Figure 8-2 on the next page. Other examples of rock art depict human hunters, or abstract symbols whose meanings are now unknown. Paintings were sometimes created deep within caves, so it is unlikely that they were strictly decorative. It is probable that they were part of rituals related to the hunt or other aspects of life crucial to the survival of these people.

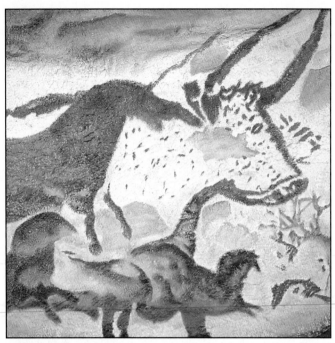

Figure 8-2 The paintings in this cave were discovered by accident in 1940 by some boys rescuing their dog, Robot, who had fallen through a small opening into the cave.

Prehistoric cave painting of various animals from the Lascaux Caves, Perigord, Dordogne, France. c. 15,000 B.C. Art Resource, NY.

In Figure 8-3, you can see another cave painting from Altamira, Spain. Do you have any theories about the creative persons who made these Paleolithic images?

What we call prehistory became history as cultures developed writing and other ways of recording, and thus remembering and honoring, events that were important to their lives. Visual art forms played a role in this recording process, as carvings and paintings were used to depict people and episodes that helped to shape history. Some of the earliest recorded history comes to us from Mesopotamia.

Mesopotamia

The valley formed by the Tigris (TIE-gruhs) and Euphrates (yoo-FRATE-eez) rivers lies about 600 miles east of the Mediterranean Sea. Some of the oldest agricultural villages we know of were established in this area around 7,000 B.C. This region is known as Mesopotamia, which comes from a Greek term meaning "between the rivers." Several ancient civilizations developed here that are notable for their art.

The kingdom known as Sumer (SOO-mer) was established in Mesopotamia by 5000 B.C. The Sumerians have been credited with inventing the first system of written language. The people of Sumer prospered, and believed they were blessed by their gods. The Sumerians constructed *massive temples called* **ziggurats** (ZIG-uh-rahts). Each ziggurat was dedicated to a specific god. Sumerian cities were built around the ziggurats. Constructed of mud bricks, the ziggurats were tall, tiered structures that eroded over time. One of the largest, the ziggurat at Ur, has been partially reconstructed (see Figure 8-4).

One of the most striking artifacts we have from Sumer is the royal harp from the tomb of Queen Paubi (see Figure 8-5). It shows us the high quality of the artistry the Sumerians practiced. The harp's surface is richly carved and decorated with gold, lapis lazuli, and **mother-of-pearl,** *which is a hard, opalescent layer found inside certain seashells.*

Figure 8-3 This paleolithic bison was sensitively rendered by cave artists.

Prehistoric cave painting: detail of bison. Altamira, Spain. Scala/ Art Resource, NY.

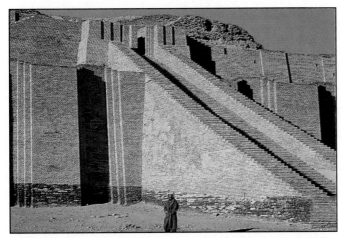

Figure 8-4 Worshipers had to climb many steps and walk completely around the exterior in a ceremonial procession before entering the sacred chambers of a ziggurat.

Ziggurat at Ur, c. 2500–2100 B.C. ©1991 Comstock.

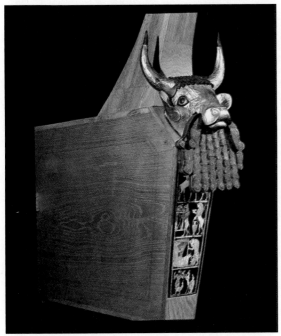

Figure 8-5 On the soundbox directly under the golden bull's head are scenes of animals performing humanlike tasks.

Bull-headed harp from Ur, c. 2600 B.C. Iraq. Soundbox inlaid with shell, approx. 9" high; bull's head covered with gold leaf and lapis lazuli with inlaid eyes, approx. 17" high. The University Museum Archives, University of Pennsylvania, Philadelphia. (Neg. #T4-29c2).

The history of ancient Mesopotamia was marked by war and invasions among rival city-states. Two civilizations that became dominant in the region after the Sumerians were the Assyrians (uh-SEE-ree-uhns) and the Babylonians (bab-uh-LO-nee-uhns). The Assyrians built great fortified palaces. Doorways were sometimes

THINKING ABOUT
AESTHETICS

Usually, visual art and music are considered separate art forms. One you see; one you hear. But can a musical instrument be a work of visual art? The royal harp pictured in Figure 8-5 seems to fit the definition of art given in Chapter One. Now look at the *gamelan* (GAM-uh-lan) instrument pictured in this box.

A gamelan is a musical ensemble found in Indonesia, on the islands of Java and Bali. Musicians perform on gongs and other percussion instruments during ceremonies and at royal courts. The xylophone pictured here has an elaborately carved and painted stand featuring two "tiger-lions," one male and one female.

1. Do you think the gamelan instrument pictured can be called a work of visual art? Why or why not?
2. Would you be surprised to see musical instruments exhibited in an art museum? Explain your answer.
3. Do you think the *sound* quality of a musical instrument could affect its value as a *visual* art object? Tell why or why not.

Saron Demung (Gamelan instrument with tiger-lion heads.) West Java, Indonesia. c. A.D. 1850. Field Museum, Chicago.

guarded by strange, massive creatures, part human and part beast, made of carved stone. The muscular creature pictured in Figure 8-6 has the strong body of a bull, the swift wings of a bird, and the shrewd head of a man. It is shown standing at attention *and* in a walking pose; this explains the fifth leg. As you can perceive from the proportions and details of this statue, Assyrian artists were both highly skilled and imaginative.

Babylonia rose and fell from prominence in Mesopotamia more than once. One of the most famous Babylonian rulers was King Nebuchadnezzar (neb-yuh-kuh-NEZ-uhr). His legendary "hanging gardens" are one of the Seven Wonders of the Ancient World. Some historians believe that the biblical Tower of Babel was a Babylonian ziggurat.

For a period of about 100 years around 575 B.C., the Babylonians flourished. They built an elaborate temple complex that included an entrance gate and walled processional path dedicated to their goddess of love and fertility, Ishtar. The walls of the path and gate were decorated with brilliantly colored glazed bricks. Against the wall's dazzling blue background, roaring lions, dragons, and bulls appear to march toward the temple. You can see one of these skillfully rendered lions pictured in Figure 8-7.

Figure 8-6 The might of Assyrian kings is reflected in this powerful creature.

Winged Bull with Head of a Bearded Man. Assyrian, from the palace of Sargon II at Khorsabad, c. 720 B.C. Limestone. Approx. 13'10" high. The Louvre, Paris, France. Giraudon/Art Resource, NY.

Figure 8-7 This fierce but elegant lion marched along an ancient Babylonian wall.

Lion from the Processional Way; relief from the Ishtar Gate of Babylonia. c. 575 B.C. Glazed brick. Approx. 3'5" high. Archaeological Museum, Istanbul, Turkey. ©1994, Gian Berto Vanni. Vanni/Art Resource, NY.

Ancient Egypt

The long, slow-moving Nile River provided easy access and routes of communication all around the narrow ribbon of the river's valley. The vast desert that surrounded the Nile isolated and protected it from invasion by foreigners.

Many settlements started along this narrow valley. The need for embankments and dams to control the annual summer flooding helped lead to alliances among the settlements. Small communities joined together under leaders powerful enough to organize large-scale projects. Two nations formed: Lower Egypt, which was located around the northernmost delta region of the Nile, and Upper Egypt, which reached inland toward the south for about 500 miles. The entire Nile valley was unified around 3000 B.C. when the armies of Upper Egypt conquered Lower Egypt.

This battle for unification is celebrated in an artwork called the *Palette of King Narmer* (see Figure 8-8). Narmer, one of the victorious kings from Upper Egypt, is shown on one side of the carved slate tablet, holding a warrior's mace above him, poised to strike down one of his enemies. Beneath him cower two more defeated Lower Egyptians. He is facing a falcon perched on a human-headed papyrus plant. The falcon symbolizes Horus, the sun god of Upper Egypt. The papyrus symbolizes Lower Egypt. Behind Narmer, a member of his royal court carries Narmer's sandals. The fact that the king is barefoot indicates that this is a holy victory. The ground on which he walks has become sacred. The reverse side of the tablet literally and symbolically depicts other aspects of Narmer's victory. One grim scene depicts Narmer inspecting beheaded victims of war— his enemies, of course. Below that, two strange creatures surround a chiseled-out well where pigments could have been mixed.

The *Palette of King Narmer* is one of the oldest surviving Egyptian artworks. Its maker utilized pictorial conventions that were to dominate Egyptian art for centuries. Narmer's head, feet, and legs are shown in profile. His shoulders, arms, and eye are rendered from a frontal view. Narmer and his sandal bearer each walk on their own horizontal ground line. Narmer, being the most important figure in the scene, is drawn larger than the others.

The unification of Upper and Lower Egypt marked the beginning of a long series of dynasties that spanned 2,700 years. A **dynasty** is a *succession of rulers who are members of a family line.* Egyptian kings are known as *pharaohs.* Some pharaohs encouraged more realism and innovation in art than others. The royal court of Pharaoh Amenhotep III (see Figure 8-9 on the next page)

Figure 8-8 This carved tablet depicts the victory of King Narmer.

Palette of King Narmer (reverse side), c. 3100–2789 B.C. Slate tablet. Height: 25". Egyptian Museum, Cairo, Egypt. Giraudon/Art Resource, NY.

obviously preferred a more naturalistic approach to art, while retaining many of the traditional pictorial conventions. Figure 8-9 depicts gods of four different Egyptian nomes, or provinces, in the act of bearing offerings to the pharaoh and to a major god, Amen. Livestock, fowl, fruit, lotus, and papyrus represent the bounty and prosperity of Egypt under the peaceful reign of Amenhotep III, who preferred diplomacy to war as a way of building and maintaining his empire. Compared with the *Palette of King Narmer,* these figures appear more relaxed and natural, more detailed, and utilize more overlapping to indicate visual depth.

The first artist whose name is recorded in history is the Egyptian named Imhotep (em-HO-tep). Imhotep

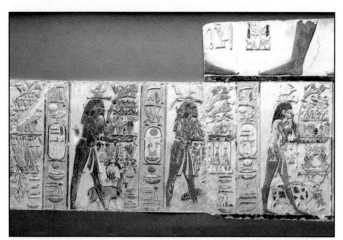

Figure 8-9 These reliefs, which probably were part of an Egyptian temple, illustrate both innovations and traditions in ancient art created under the pharaohs.

Nome Gods Bearing Offerings, 1391–1353 B.C. Egypt, Dynasty XVIII, reign of Amenhotep III. Painted limestone. 66 × 133 cm. ©The Cleveland Museum of Art, John L. Severance Fund. 61.205, 76.51.

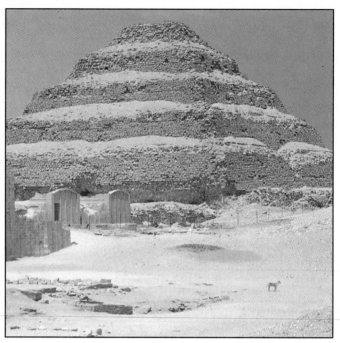

Figure 8-10 Imhotep, the architect of this pyramid, was the first artist whose name is recorded in history.

Funerary Complex of King Zoser, with Step Pyramid. Imhotep. c. 2610 B.C. Saqqara, Egypt. Scala/Art Resource.

was the royal architect of a pharaoh named Zoser. Imhotep was responsible for two important innovations. One was the pyramid-shaped tomb (see Figure 8-10). Before Imhotep built the pyramid, **mastabas** (MASS-tuh-buhs), *rectangular burial mounds with sloping sides,* were common. Zoser's tomb was a **step pyramid,** *shaped like several mastabas of diminishing size stacked one on top of the other.* Later pyramid tombs would have evenly sloping sides.

A second innovation of Imhotep was the use of stone columns. These would prove to be much stronger and longer lasting than previous columns of wood and bundled reeds.

Imhotep's genius was highly regarded. He was an architect, physician, adviser, and scribe. Subsequent generations of ancient Egyptians would honor his memory and consider him divine.

Today, people still marvel at the artistic accomplishments of the ancient Egyptians. Scholars continue to unlock the mysteries of ancient Egyptian culture, lifestyles, and beliefs. We have plenty of evidence that Egyptian pharaohs were revered, based on the quality,

DEVELOPING SKILLS FOR

ART CRITICISM

Compare the relief carvings shown in Figures 8-8 and 8-9, images from the time of Pharaohs Narmer and Amenhotep III. They were created 1,600 years apart, yet there are distinct similarities. There are also distinct differences. What do you notice?

1. Describe features they have in common.

2. Describe ways in which they differ.

3. What does the subject matter suggest about Egyptian life under the rule of each pharaoh?

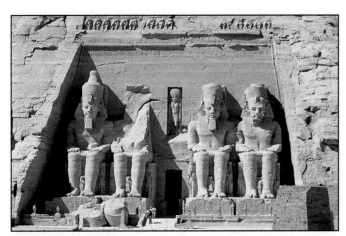

Figure 8-11 This awe-inspiring monument would be hidden underwater today were it not for the heroic efforts of modern historical preservation.

Temple of Pharaoh Rameses II, Abu Simbel, Egypt. c. 1257 B.C. Height of statues: 67'. ©1994 The Telegraph Colour Library/FPG International.

number, and size of monuments, murals, jewelry, and other artworks that pay homage to them. One such monument is the famous Temple of Pharaoh Rameses (RAM-seez) II, at Abu Simbel (see Figure 8-11). Cut from a mountainside, the temple stands over sixty-five feet high. Each of the four seated figures depicts Rameses II.

We also know that the ancient Egyptians believed in an afterlife. They mummified their deceased and buried them in elaborate tombs. The pharaohs' tombs contained great treasures. Almost all of the tombs were emptied over time by tomb robbers.

One of the most spectacular archaeological finds of the twentieth century was the discovery in 1922 of the tomb of Pharaoh Tutankhamen (to-tahk-HA-mun). Virtually intact and undisturbed for well over three thousand years, "Tut's tomb" has helped scholars to learn more about ancient Egyptian art and customs.

One of the most striking objects discovered in the tomb is the coffin of the pharaoh (see Figure 8-12). Tutankhamen is shown wearing a royal headdress and clutching a shepherd's crook and a flail, which is a whip-like tool for beating grain loose from its husk. The crook and flail are symbols of Egyptian royalty, as well as symbolic of Osiris, the Egyptian god of the dead and afterlife.

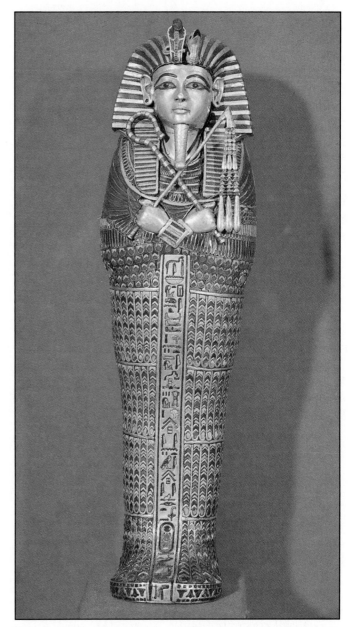

Figure 8-12 This finely crafted coffin is truly fit for a king.

Tutankhamen's Sarcophagus, c. 1350 B.C. Gold, enamel, precious stones. The Egyptian Museum, Cairo. Scala/Art Resource, NY.

Greece

Although the powerful civilization of ancient Egypt flourished for many centuries before the civilization of ancient Greece reached its zenith, the two did overlap

in time. The power of the pharaohs was growing weaker with time, due to pressures from other civilizations and internal social and political problems. The rise of Greek civilization ushered into world history many ideas, customs, and artistic styles that were quite different from the Egyptians and others who had gone before.

It would be difficult to overestimate the influence of ancient Greek art and culture on the Western world. Greek philosophy explored themes and values that we still discuss and debate today, such as the nature of truth, goodness, and rational thought. By the fifth century B.C., Athens had developed a democratic system of government that would have an impact on politics for centuries to come. The tragedies and comedies of Greek theater are still read and performed. The ideal of a "sound mind in a sound body" led Greeks to undertake programs for intellectual development and physical fitness. These are still common goals in schools today. The first Olympiad was held in Greece in 776 B.C., the forerunner of our modern-day Olympics. Greek architecture has influenced the shape of built environments for centuries, and Greek sculptors are recognized as among the finest the world has ever produced.

Much of what remains of Greek art comes to us in the form of Roman copies. The Romans were great admirers of Greek art. One such copy may be seen in Figure 8-13, *Discobolos*—"The Discus Thrower." Historians have learned that the original Greek version of this sculpture was cast bronze; the Roman copy is carved marble. This work is a clear representation of certain Grecian ideals—the athlete striving for excellence, the well-proportioned human figure, the serene expression that indicates emotional control and thoughtful concentration.

Some three centuries after the creation of *Discobolos*, another Greek sculptor—whose name has been lost to us—carved the dramatic *Nike of Samothrace* (NIGH-kee of SAM-o-thrace) (see Figure 8-14). Nike was a Greek goddess signifying victory in battle; she had wings that allowed her to fly through the air and land at the scene of battle or on the prow of a warship. This statue is sometimes referred to as the *Winged Victory*.

Although *Discobolos* depicts a moment in a vigorous athletic event, the subject appears frozen in time. In

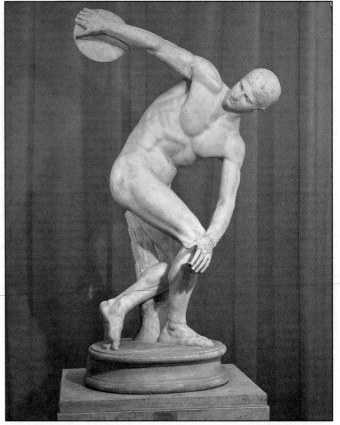

Figure 8-13 This statue embodies certain Greek ideals, such as physical fitness, emotional control, and rationality.

Myron, *Discobolos (The Discus Thrower)*. Original c. 450 B.C. Roman copy. Marble. Life-size. Museo Nazionale della Terme, Rome. Scala/Art Resource, NY.

contrast, the *Nike* looks as if the goddess is still in motion. Her beating wings throw her against the wind, which whips and curls the fabric of her gown. The thin fabric reveals the human proportions of this goddess, and gathers in pleats and folds that tumble downward and behind her. It is a stupendous feat to create such a convincing appearance of fluid movement out of solid stone.

As demonstrated by the last two figures, Greek sculpture is characterized by lifelike, if idealized, rendering and harmonious proportions. By "harmonious proportions," we mean forms that are well balanced visually, where each shape complements the adjoining shapes.

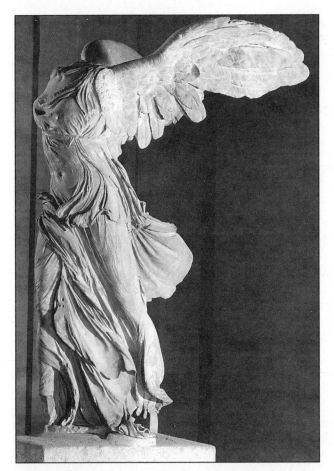

Figure 8-14 Although her head and arms have been broken off and lost, this is still considered one of the world's most magnificent sculptures.

Nike of Samothrace. Greece, c. 190 B.C. Marble. Height approx. 8′. Louvre, Paris. Art Resource, NY.

The Greeks extended their concern for harmonious proportions to other art forms. The vase pictured in Figure 8-15 has an elegant and perfectly symmetrical silhouette. Notice how the central section swells up and out in an upside-down teardrop shape from the base. The curve is reversed near the top. Matching handles also curve, creating interesting open spaces. The vase balances easily on a relatively small foot, proof that its weight is as perfectly balanced as its shape. The Greeks were highly skilled potters. This particular type of vase is called an *amphora*, which was used to store and carry foods, beverages, and oils.

Greek vases were usually decorated with a combination of repeated abstract designs—such as those visible near the mouth and foot of Figure 8-15—and pictures representing some sort of human or mythological activity. Figure 8-15 shows people gathering olives; one person is in the olive tree, one is stooped toward the ground, and two appear to be knocking olives out of the tree with long sticks. This vase has been painted in the *black-figure style*, meaning that the pictorial images are painted in black against a reddish background. Also common were vases painted in the *red-figure style*, with red images against a black background.

Harmonious proportions characterized Greek architecture as well. Greek architects carefully studied the effects of different proportions of length compared to

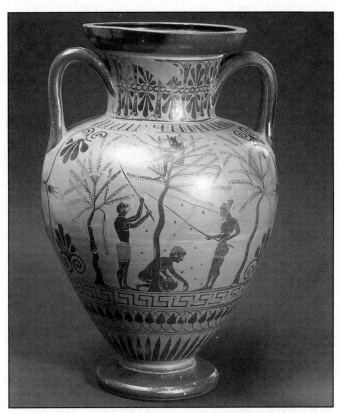

Figure 8-15 The ancient Greeks created superbly formed and decorated pottery.

Athenian black figure amphora, showing olive gathering, c. 520 B.C. Antimenes (painter; potter unknown) Black-figure style vase, Greek. British Museum, London. Bridgeman/Art Resource, NY.

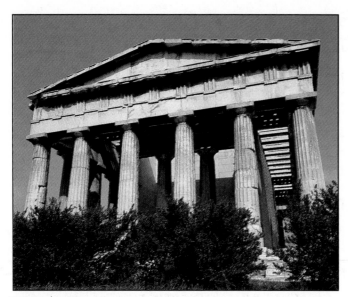

Figure 8-16 This is perhaps the best preserved of all ancient Greek temples.

The Temple of Hephaestus and Athena (also called *the Hephasteum* or the *Theseum*), Athens, Greece, c. 421 B.C. L: 104' × W: 45½' × H: 33'. Marble. ©1991 G. Clyde, FPG International.

width and to height, seeking to create the relationships that would be most pleasing to the eye. They tapered their columns so that they were wider at the base than at the top. This added a sense of loftiness to the facades of their buildings, because the columns appeared to recede into the distant sky more than they actually did. You can see this effect in Figure 8-16 above. Notice how the pediment, or the uppermost triangular portion of the facade, also points skyward. The building as a whole strikes an effective balance among horizontal, vertical, and diagonal lines. Historians have called this building different names: the *Hephaesteum*, the *Temple of Hephaestus and Athena*, and *Theseum*. Theseus was a legendary Greek hero, whose exploits were carved in stone along one side of the building. At one time, a statue of Athena stood inside the building. Athena was the Greek goddess of war and peace, and the patron and protector of Greek civilization. Historical records indicate that the building was also a temple to Hephaestus, the Greek god of fire, and the patron of Greek metalsmiths.

Greek influence spread under the reign of Alexander the Great (356 to 323 B.C.), a king from Macedonia, which was a region around northern Greece and the Balkan Peninsula. Alexander's armies swept northward to the Danube River, southward into Egypt, and as far east as India. His empire collapsed after his death. The expanding Roman empire conquered Greece in 146 B.C., and adapted many Greek traditions of art and architecture.

The Roman Empire

As we learned in Chapter Six, the Romans were mighty conquerors and great builders. The influence of Greek architecture on the Romans is evident in the Temple of Vesta (see Figure 8-17). Like the Greeks, Roman architects employed tall, **fluted columns** (*referring to the decorative pattern of grooves running from top to bottom on each column*) topped by decorative capitals. There are important differences, however. The Roman temple is rounded in shape, creating a different visual relationship with its surroundings than the box-like Greek shape. Some critics feel that a rounded shape blends more naturally with the landscape. Also,

Figure 8-17 The Temple of Vesta shows the Greek influence on Roman architecture.

Temple of Vesta. Tivoli, Italy. Scala/Art Resource, NY.

the walls of many Roman buildings are built of concrete, a mixture of sand and gravel bonded with cement. While the Greeks worked primarily with cut stone, the Romans preferred concrete, a more flexible and economic material that allowed them to build an extensive system of roads, bridges, aqueducts, and other structures throughout their vast empire.

Roman architects employed arch and vault construction techniques to open up interior spaces and to allow for buildings that were several stories high, yet not dependent on solid (that is, windowless) walls. (For more details on Roman architecture, refer back to Chapter Six.) One of the most famous buildings in the world is the Colosseum, the largest of many Roman amphitheaters (see Figure 8-18). Built around 70 A.D., this oval, four-story open-air structure is a forerunner to our modern football stadiums. It could seat 48,000 spectators, who would come to watch staged and often bloody battles between wild beasts and gladiators. The arena of the Colosseum could be flooded in order to stage mock sea battles. Great canvas awnings could be stretched across the top of the 617-by-512-foot oval in order to shield the crowd from the blazing sun.

The Romans were self-congratulatory, and frequently erected temples, triumphal arches, and other monuments to symbolize their accomplishments. At the center of the city of Rome was the Roman Forum, a dense cluster of temples, monuments, and civic buildings celebrating the glory of Rome (see Figure 8–19).

Figure 8-18 Roman architects designed tiers of seating ramps for this amphitheatre, similar to stadiums built today.

The Colosseum, Rome, Italy. c. A.D. 70–80. ©1994 Telegraph Colour Library/FPG International.

It was begun in the second century B.C. during the early years of the empire, and added to over the next 500 years. The picturesque ruins of the Roman Forum may be visited today.

Roman architecture often appeared in paintings created for homes and other structures made for wealthy

Figure 8-19 The Roman Forum symbolized the glory of the Roman Empire.

Becchetti: Artist's rendition of the Roman Forum as it probably existed. Watercolor, Soprintendenza. Scala/Art Resource, NY.

and powerful citizens. These paintings were made directly on interior walls. A fairly convincing and elaborate rendering of architecture and landscape was painted so that the room seemed to extend into the open-air environment beyond the walls. Sometimes, artists added realism to such "views" by painting porch columns in the foreground, or window frames surrounding the scene. See Figure 6-2 on page 279.

Roman sculptors excelled at portraiture. It became the custom in Rome for leading citizens to have **portrait busts** made of themselves. A portrait bust *is a three-dimensional, usually life-size portrait of someone that shows his or her likeness from the shoulders up.* Some houses would contain portrait busts of the homeowner and the family ancestors. Unlike the Greeks, who tended to idealize the human figure, Roman sculptors created very accurate representations of their subjects. Figure 8-20, for example, shows us an individual with a distinctive personality and expression, right down to the bald head and furrowed brow.

By the fifth century A.D., the Roman Empire had collapsed, the victim of invasion by external warriors and internal political instability. The Romans' artistic

Figure 8-21 This massive head had to be transported without benefit of the wheel, which was unknown in the ancient Americas.

Colossal Olmec Head. c. 800–600 B.C. Mexico. Carved basalt. Height approx. 6′. San Juan, Teotihuacan. Museo de Jalapa, Veracruz, Mexico. Foto Film/Art Resource, NY.

legacy has impressed and inspired countless artists and art lovers since that time.

Mexico and Central and South America

When Columbus landed in the "New World" in 1492 A.D., he actually set foot in a place where great civilizations had already been thriving for 3,000 years.

One of the oldest of these civilizations was the Olmec, whose influence dominated a broad region around La Venta on the east coast of Mexico from 1500 to 500 B.C. Although many small sculptures remain from the Olmec civilization, this group's most striking legacy comes in the form of colossal carved stone heads (see Figure 8-21). Such heads, each carved from a single stone and weighing about twenty tons, had to be transported over sixty miles from the site where the stone was found, across swampland, to be installed on a ceremonial platform at La Venta. With some as much as nine feet high and sporting carved war helmets, these

Figure 8-20 Roman portrait busts were often characterized by stark realism.

Portrait Bust of a Man. Roman. Early 1st century B.C. Marble. H: 17½″ (44.5 cm.). Metropolitan Museum of Art, New York, Fletcher Fund, 1926. 26.60.3.

colossal heads must have inspired the awe of people then as they do today.

Developed Civilizations.
Cultures in ancient Mexico developed a 365-day solar calendar, mathematics, books of hieroglyphics, astronomy, and artistic and architectural styles and technologies, along with complex social, religious, and political systems. Surviving artworks allow us to glimpse something of these people, their life-styles, legends, and beliefs.

Hieroglyphic Texts.
A book made by the Maya (MAH-yah) or Mixtec (meesh-TEK) is called a **codex.** *These were folding-screen books* up to twenty-one feet long; the paper was made out of pounded bark or deerskin. The hieroglyphics in these books are still being translated by historians. They provide information on history, science, ceremony, and other aspects of culture.

Ceramic Couples.
Two decorated ceramic human figures, a man and a woman, may be seen in Figure 8-22. They are similar in style, scale, color, patterning, and proportion. Couples such as these have been found in burial sites in Nayarit, Mexico. Although their original significance is lost to us, we can still gather evidence from these figures about this culture's clothing and textiles, jewelry and ornaments, and human relationships. One thing is not a mystery: these Nayarit people had skilled artists among them.

Architecture.
Numerous sites in Mexico and Central and South America attest to the architectural brilliance of these ancient cultures. Great temples in the shape of pyramids rise above the plains and jungles of central Mexico, the Yucatán, and Guatemala. The culture at Teotihuacán (tay-o-tee-wha-KAHN) erected two such pyramids between 200 B.C. and 750 A.D. Teotihuacán was probably the largest city in the ancient Americas, with as many as 100,000 residents. The culture that lived there was primarily an agricultural society, which worshiped gods associated with nature, such as Tlaloc (TLAH-lock), the rain god. The Pyramid of the Sun and the Pyramid of the Moon were designed to serve as temples for ceremonies. Sacred processions would climb the many steps to the top, which was flat to allow for ritual gatherings (see Figure 8-23).

A smaller ceremonial structure at Teotihuacán was the Temple of Quetzalcoatl (ket-zal-koh-AHT-uhl). Quetzalcoatl was a fearsome-looking god associated

Figure 8-22 Ancient couples like these, though silent, reveal things about the people who made them.

Funerary Male and Female Figures, Nayarit, Mexico. c. 300 B.C.–A.D. 400. Ceramic. Columbus Museum of Art, Ohio. CMA Purchase: Howald Fund II.

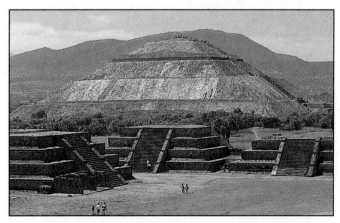

Figure 8-23 The pyramids of the ancient Americas rival those of ancient Egypt in size and splendor.

The Pyramid of the Sun, Teotihuacán, Mexico. c. 200 B.C.–A.D. 750. H: 210', L: 740' (sides). Photo ©1994 Douglas Bryant/FPG International.

Figure 8-24 The fanged heads of ancient gods appeared in many artworks of ancient Mexico.

Temple of Quetzacoatl, detail of stairs. Teotihuacán, Mexico. c. A.D. 300. The Bettmann Archive.

with agriculture and depicted in the form of a feathered serpent. You can see the snakelike, fanged, and plumed head of Quetzalcoatl on the carved stone facade of the temple (see Figure 8-24 above).

The Mayan civilization was one of the most sophisticated and powerful cultures of Mexico. The Mayan empire covered much of the Yucatán and Guatemala. This empire was built between 200 B.C. and 1100 A.D.

After the Maya's dominance in the region was well established, but before their decline due to adversaries, their arts and culture flourished in what is referred to as the classic Mayan era. A relief sculpture pictured in Figure 8-25 provides us with a glimpse of this civilization. A royal Mayan woman is seen holding an elaborate **scepter** (SEP-ter), *a hand-carried symbol of power and privilege.*

We briefly visited one of the Maya's greatest architectural complexes, Palenque, in Chapter One. A pyramid rises four stories from the jungle floor at that site, distinguishing it as the loftiest Mayan construction. Some believe the most magnificent of the Mayan cities was Uxmal (oosh-MAHL). Figure 8-26 shows a portion of the Face of the Sun Temple at Uxmal. If you look carefully, you can see that small human figures in Mayan costume, as well as coiling rattlesnakes, are part of the temple frieze. The geometric crisscross motif is reminiscent of the pattern on the backs of rattlesnakes.

Figure 8-26 Great stone rattlesnakes seem to climb the sides of this Mayan masterpiece.

Face of the Sun Temple (Detail). Uxmal, Mexico. Maya. 10th century A.D. Photo ©1994, E. Louis Lankford.

Figure 8-25 An Example of Classic Mayan Art

Royal Woman, c. A.D. 650–750. Wall panel of limestone, stucco, and paint. H: 86¾" × W: 30¼" × D: 6". Maya area; central lowlands, state of Chiapas or state of Tabasco, Mexico. Dallas Museum of Art, Foundation for the Arts Collection, gift of Mr. and Mrs. James H. Clark. 1968.39.FA. ©1991, Dallas Museum of Art. All Rights Reserved.

Student Activity 1

How Complicated Can It Be?

Diagram A

Goals

1. You will develop your ability to dig beneath the surface of cultural artifacts.
2. You will practice articulating your ideas in discussion.

Materials

1. Writing paper

Directions

1. Refer back to the ceramic male and female figures from Nayarit, Mexico (Figure 8-22). Although archaeologists have unearthed several similar pairs, no one is certain about their significance. How complicated can it be to figure out what such objects mean? In the first place, there are no written records explaining the meaning of these objects. But even if there were records, they wouldn't necessarily tell us the whole story. Ceremonial objects can have many layers of meaning. To illustrate this idea, let's analyze a common ceremonial item from our own century.

2. Look at Diagram A. Do you recognize this item? Most of you will probably recognize it as a decoration that goes on the top of a wedding cake. But as a symbolic object, it's much more complicated than that. Imagine that you are trying to explain the meaning of this object to someone who has never seen one before. Suppose this person doesn't know what a wedding cake is, or what a wedding ceremony signifies. Suppose this person has never seen people dressed like that before. In a class discussion, try to explain the symbolic and social meaning and value of the object in Diagram A. Keep track of ideas raised during the discussion by making a written list.

3. After your discussion about matrimony and its symbols, ask yourself how easy they were to explain. Would you say that some things that most people understand in our own culture might be difficult for people from other cultures or time periods to understand? Can you think of other examples like the cake top? Finally, how does this lesson apply to our understanding and interpretation of artworks from other cultures and time periods in history?

Evaluation

1. Did you really apply yourself to a thoughtful analysis of the meaning of the ceremonial object pictured in Diagram A? What were some questions you asked yourself?

2. Did you try your best to be clear and thorough in expressing your thoughts? Did you listen carefully to others? Write down one idea that you had, and one idea you got from someone else.

3. Did you extend your thoughts on the interpretation of objects from our culture to artworks from other cultures and time periods? Summarize your thoughts in a paragraph.

The rattlesnake motif can also be found at another ancient Yucatán site, Chichén Itzá (chee-CHEN eetz-AH). Although begun by the Maya, much of Chichén Itzá has been attributed to the Toltec culture. The Toltec civilization developed about the same time as the Maya in Mexico, and ultimately gained dominance over the Maya and other peoples in the region. Although in many ways the Toltecs, were a sophisticated culture, they were in other ways quite fearsome. Besides being fierce warriors, they were known to have engaged in human sacrifice. At a ball court at Chichén Itzá, young men engaged in a sport so brutal that it would inevitably result in injury or death to the players. Nevertheless, in the dense jungle growth of the Yucatán, the Maya and later, the Toltecs, carved out a monumental complex of temples and other structures. Historians are still uncertain about the purpose of many of the buildings.

One of the most elegant and symmetrical structures at Chichén Itzá is the Pyramid of Cuculcán (koo-kul-KAHN) (see Figure 8-27). Cuculcán was a Toltec god of creation and transformation similar in form and importance to Quetzalcoatl at Teotihuacán. The Pyramid of Cuculcán almost certainly was associated with the seasons and the solar calendar. Ninety-one steps lead to the top on each of the pyramid's four sides. If we multiply ninety-one times four and count the platform on top as one more step, that's a total of 365 steps, the same number as there are days in the year. At the base of some of the steps are large rattlesnake heads carved out of stone, their mouths wide open, baring their fangs. The rattlesnakes face a natural well where human bones and gold jewelry have been found, evidence of human sacrifice.

Other magnificent structures at Chichén Itzá include the Temple of the Warriors (see Figure 8-28) and the Nunnery (see Figure 8-29). The centerpiece of the

Figure 8-28 This temple gets its name from the warrior reliefs carved on the columns.

Temple of the Warriors. Maya and Toltec. c. 12 century A.D. Chichén Itzá, Mexico. Photo ©1994, E. Louis Lankford.

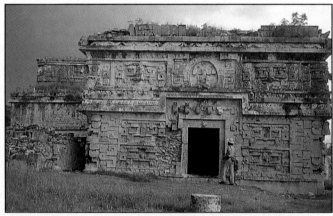

Figure 8-29 Carvings on this building are similar in style to those at Uxmal (see Fig. 8-26). The building was mislabeled, as no nuns lived among the Maya in ancient Mexico.

The Nunnery. Maya. c. 12th century A.D. Chichén Itzá, Mexico. Photo ©1994, E. Louis Lankford.

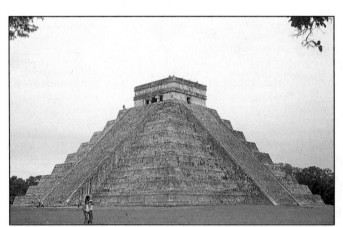

Figure 8-27 The number of steps on this symmetrical pyramid add up to 365, equivalent to a calendar year.

Pyramid of Cuculcán. Toltec. c. 12th century A.D. Chichén Itzá, Mexico. Photo ©1994, E. Louis Lankford.

Temple of the Warriors consists of a high terraced platform on which are the ruins of an ancient temple. At its base is a large group of columns. The temple takes its name from the relief carvings of warriors found on many of the columns.

The Nunnery was given its name by early Spanish explorers. They were mistaken about the function of the building, since there were certainly no nuns among the ancient Mayan or Toltec people. Like other structures at Chichén Itzá, it probably had ceremonial significance related to the customs and beliefs of the people who built it. The Nunnery probably dates from the Mayan period at Chichén Itzá, before the Toltecs moved there. The detailed carving is very similar to that found at Uxmal.

One of the most unusual structures built in the ancient Americas is El Caracol (The Snail) at Chichén Itzá (see Figure 8-30). The Spanish named this building for its round shape. Inside are narrow passageways forming concentric circles. It may have been a solar observatory.

Peru. Two thousand miles southwest of the Yucatán peninsula, other civilizations flourished. Peru, in particular, witnessed the development of art, architecture, and an expansive empire. Like many of the cultures of Mexico, Peruvians excelled in the creation of decorated ceramics. The ceremonial jar pictured in Figure 8-31 has a smiling ritual figure painted on its side.

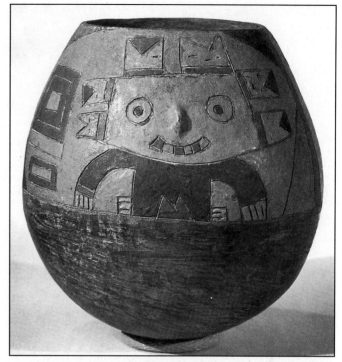

Figure 8-31 Why this figure smiles is an ancient mystery.

Ceremonial jar with an anthropomorphic figure. c. 300 B.C. South America, Peru, Ica Valley, Ocucaje Area, Paracas Culture. Ceramic with resin-based post-fired paint with incising. Ht.: 29.5 cm.; diam.: 28.3 cm. The Art Institute of Chicago. Gift of Mr. and Mrs. Nathan Cummings. 1960.897. Photo ©1993, The Art Institute of Chicago. All Rights Reserved.

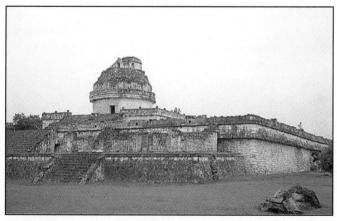

Figure 8-30 The round shape of this building is very unusual for ancient Mexico.

El Caracol (The Snail). Toltec. c. 12th century A.D. Chichén Itzá, Mexico. Photo ©1994, E. Louis Lankford.

Peruvians mined gold and silver, and worked it into beautiful, well-crafted works of art. The silver figure of a musician (see Figure 8-32 on the next page) was created by an artist of the Chimu culture over 500 years ago. Native Peruvian musicians still play similar flutes today.

The ancient Chimu built a mighty city called Chan Chan on the north coast of Peru. Chan Chan was actually a cluster of walled towns built of adobe. There may have been as many as a quarter of a million Chimu living among its temples, palaces, and houses. The walls surrounding the towns were as high as forty feet, and as thick as twelve feet. Still, they could not protect the Chimu from the might of the Incas, who conquered Chan Chan around 1400 A.D.

The Incan civilization was one of the most remarkable in history. Established near Cuzco, Peru, the Incan

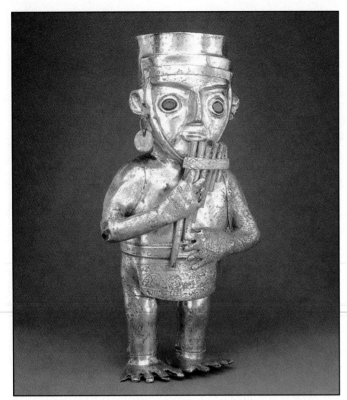

Figure 8-32 Instruments such as the one played by this musician are sometimes called panpipes. Music is made by blowing across the open upper end of bound reeds or tubes.

Standing Musician. Chimu culture, Peru, north coast. 14th–15th century A.D. Effigy vessel: silver and turquoise. H: 8¼" × W: 4¼" × D: 2¾". Metropolitan Museum of Art, New York, The Michael C. Rockefeller Memorial Collection, gift of Nelson A. Rockefeller, 1969. 1978.412.219.

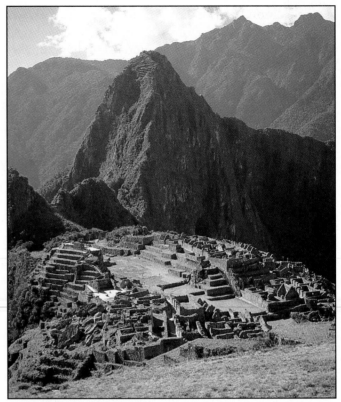

Figure 8-33 The skillful fitted-stone construction of this city was one of many amazing architectural and engineering feats of the Incas.

Machu Picchu. Inca, Peru. c. 14th–15th century A.D. ©1994 Telegraph Colour Library/FPG International.

Section ① Review

Answer the following questions on a sheet of paper.

Learn the Vocabulary

Vocabulary terms for this section are *rock art, ziggurats, mother-of-pearl, dynasty, mastabas, step pyramid, fluted column, portrait bust, codex,* and *scepter.*

1. Match each of the following descriptions to the appropriate vocabulary term:
 a. Temples built by the Sumerians, each dedicated to a specific god
 b. A succession of rulers who are members of a family line
 c. A Mayan book, made of bark or deerskin
 d. Egyptian rectangular burial mounds with sloping sides

empire spread and flourished until it was conquered by Francisco Pizarro's Spanish soldiers in 1532. At its height, the empire covered much of what is now Ecuador, Peru, Bolivia, Argentina, and Chile. The Incas linked their empire with over 3,000 miles of roads and bridges.

The Incan city of Machu Picchu was built at the breathtaking altitude of 7,000 feet in the Andes Mountains. It included a temple to the sun, plazas, palace rooms, and houses terraced along the mountainside. Even in ruins, it is one of the most amazing sites in our hemisphere (see Figure 8-33).

Check Your Knowledge

2. Describe the temple complex the Babylonians built and dedicated to their goddess, Ishtar.
3. What does the artwork *Palette of King Narmer* (Figure 8-8) celebrate?
4. Who was Imhotep?
5. Name a Grecian ideal.
6. What does the term *harmonious proportions* mean in relation to Greek art and architecture?
7. What was the purpose of the Colosseum?
8. What kind of information can a codex provide for historians?

For Further Thought

9. This section describes treasured works of art from ancient cultures. Think of something you own or have made that you consider a treasure. What does it say about your beliefs, experiences, and cultural background?

"Every animal leaves traces of what it was; man alone leaves traces of what he created."

Jacob Bronowski

Section II

Splendor and Allegiance

You have probably noticed that much art that remains from the past has reflected *loyalty to a cause, a nation, or an individual*. This loyalty is known as **allegiance.** The architects of Mesopotamia and Mexico built ziggurats and temples as a sign of allegiance to their gods. The artists of Egypt crafted objects and monuments showing allegiance to their pharaohs. Throughout history and around the world, the creation of works of art, great and small, has been motivated by a sense of allegiance. Religions and systems of beliefs and values have inspired the allegiance of countless artists. Buddhist, Christian, Hindu, Islamic, Judaic, and other faiths have been the source for much of the world's art. The spiritual lives of the native peoples of Africa, Australia, North America, and other locations have been reflected in their art.

Rulers have also inspired—and often demanded—allegiance. The titles of rulers vary from culture to culture. Whether called king, queen, emperor, empress, chief, sultan, oba, pharaoh, or some other title, ruling individuals have loomed large in the history of art. They have been depicted in tens of thousands of works of art. Rulers, often being the most wealthy and powerful members of a culture, have also served as patrons of the arts. Countless art objects have been made at their command and for their pleasure and glorification.

Whether made in the name of a religion or a ruler, artworks motivated by allegiance are often characterized by splendor. What do you think of when you hear the word *splendor*? Magnificence, maybe, or the use of rare and rich materials? Or perhaps you think of work on a grand scale, or work that has been superbly crafted. Splendor refers to all of these. We have already seen some of the splendors of the Greeks, Babylonians, and Maya. Let's look at some of the splendors of other great cultures and time periods.

Sub-Saharan Africa

We have already visited one of the most astonishing cultures in world history, located in Africa: ancient Egypt. The vast northern expanse of Africa is dominated by the Sahara Desert; on its eastern edge lies Egypt. As you learned in Chapter Seven, rock art dating from at least 6000 B.C.—long before the Egyptian civilization of the pharaohs—has revealed that northern Africa was once green. As the region became dry, the people and animals either died out, migrated southward, or adapted to the harsher conditions. The large area of Africa south of the Sahara is sometimes referred to as *sub-Saharan*, which literally translates as geographically below that desert. Some of the oldest known fossilized human skeletal remains have been discovered by anthropologists in sub-Saharan Africa.

Also, some of the world's finest artists have lived and worked there as part of civilizations that rival, in splendor and sophistication, any we have seen. Science, religion, navigation, invention, mining, metalsmithing, politics, wood carving, jewelry, and architecture all flourished in sub-Saharan cultural centers. Wars were fought, empires and cities grew and faded, and trade was carried out with merchants in far-off India, China, and Europe.

The region around what is now Nigeria was home to some of the greatest producers of art in Africa. Among the oldest surviving artworks were those produced by the Nok culture of central Nigeria between 500 B.C. and 500 A.D. (see Figure 7-12). Fragments of ceramic human and animal heads have been found. It is very probable that African sculpture began long before that with the carving of wood. Unfortunately, most wood carvings made in this region before the twentieth century have not survived the ravages of time, decay, and wood-eating insects.

Artists in the town of Igbo-Ukwu in the ninth and tenth centuries A.D. were probably the first in the region to create artworks in bronze. Since the copper needed to make bronze alloy was not available in West Africa, the Igbo people must have acquired the metal they needed through trade. Some of the sophisticated bronze bowls and vessels that have been found were probably owned by religious dignitaries of the Igbo, who traditionally have no king but are governed by a council of elders.

The bronze vessel pictured in Figure 8-34 is remarkable in its resemblance to rope-covered clay vessels still in use today. Only highly skilled artists could produce such an intricate open-weave design in bronze.

The Yoruba (YO-roo-bah) culture had established the city of Ife (IF-eh) by 800 A.D., and these people had developed expertise in bronze casting and ceramic sculpture by the twelfth century. Central to the life of the Yoruba, and to their art, are their kings and queens, each referred to by the title *oni*. Magnificent portrait busts, portrait heads, and statues of onis are naturalistic in style (see Figures 8-35 and 8-36). We get the sense that we are looking at a genuine likeness of the esteemed ruler.

Typically, the oni is portrayed as calm and confident, standing erect, with head held high and eyes aim-

Figure 8-34 The delicate but restrained patterning on this vessel add to its visual richness.

Roped Pot on a Stand. Igbo-Ukwu, Nigeria. 9th–10th century A.D. Leaded bronze. Height: 12¹¹/₁₆" (32.3 cm.). National Museum, Lagos. Photo by Dirk Bakker. Courtesy, The Detroit Institute of Arts.

Figure 8-35 This sculpture demonstrates the unsurpassed skill of Yoruba artists, as well as the regal dress of an oni.

Upper half of a figure of a crowned oni. Yoruba culture, Ife, Nigeria. 15th–16th century A.D. Bronze. Height 14½". Museum of Ife Antiquities. Photo by Dirk Bakker. Courtesy, The Detroit Institute of Arts.

Figure 8-36 A king of Ife stands with royal bearing as he has for centuries.

Figure of an oni. Yoruba culture, Ife, Nigeria. 15th–16th century A.D. Bronze. Height 14½". Museum of Ife Antiquities. Photo by Dirk Bakker. Courtesy, Detroit Institute of Arts.

ing straight ahead. Historians believe that these portrait heads were mounted on a royally clothed wooden body after the funeral of the oni, to signify that the power of the office would continue. Many portrait heads have small holes in them. These probably held feathers, coral beads, and other ceremonial regalia. The vertical **striations,** or *incised lines,* running the length of the face probably represent **scarification,** *the custom of scarring one's skin in patterns to signify family and cultural ties* (see Figure 8-37).

Some historians believe that the Yoruba of Ife passed their knowledge of bronze work to the nearby Bini culture. The Bini became well known for their bronze and brass work. Their style was quite distinct from that of the Yoruba. The Bini cultural center was Benin City, where absolute authority rested with the *oba,* or king. The power of the oba and of the royal court, which included loyal chieftains, reached its height between the fifteenth and seventeenth centuries.

Figure 8-37 Scars such as these are used to associate the bearer with a particular family, culture, or cultural group, or to mark a significant rite of passage, such as childhood to adulthood.

Typical Kamberi Woman. Kainj Lake, Nigeria. Photo ©1994, George Gerster, Comstock.

The oba controlled bronze production in the Empire of Benin. He commissioned portrait busts and other works of art from Bini artists, who lived in special sections of Benin City. The artists and their apprentices mainly produced artwork that glorified the Bini royalty. An **apprentice** *is someone who works closely with an experienced artist in order to learn the techniques of an art form.* After an apprentice has served as pupil and assistant to an artist, the apprentice is ready to open his or her own artist's studio-workshop.

In Figure 8-38 on the next page, we see an example of bronze plaques created by Bini artists. Plaques like this were attached to the pillars of the oba's palace. They depicted aspects of sixteenth- and seventeenth-century court life, and included portraits of the oba and

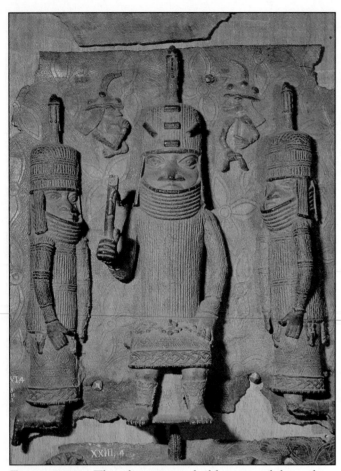

Figure 8-38 The oba, center, holds a war club, and wears a ceremonial kilt, collar, and anklets signifying his high office.

Plaque depicting oba flanked by chiefs in ceremonial garb, Benin, Nigeria. c. 15th–16th century A.D. Bronze. British Museum, London. Bridgeman/Art Resource, NY.

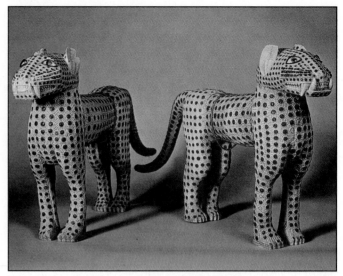

Figure 8-39 The rhythmic patterns of spots and sharp teeth make these leopards look fierce, but beautiful.

Two Leopards. Bini culture, Benin, Nigeria. 16th century A.D. Ivory and brass. Length 31½" (83 cm.). British Museum, London. Bridgeman/Art Resource, NY.

chieftains in ceremonial or warrior garments, musicians playing instruments, acrobats performing stunts, hunters, the oba's advisers, and merchants counting currency. Because the Bini had no written language, much of what we know about them has been learned from studying these pictorial plaques.

The spotted leopard was an important symbol for the Bini. Leopards signified royal power, and statues of them stood on altars honoring Bini ancestors. They are frequently found in pairs. The pair pictured in Figure 8-39 demonstrate that Bini artists were as skillful at working in ivory and brass as in bronze. Notice how the artist has given the surface of the elephant-tusk ivory a meticulously carved beaded texture.

Africans of both the Saharan and sub-Saharan regions are well known for producing colorful, highly patterned textiles. When worn in the bright African sun, clothing made from these fabrics never fails to make the wearer look special (see Figure 8-40). Such textiles enriched the splendor of the royal courts as well as the lives of people living in villages and cities.

Understanding Cultural Style

The art of Africa is as diverse as its people. There are 185 cultures in sub-Saharan Africa alone. Within cultures, traditional rules determine the material, style, and scale of ceremonial and ritual art forms. Artists have had some degree of freedom in interpreting these prescribed forms, but they have been bound by their culture not to stray too far from the rules. Such practices explain both the similarities and the variations among artworks within a given culture. This is true not just in Africa, but in all parts of the world throughout history.

had already developed its cities, Mohenjo-Daro and Harappa, by 2500 B.C. These were carefully planned cities that were built to last a long time. They even included sewer systems. Modern scholars are still attempting to decipher the writing developed by the people who lived there. Small seals bearing symbolic animal figures and writing have been found at Mohenjo-Daro. Stamps made from seals (see Figure 8-41) were probably used as a form of signature. The symbols may have had religious significance. No one knows for sure why the Indus valley civilization disappeared about 1500 B.C. It may have been a combination of enemy invasion and natural disaster.

The rise of the Hindu religion in ancient Indian society had a profound effect on its art and architecture. Hinduism has many symbolic gods, goddesses, demons, and legendary heroes. Artistic characterizations of this pantheon are found in many paintings and sculptures of India. The term **pantheon** *refers to all the gods of a culture or religion.* Let's visit two remarkable sites dedicated to Hinduism.

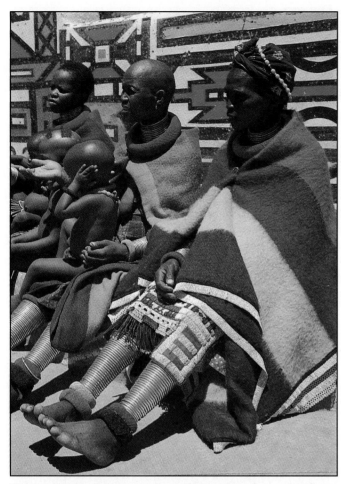

Figure 8-40 Fabrics such as these are color-stained with vegetable dyes. Soaking and heating various roots, leaves, and fruits results in dyes of different colors.

Women of Mali wearing typical clothes of patterned native fabrics. Mali, Timbuktu. Photo ©1994, George Gerster, Comstock.

Stylistic traditions give a distinctive character to artworks from particular cultures and particular periods. The art of Egypt is distinct from that of Benin, and the art of Ife is distinct from that of Mexico. We will notice further distinctions among the art forms of world cultures in the sections that follow, beginning with the ancient and varied land of India.

India

The art and cultures of the Indian subcontinent have ancient roots. The Indus River valley civilization

Figure 8-41 Seals such as this were probably used by their owners to stamp their possessions.

Seal with Two-Horned Bull and Inscription. c. 3000–1500 B.C. India, Indus Valley Culture. Steatite. 3.2 × 3.2 cm. ©The Cleveland Museum of Art. Purchase from the J. H. Wade Fund. 73.160.

In the seventh century A.D., a people called the Pallavas (pah-LAH-vahs) lived on the southeast coast of India at Mamallapuram (mah-mah-lah-POO-rum), also called Mahabalipuram. The Pallavas under the reign of King Mahamalla were great patrons of art. Evidence of their patronage can be found in the coastal landscape, where rock-cut temples still stand. A **rock-cut temple** *is one carved from solid rock, a process more similar to carving a stone sculpture than to constructing a building.* A small rock-cut temple is called a *ratham.* Figure 8-42 pictures rathams cut from the gigantic boulders that stood on this site.

Figure 8-43 A stylized lion proudly stands outside a ratham.

Draupadi Ratham and Lion. Mahabalipuram, India. Pallava culture. 7th century A.D. Photo ©1994, E. Louis Lankford.

Figure 8-42 These temples were not constructed from the ground up, but were cut from solid stone.

Rathams and stone animals at Mamallapuram. India. Pallava culture. 7th century A.D. Photo ©1994, E. Louis Lankford.

In Figure 8-43, you can see a rock-cut lion standing guard outside the Draupadi Ratham, named after a character in an Indian literary epic. The carvers of this ratham never finished. At a near corner of the ratham's base stands a carved architectural **finial,** *which is a decorative top, or fancy, uppermost tip of a spire or other structure.* This finial was carved from the same rock as the platform that is the ratham's base, but it was never cut loose and installed on top of the ratham.

Skilled Pallava stonecutters also created large-scale bas-reliefs in caves and on hillsides around Mamallapuram. Some are very dramatic, such as the one pictured in Figure 8-44, which depicts a fierce battle

between a goddess and a buffalo-headed demon. Some are gently humorous, such as the family of elephants pictured in Figure 8-45. Beneath its huge lumbering parent, a baby elephant struggles to learn how to walk. A curious monkey looks down on the scene from his rocky perch.

Figure 8-44 A contemporary guide points out the sense of drama and movement in this bas-relief. The many arms of the goddess, seen riding the lion, represent her various attributes and powers.

Durga Mahishamardini Battling Demon Mahisha. Rock cut cave. Mahabalipuram, India. Pallava culture, 7th century A.D. Photo ©1994, E. Louis Lankford.

Figure 8-45 A proud father stands guard over his two infants in this endearing portrait.

Elephant group with monkey. Pallava, 7th century A.D. Mahabalipuram. Photo ©1994, E. Louis Lankford.

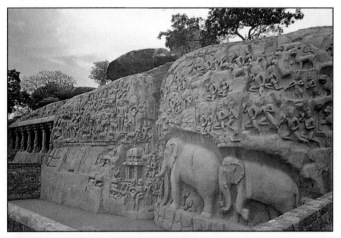

Figure 8-46 This is one of the world's most remarkable achievements in relief sculpture.

The Penance of King Bhagiratha and the Descent of the Ganges. Pallava, 7th century A.D. Mahabalipuram. Photo ©1994, E. Louis Lankford.

Perhaps the most remarkable of the Pallava bas-reliefs is the *Descent of the Ganges* (Figure 8-46). This is one of the largest relief sculptures in the world. It tells the Hindu story of a pious king who persuaded the god Siva (SEE-vah, also spelled Shiva) to allow the life-giving waters of the Ganges River to flow to earth. A *pious* person is one who shows his or her religious devotion.

Pallava artists brought the hillside to life with dozens of pious figures performing various rituals. The sculpture also includes gods and dwarves from the Hindu pantheon, and numerous animals, such as elephants, baboons, and gazelles. There is even a cat standing on its hind legs, surrounded by onlooking mice!

At another location in India, an equally remarkable temple complex was erected over a period of 100 years, between 950 and 1050 A.D. There were at least thirty and possibly as many as eighty-five individual temples constructed near one another at Khajuraho (kah-ju-RAH-ho). Of these, twenty still stand; their **sikharas** (seek-HAH-rahs), or *spires*, point toward the sky (see Figure 8-47). The largest, Kandariya Mahadev Temple, has a sikhara rising 118 feet in the air.

Each temple stands on a stone terrace. From this base, they rise in tiers of alternating vertical and horizontal patterns, tapering to a carved pinnacle. The inner sanctuaries of these temples are small and rather dark. The exteriors, however, are unsurpassed in the

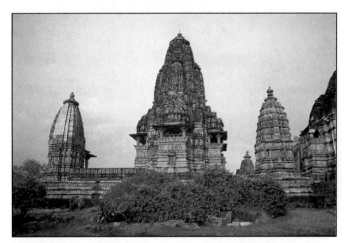

Figure 8-47 Sikharas penetrate the air at this ancient temple complex.

General view, Temple Complex. Khajuraho, India. c. A.D. 950–1050. Photo ©1994, E. Louis Lankford.

quality of the stone carving (see Figure 8-48). Literally thousands of sculptures representing royalty, saints, figures from the Hindu pantheon, musicians, camels, and elephants stand carefully posed, gazing at each other or looking out from the walls. Most appear calm and contented, symbols of religious bliss. Figure 8-49 shows the elephant-headed Hindu god, Ganesa (gah-NAY-sah), gracefully posed in a special niche reserved for him on a temple wall. Ganesa was the son of one of the most important of the Hindu gods, Siva. Ganesa has long been popular among Hindus for his

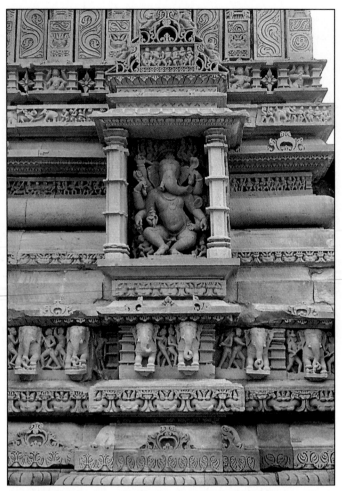

Figure 8-49 In a niche above a row of festooned elephants and their trainers, the elephant-headed Hindu god Ganesa dances.

Ganesa, detail of Temple at Khajuraho. Photo ©1994, E. Louis Lankford.

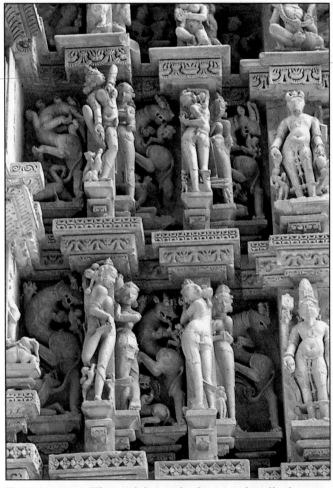

Figure 8-48 These elaborately decorated walls depict a combination of Jaina saints, Hindu gods and goddesses, and Rajput royalty.

Temple at Khajuraho, detail. Photo ©1994, E. Louis Lankford.

helpful, gentle, happy, and peaceful character. As with the artistic representation of all the gods in the Hindu pantheon, his pose and proportions are strictly prescribed by tradition.

The temples at Khajuraho were constructed by the Chandela Rajputs, a segment of a larger culture referred to collectively as the Rajputs. The Rajputs ruled vast regions of India, building beautiful temples and palaces (see Figure 8-50), and engaging in military skirmishes over territory. Eventually their dominance in northern India collapsed under the might of Islamic invaders from Turkestan (a region north of present-day

Figure 8-50 The Amber Fort was a fortified palace of Rajput kings. From here, the Rajputs valiantly resisted conquest by sultans from the north and west.

View of the Amber Fort, near Jaipur, India. c. 1600 A.D. Photo ©1994, E. Louis Lankford.

Afghanistan and east of the Caspian Sea) and Persia (the region around present-day Iran). Although Islamic influence was strongly felt as early as 1200 A.D., the Mogul empire was not securely established until 1504, when Sultan Muhammad Babur (see Figure 8-51) dealt crushing defeats to Rajput armies. You may recall that we discussed the Moguls in Chapter Six. In fact, one of Babur's first imperial orders was that a garden be designed and planted!

Few dynasties in history rival the Moguls in their patronage of the arts. They designed and constructed cities, fountains, gardens, palaces, and mosques, which are Islamic places of worship. They commissioned artwork from some of the most skillful painters, carvers, weavers, and tile setters in the world. Let's look at two great legacies of the Mogul empire, Fatehpur Sikri (FAH-teh-poor SEEK-ree) and the famous Taj Mahal.

Fatehpur Sikri was built as the capital of the Mogul empire by Akbar, the sultan, or emperor, who reigned from 1556 to 1605. His son and successor, Jahangir, described Fatehpur Sikri in his memoirs as "a magnificent city, comprising numerous gardens, elegant edifices and pavilions, and other places of great attraction and beauty." The name *Fatehpur* means "City of Victory." Sikri is the name of the original village that became the site of the capital.

Fatehpur Sikri has no streets. Its buildings are connected by broad courtyards. Covered open-air pavilions provide shady gathering places (see Figure 8-52 on the next page).

One of the most beautiful, and unusual, buildings of Fatehpur Sikri is the tomb of Salim Chisti (sah-LIM CHIS-tee) (see Figure 8-53 on the next page). The

Figure 8-51 This miniature painting uses an Islamic Persian style of achieving spatial depth: things nearer the top of the picture are more distant than things nearer the bottom.

Babur at the Spring of Khawaja Sih Yaran. From the *Babur-Nama* manuscript, folio 126. Mogul India, late 16th century A.D. National Museum of India, New Delhi. Bridgeman/Art Resource, NY.

Figure 8-52 Red sandstone gives this elegant cityscape its distinctive color.

View of Fatehpur Sikri, India. Mogul; built c. A.D. 1570–1580. Photo ©1994, E. Louis Lankford.

Figure 8-53 This tomb was built by Sultan Akbar.

Tomb of Salim Chisti. Fatehpur Sikri, India. c. A.D. 1570–1580 Marble. 24′ square. Photo © 1994, E. Louis Lankford.

tomb sits in a courtyard of the city's mosque. Salim Chisti was an Islamic holy man who had prophesied the birth of Akbar's son, Jahangir. The white marble of the tomb stands out against its red sandstone surroundings. The serpentine brackets at the top of the tomb's supporting pillars are unique in Mogul architecture. The term **serpentine** *refers to a long, thin shape that curves or coils like the body of a snake.*

Between the tomb's pillars are window panels made of carved marble. These panels required tremendous artistic and technical skill to make. Slabs of solid marble, cut very thin, are carved with intricate pierced patterns (see Figure 8-54). This type of carving is called **jali** (JAH-lee), *which means "net," although it compares much better with the intricacy of lace.* Besides being beautiful, it provides shade from the hot sun while allowing fresh air to circulate.

Akbar was a brilliant, charismatic ruler. He was equally skilled at military leadership and politics. He was interested in philosophy, literature, religion, and the arts. Akbar managed to attract accomplished artists and scholars to his court at Fatehpur Sikri. Rather mysteriously, Fatehpur Sikri was abandoned around 1585. This may have been due to severe water shortages.

Akbar, like Babur before him, was wise enough to try to adopt some of the ways of the land he had conquered, in order to gain the allegiance of new subjects. Indeed, his wife, the mother of Jahangir, was Rajput. Mogul art took on some of the characteristics of Rajput art, and it borrowed from China and Europe as well. For example, some Mogul architecture employs representational surface decoration. Traditional Islamic architecture does not allow representational or pictorial murals, carvings, or designs—such as depictions of humans, animals, landscapes, or other scenes with subject matter—on the interior or exterior of mosques and other structures. This is because the Koran, the sacred

Figure 8-54 Intricate jali panels are cut from solid marble slabs.

Tomb of Salim Chisti. Detail of jali panels. Photo ©1994, E. Louis Lankford.

book of Islam, forbade the use of such images, and called them idolatry. As a result, Islamic artists came to rely on elaborate geometric and abstract floral designs and on Arabic calligraphy to provide surface decoration on their buildings.

Figure 8-55 provides an example of such traditional geometric design, found on a pair of doors. These doors were created during the Mamluke period in Islamic Egypt. The Mamlukes were a slave class who gained control by rebellion. They became great patrons of the arts, and their artists were extremely talented.

Figure 8-56 This symmetrically carved flower indicates Rajput and perhaps even European influences on Mogul art.

Taj Mahal, detail of exterior wall. Agra, India. c. A.D. 1632–1653. Marble. Photo ©1994, E. Louis Lankford.

Figure 8-55 This door design is called a star-polygon pattern, commonly used by Mamluke artists.

Pair of Doors. Egypt, Islamic. Probably late 14th century. Wood inlaid with ivory panels carved in relief and arranged in geometric pattern with 12-pointed stars. H: 5′5″ × W: 30½″. Courtesy The Metropolitan Museum of Art, New York. Bequest of Edward C. Moore, 1891. 91.1.2064.

The abstraction of the Mamluke design contrasts with the realism found on portions of the walls at the Mogul tomb in India, the Taj Mahal, which display meticulously carved flowers (see Figure 8-56).

Akbar's grandson was Shah Jahan (jah-HAHN), a Mogul emperor who reigned from 1627 to 1659. Shah Jahan continued his grandfather's custom of allowing artists to blend cultural styles. The Taj Mahal, one of the world's most renowned buildings, was designed and constructed at his command. The Taj Mahal was built as a tomb for Shah Jahan's beloved wife, Mumtaz Mahal. It was designed by Persian architect Ustad Isa.

The Taj Mahal took twenty-one years to build, from 1632 to 1653. The tomb itself is part of a large walled complex that consists of smaller red sandstone and white marble gateways and mosques, expansive lawns and gardens, and wide avenues with reflecting pools. Each element is designed to complement the mausoleum, or tomb structure, of Mumtaz Mahal (see Figure 8-57).

The dome of the mausoleum soars 187 feet. Despite its enormous scale, the Taj Mahal possesses a delicate, airy quality. One reason is that it is constructed of milky white marble. This surface is very reflective. By the early rays of morning, the Taj Mahal glows with the soft pink light of dawn. In the bright light of midday, it shimmers a brilliant, almost blinding white. At dusk, it often reflects the golden orange of the setting sun.

The surface of the Taj Mahal is richly embellished with semiprecious stones set in delicate floral and geometric motifs. Highly polished, these stones also reflect the light from the atmosphere (see Figure 8-58).

Figure 8-58 Organic and geometric patterns of polished colored stones reflect the sun's rays and add visual interest to the facade.

Facade of Taj Mahal, detail. Photo ©1994, E. Louis Lankford.

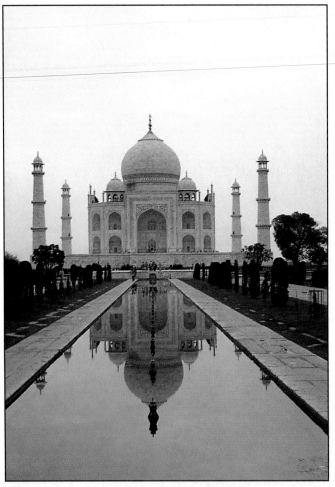

Figure 8-57 It has been said that the Taj Mahal is the most beautiful building in the world.

Front view of the Taj Mahal, near Agra, India. A.D. 1632–1653. Marble with inlay of semiprecious stones. Photo ©1994, E. Louis Lankford.

Another reason the Taj Mahal seems so light, delicate, and airy is the perfect balance of its open spaces and constructed mass. Notice the towering, recessed, pointed arch at the central entrance. It is flanked by smaller arched recesses in what would otherwise be heavy, solid walls. The flat rooftop and massive central dome are made less visually heavy and more interesting by the addition of slender spires and twin, domed **kiosks** (KEE-ahsks), or *small covered pavilions*. At each of the four corners of the terrace on which the tomb rests, a slender, white marble minaret stands. A **minaret** *is a tower with projecting balconies from which the Islamic faithful can be called to prayer*. The pinnacle of each minaret repeats the shape of the rooftop kiosks. In the large open space within the building, the high marble dome echoes any sound for a full fifteen seconds. The structure as a whole has the effect of flawless symmetry and mystical, poetic beauty.

The story of the construction of the Taj Mahal has a bittersweet ending. In 1657, Shah Jahan fell ill at a time when his subjects were unhappy with his rule. Many believed that the sultan's building projects were leading the Mogul empire toward financial ruin. During his illness, Shah Jahan's son, Aurangzeb (ah-RANG-zeb), took over the throne. Shah Jahan was imprisoned in the Agra Fort, where he would gaze wistfully across the Yamuna River at the Taj Mahal shimmering in the distance. After his death in 1666, Shah Jahan was entombed alongside Mumtaz Mahal in the marble depths of the Taj Mahal.

China

The borders of China encompass a vast area and diverse cultures. Like most civilizations in history, the Chinese people have fought invasions from outside their borders, and have suffered from bitter internal rivalries. But there have also been mighty Chinese empires that have spread their influence to distant corners of the globe.

Agricultural communities had formed in China by 4000 B.C., especially along the Huang (also called the Yellow) and the Yangtze (yang-SEE) rivers. Over time, Chinese kingdoms were established. Sometimes there were many rival kingdoms. At other times, China was unified under the rule of a single king. A Chinese king is referred to as an emperor, and his kingdom as an empire. Another term for a Chinese emperor is *Tian Zi* (tyen SEE), or "Son of Heaven." It was believed that the emperor ruled by divine right. All the power and wealth of his empire were his to do with as he pleased. Many emperors lavished their resources on the creation of fabulous palaces and works of art.

The history of China is generally divided into dynastic periods dominated by an emperor and his heirs. The earliest of these, the Shang dynasty, was established around 1500 B.C. The Shang people did not control all of China, but only a portion about the size of the state of Ohio. But in their production of artworks, they were without peer.

In Figure 8-59 you can see a Shang bronze casting. This vessel is called a *kuang*. It was probably used in

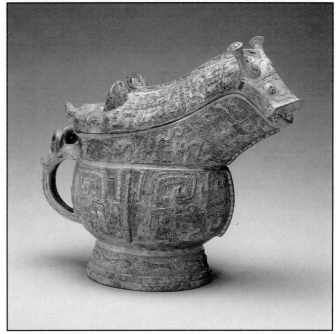

Figure 8-59 Creating a bronze vessel such as this requires extraordinary skill and imagination.

Kuang. Ceremonial vessel. Shang Dynasty, 12th century B.C. Bronze. 6½" H. Smithsonian Institution, Freer Gallery of Art, Washington, D.C.

ceremonies to hold wine, water, grain, or other foods. Highly stylized animal forms make up the design. Some sort of horned creature forms the mouth of the vessel. Another horned animal head—perhaps that of a ram—is on the handle. A row of fish swim around the base. Above them, elephants march with their trunks in the air. If you look closely, you might see a rabbit or other creature half-hidden in the intricate, spiral patterns.

The first great empire of China was the Qin (chin) dynasty. It was established when King Zheng managed to centralize military and political power under his control. He abolished rival kingdoms. Zheng is often referred to as "the First Emperor." In a brief period of fourteen years (221 to 207 B.C.), he had established uniform systems of weights and measures, law, commerce, and government. Although he promoted the advancement of philosophy and medicine, he was wary of ideas that might weaken his claim to absolute authority. He had countless books burned, a tragic loss

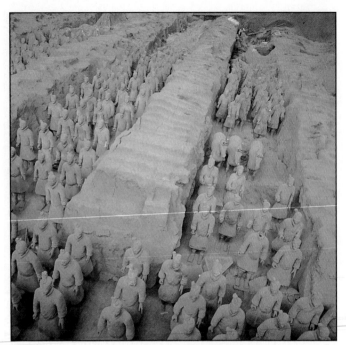

Figure 8-60 These magnificent warriors have stood at attention, underground, for two thousand years.

View of excavation near Xi'an: terra-cotta warriors in Trench 1. *Tomb complex of the Qin First Emperor.* c. 200 B.C. Lishan, Lintong County, Shaanxi Province, China. Photo ©1994 The Telegraph Colour Library/FPG International.

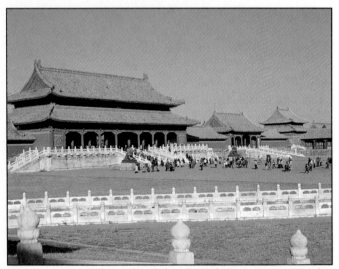

Figure 8-61 This splendid palace for emperors was the seat of all wealth and power in China.

General View of the Forbidden City, Beijing, China. 13th– 18th centuries A.D. Photo ©1988 FPG International.

to history. The Qin First Emperor also reinforced and extended the Great Wall of China, which stretches inland 1,400 miles from the seacoast. It was designed to protect the Qin empire from invasion from the north.

Zheng established a capital near what is now the city of Xi'an (SHE-ahn). Here, he had a fortress and several palaces built. He surrounded himself with jade and bronze works of art, fine silk textiles, and other decorative objects that were created in the palace workshops. He planned to continue his royal life-style in an afterlife by enclosing with him in his tomb some of the things that surrounded him during his life. The discovery of the tomb of the First Emperor was one of the most sensational archaeological finds of this century.

The Qin First Emperor's tomb took forty years and thousands of artists and laborers to prepare. It was completed under the direction of the Second Emperor. Surrounded by walls, a pyramidal burial mound rose 400 feet tall. Trees and grasses were planted on it to make it look like a mountain. Nearby were tombs of royal family members, court officials, servants, and others who were put to death so that they might accompany the emperor into the afterlife. Nearly 100 horses were buried just east of the emperor's tomb, and beyond that trenches held an army of life-size ceramic warriors (see Figure 8-60). Each of these warriors is a remarkable work of art. Each wears the armor of a warrior, and has its own unique, stern, lifelike facial expression. Also buried near the tomb are wooden and bronze chariots and life-size bronze charioteers. Ceramic horses, just under life-size, stand ready to transport the emperor to his otherworldly destinations.

The rule of the *last* emperor of China ended with the Revolution of 1911. Perhaps the most fabled legacy of the emperors is the Forbidden City, a walled palace complex within the capital city of Beijing (bay-JING). This vast complex, which stretches for about a mile from its point of entry, includes large courtyards, marble bridges, ornate ceremonial gateways, elegant pavilions resting on slender pillars, and impressive structures for living and conducting the business of government (see Figure 8-61). Most of the buildings have rooftops curving gradually upward, a shape characteristic of Chinese architecture. The palace afforded all the luxuries befitting an emperor. No one was supposed to

enter except members and servants of the royal court. It was begun by Emperor Kublai Kahn (KOO-bluh KAHN) around 1272, and added to by subsequent rulers through the eighteenth century.

Although the power of the emperors was unequaled in China during their rule, other strong influences also affected Chinese art and culture. One of these was the Buddhist religion. You may recall from Chapter Seven that Buddhism began in India around the fifth century B.C. Its influence spread far and wide, and by the sixth century A.D., China was predominantly Buddhist. Because Buddhism stresses patience, contemplation, and wisdom, Buddhist images often have an air of thoughtful, quiet repose. The large-scale Buddha shown in Figure 8-62 is sitting in the "lotus posture of meditation" with a look of contentment on his face. Similar colossal Buddhist images were carved into mountainsides in various parts of China.

Another impact of Buddhism on China was the development of the pagoda (pah-GO-dah). As you learned in Chapter Six, a pagoda is a temple that has several stories, each with its own projecting roof (see Figure 8-63). Over time, pagodas became increasingly large and elaborate. They usually contain sacred Buddhist relics. Variations of the pagoda can be found in India and Indonesia.

Figure 8-63 The distinctive look of pagodas has come to symbolize the Far East.

13 Story Pagoda (Temple) of We. China. Private Collection. Photographed by Ivan Goodknight, 1935. ©1994, Marvin Goodknight.

Figure 8-62 Buddhist art may be found throughout India, China, and Japan.

Colossal Buddha from the Yun-Kang caves, Shansi, China. c. A.D. 460. Sandstone. H: 45′. Photo ©1994, Stock Boston.

Painting. Painting came into its own as an art form in China during the Han dynasty (206 B.C. to 9 A.D.). Early on, Chinese painters used little color. Artists worked primarily with black ink alone. Using various wash techniques, artists would achieve a full range of values, from deep black to the palest of grays. Colored pigments, when used, were made from minerals and vegetables.

Paintings were produced on paper **scrolls** or silk banners. A scroll *is a length of paper with a dowel, or wooden rod, attached at each end, used for rolling the ends toward the middle.* The paper used for scrolls was usually mounted on a length of silk to add durability. Chinese painters would produce a series of related paintings along the length of the scroll. Calligraphic writing

would accompany the pictures. Each segment would tell a different portion of a tale. Horizontal scrolls were meant to be viewed from right to left. A segment of a scroll painting may be seen in Figure 8-64. Such scrolls were prized possessions among influential persons in Chinese society.

Figure 8-64 This scroll has a vertical rather than horizontal format.

White Clouds over Xiao and Xiang, by Wang Jian, 1688. Hanging Scroll, ink and color on paper. 53¼" H. China. Qing Dynasty. Sackler Art Gallery, Smithsonian Institution. Washington, D.C.

Porcelain. You were first introduced to porcelain in Chapter One. Chinese porcelain is considered some of the finest in the world. For centuries, other countries around the world have imported Chinese porcelain. Made with a special kind of clay called *kaolin*, it has a smooth texture and is white when fired. The Chinese developed porcelain during the Tang dynasty (618 to 906 A.D.), and kept their process of making it a closely guarded secret for hundreds of years (see Figure 8-65). Small wonder that fine porcelain tableware came to be called "china" by the Western world. The finest was, of course, reserved for use by the Chinese emperor.

Textiles. Chinese weavers excelled at the creation of fancy costumes and garments. It was fitting that the emperor, his family, and all who appeared before them be properly attired. Special robes were worn during ceremonial occasions. Robes were produced in rich colors of the finest silk. Figures and designs were embroidered and sometimes painted on them. **Embroidery** *is intri-*

Figure 8-65 Tang Emperors were great conquerors, but they also encouraged the arts. The art of porcelain developed during the Tang Dynasty.

Yu vase, widening into a cup. White porcelain. Tang Dynasty, 7th–10th centuries A.D. From Si-gnan, People's Republic of China. Private collection. Giraudon/Art Resource, NY.

cate needlework used to decorate fabric. In Figure 8-66, you can see a dragon robe, named for the prominent dragon motif appearing at the center on the front and back, on each shoulder, and flanking the waist. Traditionally, the dragon motif was reserved for the imperial family, although by the nineteenth century other high-ranking persons also wore it. Each household had its own crest, which was worn in place of dragons on garments similar to that shown in Figure 8-66.

In Chinese culture, the dragon—fierce as it might appear to us—was considered a symbol of benevolence, divine truth, and good fortune. It appears from the clouds above or emerges from the depths of the sea. You can see both cloud forms and curling waves on the dragon robe.

Japan

In Japan, as in most nations with histories spanning thousands of years, outside influences have had an impact on the country's art and culture. Art from China, ceramics from Korea, and Buddhism from India have each helped to shape the style and meaning of artistic production in Japan. But Japanese artists did not just copy art from elsewhere. They were highly skilled and creative in their own right, and their art influenced artists in other lands, even as distant as France. Today Japanese art remains some of the most distinctive, refined, and beautiful in the world.

Although Japan had emperors, real power rested with the regional governors, called *shoguns*. Each shogun directed a military force whose warriors were clad in elaborate armor (see Figure 8-67 on the next page). Military commanders, who had high social standing, were called *samurai*. Much like the knights of King Arthur's Camelot in Britain, the samurai lived by a rigorous code of conduct governed by a sense of honor. Their samurai status was signified by their two curving swords, one much longer than the other. Their armor was crafted not only as protection, but to make the wearers look regal and powerful.

Temples and Gardens. The volcanic rock that formed the Japanese islands is unsuitable for use as a building material. Thus, the Japanese developed sophisticated techniques for constructing buildings out of wood. In Figure 8-68 on the next page, you can see

Figure 8-66 Rich formal robes like these were worn within the Forbidden City.

Chinese Emperor's Dragon Robe, mid-18th century. Embroidered yellow silk satin with metallic thread, partially remade and over-embroidered in the early 20th century. Murray Warner Collection of Oriental Art, University of Oregon Museum of Art.

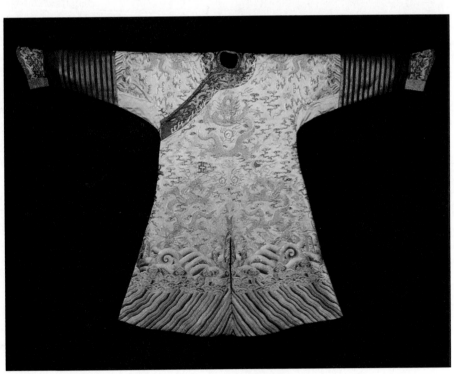

Figure 8-67 Warriors called *samurai* wore carefully fitted armour of hammered metal, tooled (hand-decorated) leather, and rich fabrics.

The warrior Yoshitsune on horseback, wearing armour. Artist: Kiyohiro. c. A.D. 1750. Woodblock print from a series titled *Mure takamatsu (Tall pines amongst the ranks of warriors.)* Victoria & Albert Museum, London, Great Britain/Art Resource, NY.

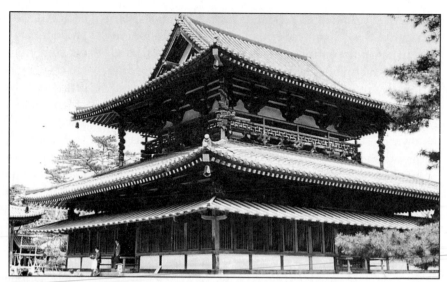

Figure 8-68 Ancient Japanese builders employed a perfect combination of structural integrity and decorative detailing in this temple.

Kondo (Golden Hall) of Horyu-ji Temple, Japan. Asuka period, 7th century. One of the oldest wooden buildings in the world. Covered porch added in 8th century; upper railing added in 17th century. Courtesy, Shashinka Photo Library, New York.

one of the oldest surviving wooden buildings on earth. The *kondo*, or "golden hall," of the Temple of Horyu-ji (HOR-you-gee), was built around 670 A.D. A kondo is the main hall of a Japanese Buddhist temple complex. Within this hall, statues associated with this religion rest on a platform.

The pagoda form we discussed in the section on China was adapted to serve various purposes in Japan.

Fortified castles, palaces, and temples utilized multistoried tiers of rectangular rooms and sweeping, tiled roofs. One of the most spectacular buildings in Japan employs this general form: the Kinkakuji, or Golden Pavilion (see Figure 8-69 on the next page). The Golden Pavilion was built in 1397 by Shogun Yoshimitsu, as part of his palace in Kyoto (KEE-oh-toh). It sits within a beautiful garden, its gold-foil covered surface forming a shimmering reflection in a still pond. This was a place where the shogun could relax and contemplate the peaceful beauty of his garden. After the shogun's death, the Golden Pavilion became a Zen Buddhist temple, and was renamed Roku-en-ji.

Gardens such as the one surrounding the Golden Pavilion are carefully designed, well tended, and highly prized by the Japanese. Unlike Western gardens, which often feature high, splashing fountains, marble statuary, and an array of colorful flowers, Japanese gardens tend to stress quietness, natural forms, and subtle differences of color and texture. (You may wish to refer back to the section in Chapter Five entitled "Nature in Far Eastern Art.") Often, a small teahouse will be nes-

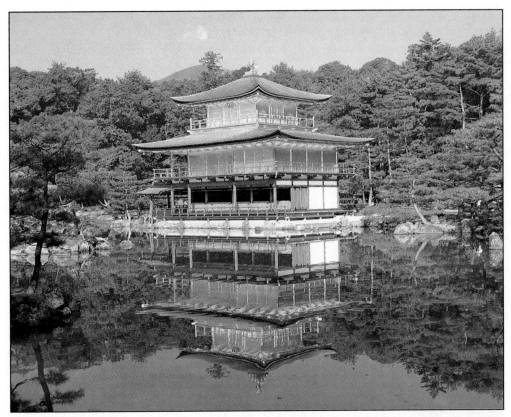

Figure 8-69 This temple was rebuilt after being burned to the ground in 1951.

Kinkakuji Temple, also known as the Golden Pavilion, or Roku-en-ji. Kyoto, Japan. Originally built in A.D. 1397; reconstructed. Photo ©1988, FPG International.

tled among the pine trees and azalea bushes. This is where the Japanese tea ceremony takes place (see Figure 1-13 and the accompanying text to learn more about this ceremony). Even the placement of rocks is a decision that is well thought out.

Figure 8-70 shows a famous *Zen rock garden* at the temple of Ryoanji (ree-o-AHN-gee). Zen is a sect of Buddhism that stresses introspection and meditation. A rock garden found in a Zen temple consists of stones and perhaps a little moss. The one pictured is composed of fine white gravel and fifteen carefully arranged larger stones. The layer of gravel covering the ground is raked frequently to keep it free of debris, and to create linear patterns on its surface. The larger rocks are grouped so that a visual balance of size and shape is achieved. The effect is at once very intimate, and yet expansive—this small patch of earth has taken on

Figure 8-70 A waterless rock garden.

Rock Garden of Ryoanji. Zen temple, Kyoto, Japan. 15th century A.D. Photo ©1994, J. Kugler/FPG International.

the appearance of a landscape with broad plains and distant mountains. As one walks around the perimeter of the garden, the vista is constantly changing. It is a place that invites contemplation.

Ink Painting. One form of painting prominent in Japan was also closely associated with Zen Buddhism. Zen ink painting is executed in washes of black ink using sweeping, spontaneous strokes of a brush. Meticulous, measured details have no place here. Artists using this technique try to strike a balance between painted and unpainted areas, leaving lots of empty space. Lines and details fade softly away, as if disappearing into fog. Figure 8-71 was painted by a Zen monk in the fifteenth century. You can see by looking at the brush strokes how rapid and free his technique

Figure 8-71 Empty spaces and a free, spontaneous technique characterize Zen ink painting.

Sesshu (Japanese, 1420–1506), *Haboku Landscape*. Japan, Muromachi Period. Hanging scroll: ink on paper. 71.9 × 26.7 cm. ©The Cleveland Museum of Art, The Norweb Collection. 55.43.

was. Notice, too, the large area that he has deliberately left unpainted.

Figure 8-72 on the next page, although much less restrained than the Zen landscape, shares some of the same visual qualities. This is one of a pair of folding screens called *Tiger and Dragon*, painted in the sixteenth century. Broad, bold, sweeping brush strokes appear to have been applied very quickly. There was skill and confidence in every movement of the artist's hand, as he made visible the image held in his mind's eye. A dragon fades into the mist and then reappears among the swirling waves of the sea. This dragon is odd and frightening, with its spiked scales, sharp claws, and bulging eyes.

Woodblock Prints. In contrast with the free, organic forms, fluid movements, and soft edges found in ink painting, Japanese wood-block prints were often highly detailed, geometric, and hard-edged. Figure 8-73 on the next page depicts a player of Kabuki (kah-BOO-kee) theater in a very stylized way. **Kabuki** *is a popular form of theater that developed in Japan during the seventeenth century. All the roles, both male and female, are played by men. Stories are told through pantomime, dance, and song.* In Figure 8-73, the folds and patterns of the robe create a dynamic, abstract arrangement of lines and shapes. To see just how abstract it is, place your hand or a piece of paper over the actor's head. It's almost impossible to recognize a human figure in the remaining portion of the composition.

The composition is dominated by layers of concentric squares. Glaring out from these geometric forms is the painted or masked face of the actor, looking very fierce indeed. Note that even his hair is stylized into a symmetrical, hard-edged pattern.

In Figure 8-73, the straight lines of the actor's costume are softened by the long curves of the samurai sword. These contrasting forms add visual interest to the composition.

Also, note that the artist has not utilized shading that would make the figure look more lifelike and three-dimensional. The deliberate abstraction of Japanese art in such wood-block prints, and in their ink paintings, was quite unlike the art being produced in Europe at the same time, as we shall see in the sections that follow. Over time, Japanese art had an influence on Western artists, and Western art influenced Japa-

Figure 8-72 This screen is a brilliant example of Japanese ink painting.

Sesson Shukei (Japanese, c. 1504–1589), *Dragon screen,* one of a pair of six-fold screens. Muromachi Period, Japan. Ink on paper. 67½" × 144" (171.5 × 365.8 cm.). ©1994 The Cleveland Museum of Art. Purchase from the J. H. Wade Fund. 59.136.

Figure 8-73 The artist has created a dramatic composition dominated by flat, abstract, square patterns surrounding the oval of the head.

The Actor Ichikawa Danjuro VII in a Shibaraka Robe, c. 1870. Toyokuni, Japan. Victoria & Albert Museum, London, Great Britain/Art Resource, NY.

Student Activity 2

Ink Painting with a Bamboo Brush

Goals

1. You will practice a form of painting borrowed from the Far East: painting in ink using a bamboo brush.
2. You will experience a spontaneous, free style of rendering subject matter.

Materials

1. Watercolor paper
2. Water-based brown or black ink
3. Bamboo brush
4. Small containers for holding ink and water
5. Photographs (may be magazine clippings): one landscape, one wild or zoo animal (or access to actual landscapes and animals)

Directions

1. A bamboo brush is a type of brush designed for use with inks and watercolors. It has a round handle made of bamboo. Its long, soft hairs taper to a point when dampened. Before you begin trying to depict subject matter, practice with the brush to get a feel for its possibilities (see the example in this exercise).
 a. Fill two containers with water and one with ink. One container of water is to help you clean your brush when you feel it's necessary. Dip the brush in the second container of water and gently stroke the hairs along the edge of the container to remove excess moisture. Then, dip the tip of the brush in ink.
 b. Hold the brush *upright or at a very slight angle* over the paper. *Gently* lower the brush to the surface of the paper and draw a line. Apply light, then gradually heavier pressure to the brush, finishing with light pressure again. You should be able to paint a line that is thin-thick-thin. *Do not allow the hand that holds the brush to touch the surface of the paper.* It will be easier for you if you hold your forearm and elbow off the table.

c. Now dip the brush first in ink, then in water. Try to paint an area of color that fades from dark to light. You will need to add some more water to the brush as you go along. Try this first on *dry* paper, then on *damp* paper. It may be easier to get an even gradation on damp paper. It's good for you to know the different effects you can achieve before beginning your final paintings.

2. Now refer to your photograph of a landscape. (An alternative is to visit and look at an actual landscape.) Look at it closely for a few moments. Notice its outstanding and essential characteristics. You may find it useful to state these to yourself to help you remember them. For example, "there are rolling hills, a clump of tall pine trees on the right, and billowy clouds behind them." *Now put the photograph someplace out of sight (or turn your back to an actual landscape). You will be working from memory.*

3. Close your eyes and picture your landscape. Then, open your eyes, take your bamboo brush, and *quickly* capture the visual essence of the landscape on paper. Use as few strokes of the brush as you can. Do not paint for more than two minutes. *Paint directly in ink; do not make preliminary drawings in pencil. Allow yourself to interpret your subject freely and spontaneously.* Also, try to leave generous amounts of *open space* on your page—that is, space untouched by the brush.

4. Get another sheet of paper. Now, still without looking at the photograph, paint the landscape again. Try to use thick-thin lines and gradations of values. Again, leave plenty of open space. This provides the suggestion of open air around your subject.

5. Repeat steps 2, 3, and 4, only this time refer to the photograph (or view) of an animal.

Evaluation

1. Did you practice using the media and methods before proceeding with the final paintings? You may wish to include your experiments in your process portfolio.

2. Did you allow yourself to interpret your landscape and animal freely and spontaneously from memory, without fussing over details? Describe your thoughts and feelings about working in this way. What are some advantages, or drawbacks, of this technique?

3. Compare your ink paintings with the one pictured in Figure 8-64 on page 424. Is there something of the same spirit in each? Are there qualities they share? Explain your answers.

nese artists. To learn more about Japanese wood-block prints, refer to Figure 5-17 and the accompanying text in Chapter Five.

Clothing. Like the Chinese, the Japanese have long excelled in the creation of exquisite textiles and garments. The Japanese have decorated their fabrics with embroidery, painted pigments, and vegetable dyes made from flowers, leaves, and roots. Some of the fancier garments had designs applied to them in gold leaf.

Both men and women wore the kimono (kee-MOH-noh), a type of garment that is shaped like a "T" when the shoulders are held parallel to the floor (see Figure 8-74). Kimonos are long but loose-fitting to allow ease of movement. They have a full-length opening at the front, which the wearer would overlap and hold in place with a sash. Women's kimonos tended to be longer than men's, and were frequently decorated with flower motifs.

Japanese men would use cords to hang swords and containers for medicine from their sashes. *Tiny sculptures would be tied to the cord as decoration. These sculptures, known as* **netsuke** (NET-s[u]-kee), were amazingly detailed considering their size—about an inch or less in any dimension. Superb, precise craftsmanship was used to depict men, women, and animals in carved ivory. Sometimes the characters depicted were religious sages or legendary heroes, but other times they were common folk. Figure 8-75 shows a netsuke; the detail on this tiny figure is extraordinary.

Figure 8-74 This is a furisode-style kimono, meaning "swinging sleeve." Another style has smaller sleeves.

Figure 8-75 This delightful figure is remarkably detailed for its diminutive size.

Southeast Asia and the Pacific Islands

As trade developed among Southeast Asian countries, the influence of Buddhist and Hindu art spread to Burma, Thailand, Cambodia, and the Indonesian islands. The most famous monument of Cambodian art is located at the ancient Khmer (kuh-MER) city of Angkor. The Khmer civilization flourished from the ninth to the fourteenth centuries. The monument, Angkor Vat (ANG-kore waht), was a Hindu temple constructed in the twelfth century. It is one of the largest temple complexes ever built (see Figure 8-76). The area enclosed by the rectangular moat was more than 900 acres. The front of the largest building is wider than the length of two and a half football fields. The symmetrical design adds to the feeling of grandeur. Decorative carvings extend all along the exterior and interior walls. There are more than 1,700 life-size celestial dancers and other large figures carved along the exterior walls (see Figure 8-77).

Angkor was sacked by enemies and abandoned. It sat isolated in the fast-growing Cambodian jungle for almost seven centuries. In 1861, a French exploratory party came across the mammoth overgrown structure.

Figure 8-77 Elaborate carvings surround the fabled temples of ancient Angkor Vat.

Detail of the Bayon, Angkor Vat. Giraudon/Art Resource, NY.

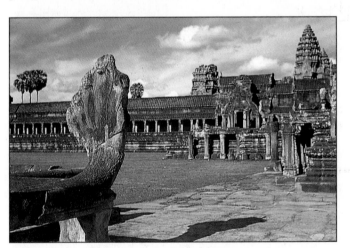

Figure 8-76 This elaborate and huge temple was abandoned, and lay hidden in the jungles for nearly seven centuries.

Front view of a portion of the Hindu Temple, Angkor Vat. Khmer civilization. Late 12th–early 13th century A.D. Angkor Thom, Cambodia. Photo ©1994, Ray Garner, FPG International.

Perhaps you can imagine the emotions of these explorers as they uncovered and studied their discovery.

The great stupa (STOO-pah) at Borobudur (BOH-roh-buh-dur) in Java is perhaps the most important Buddhist Shrine in Indonesia (see Figure 8-78 on the next page). A stupa is a Buddhist shrine whose central feature is a rounded structure sometimes referred to as a "world mountain." A stupa contained sacred relics and symbolized the heavens, as well as harmony in the universe. The first stupas were constructed in India, where Buddhism originated. The Javanese stupa is more square than round, and it includes tiers of richly carved stone. Relief sculptures depict triumph over earthly desire and the attainment of spiritual enlightenment.

Ceremonial Canoes. In the remote jungles of New Guinea and other Pacific islands, people developed their own complex social and religious systems and

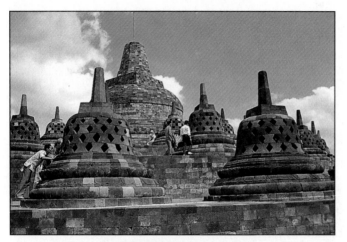

Figure 8-78 This ancient shrine is one of the largest and most elaborate in the history of Buddhism.

Close-up of top of trellised stupa at Borobudur; world's largest Buddha stupa. Java, Indonesia. 9th century A.D. Photo ©1994, Ann and Myron Sutton, FPG International.

their own styles of art. Canoes were very important to the livelihood of these people, for transportation, communication, and fishing. The secrets of navigation were passed down from one generation to the next. War and ceremonial canoes were often elaborately carved and painted. Animal spirits were represented by crocodile, fish, snake, bird, and lizard motifs. Such images were believed to enhance the strength of the canoe.

In New Guinea, secret societies would carve ceremonial canoes in the depths of the jungle, and only carry them onto the beach when finished, to mark a special occasion. The prow, or front, of the boat was intricately carved (see Figure 8-79). Placed beside the canoe were carved and painted ornaments. A celebration with feasting and ceremonial music and dancing would take place alongside the canoe. People wore their finest garments. Even the drums were ornamented with paintings and carvings.

The Middle Ages in Europe

About a thousand years elapsed between the fall of the Roman Empire and the beginning of strong national governments in Europe. This period, from about 500 A.D. to 1500 A.D., is known as the Middle Ages, or the *medieval* period. Despite uncertainty and tur-

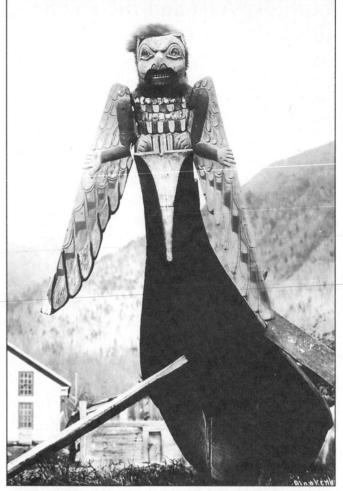

Figure 8-79 The secret societies would carve elaborate canoes in private, and bring them into the open for special ceremonies.

Ornament from Prow of a Secret Canoe. Klukwan Potlach. Tolai people, Raluana Village near Papua, New Guinea. c. 1900. Photo ©1994, The Field Museum, Chicago. Neg. #A-17348.

moil, the seeds of many economic, political, and artistic achievements were planted during this time, and some of the greatest treasures of Western art were produced.

Religious faith dominated almost every aspect of life in the Middle Ages. This is reflected in the art and architecture of the period. Paintings, sculptures, tapestries, and decorative objects were inspired by Bible stories and inspirational scriptures. As religious zeal spread, great churches were built to glorify God.

Churches became centers of wealth and power as well as worship.

Illuminated Manuscripts. Some of the most magnificent artistic achievements of the Middle Ages were **illuminated manuscripts,** *which are richly illustrated books.* Manuscript means "written by hand" and illuminate means "to make bright" or "give light." Many illuminated manuscripts were produced by Christian monks in monasteries throughout Europe. Monasteries were centers of learning and culture, and the monks who lived there were among the small minority of people in Europe at that time who knew how to read and write. The printing press had not yet been invented, so scriptures from the Bible had to be painstakingly copied by hand and bound into books that could be used for teaching and worship. *The paper used for these books was called* **vellum,** *which was made from calfskin.* Hand-painted pictures illustrated these books, and the beautiful calligraphy was embellished with ornate borders and decorations of brilliant colors and gold leaf. You can see an example of an illuminated manuscript page in Figure 8-80. It depicts a saint slaying a dragon.

Illuminated manuscripts were regarded as sacred. Many have survived to this day because they have been handled with reverence and respect. The artists who created them wanted the visual beauty of the books to reflect the importance of their contents.

Figure 8-80 Elaborate lettering was combined with pictures in illuminated manuscripts.

Saint Gregory, *St. George and the Dragon,* from the *"Moralia in Job"* illuminated manuscript (MS 168, folio 4v). Early 12th century. 13¾" × 9¼". Bibliothèque Municipale, Dijon, France. Giraudon/Art Resource, NY.

After binding, a jewel-encrusted metal cover might be added to protect the book. The skill of medieval goldsmiths in crafting such covers is evident in Figure 8-81. On this book cover, a youthful Christ figure is framed by a jeweled cross. Despite the fact that Christ is shown at the crucifixion, his face is serene. His expression does not indicate pain. Perhaps the artist wanted to show him as untouched by human suffering. His arms are spread in a gesture that seems to welcome the faithful to the church.

Some of the most imaginative and complex designs for manuscript pages were made by Irish monks, who produced large numbers of books. In Figure 8-82, intricate designs and shapes are carefully arranged in a complicated, mazelike composition on the border.

Figure 8-82 A mazelike pattern of interconnecting knots forms an intricate border around the page.

Page from the *Book of Durrow*, Folio 124v: St. Luke. 12th century. 9⅝" × 5¾". Trinity College, Dublin, Ireland. Art Resource, NY.

The Book of Hours. Illuminated manuscripts were a particular passion for the Duke of Berry, a collector in medieval France. He was the son of King John II and inherited a huge amount of property when he reached the age of twenty. His desire to own many illuminated manuscripts was most likely based more on his interest in collecting beautiful art than on his desire to own religious writings. He was especially fond of **books of hours,** *which were calendar-like books depicting labors or events associated with each month of the year.* For example, picking flowers would be depicted in April, and grape harvesting in September. The Duke of Berry commissioned three Dutch artists, the Limbourg brothers, to make for him one of the most stun-

Figure 8-81 What does the cover of this book indicate about its contents?

Upper cover of binding from the *Lindau Gospels*, c. A.D. 870. Anonymous German goldsmith. Gold and semi-precious stones. The Pierpont Morgan Library, New York. M.1., front cover.

ning books of hours ever created. Its pages provide a remarkable account of medieval life.

On the page for January (see Figure 8-83), the Limbourgs showed one of the duke's lavish parties, a New Year's feast. We see the duke seated at a banquet table, surrounded by elaborately dressed guests. Expensive gifts have been distributed, and the food is abundant. The duke, a dog lover, has allowed two of his small pets to graze among the dishes. A tapestry depicting a battle scene hangs on the wall behind, forming a backdrop for the revelry.

Reliquaries. Many European churches displayed small relics of saints as a way of adding prestige to their place of worship. For example, a bone, lock of hair, or fragment of clothing took on symbolic importance if it came from a holy person. Craftspeople created *ornate receptacles of different sizes and shapes, called* **reliquaries** (REL-uh-kwer-eez), *to contain these relics* (see Figure 8-84 on the next page). Ivory, bronze, silver, copper, and inlaid stones and jewels were among the materials used to create these containers, many of which had small windows for viewing the sacred contents.

Figure 8-83 This splendid page from a book of hours shows us what life was like for medieval French nobility.

The Limbourg Brothers, *January*, from *Tres Riches Heures du Duc de Berry (The Very Rich Book of Hours of the Duke of Berry)*, *Folio 2r.* c. 1413–1416. 8¾" × 5½". Musée Condé Chantilly. Giraudon/Art Resource, NY.

Figure 8-84 Foliage, animal forms, and circular patterns decorate this house-shaped reliquary.

Reliquary, in the shape of a sarcophagus. From the Treasury of the Benedictine Abbey of St. Peter, Salzburg, Austria. c. A.D. 900. Ivory, copper gilt, wood. L: 7³/₄" × H: 7⁵/₁₆" × D: 3¹/₄". The Metropolitan Museum of Art, New York, The Cloisters Collection, 1953. 53.19.2.

Figure 8-85 This church has round arches that are characteristic of Romanesque style.

Arches and columns of the Nave of St. Michael's Church, Hildesheim, Germany (restored). Built c. A.D. 1001–1031. Scala/Art Resource, NY.

Romanesque Architecture. As the Christian populations of cities grew, more and larger churches were needed. Many of these churches were built in the *Romanesque* style. The suffix *-esque* means "in the style of." Romanesque churches were solid, sturdy structures that can be recognized by their use of round Roman arches (see Figure 8-85).

Gothic Cathedrals. By about 1150, a new style of architecture had begun to make an extraordinary impact on the way churches were built in Western Europe. Called Gothic (GAH-thick), this style utilized sophisticated building techniques. Walls became thinner and taller because flying buttresses were used to transfer the heavy load of the roof to outside supports. (You might want to return to the architecture section of Chapter Six for a quick refresher on arches, flying buttresses, and other architectural elements.)

With new architectural engineering, more wall space could be devoted to stained-glass windows, which presented pictures of Bible stories and the lives of the saints and added subtle, multicolored light to the churches' interiors (see Figures 8-86 and 8-87). *Round stained-glass windows with a symmetrical design around the center are called* **rose windows.** Other windows and doorways fit within the shape of a pointed arch, called a Gothic arch, as you learned in Chapter Six. Such arches were often very tall and slender. On the rooftops, towering spires pointed heavenward, reminding Christians of their creator. The overall effect is called verticality (see Figure 8-88). **Verticality** *in architecture is the visual effect achieved by the use of many vertical lines: the eyes are drawn upward.*

Between 1150 and 1300, Gothic cathedrals were built in towns all over Western Europe. Highly skilled architects, stonemasons, and carvers all contributed to

Figure 8-86 This small but magnificent chapel was built by King Louis IX of France to contain important relics. Its many windows sparkle with stained glass and light.

Apse of Saint Chapelle (interior view). Paris, France. Built c. A.D. 1243–1248. Scala/Art Resource, NY.

Figure 8-87 Sunlight streaming through the intense reds and blues of this window creates a stunning and mystical effect.

North Rose Window as Viewed from the Interior. Notre Dame Cathedral, Paris, France. Built c. A.D. 1163–1250. Photo ©1988, Shinichi Kanno/FPG International.

Figure 8-88 This fantastic structure's lines stress verticality throughout.

Exterior, Milan Cathedral. Milan, Italy. Built 14th–15th century A.D. Photo ©1991, Chris Michaels/FPG International.

some of the most amazing and majestic structures ever built. Citizens, both rich and poor, donated what they could to ensure that their town's cathedral would be impressive. Cathedral building became somewhat competitive as builders tried to make their churches ever taller, lighter, and more ornate and innovative. Many cathedrals had spectacular carvings surrounding their main entries, or portals (see Figure 8-89).

One of the features of Gothic cathedrals that many people today find very curious is the gargoyle. **Gargoyles** *are strange-looking, often frightening creatures carved in stone that perch high on the corners of cathedral rooftops.* These creatures were placed there as reminders that we must be watchful and guard against evil.

Figure 8-90 Fierce-looking creatures ornament the rain gutters and rooftops of Gothic cathedrals, ever-present reminders to passers-by that evil lurks everywhere.

Gargoyle devil face on a high corner of Notre Dame Cathedral, Paris, France. Photo ©1994, The Bettmann Archive.

Figure 8-89 This detail shows the shape of a Gothic arch, the exterior of a rose window, and carvings of saints.

Central Portal, Reims Cathedral, Reims, France. Built c. A.D. 1225–1290. Scala/Art Resource, NY.

Medieval artists had to have vivid imaginations along with technical skill in order to create these sculptures (see Figure 8-90).

Gothic cathedrals are as awe inspiring today as they were in the Middle Ages. They remain some of the largest and most beautiful structures in many European cities, and tourists from all over the world visit them to experience their magnificence.

The Alhambra. Not all architecture in Europe during the Middle Ages was directly related to Christianity. Kingdoms, large and small, formed, and rulers of each kingdom built fortified castles to protect themselves against rivals. More powerful rulers built walled palaces. One of the most unique of these had Islamic origins.

The Islamic Moors first established themselves on the Iberian peninsula (Spain and Portugal) in the eighth century. By the tenth century, their capital at Córdoba rivaled in splendor other great cities of Europe and Persia. Their mosque at Córdoba was considered one of the most beautiful anywhere (see Figure 8-91).

On a hilltop overlooking Granada, Spain, the sultans of the royal Moorish line known as the Nasrids built a stronghold and a fabulous palace quite unlike any other in Europe. Called the Alhambra (ahl-HAHM-brah), it contains royal apartments, audience halls, military headquarters, baths, artisan workshops, a college, and a mosque. Its ornamental style was borrowed from the Islamic traditions of North Africa, Turkestan, and Persia. Slender marble columns, graceful arches, geometric and floral carvings, ornate windows, painted tiles, and splashing fountains fill the palace walls. A special area, called the Generalife (heh-neh-rah-LEAF-eh), is devoted to garden spaces. *Generalife* means "the garden of the architect." Water jets and fountains grace exuberant flower gardens. Canals flow between clipped hedges. Trees and arbors provide shady nooks and retreats from the hot sun. There are plenty of places where the sultan and his court could rest, read, and enjoy views of the city and the countryside below (see Figure 8-92 on the next page).

Most Islamic architecture was destroyed in military campaigns by Christian Spaniards who were determined to drive the Moors from Iberia. The Alhambra survived because it was surrendered by Boabdil, the last Moorish sultan in Spain, in 1492 without a destructive battle. The surrender followed a yearlong siege by the forces of King Ferdinand and Queen Isabella of Spain. It was from Granada, shortly after her victory, that Queen Isabella granted the necessary support to Christopher Columbus for him to undertake his momentous voyage.

Figure 8-91 Elegant columns and arches create visually rhythmic patterns in every direction.

Mesquita Mosque, interior view, Cordoba, Spain. 8th–10th centuries. Photo ©1987, Jean Kugler, FPG International.

Figure 8-92 Flowers cascade from the walls of the "garden of the architect" at the Alhambra.

View of the Generalife, the Alhambra, Granada, Spain. c. A.D. 1238–1349. Photo ©1994, E. Louis Lankford.

A Wedding Portrait. By the fifteenth century, European artists were beginning to explore the possibilities of oil paint for achieving more sophisticated effects in paintings. (You may wish to return to the *Technology Milestone* about oil on canvas found in Chapter One.) Painters sought to create realistic portraits of their patrons, so shapes, textures, and lines were recorded with almost microscopic attention to detail.

This new style of painting became popular in Flanders, an area of northern Europe that occupied what is now part of northern France, Belgium, and the Netherlands. Artist Jan van Eyck (yahn vahn IKE) produced one of the most characteristic paintings of the Flemish (meaning "from Flanders") style (see Figure 8-93). Van Eyck's *Wedding Portrait* was probably made to commemorate the union of Giovanni Arnolfini (gee-o-VAHN-nee ar-nol-FEE-nee) and his young wife Giovanna. The Arnolfinis were a family of successful Italian businesspeople who settled in Flanders. Much as a wedding of today is recorded by a photographer, van Eyck documented this special occasion in the form of a pictorial marriage certificate. (See also Figure 2-48).

We see a young, fashionably dressed couple who, at first glance, appear to be alone in a bedchamber. On closer inspection, however, we can see in the mirror's reflection that two other people have entered the room. They are witnesses, and one is most likely the artist himself, since the writing on the wall above the mirror translates, "Jan van Eyck was here."

The painting is filled with detail and symbolism. We can tell that these newlyweds come from a prosperous family by their resplendent, fur-and-lace-trimmed clothing. The bride wears an elaborately tailored green velvet gown with a long train. Although she looks like she might be expecting a child, it is more likely that her shape is created by the arrangement of gathers on the front of the gown, a design that was very stylish at the time. The groom has removed his shoes because the sacrament of marriage makes this room a holy place. The cute little dog in the foreground symbolizes fidelity (the origin of the common pet name "Fido").

The holiness of matrimony is signified by almost every object in the room: the carving on top of the bedpost represents Saint Margaret, patron saint of childbirth. The whisk broom hanging from the bedpost symbolizes domestic care. There are two references to the all-seeing eye of God: the single candle burning in the chandelier, and the mirror, which reflects the entire scene.

Figure 8-93 Van Eyck has filled this painting with symbolism.

Jan van Eyck (Flemish, 1390–1441), *Wedding Portrait*; also known as *The Portrait of Giovanni Arnolfini and Giovanna Cenami*, or *Arnolfini and His Bride*. Painted in 1434. Tempera and oil on wood panel. 32½" × 23½". The National Gallery, London. NG0186.

The Black Death. Another Flemish painter who was a master of meticulous detail was Pieter Brueghel (peter BROI-gel, with hard "g" as in "gold"). His frequent subjects were peasant laborers, village life, and religious parables. One of his most interesting and unusual paintings is the *Triumph of Death* (see Figure 8-94).

In this painting, hordes of skeletons, representing death, attack the living in a grim spectacle of destruction. The artist's idea was to show that everyone is ultimately doomed to this fate, no matter what his or her social class or position. The theme of the living being powerless in the face of death became widespread in late medieval art during the terrible epidemic called the Black Death or Black Plague. This epidemic of bubonic plague wiped out over one-fourth of the population of Europe during the fourteenth century. It killed nobles and peasants alike. The fear of death was everywhere, and lingered as a theme in artworks even after the plague had come to an end.

Figure 8-94 This grim painting was meant as a reminder that people are mortal, no matter how rich, poor, or powerful. It was created in the wake of the dreadful Black Plague.

Pieter Brueghel, the Elder (Flemish, 1525–1569), *Triumph of Death*, 1562. Oil on board. 46" × 63¾" (117 cm × 162 cm.). Museo del Prado, Madrid, Spain. Scala/Art Resource, NY.

Section **II** Review

Answer the following questions on a sheet of paper.

Learn The Vocabulary

Vocabulary terms for this section are *allegiance, scarification, striations, apprentice, pantheon, rock-cut temple, finial, sikharas, serpentine, jali, kiosks, minaret, scrolls, embroidery, Kabuki, netsuke, illuminated manuscripts, vellum, book of hours, reliquary, rose window, verticality,* and *gargoyle.*

1. Fill in the blank with the appropriate vocabulary term.
 a. Loyalty to a cause, a nation, or an individual is termed _____ .
 b. _____ is a tower with projecting balconies from which the Islamic faithful can be called to prayer.
 c. Intricate needlework used to decorate fabric is called _____ .
 d. A _____ is a special container to hold a sacred relic of a saint.
 e. _____ is a popular form of Japanese theatre that developed in the seventeenth century.
 f. The paper used to make illuminated manuscripts in the Middle Ages is called _____ .

Applying What You've Learned

2. What is an oni?
3. What do the bronze plaques created by Bini artists depict?
4. Name two reasons the Taj Mahal seems delicate and light.
5. Identify two strong influences on Chinese art and culture.
6. What is a scroll?
7. Describe how Japanese gardens differ from Western gardens.
8. What does a stupa contain?
9. What was the purpose of gargoyles?
10. Who built the Alhambra?
11. List at least two symbols relating to the holiness of matrimony that appear in Jan van Eyck's painting, *Wedding Portrait* (Figure 8-93).

Exploration

12. What do you feel allegiance to? What objects or practices symbolize this allegiance?

Section III

Western Art in Transition

The Renaissance

In time, trade and travel returned to Europe, cities and towns grew in size and prosperity, and religious crusaders who had traveled south and east returned with many new ideas. The Middle Ages drew to a close, and a new age—the Renaissance (REN-uh-sahnz)—was born. **Renaissance** *is a French word that means rebirth.* The earliest manifestations of the Renaissance took place in the middle of the fourteenth century in Italy, where there was a renewed interest in the culture of the ancient world. Greek and Roman writing and philosophy were studied and analyzed. New emphasis was placed on the dignity and worth of humanity. Art was made for secular as well as sacred settings, as the attentions of society became less consumed by religious interests. Artists painted portraits of prominent citizens and ordinary people. There was interest in paintings depicting landscapes, mythological scenes, and historical events. Architects who had used their talents to create magnificent churches now designed civic buildings and residences as well. The height of the Renaissance took place between 1500 and 1600 A.D.

The works of two of the most famous artists of the Renaissance, Michelangelo and Leonardo, are discussed in Chapter Seven.

During the Renaissance, the city of Florence in northern Italy became a center for trade because it was near the Mediterranean Sea. People who live in Florence are referred to as Florentine (flo-ren-TEEN). Nobles and merchants became wealthy and could afford to buy fine paintings, sculptures, and beautiful homes. The people who ran the government and the churches wanted their buildings to represent the work of the best architects and artists of the day.

Figure 8-95 This painting of mythological characters represents the joyous arrival of spring.

Sandro Botticelli (Italian, 1445–1510), *Primavera*, c. 1480. Tempera on panel. 80" × 124" (203 cm. × 314 cm.). Uffizi Gallery, Florence, Italy. Alinari/Art Resource, NY.

One of the greatest of the Florentine painters was Sandro Botticelli (bot-uh-CHEL-ee) (1445–1510). Although many of Botticelli's paintings were of religious subjects, some of his best-known works depict mythological stories and classical gods and goddesses. One of these, titled *Primavera* (pree-mah-VAIR-ah), is pictured in Figure 8-95.

In *Primavera*, Venus, the Roman goddess of love and beauty, stands in the center of a clearing in the forest. Over her head is her son, Cupid, the god of love, aiming his arrow at a group of dancing maidens. If a person is struck by Cupid's arrow, he or she will be smitten with love. The three dancing maidens represent sister goddesses called the Three Graces, representing pleasure, charm, and beauty. On the far left is Mercury, the messenger of the Roman gods. On the far right is Zephyr (ZEH-fer), the gentle west wind. His breeze touches a *nymph* (nimf), a nature goddess, always depicted as a beautiful young woman living in the mountains, woods, or water. The touch of Zephyr transforms the nymph into Flora, the Roman goddess of flowers and springtime. We see the transformation begin with flowers pouring from the mouth of the nymph. The flowers are repeated in the bouquet and in the pattern of the gown on the next figure, who represents Flora in full glory. Fruit and flowers are abundant, and the

mood of the painting suggests a joyous celebration of spring. You can see another painting by Botticelli in Chapter Two (see Figure 2-42).

Raphael (1483–1520), another great Italian painter, also studied in Florence before moving to Rome. Rome became an art center during the Renaissance because officials of the Roman Catholic Church sought out the best painters, sculptors, and architects to build and decorate the Vatican City within Rome. The Vatican City is home to the pope. Raphael was commissioned to paint frescoes on the walls and ceilings of four rooms in the Vatican. One of these (also pictured in Chapter Two), titled *The School of Athens*, represents harmonious relationships between ancient philosophy and contemporary Christian theology (see Figure 8-96).

Giorgio Vasari (vuh-ZAH-ree) (1511–1574) was both a Renaissance artist and the biographer of some of the great artists of the period. In describing the style

Figure 8-96 Among the many interesting aspects of this work is Raphael's choice of people to include. In the center are Plato and Aristotle of Ancient Greece. Among many other identifiable figures is the brooding Michelangelo, head on hand, in the middle foreground.

Raphael, *The School of Athens*, 1509–1511. Fresco. Stanza di Raffaelo, Vatican Palace, Rome. Scala/Art Resource, NY.

of the Renaissance masters, Vasari used the term la maniera ("the manner"). In the late sixteenth century, this term assumed a different meaning as artists began to take liberties with earlier Renaissance style. The *Mannerists*, as they are known, made strong personal interpretations of their subjects through the use of physical distortion, unusual poses and gestures, and unorthodox color combinations. The subject of Figure 8-97, by the Florentine artist Bronzino, depicts an aloof, impassive sitter in an artificial pose. He appears to think of himself as intelligent, poised, cool, dashing, and frankly superior. The Mannerist period was succeeded by an explosion of talent and vigor known as the Baroque (buh-ROAK).

The Baroque Period

Baroque art is extravagant, expansive, ornate, and sometimes garish. The time span of the Baroque is from approximately 1600 to 1750. This was a period in which enormous power was consolidated in European nations. These nations fought great battles and struggled over colonial territory around the globe. The Baroque was a vigorous extension of the Renaissance spirit into a new era—an era of high expectations and strong emotions in which enthusiasm for scientific and artistic discoveries combined with the rise of powerful monarchies.

Scientists and artists were concerned with new ideas about time, space, geography, motion, and light. Baroque artists often rendered a very specific instant of movement in time. They frequently pictured their subjects engaged in spirited activity. Let's look at an example that typifies the Baroque, Gianlorenzo Bernini's (behr-NEE-nee) (1598–1680) *David*. The biblical hero David (see Figure 8-98), in true Baroque fashion, is shown in action, at the instant when he is beginning to fling the stone that will kill the giant, Goliath. We can, in our mind's eye, follow the motion of David's swing, and the power that is being unleashed. This statue commands the space around it. Energy bursts from David. The viewer's reaction is to duck—get out of the way! We feel that the power of this young David could overcome any adversary.

Dutch Painting. In Holland, Dutch artists were experimenting with the dramatic as well as subtle effects that could be achieved with the use of bright highlights and deep shadows. They were also seeking new levels of realism in their paintings, depicting naturalistic landscapes rather than mythological ones, and showing ordinary people going about the business of daily living. Let's look at artworks exemplifying each of these concerns.

One artist who took full advantage of the effects of light and shadow was Rembrandt van Rijn (van RINE) (1606–1669). Three paintings by Rembrandt can be found in this book. Each displays a splash of light that adds importance to some of the features in the scene

Figure 8-97 The impassive demeanor of this young man is typical of Mannerist portraits.

Bronzino (Italian, 1503–1572), *Portrait of a Young Man.* c. 1550. Oil on wood panel. Approx. 37⅝" × 29½". The Metropolitan Museum of Art, H. O. Havemeyer Collection, Bequest of Mrs. H. O. Havemeyer, 1929. 29.100.16.

Figure 8-98 Bernini spent long hours of study perfecting the facial expression and bodily gesture of this sculpture.

Gianlorenzo Bernini (Italian, 1598–1680), *David*, 1623. Marble. Approx. life-size. Galleria Borghese, Rome, Italy. Scala/Art Resource, NY.

depicted, while other parts of the scene are half-hidden in shadows (see his *Aristotle with a Bust of Homer* and *Self-Portrait* in Chapter Seven, Figures 7-26 and 7-27). As you learned in Chapter Seven, such dramatic contrasts in light and shadow are referred to as chiaroscuro (kee-ah-roh-SKEW-roh).

In Chapter One (see Figure 1-15), you can see Rembrandt's *The Nightwatch*. The artist has portrayed a military company. Each member of the company contributed money to pay for this painting. Instead of showing each member of the company to best advantage, Rembrandt chose to place them in an artful composition of brilliant light and mysterious shadows. As a result, some of the company are in clear view. Others are almost hidden in darkness. Although there are no records to prove it, it is likely that many members of the company were unhappy with the painting. Prior to this, Rembrandt was one of the most sought-after and successful artists in Holland. Following this group portrait, his fortunes gradually declined.

In Figure 8-101 on page 452, you can see an example of a Dutch landscape by one of Holland's leading landscape painters, Jacob van Ruisdael (YA-kop vahn RISE-dale) (1628–1682). Van Ruisdael was fond of painting panoramic views of the earth and sky. Often in his paintings, clouds billow majestically. Although he imagined many features of his landscapes and exaggerated natural elements to achieve idealized results, he tried to maintain in his paintings a sense of believability and of the ordinary world of experience. No Roman gods or nymphs cavort in his landscapes; no trumpeting angels fly through the air.

One of the greatest figurative painters of all time was Jan Vermeer (1632–1675). A **figurative painter** *is one who specializes in the portrayal of the human figure.* Vermeer depicted members of the growing middle class of seventeenth-century Holland—neither rich nor poor, but ordinary people, going about their household tasks or enjoying after-work leisure pursuits. Figure 8-102 portrays a young woman engaged in the intricate process of making lace. Her tools surround her worktable as she deftly manipulates the fine cotton thread. She is obviously accomplished at lacemaking, since her face shows calm and confident concentration, not the grimace of a fumbling beginner. Like his contemporaries Rembrandt and van Ruisdael, Vermeer was skillful at manipulating light and shadow. The lacemaker is bathed in the glow of sunlight. Unlike Rembrandt's mysterious deep shadows, however, Vermeer's shadows are soft.

Lacemaking. At the time Vermeer painted this picture (see Figure 8-102), Holland was famous for its lace-

How the Other Half Lives

Much of the art that survives from older civilizations and cultures was produced for privileged classes of people. This is because wealth and power were often controlled by royal courts. These were the people who could afford to commission artists—and in many cases, *command* artists—to produce art objects. Artists also frequently worked in the service of religion, designing churches, temples, paintings, and carvings to represent the stories and principles of a faith. As a result, much of the art we see from the past contains information about court life or religious beliefs. Less frequently do we find images that reveal something about how common or poor people lived. A few artists did paint realistic scenes of peasant life. One of these was the French artist Louis Le Nain (c. 1593–1648).

Le Nain's painting is titled *A French Interior* (see Figure 8-99). It shows the household of a family living on very modest means. Figure 8-100 is a portrait of Louis XIV, the king of France during the late seventeenth and early eighteenth centuries. It was painted by artist Hyacinthe Rigaud (1659–1743), a leading French court painter. Significant differences establish the mood and meaning of these pictures.

King Louis is regally attired in a plush white fur-lined cape decorated with a pattern of golden fleur-de-lis (flurd-uh-LEE), the coat of arms of the French royal family. His head is covered by a luxuriously long, thick, curly wig. In his right hand, he holds an ornamental staff, both a part of the fashion of the day and a symbol of his social rank. Although he may look silly to us, in his royal court this costume was the height of fashion. Indeed, so great was his power that King Louis *set* the fashions.

The peasants' clothes are in tatters and made of simple, drab fabrics. They appear stained. The woman holds what may be a spindle for spinning thread. It is prominent, so perhaps she uses her spinning skills to earn money for their meager food and possessions. The old man carries a staff to help him walk.

Now study the environments shown in each picture. The king stands on an elaborate woven rug. Yards of brocades and lush red tassled fabrics are draped behind him. The whole scene is bathed in light, with the spotlight on the king.

Le Nain also spotlights his characters, although the room is dim and cloaked in shadow. The young girl stands out in an otherwise dark and unadorned room because she stands beside the light of a fire. The floor

Figure 8-99 The artist has effectively portrayed the inherent worth and character of these people.

Louis Le Nain (1593–1648), *A French Interior*, c. 1645. Oil on canvas. 21⅞" × 25⅜" (.556 × .647 m.). Samuel H. Kress Collection, ©1993 National Gallery of Art, Washington, D.C.

appears to be packed clay, and the furniture is simply crafted of wood and rope. The scene is dominated by dull earth tones. The boy holds in one hand a plain crockery pitcher. In the other, he holds one of the brightest spots in the painting, a stemmed glass goblet filled with a red liquid, perhaps wine. The gleaming glass seems incongruous in this setting; perhaps it is a prized possession in this household, brought out to be included in this portrait.

Now study the poses held by the people. The king is carefully and artificially posed. Clearly, he wants to show himself to best advantage.

The peasants are portrayed sympathetically, but not sentimentally, by Le Nain. They pose in natural, relaxed positions. Although they suffer hardships, they have retained their dignity. They are shy and self-conscious about being put in a work of art.

Although at court the king is in charge, it is clear that in the peasants' household, the woman is the strongest figure. She sits in the center of the room, dominating the cramped quarters. She appears sturdy, compared with the sickly countenance of the boy, the fragile youth of the girl, and the feebleness of the old man. The man appears to be a grandfather figure. Where is the father in this family? Could that be him opening the door at the rear of the scene, returning from a day's labor in a field or workshop?

Both Le Nain and Rigaud seem to have accomplished their objective: to portray people in their socially constructed environments, with dignity and grace. It's interesting how this was achieved with subjects who were at opposite ends of the social spectrum. It's also interesting how much the artists were able to teach us about these people and their culture through the medium of visual art.

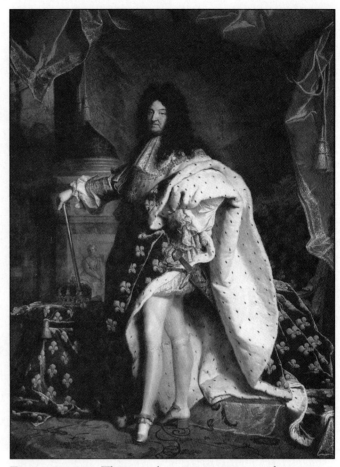

Figure 8-100 This stately portrait captures the spirit of the French royal court at Versailles.

Hyacinthe Rigaud, *Portrait of Louis XIV*, 1701. Oil on canvas. 9'2" × 7'10¾". Louvre, Paris. Scala/Art Resource, NY.

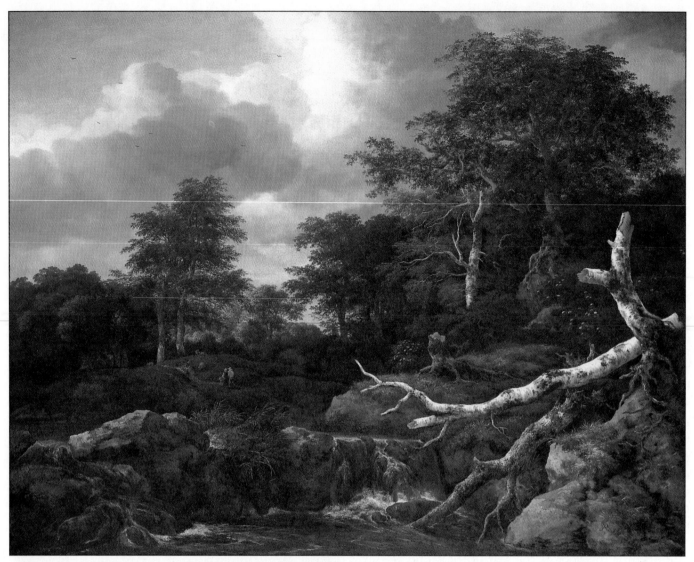

Figure 8-101 Van Ruisdael employed attention to detail and contrasting light and shadow to make this scene more dramatic and lifelike.

Jacob van Ruisdael (Dutch, 1628–1682), *Forest Scene*, 1660–65. Oil on canvas. 41½" × 51½" (1.055 × 1.310 m.). Widener Collection, ©1993 National Gallery of Art, Washington, D.C. 1942.9.80 (676)/PA.

making. Lacemaking is an art form that has been practiced since the Middle Ages in Europe. Its popularity grew among the aristocracy, so that by the sixteenth and seventeenth centuries, thousands of lacemakers endured long hours, chilly rooms, and dim light to try to keep up with the demand. Ever more intricate patterns of lace were designed. The creation of one square inch could take many hours of work. Although lace was made almost exclusively by women, in the sixteenth through eighteenth centuries it was worn as often by men as women. So extravagant was the use of lace, embroidery, gold thread, and lush fabrics among the aristocracy that some countries passed "sumptuary laws." These were laws designed to cut back on lavish displays of wealth by, for example, limiting the amount of lace one could wear in public. Lacemaking is still practiced today in Europe, Asia, and other parts of the world (see Figure 8-103).

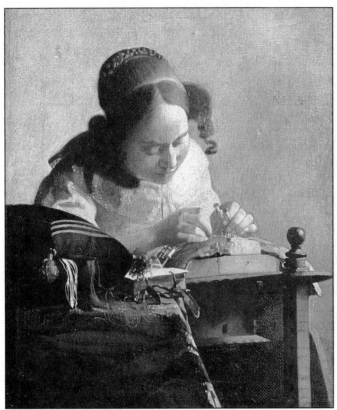

Figure 8-102 Vermeer is noted for his simple and realistic portrayals of ordinary men and women going about their daily lives.

Jan Vermeer (Dutch, 1632–1675), *The Lace-Maker*, 1660. The Louvre, Paris, France. Scala/Art Resource, NY.

Figure 8-103 The art of lacemaking by hand requires a keen eye, skilled hands, and great patience.

Modern lacemaker, Salamanca, Spain, 1988. Photo by Sandra K. Mims. Collection of E. Louis Lankford.

The Glories of France

Baroque buildings were huge, ornate structures. One symbol of absolute monarchy was the enormous palace of Versailles (ver-SIGH) built by the "Sun King" of France, Louis XIV (pronounced "Louie the fourteenth"). Louis came to the throne at the age of five and ruled for seventy-two years. Many French people lived out their lives during his reign, knowing no other ruler. Versailles has come to symbolize the architecture of the Baroque. Before Louis XIV, the country estate at Versailles had consisted of a royal hunting lodge. With an army of architects, landscape architects, and craftspersons, Louis transformed this estate into a combination royal residence and seat of government (see Figure 8-104). Outside the enormous building complex were some of the most elaborate gardens and landscaped forest areas ever produced (see Figure 5-38). Inside, exquisite furnishings filled rooms of carved and polished marble, mirrors, and gold (see Figure 8-105).

In 1715, the Sun King died. He was succeeded by his great-grandson, who was crowned Louis XV. During the reign of Louis XIV, the French nobility had been required to stay at Versailles. These restrictions were lifted by Louis XV. Many moved to Paris and built elaborate homes, decorating them in a new style known as *Rococo* (ruh-KOH-koh). The Baroque style led to the enormous reception halls of kings and the

Figure 8-104 The Palace of Versailles shows the French Classical style of the mid-seventeenth century.

Fountain and statuary in front of the Palace of Versailles near Paris, France. Photo ©1988, Robert Fried, Stock-Boston.

nobility. Rococo interior design is on a more intimate scale, but still sumptuous (see Figure 8-106). Rococo decoration is smaller and more flat than the large, deeply carved ornaments of the Baroque. Rococo artists favored the use of oval shapes and curling lines.

Rococo painting matched the elaborate interiors. Artists used lighter tints than their Baroque forebears. They often worked in pastels. The subject matter of Rococo painters was also generally of a much lighter vein than that of Baroque painters, as we see in Figure 8-107 on the next page.

In 1774, yet another Louis (the XVI) came to the throne. The extravagance of the aristocrats during the Baroque period, and even more during the Rococo, embittered the citizens of Paris and the people of rural France. The Rococo era ended abruptly and brutally with the French Revolution in 1789.

Figure 8-105 This large, splendid reception hall was often filled with the well-heeled, well-dressed members of the French royal court.

Interior Hall, Palace of Versailles. Photo ©1982, Dick Luria, FPG International.

Figure 8-106 The "hotel" in the title means "mansion" in this instance.

Gabriel-Germain Boffrand (French, 1667–1754), Salon de la Princesse, Hôtel de Soubise, Paris, France. Scala/Art Resource, NY.

Figure 8-107 Rococo aristocrats constantly pursued pleasure. The young man in the shrubbery at the lower left commissioned this painting. His lady-love's swing is pulled by the wigged servant at the lower right who appears to be enjoying his task.

Jean-Honoré Fragonard (French 1732–1806), *The Swing,* 1776. Oil on canvas. Approx. 32" × 35". Courtesy Trustees of the Wallace Collection, Hertford House, London.

Marie-Louise-Élisabeth Vigée-Lebrun

One day Marie-Louise-Élisabeth Vigée-Lebrun (1755–1842) was a privileged and fashionable lady of the royal court of France; the next day she was fleeing for her life, just ahead of angry mobs determined to behead aristocrats like her on the guillotine! The year was 1789, during the French Revolution. The people of France had vowed to bring an end to rule by monarchy. The king and his queen, Marie Antoinette, were arrested. The very night of their arrest, Élisabeth Vigée-Lebrun fled Paris with her young daughter, Julie.

Élisabeth was born in Paris. Her father was a teacher and artist who specialized in portrait painting. He taught young Élisabeth some of what he knew about painting, but he died when she was only twelve years old. Élisabeth continued to develop her talents as a portraitist. By age fifteen, she was earning enough money from her portraits to support herself, her mother, and her younger brother.

At age twenty-one, Élisabeth married an artist and art dealer named Jean-Baptiste-Pierre Lebrun. He took over the financial aspects of her career, and helped her to get commissions for portraits of some of the wealthiest and most influential people in French society. Some historians think he controlled Élisabeth's money more to his advantage than to hers. Still, her skill as an artist and her sparkling personality charmed and delighted art patrons. She was well on her way to becoming a wealthy woman and socialite.

When she was twenty-four years old, she received the first of several royal commissions to paint a portrait of Queen Marie Antoinette. She became one of the queen's favorite artists (see Figure 8-108). It was this association that put Élisabeth in grave danger during the revolution.

Fortunately for her, Élisabeth's reputation as an artist spread beyond the borders of France. While in exile from her native land, she continued to paint portraits of wealthy and influential individuals wherever she went. She always managed to capture the beauty of her subjects. She painted each person with glistening, intelligent eyes and a glowing complexion. She depicted them in graceful poses and gestures. Their hair would cascade becomingly over their shoulders, and they would be tastefully dressed. The light would fall just right to show them to best advantage. No wonder Élisabeth Vigée-Lebrun was such a popular portrait painter! She exercised her great skill in her own self-portrait (see Fig. 8-109).

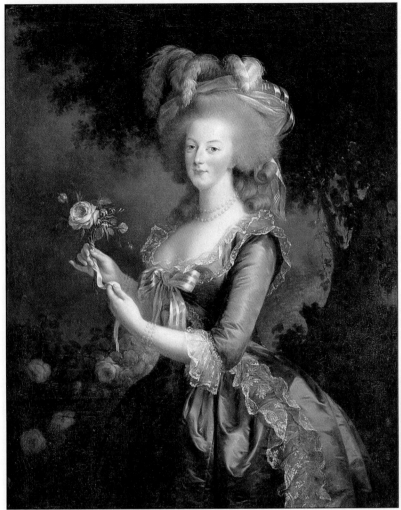

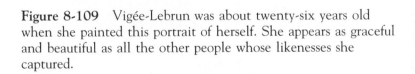

Figure 8-109 Vigée-Lebrun was about twenty-six years old when she painted this portrait of herself. She appears as graceful and beautiful as all the other people whose likenesses she captured.

Marie-Louise-Élisabeth Vigée-Lebrun (French, 1755–1842), *Self-Portrait*, c. 1781. Oil on canvas, 25½" × 21¼". Kimbell Art Museum, Fort Worth, Texas. Photo by Michael Bodycomb.

Figure 8-108 Vigée-Lebrun's association with the Queen of France initially brought the artist fame and fortune. Later, it put her life in grave danger.

Marie-Louise-Élisabeth Vigée-Lebrun (French, 1755–1842), *Marie-Antoinette with a Rose*, 1783. Versailles, France. Giraudon/Art Resource, NY.

The Louvre.　One outcome of the French Revolution was the creation of one of the world's greatest public art museums, the Louvre (LOO-vruh) in Paris, France. The Louvre was begun in the thirteenth century as a royal fortress. Over time, it was changed into a lavish royal palace. When King Louis XIV moved his court to Versailles, the Louvre became a repository for royal treasure, and contained living quarters and studios for the king's artists. In 1793, the French revolutionary government opened the Louvre as a public museum. The public could come to view, admire, and study the artworks. Artists could bring their sketchbooks and easels and paints in order to practice and learn techniques by copying works of art (see Figure 8-110). Today, the Louvre houses one of the most extensive collections of art on earth. You would have to walk a distance of over eight miles in order to visit all of its rooms.

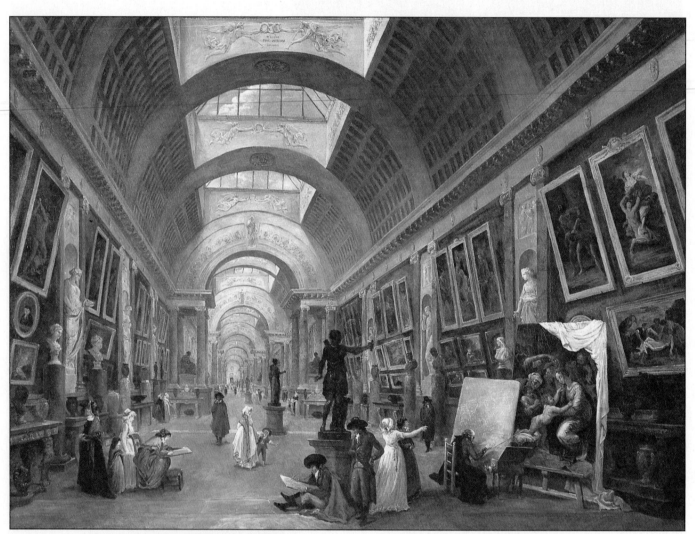

Figure 8-110　Robert would imagine improvements to the museum and paint them into his pictures, such as the skylights seen here.

Hubert Robert (French, 1733–1808), *View of the Grande Galleria of the Louvre*, 1796. Oil on canvas. 115 cm. × 145 cm. Louvre, Paris, France. Scala/Art Resource, NY.

Russia

Located on the eastern edge of the European continent, Russia, before the twentieth century, was controlled by royal families in which the king was referred to as a czar (ZAR) and the queen as a czarina. They had great power and controlled great wealth, much of which they used to build sumptuous palaces. One of these palaces, begun in 1718 near St. Petersburg by Empress Catherine and completed by Empress Elizabeth about thirty years later, is called Yekaterininsky,

Figure 8-112 This is one of the most elaborate stairways in the world.

The Jordan (Main or Ambassadorial) Staircase of the Winter Palace, the State Hermitage Museum, St. Petersburg, Russia. Built by the architect Francesco Bartolommeo Rastrelli, 1756–61. After the Great Fire of 1837, the staircase was restored by Vasily Stasov. RIA-"NOVOSTI".

Figure 8-111 Russian royalty was not to be outdone by other European monarchies in terms of luxurious palaces.

View of facade, showing three of the golden onion domes of the church of Yekaterininsky (Great Catherine Palace) at Pushkin, outside St. Petersburg. 18th century. Photo ©1985, Bobbie Probstein, FPG International.

or Great Catherine Palace. Like the palace of Versailles in France, Great Catherine Palace was once a royal hunting lodge, and then it grew into a royal residence and seat of government on a grand scale. The facade of the palace is an impressive 1,000 yards in length. At one end is the church, designed by Russian architect Chevakinsky. It is crowned by five golden domes (see Figure 8-111). Like Versailles, this palace is luxuriously furnished and decorated, and surrounded by formal gardens.

Another palace in St. Petersburg, begun in 1703 by Czar Peter I, was equally impressive in scale and lavishness. Ambassadors to Russia would climb the staircase pictured in Figure 8-112 to present their credentials to the czar. This palace, originally referred to as the Winter Palace, today houses one of the world's great art museums, the Hermitage.

The domes of the Great Catherine Palace are referred to as *onion domes* because each is shaped like an onion. Perhaps the most unusual and colorful array of onion domes in the world is to be found on the Cathedral of Saint Basil the Blessed in Moscow (see Figure 8-113). This church was built for Czar Ivan IV between 1554 and 1560. The many chapels within this cathedral—nine octagonal, two square, and two heart-shaped—are topped by ornate spires and onion domes. These are twisted, striped, or surrounded with crisscross or zigzag patterns. Contrasting green, white, and reddish orange further accentuate the fantasy-like appearance of this structure.

Figure 8-113 The forms, colors, and patterns of the spires and onion domes make a fantastic sight.

Cathedral of St. Basil the Blessed. Built c. 1554–1560. Moscow, Russia. Photo ©1990, Travelpix/FPG International.

Neoclassicism

Excavations in the ancient Roman city of Pompeii (pom-PAY) began in 1763. While relics of ancient Rome had influenced the Renaissance in the fifteenth and sixteenth centuries, the ruins of Pompeii had perhaps an even greater impact. Here was a complete Roman city, exactly as it had been on the fateful day in 79 A.D. when it was covered by lava and ash from the eruption of Mount Vesuvius.

The discovery of Pompeii and its treasures led to a new movement in Europe known as the "classical revival," or Neoclassicism. In France, people were attracted to and fascinated by the styles and virtues they attributed to ancient Greece and Rome. Consequently, anything "classical" became fashionable, from literature and the visual arts to styles of clothing.

Jacques-Louis David (zhohk louie dah-VEED) (1748–1825) was an influential artist of this period shortly before the French Revolution. After the revolution, in 1789, David became the virtual dictator of art in France. Many of David's prerevolutionary works were somber paintings of sacrifices that had been made by heroes and heroines of ancient Greece and Rome. He adapted this theme to a postrevolutionary painting depicting the death of Marat (mah-RAH), a political leader of the French Revolution (see Figure 8-114). At the time of his death, Marat was afflicted with a severe skin disorder. He could only find relief by soaking, so he used to work immersed chest-deep in water. He was stabbed to death by a woman with a political grievance who unexpectedly burst in on him.

After the revolution, David was elected to the government that ruled France. In this capacity, he cast one of the 361 votes in favor of the execution of his former patron, Louis XVI. This decision carried by a majority of one vote, and Louis XVI was decapitated.

Neoclassicism in the United States. Neoclassicism was one of many European art movements to have a major impact in America. The Neoclassical style has been particularly important in American architecture. The style of the Capitol building in Washington, D.C., and of many other federal buildings is firmly rooted in the architecture of ancient Greece and Rome (see Figure 8-115).

Figure 8-114 Notice how the neutral space above Marat's body emphasizes the fine detail below. Marat had been David's personal friend. The inscription on the box reads "To Marat, David, Year Two."

Jacques-Louis David (French, 1748–1825), *The Death of Marat*, 1793. Oil on canvas. 65" × 50¼". Musées Royaux des Beaux-Arts de Belgique, Brussels. Giraudon/Art Resource, NY.

Romanticism

The Romantic movement in the late eighteenth and early nineteenth centuries consisted in part of a desire to "return to nature," and it encompassed many art forms, including visual art, music, and literature. People and nature were portrayed sympathetically in the visual arts, and in each of the arts emphasis was placed on sentimental or emotional impact and beauty.

Figure 8-115 The design of Washington, D.C.'s famous buildings was influenced by the Neoclassical movement as well as ancient Greek architecture.

The United States Capitol Building, Washington, D.C. Photo ©1994, Alex Bartel/FPG International.

TECHNOLOGY MILESTONES IN ART

Framing

Most of us are used to seeing framed paintings. A frame can enhance the appearance of a painting by visually setting it off from the surrounding environment. Prior to the fourteenth century, however, there were few framed paintings. Most paintings were designed to fit a specific architectural space, such as a wall nook. Paintings were created directly on walls, or on wooden panels that were permanently installed when finished.

By the Renaissance, many art patrons desired paintings they could move from place to place. Artists created more movable pieces that would fit easily and look good in a variety of settings. Frames were constructed specially for these artworks by woodworkers and carvers. Often, rare and expensive woods, such as ebony and rosewood, were used. Elaborately carved frames were usually gilded with gold or silver leaf by gently tapping, or "pounding," ultra-thin sheets of precious metal onto an adhesive applied to the frame's surface. Preparation of frames required great skill and artistry. In the early days of framing, the names of framers were preserved and honored alongside the names of painters.

Sometimes frames were designed to blend visually with the subject or style of the painting. A perfect example of this may be seen in Figure 8-116. The painting, by early American artist Charles Willson Peale (1741–1827), depicts two men on a staircase. The frame takes the form of a doorway molding and bottom step. George Washington is said to have been fooled by the realism of this artwork. When rushing past and spying the two gentlemen on the stairs from the corner of his eye, he paused to give a quick but courteous bow.

Figure 8-116 Someone in a hurry might easily be fooled by this cleverly framed painting!

Charles Willson Peale (American 1741–1827), *The Staircase Group,* 1795. (Note: sons of the artist, Raphael Peale in foreground and Titian Ramsey Peale above.) Oil on canvas with wood frame. 89" × 39½" (226 cm. × 100.4 cm.). Philadelphia Museum of Art: The George W. Elkins Collection. E'45-1-1.

The work of John Constable (1776–1837) offers one example of the Romantic movement. In his paintings, he glorified his beloved English countryside (see Figure 4-19) and the sweeping, powerful forces of nature.

The American painter George Caleb Bingham (1811–1879) pictured life on the Missouri River in a Romantic style (see Figure 8-117). In this scene, flatboat-men appear to be living an easy life, having fun on a peaceful river. In reality, their jobs were strenuous, dirty, and often dangerous. Bingham's Romantic paintings are often associated with Mark Twain's tales of life on the great Mississippi and Missouri rivers.

Another artist associated with Romanticism is the French painter Eugène Delacroix (dell-uh-KWA)

Figure 8-117 The rivermen relax in the lower stretches of the Missouri. The upper Missouri had treacherous currents, and was quite dangerous.

George Caleb Bingham (American, 1811–1879), *The Jolly Flatboatmen*, 1846. Oil on canvas. 38⅛" × 48½" (.969 × 1.232 m.). Private Collection, on loan to the National Gallery of Art, Washington, D.C.

(1798–1863). Delacroix's portrait of the Polish composer Frédéric Chopin (see Figure 8-118) captures Chopin's Romantic spirit as well as his likeness.

Figure 8-118 Chopin's work is the very essence of Romantic music. He established the piano as a premier solo instrument.

Eugène Delacroix (French, 1798–1863), *Frédéric Chopin*, 1838. Oil on canvas. 18" × 15". The Louvre, Paris.

Goya

Spanish artist Francisco Goya (GOY-ah) (1746–1828) does not fit neatly into any one specific category or movement. In his early work, we find elements of Mannerism and Romanticism. But the grim realism and social and political criticism contained in his later works were quite innovative and influential.

Goya's *The Family of Charles IV* (see Figure 8-119) shows the king of Spain and his family in the year 1800. The royal family has come to call on the artist in his studio. Goya is seen seated before his canvas in the background. The artist has been brutally honest in his depiction. Frightened children and spoiled and arrogant relatives surround the mature king and queen at the center of the picture. Even the king and queen have not been "prettified." It is still something of a mystery why the royal family tolerated such an unflattering portrayal.

A few years after Goya painted Charles IV's family, the French forces of Napoleon took control of Spain. Some Spaniards hoped that the conquering French might bring about badly needed reforms in the Spanish government. These supporters were terribly disappointed when French troops began a reign of terror, including mass public executions of those who resisted them. One of the most moving and powerful images to show the sad consequences of tyranny is Goya's *Third of May, 1808* (see Figure 8-120). It shows a fateful day in the history of Madrid. A faceless, unfeeling firing squad is executing Spanish citizens. The bloody scene is lit by the stark glow of a cube-shaped lantern. You might find it rewarding to study this painting in depth by using the critical method described in Chapter Two.

Although Goya's paintings were brutally realistic, they were not always created from the artist's personal experience. Goya would sometimes reconstruct a scene from accounts told by others. A movement known as realism, however, insisted on personal experience. One of the earliest advocates of realism was Gustave Courbet (goo-STAHV koor-BAY).

Realism

Courbet (1819–1877) believed that artists must rely for subject matter solely on their own personal tangible experience. This ruled out the interpretation of historical, religious, and mythical themes or the rendering of anything from the artist's imagination. Courbet said, "Show me an angel, and I'll paint it." In 1849, he exhibited *The Stonebreakers* (see Figure 8-121 on page 466). Courbet had seen the two men working on a road—one seemingly too old for the task, one too young. The stark realism was unusual for the time.

Courbet's work was denounced by critics. After he was refused permission to exhibit at the 1855 World's Fair in Paris, he opened his own studio-gallery and boldly painted the word *Realism* above the door.

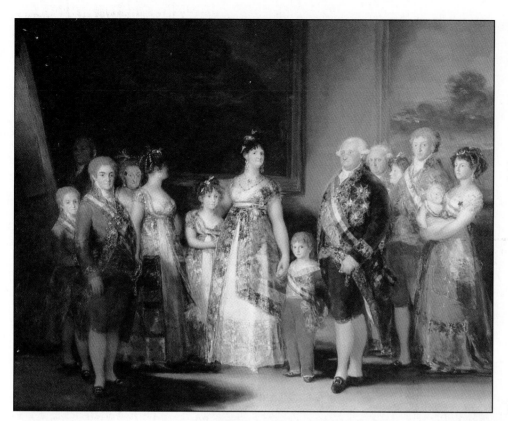

Figure 8-119 Goya's unbecoming portrait thinly disguises his criticisms and honest perceptions of the royal family.

Francisco Goya (Spanish, 1746–1828), *The Family of Charles IV*, 1800. Oil on canvas. Approx. 9'2" × 11'. Museo del Prado, Madrid, Spain. Giraudon/Art Resource, NY.

Figure 8-120 By not painting the faces of the firing squad, Goya made them seem almost like robots. What emotions can you see in the expressions of the victims?

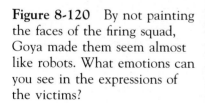

Francisco Goya (Spanish, 1746–1828), *The Third of May, 1808.* Painted in 1814. Oil on canvas. Approx. 8'8" × 11'3". Museo del Prado, Madrid, Spain. Scala/Art Resource, NY.

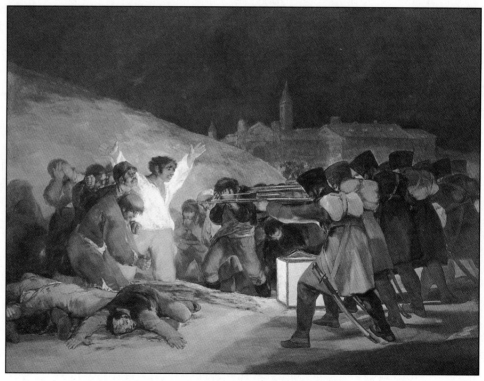

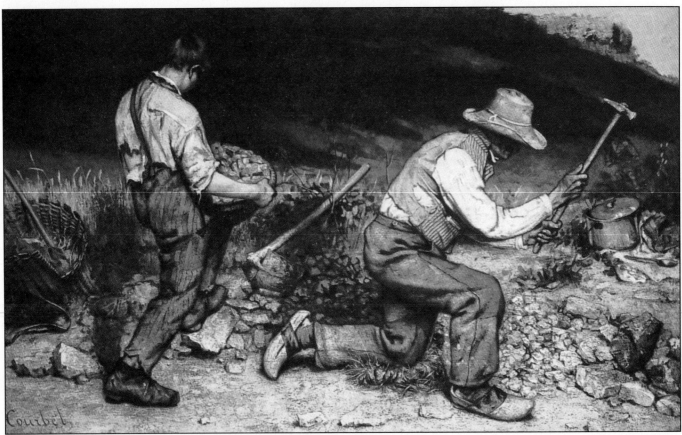

Figure 8-121 Courbet chose to paint only what he could see with his own eyes.

Gustave Courbet (French, 1819–1877), *The Stonebreakers*. 1849. Approx. 5'5" × 7'10". Staatli-che Kunstsammlungen, Dresden, Germany. (Painting lost during World War II.) Alinari/Art Re-source, NY.

Courbet placed large daubs of color onto his can-vases, and this gave his paintings a rough surface. His ideas and technique inspired many who would follow, including the Impressionists.

Realism was also initially denounced in America by both the critics and the public. Thomas Eakins (AY-kinz) (1844–1916) completed *The Gross Clinic* (see Figure 8-122) in 1875. It was rejected for exhibi-tion in Philadelphia because it was considered too graphic. *The Gross Clinic* depicts Dr. Samuel Gross in the operating amphitheater of Philadelphia's Jefferson Medical College. The surgeon's assistants surround the patient. Dr. Gross is shown pausing during the opera-tion to lecture medical students on the operating pro-cedure. The sight of his bloody hands and scalpel is too much for the patient's mother, who covers her face.

Eakins is now considered one of the finest painters in American art history. He was concerned not only that painting be realistic, but that art produced in America should reflect American ways of life.

> "If America is to produce great paint-ers and if young art students wish to assume a place in the history of the art of their country, their first desire should be to remain in America, to peer deeper into the heart of American life."
>
> **Thomas Eakins**

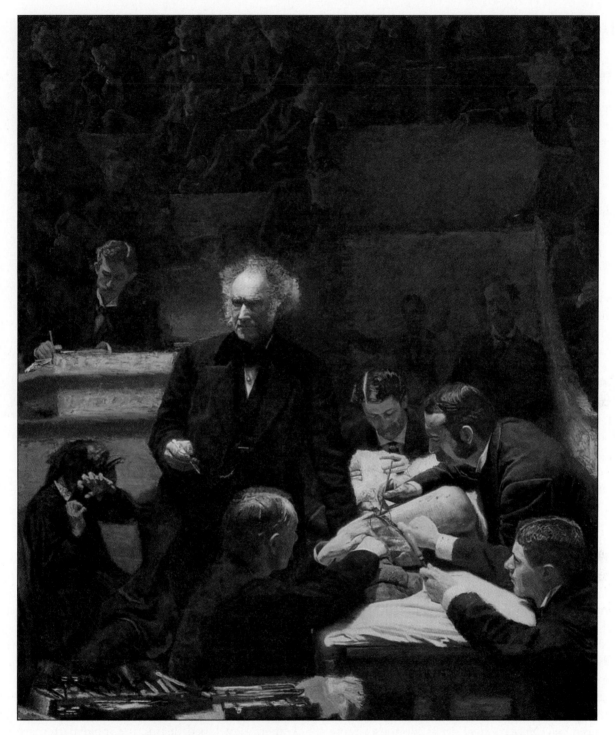

Figure 8-122 This graphic view of an operation in progress was too much for the sensitivities of the people of Philadelphia at the time. It now is considered one of the greatest American paintings of the nineteenth century.

Thomas Eakins (American, 1844–1916), *The Gross Clinic*, 1875. Oil on canvas. 96" × 78" (2.44 × 1.98 m.). The Jefferson Medical College of Thomas Jefferson University, Philadelphia, Pennsylvania.

Early American Art

In this final section of the chapter, we will study artworks created in the early years of the United States. The earliest "American" art was created by cultures native to North America long before this continent was named "America" by Europeans. We have already seen examples in this book of Native American art and architecture: pottery created by the celebrated Pueblo artist Maria Martinez (see Figure 4-14C) in Chapter Four, a Crow shield (see Figure 5-13) and the mysterious Great Serpent Mound (see Figure 5-54) in Chapter Five, dwellings at Mesa Verde (see Figure 6-3) in Chapter Six, and a Hopi kachina (see Figure 7-14) in Chapter Seven.

Early Native Americans worked with materials that they got from the environment, such as feathers and hide, and those they acquired through trade. Although often visually decorative, most Native American art forms have symbolic or spiritual importance. Many artistic traditions have continued into the twentieth century.

In Figure 8-123, you can see a nineteenth-century quilled buckskin shirt created by a member of the Blackfoot nation. Before signing treaties with the United States government, Blackfoot warriors controlled considerable territory from the headwaters of the Missouri River into northern Saskatchewan. A shirt as fine as this would have been reserved for ceremonies or worn to greet visiting dignitaries. Dyed porcupine quills were used to create the long patterns extending from the shoulder over the chest and down the arms. Long fringe and trade beads and bells add to the ornamental quality of the shirt. Feathers and scalp locks indicate the wearer was a strong and respected warrior.

Fancy garments and costumes of fur, hides, feathers, wood, bells, and other materials are worn for special occasions and ceremonies by Native American nations across the United States. A **powwow** (POW-wow) *is a special gathering of Native Americans marked by ceremonial music and dance.* Visual art is gloriously represented in the costumes worn by participants in the powwow (see Figure 8-124).

Figure 8-123 This elaborate shirt was proudly worn by a Blackfoot warrior.

Blackfoot Quilled Buckskin Shirt. Late 19th century. Buckskin, feathers, quills, scalp locks, bells. L: approx. 42". Glenbow Collection. Courtesy Glenbow Museum, Calgary, Alberta, Canada, AF 83.

Basket and Blanket Weaving. Native American basket weaving is unsurpassed in the history of this art form. Baskets are made to hold everything from corn to jewelry, and they range in size from one that can sit on the end of your finger to one large enough to sit down in. Baskets typically bear decorative and symbolic patterns characteristic of the culture that has made them.

Textile weaving in the Navaho culture dates back to the eighteenth century. Navaho weavers, primarily women, developed distinctive, bold patterns for their blankets. Color schemes were equally bold, with contrasting deep red, black, yellow, and green appearing

Figure 8-124 Special and symbolic garments are worn during ceremonial dances.

Chippewa dancer at inter-tribal powwow, Chippewa Reservation, Wisconsin. Photo ©1982, Paul Sequeira/Photo Researchers, Inc.

Figure 8-125 This chief's blanket illustrates the use of geometric design.

Navaho blanket, third phase chief's style, c. 1880–90. Courtesy of the Southwest Museum, Los Angeles. Photo by Ray Swartz. 761.G.8.

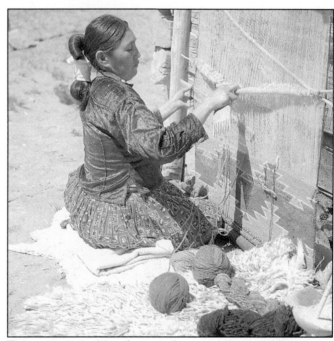

Figure 8-126 Navaho people are well known for their artistic weaving abilities.

Navaho Weaver, Arizona. Photo ©1971, Richard Erdos/FPG International.

frequently. Dyes were made from plants found in the deserts and mountain regions of their homeland, where Arizona, New Mexico, and Utah meet. Although originally made to be used as blankets, the cloth was so thick and heavyweight that traders were able to sell these items as rugs. The chief's blanket pictured in Figure 8-125 shows one of the many characteristically geometric designs produced by the Navaho (see also Figure 8-126).

Totem Poles. Native Americans of the Pacific Northwest are known for their **totem poles.** *These are wooden poles that were carved and painted with symbolic designs, and that stood upright in front of native houses.* Usually, the poles were made from split tree trunks that had been hollowed out. Some, such as the one pictured in Figure 8-127, were so large that doorways could be cut through them. Symbols on totem poles took the form of highly stylized real or mythological creatures. For example, one might find a "sea bear," which incorporated features of both land and sea animals. Some of the creatures found on totem poles represented family crests, to be used only by members of a certain family line. The figure at the top of the totem pole in Figure 8-127 is called a "watcher." It was always on the lookout for any sign of danger.

Depictions of Native Americans. American artists of European descent depicted Native Americans in their art, especially in the nineteenth century. Some artists were more concerned with accuracy than others. George Catlin (1796–1872), whom you met in Chapter Seven was one of the first to try to study Native American nations firsthand and make visual records of his encounters. His paintings and drawings depict the ceremonial dances he observed, and often provide striking portraits of noble chiefs (see Figure 8-128).

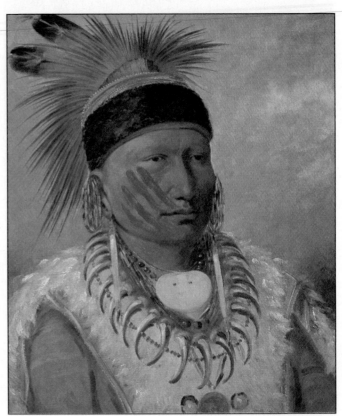

Figure 8-127 Totem poles displayed family crests and other imagery important to the people who made them. Some were so large that they formed the doorway to the house.

Totem pole as it originally stood at the entrance to a Haida village house on the west coast of the Queen Charlotte Islands, British Columbia. Mid-19th century. Red cedar. Courtesy of the Royal British Columbia Museum, Victoria, B.C.

Figure 8-128 Catlin captured the dignity and customs of Native Americans in his many paintings and drawings.

George Catlin (American, 1796–1872), *The White Cloud, Head Chief of the Iowas,* 1844–45. Oil on canvas. 28" × 22⅞" (.710 × .580 m.). Paul Mellon Collection, National Gallery of Art, Washington, D.C. Photo by Richard Carafelli. ©1993 National Gallery of Art. 1965.16.347.(2305)/PA.

Catlin's drawings of Native American life sparked interest among other artists. Accounts from Catlin and others of dangerous buffalo hunts inspired numerous paintings of this subject. Not all of them were made by people who had actually observed one of these hunts. Because the name of the artist is lost to us, it is unknown whether the artist who painted *Buffalo Hunter* had seen one or not (see Figure 8-129). This artist was not highly trained in European painting traditions. The proportions of the head, legs, and body of the horse are inaccurate. The buffalo is supposed to be galloping across the plains, but his hindquarters ap-

pear to float free of the ground. Nevertheless, the artist is highly successful in capturing the drama and excitement of a tense moment during the hunt. The horse hesitates in its movements, fearful of the huge, horned, wild-eyed beast. The brave hunter is shown taking careful aim; if his arrow misses its mark, he may be trampled and gored by the furious buffalo. Dusty storm-clouds skirt the horizon, their billowing shapes echoed by the buffalo hide fluttering from the shoulders of the hunter. A stiff wind adds drama by tossing the hair of the man and the mane of his horse.

Figure 8-129 This painting, although not altogether convincing in its realism, successfully conveys a dramatic moment.

Buffalo Hunter, c. 1844. (artist unknown). American. Oil on canvas. 40" × 51⅛". Santa Barbara Museum of Art, Gift of Harriet Cowles Hammet Graham in memory of Buell Hammet. Photo by Scot McClaine, 1993. 1945.1.

Artists on the Frontier. In the mid to late nineteenth and early twentieth centuries, the frontiers of the "Wild West" were of great interest to Americans who lived on the East Coast. Stories of cowboys and gunslingers made sensational reading in the newspapers. Frederic Remington (1861–1909) was an artist who made his way west to record what he saw for the benefit of curious folks back east. He illustrated magazine stories, and created "western" images in oil paints and bronze. Often, his work depicts a dramatic or tense moment in an eventful story. Can you describe the action taking place in Figure 8-130?

While some artists concentrated on the people of the American frontier, others focused on the spectacular, unspoiled wilderness landscape. In Chapter Five, you can see several examples from these artists and read more about them (see Figures 5-26, 5-27, and 5-28).

American Portraits. Early American painters developed their own distinctive heritage of portrait painting. Many were not formally trained in art schools, but were self-taught or learned from other individual artists. Early American portraits tended to be more simple and direct than their European counterparts. Individuals were usually shown in ordinary rather than lavish surroundings. Their garments were fashionable but not gaudy. One such portrait painting is shown in Figure 8-131. The artist, Joshua Johnson, was one of several itinerant artists working in the early years of the United States, during the late eighteenth and early nineteenth centuries. An **itinerant artist** *is one who travels from place to place, making a living by seeking and fulfilling commissions to make art.* Distinguished citizens would often jump at the chance to have a portrait painted of themselves, their spouses, and children. Remember, this was long before the camera was invented, so portraits were hard to get and prestigious to own. The children depicted in Figure 8-131 are dressed up for the occasion, wearing fancy collars. They are obviously on their best behavior. The artist has even included the family pet in the painting.

Early African American Artists. Joshua Johnson had to carry "freedom papers" with him when he traveled. This is because he was an African American during the period when slavery was permitted in this country. Freedom papers had to be carried by African Americans who were not slaves. These documents stated that the carrier of the papers was free, and they were signed by the carrier's former slave owner or a

Figure 8-130 A gallop across the prairie was always dangerous due to prairie dog holes. Remington dramatically depicts a cowboy facing multiple perils.

Frederic Remington (American, 1861–1909), *The Stampede*, 1907. Oil on canvas. 27" × 40". From the Collection of Gilcrease Museum, Tulsa. 0127.2329.

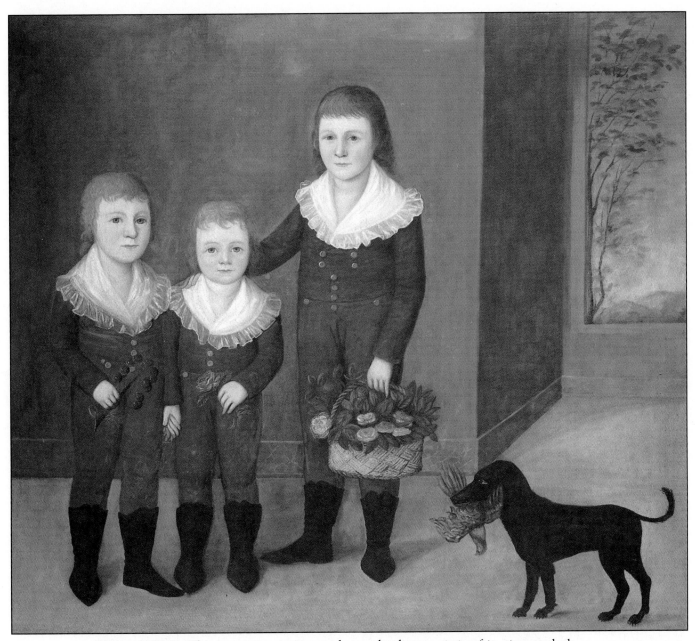

Figure 8-131 This portrait painting, with a style characteristic of its time and place, was created by one of the first African American artists recorded in history.

Joshua Johnson (American, active 1796–1824), *The Westwood Children*, c. 1807. Oil on canvas. 41⅛" × 46" (1.045 × 1.168 m.). Gift of Edgar William and Bernice Chrysler Garbisch, National Gallery of Art, Washington, D.C. 1959.11.1.(1536)/PA.

prominent citizen. Johnson was one of the first African American artists recorded in history.

African Americans made many contributions to early American art both before and after Joshua Johnson's time. In colonial America and through the nineteenth century, African Americans excelled at quilt making, basket weaving, architectural carpentry, furniture making, wood carving, pottery, and ironwork.

Unfortunately, most of their names and life histories have been lost. Figure 8-132 shows a *coverlet*, a woven bedspread, said to have been made by a slave woman in North Carolina. The eye-popping pattern was designed to ward off evil spirits and bring good luck to the user. An interesting comparison can be made between nineteenth-century works like this one and the Op art of the twentieth century, which you'll read about in Chapter Nine. Figure 8-133 shows a sample of skilled, artistic ironwork.

Figure 8-132　A Bedspread that Brings Good Luck

Overshot coverlet. Reportedly made in Rockingham County, North Carolina, by an anonymous African-American slave woman. Courtesy The Museum of the Confederacy, Richmond, Virginia. Photo by Katherine Wetzel.

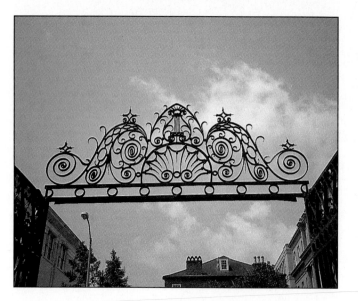

Portraits of Children.　Viewers today are sometimes perplexed by portraits of children made in early America. From colonial days through most of the nineteenth century, parents clothed young boys as well as girls in dresses. By age four, boys would have graduated to pants. We can guess that the boy in Figure 8-134 is between ages two and four. White undergarments like his, called *pantaloons*, were also common.

The Monkey Picture.　Still-life painting was popular in early America. Usually these paintings showed artful arrangements of motionless objects, like fruits, flowers, or fowl brought home from a hunt. Occasionally, an imaginative artist would spice up a still-life by adding animated characters, such as strutting peacocks. One of the liveliest still-life paintings ever produced is *The Monkey Picture* by Henry Church, Jr. (1836–1908). Church lived most of his life in Chagrin Falls, Ohio, where he was known as a skilled blacksmith but an eccentric artist. *The Monkey Picture* (see Figure 8-135) may have been created to shock and amuse people who were used to more serene still-life paintings. The central action in this painting consists of the two monkeys fighting over possession of one banana. They may have escaped from the cage that is visible through the open window. Also framed by the window is a police officer, rushing to investigate the commotion.

Church has added clever and humorous touches to this picture. Can you see the face in profile that is formed by the edge and seeds of the watermelon? Notice, too, the face on the tiger-skin rug—obviously, this creature is upset by having a monkey's tail wrapped around its neck! Although the artist has signed his name prominently in the lower right-hand corner, he has hidden it again in the texture of the cantaloupe rind. What other details in this painting can you describe?

Figure 8-133　It took physical strength, skill, and imagination to work iron into beautiful forms.

Decorative ironwork panel. African American. Mid-nineteenth century. Photo by E. Louis Lankford.

Figure 8-134 The young lad holds a toy whip to drive his steed faster.

William Matthew Prior (American, 1806–1873), *Boy with Toy Horse and Wagon*, c. 1845. Oil on Canvas. 30¼" × 25" (.768 × .635 m.). Gift of Edgar William and Bernice Chrysler Garbisch, National Gallery of Art, Washington, D.C. ©1993 National Gallery of Art. 1953.5.67.(1290)/PA.

Fooling the Eye. A form of still-life painting that gained favor in late nineteenth-century America is known as **trompe l'oeil** (tromp LUH-ee). *This is a type of painting that is so realistic that viewers are not sure whether they are looking at a painting of objects or at the objects themselves!* William Harnett (1848–1892) specialized in trompe l'oeil paintings. Figure 8-136 on the next page shows an example of his work. The bugle and violin are so convincingly portrayed that you expect to be able to pluck them from their perches and play them. Harnett has also created the illusion of torn, yellowed paper, split wood, and rusty metal. His control of light and shadow, and of form and texture, allows him to deceive our eyes.

Figure 8-135 This bright and lively painting is barely what one would call a "still-life."

Henry Church, Jr., *Still Life: The Monkey Picture*. c. 1895–1900. Oil on paper mounted on oilcloth. 28" × 44" (71.1 cm. × 111.8 cm.). Abby Aldrich Rockefeller Folk Art Center, Colonial Williamsburg, Virginia. 81.103.1; T91-622.

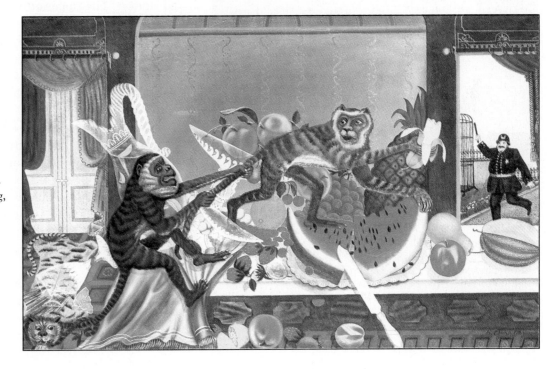

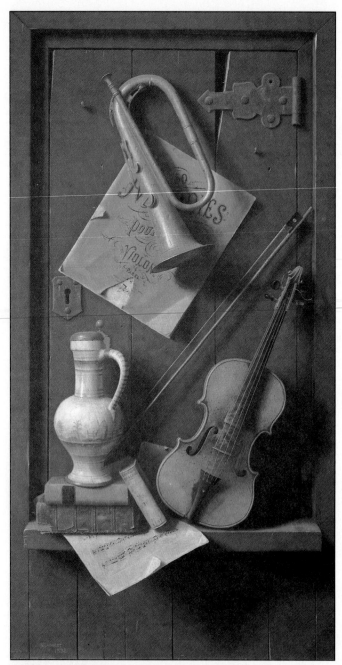

Figure 8-136 This painting is meant to fool the eye into believing the objects are really before us.

Folk Art. One of the first images we studied in this book was that of the *Flag Gate* (see Figure 1-3), an expression of all-American spirit made in the nineteenth century. It was designed for practical use on a farm, and its maker was probably not an artist by trade. Still, the creator of the *Flag Gate* was very concerned about making an aesthetically pleasing object that expressed ideas and feelings. *Artistic work by individuals who have not been trained as artists is referred to as* **folk art.** We saw another fine piece of folk art in Chapter Four: *Crocodile*, by Elijah Pierce (see Figure 4-3).

One type of folk art that originated in Europe but reached new creative heights in the United States is the *weather vane*. A weather vane is a flat device that is mounted on the top of a house, barn, or other building and that swivels freely in the wind. Its movements indicate the wind's direction. Mounted on a boat house, a weather vane could show sailors the prevailing winds. On the plains, they helped farmers forecast storms. Weather vanes were functional works of art that came in many sizes and shapes. When they took the shape of a rooster or a trumpeting angel, they were symbolic of good fortune or religious faith. Trotting horses, dairy cows, or other animals would signify the specialty of a farm or ranch. The weather vane in Figure 8-137 was mounted atop—can you guess?—a railroad station. The uppermost part is a lightning rod. If lightning struck the weather vane, the electricity from the strike would travel down an attached wire into the ground. This could keep the roof from catching fire.

Even more fanciful than weather vanes were **whirligigs,** *which were wind toys.* A whirligig could be mounted in place of a weather vane on a rooftop. Whirligigs have parts that serve as propellers whose blades whirl when they catch the wind. The whirling blades set in motion other parts of the toy. The whirligig pictured in Figure 8-138 shows Uncle Sam riding a bicycle. When this object was made around 1900, bicycles had one large front wheel and a small rear wheel. When the propeller turned, Uncle Sam began to pedal his bicycle. The stronger the wind, the faster he would pedal. The flag fluttering behind him is American on one side, Canadian on the other. Obviously, the artist wanted to promote friendly relations with our neighbors to the north.

Figure 8-137 This dual-purpose device was cleverly designed to look like a locomotive steaming past a tree.

Steam Locomotive Weathervane with Lightning Rod, c. 1840. Anonymous artisan in Rhode Island, c. 1840. Sheet zinc, brass, iron. L: 34". Courtesy The Shelburn Museum, Shelburn, Vermont.

Figure 8-138 This colorful whirligig represents the ingenuity of American folk artists.

Whirligig: Uncle Sam Riding a Bicycle. Anonymous artisan in the northeastern United States, 1880–1920. Carved and polychromed wood, metal. 37" × 55½" × 11". Collection of the Museum of American Folk Art, New York; Promised bequest of Dorothy and Leo Rabkin. P2.1981.6.

The Pennsylvania Dutch. People from all over the world have settled in the United States. As a result, we are able to see diverse artistic and cultural influences in our communities. In parts of Pennsylvania, the influence of the Pennsylvania Dutch is evident. These were actually German immigrants and their descendants, although they shared some artistic traditions with their Old World neighbors, Holland. For example, Holland tulips appear in many Pennsylvania Dutch designs. The Pennsylvania Dutch developed a rich visual language of symbols, which they applied to their belongings. They painted their symbols on the sides of barns, on their furniture, and on birth certificates. The dower chest pictured in Figure 8-139 displays some of these designs. A dower chest was a chest in which a young woman could store items that would be necessary to set up a household after she married. She would keep in it such things as table linens, quilts, and crockery. The painted designs, which include tulips, unicorns, and horseback riders, represent wishes for a successful marriage: love, fidelity, and happiness.

Figure 8-139 This beautifully painted chest was made to contain items necessary to establish a household after marriage.

Pennsylvania German Dower Chest, 1803. American; Berks County, Pennsylvania. Painted wood, with central tulip and unicorn panel. 54". Philadelphia Museum of Art: Gift of Arthur Sussel. '45-12-1.

Section III Review

Answer the following questions on a sheet of paper.

Learn the Vocabulary

Vocabulary terms for this section are *Renaissance*, *figurative painter*, *powwow*, *totem poles*, *itinerant artists*, *trompe l'oeil*, *folk art*, and *whirligigs*.

1. How did itinerant artists earn a living?
2. What type of painting is called trompe l'oeil?

Check Your Knowledge

3. In which European country did the earliest manifestations of the Renaissance appear?
4. What event led to the period of Neoclassicism?
5. What subject often appears in the paintings of John Constable?
6. What movement is Courbet associated with?
7. How do American portraits differ from European portraits?
8. List at least two types of art in which African Americans excelled in early America.

For Further Thought

9. You are assigned to paint the portrait of your favorite actor or actress. Describe how you would portray your subject in a Realist style. How would you change your approach if you were to paint in a Romantic style?

EXPLORING

HISTORY AND CULTURES

At one point, the fate of the 3,200-year-old Temple of Pharaoh Rameses II (see Figure 8-11) was in doubt. In 1965, Egypt had completed construction of the Aswân High Dam across the Nile. The gigantic glory of the temple of Rameses II would soon be under the waters of Lake Nasser unless something was done. Fifty-two nations, including the United States, contributed money, machinery, and expertise to save the monument. Their decision: to move the sandstone mountainside to higher ground. To accomplish this, stonecutters cut the temple into 1,300 pieces, some weighing up to thirty tons. Each piece was carefully cataloged in order to identify correctly its position in this huge jigsaw puzzle. Powerful cranes lifted each piece to a plateau above the original site, where the temple was reassembled (see Figure 8-140 on the opposite page). Moving the hand-hewn tunnels and statues contained inside the mountain was even harder to accomplish than moving the four huge exterior figures. The whole job required a great deal of time, talent, and money.

1. Do you think the expense was worth it? Why or why not?

2. Would you be willing to have your taxpayer's dollars go toward government projects like this in the future? Explain your answer.

3. What monuments in the United States would be worth preserving if put in similar risk?

Figure 8-140 A crane lifts the head of Rameses out of danger of flooding in preparation for the Aswan High Dam across the Nile River.

Photo ©1994 Comstock.

SUMMARY

In this chapter, we have examined many treasures from art history. We have probed the mysteries of ancient worlds and witnessed the glories of mighty kings and queens. Our journey has taken us into the jungles and across the deserts of the earth.

Wherever we searched, across nations and through time, we discovered that people have made art. They may not have thought of their art forms in the same way that we think of ours. For people in other cultures, art may serve ceremonial or sacred purposes. It may pay homage to the authority of powerful rulers. But art has always been an expression of deeply felt ideas, values, and feelings.

Artworks may be gigantic or tiny, frightening or humorous, made of gold or of stone. Artistic expression has come in countless forms, and there is no limit to what art can be today, or tomorrow. Much of what we understand about civilizations throughout history comes from studying the art forms these cultures have left behind. It's interesting to imagine what future generations will think of the civilization in which we dwell.

CHAPTER 8 REVIEW

VOCABULARY TERMS

Write a paragraph or story about one culture using at least five of the vocabulary terms.

allegiance	illuminated manuscripts	portrait bust	serpentine
apprentice	itinerant artist	powwow	sikharas
book of hours	jali	reliquary	step pyramid
codex	Kabuki	Renaissance	striations
dynasty	kiosk	rock art	totem pole
embroidery	mastabas	rock cut temple	trompe l'oeil
figurative painter	minaret	rose window	vellum
finial	mother-of-pearl	scarification	verticality
fluted columns	netsuke	scepter	whirligig
folk art	pantheon	scroll	ziggurat
gargoyle			

Applying What You've Learned

1. What kinds of things can you learn from an artwork?

2. Name some places where ancient rock art has been found.

3. What are Egyptian kings called?

4. Why did Greek architects taper their columns so that they were wider at the base than at the top?

5. What material did Roman architects prefer to work with?

6. What does a scepter symbolize?

7. Name two ways in which rulers have been involved with the creation of art.

8. For what purpose do art historians believe the portrait bust of an oni was used by the Yoruba people?

9. What does the name of the Mogul capital, Fatehpur Sikri, mean?

10. What does the dragon symbolize in Chinese culture?

11. Describe the design of the kimono.

12. What dominated almost every aspect of life in Europe in the Middle Ages?

13. What does a book of hours depict?

14. What famous structure was Raphael commissioned to paint frescoes for?

15. Where is the Louvre located?

16. Name a famous American building whose design is firmly rooted in the architectural style of ancient Greece and Rome.

17. What sort of images were often painted on a dower chest?

Exploration

1. We have seen how allegiance to a ruler or a religion can inspire people to create treasured artworks. Can you think of any way such an allegiance could also hinder or limit artistic expression?

2. Inspired by traditions of Native Americans of the Pacific Northwest, design your own totem pole and describe its components. Unless you happen to be a Native American of the Pacific Northwest, you may not feel qualified to design a totem pole using their artistic styles and symbols. But you might enjoy designing something contemporary, something personal, in the *spirit* of a totem pole. What animal images would you use, and what would they represent to you? If you create your own mythological creatures, explain what they symbolize. Don't forget to include a "watcher." What would your family crest look like? Which colors would you paint your totem pole? Why?

Building Your Process Portfolio

In this chapter you have been invited to paint with a bamboo brush, examine the meanings of cultural artifacts, answer questions about art history, and explore aesthetics and criticism. You may have been inspired to do extra reading and research about an artist, culture, or style. Write a summary of any extra work you did and place it in your portfolio, along with samples of your artwork and other written assignments.

Figure 8-141 The Jefferson Memorial in Washington, D.C. is grounded in the architectural style of Greece and Rome.

Photo ©1994 Peter Gridley/FPG International.

Art in Transition: Modern to Postmodern Art

Figure 9-1 Twentieth-century artist Philip Evergood has captured the energy of a city street.

Philip Evergood, *Sunny Side of the Street*, 1950. Egg-oil-varnish emulsion with marble dust and glass on canvas. 50" × 36¼" (127 × 92.08 cm.). In the Collection of the Corcoran Gallery of Art, Museum Purchase, Anna E. Clark Fund. 51.17.

Contents

Section I Impressionism to Abstractionism

In this section we will explore many of the movements that formed the foundations for twentieth century artistic expression. These movements supplied many of the theories that fueled the imaginations of the later twentieth century. The theories you will read about will illustrate the motivations which brought about changes in style and thinking.

Section II Twentieth-Century Trends

This section presents a survey of the different forms of expression from the 1950s to present day. These forms defied even the unconventional art of the early twentieth century.

Terms to look for

Abstract Expressionism
American Abstractionism
Art Brut
Ash Can School
avant-garde
burnished
Color Field art
Cubism
dynamics
encaustic
Expressionism

Fauvism
Femmage art
Fluxus movement
Futurism
Harlem Renaissance
Installation art
Kinetic art
Light art
manifesto
Minimal art
modern art

Modernism
Op art
Pop art
Postimpressionism
Postmodern art
Process art
pure painting
Regionalism
simultaneity
Suprematism
Surrealism

Objectives

- You will understand the importance of experimentation to the formation of early twentieth-century art movements.

- You will explore the philosophies of twentieth-century art making.

- You will learn to think about the many ways art may be expressed.

- You will understand through the examples set by the twentieth-century artists in this chapter that art is a continuous process of change and growth.

Art in Your Life

In this chapter you will get to examine art of the past one hundred years, right up to our own time. Although art has always reflected something of the life of the age in which it was made, the art you will study in this chapter has special significance. This is art created during the time period when you, your parents, and grandparents have been witnesses and participants in the great and small events that have shaped the contemporary world.

Artists living and working today address in their artworks environmental and social issues you're likely to find on the front pages of your local newspapers, such as pollution, equality between women and men, and racial discrimination. Such artworks can stimulate discussions and get us to think about important issues in our world.

Sometimes people are confronted with art they don't like, or art that they think is immoral. In such cases, artists and the public can struggle over issues of freedom of expression, censorship, and use of tax dollars to fund the arts. The more you know about art, the more intelligent and persuasive your own opinion will be.

Finally, contemporary art can be a refuge from the issues and troubles of the world. Many artists continue to concentrate their efforts on making beautiful and serene artworks. We can find peace in the contemplation of such art.

It is almost impossible for anyone to live in today's world without encountering art. Whether you use art as a way to confront social issues or use it to escape from your worries, you will discover that the visual arts can add new dimensions of meaning to your world. You may choose to be an artist or choose to be a patron of the arts—either way, opportunities abound to enhance your quality of life through participation in the arts.

Section I

Impressionism to Abstractionism

The political revolutions of the late eighteenth century in Europe stirred debates about the rights of citizens, the responsibilities of government, and the limits of authority. These debates led to different political philosophies, such as conservatism, liberalism, and nationalism. We call these philosophies the "isms." These philosophies led to the formation of political systems such as capitalism, socialism, and communism. Political systems consist of people who band together to define and implement common goals and ideas.

Artistic "isms" are formed in much the same way. We have already looked at two of these movements in the art world of the nineteenth century—Romanticism and Realism. Many more developed in Western art as outside influences began to challenge the old traditions.

In the last chapter, when we left Western art in the late 1880s, the movement attracting attention in the art world was Realism. Its most significant European artist and acknowledged leader was Gustave Courbet. The Realists insisted on painting only what the eye could see—no scenes from history, no fantasies, no idealistic images. Yet within these restrictions, Realists still worked in what was known as the "tradition"—a set of guidelines that were supposed to produce great art and that were passed down from the art of Greece, Italy, and the Netherlands.

By the latter years of the nineteenth century, printed reproductions and photographs were beginning to flood the world with visual images. As a result, visual art took two courses. The tradition—that of visual realism—would be carried on by Realist artists and others who followed them. Eventually, this course would also be represented by the realistic images of photographs, motion pictures, and the electronic media of our mod-

ern world. The other course is the path we will now discuss. This path led to the abstract art of the twentieth century.

Impressionism: Departure from the Tradition

We are now about to embark on a journey that will take us from the realistic image to the art we see today. As we look at the steps that led artists away from Realism, try to relate each step to the art of the time. By today's standards, the trends don't seem radical at all. But new directions in art are almost always refused initially, and the artists who dare to challenge the standards of the time are characterized as wild radicals, or worse. The image in Figure 9-2, by Impressionist leader Claude Monet, surely was met with strong reactions when it was first seen.

Our journey starts with the French realist painter Édouard Manet (mah-NAY) (1832–1883). Manet's training was traditional. He copied the old Renaissance and Baroque masters, and was particularly impressed by

Figure 9-2 Monet's quick brush strokes and complementary colors help us anticipate the beginning of a new day.

Claude Monet (French, 1840–1926), *Impression: Rising Sun*. Painted in Le Havre, France, in 1872. Oil on canvas. 19½" × 25½". Musée Marmottan, Paris, France. Photo ©1994 Erich Lessing. Art Resource, NY.

Hals and Goya. However, Manet broke with the tradition, and in doing so, took painting in a new direction. How did he do this, and what did he do?

Consider the work shown in Figure 9-3, painted in 1866. Manet uses flat "patches" of paint, and very little shaping of the image. Shadows are only suggested. The overall appearance of the work is one of flatness, very much like the Japanese prints that Manet admired. The background seems as close to us as does the figure of the fifer. If the fifer were to step forward, it looks like he would leave a hole in the canvas. Instead of providing a window onto a view of the outside world, as traditional artists had, Manet called the viewer's attention to the painting's surface. The important thing to the artist is not the subject, but how it is painted. Manet gave no name to this style, but soon it would influence a revolution—the first true revolution in Western art since the Renaissance.

The title of the painting in Figure 9-2 gave a name to this revolution—Impressionism. It was a new way of looking at reality, a new way of seeing. When you think of Impressionism, perhaps the key word to keep in mind is *light*. Scientists were making new discoveries about the effects of light and color. In the late 1860s, a group of Parisian painters met frequently to discuss these new ideas and to explore the effects of light in painting. These artists chose to work outdoors.

Manet's "patches" of paint were an important influence. As was discussed in Chapter Five, The Impressionist painters began to place small patches of color side by side on their canvases. The patches of color come together in the viewer's eye to produce recognizable shapes and forms. This resulted in softer shapes with no outlines, as in real life. Because the Impressionists rendered exactly what they saw, and they were accurately capturing the effects of light, they considered their works more realistic than those using the traditional method.

The critics and the public didn't share this belief. In 1874, the first Impressionist exhibit was held in Paris. Critics were not just shocked—they were enraged.

A central figure among the Impressionists was Claude Monet (moh-NAY) (1840–1926), whose work we studied in detail in Chapter Five. Monet wanted to capture the effects of light at an exact moment of a visual experience. Camille Pissarro (puh-SAR-oh)

Figure 9-3 Manet painted this work shortly after returning from Spain where he had closely studied the work of Velázquez (see Figure 3-1 on page 124).

Édouard Manet (French, 1832–1883), *The Fifer*, 1866. Oil on canvas. 63" × 38¼". Musée d'Orsay, Paris, France. Scala/Art Resource, NY.

(1830–1903) painted several scenes of Paris boulevards, such as that shown in Figure 9-4, which demonstrate this effect.

The extraordinary use of brilliant color and the impression of capturing a fleeting moment are further illustrated in works by Pierre Auguste Renoir (ren-WAHR) (1841–1919) and Edgar Degas (day-GAH)

Figure 9-4 This painting reflects Pissarro's "freer" style that characterized his work towards the end of his life.

Camille Pissarro (French, b. West Indies, 1830–1903), *La Place du Théâtre Français*, 1895. Oil on canvas. Approx. 28½" × 36½". Los Angeles County Museum of Art, The Mr. and Mrs. George Gard De Sylva Collection.

(1834–1917). Renoir's choice of subject in Figure 9-5 on the next page—people enjoying themselves, visiting, and dancing—is a typical Impressionist theme, as are the theater, ballet, and racetrack scenes of Degas (see Figure 9-6 on the next page).

Sculpture was also in a state of transformation. Many think that Auguste Rodin (oh-gust roh-DAN) (1840–1917) was the greatest sculptor since Gianlorenzo Bernini (jee-ahn-low-RENTS-oh bair-NEE-nee). During the eighteenth and nineteenth centuries, sculpture had been overshadowed by painting. Rodin's strong, personal style revived the importance of sculpture (see Figure 9-7). He modeled his forms in clay or plaster, rather than carving them. Often he left rough patches. The play of the light on the rough and smooth patches of his bronze statues seemed to capture the same effects the Impressionist brushstrokes achieved on canvas.

Emile Zola (a-MEEL ZO-la) one of France's foremost writers, approved of Rodin's style. He convinced

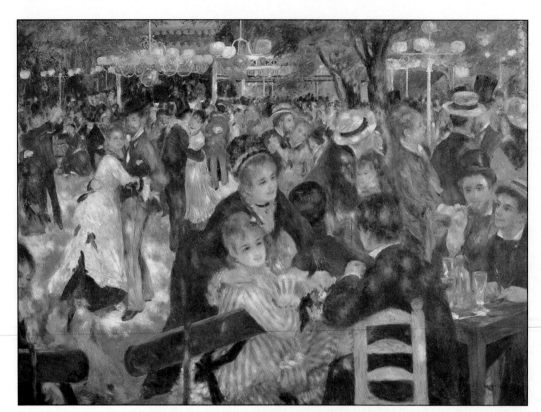

Figure 9-5 Notice the effect of the dappled sunlight on this charming scene.

Pierre-Auguste Renoir (French, 1841–1919), *Dance at Le Moulin de la Galette Montmartre*, 1876. Oil on canvas. Approx. 5′8″ × 4′3″. Musée d'Orsay, Paris, France. Giraudon/Art Resource, NY.

Figure 9-6 Degas has captured a glimpse of ballet dancers practicing their art.

Edgar Degas (French, 1834–1917), *Four Dancers*, c. 1899. Oil on canvas. 59½″ × 71″ (1.511 × 1.802 m.). Chester Dale Collection, National Gallery of Art, Washington, D.C., Photo by Richard Carafelli. ©1993 National Gallery of Art. 1963.10.122.(1786)/PA.

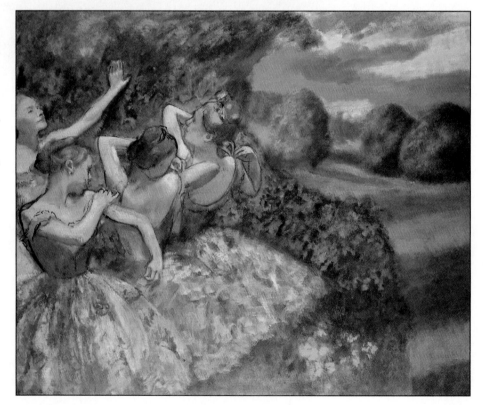

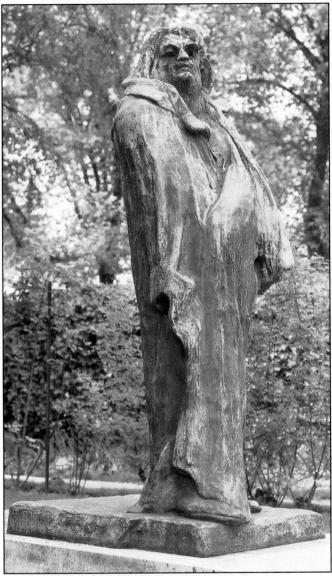

Figure 9-7 This sculpture shocked the literary society that commissioned it. It is considered a fine example of Impressionism.

Auguste Rodin (French, 1840–1917), *Le Monument à Balzac (Balzac Monument)*, 1897. Bronze. Approx. 9′10″ high. Musée Rodin, Paris. Photo ©1994 Bruno Jarret/Artists Rights Society (ARS), New York/ADAGP, Paris; and Musée Rodin. S.1296.

the literary society in Paris to commission Rodin to create a memorial to Honoré de Balzac (on-oh-RAY de BAL-zak), a famous author. Instead of creating a representational sculpture as the society expected, Rodin interpreted the writer as a *person*. Believing that "a true portrait reveals the soul within," the artist searched for the best way to express what was inside the author.

Rodin produced over forty clay models of Balzac in various sizes and positions. He was so thorough in his study that he commissioned a tailor to make a dressing gown identical to the one Balzac wore while writing. The gown was encased in plaster after it was draped around the figure, then bronzed.

When Rodin unveiled the sculpture to the literary society, they were horrified! Refusing to apologize for his work, the artist returned his payment and kept the sculpture. So why is it that Rodin's Balzac is now considered a masterpiece? It has become a symbol of the spirit of Impressionism, a break from convention, and a triumph of the modern spirit.

Postimpressionism

By the late 1880s, many artists felt that Impressionism, while beautiful, also had its limits. They wanted to get away from what they considered to be merely recording what one could see at a particular instant. Many wanted to express their emotions and dreams. Others felt the need for more formal order in their paintings, stressing compositional principles. Most, however, still wanted to use the bright Impressionist palette of colors.

As a result, many different styles developed in the late nineteenth century. The term **Postimpressionism** *refers to a movement that placed new emphasis on the importance of subject, and the formal ways in which a subject was represented.* It was developed in reaction to the theories behind Impressionism.

Among the variety of styles that emerged, we can identify two major categories. The first we may think of as coming from a group of artists who wanted to impose a more formal structure on Impressionism—a structure more solid and durable. The two most important artists who were associated with this change were Paul Cézanne (say-ZAHN) (1839–1906) and Georges Seurat (suh-RAH) (1859–1891). The second category is a group of artists who wanted to express their emotions through their work, and felt the Impressionist style too limiting, too cool, and too detached. Vincent van Gogh (van-GO) (1853–1890) and Paul Gauguin (go-GA) (1848–1903) are two artists

who expanded Impressionist techniques to express their strong emotions.

Paul Cézanne was the leader of those artists who wanted a more formal structure. In the early 1870s, Cézanne had been introduced to Impressionism by Camille Pissarro. Both artists were represented in the first notorious Impressionist exhibit of 1874. However, Cézanne became dissatisfied with his work. He wanted to produce, in his words, "something solid and enduring as the art of the museums." After much careful experimentation (Cézanne was very methodical), he came to the conclusion that he could not achieve this goal using Impressionist techniques alone. In his middle years and later life, he would spend years on one painting, striving for a perfect composition. Rather than using the short daubs of color of the Impressionists, he began using "planes" of color. He did not hesitate to distort his subjects in order to achieve the compositional effects he desired. Cézanne worked on the painting shown in Figure 9-8 for five years.

Manet had focused the viewer's attention on the canvas itself. Cézanne carried this concept a step further—he wanted the viewer of his canvases to see a perfect example of the compositional principles of design. He recreated the world to fit his concepts of design, and because of this, Cézanne is considered a leader of the abstract art movement.

Georges Seurat also created his own method of achieving a more formal order of design. He called the technique Divisionism. It is often referred to as *poin-*

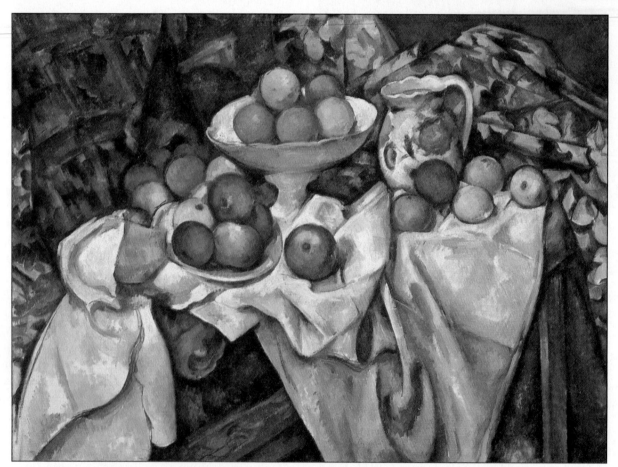

Figure 9-8 Cézanne's objects are pure forms made from color. He had to substitute fruit models for painting a still-life such as this because he worked on it for five years.

Paul Cézanne (French, 1839–1906), *Still Life with Apples and Oranges*, 1990. Oil on canvas. 28¾" × 36¼" (74 × 93 cm.). Musée d'Orsay, Paris, France. Erich Lessing/Art Resource, NY.

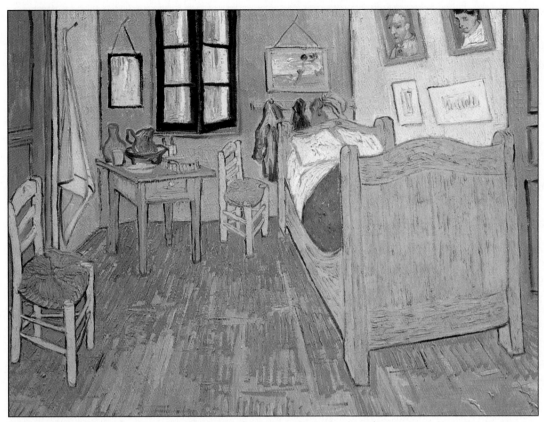

Figure 9-9 How has van Gogh made this room look cool and inviting?

Vincent van Gogh (Dutch, 1853–1890), *The Artist's Bedroom at Arles*, 1889. 22" × 29" (56.5 cm. × 74 cm.). Musée d'Orsay, Paris, France. Erich Lessing/Art Resource, NY.

tillism, and is very difficult and time-consuming. Tiny points of color are placed next to each other. Each point is in full intensity—the eye is to do the blending. This gives a distinctive, dramatic shimmer to the surface. Seurat's acknowledged masterpiece, *A Sunday on La Grande Jatte*, was discussed in Chapter Five.

Vincent van Gogh's paintings and drawings were not fully appreciated during his lifetime. You met van Gogh earlier in the text in Chapters Three, Five, and Seven. His remarkable body of work was to have an enormous impact on twentieth-century Expressionist art. Van Gogh's greatest works were accomplished late in his short life, after he had moved from Paris to Arles (ARL) in the south of France. It was van Gogh's hope that Arles would attract many artists, and eventually become a center where they could create and share their works of art.

Van Gogh rented a quaint yellow house in the village with the intention of sharing it with his fellow artist, Paul Gauguin who had returned to Paris from the South Seas. Van Gogh held Gauguin in the highest esteem, and hoped that they would become lifelong friends. Vincent's love for the house is evident in the work entitled *The Artist's Bedroom at Arles* (Figure 9-9). The "room" in the painting was actually Vincent's bedroom, a cool and inviting place to rest and relax. To van Gogh, this room represented personal stability in what had been a troubled life.

This stability, however, was shaken due to the incompatibility of Gauguin and van Gogh. Being at odds with Gauguin drove Vincent into a deep depression. Eventually the two artists parted company. Van Gogh continued to paint until his death a short while later.

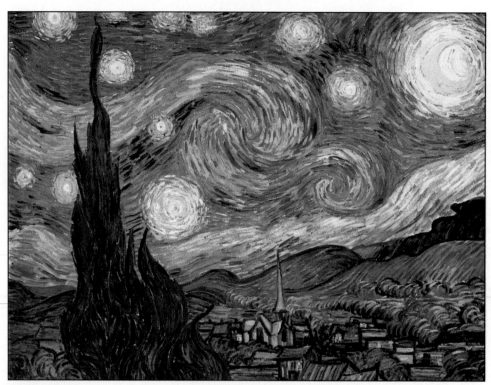

Figure 9-10 Van Gogh's very powerful expression whirls the eye around this landscape upward, downward, and then back upward again. How does he accomplish this?

Vincent van Gogh (Dutch, 1853–1890), *The Starry Night,* 1889. Oil on canvas. 29" × 36¼". The Museum of Modern Art, New York. Acquired through the Lillie P. Bliss Bequest. ©1992 MOMA.

Despite his despair, he left behind a number of paintings of the French countryside, resplendent with color (see Figure 9-10).

Paul Gauguin's expressive work had a great influence on the art world. He, too, rejected the Impressionists' use of patches of color for flatter areas of intense color. Instead of imitating nature, he was interested in dramatic, decorative patterns inspired by the islands where he spent the majority of his life. His paintings of the native people in their tropical paradise are characterized by his use of huge areas of brilliant, flat color with strong outlines. Along with the tropical subject matter came Gauguin's intrigue with the spirituality of native beliefs. This is evident in the images he placed in his self-portrait seen in Figure 9-11 on the next page.

Gauguin, van Gogh, and Cézanne would become major influences on the art of the twentieth century.

Gauguin's brilliant use of flat color would be emulated by the American Abstractionists and van Gogh would influence the Fauves. The philosophies of Cubism would be based on the art of Cézanne. You will read further about these movements in this section.

As the nineteenth century ended, improvements in photography were threatening to take over the traditional role of the painter in supplying a reliable image of nature. Mass-produced prints and printed reproductions in books and magazines provided the world with countless realistic images. Faced with these circumstances, most artists abandoned Realism. Instead, they began to render unique personal interpretations of the visual world. This trend took many different directions in the twentieth century. The subsections that follow examine some of the trends in late nineteenth-century and early twentieth-century art.

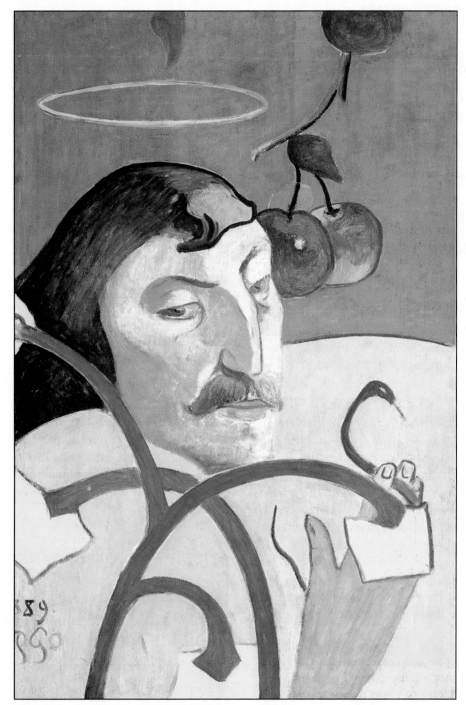

Figure 9-11 Gauguin used color in flat, contrasting areas to emphasize its emotional effect. What meaning can you attach to Gaugin's own expression, the halo, the serpent, and the forbidden apples?

Paul Gauguin (French, 1848–1903), *Self-Portrait*, 1889. Oil on wood, 31¼" × 20¼" (.792 × .513 m.). Chester Dale Collection, ©1993 National Gallery of Art, Washington, D.C. Photo by Jose Naranjo. 1963.10.150.(1814)/PA.

Jason Martin, 18
Buena High School; Sierra Vista, AZ

Fauvism

Many of the turn-of-the-century art movements seemed to shock or appall both art critics and the public. As you discovered in Chapter Three the Fauves were no exception. The modern art being exhibited in Paris around 1905 seemed scandalous to the French public. The Fauves believed that color should never be overpowered by subject matter. **Fauvism** *is the arbitrary use of color.* In other words, they would select a color for a subject without regard for what color the subject was naturally. For example, faces might be green and red, and hair would be purple. Instead of shadows being the customary gray or dark blend of colors, they might be blue or green.

Henri Matisse, a leading member of the Fauvist group, expressed himself with bold colors and rhythmic lines. He simplified his work to exclude any lines that were not important while holding the idea that color was more important than subject matter. In Matisse's *Red Room* (see Figure 9-12) we focus for a moment on the woman at the table, our eyes quickly move around the picture. There seems to be no part of this picture that is more important than another. Matisse even integrates the pattern on the tablecloth with the other shapes in the room. It is hard to tell, in places, where the tablecloth ends and the wall begins. This is what Matisse wanted. The colors and shapes are the important forces here, not the subject matter.

Described by Picasso as "having sun in his belly," Matisse devoted a lifetime to discovering the joyous nature of "shapes, uplifting colors, and appealing subjects."

With its wildly experimental nature, Fauvism lay the groundwork for expressive color experimentation in later artistic movements. By 1907, members of the movement had moved on to other forms of expression. Matisse was the only artist who continued to focus on exploring the nature of pure color.

Additional members of the Fauvist movement included Maurice de Vlaminck (1876–1958), André Derain (1880–1954), and Georges Rouault (1871–1958).

Expressionism

One of the things that makes human beings unique is the capacity to react to events with emotions. *The expression of deeply felt emotions was the unifying principle* behind **Expressionism,** an artistic movement that began in Germany during the early part of the twentieth century. Although expressing emotions through works of art was not a new idea, making that expression the principle goal set the Expressionists apart as a movement.

"All I wish for is that my picture should communicate the emotion that went into it."

Pablo Picasso

In 1905, a number of young German artists formed the first of two Expressionist groups. This first group was called Die Brucke or "The Bridge." They felt that

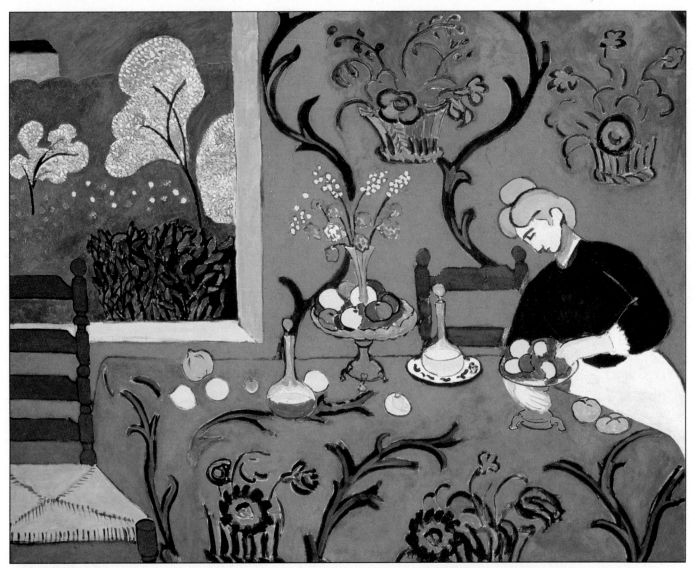

Figure 9-12 How would you describe the impact of Matisse's intense use of color on the viewer?

Henri Matisse (French, 1869–1954), *Red Room (Harmony in Red)*, 1908–09. Approx. 71" × 97". State Hermitage Museum, St. Petersburg, Russia. ©1994 Succession H. Matisse/Artists Rights Society (ARS), New York. Scala/Art Resource, NY.

their art was a way to "bridge," or unite the artistic efforts of the young German artists. Their paintings and woodcuts openly expressed deep and intense feelings about a world that troubled them. Their works were not always heavy, depressing statements. They could be lighthearted, as well. Nevertheless, the emotions expressed in their art were always intense.

The Expressionists often painted grotesque images of the human figure. Faces and bodies were stretched and twisted in disturbing ways. They did this to create great tension and agitation between the elements in their compositions. They used jarring colors and disturbing combinations of shapes to paint what they believed could not be seen—the dark side of life.

Some of the most successful members of Die Brucke were Max Ernst (1891–1976), Ernst Ludwig Kirchner (1880–1938), Erich Heckel (1883–1970), Emil Nolde (1867–1956), and Max Pechstein (1881–1955).

Emil Nolde, whom you met in Chapter One, studied painting in Germany and in Paris, France. His work was Impressionist in style until about 1904. Then, while in Paris, he was exposed to and greatly influenced by African art. African masks intrigued him the most. Nolde described the masks he saw as "intense,

Figure 9-13 Nolde expresses great emotion and tragedy in these distorted faces.

Emil Nolde (German, 1867–1956), *Masks*, 1911. Oil on canvas. 28¾" × 30½" (73.0 × 77.5 cm.). Collection of The Nelson-Atkins Museum of Art, Kansas City, Missouri; Gift of the Friends of Art. ©Nolde-Stiftung Seebüll.

grotesque, expressive of strength and life."

Nolde's series of masks are disturbing images hanging by strings (see Figure 9-13). They are crude and horrifying forms, painted in colors. Nolde considered these masks to be sinister. There is an emptiness to them that seems to touch the very soul of the viewer.

In 1910, a second group of Expressionist painters, Die Blaue Reiter ("The Blue Horsemen"), was founded by a Russian artist named Wassily Kandinsky. The group took its name from a painting by Kandinsky with the same title. This second movement brought together Expressionist artists who lived in countries other than Germany, as well as a few young German artists. Members of Die Blaue Reiter included two Russian artists, Kandinsky (1866–1944) and Alex von Jawlensky (1864–1941); Swiss artist Paul Klee (1879–1940); and German artist Franz Marc (1880–1916). These artists were more diverse in their approaches to making art than the first group of Expressionists had been.

Marc's style of painting is very different from Nolde's. Marc loved to use animals as his subject because he was fascinated by their movements. While the subjects of Marc's work may be different from those of other Expressionists, the emotions he communicates are still very clear to the viewer.

In *Two Cats* (see Figure 9-14), Marc has placed his colorful cats in familiar surroundings. He would make representational studies of animals before starting a painting. Then Marc would abstract the subjects and paint them with brilliant colors. He would render the environment in the same manner as the animals.

Figure 9-14 Marc's cats capture the essence of the animals as one turns to groom itself and the other gets ready to pounce on the yarn.

Franz Marc (1880–1916), *Two Cats*. Oeffentliche Kunstsammlung, Basel, Switzerland. Bridgeman/Art Resource, NY.

Wassily Kandinsky (vahs-i-lee can-DIN-skey) (1866–1944) is one of the most notable pioneers of abstract art during the twentieth century. Born in Moscow, Kandinsky began a career in law and politics before turning to art at age thirty. He settled in Munich to study painting, meeting Franz Marc in 1911. Together, the two artists led the Die Blaue Reiter movement. Kandinsky's earliest works, primarily landscapes, were not totally abstracted. The elimination of recognizable subject matter from his paintings took place over several decades. In 1917, Kandinsky returned to Russia and developed a curriculum to be taught in art schools. He would later teach at the Bauhaus in Germany (Chapters Six and Ten).

According to Kandinsky, his art was "pure painting." **Pure painting** *was abstracting and simplifying images until only color, line, and shape remained.* Eventually, Kandinsky would limit his shapes to geometric, ordered ones. In (see Figure 9-15) *Improvisation without title*, we see colors that are rhythmically placed across the canvas, creating a lighthearted mood. Kandinsky gave many of his paintings musical titles such as "Improvisation" and "Composition," suggesting that they possess a spontaneous, lyrical quality.

In addition to the members of Die Brucke and Die Blaue Reiter, there were many individual Expressionists who worked on their own. They included artists like Käthe Kollwitz (1867–1945), Oskar Kokoschka (1886–1980), Max Beckman (1884–1950), and George Grosz (1893–1959), among others. Max Beckman and George Grosz came to the United States to continue their careers after the Nazis took over Germany.

Cubism

Cubism is used to describe an art movement begun by Pablo Picasso (pah-blow pee-KAH-so) (1881–1973), Juan Gris (wahn gree) (1887–1927), Fernand Léger (fair-nahn le-ZJEH) (1881–1955), and Georges Braque (GEORG-ess brahk) (1882–1963). Picasso, whom you have met in earlier chapters, prompted the movement with his painting *Les demoiselles d'Avignion* (1907). In this work, five female figures have faces, arms, and legs that have visually fractured and shifted on the canvas surface. Picasso's approach to his work during this time in his life was influenced by the geometric forms in

Figure 9-15 One of his many improvisations. Kandinsky called this "pure painting."

Wassily Kandinsky, *Improvisation without title*, 1914. Staedtische Galerie, Munich ©1994, Artists Rights Society (ARS), New York/ADAGP, Paris. Giraudon/Art Resource, NY.

African masks. The word *cubism*, however, was invented by a critic, Louis Vauxcelles, during a review of Braque's paintings at an exhibition. **Cubism** *is art in which the subject matter is rendered using geometric forms.*

The development of Cubism during the twentieth century is viewed in three stages. The first stage, devoted almost entirely to landscapes, was inspired by Cézanne's paintings. The Cubist landscapes consisted of

Figure 9-16 There is no mistaking the agony this woman feels.

Pablo Picasso (b. Spanish, worked in France, 1881–1973), *Weeping Woman*, 1937. Oil on canvas, 23½" × 19¼". Courtesy The Tate Gallery, London/Art Resource, NY. ©1994 Artists Rights Society (ARS), New York.

interrupted planes of images and geometric forms. In 1910, the artists abandoned outdoor scenes for still-lifes. Working strictly in studios they fragmented objects such as glasses, violins, and pitchers. Their palettes were limited to greys, browns, and deep yellows. This period is referred to as the *Analytic Period*.

The third time period during the movement was the most experimental and influential upon future artists. The *Synthetic Period* witnessed the inclusion of stenciled letters, imitation wood, wallpaper pieces, and newspaper in the paintings. Combined with the fractured images, these objects formed what is known as the *collage* technique.

Appreciating Cubist art is not difficult when you understand how it is made. A subject (a still-life, the human figure, or a single object) is broken down into its simplest forms, taken apart, and reassembled in a brand-new way. Although the Cubists always left something recognizable in their compositions, the object would be abstracted. Often, Cubist compositions showed their subjects from many different angles or viewpoints all at the same time. This is known as **simultaneity,** *the viewing of many of a subject's surfaces at once.*

In Figures 9-16 and 9-17, we can see the principle of simultaneity in action. Picasso's *Weeping Woman* (Figure 9-16) is not a realistic portrait of a woman crying. Yet in some respects, it is a more convincing portrait of grief than a strictly representational one would be. We can feel the extreme anguish the woman is experiencing in the combination of green and yellow surfaces that Picasso has chosen for her face viewed at different angles. In addition, Picasso has heightened the message of grief by showing the woman biting a white handkerchief clutched tightly to her face with one hand, while she wipes away tears with the other.

In *The Enamel Casserole* (Figure 9-17), Picasso shows us the analytical nature of his art. Here we see three items—a pitcher, a candle, and a pot—all arranged on

Figure 9-17 Picasso used simple geometric forms to create this still-life.

Pablo Picasso (b. Spanish, worked in France, 1881–1973), *The Enamel Casserole*, 1945. Oil on canvas. 32⅝" × 41⅜". Musée National d'Art Moderne, Paris, France. ©1994 Artists Rights Society (ARS), New York/SPADEM. Giraudon/Art Resource, NY.

Student Activity 1
Cubist Cut Paper Still-Life

Goals

1. You will create a two-dimensional composition that demonstrates the geometric nature of the Cubist style.
2. You will study three-dimensional objects and translate their forms into two-dimensional geometric shapes.
3. You will use the geometric shapes to create still-life images with cut paper.

Materials

1. An assortment of brightly colored construction paper
2. Scissors
3. Glue
4. 24" × 36" white drawing paper or poster board
5. Drawing pencil
6. An assortment of fresh or imitation fruits
7. A large and interesting fruit bowl (one with a pedestal would be ideal)
8. Sketch paper and pencil

Directions

In the formative years of the Cubist movement, a favorite subject of the Picasso and Braque was the still-life. Their still-lifes were simple arrangements of two or three objects, or a bowl of fruit. In your compositions, you will be using a bowl of fruit as your subject as well.

1. To start, lay out your assortment of fruits on the table in front of you. Study them carefully, paying attention to their form. What geometric shapes do you see in them? If you are using fresh fruit, consider cutting one of the fruits open. Observe the different geometric shapes present in the slice removed from the fruit. What about the opening made by removing a slice of fruit from the whole? Are there more geometric shapes visible on the inside of the fruit as well?

2. After you have thoroughly observed the fruit and fruit bowl, make a series of sketches showing the shapes of the fruit and bowl translated into geometric shapes. One piece of fruit may be made up of many smaller shapes, and so may the bowl. Try to keep your sketches approximately life-size.

3. Select your best sketch of the bowl and each fruit, and cut it out of the paper. Then cut the sketch into the shapes you have observed and drawn from inside each object.

4. Start with the bowl first. Trace each piece of paper you have cut from your bowl sketch onto a piece of construction paper. You may cut your shapes for the bowl, or one piece of fruit, out of several colors of construction paper. This will allow for the fact that some objects have multicolored surfaces. Be careful to do only one object at a time. If you cut them all up at the same time you will find that you have too many pieces of paper to manage.

5. After you have cut the shapes (for one object) from the construction paper, reassemble them to create the whole object. Then glue the shapes down. Complete the fruit bowl first, and then position the fruits in the bowl as you finish each one.

6. Although you are assembling and positioning only one object at a time, be careful to consider the composition as a whole as you are working.

7. When your fruit bowl is done, use colored paper to create an appropriate background for your composition. When you are done, mat and display your work.

Evaluation

1. Did you find an assortment of fruits for your work that added interest to your composition? What qualities did they have that made them unusual? Did you find a bowl for the fruit that was interesting as well? Why did you choose that particular one?

2. What problems did you encounter when translating the three-dimensional objects into geometric shapes? How did you solve those problems?

3. How did you use the elements and principles to complete your composition?

Figure 9-18 Has Braque created a "symphony" in this painting?

Georges Braque (French, 1882–1963), *The Musician's Table*, 1913. Kunstmuseum, Basel, Switzerland. ©Artists Rights Society, NY. Giraudon/Art Resource, NY.

a table. The artist has broken these objects down into simple geometric forms. The pitcher is viewed from the side while the mouth of the pitcher is seen from above.

Georges Braque created his art with the same goals in mind. In *The Musician's Table* (see Figure 9-18), we see layer upon layer of music, programs, and instrument parts scattered across the table. Braque's visual arrangement is as complex as music itself, layer upon layer of melody and harmony all working together to produce a beautiful composition.

As time went on, the Cubists continued to invent new ways of representing their subjects. Some of the principles of Cubist art were adopted or added to by later artistic movements, as you will see. One thing is sure: the Cubists showed other modern artists the way to new and exciting experimentation in their art. The art world would never be the same!

> "I treat paintings as I treat objects. If a window in a picture looks wrong, I close it and draw the curtains, just as I would do in my own room."
>
> **Pablo Picasso**

Mexican Muralists

The year 1921 saw the end of the Mexican Revolution, and the fall of Mexican dictator Porfirio Díaz (por-FEER-e-oh DEE-az). The end of his tyranny signaled the beginning of the art of the Mexican muralists, and for the Mexicans, a new awareness of themselves as a nation and a people. Now the government would begin to reform, and the art of Diego Rivera (1886–1957), whom you met in Chapter One, José Clemente Orozco (1883–1949), and David Siqueiros (1896–1974), would set the spirit of the Mexican people free.

Although these artists did not form an "ism" or an organized group like the Cubists or Fauves, the Mexican muralists were all inspired by the same sense of mission. That mission was to tell the story of the people, to the people. In order to take their art to the people, the muralists painted their works on both the inside and the outside walls of buildings.

Some of the muralists studied art in Europe. As a result, they responded to several influences on their work. Diego Rivera, for example, received his formal art training in Europe between 1907 and 1921. He was greatly influenced by the images created by the Cubists. In addition, both he and Orozco spent time studying the art of the master Italian fresco painters. They concentrated in particular on the techniques and practices of Michelangelo. Although the Mexican people had a history of mural painting inherited from some of their pre-Columbian cultures (see Chapter Six), the tech-

niques these artists learned in Europe added to their knowledge.

The subject matter of the Mexican muralists was the central focus of their work. The Mexican muralist art represented images of Mexican people, revolution and oppression, native traditions, customs and festivals, legends, industrialization, and hope for the future of the people of Mexico.

The murals of Diego Rivera were monumental in size, and equally grand in their passionate messages. In *Flower Day* (see Figure 9-19), we can see soft geometric shapes, like those of the Cubists, in the stylized bodies of the peasants. There is a sense of reverence in this picture. The peasants give thanks to God for giving them the bounty of flowers with which to make a living. Rivera has echoed their prayers in the cross-like

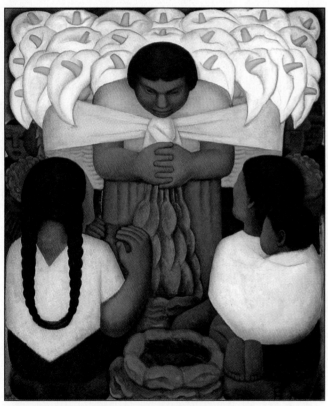

Figure 9-19 Diego Rivera shows the reverent nature of his peasant subjects as they give thanks for the flowers that provide their living.

Diego Rivera (Mexican, 1886–1957), *Flower Day*, 1925. Oil on canvas. 58" × 47½". Los Angeles County Museum of Art. Photo ©1993 Museum Associates. 25.7.1. Reproduction authorized by the National Institute of Arts and Literature in Mexico.

image superimposed (having one image appear on top of another) over the body of the man carrying the basket of pure white lilies.

Rivera's images were also influenced by the graphic characters and political satire of newspaper artist José Guadalupe Posada (1852–1913). Posada used distortion and expression in his works to emphasize his messages. These qualities heighten the sense of drama in Rivera's works.

Although Rivera did come to the United States to do some mural work for Henry Ford and the Rockefeller family, his Communist party ties caused him to be rejected by many American patrons. This did not dampen his spirit or his sense of social obligation. He continued to paint about the success of creative labor, and the destructive aspects of capitalism and poverty.

The work of artist José Orozco was quite different from that of Rivera. His works were highly emotional statements expressing his hatred of any form of tyranny. Orozco's paintings are full of rage and fury, and his characters seem to possess a wild and untamed quality. Figure 9-20 on the next page offers a good example.

Mexican artist David Siqueiros was a good friend of Diego Rivera. They were both considered to be influential members of the Mexican Communist party. In 1929, Siqueiros gave up painting altogether to devote his life to political activism. He was eventually imprisoned and later exiled. In Spain, he continued his fight against tyranny in the Spanish Civil War.

Some people have considered Siqueiros's art to be spectacular. His themes centered around folklore, and a sense of Social Realism. His style is described as unreal, possessing a dream-like quality. He has also been credited with pioneering new techniques, such as the direct application of photographs and the use of air propelled paint (air-brushing) on his canvases.

The Mexican muralists presented strong social and political views of a nation struggling to free itself from generations of tyranny and oppression that had been imposed on its people by cruel and corrupt landowners. The muralists set an example for future groups of socially minded artists who wanted to make a nation take a good look at itself. Social and political issues would surface again as themes in art, and artists would continue to question and represent the plight of their people.

Figure 9-20 Orozco's subjects seem unable to escape a fiery end.

José Clemente Orozco, (Mexican), *El hombre de fuego (Man of Fire)*, 1939. Fresco. Hospicio Cabanas, Guadalajara, Mexico. Schalkwijk/Art Resource, NY.

Futurism

At the turn of the century, most of the Western world entered the machine age. This was a time when machines began to make work more productive and life a little more pleasant. These wondrous machines captured the imaginations of a small group of Italian artists in 1909. They called themselves the Futurists. **Futurism** *is the marriage of the qualities of modern technology with the expressive images of art.*

The Futurists were very vocal about their ideas and beliefs. In February of 1909, they issued a manifesto stating their aims as artists. A **manifesto** *is a proclamation of ideas or intentions.* In this radical document,

the Futurists stated their ideas about "looking to the future" for dynamic inspiration. The word *dynamic* is very important to Futurist art. **Dynamics** refers to the *rhythm and movement in their art that expresses great action, energy, and force.* These qualities were observed by the Futurists as being "machine like." When machines moved, they would grind and crank and spin, and there was a sense of forcefulness and energy in their movement.

Playwright and poet Filippo Tommaso Marinetti (1876–1944) wrote that Futurist art "celebrated technology and scientific advance. . . . We shall sing the love of danger, the habit of energy, boldness . . . new beauty—the beauty of speed . . . a roaring automobile, which seems to run like a machine gun, is more beautiful than *Nike of Samothrace*" (an ancient Greek sculpture that we discussed in Chapter Eight).

Marinetti's statement is not hard to understand. When we buy things like a bicycle, a car, or an appliance, we often make our selection based on how an

> "**H**e that seeks popularity in art closes the door on his own genius . . ."
>
> **Anna Brownell Jameson**

object looks, as well as on how well it might function. Marinetti is suggesting that machines can be as beautiful as a classic piece of sculpture, because machines can be dynamic in appearance as well as in function. As impressive as the "roar" of an automobile are its bright shiny color and the movement of its powerful engine.

The Futurists glorified machines and the way in which they moved. They translated this movement and forcefulness in their art into lines, shapes, and colors. Their images were bold.

Sculpture was a particularly good art form in which to express these forceful images. Machine parts inspired shapes and forms. Futurists like Umberto Boccioni (oom-BAIR-toe bought-she-OH-nee) (1882–1916) created dynamic sculptures that expressed a feeling of

Figure 9-21 Does this sculpture seem to have motion?

Umberto Boccioni, *Unique Forms of Continuity in Space*, 1913. Bronze (cast 1931), 43⅞" × 34⅞" × 15¾". The Museum of Modern Art, New York. Acquired through the Lillie P. Bliss Bequest. Photo ©1994 The Museum of Modern Art, NY.

movement. The sculpture entitled *Unique Forms of Continuity in Space* (see Figure 9-21) is a good example of such dynamics. The bold geometric shapes appear to move, even though they actually do not. Looking more closely at this sculpture, you may notice that the shapes look very much like those developed by the Cubists. The Futurists were greatly influenced by the Cubists' work. The Futurists were excited by the radical changes in style and technique brought about by the Cubists. However, they also felt that the Cubists stuck to the same old subject matter—still-lifes, portraits, and so on—that had dominated the art world for too long. The Futurists felt that Cubist images just sat still. They liked the forms and shapes that the Cubists used, but felt that what Cubist art needed was a sense of movement.

Figure 9-22 Balla's use of color in a repetitive pattern lets us "see" the light radiating from the bulb.

Giacomo Balla, *Street Light (Lampada—Studio di luce)*, 1909. Oil on canvas, 68¾" × 45¼". The Museum of Modern Art, New York. Hillman Periodicals Fund. Photo ©1993 The Museum of Modern Art.

So Futurist painters like Giacomo Balla (GEE-ah-co-mo BAH-la) (1871–1958) became fascinated with representing motion on canvas. Some of Balla's works look as if they were based on a series of slow-motion photographs.

In *The Street Light* (see Figure 9-22), we get a sense of the street lamp's rays of light, radiating into the night's darkness. Although we cannot touch these rays of light, we can see their dynamic effect on the atmosphere.

In addition to Balla and Boccioni, there were two other important Futurists, Gino Severini (1883–1966) and Italian American artist Joseph Stella (1877–1946). We discussed Joseph Stella in Chapter Two. He chose to paint American subjects, and his work includes a series of Brooklyn Bridge paintings and a five-panel series entitled *Voice of the City of New York Interpreted*.

The Futurist movement lasted only about four years and, except for Stella, never really moved outside Italy. It did, however, have a lasting impression on the innovative work of later twentieth-century artists.

The Ash Can School

As you learned in Chapter Six, the Ash Can School was a name given by an art critic to American urban realist painters who produced works from 1908 until the United States went to war in 1917. The term *Ash Can* referred to the subject matter that these artists chose to paint. The **Ash Can School** *was a group of painters who filled their canvases with images of the American city:* tenement buildings, the streets and back alleys, and the theaters and night spots that teemed with the bustle of the city. These painters wanted to be associated with the United States and the American way of life (see Chapters Six and Seven).

The group included five members of "The Eight," an earlier gathering of artists known for their disregard of nationally accepted styles and subject matter. These five included Robert Henri, John Sloan, George Luks, William Glackens, and Everett Shinn. These artists painted life around them as they saw it. Their painting styles reflected the influence of European art schools but their subject matter was uniquely their own. They painted the rich diversity of city dwellers and their environments with subdued colors, and with broad, quick, brush strokes. Their art was considered radical, but it seldom dealt with serious controversial issues. Instead, the Ash Can artists focused on the "picturesque" (scenic) quality of their subjects and locations.

Nowhere is this more true than in the works of John Sloan and George Bellows, two of the Ash Can School's most prominent painters. Their paintings of urban life startled the public and appalled the critics. Like the other Ash Can artists, Sloan and Bellows tried to paint reality as opposed to beauty. They painted the rough and unsightly side of life in the city.

In *Dust Storm, Fifth Avenue* (Figure 9-23 on the next page), Sloan sends the smartly dressed crowd scattering in panic as huge clouds of dust roll down the street. It seems an unlikely sight—something you would expect to see on the prairie, not Fifth Avenue! People hold onto their hats as they run, looking for shelter and safety. The trees bending and blowing in the wind create a sense that the forces at work here cannot be controlled. The fashionable avenue is now at the mercy of Mother Nature.

Living conditions, and the practices of daily life, gave Ash Can artists like George Bellows a wealth of subjects to paint. In his work entitled *Cliff Dwellers* (Figure 9-24 on page 509), Bellows shows us the very subject that shocked the critics and made the Ash Can artists famous: tenement living at its most active.

Horrified at the sight of Bellows's painting, *New York Sun* critic Henry McBride said, "George Bellows's *Cliff Dwellers* is appalling. Can New York really be like that in the summer?" In fact, it could be, and it was. Bellows painted New York as he saw it: rough, dirty, and overcrowded. In spite of these conditions, the people in Bellows's work appear, for the most part, to enjoy life—working, playing, and loving.

In addition to Sloan, Bellows, and the others mentioned earlier, members of the Ash Can School included Glenn Coleman (1887–1932), Arthur Bowen Davies (1862–1928), Guy Pène DuBois (1884–1958), Edward Hopper (1882–1967), and Alfred Henry Maurer (1868–1932).

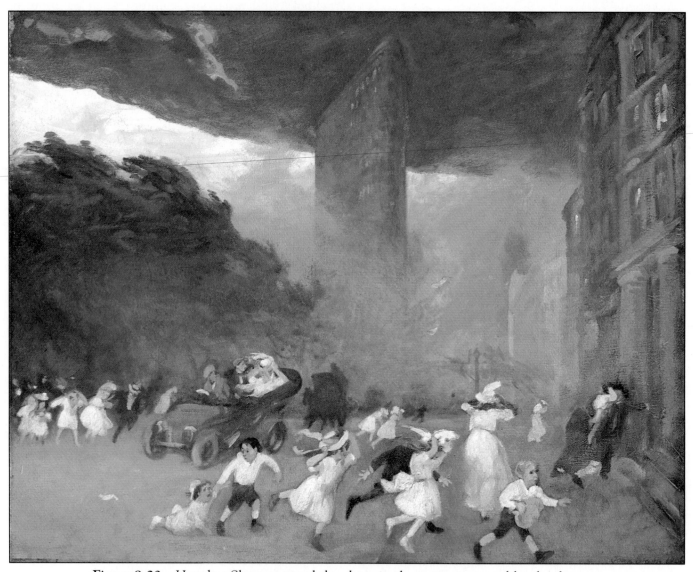

Figure 9-23 How has Sloan captured the chaos in the street generated by the dust storm?

John Sloan (American, 1871–1951), *Dust Storm, Fifth Avenue*, 1906. Oil on canvas. H; 22" × L: 27" (55.9 × 68.6 cm.). Metropolitan Museum of Art, New York, George A. Hearn Fund, 1921. 21.41.2.

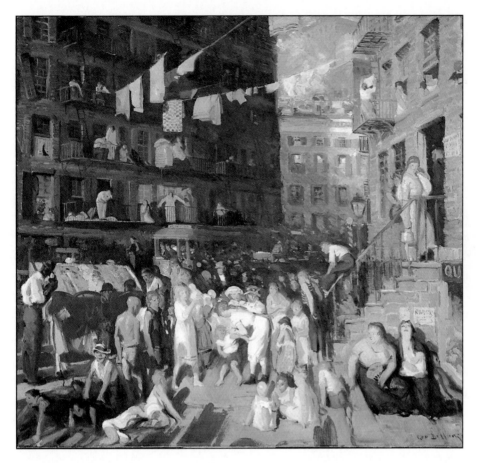

Suprematism

In 1913, a small group of Russian artists met in Moscow to form a new artistic movement called Suprematism. In its first stages, the movement was characterized by some as being both Cubist and Futurist. This was because the basic look of their art included a combination of both solid, geometric shapes and a sense of dynamics.

This was not the case with their later works of art, however. Suprematist artists quickly moved away from the traditions of the Cubists and Futurists to refine and perfect a style of their own.

As we mentioned before, the Cubists left identifiable objects in their works. The Futurists, however, moved closer to obscuring recognizable subjects in their works. In Suprematist works of art, recognizable subject matter is completely left out. **Suprematism** *is the making of paintings of geometric shapes of color that interact subtly with backgrounds of similar intensity.* The interesting thing about these works is that the shapes in them represent nothing. In other words, the shapes of color are just that, shapes of color and nothing more. They are not symbolic of other objects or persons.

This presented a special challenge to the Suprematists. If the only subjects in their works were to be geometric shapes, then the arrangement of them needed to be as perfect as the artist could make it. The artist needed to be completely aware of the precise placement of each of the shapes, and of how the colors of the shapes interacted in the composition.

One of the prominent founders of the Suprematist movement was Kasimir Malevich (ka-see-meer MAL-EH-vitch) (1878–1935). Malevich said of the term *Suprematism* "By Suprematism I mean the supremacy (superior quality) of pure feeling or perception (understanding expressed) in the pictorial arts." Born in Kiev, he lived a very humble life. When he came to Moscow,

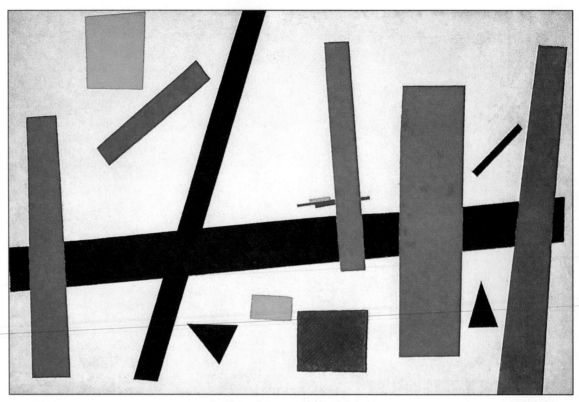

Figure 9-25 Can you explain how this work exemplifies Suprematism?

Kasimir Malevich, *Suprematism No. 50*, 1915. Oil on canvas. Stedelijk Museum, Amsterdam, The Netherlands. Art Resource, NY.

he taught himself to paint in the style of the Impressionists and, in particular, of Cézanne. He painted with a bright and intense palette, using rich hues of red, sky blue, yellows, and greens. He quickly progressed from Cubist forms to works of art like *Suprematist Composition: White on White*. In this work, Malevich painted nothing but a white square on a white background. One square has a slightly warm hue to it, while the other has a slightly cool hue to it. With such limited subject matter, Malevich had to be sure that he created the best arrangement possible for his composition. The question of why only white was used in the painting was explained by the artist: "I have cracked the links and the limitations of color. I want you to plunge into whiteness . . . and to swim in this infinity."

In another work, entitled *Suprematism No. 50* (see Figure 9-25), Malevich experimented more openly with contrasting colors and shapes. There is more movement in this composition, but the emphasis is still on the artist's choice of basic shapes and colors.

Although Suprematism did not have a large following of artists, and did not last very long, it did help artists outside the movement develop a greater technical understanding of composition. Much of what they learned has been applied to later twentieth-century works of art.

Surrealism, Dada, and Fantasy

At the end of World War I, instead of experiencing the prosperity and peace that everyone had hoped for, Europe was in a state of turmoil. This unrest prompted a group of artists to express their feelings about the plight of the European nations through a nonsensical approach to making art. This movement, known as Dada (DAH-dah) (1915 to 1923) and explained in Chapter Three, combined ordinary objects together to create thought-provoking images (see Marcel Duchamp's *Bicycle Wheel* in Chapter Three).

When Dada ended, a new form of altering reality began during the 1920s. This movement, called **Surrealism,** *was an art style in which artists combined naturally unrelated events, images, objects or situations in a dreamlike scene.* It began with French writer André Breton, who embraced the Dada philosophy that art, like other events in life, occurs at random instead of in logical order. Breton would write compositions that consisted of thoughts as they came to him, rather than describing them in a logical sequence. Time and space as we know them were ignored. Objects became distorted and altered to create a "new reality." Dreams and the subconscious mind (images and thoughts in your mind that you are not aware of) became the source of ideas for subjects in drawings and paintings.

Salvador Dali (1904–1989) was a Surrealist artist whose work continues to influence the art world. Dali attended a school of fine arts in Madrid, Spain where his work was influenced by Futurist and Cubist artists.

He joined the Surrealist movement in 1928 after meeting Breton. In his most famous work, *The Persistence of Memory* (see Figure 9-26), he presented a world of decomposing organic forms, pocket watches that are limp, and an eerie landscape without a sign of humanity. In this painting, solids become liquid, and time literally stands still. Dali once described how he worked in the hopes of capturing his dreams on canvas. "I would awake at sunrise, and without washing or dressing sit down before the easel which stood right beside my bed. Thus the first image I saw on awakening was the painting I had begun, as it was the last I saw in the evening when I retired. And I tried to go to sleep while looking at it fixedly, as though by endeavoring to link it to my sleep I could succeed in not separating myself from it".

Spanish artist Joan Miró (1893–1983), whose art you saw in Chapter Five, created another type of fantasy. Whereas Dali created fantasy worlds based upon recognizable objects, Miró used visual symbols which

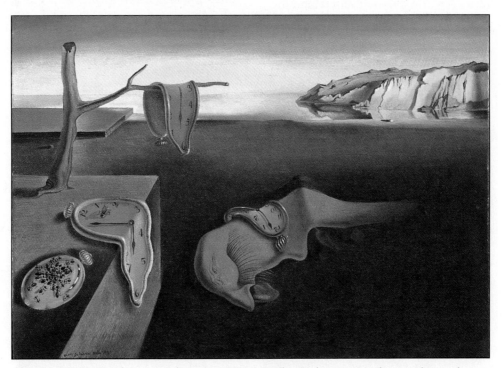

Figure 9-26 In this surrealistic composition by Dali, time and everything else seem perfectly still.

Salvador Dali (Spanish, 1904–1989), *The Persistence of Memory (Persistence de la mémoire)*, 1931. Oil on canvas. 9½" × 13" (24.1 × 23 cm.). Collection, The Museum of Modern Art, New York. Given anonymously. ©1994 Demart Pro Arte, Geneva/Artists Rights Society (ARS), NY.

he invented. He created signs and symbols to represent a personal language that only he understood. The results included accidental marks, doodles, and an apparent wandering of the brush and paint over the canvas surface.

In Miró's *Carnival of Harlequin* (see Figure 9-27), organic and geometric shapes, some connected with fine lines, seem to float around a room. It is as if a laboratory had exploded and its contents are floating around the room. Some of the images seem to have human characteristics, such as heads and arms, that have been created from shapes, lines, and squiggles!

Marc Chagall (Mark sha-GAHL) (1887–1985) also painted a fantasy world. Although he was born in Leningrad, Russia, he pursued his career in Paris where he became a refugee in 1941. Chagall designed the costumes and sets for Igor Stravinsky's (stra-VIN-ski) *Firebird Suite* ballet. He also designed stained glass windows for cathedrals and synagogues. However, his passion was painting fantasies of the Russian homeland he

Student Work

Orrin Mitchell, 16
Buena High School; Sierra Vista, AZ

Figure 9-27 What do you think of when you hear the word carnival? Does Miró's painting give you the same feeling?

Joan Miró (Spanish, 1893–1983), *Carnival of Harlequin*, 1924–25. Oil on canvas. 26" × 36⅝". Albright-Knox Art Gallery, Buffalo, New York, Room of Contemporary Art Fund, 1940. ©1994 Artists Rights Society (ARS), NY/ADAGP, Paris.

loved. Some of these scenes are a combination of the folk stories he heard as a child and dreams. In *I and the Village* (see Figure 9-28), animals, people, houses, and landscape defy gravity. They float around and within the profiles of a green human and an animal. A fantasy plant is held in a hand as if to nourish the cow while on the left side of the composition, a woman milks another cow as if the cycle of the food chain has been completed. The pair have been placed inside the first cow's head, as though the animal is dreaming. A village with several upside down houses floats across the top of Chagall's composition.

Figure 9-28 Chagall often recalled his native Russia in his paintings. What images in this work look Russian to you?

Marc Chagall (b. Russian, worked in France, 1887–1985), *I and the Village*, 1911. Oil on canvas. 6′3⅝″ × 59⅝″ (192.1 × 151.4 cm.). The Museum of Modern Art, New York, Mrs. Simon Guggenheim Fund. ©1994 Artists Rights Society (ARS), NY/ADAGP, Paris.

Art Begins to Change

You are about to enter the world of modern art. **Modern art** *is a term used to describe the work of nineteenth- and twentieth-century artists who explored new means of creative expression other than traditional methods from the past.* Modern art was not a specific movement, but rather an approach to making art during the late nineteenth and twentieth centuries that spanned many movements.

At times you may not understand why modern artists made art that looked different from some of the art you have studied in previous chapters. You may wonder why artists used media and techniques in ways that challenged established methods of creating art. Some of the art that you encounter may appear to be too simple or lacking in content. It may look like the artists abandoned or did not master such basic skills as shading and perspective. In some instances artists abandoned all suggestion of representational images. Their art may have consisted of one color or shape. You may question at times what messages artists were trying to communicate.

There are different ways in which artists declare feelings or moods through art. For example, an eighteenth-century artist might have expressed happiness by painting a landscape with a setting sun of red, orange, and yellow. A twentieth-century artist might show the same feeling by painting a simple red square in the middle of an empty canvas. How do you begin to understand the art of the twentieth century? Why do historians call art from a period in history before you were born "modern"?

Student Work

Jennifer Heinz, 16
Overland High School; Aurora, CO

Why Art Changed Directions

The first step toward appreciating modern art is to understand why artists changed the way art was made. As mentioned in the previous section, the invention of the camera altered the way artists viewed realistic images. At first, artists were in competition with the camera. They tried to make their paintings look like photographs. Then, artists became less concerned with replicating the realistic world. Henri Matisse (1869–1954), a French artist whom you met in Chapter Five, once said, "The painter need no longer concern himself with paltry details. Photography does it much better and more quickly."

As was discussed in Chapter Seven, works of art prior to the nineteenth century were usually commissioned by wealthy aristocrats, churches, royalty, or government officials. Artists had to accommodate the wishes of the patron in terms of the subject matter, technique, size, and color of the artwork. Toward the end of the nineteenth century, art dealers began to make art available to the public for purchase. Suddenly, there was a demand for a variety of art. Artists now had the freedom to experiment with media and

methods of making art, while still earning a living. Experimentation often led to abstraction. The word *abstract* is used in two ways. If the word is used as an *adjective*, then it means art whose subject matter has been invented, distorted, or rearranged—there may or may not be recognizable images from the world around us. For example, a critic might proclaim, "The painting was a premier example of American abstract art from the 1940s." If the word is used as a *verb*, it is the process of making art by altering or changing the way images or objects look. An example might be "The artist chose to abstract the facial features of the portrait by distorting the mouth and placing each eye on a different plane of the face."

You will discover that modern artists have worked together to create art movements as did artists from the past. They combined their efforts because the chances of being taken seriously by society were greater if more than one artist represented a style of art. However, each artist was unique in his or her approach to the philosophy of the movement.

But . . . What Is It?

As you study some abstract art in a book or museum, you may think, "What *is* it?" You may exclaim, "Anyone can make that!" or "It doesn't look real." Although your feelings may be valid, try to understand why the artist approached the subject or medium in a unique way. This will help you appreciate what you see, regardless of your first impressions of the work.

Some people may feel that representational art is "good art" because it may appear to emulate an object, person, or scene. But we must remember that even though a representational work of art may look real, it, too, still provides only an *illusion* of reality. Simply deciding how difficult a work is, based on representational techniques, should not be the measure of its success or failure. For example, creating a modern abstract painting may be just as much of a challenge to one artist as creating a representational painting is to an-

Student Work

Shayne Heather, 18
Overton High School; Memphis, TN

other. Remember, it is important not simply to dismiss a work of art because the artist has been inventive. Let's now look at some of the artists and the movements they invented during the late nineteenth century.

American Abstractionism

The American Abstractionism movement was prompted by the Armory Show that took place in New York City in 1913. As was discussed in Chapter Six, Americans were introduced to the art of Matisse, Kandinsky, van Gogh, Picasso, and other European artists through an exhibition in New York City. America's artists realized that they needed to change their traditional approaches to making art if they were going to compete for attention in the art world.

A small group of artists known as the American Abstractionists adopted the art style of the Europeans which brought modern art to the United States. **American Abstractionism** is the reduction of objects to their main features.

John Marin (1870–1953) was one of the first American painters to explore abstract art and lead the movement in the United States. He abstracted landscapes, cityscapes, and seascapes with quick brush strokes, lines, and brilliant watercolor. Marin simplified objects in these environments by reducing them to their simplest features (see Figure 9-29).

From childhood, Stuart Davis (1894–1964) was familiar with modern art. Four artists of "The Eight" were employed by Davis's father who was the art editor of a Philadelphia newspaper. Davis began his painting studies under the direction of Robert Henri, leader of the group. Davis abstracted images of the city using Cubist techniques. He used bright colors and flat,

Figure 9-29 Can you locate the boats, houses, and landscape in this Marin abstracted seascape? The main elements in the actual scene have been reduced to the simple elements by the artist.

John Marin (American, 1870–1953), *Ship, Sea and Sky Forms (An Impression),* 1920. Watercolor on paper. 13½" × 17". Columbus Museum of Art, Ohio. Gift of Ferdinand Howald.

overlapping, geometric patterns in his interpretation of the signs, lights, colors, and rhythms of city life. His paintings have been described as artistic "jazz" because the patterns dance across the canvas like notes in a musical score (see Figure 9-30).

Mark Tobey (1890–1976) created an artistic jazz of his own. Beginning his career as an illustrator and art teacher, Tobey traveled to China in 1934 to study the art of calligraphy. This trip would change the direction of Tobey's career.

He lived in a Zen monastery while perfecting his ability to write the characters that make up the Chinese language. The basis of the Zen religion, as discussed in Chapter Eight, is meditation, a process that involves sitting quietly without any distractions. After a period of meditation, the Zen follower acts spontaneously on a problem in his or her life. Tobey believed that this ritual resembled the way an Abstract Expressionist artist should approach a painting.

Look for a moment at Tobey's *Broadway* in Figure 9-31 on the next page. In this painting, the artist has combined his interest in Eastern religion with a New York City scene. Tobey developed his own painting technique called "white writing" which involved painting white calligraphic lines, against a dark background. In *Broadway*, the colors, lights, sights, and sounds of the city have been captured by Tobey's abstracted style of Chinese writing.

Mark Tobey

Mark Tobey was born on December 11, 1890, in Centerville, Wisconsin. His father was a carpenter and a farmer. Tobey was the youngest of four children. In Wisconsin, his childhood consisted of swimming, fishing, and playing in the nearby woods. Many of his earliest works are scenes taken from his childhood memories.

In 1906, the family moved to Hammond, Indiana, where Tobey attended high school. He was interested in science, botany, zoology, and nature studies. He traveled twelve miles to Chicago each Saturday morning to attend classes at the Art Institute of Chicago. He concentrated on watercolor and oil painting during these teenage years.

Three years later, Tobey and his family moved to Chicago. His father became ill, and Tobey had to give up his Saturday morning classes and withdraw from high school. He became a technical draftsman in a steel manufacturing plant, but he did not consider himself a success at the job. He finally took a position as an assistant in a fashion design studio. It was here that his drawing talent was discovered and he became a fashion illustrator. Tobey moved to New York City in 1911 and continued to work as a fashion illustrator while developing his own style of painting.

Figure 9-31 Tobey's studies of oriental brush drawings are evident in this tempera painting.

Mark George Tobey (American, 1890–1976), *Broadway*, 1936. Tempera on composition board. H: 26" × W: 19³/₁₆" (66 × 49 cm.). The Metropolitan Museum of Art, New York. Arthur H. Hearn Fund, 1942. ©1994 Artists Rights Society (ARS), New York/Pro Litteris, Zurich.

Regionalism

Some critics called for artists to return to representational images in art. **Regionalism** *realistically depicted the American way of life in the part of the country in which the Regionalist artists lived.* Their subject matter tended to focus on hard working people.

You were introduced to one regionalist artist, John Steuart Curry, in Chapter Five and to another, Edward Hopper, in Chapter Six. We also looked at the landscapes of Grant Wood in the discussion on the elements and principles of art in Chapter Two.

African American Folk Artist Horace Pippin

The Harlem Renaissance, as discussed in Chapters Six and Seven, began in America during the 1920s. Harlem, a community in New York City, became the center of activity for African American musicians, artists, actors, and writers. The **Harlem Renaissance** *was a time when African Americans created art that illustrated African American themes about life.* The Harlem Renaissance opened the doors for future African American artists.

Horace Pippin (1888-1946), a folk artist, became interested in drawing and painting during his early childhood. As a young man, he enjoyed creating portraits of people who lived in West Chester, Pennsylvania where he grew up. When Pippin painted the portrait of a farmer for whom he worked, the man wanted to pay for the artist's tuition at an art school. Due to the poor health of his mother, Pippin had to remain close to home and declined the offer. Later, he joined the armed forces and fought in World War I, where he received a permanent injury to his right arm. He was forty years old before he picked up a brush and began to paint again. Although his injured right hand was virtually useless, he still held the brush in that hand and used his left hand to guide the brush around the canvas. He painted scenes from his childhood, local community events, and his relatives. *The Domino Players* (see Figure 9-32) shows a game of dominoes in progress. People have gathered around the table to watch. The painting is filled with patterns of dots and of black and white clothing, all of which repeat the pattern of the dominoes. The touches of red in the stove, the

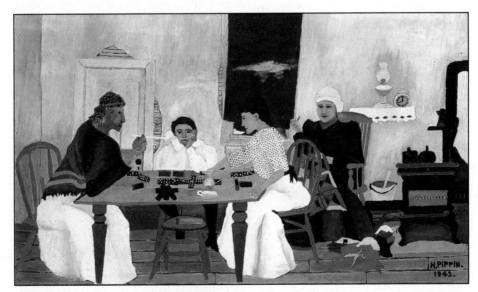

Figure 9-32 This everyday scene of a family playing dominoes may recreate a scene from Pippin's own childhood.

Horace Pippin (American, born and died in West Chester, Pennsylvania, 1888–1946), *The Domino Players*, 1943. Oil on composition board. 12¾" × 22" (32.3 × 51.8 cm.). ©The Phillips Collection, Washington, D.C.

quilt across the woman's lap, and her head scarf add warmth to an otherwise plain room.

THINKING ABOUT
AESTHETICS

Read about Horace Pippin and his career as an artist. Do you feel that a person must be trained at an art school in order to be considered a true artist? Why or why not?

Section ① Review

Answer the following questions on a sheet of paper.

Learn the Vocabulary

Vocabulary terms for this section are: *modern art, Postimpressionism, Fauvism, Expressionism, Futurism, pure painting, Cubism, simultaneity, manifesto, dynamics, Ash Can School, Suprematism, Surrealism, American Abstractionism, Regionalism,* and *Harlem Renaissance.*

1. Define ten of the vocabulary terms by writing one sentence describing the art style of each movement.

Check Your Knowledge

2. How did Manet's work change the direction of art during the late nineteenth century?
3. Why did the Postimpressionist artists feel the need to make their art different from the Impressionists?
4. Describe the Fauves' concern for color in their paintings.
5. What were *Die Brucke* and *Die Blaue Reiter*?
6. Describe the three stages of Cubism.
7. What were the goals of the Mexican muralists?
8. Explain the Futurist interest in the age of machinery.
9. What was the philosophy of the Suprematist artists?
10. Describe the "new reality" of the Surrealists.

For Further Thought

11. If you were a late-nineteenth-century artist, which art movement would you join and why?

Section II

Twentieth-Century Trends

The changes in art that occurred during the late nineteenth and early twentieth centuries can be compared to the Renaissance movement. For example, artists such as Michelanglo, da Vinci, and Raphael challenged the way art was made during medieval times. Now, the artists of the 1950s presented in this section will challenge the art of the early twentieth century with the same convictions as their predecessors.

We will turn our attention to a brief survey of twentieth-century trends from the 1950s to the present. Although these movements are presented in chronological order they will sometimes overlap one another. Additionally, some artists worked under the philosophies of more than one movement. Let's begin our survey of twentieth-century trends with a look at Abstract Expressionism.

Abstract Expressionism

The effects of war on society are always devastating. However, when we look at art history, we find that new approaches to making works of art are often artists' responses to conflict. This was the case at the end of World War II. European artists immigrated to America from Europe to flee their war-ravaged homeland. Up to this point in time, Europe had been the art "headquarters" of the world. Now, the spotlight was on New York City, the destination for most European artists defecting from their homeland.

Hans Hofmann. Abstract Expressionism *was a product of Expressionism,* which was discussed in Section One. One artist who embraced the Abstract Expressionist movement was Hans Hofmann

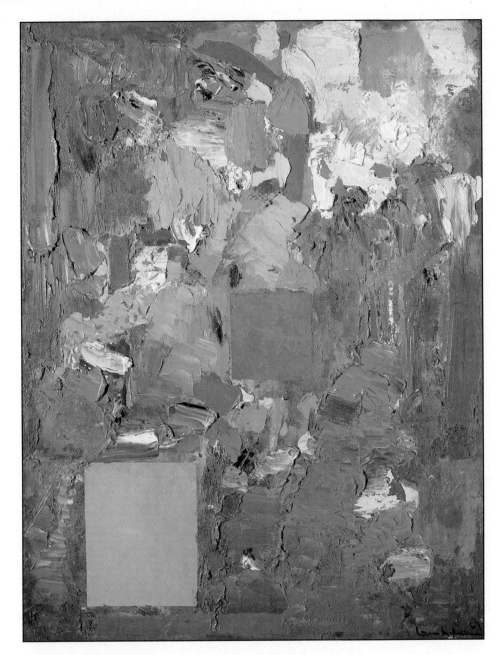

Figure 9-33 This is an example of Abstract Expressionism.

Hans Hofmann (American, born Germany, 1880–1966), *Flowering Swamp*, 1957. Oil on wood. 48⅛" × 36⅛" (122.0 × 91.5 cm.). Used with the permission of the Estate of Renate Hofmann, Hirshhorn Museum and Sculpture Garden, Smithsonian Institution, Gift of Joseph H. Hirshhorn Foundation, 1966. Photo by Lee Stalsworth. 66.2482.

(1880–1966). Hofmann, born in Bavaria, Germany, moved to Paris in 1904 to study art at the Ecolé de la Grande Chaumiere. It was there that Hofmann met Pablo Picasso and Georges Braque and adopted the Cubist style of painting for his own work. In 1925, after returning to Germany, he established the Hans Hofmann School of Fine Arts in Munich. Those who studied at the school were influenced by Hofmann's approach to painting. It was labeled by the artist as Abstract Expressionism, an extension of Kandinsky's style of Expressionism (see Figure 9-33).

Seven years later, the artist was forced to close his school due to the German government's suppression of artistic freedom. In order to escape a country headed towards the dictatorship of Adolf Hitler, Hofmann immigrated to the United States. Within a year, he had established a new art school on Madison Avenue in New York City and a branch in Provincetown, Mas-

sachusetts. The artist would continue to operate his schools until 1958 when he decided to concentrate solely on his painting.

It can be difficult to explain how the Abstract Expressionists' approach to art was different from the Expressionists'. Most of these artists would begin with a single mark on their canvas, then add to that mark until the canvas was filled with color, shape, or texture. This was a spontaneous process; the artists usually did not have an idea when they began of what their work would look like when it was finished. Each mark, color, shape, or line would give the artists a new sense of direction for the piece.

"Art is the unceasing effort to compete with the beauty of flowers—and never succeeding."

Marc Chagall

Jackson Pollock. American artist Jackson Pollock, born in Cody, Wyoming (1912–1956), began his career in New York City in 1929 as a student of Regionalist painter Thomas Hart Benton, whom we discussed in Chapter Five. At the Art Student's League, Pollock developed his own style as an Abstract Expressionist. This style would change the art world's definition of modern art not only in image but technique. Rather than using a traditional easel, Pollock placed large sheets of canvas on the floor of his studio. He then walked around the perimeter of the canvas, dripping, pouring, and throwing paint on its surface. He believed that traditional strokes of a brush inhibited artists. The oil and enamel paint would fall at random as it dripped from brushes, sticks, and cans punctured with holes. Pollock "controlled" the paint through the force and direction with which his body moved. The artist ex-

plained how important his physical movements were to the process of painting: "When I am *in* my painting, I'm not aware of what I am doing. It is only after a sort of 'get acquainted' period that I see what I have been about. I have no fears about making changes, destroying the image etc. because the painting has a life of its own. I try to let it come through. It is only when I lose contact with the painting that the result is a mess. Otherwise there is pure harmony, an easy give and take, and the painting comes out well." In *No. 1 1950 (Lavender Mist)* (see Figure 9-34), the artist built up multiple layers of dripped paint. These layers create a rhythm and texture made up of small webbed lines.

Franz Kline. Franz Kline (1910–1962) used lines in a different way. Born in Wilkes-Barre, Pennsylvania, Kline's early paintings reflected the plight of his hometown following World War I. He painted his first abstract work in 1947 after establishing a friendship with Jackson Pollock and Willem de Kooning (Chapter Seven). As did Pollock, Kline found conventional-size canvases too restrictive. He would nail a large sheet of unstretched canvas to a wall or floor. Rather than using standard artist's brushes, Kline purchased wide house-painting brushes from the hardware store. He painted broad, thick strokes of flat black paint, often at sharp angles, across a pure white canvas (see Figure 9-35).

David Smith. The Abstract Expressionist movement was not limited to painting. Sculptor David Smith (1906–1965) used the Abstract Expressionist

DEVELOPING SKILLS FOR

ART CRITICISM

Read about Jackson Pollock's painting techniques and then answer the following questions:

1. Can throwing or dripping paint on a canvas be considered a technical skill? Why or why not?

2. List the ways in which Pollock can control the paint with his arms and body.

Figure 9-34 This painting by Jackson Pollock is almost ten feet in length.

Jackson Pollock (American, 1912–1956), *Number 1, 1950 (Lavender Mist)*, 1950. Oil, enamel and aluminum on canvas. 87" × 118" (2.210 × 2.997 m.). ©1994 Pollock-Krasner Foundation/Artists Rights Society (ARS), New York. Ailsa Mellon Bruce Fund, National Gallery of Art, Washington, D.C. Photo by Richard Carafelli. 1976.37.1.(2697)/PA.

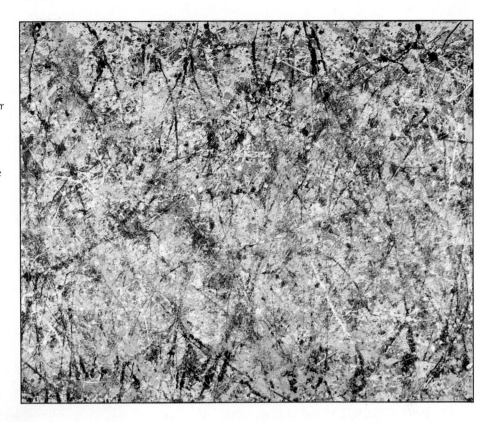

Figure 9-35 Kline used house-painting brushes to create energetic strokes of black across the canvas surface.

Franz Kline (1910–1962), *Meryon*, 1960. Duco house paint on canvas. 236 cm. × 170 cm. Tate Gallery, London, Great Britain/Art Resource, NY.

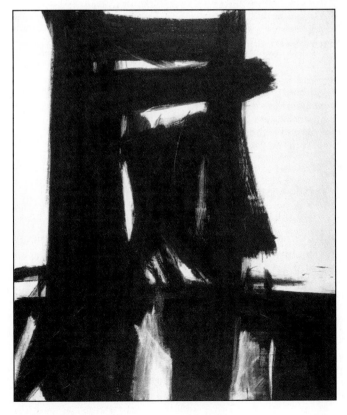

approach to making art and applied it to his sculptures of hollow cubic forms made out of steel. Smith worked in an automobile factory while he was in his early twenties. He learned how to work with metals and developed soldering techniques or different ways of joining metal parts with melted tin or lead. Smith was one of the first American sculptors to weld metal. He applied these skills to the construction of his sculptures, such as the one shown in Figure 9-36. *Cubi XVIII* is one of a series of abstract-shaped sculptures Smith assembled from cubes of stainless steel. The forms have been **burnished**—that is, *highly polished in certain areas*—so the environment surrounding the sculpture reflects off the metal surface.

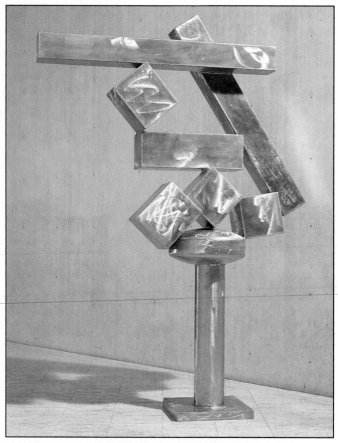

Figure 9-36 Sculptor David Smith used his experiences in an automobile factory throughout his career.

David Smith (American, 1906–1965), *Cubi XVIII*, 1964. Polished stainless steel. H: 9'7¾" × W: 21¾" × D: 20¾". Gift of Susan W. and Stephen D. Paine, Courtesy, Museum of Fine Arts, Boston. ©1994 Estate of David Smith/VAGA, New York. 68.280.

Art Brut

Art Brut (BROOT) was an art style developed by one artist, Jean Dubuffet (dyoo-buh-FAY) (1901–1985). **Art Brut** *rejected art made by professional artists and embraced the artwork of children, of developmentally handicapped individuals, and of people not professionally trained as artists.* Dubuffet believed that their art was "pure," untouched by the influence of formal art training. Believing that to create art was a natural human instinct, Dubuffet said, "Everyone is a painter. To paint is like to speak or to walk. For the human being it is just as natural to draw on any surface available and to make some kind of image as it is to speak."

Dubuffet wanted to create in his own painting the qualities he enjoyed in his "art brut." In order to do this, he used nontraditional materials, such as asphalt, ground glass, and mud mixed with paint. Dubuffet scratched through these mixtures fixed to the canvas with palette knives and brushes, creating heavy, frantic lines. In *The Cow with the Subtile Nose* (see Figure 9-37), we can see that Dubuffet's version of a cow resembles the work of a person more concerned with expressing energy and emotion than rendering a painting of the typically docile animal.

Pop Art

While the art world was focused on the abstract style of Kline and Pollock, another change in the subjects and techniques of the 1960s artist was about to take place. Pop art took the American public by surprise. The movement originated in England during the 1950s, but no one could have predicted how it would affect the art, fashion, and music industries in the United States. **Pop art** *was a reflection of popular culture, the media, and advertising images.* In fact, the term *pop art* is abbreviated from "popular art," meaning the images currently accepted by society.

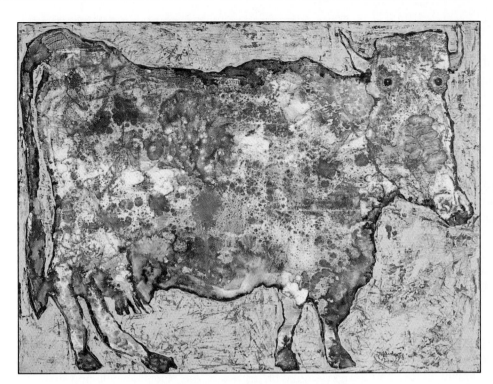

Student Work

Eleodoro Hernandez, 18
Edinburg High School; Edinburg, TX

The United States was in the middle of the Vietnam War. The public saw images of war on television. The daily reports from Vietnam seemed to the Pop artists to conflict sharply with other commercial messages. The mass media were encouraging the public to acquire material possessions and at the same time American families were facing the loss of their loved ones who were serving in the military. The Pop artists questioned these values and contrasts through the popular images they selected for their work. Objects commonly found around the house and in advertisements—objects such as soup cans, hamburgers, cleaning products—became the subjects for works of art.

Roy Lichtenstein. Some Pop artists were involved in commercial art before joining the movement. Roy Lichtenstein (born 1923) is one of these artists. He designed window displays for department stores, then turned to creating large scale cartoonlike paintings. The inspiration for his artworks comes from cartoon characters such as Mickey Mouse, Donald Duck, and Popeye comic books and television soap operas. His work points out the overdramatizing of human relationships that these television shows promote.

Lichtenstein replicates the dot patterns created by the newspaper color printing process. He does this by placing metal screens with small holes drilled in them over select areas of his composition. Then he sprays or rolls paint over the screen. Once the screen is lifted, the process leaves small dots on the canvas. Many of Lichtenstein's paintings include written dialogue between the characters (see Figure 9-38). This technique represents what the artist considered to be the trivial dialogue between couples in soap operas.

Figure 9-38 In this Roy Lichtenstein painting, the cartoonlike characters of the "ideal" female and male personalities are engaged in dialogue.

Roy Lichtenstein, *Masterpiece*, 1962. Oil on canvas. 54" × 54" (137.2 × 137.2 cm.). Courtesy of the artist. ©1994 Roy Lichtenstein. Photo by Robert McKeever.

Claes Oldenburg. As with Abstract Expressionist art, the Pop art movement has influenced sculptors as well as painters. George Segal, whom you met in Chapter Six, and Claes Oldenburg (klahass OLD-en-berg) (born 1929) also used ordinary objects as the subjects for their works of art. Oldenburg wants the viewer to examine these objects in a different form and scale. He does this by using materials that are not typically used in the manufacturing of such products. Look for a moment at Oldenburg's *Soft Toilet* (Figure 9-39). The artist plays here with our perception of the normal form and function of a toilet. Soft vinyl has replaced rigid material. The seat and toilet tank seem to have been "deflated." The float, normally located inside the toilet and designed to level the water, is hanging outside the tank like a tongue! This sculpture is both humorous and strange because it alters our understanding of this ordinary object.

EXPLORING

HISTORY AND CULTURES

List on paper five popular images of the 1990s in television, movies, and fashion. Describe how each has changed since the 1960s in the United States.

Some examples are: cars, cartoons, and movie stars.

Robert Rauschenberg. Pop artist Robert Rauschenberg (born 1925) studied art at the Kansas City Art Institute. He then studied in Paris and New York. His travel and study included a summer in Europe working with Cy Twombly.

Rauschenberg uses scrap materials and functional ordinary objects that are not typically used as artistic media. Look for a moment at the artist's painting, *First Landing Jump* (see Figure 9-40), and see if you can find these items: tin cans, cloth, a license plate, a khaki shirt, a mirror, leather straps, a blue light bulb, steel springs, and a car tire! All of these things have been attached to the canvas surface using the collage technique in three-dimensional form. By placing them together in one composition, the artist asks us to consider their similarities rather than their differences. Rauschenberg refers to his collages as *combine paintings*.

Figure 9-39 Claes Oldenburg's sculpture is one example of how the Pop artists changed the way society viewed ordinary, functional objects.

Claes Oldenburg (American, born Sweden 1929), *Soft Toilet*, 1966. Vinyl, Plexiglas, and kapok on painted wood base. Overall: 57¹⁄₁₆" × 27⁵⁄₈" × 28¹⁄₁₆". Collection of Whitney Museum of American Art, New York; 50th Anniversary Gift of Mr. and Mrs. Victor W. Ganz. Photo by Jerry L. Thompson, NY. 79.83.

Figure 9-40 What comparisons can you make between the objects shown above?

Robert Rauschenberg, *First Landing Jump*, 1961. Combine painting: cloth, metal, leather, electric fixture, cable, and oil paint on composition board: overall, including automobile tire and wooden plank on floor, 7'5¹⁄₈" × 6' × 8⁷⁄₈". The Museum of Modern Art, New York, Gift of Philip Johnson. ©1994 Robert Rauschenberg/VAGA, New York.

Student Activity 2

Pop Art Collage Paintings

Goals

1. You will integrate fragments of commercial packaging with oil crayons and acrylic paint to create a work of Pop art.
2. You will use your knowledge of the elements and principles discussed in the chapter to guide your use of the media to explore composition.

Materials

1. Canvas and stretchers, or canvas board
2. Gesso or white latex house paint (only if using the canvas)
3. Assorted colors of acrylic paint
4. Oil crayons
5. White glue or nontoxic adhesives
6. Scissors
7. An assortment of box parts, can labels, fragments of plastic bottles, jar lids, foam meat trays, yogurt containers, milk cartons, plastic bubble packs, and so on. Choose your assortment of commercial containers for their bright colors, imaginative packaging concepts, and decorative and textural qualities.

Directions

1. If you are not using canvas board, stretch and prepare your canvas with gesso or white paint. Allow the surface to dry.
2. Carefully look over your assortment of commercial containers. Cut parts from them that seem interesting because of color, texture, or design. Remember that you must be able to glue these pieces down onto the canvas or canvas board. Avoid always picking the part of the packaging that has the product name on it. If, however, that seems to be the most interesting part of the packaging, fragment the words or letters. Don't forget to include side and back panels in your arrangement as well.

3. When you have selected the pieces you will use, place them on the table in front of you and experiment with several different arrangements. Keep in mind what you have learned about the elements and principles of art.

4. When you achieve the arrangement that you think is best, transfer it to your canvas, and glue it down. Some items will be more difficult than others to secure to the surface of the canvas. This will present a challenge to you as to how best to secure them. Once you have glued the items down, let the composition dry thoroughly.

5. While the composition is drying, take the opportunity to look carefully at your arrangement again. Assess where might be the best places to add your paint and oil crayons. Consider the distribution of color. Are there textured areas that need balancing? Are there areas of light and shade that need more defining? And, are there patterns or shapes that could be echoed with the oil crayons or paint?

6. Next, add to the areas you identified with your paint and oil crayons. Be sure not to cover up too much of the fragments that are glued down. Only you will know when your composition is complete. Allow it to dry. Frame and display your work in the art room or in an appropriate place in your building.

Evaluation

1. Did you find a varied assortment of commercial containers from which to select fragments for your composition? What were some of the most interesting ones?

2. Describe the process of experimentation you went through to achieve your composition.

3. What do you think is most striking about your composition? Do you think it successfully represents the Pop artist's ideas about commercial images? In what ways?

Student Work

Installation by students at Overland High School
Aurora, CO

Op Art

Op Art *is the arrangement of lines, colors, and geometric shapes to produce an optical effect.* The term *op* is derived from the word *optical,* as in *optical illusion.* For instance, the Op artists explored scientific principles to determine how the illusion of motion could be created on a flat surface.

> " I want to create an image which will stimulate a fresh way of seeing again something that was experienced but not forgotten with the passage of time."
>
> **Bridget Riley**

Victor Vasarely. Victor Vasarely (born 1908) (va-sah-RELL-ee) was born in Hungary but immigrated to America. Here he became the leader of the Op art movement. Vasarely uses geometric shapes and brilliant color to create his illusions. By changing the shape, size, and width of the lines in precise mathematical order, the artist seems to make a design move across the canvas (see Figure 9-41).

Bridget Riley. Bridget Riley (born 1931) is an Op artist from England. At about the time she was withdrawing from college, her father became ill, and she devoted her time to caring for him. She suffered a psychological breakdown at age twenty-four as a result of her struggles with her failing career and her father's condition. As part of her recovery, Riley traveled throughout Europe where she was introduced to the work of the Futurists. Studying Futurist techniques for creating the illusion of motion prompted Riley to explore optical illusions in painting.

Figure 9-41 Victor Vasarely created the illusion of a dome appearing from the flat surface of this canvas.

Victor Vasarely, *Vega-Kontosh-Va*. Tempera on panel. H: 25⅝" × W: 25⅝". Gift of Mr. and Mrs. Donald Winston through the Contemporary Art Council. Los Angeles County Museum of Art. ©1994 Artists Rights Society (ARS), New York/ADAGP, Paris. M.72.35.

The influence of Riley's European travels on her work is evident in *Movement in Squares* (not shown here). The optical illusion in that painting was inspired by an Italian plaza that had a white and black checkerboard pattern, which Riley could see from her hotel window. She contracted and expanded the squares in specific areas by changing the amount of space in between them, creating a sense of motion.

Whereas Vasarely and Riley are concerned with optical effects, another group of artists has concerned themselves with *color* minus lines or shapes.

Color Field Painting

When a person makes a verbal *statement*, a fact or an opinion has been expressed. In the 1950s and 1960s, **Color Field art** *expressed visual statements about color.* The Color Field artists treated the canvas as if it were one plane or surface. Large areas of color were swept across the canvas with large brushes or paint rollers.

Creating the illusion of depth or background was not a concern for the Color Field artists. This movement has also been given other names, such as Postpainter Abstraction and Hard-edge painting.

Mark Rothko. Mark Rothko (1903–1970) was born in Russia, then immigrated to the United States in 1913. He attended Yale University for a brief period before leaving for the Art Student's League in New York City. Rothko was so impressed by the Surrealist art he studied at the school that he adopted the style as his own for a brief period of time. In the early 1940s, Rothko abandoned all references to images in his paintings. He filled his canvases with large rectangular and square areas of intense color. There are no subjects, images, lines, or textures in Rothko's works. He wants us to contemplate the effect of color on the eye when it does not interact with the other elements of art (see Figure 9-42).

Helen Frankenthaler. Helen Frankenthaler (born 1928) developed her own style of Color Field painting called "stain painting." Like Jackson Pollock and Franz Kline, Frankenthaler places her canvas on the floor

Figure 9-42 Mark Rothko's paintings allow us to experience color as a single element in a painting.

Mark Rothko (American, born Russian, 1903–1970), *Orange and Yellow*, 1956. Oil on canvas. 91" × 71". Albright-Knox Art Gallery, Buffalo, New York. Gift of Seymour H. Knox, 1956. Photo by Biff Henrich.

Figure 9-43 Helen Frankenthaler's technique of pouring paint onto unprimed canvas resulted in flowing, organic images.

Helen Frankenthaler (American, b. 1928), *The Bay*, 1963. Acrylic on canvas. 205 × 208 cm. ©1994 The Detroit Institute of Arts, Gift of Dr. and Mrs. Hilbert H. DeLawter. 65.60.

before painting. She uses unprimed canvas—that is, canvas that has not been prepared with gesso. Frankenthaler slowly pours oil paint, which has been thinned with turpentine, or acrylic onto the canvas. The colors mix and blend with one another as they flow across the surface dying the canvas. Using a brush or sponge, Frankenthaler pushes the paint in certain directions to control the blending process. *The Bay*, in Figure 9-43, provides an example.

Frank Stella. The paintings of Frank Stella (born 1936) are also Color Field art. However, Stella's trademarks are the shaped canvases and geometric forms of his designs. Stella was born in a town outside of Bos-

Figure 9-44 Frank Stella's design echoes the curved shape of his canvas.

Frank Stella, *Abra II*, 1967. Fluorescent acrylic on canvas. 120" × 120". ©1993, Frank Stella/Artists Rights Society (ARS), New York. Joseph H. Hirshhorn Collection, Leo Castelli Gallery, New York. 252-A.

"Everyone is a painter. To paint is like to speak or to walk. For the human being it is just as natural to draw on any surface available and to make some kind of image as it is to speak."

Jean Dubuffet

ton, Massachusetts. He attended Princeton University where he was introduced to the art of the Abstract Expressionists. Although he painted in their style, dur-

ing the last half of his senior year he produced art inspired by Rothko.

Stella moved to New York City after graduating from Princeton. He rented a studio and began working on geometric, monochromatic (primarily white on black) paintings. Stella gradually developed a style that focused on the shape of the canvas. Rather than using a rectangular canvas, he created canvases with curves. The geometric patterns that he designed using protractors, followed the curves of the canvas frame (see Figure 9-44). Stella experimented with the mathematical precision of each pattern.

Postmodernism

Some artists, critics, and art historians refer to the 1970s, '80s, and '90s as the Postmodern era. Since the prefix "post" means "following after," the term Postmodern suggests that the world of modern art has come to a close. It is more accurate to think of Postmodern art as existing alongside modern art in today's world, since both may be found. **Postmodern art** *refers to artworks and ideas that are rich and diverse in terms of meanings, materials, cultural traditions, and historical references. Further, Postmodern artists often work collaboratively.* In order to understand Postmodernism, it is necessary to compare and contrast it with Modernism.

Modernism *refers to art and ideas that stress individuality, originality, universal meaning, and "art for art's sake."* The roots of Modernism can be traced to late nineteenth-century Western art, when many artists, including Impressionists and Postimpressionists, began catering less to the tastes of traditional patrons and pursued more vigorously their own ideas about art. As you learned earlier in this chapter, after the turn of the century many artists became increasingly daring and abstract in their style. They purposefully turned their back on art history and strived to generate even more original art forms. *The term used to describe very original, experimental art is* **avant-garde** (ah-vahn-gard). An avant-garde artist was supposed to be independent, innovative—the lone revolutionary genius operating on the fringes of society. By the mid-twentieth century, avant-garde artists like Jackson Pollock had abandoned subject matter altogether. Artworks no longer had to make reference to the "real world" of human perception and experience. The slogan of modern art became "art for art's sake." The relationship of art to the life of society at large became—in the minds of some in the world of art—unimportant. And, since art referred to no culture in particular, it was, theoretically at least, equally accessible to all—art as a universal language. Unfortunately, it seemed like most people couldn't read the language of modern art in the mid-twentieth century, and many have difficulty with it today.

Pop art in the 1960s signaled a turning point in modern art. Not only were artists introducing subject matter again, their images were drawn from popular culture: comic books, household appliances, junk food,

and other subjects that ordinary people could relate to. As time passed, many Modernist ideas were replaced with their opposites. Realism became acceptable once again as an alternative to abstract art. Originality was no longer a quality necessary for an artist to be considered accomplished. Many artists realized that world history provided a wealth of artistic ideas and symbols that could be tapped and applied to present-day circumstances. In fact, "appropriation" became a popular term in the late 1980s, as artists freely borrowed, or "appropriated," styles and images from art history and adapted them to suit their own artwork.

Postmodern artists sometimes work alone, but just as often collaborate with others in the art-making process. The idea of artistic collaboration was influenced by, among other things, "quilting bees" of eighteenth- and nineteenth-century America, when several women would work together on a single quilt. Such quilts, following traditional patterns, would not have been considered serious or fine art by Modernists. Postmodernism breaks down such barriers and accepts all manner of cultural, creative expression as art.

Because art originates within different cultures and time periods, Postmodern critics no longer assume that art is a universal language. In order to understand and appreciate works of art, one must know something about the cultural ideas and circumstances of the time and place in which it was made. While Modernism would align itself with intrinsic criticism, Postmodernism promotes contextual criticism (both types of criticism are discussed in Chapter Two).

One other difference between much modern art and Postmodern art is that Postmodern art frequently addresses social issues, and often takes a stand. This is the opposite of "art for art's sake."

You have examined several Postmodern works of art in earlier chapters of this text. Christo's *Surrounded Islands* in Chapter One is an excellent example of the collaborative nature of Postmodern art. Another work in that chapter, Jenny Holzer's *Truisms,* demonstrates the way in which Postmodern works make social comments. A third aspect of Postmodernism—the appropriation of images by other artists—is evident in James Mason's topiary (Chapter Five). Of course, all three of these works are Postmodern in their use of untraditional media and methods.

A work entitled *Unprojected Habit* shown in Figures 9-45A and 9-45B, is a good example of all the qualities that go together to make a work Postmodern. *Unprojected Habit* was a six week installation in the Storefront for Art and Architecture Gallery in New York City in 1992. It was collaboratively designed by James Cathcart, Frank Fantauzzi (fahn-tah-OOTZ-see), and Terrence Van Elslander, a team that specializes in site-specific installations. Trained as architects, their method is to analyze the physical location for an installation in relation to its social environment, then to base their design on a perceived local, social issue.

The creators of *Unprojected Habit* learned that the urban setting of the Storefront for Art and Architecture was populated with many homeless people who had difficulty meeting basic human needs, such as shelter from the cold, food, and clothing. Even access to bathrooms was a problem. In fact, finding a public restroom can be difficult for anyone, homeless or not, in many big cities. Cathcart, Fantauzzi, and Van Elslander wanted to make a very direct statement about the importance of providing for human needs.

Unprojected Habit was "anti-art," declared Fantauzzi in a telephone interview with textbook author Lankford. "It was about social activism. Aesthetic considerations were secondary." In other words, this artwork was a rejection of Modernism and art for art's sake. It was a Postmodern unification of art and life. It was also Postmodern in that it was collaborative, addressed social issues, and utilized materials which normally are considered outside of the world of art yet familiar to society at large. Further, this artwork is best understood when considered in relation to the social context and physical environment in which it was installed. Like modern art, Postmodern art is not always pretty or easy to understand. It can challenge our thinking about art, the meaning of our lives, and the world in which we live.

Figure 9-45A Figure A shows *Unprojected Habit* as the general public saw it from the street outside the gallery.

Figure 9-45B This is the view of *Unprojected Habit* that one sees from inside the gallery.

James Cathcart, Frank Fantauzzi, Terrence Van Elslander (American contemporary), *Unprojected Habit*, 1992. Five portable toilets were inserted through the facade of the Storefront for Art & Architecture in New York. The toilets were free and open to the public during the six weeks of the exhibition. Courtesy of the artists. Photo ©1994, Frank Fantauzzi.

Photo-Realism

Another art movement was evolving during the mid 1960s through the 1970s that was the opposite in philosophy from the twentieth-century artists. As was discussed earlier in the chapter, photography inspired fine artists to discover other avenues of artistic expression. Now a group of artists used photographs to produce a new reality in their paintings. Photo-realism was an artistic movement in which artists tried to capture a scene as realistically as it would look in a photograph. You met Photo-realist artist Duane Hanson and his sculptures in Chapter Seven.

Photo-realists painted with such precision and detail that their work resembled a photograph of the image they used as their subject. In fact, some Photo-realists created their paintings by projecting a photograph on to the canvas and then painting the image with thin layers of paint.

Richard Estes. Photo-realist Richard Estes (born 1936) uses city scenes as subjects for his work. In *Woolworth's* (see Figure 9-46), Estes has presented the viewer with a glimpse of the opposite side of the street through the reflections in the store's window. The scene is nostalgic of the 1950s and 1960s, when such

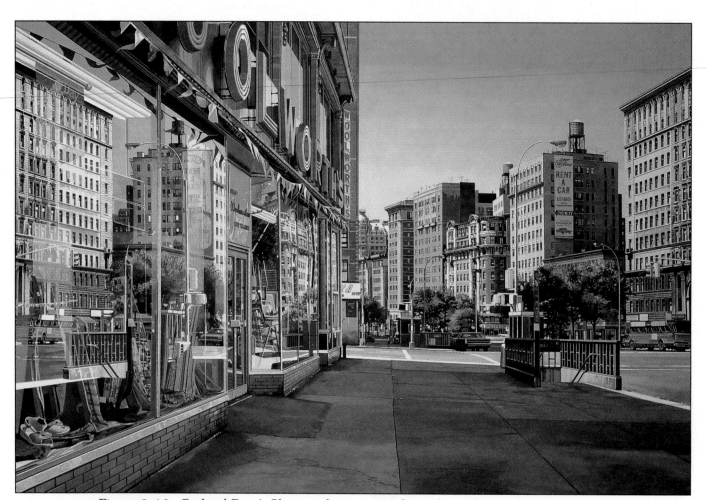

Figure 9-46 Richard Estes's Photo-realistic store reflects the opposite side of the street.

Richard Estes, *Woolworth's* 1974. Oil on canvas, 38" × 55". ©Richard Estes/VAGA, New York, 1994. Courtesy The San Antonio Museum of Art, San Antonio, Texas. Purchase. 82.76.289P.

Figure 9-47 Photo-realist Chuck Close painted this large portrait from a small snapshot.

Chuck Close (American, b. 1940), *Frank*, 1969. Acrylic on canvas. H: 108" × W: 84". The John R. Van Derlip Fund, The Minneapolis Institute of Arts. 69.137. Courtesy Pace/Wildenstein.

stores were popular with Saturday shoppers. The images are precise and invite the viewer to observe and analyze every detail.

Chuck Close. In Chapter Seven, we looked at the different ways in which artists have portrayed the human image. Portrait artist Chuck Close (born 1940) uses photographs of human faces as the source for his paintings. The photographic image, with every detail, is transferred to a large canvas, resulting in a magnified portrait (see Figure 9-47). The use of photographic images was defended by Close: "I believe people sometimes think that the use of a photograph to paint produces inevitably a particular picture. But it is possible to make paintings as different from one another when working from a photo, as when working from nature."

Minimal Art

During the 1960s and 1970s in the United States, people were expected to be concerned with environmental and social issues. These concerns were the result of the United States' involvement in the Vietnam War and public sentiment about the conflict. Minimal

Student Activity 3

Xerographic Composition

Goals

1. You will create a composition using multiple xerographic images.
2. You will alter each xerographic image with a different medium making it a unique composition in its own right.
3. You will use the elements and principles of color, texture, and balance to complete your composition.

Materials

1. An image of a commercial object from a magazine advertisement
2. Access to a copy machine
3. Oil crayons
4. Acrylic paint and brushes
5. Assorted colors of construction paper
6. Colored ink and brushes
7. Colored chalk
8. An assortment of colored pencils
9. Glue
10. Scissors
11. One sheet of poster board
12. An assortment of magazines

Directions

1. Look at the repetitive image by Andy Warhol (Figure 3-12) on page 145. You will see that repetition of images was a favorite theme that recurred many times in his works of art. Often, he would repeat the same image side by side, and then alter each image, making each one slightly different and interesting in its own right. You are going to create a multiple image composition in this style.
2. Look through the assortment of magazines and select an image of a commercial product. Make sure that the one you choose is not too small. You will need to have room on this image to apply all the different media that have been suggested. Don't stop looking with the first image you find; spend some time looking for an image that, when repeated side by side, will create an interesting field for your media.

3. When you have selected the appropriate image, go to the copy machine and duplicate it six times. If the image is small, enlarge it when you duplicate it. For best results, duplicate the image on the lightest possible setting allowed on your copy machine. Since you will be almost completely obscuring the copied image with media, all you need to see is a pale representation of the image.

4. After you have duplicated your image six times, crop any excess paper that surrounds the images. You must be careful to keep the size of the images identical. Then, lay the images out on the poster board side by side, in two rows of three. Carefully glue the images down. Set your work aside, and allow it to dry thoroughly.

5. When the glue is dry you are ready to apply your variety of media directly to the xeroxed images. Be careful to consider what you will do to alter each image before you start. Although each image will be rendered with a different medium, you will not want to lose sight of the fact that all of the images when completed must work together as a unified composition. This means, that when you finish with one image, you should give some thought as to how it might be affected by what you plan to do with the image next to it as well as the one below or above it. Some media will look stronger next to others, and the placement of some colors and textures will alter the balance of the entire composition. Whatever you decide, be sure to cover most of the copied image leaving only small portions of it visible.

6. When you have completed all six images, display your work as a class in an appropriate location in your building.

Evaluation

1. Did you give careful consideration to a variety of images before you selected the one you used? What made you select that particular one?

2. Describe the process by which you determined which medium you would use on each of the images.

3. What is your opinion of how successfully you have balanced the use of the elements and principles within each image, and within the overall composition as a whole?

art, during the 1960s, provided an escape from media images of social and political unrest. The artists of this movement believed in only concentrating on forms and shapes. **Minimal art** *was a twentieth-century art movement that sought to present ideas in the simplest forms possible*. To simplify art was to purify art according to the minimalists. They did not want their own personalities, feelings, or preferences for colors, textures, or images to be evident in their art. This was a concept not easily understood by the public and is still viewed with curiosity today.

Minimal painting typically consisted of one simple shape placed on a canvas. Minimal art typically consisted of a few simple geometric shapes, as shown in Figure 9-48.

Figure 9-48 Minimal artist Barnett Newman reduced shape to a simple form.

Barnett Newman (1905–1970), *Adam*, 1951. Oil on canvas. 243 cm. × 202 cm. Courtesy Tate Gallery, London, Great Britain. Tate Gallery/Art Resource, NY.

Figure 9-49 The interior of this plexiglas cube undergoes a continuous process of forming condensation, then dissipating.

Hans Haacke, *Condensation Cube*, 1963–65. Plexiglas with water. 11¾" × 11¾" × 11¾". Courtesy of John Weber Gallery, New York.

Process Art

The Process art movement began during the 1960s and lasted for approximately eight years in the United States and Europe. **Process art** *is art that undergoes a performance or transformation.* Process artists would create a sculpture or assemblage designed to trigger an action at a specific point in time. A performance or a series of interactions among the different assembled materials would then occur. Process artists usually used temporary materials, such as ice, food, water, or wax. These materials would change their appearance or decay during the performance. The artists would also allow the environment of the gallery or museum, such as temperature or air currents, to interact with the materials. And these interactions—which together made up the "process"—were considered by the artists to be works of art.

Hans Haacke. Process artist Hans Haacke, born in Germany in 1936, has lived in New York since 1967. He challenges what people believe to be traditional museum art by establishing miniature ecosystems (a community of living organisms in an environment). Haacke made his first transparent cube with tubes attached to filter air in 1963. The cubes were designed to respond to temperature and air pressure changes. Haacke was also intrigued by how water, snow, ice, and wind would react when affected by changes in climate while inside his cubes. The artist was so involved with the process of his art that he would document meteorological data about the reactions taking place between the elements. The plastic cube in Figure 9-49 was designed by Haacke to create a "climate" in its interior. Condensation forms inside the cube when the room temperature changes from cool to warm or when the light levels are altered. The process is a continual one. Condensation forms, dissipates, then forms again. The art then is never complete, or in a final state, as the *process* to Haacke is the art.

AESTHETICS

Study *Condensation Cube* by Hans Haacke (Figure 9-49). Read the information about Haacke and Process art. Answer the following questions on paper, or discuss them as a group.

1. Describe or list all of the media other than plastic that Hans Haacke used for his work. List all of the conditions that need to be right in order for the artistic process to begin. Should these conditions be considered part of the artwork? Why or why not?

2. What part of the process should the artist receive credit for? Why?

3. Can a scientific reaction such as condensation be called art? Why? Why not?

4. Is the plastic box still a work of art during the time period when the condensation dissipates and when the process begins once again?

5. Do viewers need to experience the entire condensation process in order to say they have seen *Condensation Cube*?

Figure 9-50 This kinetic sculpture is "powered" by the air around it.

George Warren Rickey (American, b. 1907), *Two Lines Up Excentric Variation VI*, 1977. Stainless steel. H: 22'. Columbus Museum of Art, Ohio, given by the family of the late Albert Fullerton Miller in his honor and memory. 78.31.

Kinetic Art

Kinetic art *is sculpture in motion*. The sculptures are designed to move by air currents or motors.

The Kinetic art movement began during the late 1950s and continued throughout the 1960s. The Kinetic artists adopted the philosophy of motion used by Alexander Calder (Chapter Two) to create their own versions of art in motion.

George Rickey. George Rickey (born 1907) was born in Indiana, but his family soon moved to Scotland. He studied art in Paris and London before returning to the United States where he pursued a career in painting. However, after learning how to weld, Rickey turned to sculpture. *Two Lines Up Excentric*

Variation VI (Figure 9-50) is a twenty-two foot high stainless steel kinetic sculpture. The sculpture is located outdoors, and its two thin triangular prongs sway back and forth in the air. They are balanced so that they will not touch each other even though they remain in a constant state of motion.

Len Lye. Len Lye (born 1901) also creates Kinetic art. Lye's sculptures can be moved in several ways: by hand, electricity, or air currents. His sculpture entitled *Grass* (Figure 9-51) is made from stainless steel strands that are attached to a motorized wooden base. When the sculpture is turned on, the base moves back and

Figure 9-51 When this sculpture is turned on, the base moves back and forth and the wires move.

Len Lye, *Grass*, 1965. Stainless steel and wood, motorized and programmed. 36" × 35⅝" × 8½" (incl. base). Albright-Knox Art Gallery, Buffalo, New York. Gift of Howard Wise Gallery, 1965.

forth, and the wires bend and wave like grass in the wind.

Art and Technology

The merger of electronic technology to the world of art began with a collaboration between artists and scientists in 1967. In that year, the Los Angeles Museum of Art opened an exhibition of Light, Sound, and Kinetic art that bridged the two fields. Following this unique presentation, the Center for Advanced Visual Studies at the Massachusetts Institute of Technology was opened. The purpose of the institute was to continue exploring the relationship between art and science. The merger of art and technology paved the way for electronic equipment such as computers, lasers, holograms, facsimile machines, photocopies, and neon lights to be used as tools in the artistic process.

Nam June Paik. Nam June Paik (nahm june pike) is a leader in using video as an art medium. He was born in Seoul, Korea, in 1932. Paik began his education as a student of musical composition before his family moved to Japan to avoid the Korean War. He entered the University of Tokyo to study music and art history. Paik's interest in these two areas, as well as in technology, prompted him to begin a career combining television and musical instruments into a performance.

Paik held his first professional exhibition in West Germany in 1963. This exhibit involved thirteen television sets, three pianos, and an assortment of handmade objects that made noises. The piano music and noisemakers were synchronized with the images on the television monitors. The exhibit was well received by critics and the art community.

After establishing himself as a video artist, Paik moved to New York City where he joined the **Fluxus movement** of the 1960s. The Fluxus artists (*fluxus meaning "to flow") presented live events involving music, literary readings, and spontaneous art.* Paik created robots that would conduct an "opera" performance with a radio or television, which was part of the robot, providing the music (see Figure 9-52 on the next page).

During the 1970s, Paik began making plans for a global video event. The actual event occurred on New Year's Day in 1984. This was a satellite production that was broadcast simultaneously in Paris and New York. A group of international artists performed. The success of the multiple images being viewed around the world encouraged Paik to create video "walls," for his next project. The walls were constructed from television monitors stacked on top of one another in a museum or gallery. Each of the monitors played an individual image that together formed one large image. Paik's first video wall used 384 monitors, which played tapes that had images of a small portion of the French flag. Since then, Paik's innovative techniques have inspired other artists to explore the use of electronic media in art.

Light Art

Light art *is art that uses electric light to create a special visual effect.* Typically, neon tubing is used by the artist to combine color and light in a composition. The light beams that radiate from the tubing can be compared to the colors from tubes of paint. The Light artist must be familiar with electrical currents, power, and how to wire portions of the light composition. The artist needs to have an excellent sense of composition and understanding of color theory.

Dan Flavin. Dan Flavin (flay-vin) (born 1933) cre-

Figure 9-52 Korean artist Nam June Paik has used television to assemble this "child."

Nam June Paik, *High-Tech Baby*, 1986. Mixed media with 13 color TV sets. Courtesy of Carl Solway Gallery, Cincinnati, Ohio. Photo by Cal Kowal.

ates museum and gallery installations with colored and white fluorescent bulbs. He creates each work to fit into the interior space of a gallery. Flavin refers to his work as "poststudio art" since it is created for a specific museum space rather than in an artist's studio. Often, the work is temporary, and is completely dismantled after the exhibition is over. One example of Flavin's light sculptures is shown in Figure 9-53, *Untitled (to Janie Lee) One*. A series of yellow, green, and pink fluorescent bulbs are located behind a blue bulb. When the light is illuminated, it projects triangular shapes on the walls of the museum from ceiling to floor.

TECHNOLOGY MILESTONES IN ART

Video Technology

Prior to the 1960s, video equipment was designed strictly for use in television and movie studios. The size and cost of the equipment made it nearly impossible to purchase it for individual or private use. In 1968, the Sony Corporation of Japan began to develop and produce video technology that was affordable and portable. Video cameras were designed to be compact, and video players became available to the public. The arts community quickly adopted video equipment as a medium for arts production.

Read about the Light art movement. Think about the following questions, and write your responses on paper.

1. Can an electric light bulb be considered an art medium? After all, it is not made of paint or clay. Explain your answer.

2. What happens to the work of art when the lights are turned off?

3. Since the architect of the museum or gallery designed the wall space on which Dan Flavin displays his work, has the architect participated in the artistic process?

Earthworks

The earthworks movement occurred during the mid 1960s through the 1970s. As you may recall from our discussion of earthworks in Chapter Five, this group of artists rejected the idea that works of art should be commercial products. They were also concerned with environmental issues and the earth's natural properties.

Dennis Oppenheim. Dennis Oppenheim (born 1938) is known for his earthworks, especially for the patterns he plows or mows into farmers' fields. Oppenheim, originally from Iowa, rents the amount of acreage he needs from the farmer. He then plows the field, using curved or diagonal lines to form a pattern (Figure 9-54 on the next page). Often, Oppenheim plants and grows grain before he creates a design in the field. After a period of time, he harvests the field, and his work of art is gone. Sometimes, he allows the mature grain to go to seed, rather than harvesting it. This completes

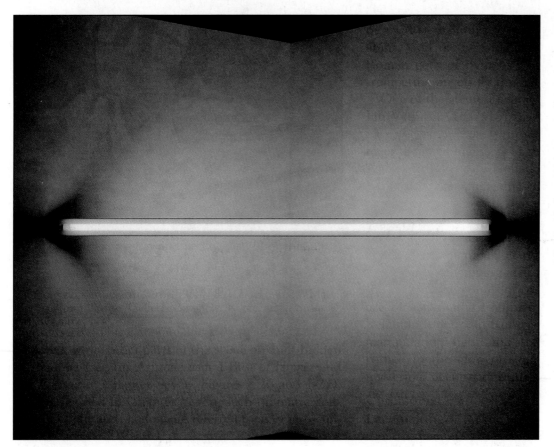

Figure 9-53 This Light art by artist Dan Flavin is mounted from one side of the gallery wall to the other.

Dan Flavin (American, b. 1933), *Untitled (to Janie Lee) One*, 1971. Blue, pink, yellow, and green fluorescent lights. H: 196". Columbus Museum of Art, Ohio. Gift of Mr. and Mrs. William King Westwater. ©1994, Dan Flavin/Artists Rights Society (ARS), New York. 79.053.

Figure 9-54 Oppenheim uses acres of land as his "canvas."

Dennis Oppenheim (American), *Maze*, 1970. Location: An unseeded field in Whitewater, Wisconsin. Blocks of baled hay for walls arranged in the shape of a laboratory maze; deposits of corn along edges and center of maze; cattle stampeded through maze to locate food deposits. 500' × 1000'. ©1994 Dennis Oppenheim.

the natural cycle and symbolizes how humankind can modify the natural environment.

Graffiti Art

The Graffiti art movement was not created by professional artists; rather, it was started by teenagers on the streets of New York City.

> "The heart is an instrument which goes rusty if it isn't used. Is it possible to be a heartless artist?"
>
> **Edgar Degas**

THINKING ABOUT
AESTHETICS

Read about Dennis Oppenheim's work and answer the following questions:

1. Can a farmer's tractor be considered an art tool? Defend your answer.

2. Can grain be considered to be an art media? Defend your answer.

3. Can allowing mature grain to go to seed after it has been cut into a pattern be considered art? What other form of art that has been described in this chapter might be used to describe Oppenheim's earthwork?

The development of aerosol spray paint during the early 1970s gave the young artists a medium that they could easily carry with them. Elaborate paintings were applied to any available surface in the city environment and labeled with a "tag"—that is, the name of the Graffiti artist (see Chapter Six).

Eventually, Graffiti art was popularized by professional artists such as Keith Haring (1958–1990). Art based on the street graffiti soon appeared in the galleries of New York and Europe. This transition from street to popular art shifted the attention away from the streets to the galleries.

Cy Twombly. Other artists were intrigued by the spontaneous acts and verbal messages of the Graffiti artists and incorporated this philosophy into their own work. One of these artists was Cy Twombly (born 1928). *Untitled (Stones Are Our Food to Gorky)* (Figure 9-55) is a drawing by Twombly. We see what appears to be a series of scribbles in red, orange, yellow, and black crayon. The writing at the top of the composition states, "Stones are our Food to Gorky." The work seems to have been produced in the quick, spontaneous manner of the Graffiti artist.

Twombly's drawing is actually an illustration of special stones found only in Armenia, which is located between the Caspian and Black seas. These stones absorb and store water for long periods of time. When droughts occur, the stones release the water. "Gorky" refers to Armenian artist Arshile Gorky (1904–1948), who was an Abstract Expressionist. Twombly admired Gorky as an artist and dedicated this drawing, one of five in a series, to him.

Figure 9-55 In what way is Twombly's drawing technique similar to that of Graffiti artists?

Cy Twombly (American, b. 1928), *Untitled (Stones Are Our Food to Gorky)*, 1982–84. Oil pastel, crayon, and graphite on paper. Sheet: 44½" × 30⅛" (113 × 76.5 cm.). Collection of Whitney Museum of American Art. Gift of the artist. Photo by Robert E. Mates. 84.30.

THINKING ABOUT

AESTHETICS

Look at Cy Twombly's drawing *Untitled (Stones Are Our Food to Gorky)*, (Figure 9-55), and then answer the following questions on paper:

1. Do you consider Twombly's drawing to be a work of art? Why or why not? Does your opinion change when you have read about the significance behind the drawing? Defend your answer.

2. Do you think Twombly needed to have any technical drawing skills in order to create his drawing? What might these skills be, and where are they evident in the work?

3. Do you think Twombly's title for the drawing is supposed to influence our interpretation of it? How?

Arshile Gorky

Cy Twombly's drawing *Untitled (Stones Are Our Food to Gorky)* (Figure 9-55) is the artist's tribute to Abstract Expressionist Arshile Gorky. Gorky was born Vosdanik Manoog Adoian in Turkish Armenia in 1904. When Gorky was two years old, his father left his family and defected to America to avoid the Armenian army. This left Gorky's mother to raise four children alone. She wanted Gorky to be involved in the arts in school, since her ancestors included architects, painters, and draftspeople. However, Gorky's education was affected by the political unrest in Armenia, which included World War I and the Bolshevik Revolution. The number of days he spent in school became fewer as he entered his teenage years. His mother's dream of her son's career in art seemed to vanish.

Gorky's mother became seriously ill and was denied medical help because his father had left the country. Upon her death Gorky and his younger sister left their homeland for America. Upon his arrival in New York, the former Vosdanik changed his name from Vosdanik Adoian to Arshile Gorky (Maksim Gorky was a Russian writer whom the artist admired). Gorky entered the Rhode Island School of Design. He was soon introduced to the art of Kandinsky, Picasso, and Miró, who were major influences on his work.

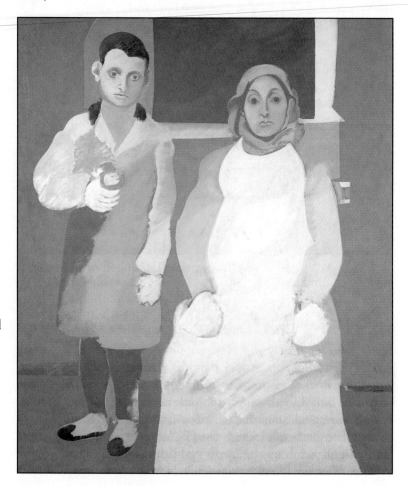

In Figure 9-56, you see Gorky's tribute to the woman who encouraged the teenager of years ago to obtain his dream. *The Artist and His Mother* was the first painting Gorky completed after arriving in the United States. He painted the portrait from memory and from a photograph he carried with him from Armenia.

Figure 9-56 One of Arshile Gorky's early paintings was a tribute to his mother. He painted it from a photograph he carried with him from Armenia.

Arshile Gorky (American, b. Armenia, 1904–1948), *The Artist and His Mother*, c. 1926–36. Oil on canvas. 60" × 50" (152.4 × 127 cm.). Collection of Whitney Museum of American Art. Gift of Julien Levy for Maro and Natasha Gorky in memory of their father. ©1994 Estate of Arshile Gorky/Artists Rights Society (ARS), NY. Photo by Geoffrey Clements. 50.17.

Installation Art

When we talk about preparing an exhibition for a museum, we use the word *install* to describe hanging works of art on a wall or placing sculpture in a gallery. **Installation art,** however, *is art that is built temporarily or permanently into a museum or gallery space.* An environment is usually created in which the viewer physically experiences the work of art.

The Installation art movement began in the late 1970s and was inspired by the Pop art movement. It continues today in the United States and Europe.

Sometimes Installation art is exhibited for a short period of time, and then dismantled. In this case, photographs and written commentaries document the event. Other Installation art is created for a specific location in a museum, gallery, or office building and is permanent. One example of a permanent installation is *The Cliff Dwellers* in Chapter Six.

Lucas Samaras. Figure 9-57 is another example of Installation art. The name of the work is *Mirrored Room* and it was created by Lucas Samaras (born 1936). This "room," lined entirely with twenty-four-inch-square mirrors, is eight-feet wide, eight-feet high, and ten-feet deep. A door opens to the room, which allows light to reflect off the mirrored walls. A mirrored table and chair are located in the middle of the room. These two objects invite you to enter the room and view the area as a living space.

Samaras considered the viewer a part of the artistic process. In *Mirrored Room*, viewers' bodies become the "paint" that makes "marks" on the mirrors. The marks are repeated countless times. Samaras, in referring to his room of mirrors, stated, "[People] paint with their bodies when they enter the room; you know, they inspect themselves, 'paint' themselves; they scribble. Then they go away and the scribble goes away, too—kind of an instant erasure."

Figure 9-57 Imagine yourself walking through Lucas Samaras's room created from mirrors.

Lucas Samaras (American, b. Greece, 1936), *Mirrored Room*, 1966. Mirrors on wooden frame, 8' × 8' × 10'. Albright-Knox Art Gallery, Buffalo, New York. Gift of Seymour H. Knox, 1966.

"One cannot enjoy beautiful scenery or works of art in the company of anyone but the right company."

Murasaki Shikibu

Sandy Skoglund. Sandy Skoglund is also an Installation artist. She combines figures of people and animals in unusual environments. Skoglund sculpts each object in her environment. She then paints the objects, using intense, mood-creating colors. To complete the process, the artist photographs the installation. Skoglund's art transports the viewer to an unidentifiable world. As in *The Green House* (Figure 9-58 on the next page), we are drawn into the scene, wondering where such a world exists.

Figure 9-58 Who are these people in Sandy Skoglund's *The Green House*? Would you like to live in this environment of blue dogs and grass-covered furniture?

Sandy Skoglund, *The Green House*, 1990. Cibachrome photograph, 50" × 70". Collection of the artist. ©1994 Sandy Skoglund.

Four Artists . . . Four Styles

To conclude our survey of twentieth-century art, we will look at four very different artists whose work can be categorized as Postmodern art. However, each artist has been influenced by movements discussed in this chapter.

Jasper Johns. During the 1980s, some artists returned to traditional themes, such as landscapes and portraits. Others continued to experiment with Abstract Expressionist techniques, using materials such as glass or neon lights. Jasper Johns (born 1930) is an example of an artist who began his career in one period, Abstract Expressionism, and moved into the Postmodern era. Johns uses common objects such as letters, maps, and numbers as subjects for his paintings. He abandoned the use of popular images in his 1980s paintings and began experimenting with pattern.

Wako Ito. Look for a moment at a work of art that is different from Johns's subject or technique, yet was also created during 1981. Japanese artist Wako Ito (born 1945) has painted a still-life of delicate petunias and foliage against a solid background (Figure 9-59). This painting has been created in the style of traditional still-life and is a departure from the Japanese art of ancient times.

Peter Voulkos. In contrast to the delicate nature of Ito's work, the ceramics artists responded to the Abstract Expressionist movement at the end of the 1970s.

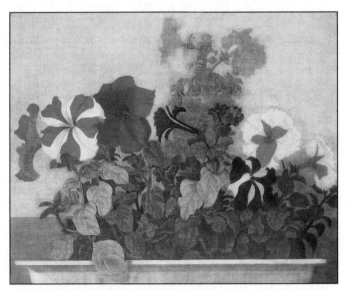

Figure 9-59 The technique used in this painting is called messotint.

Wako Ito (Japanese, b. 1945), *Petunia Basket*, 1981. Messotint. 11¾" × 14⅛". The National Museum of Women in the Arts, Washington, D.C. Gift of Kappy Hendricks.

Clay began to be used in the same expressive way the Abstract Expressionists approached their paintings. Artists applied paint to the clay surface with brilliant glazes, creating designs or figurative scenes. Ceramists began to experiment with nontraditional clay construction techniques. One ceramist, Peter Voulkos (born 1924), has discovered new ways to break away from traditional hand-built and wheel-thrown pottery. Voulkos has been influenced by both Abstract Expressionist painting and oriental ceramics techniques. Voulkos combines the decorative nature of oriental art with the spontaneity and expressive qualities of contemporary painters. In Figure 9-60, Voulkos has cut into a wheel-thrown cylinder, leaving slashes and crevices in its surface. The edges are raw and exposed where the slashes have been pulled apart. The container is not designed to be functional; rather, it is an expressive sculptural form. Voulkos invites viewers to change their opinion of a ceramic container as a functional object.

Miriam Schapiro. The last artist whom we will discuss is Miriam Schapiro (born 1923), who uses traditional techniques to make contemporary art. Schapiro was born in Toronto, Canada. She started her art ca-

THINKING ABOUT

AESTHETICS

In a few years, our world will be leaping into a new era. You will experience the transition from the twentieth century to the twenty-first. What will life be like in the next century? What types of changes might we expect to find in the following areas of living?

- clothing
- transportation
- entertainment
- art
- music

Figure 9-60 This ceramic piece could probably hold something, but what Voulkos wants it to hold is your attention.

Peter Voulkos, *Untitled, 1981*. Stoneware, wood fired. 21" diameter. Courtesy The Braunstein-Quay Gallery, San Francisco, California. Photo by Joe Schopplein.

Flags

In Chapter One, you were introduced to *Flag Gate* as a visual symbol for most Americans. Let's now look at two modern paintings where flags have also been used as the subject for art. In Figure 9-61, we see a painting of three flags of different sizes, placed on top of one another. The artist, Jasper Johns (1930) created a series of flags that were representational rather than abstract. The image of the flag is not blowing gently in the breeze. Instead, it has been painted from one straight edge of the canvas to another. The painting, *Three Flags* (1958), is made from three separate canvases which are bolted to one another. This results in a three-dimensional painting. The flags have been made by the **encaustic** method of painting *which is hot wax and pigment applied to the canvas with a brush.* The intensity of the

Figure 9-61 Johns' painting is actually three separate canvases attached to one another.

Jasper Johns (American, b. 1930), *Three Flags*, 1958. Encaustic on canvas. 30⅞" × 45½" × 5" (78.4 × 115.6 × 12.7 cm.). Collection of Whitney Museum of American Art. 50th Anniversary Gift of the Gilman Foundation, Inc., The Lauder Foundation, A. Alfred Taubman, an anonymous donor, and purchase. ©1994 Jasper Johns/VAGA, NY. Photo by Geoffrey Clements, New York. 80.32.

Comparing Works of Art

red, blue, and white along with the repetition of stars and stripes forces the viewer to "look at an object that is really never seen."

In Figure 9-62, we see a composition made from sections of flags from another country. Marsden Hartley has created a collage of German flags and military uniform badges. The brilliant colors and geometric patterns extracted from the flags are woven together into a composition. In *Portrait of a German Officer* (1914), Hartley has indicated movement of the flags through curved and wavy strips of symbolic color.

Although both Hartley and Johns were born in the United States, only Johns would remain to pursue his painting career. Hartley was born in Maine where he began his art career painting landscapes. His first exhibition was in New York City in 1909 where he was introduced to the art of Pablo Picasso and Henri Matisse. Hartley then went to Paris where he studied the techniques of the Cubists and Fauves. He also worked in Munich, Germany after adopting the philosophies of Kandinsky and the Blue Rider movement. His painting can be viewed as a tribute to his artistic growth during the time he spent in the country.

Jasper Johns was born in Augusta, Georgia. He moved to New York where his first exhibition was held at the Museum of Modern Art. While in New York, he met Abstract Expressionist Robert Rauschenberg and together they led a movement among painters to include images of daily life in their work. Johns's art would soon be a premier example of the Pop art movement in the United States.

Figure 9-62 Hartley has repeated the bold colors and shapes of military badges and flags.

Marsden Hartley (American, 1877-1943), *Portrait of a German Officer*, 1914. Oil on canvas. H: 68¼" × W: 41⅜". The Metropolitan Museum of Art, The Alfred Stieglitz Collection, 1949. 49.70.42.

reer as a painter, then began to create fabric collages that emphasized shape and pattern. The collages were created through the use of traditional sewing and other fiber techniques that had been invented by women over the past several centuries. Because these techniques had been designed by women, Schapiro labeled her work **Femmage art** a term that *combines "female" and "collage."* *Heartland* is an example of Schapiro's Femmage art. The artist "borrowed" a traditional block-quilt pattern for her composition. She repeated the pattern from several angles forming what Schapiro termed a *pattern painting*. She would include stylized figures in some of her designs which seemed to dance across the fabric.

Miriam Schapiro's career changed when, at the age of sixty-four, she decided to abandon her fabric collages for monumental sculptures. Suddenly, the human images used in her collages became models for her stainless steel sculptures. *Anna and David* (Figure 9-63) is made from sheets of stainless steel and aluminum that have been painted with acrylics. The two figures dance with such energy that their toes barely graze the grass below. The brilliant colors of red, blue, and yellow used in the clothing add to the exuberance of the work. Arms and legs bend to the energy of silent music as the figures jitterbug into the twenty-first century.

Figure 9-63 This is the first sculpture ever created by Miriam Schapiro. It is thirty-five feet tall and weighs 22,000 pounds.

Miriam Schapiro, *Anna and David*, 1987. Painted aluminum and stainless steel. 35' × 31' × 9". Commissioned by J. W. Kaempfer for an office building in Rosslyn, Virginia. Courtesy Bernice Steinbaum Gallery, New York. ©1994 Miriam Schapiro.

Student Work

Emily Cozen, 17
Overton High School; Memphis, TN

Learn the Vocabulary

Vocabulary terms for this section are *Abstract Expressionism, burnished, Art Brut, Pop art, Op art, Color Field art, Postmodern, Minimal art, Process art, Kinetic art, Fluxus movement, Light art, Installation art, encaustic,* and *Femmage art.*

1. Define twelve vocabulary terms by describing the style of one artist from each movement.

Check Your Knowledge

2. What effect did World War II have upon the art world?
3. Why were Jackson Pollock's painting techniques revolutionary?
4. Why did Jean Dubuffet make paintings that resembled the art of young children?
5. Describe the subject matter of the Pop artists' work.
6. What is a combine painting?
7. Describe the link between Op art and science.
8. Describe Helen Frankenthaler's "stain-painting" process.
9. What was the Photo-realist attitude toward using photographic images as subjects?

For Further Thought

10. List all of the ways you can think of that modern artists use technology. How do you think artists of the future will use technology in their art?
11. Write a paragraph on what you think the next twentieth-century art movement might be named and why.

SUMMARY

This chapter has explored the many different art movements that tell the story of Western art during the late nineteenth and twentieth centuries. We have seen how war has influenced the art of both centuries. Trends in art have been created and directed because of advancements in technology such as the camera and television.

We have seen how artists have redefined what art is and how it is to be made. Our perceptions of reality have been challenged while we have been asked to witness the subconscious mind at work.

In this chapter we have seen art which has been altered, fragmented, motorized, and reduced to its simplest form. It has been distorted, shifted, made from unusual materials, and scrawled across city walls. Art has fluxuated between the acute reality of the Photo-realists and simplified to almost nonexistence by the Minimalists. Above all, the diverse trends of modern art have challenged our opinions as to what is and what is not a work of art.

CHAPTER 9 REVIEW

VOCABULARY TERMS

Define the terms by explaining how each is an example of abstract or representational art.

Abstract Expressionism	Fauvism	Modernism
American Abstractionism	Femmage art	Op art
Art Brut	Fluxus movement	Pop art
Ash Can School	Futurism	Postimpressionism
avant-garde	Harlem Renaissance	Postmodern art
Color Field art	Installation art	Process art
Cubism	Kinetic art	pure painting
dynamics	Light art	Regionalism
encaustic	manifesto	simultaneity
Expressionism	Minimal art	Suprematism
	modern art	Surrealism

Applying What You've Learned

1. How did the effects of war influence the artists of the late nineteenth and twentieth centuries?

2. Do you believe that understanding the philosophies of modern art movements helps the viewer to appreciate the art? Give a specific example.

3. Compare the Photo-realists' attitude toward photography to that of the Impressionists and Postimpressionists.

4. How would you describe Surrealist Salvador Dalí's approach to his paintings? How important is the process to the artist?

5. What does a painting characterized by simultaneity look like?

6. Why did the French literary society reject Rodin's *Balzac*?

7. Describe the Impressionists' use of color and brushstrokes in their paintings.

8. Briefly explain the influences on the art of Diego Rivera.

9. Why can the art movements of the twentieth century be compared to the Renaissance?

Exploration

1. Select one art movement described in the chapter and research possible influences of the style upon the music, literature, or clothing of the time.

2. Take a walking trip around your community or through the local mall. List all examples you can find of twentieth-century art styles in products or advertising.

3. Use the architecture information in Chapter Six and additional information from the library to write a paper on *Architecture of the Twentieth Century*.

4. Defend this statement in writing: "It is the art product that is important, not the process of making it."

5. Look through magazines such as *Art News*, *Art in America*, and *Architectural Digest*.

6. Describe on paper or audiotape your impressions and opinions on art of the 1990s.

Building Your Process Portfolio

In this chapter, you have been introduced to artists who have grasped the spirit of change. This spirit led them to break the boundaries of conventional artistic expression. Your process portfolio can reflect the innovations that you achieve in exploring new ways of expression. You may also wish to include in your portfolio the following items:

- Your completed Student Activities and any preliminary sketches

- Responses to Thinking About Aesthetics, Developing Skills for Art Criticism, and Exploring History and Culture

- Lists of questions about issues in modern art

- Lists of modern artists you would like to research

- For your sketchbook: Look through magazines and newspapers and collect advertisements that reflect the influences of modern art. Select one image. Draw the image by rearranging its parts so that it reflects one of the modern art styles in this chapter.

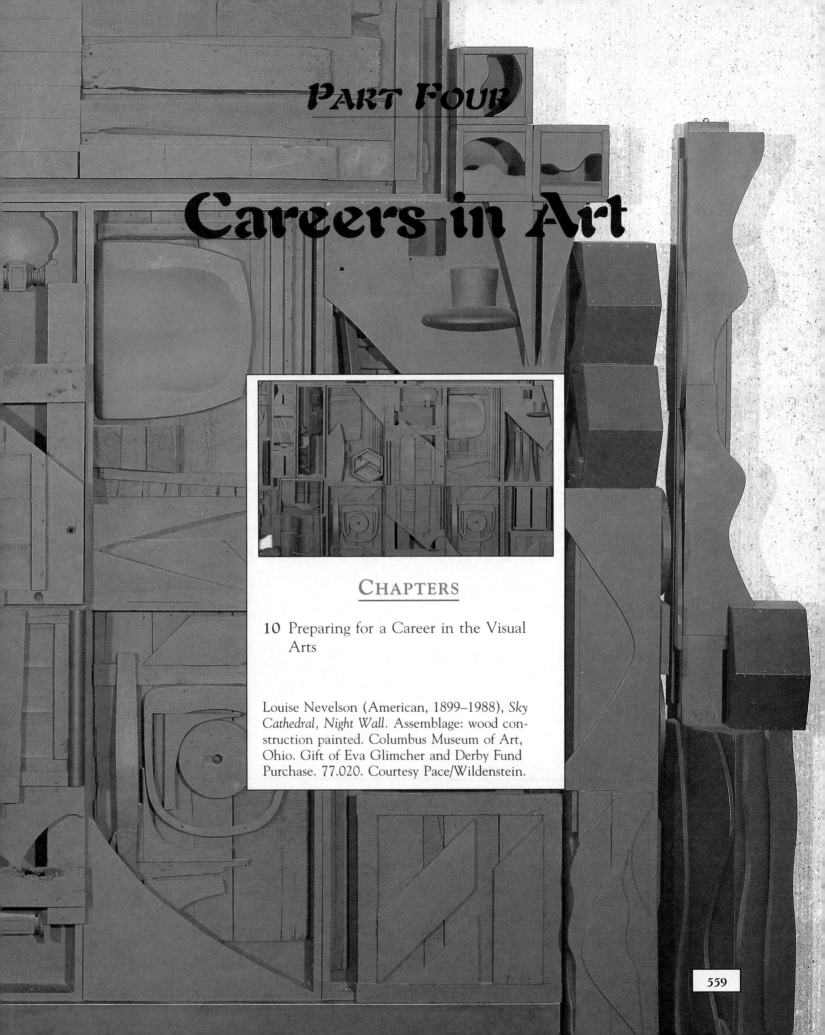

PART FOUR

Careers in Art

CHAPTERS

10 Preparing for a Career in the Visual Arts

Louise Nevelson (American, 1899–1988), *Sky Cathedral, Night Wall*. Assemblage: wood construction painted. Columbus Museum of Art, Ohio. Gift of Eva Glimcher and Derby Fund Purchase. 77.020. Courtesy Pace/Wildenstein.

Preparing for a Career in the Visual Arts

Figure 10-1 Estes shows us not only the baked goods for sale but also the neighborhood around Grossinger's Bakery by use of reflections.

Richard Estes, *Grossinger's Bakery*, 1972. Oil on canvas. 35" × 24". ©1994, Richard Estes/VAGA, New York. Courtesy Allan Stone Gallery, NY.

Contents

Terms to look for

acetate
admissions portfolio
advertising artist
aerial drawings
architect
area of concentration
art director
art restorer
book illustrator

commission
court artist
darkroom
docent
editorial cartoonist
elevational drawings
fashion designer
fashion illustrator
graphic designer

industrial designer
interior designer
internship
jewelry designer
life studies
logo
matting
medical illustrator
museum director

museum educator
package designer
proof
scenic designer
storyboard
syndicated cartoon
television graphic artist
thesis

Objectives

- You will discover the many different art careers that are found in the business, independent, and educational environments.

- You will become aware of the classes that you need to complete in high school in preparation for specific careers in the visual arts. You will also learn how to assemble an admissions portfolio as part of the process for college acceptance.

- You will understand the differences between schools that prepare you for a career in art after high school.

- You will understand the many different careers found within a museum.

Art in Your Life

Look around the halls of your high school, in the cafeteria, the offices, the gymnasium, and your art room. From the desks that you sit in each day to the cafeteria lunch trays, you are seeing the touch of an artist. Your life is influenced by artists in the clothing that you wear, the car that you drive, and your home. The artists who make the functional and decorative objects in your world have chosen to spend their adult lives making the world an aes-thetically pleasing place in which to live.

People who chose to teach others how to make art and study art may have already touched your life. Your elementary and middle school art teach-ers attended a college or university described in this chapter in order to receive a teaching degree. Now in this course, your teacher has used a lifetime of art experiences combined with art education training to guide you toward achieving your poten-tial in art.

Section I

Preparing for a Career in Art

There are art careers for people who like to make works of art for aesthetic, decorative, or personal rea-sons. Other artists create products or designs for busi-nesses and companies. Art careers also include the administration of art programs in schools, museums, and community centers. This chapter will describe some of these art-related jobs and how they serve the public.

Throughout this textbook, you have experimented with a variety of media and methods of making art. You have learned how to be an art historian and an art critic. These experiences have already given you the foundation knowledge needed for a career in the visual arts. You should begin to prepare early in high school, by researching specific careers, completing art classes, and becoming involved in extracurricular ac-tivities. There are three major areas to consider in pre-paring for an art career while you are still in high school:

1. Which high school classes to take that will prepare you for an art-related career

2. How to organize your artwork to apply to college or art school

3. How to select a college or art school that offers programs in the areas that interest you

Let's begin by discussing the courses you can take dur-ing high school.

High School Preparation

The first step toward a career in the visual arts is to complete the courses offered by your high school art department. Not only will these courses prepare you for a variety of fine arts careers, but they are also ex-cellent preparation for careers in the design, education, and communication fields. For example, sculpture and ceramics courses will strengthen the skills needed for industrial design. Learning drawing and painting tech-niques are essential if you want to be an illustrator or interior designer. Computer training within or outside of the art program is valuable for many different art careers. These professions include graphic design, ar-chitecture, or work in film and television.

Contact advertising agencies, museums, design studios, and performing arts centers in your community to schedule a visit. Observing professionals at work will give you some insight into the daily routine of each field. Before you visit, prepare a list of questions to ask people whom you meet in the workplace. The following list provides examples of appropriate questions:

- What type of college education is required for this art career?

- Does the job involve daily contact with the public or focus on a small population of people?

- What skills should high school students work on in order to prepare themselves for this field?

- What is the salary scale in the profession? Are there opportunities for career advancement in the field?

- Are there obstacles or challenges to overcome when starting out in the career?

Take notes or use a tape recorder during your conversations with these professionals. Review the information when you return to school, and keep it with your process portfolio materials for future reference.

Preparing a Portfolio for Admission to College

The type of portfolio that you develop as part of the admission process for college is different from your process portfolio. An **admissions portfolio** *is approximately twelve to twenty works of art that best represent your visual art talent.* You can begin assembling an admissions portfolio now and revise it each year as you complete your art classes.

You need to make good choices about the artwork that you select for your portfolio. Most art colleges suggest that **life studies,** *drawings of objects in their environment,* be included in the portfolio. These studies can include perspective drawings of buildings, human figure drawings and landscapes. Include several examples that exhibit your proficiency in one medium, technique, or subject. This will demonstrate your ability to explore and experiment with making art. Make sure that all artwork used in your portfolio is original work.

Student Work

Danielle Brown, 17
Overland High School; Aurora, CO

Copying from existing drawings or photographs is not recommended.

The artwork that you select for an admissions portfolio should be carefully prepared for review. The two-dimensional work should be matted. **Matting** *means to frame your artwork with mat board or poster board.* Mats should be clean and precisely cut with an X-acto knife or mat cutter. It is wise to use only black or white mats for portfolio work. Color mats distract the viewer from the art being evaluated. Attach a flat piece of cardboard or mat board to the back of the work for durability. Some art work can be mounted on mat board without a frame. However, the edges of the work must be clean and free of any tears or cuts. It is also a good idea to cover your pencil, pastel, or charcoal work with **acetate,** *or sheets of thin, clear plastic,* to prevent smudging. Attach a label with your name and school address to each work. If you want to submit three-dimensional art, use slide film to photograph the work from several viewpoints. Label each slide and place them all in plastic pages designed to hold slides.

Arrange your work in the order you want admissions personnel to view it. Then, package the art in a sturdy,

Student Activity 1

Selecting Work for an Admissions Portfolio

Goals

1. You will learn how to analyze the artwork in your process portfolio in order to assemble an admissions portfolio.
2. You will experience another person's *critique*, or review of your work.

Materials

1. Your process portfolio
2. Paper and pencil for notes

Directions

1. Look through the artwork that you have completed during this course. Select the artwork that you believe best represents your artistic ability.
2. Divide at random the work you have selected into two groups. Stand the work up against tables or a wall so that they may be viewed from a distance.
3. Select a partner from your class to review your work. It is probably a good idea not to select a close friend but rather someone who will give you his or her honest opinion about your artwork.
4. Ask the person to evaluate the work in the two groups and select six works from each. The work should be evaluated for composition, technique, use of media, and subject matter. Your teacher should help your evaluator begin the process if necessary.
5. The reviewer should then discuss with you the reasons why he or she selected these works. Take notes as you receive suggestions on how to improve the composition, color, texture, subject matter, or media of your work.
6. After the critique, spend a few moments analyzing the twelve works selected by the reviewer. Do you agree with the reviewer's decision? Is there work that you would *not* include in your portfolio? Why? If you have difficulty accepting the opinion of your reviewer, repeat the steps with another person or with your teacher.

Evaluation

1. Did the reviewer select twelve works from your portfolio and give reasons for his or her decision?
2. Did you take notes as to how you could improve your work?

easy-to-transport container. Commercial packaging such as the envelope style or vinyl cases are also available. Label the outside of your portfolio with your name and address. As a precaution against misplaced work, include an inventory of portfolio contents.

Find out about the portfolio scholarship processes and application deadlines at the schools you are interested in attending. You can obtain this information by requesting brochures of program descriptions, attending college fairs, or visiting the campus. The guidance department of your high school may be able to provide information about national, state, or local scholarship competitions. Deciding where to submit your application might depend upon geographic location, available programs, and your academic standing in high school.

When it is time for you to apply to college, you may want to have someone in the admissions office conduct a preliminary review of your work, if possible. This will help you to identify your strengths and weaknesses and allow for improvement before the final application deadline. Remember to maintain your process portfolio, conduct critiques of your progress, and allow plenty of time to prepare your work for admission.

Selecting a College or University for a Visual Arts Program

The final selection of the art colleges or universities to which you will apply usually occurs during the first part of your senior year. However, the process of evaluating and gathering information about college art programs can begin now. Lists of schools and their addresses can be obtained from your guidance counselor or art teacher. Write to the admissions offices of the schools you have selected for program descriptions and application materials.

There are several types of schools that will prepare you for an art career. We will look at three types here.

Four-Year College or University. A four-year college typically requires that you take liberal arts courses, such as mathematics, science, language, and electives, along with an art concentration. An **area of concentration** is *the subject area in which you complete*

Figure 10-2 If you choose a visual arts program at a four-year university, you may have access to a university museum such as this student has at the Fogg Museum at Harvard University.

©Farrell Grehan/FPG International.

beginning, intermediate, and advanced courses. For example, you might concentrate on drawing, painting, ceramics, computer graphics, or design. Most four-year colleges do not require an admissions portfolio for acceptance into the school. However, a review of your work before beginning studies in an area of concentration may be required.

Visual Arts College. Visual arts colleges specialize in several areas of the fine arts. An admissions portfolio is usually required for acceptance to the college. The freshman-year program requires that students complete

exploratory classes in drawing, painting, and design before selecting a specific area of concentration. The selection of a concentration usually occurs at the end of the sophomore year of college.

During your senior year, a **thesis** is usually required for graduation. A thesis at an art school consists of *an exhibition of your artwork that demonstrates your proficiency in your area of concentration*. Depending on the area of concentration, a fifth year of study or an **internship** with a practicing artist may be required. An internship *is a period of time during which a graduating student works with a professional artist in a studio environment*. A four-year bachelor of fine arts degree (BFA) is usually awarded to students completing all requirements for graduation.

Technical Art Schools.

A technical art school offers a two-year training program in specific areas, such as commercial art or photography. Most technical schools do not require a portfolio as part of the admission process. The philosophy of a technical school is that motivated students can be instructed in art techniques once they have entered the program and prior experience is not necessary. Language, math, and science classes are typically not included in the technical school curriculum. An entering freshman student typically begins working immediately on an area of concentration.

A two-year or associate degree is awarded to the student on successful completion of the program. Depending upon your area of concentration additional studies at a four-year school may be necessary in order to obtain a job.

Section ① Review

Answer the following questions on a sheet of paper.

Learn the Vocabulary

Vocabulary terms for this section are: *admissions portfolio, acetate, matting, life studies, area of concentration, thesis* and *internship*.

1. Fill in the blank with the appropriate vocabulary term.
 a. A period of time in which a graduating student works with a professional artist in a studio environment is called an _____ .
 b. A _____ is a college exhibition of your artwork that demonstrates your proficiency in your chosen area of study.
 c. A group of your best high school artwork used for applying to college is called an _____ _____ .
 d. It is recommended that an admissions portfolio include _____ _____ .
 e. All two-dimensional artwork should be protected with _____ before being submitted to a college for scholarship consideration.
 f. The subject area in which an art student completes beginning, intermediate, and advanced courses toward a degree is called an _____ _____ _____ .

Check Your Knowledge

2. What are the three major areas to consider in preparing for an art career while you are still in high school?
3. What is the first step toward a career in the visual arts?
4. List at least three helpful questions you can ask professionals when you visit them in the workplace.
5. How should you prepare the artwork you select for your admissions portfolio?
6. Explain the differences in the art programs offered by four-year colleges or universities, visual arts colleges, and technical art schools.

For Further Thought

7. Why do you think art schools consider life studies to be particularly good examples of an applicant's talent?
8. What kind of college would probably be best for someone who wants to become a painter? Why?

> "I realized that all the really good ideas I'd ever had came to me while milking a cow. So I went back to Iowa."
>
> **Grant Wood (on leaving Paris)**

Section II

A Survey of Art Careers in Business Environments

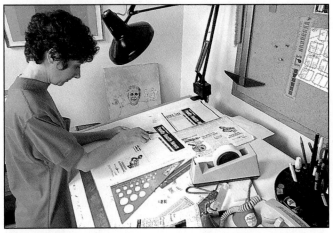

Figure 10-3 As a graphic designer, you may work at a drawing board like this or with a computerized drawing program.

©Michael Tamborrino/FPG International.

There are a variety of exciting and challenging art careers in the business world for you to choose from. The following brief overviews will give you an insight into the working environment and the skills needed for each career. You may want to do further research on the professions that interest you.

Graphic Design

Graphic designers *solve visual problems by using the elements and principles of art.* These visual problems typically include creating designs for product advertisements, packaging, brochures, and letterheads for businesses or corporations.

You can find graphic designers in television and movie studios, department stores, advertising agencies, and magazine publishing houses. If you look at your shoes, jackets, and shirts, you will probably see a **logo,** *the graphic design that identifies the product of a specific manufacturer.*

One branch of this field is computer graphic design. The use of computers has revolutionized the graphic design industry in the areas of lettering, planning compositions, and special effects. Computers are an effective tool for companies that need a quick, cost-efficient means of production. Images on a computer screen can be altered quickly and easily, and then multiplied to generate special effects. The computer graphic designer must have a strong foundation in the fundamentals of graphic design in order to use the computer effectively.

You can prepare for a career in graphic design by taking drawing, painting, design, business, and computer education courses in high school. It is also a good idea to visit industries and businesses that use computer systems to make labels and graphics for their products.

Industrial Design

Industrial designers *design functional products for public and private use.* The artist begins with a basic sketch for a product, then develops specific designs at each stage of development until the final product has been approved. Next, a model is made from the designer's drawings, and the model is passed on to the manufacturer for production. Today, computers are widely used in this field. They allow designers to visualize multiple viewpoints of the product before a model is created.

There are five stages of development that most industrial designers go through while working on an idea:

1. *Problem recognition:* The first step in product design is to study the request by a manufacturer for a new product. What form should the product take? Has the manufacturer specified that the product be a certain size or color, or that it appeal to a certain age group? Are there cost restrictions established by the manufacturer?

The Chair as Art

Look at the two chairs in Figures 10-4 and 10-5. Have you seen chairs like these before? Do they look like the chairs in your home, school, or doctor's office? The chairs have been made by two product designers. The chair in Figure 10-4 is a rocking chair designed by Michael Thonet (1796–1871). It is made from beechwood that has been steamed and bent into long curves. The flowing lines and spirals that create the design of the rocker invite the viewer to relax in its gentle motion. The seat and back are curved to follow the lines of the beechwood rods. The chair appears to have been designed to comfortably fit the human body.

In Figure 10-5, we see another chair design. This chair is by Charles Eames (1907–1978) and Ray Eames (1912–1988) who were a husband and wife design team. It is not as decorative as the bentwood rocker and at first glance, it may not appear to be as comfortable as the rocking chair. However, a closer look at the design will prove otherwise. The plywood seat and back are connected with a steel tubular frame. They are both gently curved to fit the contours of the human body. Like the steamed beechwood of the rocker, the plywood has been molded into curves. The front of the chair seat is turned downward to conform to the inside of the kneecap.

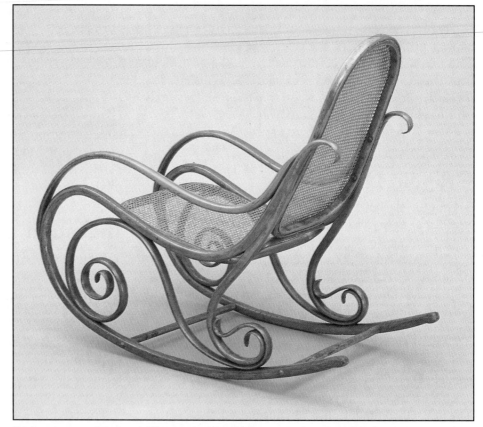

Figure 10-4 Michael Thonet's graceful bentwood rocker has been copied and produced by many manufacturers because of its comfort and popularity.

Gebruder Thonet (Austrian), *Rocking Chair*, 1880. Company design. Beechwood and cane. H: 37⅝", W: 22¾", D: 42½"; seat: H: 17¼". Manufactured in Vienna, Austria. Courtesy The Museum of Modern Art, New York, Gift of Cafe Nicholson. Photo ©1994 Museum of Modern Art.

Comparing Works of Art

Michael Thonet, a cabinet-maker who lived in Germany, designed his first bentwood chair between 1836 and 1840. Although bending wood for furniture had been invented during the eighteenth century, Thonet revived the technique in hopes of receiving support for starting a production company. Finding a lack of interest for his design in Germany, Thonet went to Vienna where he was able to establish a business in 1853 that grew quickly. The furniture was popular because it was lightweight, comfortable, and inexpensive. Furthermore, with the elimination of carved joints to make the legs of chairs, mass production was possible. The bentwood rocker was presented at the Great Exhibition of 1851, a show of contemporary product designs.

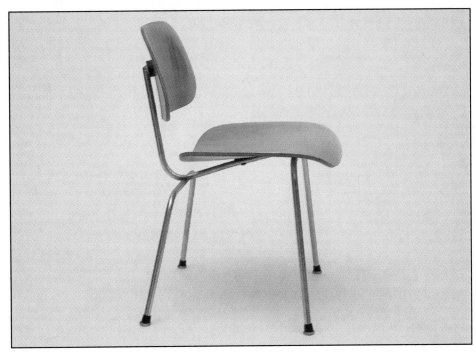

Figure 10-5 Charles and Ray Eames combined technology and art into a functional, comfortable unit.

Charles Eames (American), *Side Chair, Model DCM*, 1946. Molded walnut plywood, steel rod, rubber shockmounts. H: 29½", W: 20½", D: 21½". Manufactured by Herman Miller Furniture Company, Zeeland, Michigan. Courtesy The Museum of Modern Art, New York, Gift of the manufacturer. Photo ©1994 The Museum of Modern Art.

Charles and Ray Eames lived and worked in the United States. Ray began her art career by studying painting with Hans Hofmann. Charles was also an architect and headed the experimental design department at Cranbrook Academy of Art located in Bloomfield, Michigan. Like Thonet, the Eameses found their new molded plywood chair a blend of aesthetics and new manufacturing technology. The Eames chair received accolades because of their innovative use of materials (specifically the plywood) and its form and physical comfort. Soon the Eames chair and their other new designs in furniture were mass-produced for offices, hospitals, and private home use. In 1946, Charles Eames had a one-person exhibition at the Museum of Modern Art where today the chair is on permanent display.

Student Activity 2

Industrial Design

Goals

1. You will practice analyzing existing products for possible improvements in form, design, and function.
2. You will learn how to use the steps in the product design process to create a new product for consumers.

Materials

1. Assorted mixed media
2. Drawing paper
3. *Optional:* acetate or tracing paper
4. Pamphlets, books, or magazines showing examples of functional objects currently on the market

Directions

1. New products manufactured for consumer use are often improvements in the design of products already in use. Product designers analyze the parts of an object, its size, its shape, and color. Unique features such as automated parts or dual uses make the product attractive to the buyer. Once a designer determines the part of the object to be improved, he or she begins to execute the product design process outlined on pages 567 and 572. Select one product from the list provided here, or choose one of your own. What changes or improvement in form or function would you make? Think about your own experiences with the product. What makes the product enjoyable to use? What makes the product difficult to use?

Ideas for a Product Design

toothbrush	lamp	hair dryer
radio	musical instrument	toaster
television	glasses	tennis shoe
car	watch	sports equipment
bicycle	computer	CD player

2. Begin with the product design process on page 567, and complete each step until you have created a new design for a functional product. Complete at least three drawings from different viewpoints. You may want to enlarge one section of one drawing to show a detailed portion of your product.
3. Compare the new product design to the product you used in the first step of this activity. List the improvements in function and design on another piece of paper, and attach it to your work.
4. Give your new product a name. You can use your own name or your initials in the name of your product to add the personal touch of the designer!

Evaluation

1. Did you evaluate products currently on the market for needed improvements in function or design? What features were important to you as a consumer? As a designer?

2. Were you able to complete each step of the product design process? Do you think you can apply this process to other studio work? Explain by using an example.

3. Did you use good painting, drawing and composition skills while designing your product? If not, what areas would you improve upon if you did the project again?

Student Work

THE GREAT AMERICAN

PYR△MID

INTO THE FUTURE WITH A POINT FROM THE PAST

*Ninth-grade group project at Snowden Junior High School
Memphis, TN Instructor: Emily Ruch*

2. *Product research:* The next step is to analyze existing models of the product. Decide what can be improved or changed to make this version more functional and attractive for the consumer. How should the form be improved? Are the colors or textures of the product appealing? Are the object's parts safe and durable? Do they hold up under extensive use?

3. *Visual brainstorming:* The third step is to produce quick sketches of the new product design. These sketches should be of different viewpoints, special features, and details of the proposed product.

4. *Product decision:* The next step is to decide on the one new design that should be considered for the final product. This might involve soliciting ideas and suggestions from colleagues as to which idea is most aesthetically or functionally pleasing. Any changes in form, color, or parts must be made during this step in preparation for the final plan.

5. *Product completion:* The last step is to complete the final drawings. At least three different viewpoints of the product should be shown. These viewpoints are selected based on how well they show the different parts or special features of the product. The completed drawings are then passed on to a designer who produces a prototype (model) of the product. This prototype is used as reference during the manufacturing process.

If you are considering a career in this field, take drawing, painting, three-dimensional design, sculpture, and ceramics classes. If your school has an industrial technology department, courses in drafting will also prepare you for the industrial design.

Advertising Art

The job of the **advertising artist** *is to create visual images that will persuade the public to purchase a product or patronize a business.* Advertising artists design television commercials, magazine advertisements, and billboards for consumer products or community events. Sometimes, an advertising agency will be in charge of producing an entire promotional campaign, from the original layouts for a newspaper advertisement to television commercials and billboard displays.

High school drawing and painting courses will help you build your skills in representational art, shading, and human figure renderings, which are foundational in the advertising field. Since written words are often a part of the advertising designs, completing illustrations or logo activities involving lettering techniques will also be beneficial.

Package Design

The **package designer** *creates containers for products.* The designer must use three-dimensional design skills in order to make a container that will fit the form or parts of a product. The exterior of the package must also show the name of the product in a way that will catch the eye of the buyer.

Sometimes package designers have to create a package that is durable so that it can be shipped to the selling points. Such packaging must be carefully designed so that more than one product can be shipped in a box. Other packages are designed to hold food that may be fragile or difficult to wrap, such as milk or eggs.

The artist begins the design process by creating quick sketches of the product and possible containers. The manufacturer or inventor of the product is often consulted for feedback on the design.

A model is typically made to check for any problems that may occur during the production of the package.

Student Work

Jennifer Brommer, 19
Overton High School; Memphis, TN

Take design, sculpture, or ceramics courses in high school to prepare you for working with three-dimensional problems. Practicing different lettering, drawing, and painting styles will prepare you for designing labels and other ways to communicate the package contents to the consumer.

Interior Design

Interior designers *plan the interior spaces of homes, businesses, schools, or industries.* The designer must consider floor and wall spaces, furniture arrangements, lighting designs, and display areas. The interior designer sometimes assists the client in selecting fabrics, floor coverings, kitchen and bathroom appliances, antiques, and artwork.

If you are interested in interior design as a career, drawing, painting, and art history courses would be excellent preparatory courses. The home economics department in your high school may also offer a textile or fabric construction class that would introduce you to the diversity of materials available to the designer.

Entertainment and Media Industries

The public spends many hours of leisure time going to movies and watching television. The demand for new forms of entertainment has resulted in a need for professionals in computer arts, animation, set design, costume design, and special effects. *The person who coordinates the activities of set and costume designers, graphic artists, and lighting technicians is the* **art director.** An art director must have some knowledge of each career involved in film and theatre productions.

Film animation is a career within the entertainment and media industry. Film animators begin the animation process by creating storyboards for movies. **Storyboards** *show the frame-by-frame sequence of events for a movie.* Animators work with film soundtracks producers and the art director's vision about the visual appearance of the animated characters and the movie setting. Storyboards are also used for live-action films. They were invented by the Disney studios during the 1930s and soon became standard practice in the industry (see *Artist as Young Adult* on page 582).

Figure 10-6 Interior designers try to fit all the pieces together to form a pleasing arrangement for their clients.

©Jeffry W. Myers/FPG International.

Student Activity 3

Advertisements in our Society

Goals

1. You will develop your ability to analyze product advertisements.
2. You will become aware of effective advertising techniques for selling functional products.
3. You will become aware of the various places in your environment and in the media where advertisements can be found.

Materials

1. Magazines, newspapers, pamphlets, brochures containing product advertisements
2. Writing paper
3. Pen or pencil

Directions

1. Look through the magazines, newspapers, pamphlets, or other materials, and select two advertisements with a product similar to the one you designed in Student Activity 2.
2. For each advertisement, answer the following questions on paper.
 - Who is the *target audience?* The target audience is the age, cultural group, or sex of the individuals the manufacturer wants to sell the product to.
 - Does the lettering or typeface used in the advertisement enhance or distract from the ad's design?
 - What special effects did the artist use to attract the attention of the buyer?
 - What information about the product does the advertising artist provide?

Evaluation

1. Did you locate two interesting advertisements? Where did you find them?
2. Did you complete each question, using the examples as reference? Which question did not apply to the example you selected? What questions would you add to this list?

Student Activity 4

Creating an Advertisement for a Product

Goals

1. You will discover how to design an advertisement that will communicate information to the public about the product you designed in Student Activity 2.

Materials

1. Drawing paper or hot-press paper
2. Markers
3. Colored pencils
4. Acrylic or tempera paint
5. Lettering charts, of different typefaces

Directions

1. Decide where your advertisement will be located. Brainstorm with other students, the possibilities for where an advertisement might be located. Will it be in a magazine, on a billboard, a city park bench, the subway, the side of a truck, and so on?
2. Once you have selected a location, analyze the benefits and limitations of using that location. Consider the traffic flow, age group that your product is designed for, whether the product is for men, women, or children, and the type of product. For example, advertising a weed control product for farmers would probably not be effective in a New York subway station!
3. Decide what lettering style will enhance the message of your advertisement. Refer to the typeface charts. Practice the style you choose before working on your final layout.
4. Sketch several ideas for your advertisement composition on paper. Select one for your final design.
5. After you complete your advertisement on paper, make a drawing or painting of where the advertisement will be located. For example, if the advertisement is to be on a billboard or park bench, then create that scene, complete with the landscape or environment.

Evaluation

1. Did you determine the best possible location for your product advertisement? Where might you display a second advertisement?
2. Did you research lettering styles that would enhance your product message? Why did you select the particular style you used for your advertisement?
3. Did you complete the activity by creating a drawing or painting of the advertisement in its environment? What special features did the environment have that made you select it for your advertisement?

Student Activity 5

Creative Package Designs

Goals

1. You will explore the shape, form, and texture of an object in order to create a package for it.
2. You will understand the challenge of designing a package that reflects its contents.
3. You will combine two-dimensional and three-dimensional techniques to design the package.

Materials

1. Tempera or acrylic paints
2. Brushes
3. Poster board or cardboard
4. Assorted mixed media
5. Glue, tape
6. *Optional:* nontoxic plastercraft or papier-mâché

Directions

1. Select one of the never-before-packaged objects from the following list. Or think of your own "nearly impossible" object!

octopus	daisy	pineapple
miniature palm tree	one cloud	one doughnut
artichoke	skateboard	car

2. Create several preliminary sketches of a design for a package for this object. How will the package open and close?
3. Finalize your design and draw several viewpoints of the package. Plan how you will construct the package, what materials you will need, and any potential obstacles.
4. Construct the package design for your product. The package *does not* have to be in scale to the object. For example, the package for a car may be on a smaller scale as a prototype (model). However, *you cannot put the object in a square or rectangular box!* The package form and design must reflect the shape of the product. The colors and graphics that you choose should also represent the product. Lettering style should also complement the object's characteristics. For example, the lettering for a miniature palm tree could be made up of coconuts.

Evaluation

1. Did you consider all the parts and the shape of the object while designing the package? What parts of your object were the most difficult to package and why?
2. Do the exterior shape and design of the package reflect the shape, color, or texture of the object? If not, what could you have done during the planning stage to conform to the shape of the object?
3. Did you design a way to open and close the package? What makes your design unique?
4. What do you think is the most unique feature of the package design?

Figure 10-7 A graphic artist could be called upon to prepare a wide variety of drawings for almost any type of product.

©James Porto/FPG International.

An important person in television production is the television graphic artist. **Television graphic artists** may serve in a variety of capacities for the studio. They *may design promotions for advertising campaigns, create sets for game or talk shows, and invent new logos for the station.* Professionals in this specialty must be familiar with electronic equipment and computer graphic capabilities for special effects.

Preparing for a career in the entertainment and media industries can begin while you are in high school. Drawing, painting, design, and computer classes will provide you with beginning experiences in creating television or film graphics. Communication classes, such as speech, drama, or television production, will help you understand the diversity of careers involved behind the scenes.

Set and Costume Design for the Theater

The art of creating sets and scenic designs for theater production dates back to early Greece, when plays were staged for aristocrats and government leaders. Stages were built, and costumes were designed to enhance the visual effect of the drama being presented. These traditions continue today in school, local, and national theater productions.

Scenic Designers. Scenic designers *translate the vision of the playwright into a stage setting.* The designer works closely with the play and lighting directors throughout the construction of the sets. Scenic designers oversee the building of the set, from the preliminary drawings to the finished scene.

Costume Designers. The costume designer also works with the director, scenic designer, and lighting director to bring a play to life onstage. Drawings are made, evaluated, and revised before each costume is finalized. If the play is set in a particular period in history, the designer must research the clothing of that era to ensure authenticity of the designs. Once the designs have been finalized and approved, the drawings are passed on to the production shop of the theater where experienced clothing-construction personnel make the costumes.

If you are interested in set or costume design for the theater, become involved in high school or community theater productions. Take drawing, painting, and three-dimensional design classes. Home economics courses in sewing and clothing construction will give you foundational skills in costume production.

Fashion Design and Fashion Illustration

Fashion designers *create styles in clothing and accessories.* They experiment with textiles, colors, and

patterns to make new and exciting fashions for consumers. Accessory designers create new designs in eyeglasses, jewelry, shoes, and scarves, among other items. **Fashion illustrators** *draw the plans of the designer for catalogs, magazines, and store advertisements.* Manufacturers also rely on these drawings in order to produce the new clothing and accessories.

If you are considering a career in fashion illustration, practice drawing the human figure, hands, and facial features. The rules of proportion for fashion illustration are usually different from those used in drawing representational human figures. Taking clothing construction or the history of fashion through your school's home economics department will help prepare you for the world of fashion design.

Illustration

The artwork of the illustrator can be found in textbooks, children's books, magazines, newspapers, and on book jackets. Let's take a closer look at several types of illustration careers.

Book and Textbook Illustration. A **book illustrator** *is responsible for the visual images that accompany a text.* The illustrator works closely with authors and editors to capture in visual form the pertinent emotions and events described by the written word. Textbook illustrators create diagrams, charts, or drawings of objects needed to illustrate educational material.

Editorial Cartoons and Comic Strips. The **editorial cartoonist** *analyzes and illustrates public attitudes toward issues in society.* Editorial cartoonists identify and exaggerate the dominant characteristics of public officials. The artist usually has a limited compositional space in order to make a social statement. Thus each feature, expression, or gesture is vital to the cartoon's success.

The comic-strip artist works for a local or national newspaper. *Cartoons that are published nationally are called* **syndicated cartoons.** A story is usually told within a few frames, or it may appear as a drama that unfolds over several days.

If you enjoy drawing cartoons, drawing classes will help you learn how to capture the facial characteristics

Student Work

Ninth-grade group project at Snowden Junior High School Memphis, TN Instructor: Emily Ruch

and body positions of cartoon characters. Studies in the language arts will give you experience in expressing emotions and situations through words.

Medical Illustration. **Medical illustrators** *produce renderings of the external and internal parts of humans and animals, such as tissues, organs, skeletal systems, and cells.* Medical illustration is a highly specialized field. These illustrators must have technical drawing ability in order to render accurately aspects of anatomy. These illustrations are used as references for medical doctors and for public education.

Figure 10-8 Have you ever had your portrait done by a caricature artist such as this one?

©Art Montes de Oca/FPG International.

Paul Velasquez, 15
Overland High School; Aurora, CO

Medical illustrators work for hospitals, medical centers, public health agencies, pharmaceutical companies, and medical textbook publishers. Others produce illustrations for veterinary schools or research groups needing charts and educational materials.

Since medical illustrations are also used as references during medical procedures, they must accurately represent biological parts. The illustrator should have some knowledge of science, biology, and anatomy. If you are interested in medical illustration as a career, take advanced science classes while in high school. Volunteer to work at your local hospital or medical center to familiarize yourself with the atmosphere and personnel associated with the field. Obtain biology or medical books from the library, and practice drawing illustrations in order to understand the skill and precision that the field demands.

Court Artist

The **court artist** *is usually employed by television stations or newspapers to capture the drama of court proceedings.* Court artists are used when cameras are not allowed in the courtroom to film the proceedings. The court artist must be able to analyze the features and gestures of court participants quickly and transfer them to paper. Pastels are often used by court artists because pastels can be easily blended and cover the paper surface quickly.

To prepare for a career as a court artist, you should spend time learning how to draw the human figure and accurate facial features. Practice working under pressure.

Architecture

An **architect** *designs the interior and exterior structures of homes and buildings.* Architects create **elevational drawings,** *which show the height dimensions of the building.* They also produce **aerial drawings,** *which are plans for the placement of the building in the landscape as one looks down at it.*

Architects also design the interior spaces of homes, schools, churches, and businesses. They must analyze

Student Activity 6

Can You Judge a Book by Its Cover?

Goals

1. You will illustrate a book cover for a made-up title.
2. You will research or invent a lettering style suited to the title of your book.

Materials

1. Drawing paper or tag board
2. Tempera, acrylic, or watercolor paints
3. Brushes
4. Colored pencils
5. Colored inks

Directions

1. Spend time looking at and analyzing book covers in the library or in your art room. Does the design or illustration on the front of the book encourage you to read it? Does the lettering fit the subject of the book? For example, a book on medieval courts might have Gothic lettering in the cover design. Do the colors complement the theme of the book?
2. Select one of the fictitious book titles from the following list. Create a cover for this book using images, colors, and lettering suggested by the title.

The River of Tears	Automobiles of the Future
Dawn over the City	Music for Children
Monsters in the Cellar	Midnight at the Cemetery
Football Legends	School Survival Techniques

Evaluation

1. Did you create a book cover that will interest the reader in reading the book? What feature on the cover will attract the attention of the reader?
2. Did you use good lettering and compositional skills while designing the book cover? If you feel that one area of your composition is weak, what would you do to improve it?

Walt Disney

Walt Disney was born on December 5, 1901 in Chicago, Illinois. His father Elias was a farmer and carpenter. His mother was a teacher. Soon after Walt's birth, his family moved to Marceline, Missouri. This would be the first of many moves for the family.

Elias Disney purchased a small farm and attempted to support his family through farming crops and livestock. However, the farm was not successful and facing financial loss, Elias moved his family to Kansas City, Missouri in 1910. He acquired a paper delivery route that Walt and his two brothers were expected to maintain. Up at 3:30 A.M. each day, nine-year-old Walt spent several hours delivering the *Kansas City Star* before going to school. It was this type of personal discipline that Disney would later credit for his success as an animator and builder of the world's largest entertainment empire.

At age fourteen Walt studied cartooning through a correspondence school and attended classes at the Kansas City Art Institute and School of Design. Although he had always displayed an interest in drawing and painting, this formal training allowed him to develop a personal style of cartooning. Another family move, this time back to Chicago, interrupted his studies.

In Chicago, Walt enrolled in McKinley High School. He soon became involved with school activities and spent hours illustrating stories and taking photographs for the school paper. While at McKinley, he studied cartooning with professional newspaper cartoonist Leroy Goosett.

Walt's high school days soon came to an end when at age sixteen, he tried to join the army. After he was denied induction because of his age, Walt signed up as an ambulance driver for the American Red Cross. He was stationed in France where he gained the reputation as the troop's unofficial artist. Free time was spent painting fake medals on leather bomber jackets and camouflaging helmets.

Disney returned to the United States at age eighteen. He landed his first job as a draftsman for a commercial arts studio in Chicago. Later, he moved back to Kansas City where he began producing short films including *Alice's Wonderland* and other animated features. At age twenty-one, Disney moved to California where working out of a studio set up in his brother Roy's garage, he produced *Oswald the Lucky Rabbit*. Oswald would later become the model for Mickey Mouse.

Disney once talked about the character that changed the entertainment industry forever:

"His head and ears were circles so they could be drawn the same way, no matter how he turned his head. His legs were pipestems put into huge shoes to make him look like a kid wearing his father's shoes. He was supposed to be part human, so we gave him gloves."

Figure 10-9 This young cartoonist works in the Disney animation studio in Paris, France, completing animation sequences in the same manner as young Walt did in his early days in California.

©Thomas Craig/FPG International.

Mickey Mouse and the rest of the Disney characters have delighted generations of children and adults. An entire empire of cartoons, movies, merchandise, and theme parks has sprung from Disney's vision of a mouse with human characteristics. Today, Walt Disney Studios employs numerous animators who keep alive the vision of a young boy from Missouri.

Student Activity 7

Comic-Strip Drawing

Goals

1. You will learn the procedure for creating a comic strip.
2. You will learn how to make a statement or tell a story within a limited amount of space.
3. You will discover ways to coordinate words with visual images.

Materials

1. White drawing paper
2. Pencils (drawing and colored)
3. Markers
4. Watercolors and brushes
5. Ruler
6. Comic strips from newspapers
7. *Optional:* black ink and pen

Directions

1. Analyze the comic strips from your local paper. Select one, and answer the following questions:
 - How many frames did the comic-strip artist use to tell the story?
 - Is the comic serious or humorous? What mood has been established for the reader?
 - Is the story line for the comic strip completed within the frames, or is it one of a series?
 - Are human figures used in the comic, or has the artist invented the characters?
2. Sketch ideas for your comic strip first. What will your characters look like? Where are they located? What will the background look like? Plan the dialogue.
3. Divide a strip of six-inch-by-eighteen-inch paper into rectangular or square spaces according to the number of frames you will need. Consider how many objects you are going to place in each box in order to determine the size of these spaces.
4. Begin your drawing with pencil first, arranging the objects and lightly sketching them in each space.
5. Place words in the boxes where they are needed to tell the story. You can use bubble or balloon shapes to hold the words. Sometimes comic-strip artists will use small rectangular shapes to contain the words. Whatever you choose for your cartoon, it is a good idea to separate the words from the characters.

6. Use a black fine-point marker or black ink to go over your pencil lines. Watercolor and colored markers and pencils can be used to add color to your drawing.

7. If your comic is one in a series, repeat the steps and continue the story.

Evaluation

1. Did you analyze several existing comic strips for content, images, and story line? Did you borrow any of the artists' techniques?

2. Did you coordinate the written words with the images in each box? Would you change any portion of the written dialogue? Why?

3. Did you establish a mood in your comic strip? In what ways is the mood obvious to the reader?

Student Activity 8

Jewelry

Goals

1. You will create a brooch from a variety of found objects.
2. You will use the found objects to create an interesting arrangement of shapes and patterns.

Materials

1. A variety of found objects such as the following: beans or seeds, scraps of lace or velvet, pieces from old jewelry or broken watches, nuts and bolts, nails, buttons, shells, beads, dried flowers and so on.
2. Epoxy glue, tacky glue, or a hot glue and a dispenser.
3. Small scraps (for the background of your brooch) of metal, plastic, wood, cardboard, or Styrofoam.
4. Findings (pin backings).
5. Scissors
6. Polymer medium
7. Acrylic paint or spray paint

Directions

1. Begin by selecting a small piece of one of the suggested background materials. The background material that you select should be rigid enough to support the objects that will be glued to it, but at the same time flexible enough to allow you several options in creative designing. Shape the background piece into an interesting form. The form may be organic or geometric.
2. When the background piece has been shaped, it is ready to be decorated with several of the found objects you have collected. Try several possible combinations before choosing the final arrangement of objects. When you have decided on the best possible combination of objects, glue them down to the background piece. Be careful to use only enough glue to hold the objects firmly. If you are using scraps of lace or velvet, brush the back of each with polymer medium to stiffen them.
3. Consider spray painting or touching some color to the piece with acrylic paint.
4. When your piece is finished and thoroughly dry, attach a pin backing to it with epoxy glue.

Evaluation

1. Did you find a variety of interesting objects? Why did you select these items?
2. How did you determine whether you would add colored areas of paint, or spray paint the finished piece?
3. Were you able to create interesting patterns in your brooch with some of the smaller objects? How did you accomplish this?

Student Activity 9

Designing a Recreational Center

Goals

1. You will design a building for recreational purposes.
2. You will use architectural techniques and tools to design your building on paper.
3. You will combine your mathematical skills with your drawing skills to create an architectural structure.

Materials

1. Large sheets of drawing paper
2. Tracing paper or acetate
3. Pencils and colored pencils
4. Rulers, compass, templates

Directions

1. Work together in a group of three or four people and think about the ideal recreational center. This would be a place where you and your friends could meet to listen to music, dance, watch videos, and talk. What would that place look like? Where would it be located? Will it be in your community or in another state? How about in the middle of the desert, or perhaps in the rain forest? You may want to research the environment of an exotic location, such as a South Sea island, before designing your recreational center. Write your ideas on paper.

2. List on paper the special features you would want in a clubhouse, such as a video room, space for a pool table, a kitchen area, bowling alley, an indoor swimming pool—the sky is the limit!

3. Select a theme for your recreational center architecture. The structure of the building should reflect that theme. For example, if music will be the focus of your center, perhaps the building could take the shape of a compact disc player or of several large musical notes.

4. Design the interior space of the recreational center. Establish a scale for your floor plan. Determine the amount of space needed for each special feature.

5. Create entrance and exit areas for your center.

6. On another sheet of paper, draw or paint the exterior view of the building, complete with landscape and environment.

Evaluation

1. Did you plan the interior and exterior space of your recreational center? If you were asked to add an addition to your building, what would you design?

Figure 10-10 Architects not only draw plans for buildings, they also perform field inspections at projects which they coordinate.

©FPG International.

then draw spaces for traffic patterns, desk and storage spaces, plumbing, and lighting. Decisions architects make during the planning process are usually made with the client's wishes in mind. Architects are often responsible for selecting the type of materials used throughout the construction process. This means that they need to know about new technological advances in building materials and interior fixtures such as light switches.

Since the construction of large business or industrial buildings is accomplished by a team of engineers and contractors, the architect must act as a coordinator. Whenever a change needs to be made during the building process, the architect needs to consult with the team leaders before a decision is made.

Look again at the Thonet rocker on page 568. Remember that he was a cabinetmaker who revived the technique of bending wood for furniture.

Figure 10-4 shows the rocking chair he has become famous for.

1. How do you think it might feel to sit in this chair?

2. Would you encourage your family to purchase this chair for your home? Why or why not?

3. Would you agree with some critics who believe that Thonet's chair is a work of art?

4. If you were Michael Thonet, how would you defend your chair design against critics who might claim that it is not a piece of art?

If you are thinking about architecture as a career, you need to take the mathematics classes offered at your high school. Architects use their mathematical skills to calculate the precise measurements needed to construct a building.

There are several careers within the architectural field that you may want to investigate. They include landscape architecture, environmental and city planning, teaching architecture, model building, and architectural criticism.

Additional Art Careers in Business Environments

The following list names additional art careers that are found in the business world. You can find out more about those that interest you through your guidance center.

Student Work

Bryan Redd, 18
Overton High School; Memphis, TN

Graphic Design

- Sign painter
- Typographer
- Graphic arts technician
- Airbrush artist
- Mural specialist
- Showcard artist

Industrial Design

- Tool designer

EXPLORING

HISTORY AND CULTURES

During the late nineteenth century in Europe, new machinery was invented and industry grew. This industrial revolution prompted a group of German artists to merge with people who were working in the architectual and technological fields. They formed a school, Staatliches Bauhaus (Public House of Building), in 1919. Architect Walter Gropius led the artists in formulating the school's curriculum. The students at the Bauhaus were asked to study the materials used to create the products they made and the production process. Some of the courses taught at the Bauhaus that merged technology with crafts and art were carpentry, metals, typography, weaving, pottery, and stained glass.

The Bauhaus soon became the main source of innovations in design, art, and architecture. Eventually, the Bauhaus closed, and many of its students and teachers brought their talents and innovative ideas to the United States.

Select one of the following artists who were instructors at the Bauhaus. Research the artist's career. Write a brief report on how the artist's approach to art and design influenced the art world.

- Wassily Kandinsky
- Paul Klee
- László Moholy-Nagy
- Lyonel Feininger
- Marcel Breuer
- Mies van der Rohe

- Automobile designer
- Airplane designer
- Cartographer (refer to Chapter Three)

Figure 10-11 At some time, you will probably have to closely examine slides of your own or others' work to choose appropriate artworks for exhibitions, advertisements, or publicity of some type. You might even have a job as a photo editor.

©Tom Wilson/FPG International.

- Lighting specialist
- Sports equipment designer

Illustration

- Greeting-card designer
- Lettering specialist
- Book-jacket designer
- Airbrush artist
- Caricaturist

Photography

- Microfilm supervisor
- Museum photographer

Theater Stage Design

- Makeup artist
- Program designer
- Lighting designer
- Set construction
- Scene and set painters

Fashion Design

- Fabric designer
- Fashion coordinator
- Fashion display specialist
- Fashion merchandising
- Fashion consultant

Section II Review

Answer the following questions on a sheet of paper.

Learn the Vocabulary

Vocabulary terms for this section are *graphic designers, television graphic artist, logo, industrial designers, advertising artist, art director, storyboards, fashion designer, fashion illustrator, syndicated cartoons, medical illustrator, architect, elevational drawing, package designer, editorial cartoonist, book illustrator, scenic designer, interior designer, court artist,* and *aerial drawing.*

1. Match the following description to the appropriate vocabulary term:
 a. A highly specialized field requiring technical drawing ability in order to render aspects of anatomy
 b. The frame-by-frame sequence of events for a movie
 c. Person who designs the interior and exterior structures of homes and buildings
 d. Person who designs promotions for advertising campaigns, creates sets for game or talk shows, and invents new logos for a television station

Check Your Knowledge

2. How has the use of computers revolutionized the graphic design industry?
3. List the five stages of development that industrial designers go through when working on a new product.
4. What courses should you take to prepare for a career in interior design?
5. What does an art director do?
6. Describe the difference between elevational and aerial drawings.

For Further Thought

7. List at least two factors that package designers had to consider when they created containers for compact discs.

Student Work

Damian Marcano, 16
Whitehall-Yearling High School; Whitehall, OH

You have had the opportunity to experiment with a variety of artistic media and methods throughout this book. You have also read about artists who have chosen to focus on one medium or method of making art for their career. Perhaps you have discovered a way of creating images that has been exciting and personally rewarding. These encounters may lead you to pursue a career in the fine arts. The following subsections describe a few of the major categories.

Painter

Artists who paint typically use one medium, such as watercolors, oils, or acrylics, to produce their artwork. Painters also sometimes specialize in one subject matter, such as portraits, landscapes, still-lifes, or animals. Painters may rent studio space, work in their homes, or paint in community arts centers.

Although painters are considered to be self-employed, most establish regular working hours in order to fulfill the demands of private or gallery **commissions.** Commissioned art work *is when the artist has been asked by the customer to produce a piece in a particular style or with a certain subject matter, for which the customer will pay.*

Painters often do their own bookkeeping. Like those in other fine arts careers, painters sometimes hire managers to assist them in making gallery or museum exhibition arrangements. Managers may also handle the financial aspects of the artist's career.

You can begin to prepare for a career as a painter by completing drawing and painting classes during high school. Local colleges or cultural arts centers may offer courses during the evenings or weekends that will provide additional experience. Color theory exercises and experimentation with painting methods will help prepare you for college.

Printmaker

Printmakers, like painters, typically specialize in a particular printmaking method and work independently or on a commission basis. Since the printmaking process usually produces more than one art image, several clients can be supplied simultaneously. The necessary equipment for printmaking, such as presses, drying racks, and tools, require special storage in the artist's studio or work environment.

Some printmakers are commissioned by businesses for special advertisement artwork. Corporations wanting to decorate more than one office will pay the printmaker to produce several works at one time. Although

Figure 10-12 A sculptor applies finishing touches to a large plaster of paris artwork.

©Jose Luis Banus-March/FPG International.

the artist sells the multiple prints, the first print is usually kept in the artist's portfolio. *This initial print is called a* **proof.**

If you are thinking about a career as a printmaker, spend time drawing and sketching, experimenting with color, and working on design exercises. Visit galleries or museums, and analyze prints for composition and technique.

Sculptor

Sculptors work in a variety of studio settings, depending on the medium, method, and size of their sculptures. Metal casting or large assemblage sculptures are often created with foundry equipment such as liquid vats, torches, and ovens. Use of this equipment requires additional space and safety considerations for the artist. Some sculptors use unusual materials, such as neon tubing, or large construction or farm equipment, as did artist Robert Smithson in creating his earthworks (see Chapter Five).

Some sculptors work on a commission basis through architects or builders who have planned for a sculpture to be located in a specific space. Since most large works may take several months or a year to complete, many sculptors require some form of advance payment in order to afford materials and living expenses. Some sculptors teach at colleges and universities to supplement their incomes in between commissions.

To prepare for a career in sculpture, complete as many ceramics, sculpture, and three-dimensional design classes as possible. Drawing courses will help you generate ideas and solve problems on paper before beginning the work process. You should also take any metal and wood courses offered in your school's industrial design department. Learning how to manipulate wood and solder metals will provide you with necessary skills for this career.

Photographer

There are many different work settings for photographers. Recent improvements in photographic equipment and techniques have broadened the range of possibilities for the artist.

The commercial photographer works for magazine and book publishers, newspapers, or portrait studios. Fine arts photographers produce individual works or thematic series of photographs for galleries, art exhibitions, or private sales. Some fine arts photographers experiment with a variety of techniques by mixing photography with other media, such as painting and printmaking. Others, like the painter, specialize in landscape or nature photography.

Photographers also work on a commission basis with stores who need to produce weekly photographs of their merchandise for advertisements.

Photography is an expensive career for the artist due to the equipment, chemicals, and papers necessary to establish a **darkroom,** *an enclosed room for developing prints from exposed film.* When a photographer works for a company, much of the equipment is provided in an assembly-line atmosphere.

If there is a photography class available in your high school, take advantage of it to get as much experience as possible. You can also join your high school yearbook or newspaper team as a photographer.

TECHNOLOGY MILESTONES IN ART

Super 8 Film

An advancement in photography made the teaching of film and photography in the public schools possible. In the mid-1960's, Super 8 film was invented. It was less expensive than previously available films; it could be placed in a cartridge; and it was easier to store and transport. Inexpensive technical equipment was also invented to accompany the new film. One example of this equipment was the automatic exposure meter which allowed light into the camera mechanically.

You might want to consider working in a photography lab to experience firsthand the process of developing an image. There are also many photographic magazines and journals available for you to read, such as *Modern Photography and American Photographer*.

Careers in photography include photojournalism, architectural photographer, fashion photographer, film developer, and photofinishing specialists.

Additional Careers in the Visual Arts

The following list highlights additional careers in the visual arts. You may want to conduct your own personal research of the careers that interest you.

- Art dealer
- Muralist
- Portrait artist
- Frame specialist
- Art critic
- Newspaper art critic
- Art appraiser
- Environmental artist (see Chapter Five)

Ceramist

Ceramic artists work in one of two environments: the commercial ceramic artist mass-produces objects for a company; the independent ceramist works in a private studio.

Ceramic artists work with a variety of clays and techniques in producing functional or decorative works of art. Large studio spaces are necessary to provide space for potter's wheels, worktables, kilns, and storage areas for completed work. The fine arts ceramist usually sells his or her finished work at art exhibitions, crafts fairs, or in galleries.

To prepare for a career as a ceramist, work with clay in your high school art program, or complete a ceramics course. Sculpture and three-dimensional design classes are also good preparation for the work you will do in college. The student who majors in ceramics must be ready to spend long hours perfecting the craft of manipulating clay on a potter's wheel or through hand-building techniques.

Jewelry Designer

The jewelry designer typically works in one of two ways. **Jewelry designers** *produce models for mass-produced jewelry, or they create a commissioned piece of jewelry for a client.* Jewelry designers use a variety of techniques in working with precious metals and stones. They must learn how to design the piece of jewelry, manipulate these metals into the desired shape, and set the stones in place. Because the materials used in jewelry design are expensive, the jeweler must be precise in assembling the work.

If a jewelry course is available in your school or at a community arts center, it will provide a good opportunity for you to acquire foundational skills. Craft

TECHNOLOGY MILESTONES IN ART

Power Loom

An English inventor named Edmund Cartwright designed and made the first power loom in 1785. This invention mechanized weaving, which allowed for yards of woven fabric to be produced at a high rate of speed.

The power loom also contributed to the Industrial Revolution and growth of the textile industry.

stores may have simple jewelry materials, such as plastics, sequins, feathers, and glues. You can use these materials to begin experimenting with composition, balance, and color in jewelry design. Drawing and three-dimensional design courses will also strengthen your design skills. Math and science classes, such as calculus and chemistry, will help you understand the composition of metals and the rules of proportion.

Weavers and Textile and Fiber Artists

The crafts of weaving and working with textiles and fibers date back to ancient times. Originally, these crafts were developed to create materials that would protect people from the elements of nature. Over the centuries, people discovered ways to create fabric for clothing, shelter, decorative purposes, and slings for carrying objects. During the 1960s and 1970s, these crafts became part of the art curriculum. Batik and tie-dye (see Chapter Four) soon were included in the fashion industry's clothing production.

In Chapter Four, you discovered the different weaving methods used to produce cloth or decorative fibers. If you are interested in textile design, the drawing and painting classes offered through your high school art department will give you a foundation in composition, texture, and design patterns. Check with local cultural arts centers for classes that focus on weaving or textile production.

Additional Fine Arts Crafts Careers. There are many different crafts careers in the art world. Some of them are listed here.

- Bookbinder
- Papermaker
- Leather artist
- Glassblower
- Furniture designer
- Candlemaker
- Needleworker/appliqué artist
- Stained-glass artist
- Woodcraft artist
- Mosaic artist
- Metalsmith/goldsmith

Section III Review

Answer the following questions on a sheet of paper.

Learn the Vocabulary

Vocabulary terms for this section are *commission, proof, darkroom, jewelry designer.*

1. Fill in the blank with the correct vocabulary word.
 a. A _____ is where prints are developed from exposed film.

b. The first print of a series, usually kept in a print-maker's portfolio, is called a _____ .

Check Your Knowledge

2. What does it mean for an artist to work on a commission basis?

3. Describe some of the possible work settings for photographers.

4. What classes should you take if you are interested in jewelry design? Why?

For Further Thought

5. What kind of business or organization might seek the services of a painter? A sculptor? A ceramist?

Section IV

A Survey of Educational Careers in the Visual Arts

So far in this chapter we have looked at visual arts careers in business environments and in fine arts settings. Now we will turn our attention to people who are interested in teaching others about those careers. When we look at a work of art, we seldom think about the teachers who inspired and guided the artist. We have divided the following descriptions of art educa-tion careers according to the educational environments in which they take place.

Art Teachers in Elementary, Middle, and Secondary Schools

A visual arts program is one of the most vital elements of a school's curriculum. The visual arts can be taught independently from other school instruction, or in connection with other studies. For example, since art is an integral part of the development of cultures throughout the centuries, its teaching can be directly linked to science, mathematics, language, and social studies classes.

As you have discovered in the first part of this book, art education includes learning about art history and about how art is created, talking and writing about art, and learning how to make works of art. It is the responsibility of the art teacher to prepare students for an art career or to help them become aware and informed consumers and appreciators of art in their environment.

The role of the art educator usually extends to exhibiting student work, providing assistance to other teachers concerning integrated studies, working on play and concert sets, and contributing to community events requiring the skills of artists.

Elementary Art Teachers. The art teacher in the elementary school gives students opportunities to experiment with different media and methods of making art. These experiences are specifically designed for each grade level. Art teachers help young students express their feelings and emotions through art. Students also learn how to transfer onto paper or into sculptural form the mental images they have of what they want to make.

Elementary art teachers need to understand the stages in which skills develop in elementary school children. Most art education departments require their students to complete psychology and child development courses. They also need to be familiar with how to teach art to the physically challenged, mentally challenged, and artistically gifted student.

Student Work

Lamar Bryant Jr., 18
Tri-Cities High School; East Point, GA

teacher must provide experiences for students who are taking a course for credit as well as for career preparation. Courses must include a variety of media and methods while providing advanced training in individual subject areas for certain students.

High school teachers work closely with students who have decided on a career in the arts. They assist the students in assembling an admissions portfolio; they write recommendations for students' applications to college; and they help students acquire career information.

Teacher Preparation in Art Education. If you are considering a career as an elementary, middle, or high school art teacher, you need to select a college with a strong art education program. The program will typically consist of fine arts courses, special methods of instructing different grade levels, psychology, and curriculum writing courses.

Complete a high school college preparatory program and art classes if you are interested in becoming an educator. If your school has early childhood or after-school elementary programs, volunteer as a teacher's assistant.

Above all, you need to believe that the visual arts are vital to the intellectual, emotional, and physical growth of students. The skills, concepts, and attitudes toward art that students learn in first through twelfth grades will be a part of their lives long after they leave high school.

Middle School or Junior High Teachers. Teachers of middle school students must reinforce the students' skills learned during elementary school through a more advanced curriculum. The teacher must also prepare the student for the high school art curriculum by introducing advanced art materials, as well as historical and critical experiences.

High School Art Teachers. The role of the high school art teacher is similar to that of the elementary and middle school teacher. However, the high school

College or Art College Instructor

College art teachers instruct adults in the fine arts, philosophy, art history, and aesthetics. Other college teachers instruct students in how to teach elementary through high school art education programs. Many college teachers specialize in one area of the arts, such as painting, printmaking, or ceramics. The college-level teacher must work closely with students, advising them on their course selections and on their senior thesis.

Often, college instructors write for art journals, educational publications, and textbooks in addition to

teaching. Some college teachers make their own art and exhibit at galleries or museums while they teach at local colleges or universities.

Preparing to become a college instructor while in high school involves completing college preparatory and visual arts courses. Advanced college degrees such as a master of arts or doctorate degree are required in order to teach at the college level.

Additional Arts Education Careers

Here are some additional arts education careers that you can research:

- Art supervisor
- Private art teacher
- Cultural arts center instructor
- Artist in residence
- Art consultant
- Museum educator
- Senior center art coordinator
- Pre-school or early childhood art teacher
- Art therapist

Section IV Review

Answer the following questions on a sheet of paper.

Check Your Knowledge

1. What do you need to believe if you want to be a teacher of art? Why?
2. What else do college art instructors do besides teach?

For Further Thought

3. If you were a high school art teacher, what would you say or do to help your students understand that studying art is a worthwhile activity for everyone, even for those who aren't interested in pursuing an art career?

Section V

A Survey of Careers in Historical and Art Museums

The daily operation of a fine arts or historical museum requires the talents of many different people. Let's take a look a several careers specific to museums.

Museum Directors

Museum directors *are in charge of the daily operation of a museum.* They must know about each employee's job and daily responsibilities. Directors distribute funds to departments, oversee budgets, and write grants. They in turn must report museum expenditures and operational information to the board of directors (see page 600). Museum directors also work with public personnel such as mayors and governors who have an interest in maintaining the museum for the community. A museum can have one director or several depending upon its size and number of departments.

Docents

If you have visited a museum with your art class, you may have been given a tour by a **docent.** A docent *is a guide who conducts group and individual tours of the museum's collection.* The docent must be knowledgeable about all the works in the museum's permanent collection as well as those in special exhibitions. Depending upon the museum's policies, size, and operating funds, docents are paid or volunteer their time.

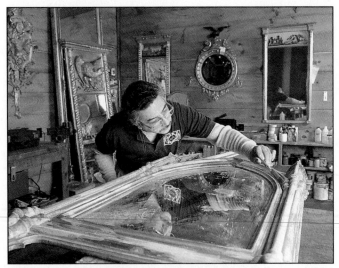

Figure 10-13 An art restorer must have a variety of skills including cleaning, repairing, and the knowledge of techniques to return a work of art as close as possible to its original state.

©Michael Nelson/FPG International.

Curators

As you learned in Chapter Two, a curator is in charge of the collection of artwork in a museum or gallery. Curators acquire works of art for the museum, arrange for loans of artwork from other museums, and plan traveling exhibitions. They also oversee the development of special catalogs about the museum's collection or special events.

Art Restorers

The **art restorer** *cares for and preserves the works of art in a museum.* New acquisitions are studied for their authenticity. Older works of art are cleaned and repaired on a regular basis. Technological advancements in equipment and chemicals assist the restorer in cleaning canvases and repairing fragile artifacts.

Museum Educator

Many museums employ **museum educators** *to conduct educational programs for children and adults.* The programs may include workshops on making art, as well as lectures and films about art and particular artists.

Sometimes educational tours of galleries or artists' studios are offered through the museum education department. Museum educators also work with local teachers in developing materials that students can use in the classroom before visiting the art or historical museum.

In order to prepare for a career in a museum, volunteer at a local museum, historical society, gallery, or science center. There, you will receive a firsthand look at the daily operation of such an institution. Complete the art courses available in your school, along with history, science, and language classes. Foreign languages will help you understand the different cultures represented in the museum collection.

Additional Museum Careers

The following careers are also found in art and historical museums. You may want to research some of these careers by contacting a local museum or by requesting information from your school's guidance office.

- Public relations
- Slide and book librarian
- Research specialist
- Display designer
- Museum bookstore manager
- Exhibitions coordinator
- Art historian
- Archaeologist (refer to Chapter Three)
- Registrar

Section V Review

Answer the following questions on a sheet of paper.

Learn the Vocabulary

Vocabulary words for this section are *museum director, docent, art restorer,* and *museum educator.*

1. Explain the difference between a museum director and museum educator.

Check Your Knowledge

2. List some of the activities of an art restorer.
3. What can you do to prepare for a career in a museum?

For Further Thought

4. Museum directors, curators, art restorers, and museum educators all need to be knowledgeable about art and history. For each of these careers, name at least one other skill that you think a person needs in order to perform the duties of the job successfully.

Section VI

Special Project: Assembling a Museum

No two museums are exactly alike. Each museum is unique in its collection of architecture, location, personnel, and public services. Museums have been built for many different reasons. There are museums that contain fine art, while others display the natural wonders of the earth. Some museums feature scientific advancements, airplanes, automobiles, information and artifacts from state or national history, or memorabilia of famous athletes. Museums also come in different sizes and shapes and a variety of interior spaces. Some museums include special services, such as restaurants, bookstores, children's discovery rooms, or educational classrooms.

Sometimes a group of individuals believes that a museum would enhance the cultural life of a community. In other cases, museums are created because someone has a private collection of objects that he or she wants to share with others. Museums are also developed as a business venture by people who think they can make

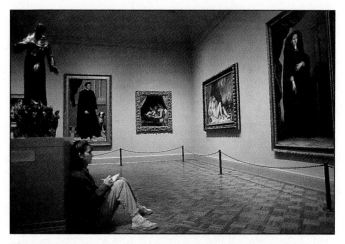

Figure 10-14 As you assemble your museum, think about how you are going to make your artworks accessible to people who really want to study works in depth.

©Lee Balterman/FPG International.

a profit from museum admissions and museum store sales.

It takes many people to make a museum. In this chapter, we have described the jobs of some of the people who are needed to develop a museum, such as architects, designers, interior decorators, and artists.

If you were given the opportunity to build a museum, where would you begin? What objects would you put in your museum? Where would the building be located? Would it have any special features? Let's discover the answers to these questions by building a museum on paper! Work together in groups to collect and assemble data.

Step One: Researching Public Opinion

The first step you might take would be to examine public opinion about building a museum in the community. Develop a questionnaire format for family and friends that you can use as a reference as you work through the project. Some appropriate questions might be the following:

• Have you ever visited a museum?

• What type of museum was it?

- Did the museum feature a certain theme?

- Do you think that the community needs a museum (or another museum, if one already exists)?

- What type of museum does the community need (science, history, specific ethnic group, French Impressionist art, and so on)?

- What special features are needed in the museum, such as children's programs, adult lectures, art and activity rooms, or restaurants?

- Would you support the museum by contributing financially and by attending special events?

After administering the questionnaire to family and friends list the responses under each question. Refer to these responses as you work your way through the following steps.

Step Two: Playing Different Roles

Activity One: Museum Board of Directors. The way in which a museum is operated is determined by a group of community people. This group is referred to as the board of directors. The board of directors makes decisions as to the type of museum, location, financial organization, acquisitions of artwork, and hiring of personnel. A board member may be a businessperson, civic leader, or community volunteer. Board members typically have careers outside of the art world but are interested in maintaining a cultural community.

Many museum board members are business or educational leaders in the community who volunteer their time to ensure the smooth operation of the facility. Acting as a board of directors, your group should complete the following tasks in order to begin assembling your museum:

- Analyze the results of the opinion survey.

- Determine what type of museum you will build. Will it be an art museum, a sports museum, a natural history museum?

- Establish plans for obtaining community funding. What organizations, such as arts councils, might grant financial support to build the museum?

- Research the community for a location for the museum. Will it be built on a vacant piece of land, or would renovating an older building be more cost efficient? Take into consideration as you plan, land and material costs today. Use maps of your city or town to help with this process.

- "Hire" museum personnel, such as a museum director, curator, educational staff, docents, and food service specialists. (Appoint members of your group to serve in these capacities.) These staff members will work together later in this project.

- Select a collection of art or objects for the museum. Develop a list of titles and artists that you want the museum curator to locate. Are there private collectors in the community who might donate items to the museum?

- Decide what special features your museum will have in the way of children and adult programs, gift shops, food services, or educational programs for teachers.

Activity Two: Museum Architects. Now that your group has made decisions as a board of directors, you can begin to design the architectural structure of the museum. The group may be divided into research teams to complete the following tasks:

- Conduct a site analysis for the construction of the museum. Use the board of directors, decisions from step two to determine any obstacles that must be removed (removing or filling areas with dirt or gravel), land reconstruction that must be done, and how much space is available at the selected location.

- If the board has decided to use an existing building, analyze the structure for renovation possibilities. What floors can be turned into gallery or exhibition space? Are there rooms that can be turned into art classrooms, storage space, or offices? Can handicap facilities be installed?

- Write to existing museums for brochures and maps to gather ideas for the building structure and floor plans.

Figure 10-15 Publicity is an important part of making a success of any venture.

©Edward L. Taylor/FPG International.

- Interview your parents, friends, or local businesspeople for suggestions.

 Create the preliminary architectural designs for the exterior and interior of the museum. Use large sheets of paper, mechanical tools such as rulers, compasses, and templates, and pencils to create layouts of each section of the museum. Consider the following museum features as you plan:
 Restaurant or food service area
 Educational classrooms
 Handicapped access
 Offices
 Auditoriums
 Museum gift shop
 Entrance and exit

- If several sets of architectural drawings are created, decide as a group which plan will best satisfy the desires of the board of directors and the community.

Activity Three: Public Relations Personnel.
The museum public relations personnel serve as the communication link between the museum and the community. Their job is to educate the public as to the special place the museum has in the community. They must also inform people about events, educational programs, guest speakers, and traveling exhibitions. Public relations people must work directly with advertising agencies and graphic design studios to produce brochures, pamphlets, posters, and advertising for the museum. Here are some suggestions for developing effective public relations for a museum:

- Analyze the museum pamphlets that your group has collected. Categorize them according to the areas they address, such as children's programs, museum memberships, reproduction-loan programs, special events, or guest lecturers.

- Decide what special events or programs should be a part of your museum. List them on paper so that brochures can be created at a later date.

- Explore methods of advertising the museum, such as billboards, displays, television and radio commercials, signs in subways, bus stations, or community centers, and newspaper advertisements or listings.

- Develop a public relations budget for a year. Most boards of directors require a report from their public relations directors. Research local agencies to obtain estimates of costs for billboards and newspaper advertisements. Ask for information from the mathematics department at your school on the proper procedures and format for creating a budget. The board of directors would need to approve the proposed budget.

- Once your group has established which methods of advertising are needed for your museum, design the brochures, billboards, or magazine advertisements. Use a variety of media, computers (if available), and lettering techniques to design the materials.

Step Three: Preparing for the Museum Opening

The board of directors, architects, public relations personnel, and museum staff must work together to-

ward the grand opening of the museum. As part of this step, complete the following tasks:

- Use foamboard or heavy cardboard to construct a small model of your museum.

- Display the brochures, billboard designs, or posters on the classroom bulletin boards.

- Design a small set for a television commercial about the museum and the special events planned for the opening (see the last two tasks in this list). Video-tape the commercial, using group members as actors.

- Locate in books reproductions or examples of the works of art, objects, or artifacts that your group plans to have in the museum. Display them in the classroom along with the public relations materials.

- Plan a menu for the museum restaurant, if food serv-ices are included.

- Plan the opening ceremony. Will a band, food, free gifts, and special exhibits be a part of the event? Decide which community officials or individuals who have contributed to the creation of the museum should be invited to the event.

- The docents, museum director, and curator hired during step one should plan for the opening by scheduling tours and determining how the art or ob-jects will be displayed in each room of the museum (use the model).

Step Four: Evaluating Your Museum Planning

Once steps one through three have been completed, evaluate the work of your group by using the following checklist:

1. Did all members of the group work together to solve problems and to make creative decisions? If not, what steps could have been taken to resolve these conflicts?

2. Did the group refer to the career information earlier in this chapter to act out the roles of member of the board of directors, architect, advertising agent, museum director, and docent? How, specifically, was the information used?

3. Will the museum serve the needs and interests of the community? In what ways?

4. Was a yearly budget for advertising expenses de-veloped by the group? How did you arrive at nu-merical figures for each expenditure?

5. Was the group able to plan, design, and create ad-vertisements for the museum? What factors did you consider when selecting the method of advertising?

6. Did the group plan, debate, research, and complete each step of the architectual designing process? Which steps were the most challenging? Which were the easiest to complete?

SUMMARY

In this chapter we have investigated a variety of art careers. Some careers require technical and ar-tistic skills. Others demand a knowledge of art his-tory and the aesthetic qualities of art. Careers in art can be found in a diversity of work settings, from museums to outdoor environments.

It is wise to begin preparation for an art career while you are in high school. Read as much as you can about careers that interest you. Practice your drawing and painting skills. Study the work of a variety of artists and periods in history. Plan to "shadow a professional for a day" to experience a typical work setting. Finally, complete as many art courses as are offered in your school while main-taining good academic standing in the rest of your classes.

CHAPTER 10 REVIEW

VOCABULARY TERMS

Write a story about a day in the life of a person in one of the art careers listed below.

acetate	commission	industrial designer	museum educator
admissions portfolio	court artist	interior designer	package designer
advertising artist	darkroom	internship	proof
aerial drawing	docent	jewelry designer	scenic designer
architect	editorial cartoonist	life studies	storyboard
area of concentration	elevational drawings	logo	syndicated cartoon
art director	fashion designer	matting	television graphic artist
art restorer	fashion illustrator	medical illustrator	thesis
book illustrator	graphic designer	museum director	

Applying What You've Learned

1. You have decided to pursue a career in art. What type of preparation should you complete while you are in high school?

2. What processes should you complete in assembling a portfolio of your art work for admission to college?

3. What three types of colleges offer a visual arts curriculum?

4. What careers are part of the entertainment and media industry?

5. Name at least three types of things museums may contain.

Exploration

6. Select one of the fine arts careers. Research the career through your school and local library. Ask your teacher or guidance department to help you locate a local artist to "shadow" for the day. Keep a diary of your experience.

7. Gather the work you have completed in class and begin to assemble a portfolio. Discuss with your teacher which pieces best represent your talent. Keep notes as to which works might be replaced with stronger pieces as you progress through the course.

APPENDIX A
Theories of Art

Everyone who uses the word *art* in ordinary conversation has some concept of art, or ideas about what the word *art* means. People use a concept of art as a way of distinguishing artworks from other kinds of objects. The word *art* allows people to look at a variety of things and tell which are art and which are not art. A concept of art is also used to distinguish artistic activities—making art—from other kinds of activities. Sometimes, too, a concept of art is used to judge whether an artwork is worthy or unworthy of praise and admiration. (Chapter One opens with a basic discussion of what constitutes art.)

Most people in the United States probably have a concept of art, although we do not all share the *same* concept of art. This explains why two people can visit an art museum together and disagree about whether or not some object belongs there. "This is not art!" one may exclaim; "It's just an ugly pile of scrap metal that belongs in the junk yard! The person who made this is certainly no artist!" The other visitor may respond by saying, "You have never had an appreciation for modern, abstract art. This 'junk' happens to be one of the best pieces in the art museum's collection. The person who made it certainly *is* an artist, and a good one!"

Which visitor is correct? No answer can satisfy everyone. Each person must form an opinion that reflects his or her own ideas, feelings, and values. But there is more to having a concept of art than just forming a personal opinion. Despite differences of opinion, many people will agree on whether or not something is art, whether its good or bad art, and whether or not someone is an artist. This is because certain ideas about art are commonly held during any given time period.

It is not clear how we acquire our concepts of art. Most of us probably develop our theories from ideas about art that we've heard expressed by our parents and teachers. But few people take the time to really think about, analyze, evaluate, and explain their concepts of art. Some philosophers, though, have done just that, and the resulting, well-developed concepts are referred to as art theories. An **art theory** *is a carefully examined and explained concept of art that serves to distinguish art from other kinds of objects and events.* Having some familiarity with theories of art can help you sort out and understand different points of view about the nature of art. Knowledge of art theories might even help you to better identify, explain, and defend your own point of view.

Philosophers of art have been unable to agree on a single art theory. In fact, there may be several different versions of any one art theory. Let's consider six art theories that have been influential in how art has been created and understood in our lifetime.

Imitation Theory

The idea that art is an imitation of the visible world in which we live dates back at least to the ancient Greeks. The **imitation theory** *is the view that visual art should pictorially represent living things and inanimate objects in the environment.*

Sometimes artists have applied this theory to "tell it like it is" and depict the world exactly as they see it, including unpleasant as well as pleasant scenes. War, poverty, crime, filth, and human suffering may appear in their artworks.

Other artists have chosen to idealize the visible world by depicting only what they think of as perfect beauty. Idealized artworks are not absolutely realistic since they show things in a better light than one would normally see them. Such artworks include lavish still-life paintings, dramatic landscapes, and flattering portraits.

If you wish to apply this theory to a process of judging works of art, you would look for the degree to which the artist has created a *convincing* (although not necessarily correct) depiction of people and things in the visible world. According to this theory, the more convincing the image, the better the artwork.

Look back through the text. Can you identify some works of art that seem to fit this theory?

Instrumentalism

Instrumentalism *emphasizes the use of art as an instrument to promote ideas, causes, or points of view.* Artists may want you to think hard about a certain issue, or they may try to convince you to share their points of view. Some artists may try to teach moral or religious lessons through their art.

Many artworks found in places of worship are devoted to delivering religious messages and stories to people. For example, stained glass windows in Gothic cathedrals were designed to inspire and sustain belief in Christian doctrines.

Art has also been used to glorify kings and queens, and inspire loyalty to rulers. Art has promoted systems of government and feelings of patriotism. Art has also been used to criticize governments and laws that some artists believed to be wrong.

Applying this theory, a work of art would be judged by how effectively it conveyed its message or lesson to viewers. According to instrumentalism, a good artwork successfully communicates a particular point of view about what's right or wrong, good or bad, or worthy or unworthy of support.

Can you find examples of artwork in the text that seem to match instrumentalism?

Expressionism

Expressionism *is a theory that relates the emotional life of the artist to the emotional impact of the work of art.*

This theory holds that an artist needs to have experience with an emotion in order to express it to viewers through a work of art. Although it's not necessary for an artist to be sad when painting a picture expressing sadness, it is necessary for the artist to have felt sadness at some point and be able to recall the experience. If the artist was successful, viewers will recognize sadness in the painting.

Similarly, viewers do not have to become sad when looking at a work of art in order to appreciate an artistic expression of sadness. If the viewers did need to experience the emotion to appreciate it, a visit to an art museum would become a nightmare of wild mood swings as visitors encountered artworks expressing various human emotions. Still, we can recognize, and maybe even sympathize or empathize with, emotions expressed in works of art.

Expressionism promotes the point of view that we are able to explore, examine, and enjoy the breadth and depth of our emotions by making and viewing art. This theory further states that we can react to these emotions without suffering the stresses that can accompany real emotions in real life situations.

Judging artworks from an expressionist point of view means that you must look for vividness and sophistication in an artwork's emotional impact. From the standpoint of expressionism, the more vivid and sophisticated, the better the work of art. But what do we mean by vivid and sophisticated?

If you can clearly perceive the expression of emotion, it is *vivid*. You and others around you should be able to agree on the emotion expressed.

If the expression is mature and has depth of meaning, it is *sophisticated*. The difference between a sophisticated and unsophisticated expression may be explained as follows. An unsophisticated expression is an obvious ploy to get your emotions stirred up. A picture of a person crying with tears running down cheeks may make us feel sorry for the person, but it's not likely to make us reflect deeply on the experience of sadness. We may wonder why the person is crying. In this case, the experience of sadness is limited to a facial expression.

On the other hand, a sophisticated expression will set a mood that spreads throughout the entire artwork. It may not be obvious what that mood is until you spend some time studying the work. Artists have ef-

fectively portrayed sadness and loneliness without even showing people in their work. For instance, a painting might depict a bleak landscape with a gray, wintry sky. Viewers may perceive a chill in the air, silence, and gloom.

Try to locate pictures in the book that express emotions. How would you judge the vividness and sophistication of these artworks?

Formalism

Formalism *is a theory emphasizing the relationship of two things: (1) the visible elements and composition of artworks; and (2) the way people respond to those compositions.* According to this theory, lines, colors, textures, shapes, spaces, and the arrangement of these elements in a composition can stimulate a special kind of response called an aesthetic experience. An **aesthetic experience** *is a strong feeling we may have when we greatly admire and personally respond to the visual impact of a work of art.* Some people claim that an aesthetic experience can be deeply moving and leave one with a sense of fulfillment. Perhaps you can recall a time when you felt deeply touched by and attracted to a particular work of art.

What is unique about formalism is that the arrangement of visible elements is held to be responsible for stimulating aesthetic experience. In other words, the composition is more important than the subject matter or theme of a work of art. For example, according to this theory, the *least* important artistic features of a landscape painting would be the trees, mountains, streams, and clouds depicted. The *most important* features would be the choice and arrangements of colors and shapes. This emphasis on composition over subject matter made formalism very popular among artists and critics in the early-to-mid-twentieth century, who preferred abstract art to realistic art.

Formalists believe that a work of art should be admired *for its own sake* rather than for any practical purpose it may serve. In the case of the landscape painting, the painting's primary purpose as a work of art would be to stimulate aesthetic experiences. It might also express an idea or theme about preserving the wilderness against pollution, but that would be of secondary importance. A formalist might admit that it is important to address environmental issues, but that it is possible to confront such issues without a work of art being present. To take advantage of the unique qualities of a work of art, one should concentrate on the composition.

Applying this theory, a work of art would be judged by how satisfying its visual composition is, regardless of any subject matter or theme represented.

Choose some realistic and some abstract works of art in the book. Try to judge each from the standpoint of formalism.

The Open Concept

An **open concept** *is a concept that is always open to change.* It is a flexible concept. The "open concept" in art is not a theory like those previously described, which are sometimes referred to as "traditional" theories. Traditional theories—imitationalism, instrumentalism, expressionism, and formalism—each claim to identify the most important characteristics of art. The open concept, on the other hand, makes no such claim. In fact, its chief claim to fame is its contention that there can be no true theory of art.

The open concept argument is based on the fact that art is always changing. Throughout the history of art, and especially in the twentieth century, there have been countless revolutions, changes, and variations in art styles, media and methods, and the meanings and values associated with art. Furthermore, art continues to change. No one can predict just what art will be like ten or one hundred years from now.

Supporters of the open concept believe that no theory can possibly account for all of this variety. There can be no single set of "most important" characteristics. The best a person can do to distinguish art from other objects is to compare each new object with similar objects encountered in the past.

Certain kinds of objects have historically been categorized as art. We know this is so because certain kinds of objects have been exhibited in art galleries, art collections, and museums for a long time. According to the open concept, if a new object is similar to the prized older objects, it, too, might be categorized

as art. A new work of art would not have to be exactly like previously made artworks. But *something* must be similar.

For example, there is a big difference between seventeenth-century Dutch and twentieth-century Cubist still-life painting. One is realistic, and the other highly abstract in form (compare Figures 2-2 and 9-17 in text). Yet each is an image painted on a flat surface, depicting various objects in an arrangement.

People who support the open concept can still use traditional theories to help them understand and judge works of art. For example, formalism can be used to help appreciate the composition of a painting. Expressionism can help identify the emotion or mood expressed by an artwork. The key is to remain flexible in your view of what art can or should be. The open concept has had a big influence on the way artists, critics, curators, and others have thought about art in the last half of the twentieth century.

Institution Theory

The **institution theory** *says that whether or not something is art is determined by the reactions that people have to an object.* This theory emerged partly as a reaction to the open concept.

Some theorists wondered: if a new object is categorized as art because of its similarity to an older, recognized work of art, how did the *older* work come to be called "art" in the first place? The answer, they felt, was not to be found in the artwork itself, but in the *people* who came in contact with it. In other words, if you want to know whether or not something is art, don't look at the object in question; instead, look to see how people are treating it, where they put it, and what they are saying about it. If people value an object highly, protect it, study it, exhibit it in art galleries and museums, and write about it in art magazines and art history books, then it's clear that people involved have decided that the object is art.

Look to see *who* is talking or writing about an object as if it were a work of art. Are these people recognized authorities in the world of art? If artists, critics, museum curators, gallery owners, art historians, and art collectors are all making a fuss over something that, in

their opinion, is a work of art, it *is* art. No one person has the authority to make this decision. The decision is made collectively by members of the artworld.

The **artworld** *is a large and diverse group of people scattered throughout the world who share much of the same knowledge about art and its history, and many of the same tools, terms, symbols, values, and goals related to art.* But the artworld is not an organization. There are no official rules, membership dues, or identification cards. People in the artworld do not all know each other, nor do they always agree on art issues. But they have enough interests in common that together they may be referred to as a social institution.

A **social institution** *is a group of people who share similar interests and goals in life and in their professions.* For example, in the United States, public school education is a social institution. Almost anywhere you go across the nation, you will find a school nearby, and teachers and principals who work there. You will find students of similar ages engaged in similar coursework.

The artworld is another social institution. People across the nation and around the world work to support the arts in various ways. Some members of the artworld have more influence than others. A director of a major art museum, for instance, may make decisions that affect many people and objects of art.

Everyone, however, can play an important part in the artworld. Each time you visit an artist's studio, gallery, or art museum, you are contributing to the life of the arts. You can increase the quality and quantity of your participation in the artworld by becoming knowledgeable and active in the arts in your community and by visiting art-related sites when you travel.

The institution theory of art does not lend itself to judging artworks the way that traditional theories do. This is because the institution theory shifts attention away from art objects and toward people involved in art. The institution theory can be used to explain how an object gets to be categorized as art.

This theory may also explain how a work of art can come to be regarded as "great." If lots of people in the artworld, after careful consideration, judge a work of art to be great, it will probably attain that status in the annals of art history, and its value will increase.

Can you think of activities that you can participate in to become more active in the artworld of your community?

APPENDIX B
Art Resource Maps

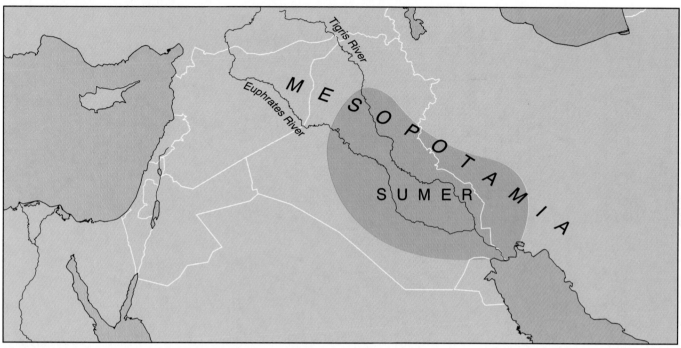

Mesopotamia

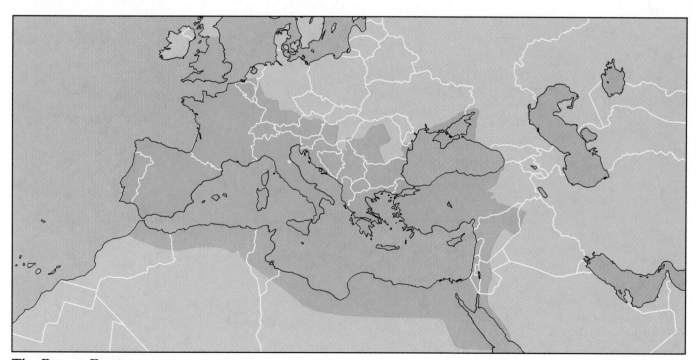

The Roman Empire

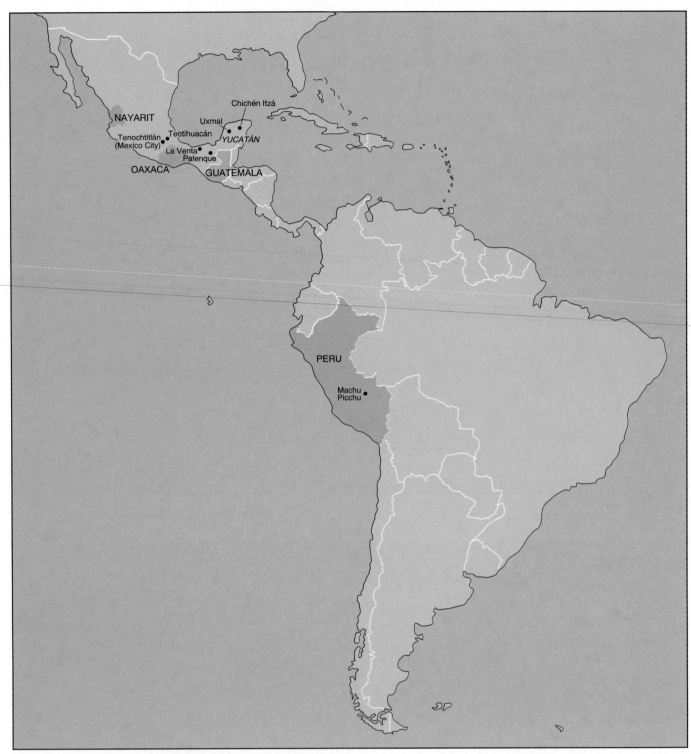

Mexico, Central and South America

Africa

India

China and Japan

Cambodia, Java, and New Guinea

Western Europe

APPENDIX C
Annotated Bibliography

The books listed below will help you expand your knowledge of art. Many additional books are available in your school and community libraries.

Adams, William Howard. *Nature Perfected: Gardens Through History*. New York: Abbeville Press, 1991. A dazzling color exploration of the art of gardening, including Islamic, Far Eastern, European, and American expressions.

American Folk Art: Expressions of a New Spirit. New York: Museum of American Folk Art, 1983. Folk painting, quilts, samplers, stoneware, baskets, decoys, weathervanes, and whirligigs—it's all here, in full color with informative text.

Atkins, Robert. *Artspeak: A Guide to Contemporary Ideas, Movements, and Buzzwords*. New York: Abbeville Press Publishers, 1990. A chronological survey of contemporary art movements including Funk art and Junk art. Illustrations and listings of artists, and definitions of each art form, such as Grafitti art, Installation art, Fluxus movement, and Art Brut.

Bearden, Romare, and Henderson, Harry. *Six Black Masters of American Art*. New York: Zenith Books, 1972. Fascinating and easy-to-read biographies of Joshua Johnston, Horace Pippin, Jacob Lawrence, and three other African American artists.

Beardsley, John. *Earthworks and Beyond*. New York: Abbeville Press, 1989. Explains and illustrates the daring work of visual artists who, in the 1960s, 1970s, and 1980s, fused their artworks with natural and urban landscapes.

Brommer, Gerald F., and Gatto, Joseph A. *Careers in Art: An Illustrated Guide*. Worcester, Massachusetts: Davis Publishing Company, 1984. Complete descriptions about careers in the visual and performing arts. Includes information concerning what classes to take in high school to prepare for each career.

Charensol, Georges. *The Great Masters of Modern Painting*. New York: Funk and Wagnalls. Contains seventy-eight illustrations of artists' work from the first half of the twentieth century. Critics discuss modern movements in art and artists explain their techniques. A chronology from 1920–1940 and a dictionary of art terms is included.

Feldman, Edmund Burke. *Thinking About Art*. Englewood Cliffs, New Jersey: Prentice Hall, 1985. Explores issues such as who makes art, how art speaks to us, and the importance of art, with examples of sculpture, painting, photography, and architecture.

Ferrier, Jean-Louis. *Art of Our Century: The Chronicle of Western Art*. New York: Simon and Schuster Inc., 1989. Eighty-nine years of magazine-style information about modern art. Full of information about artists and national and world events, year-by-year. Artist biographies and quotes by artists are woven throughout the material.

Finch, Christopher. *The Art of Walt Disney: From Mickey Mouse to the Magic Kingdoms*. New York: Crown Publishers, Inc., 1988. An account of Walt Disney's career along with illustrations of the basic techniques of animation.

Gardner, Helen; with Horst de la Croix and Richard G. Tansey. *Art Through the Ages* (eighth edition) New York: Harcourt Brace Jovanovich, 1986. This massive survey of art history is a classic, first published in 1926, although it has been revised and updated many times since then. Excellent timelines.

Harlem Renaissance: Art of Black America. New York: Harry Abrams, Incorporated, 1987. A comprehensive study of African American art and artists during the 1920s and 1930s in Harlem, New York, which was the center of America's writers, actors, and artists during this period.

Hunter, Sam. *George Segal*. New York: Rizzoli International Publications, Inc., 1989. This book features 125 large color photographs of Segal's work. A brief history tells of the things that influenced his work.

Hutt, Julia. *Understanding Far Eastern Art*. New York: E. P. Dutton, 1987. A concise and readable survey of ceramics, sculpture, paintings, prints, lacquer, textiles, and metalwork from China, Japan, and Korea. Organized by media and methods.

Lee, Stan, and John Buscema, *How To Draw Comics the Marvel Way*. New York: Simon and Schuster, Inc., 1978. A comprehensive look at the process of making a comic book. It also includes lessons on drawing heroic figures, perspective, shading and shadowing, drawing a villain, and drawing figures in motion. It's like having a conversation with the artists.

Merken, Betty, and Merken, Stephan. *Wall Art Megamurals and Supergraphics*. Philadelphia, Pennsylvania: Running Press Book Publishers, 1987. A photograph collection of wall murals in Los Angeles. The murals were painted by groups of community people and by professional artists.

Nigrosh, Leon. *Claywork: Form and Idea in Ceramic Design*, 2nd Ed. Worcester, Massachusetts: Davis Publishing Co., 1986. Instructions for hand-building and wheel techniques are given. Glaze and surface decorations are also discussed.

Norwich, John Julius. *Great Architecture of the World*. New York: Bonanza Books, 1979. Plenty of photos and diagrams, along with brief descriptions that place buildings into historical context, make this an appealing book to use in gaining an appreciation of world architecture, from ancient Indian temples to the modern Sydney, Australia, Opera House.

Petersen, Karen, and J. J. Wilson. *Women Artists: Recognition and Reappraisal From the Early Middle Ages to the Twentieth Century*. New York University Press, Art history from a woman's point of view. Biographical information on women artists. Special feature on women artists of China.

Peck, Judith. *Sculpture as Experience*. Radnor, Pennsylvania: Chilton Book Company, 1989. Instruction on how to work with clay, wire, wax, plaster, and found objects to create sculpture.

Rennolds, Margaret B. (Ed.). *National Museum of Women In The Arts*. New York: Harry Abrams, Inc. Publishers, 1987. A richly illustrated survey of a collection of women's art from the National Museum in Washington, D.C.

Richards, J. M. *Who's Who in Architecture From 1400 to the Present*. New York: Holt, Rinehart and Winston, 1977. A chronology of architects from the early Renaissance to contemporary times. Includes essays from leading architects.

Roukes, Nicholas. *Design Synetics: Stimulating Creativity in Design*. Worcester, Massachusetts: Davis Publications, 1988. A guide to thinking visually and creative problem solving. This book will encourage you to make connections between objects and explore fantasy images. Lessons and exercises in two- and three-dimensional projects are included.

Safford, Carleton L., and Bishop, Robert. *America's Quilts and Coverlets*. New York: Bonanza Books, 1980. A full range of American quilt design is illustrated, with notes on history, materials, techniques, and lore.

Smith, Bradley. *Mexico: A History in Art*. Garden City, New York: Gemini-Smith, Inc., 1968. A heavily illustrated survey of the visual arts and cultures of Mexico from ancient times to the mid-twentieth century.

Stein, Judith; Ashberry, John; Cutler, Janet K. *Red Grooms: A Retrospective*. Pennsylvania Academy of the Fine Arts, 1985. This book tells the story of the life of Red Grooms. It briefly discusses his work as an artist, actor, and filmmaker. It includes large, full-color reproductions of his work.

Tate, Elizabeth. *The North Light Illustrated Book of Painting Techniques*. London: Quarto Publishing Ltd., 1991. Over forty-five painting techniques in acrylic, gouche, oil, pastel, tempera and watercolor as well as tips for painting landscapes, portraits, animals, and still-lifes.

The American Indians (multivolume series by the Editors of Time-Life Books). Alexandria, Virginia: Time-Life Books 1992–1993. Richly illustrated series covering Native American social life, customs, history, art, ceremonies, and more.

Treasures from the National Museum of American Art. Baltimore, Maryland: Smithsonian Institution Press, 1985. A selection from the museum's collection from the 1700s to contemporary art. Biographies on artists plus artists' quotes. Full-color reproductions and historical information on each painting.

Volz, Wolfgang. *Christo: Surrounded Islands, Biscayne Bay, Greater Miami, Florida, 1980–83*. New York: Harry N. Abrams, 1985. A thorough documentary account, in words and pictures, of Christo's monumental artwork that captured attention and imaginations worldwide.

Walker, Lou Ann. *Roy Lichtenstein: The Artist and His Work*. New York: Loadstar Books, a division of Penguin Books USA Inc., 1994. An up-close and personal look at the artist in his studio. Beautiful photographs bring the reader into the studio to watch the creative process as it happens. Includes the artist's thoughts about ideas, techniques, interpretation of works, and a lesson.

Welch, Stuart Cary; Schimmel, Annemarie; Swietochowski, Marie L.; and Thackston, Wheeler M. *The Emperor's Album: Images of Mughal India*. New York: The Metropolitan Museum of Art, 1987. A close examination of Indian miniature painting.

Welton, Jude. *Monet*. New York: Dorling Kindersley, 1992. A broad look at Monet's life, his work, and the tools he used. This book includes thematic sections that include in-depth discussions of many of Monet's sketchings and paintings.

Willett, Frank. *African Art*. New York and Toronto: Oxford University Press, 1971. A scholarly and informative text accompanied by many photographs and reproductions presents African art in historical and cultural context.

Young, Gavin. *Art of the South African Townships*. New York: Rizzol International Publications, Inc., 1988. A forward by Archbishop Desmond M. Tutu. A comprehensive look at works of art that embody the spirit of customs and change. A wonderful mix of traditional and contemporary works that speak for the South African people.

APPENDIX D
Art Museums and Galleries in the United States

The following list presents more than 200 museums and galleries of art in the United States, listed state-by-state. This list is not intended to be complete. Rather, it is a sampling, so that students will be aware of some of the museums they might possibly visit when traveling throughout the United States. An asterisk denotes museums from which works of art are reproduced in this text.

Each listing includes the name of the museum, address, telephone number, admission costs, and a general comment about the types of collections on exhibit. The information is current as of January 1994. Obviously admission costs and telephone numbers will change over a period of time.

ALABAMA

Birmingham Museum of Art
2000 8th Ave. N.
Birmingham, AL 35203
205-254-2565
Admission: No charge; donations accepted
Collections: European and American paintings, African and Pre-Columbian art

The Fine Arts Museum of the South at Mobile
4850 Museum Drive
Langan Park
Mobile, AL 36689
205-343-2667
Admission: No charge
Collections: Special collection of 1930s and 1940s American paintings

Huntsville Museum of Art
700 Monroe St. S.W.
Huntsville, AL 35801
205-535-4350
Admission: No charge; donations accepted
Collections: 19th- and 20th-century American paintings

ALASKA

Anchorage Museum of History and Art
121 W. Seventh Avenue
Anchorage, AK 99501
907-343-4326
Admission: $2.50
Collections: Alaskan art

Visual Arts Center of Alaska
713 W. 5th Avenue
Anchorage AK 99501
907-274-9641
Admission: No charge
Collections: Contemporary visual arts

ARKANSAS

The Arkansas Art Center
MacArthur Park
Little Rock, AR 72203
501-372-4000
Admission: No charge; donations accepted
Collections: 19th- and 20th-century drawings; American, European, and Asian decorative arts

Arkansas State University Art Gallery
Caraway Rd.
Jonesboro, AR 72467
501-972-3050
Admission: No charge
Collections: Contemporary and historic prints, drawings, paintings, and sculpture

The Arts and Science Center for Southeast Arkansas
220 Martin Street
Pine Bluff, AR 71601
501-536-3375
Admission: No charge
Collections: 20th-century American paintings and prints; John Howard Memorial Collection of African-American artists; botanical paintings

ARIZONA

The Heard Museum
22 E. Monte Vista Rd.
Phoenix, AZ 85004-1480
602-252-8840
Admission: Juniors (13-18) $3.00; children (4-12) $2.00; adults $5.00
Collections: Exhibits of native arts from cultures of Africa, Asia, Oceania, and Upper Amazon; works by Native Americans

Northern Arizona University Art Museum and Galleries
Fort Valley Rd.
Flagstaff, AZ 86001
602-774-5211
Admission: No charge; donations accepted
Collections: Graphics, paintings, ceramics, sculpture

*Phoenix Art Museum**
1625 N. Central Ave.
Phoenix, AZ 85004-1685
602-257-1880
Admission: Adults $4; students $1.50
Collections: American, European, and Oriental painting and ceramics; sculpture, graphics; Mexican and Western American art

*Museum of Art**
University of Arizona
Tuscon, AZ 86721
602-621-7567
Admission: No charge; donations accepted
Collections: 14th- to 19th-century European art; contemporary American and European painting and sculpture; American painting and graphics

Yuma Fine Arts Association
281 Gila Street
Yuma, AZ 85364
602-783-2314
Admission: Adults $1.00
Collections: Contemporary and historic Southwest paintings, photographs, ceramics, sculpture

CALIFORNIA

Crocker Art Museum
216 O Street
Sacramento, CA 95814
916-264-5423
Admission: Adults $3.00; youth $1.50
Collections: Old Master drawings and paintings; 19th-century California art; Asian art; African art

*Fine Arts Museum of San Francisco**
California Palace of the Legion of Honor
Lincoln Park
San Francisco, CA 94121
415-750-3600
Admission: Adults $5.00; students $3.00
Collections: paintings, prints, drawings, sculpture and decorative art of America and Britain; art of ancient Egypt, Greece, and Rome; traditional art of Africa, Oceana, and the Americas

Fowler Museum of Cultural History
UCLA
405 Hilgard Ave.
Los Angeles, CA 90024
310-825-4361
Admission: no charge; parking $5.00
Collections: African, Oceanic, Southeast Asian, North, Middle, and South American art

Fresno Metropolitan Museum
1555 Van Ness Avenue
Fresno, CA 93721
209-441-1444
Admission: Adults $2.50; students, senior citizens $1.50
Collections: 17th- to 20th-century American and European still-life and trompe-l'oeil paintings; Ansel Adams' photography

*The J. Paul Getty Museum**
17985 Pacific Coast Highway
Malibu, CA 90406
310-485-2003
310-459-7611
310-454-6633
Admission: No charge; parking reservations required Call 310-458-2003
Collections: Greek and Roman antiquities; pre-20th-century Western European paintings; illuminated manuscripts

*Los Angeles County Museum of Art**
5905 Wilshire Blvd.
Los Angeles, CA 90036
213-857-6111
Admission: Adults $6.00; students with I.D. $4.00; children 6-17 $1.00
Collections: Egyptian and Greco-Roman antiquities and sculpture; Chinese and Japanese art; European and American art and decorative arts

Monterey Peninsula Museum of Art Association
559 Pacific Street
Monterey, CA 93940
408-372-5477
Admission: No charge; requested donation, adults $2.00
Collections: California and regional artists; Asian and Pacific art; international folk, national, ethnic, and tribal art

*Norton Simon Foundation**
411 Colorado Blvd.
Pasadena, CA 91105
818-449-6840
Admission: No charge

Collections: European painting from Renaissance to mid-20th-century; sculpture from India and Southeast Asia; 20th-century European and American art

San Diego Museum of Man*
1350 El Prado
Balboa Park
San Diego, CA 92101
619-239-2001
Admission: Adults $4.00; students $2.00
Collections: Egyptian antiquities; ethnological and archeological collections pertaining to the peoples of the Western Americas

Santa Barbara Museum of Art*
1130 State St.
Santa Barbara, CA 93101-2746
805-963-4364
Admission: Adults $3.00; children $1.50
Collections: Greek, Roman, and Egyptian antiquities; Asian sculpture, woodblock prints, painting, ceramics, decorative arts; American painting from colonial period to present

University Art Museum and Pacific Film Archive
University of California
2625 Durant Avenue
Berkeley, CA 94720
510-642-1207
Admission: General $5.00
Collections: 20th-century American and European paintings, sculpture, drawings, prints, photographs; Asian paintings; film posters; movie stills

COLORADO

Colorado Springs Fine Art Center
30 W. Dale Street
Colorado Springs, CO 80903
719-634-5581
Admission: Adults $2.50; students $1.50
Collections: Historic and contemporary art and material culture, including major Hispanic and Native American collections

Denver Art Museum*
100 West Fourteenth Avenue Parkway
Denver, CO 80204-2788
303-640-2295
Admission: Adults $3.50; students $1.50
Collections: Northwest coast, African, Oceanic and Native American art; New World Pre-Columbian and Spanish Colonial art; European and Asian art; photography

Museum of Western Art
1727 Tremont Place
Denver, CO 80202
303-296-1880
Admission: Adults $3.00; students $2.00
Collections: Western American art collections by Bierstadt, Moran, Farney, Russell, Remington, Blumenschein, and O'Keefe; artist biographies

University of Colorado Art Galleries
University of Colorado—Boulder Campus
Box 318
Boulder, CO 80309
303-492-8300
Admission: No charge; donations accepted
Collections: 19th- and 20th-century paintings and prints; 15th- to 20th-century drawings, watercolors, sculptures, and ceramics

CONNECTICUT

Housatonic Museum of Art
510 Barnum Avenue
Bridgeport, CT 06608
203-579-6727
Admission: No charge
Collections: 19th- and 20th-century European and American art; contemporary Latin American and Connecticut artists

Lyman Allyn Art Museum
625 Williams Street
New London, CT 06320
203-443-2545
Admission: No charge; $3.00 donation requested
Collections: American and European drawings and painting; Asian and African art

New England Center for Contemporary Art
Route 169
Brooklyn, CT 06234
203-774-8899
Admission: No charge; donations accepted
Collections: Contemporary art from People's Republic of China; contemporary American paintings and sculpture

Wadsworth Atheneum*
600 Main St.
Hartford, CT 06103
203-278-2670
Admission: Adults $5.00; students $1.50
Collections: American and European art and decorative art; French and American Impressionist painting; contemporary painting and sculpture

Yale University Art Gallery*
2006 Yale Station
New Haven, CT 06502
203-432-0600
Admission: No charge, donations accepted
Collections: European and American painting and sculpture; French Impressionist and Postimpressionist painting; Italian Renaissance painting; African sculpture; Near and Far Eastern art

DELAWARE

Delaware Art Museum
2301 Kentmere Parkway
Wilmington, DE 19806
302-571-9590
Admission: Adults $4.00; students $2.50
Collections: American paintings, 1840–present; English pre-Raphaelite; Howard Pyle, John Sloan, and Wyeth family collections

Henry Francis DuPont Winterthur Museum*
Rte. 52
Winterthur, DE 19735
302-888-4600
Admission: Adults $7.00; students $4.50
Collections: Colonial American decorative arts; Chinese porcelain; English and Chinese rugs

DISTRICT OF COLUMBIA

Corcoran Gallery of Art*
17th and New York Ave., N.W.
Washington, DC 20006
202-638-3211
Admission: No charge
Collections: American painting and sculpture from 18th- to 20th-centuries; European painting, sculpture, and decorative arts

Freer Art Gallery*
Smithsonian Institute
Washington, DC 20560
202-357-2104
Admission: No charge
Collections: Far and Near Eastern, South and Southeast Asian bronze, jade sculpture, painting, pottery, and porcelain; 19th- and 20th-century American art

Hirshhorn Museum and Sculpture Garden*
Smithsonian Institute
Independence Avenue at 7th St. SW
Washington, D.C. 20560

Admission: No charge
Collections: 19th to 20th century modern and contemporary European and American painting and sculpture

Howard University*
Moorland Spingarn Research Center
500 Howard Pl., N.W.
Washington, DC 20059
202-806-7139
Admission: No charge
Collections: African American and American painting, sculpture, graphics, and art; European graphic art; Italian painting and sculpture

National Gallery of Art*
4th and Constitution Ave., N.W.
Washington, DC 20565
202-842-6594
Admission: No charge
Collections: European and American painting, sculpture, decorative arts, graphics from 12th- to 20th-century; French, Spanish, Italian, American, and British 18th- and 19th-century paintings; European old masters paintings; Chinese porcelains

National Museum of African Art*
950 Independence Ave., SW
Washington, DC 20560
202-357-4600
Admission: No charge
Collections: 6,000 objects of African art, wood, metal, ceramic, ivory, and fiber

National Museum of American Art*
Smithsonian Institute
PO Box 1641
Washington, DC 20013
202-357-2700
Admission: No charge, donations accepted
Collections: painting, sculpture, graphics, contemporary photography and crafts; folk art

National Portrait Gallery*
F Street at 8th, N.W.
Washington, DC 20560
202-357-1915
Admission: No charge; donations accepted
Collections: portraits of men and women making notable contributions to the history and development of the United States

Phillips Collection*
1600 21st St., N.W.
Washington, DC 20009
202-387-2151

Admission: Adults $6.50; children under 18 free
Collections: 19th- and 20th-century European and American paintings and sculpture

FLORIDA

Boca Raton Museum of Art
801 W. Palmetto Park Rd.
Boca Raton, FL 33486
407-392-2500
Admission: No charge; $2.00 donation requested
Collection: Sculpture, 20th-century paintings; Dr. and Mrs. John Mayers Collection (early 20th-century art)

Florida State University Fine Arts Gallery and Museum
Fine Arts Building, Room 205
Tallahassee, FL 32303-2348
904-562-0042
Admission: No charge
Collections: The Victor and Mary Carter Collection of Peruvian Art; European, Asian, and contemporary art

Museum of Fine Arts—St. Petersburg
255 Beach Drive, N.E.
St. Petersburg, FL 33701
813-896-2667
Admission: No charge; donations requested
Collections: American and European paintings; Ancient, pre-Columbian, and Eastern art

GEORGIA

Albany Museum of Art
311 Meadowlark Drive
Albany, GA 31707
912-439-8400
Admission: Suggested donation—adults $3.00; students $1.00
Collections: 20th-century American art; regional art; African art

Georgia Museum of Art
The University of Georgia
Jackson St., North Campus
Athens, GA 30602
706-542-3255
Admission: No charge; donations accepted
Collections: 19th- to 20th-century American paintings; Kress Study Collection of Italian Renaissance paintings

The High Museum of Art*
1280 Peachtree St., N.E.
Atlanta, GA 30309
404-892-3600

Admission: Adults $5.00; children $1.00
Collections: Various media of art; folk art; photography

Marietta/Cobb Museum of Art
30 Atlanta St., N.E.
Marietta, GA 30060
404-424-8142
Admission: Adults $2.00; children $1.00
Collections: 19th- and 20th-century American art; watercolors, pastels, Ash Can School works

Telfair Academy of Arts and Sciences
121 Barnard Street
Savannah, GA 31401
912-232-1177
Admission: Adults $2.50; students $1.50
Collections: 18th- to 20th-century American and European paintings; prints; drawings; collection of works by Kahlil Gibran

HAWAII

The Contemporary Museum
2411 Makiki Heights Drive
Honolulu, HI 96822
808-526-1322
808-536-5973
Admission: $4.00 one-time fee
Collections: Regional and national contemporary art

Honolulu Academy of Arts
900 S. Bertania Street
Honolulu, HI 96814
808-538-3693
808-521-6591
Admission: No charge; donations accepted
Collections: Asian paintings, sculpture, ceramics; ancient Mediterranean art; Medieval Christian art; traditional arts of Oceania, the Americas, and Africa

Lyman House Memorial Museum
276 Haili Street
Hilo, HI 96720
808-935-5021
808-969-7685
Admission: General Admission $4.50; children 6-17 $2.50
Collections: 19th- and 20th-century Hawaiian artists; Oriental collections

IDAHO

Boise Art Museum
670 S. Julia Davis Drive
Boise, ID 83213

208-527-3257
208-345-8333
Admission: Adults $2.00; students $1.00
Collections: Northwest artists; Japanese netsuke; Glenn C. Janss Collection of American Realism

Rosenthal Gallery of Art
Albertson College of Idaho
2112 Cleveland Blvd.
Caldwell, ID 83605
208-459-5426
Admission: No charge
Collections: Prints, traveling exhibitions

ILLINOIS

Art Institute of Chicago*
Michigan Ave. at Adams St.
Chicago, IL 60603
312-443-3600
Admission
Collections: American and European painting, sculpture, prints, drawings, decorative arts, textiles; Chinese, Japanese, Indian, Middle Eastern, and African art

Krannert Art Museum
500 E. Peabody Drive
University of Illinois
Champaign, IL 61820
217-333-1860
217-333-0883
Admission: No charge; donations accepted
Collections: Trees and Kannert Collection of Old Master paintings; Moore Collection of decorative arts; ancient, medieval, pre-Columbian, African, and Asian art

Museum of Contemporary Art*
237 Ontario St.
Chicago, IL 60611
312-280-2687
Admission: suggested donations: Adults $4.00; children under 16 $2.00
Collections: post-WWII painting, sculpture, graphics, photography, and mixed media; artist's conceptual work; sound installation

Springfield Art Association
700 N. Fourth Street
Springfield, IL 62707
217-523-2631
Admission: No charge; donations accepted
Collections: 19th- and 20th-century paintings; African sculpture; Oriental collection

Terra Museum of American Art
666 N. Michigan Avenue
Chicago, IL 60611
312-664-3939
312-664-2052
Admission: Adults $4.00; students $2.50
Collections: American art from the 18th- to 20th-centuries with a strong emphasis on American Impressionism

University Museum
Southern Illinois University
Carbondale, IL 62901
618-453-5388
618-453-3000
Admission: No charge
Collections: European and American paintings, drawings, prints from the 13th- to 20th-century; 19th- and 20th-century photography; 20th-century sculpture, ceramics

INDIANA

Ball State University Museum of Art
2000 University Avenue
Muncie, IN 47306
317-285-5242
Admission: No charge; donations accepted
Collections: Italian Renaissance art; 17th-, 18th- and 19th-century European paintings; Ball-Kraft Collection of Roman glass

Evansville Museum of Arts and Sciences
411 S.E. Riverside Drive
Evansville, IN 47713
812-425-2406
812-421-7507
Admission: No charge; donations accepted
Collections: Paintings, sculpture, prints, drawings, decorative arts

Greater Lafayette Museum of Art
101 S. Ninth Street
Lafayette, IN 47901
317-742-1120
Admission: No charge
Collections: 19th- and 20th-century American and European art; historical Indiana art

The South Bend Art Center
120 S. St. Joseph Street
South Bend, IN 46601
219-284-9102
Admission: No charge; donations accepted
Collections: 19th- and 20th-century American and Euro-

pean paintings and works on paper; historic and contemporary Indiana artists

IOWA

Cedar Rapids Museum of Art
410 Third Avenue, S.E.
Cedar Rapids, IA 52401
319-366-7503
Admission: Adults $2.50; students $1.50
Collections: 20th-century modern and regionalist paintings; works by Grant Wood, Marvin Cone, James Swan; 19th- and 20th-century paintings and sculpture

Davenport Museum of Art*
1737 W. Twelfth Street
Davenport, IA 52804
319-326-7804
319-326-7876
Admission: No charge; donations accepted
Collections: American, European, Haitian, Mexican Colonial, and Oriental art; Grant Wood and the Regionalists permanent exhibition

Des Moines Art Center
4700 Grand Avenue
Des Moines, IA 50312
515-277-4405
Admission: Adults $2.50; children over 12 $1.00
Collections: 19th- and 20th-century American and European paintings and sculpture; African art

Sioux City Art Center
513 Nebraska Street
Sioux City, IA 51101-1305
712-279-6272
Admission: No charge; donations accepted
Collections: Work by contemporary regional, American, and international artists

KANSAS

Mulvane Art Museum
17th and Jewell
Topeka, KS 66621
913-231-1010
Admission: No charge
Collections: 19th- and 20th-century American art; 18th- and 19th-century Japanese fine and decorative arts; contemporary regional Mountain-Plains paintings, sculpture

Spencer Museum of Art
University of Kansas
1301 Mississippi Street
Lawrence, KS 66045
913-864-3112
Admission: No charge; donations accepted
Collections: European and American paintings and sculpture; Japanese paintings and prints; Chinese paintings and sculpture

Wichita Art Museum
619 Stackman Drive
Wichita, KS 67203
316-268-4921
Admission: No charge
Collections: American and European art; pre-Columbian Mexican art; British watercolors

KENTUCKY

The Folk Art Collection
Morehead State University
Morehead, KY 41064
606-783-2760
Admission: No charge; donations accepted
Collections: Traditional, contemporary, and expressive regional folk art

John James Audubon Museum
Audubon State Park
U.S. Hwy. 41 N.
Henderson, KY 42420
502-827-1893
Admission: No information
Collections: Works, prints, and personal memorabilia of John James Audubon

University of Kentucky Art Museum
Rose and Euclid
Lexington, KY 40506
606-257-5716
Admission: No charge; donations accepted
Collections: 14th- to 20th-century painting, sculpture, works of art on paper; regional art; African and Asian art

LOUISIANA

Alexandria Museum of Art
933 Main Street
Alexandria, LA 71309
318-443-3458
Admission: Adults $1.00

Collections: Contemporary works on sculpture, painting, and on paper; contemporary Louisiana artists

Louisiana Arts and Science Center
100 S. River Road
Baton Rouge, LA 70802
504-344-9463
Admission: Adults $1.50; students $.75
Collections: Ivan Mestrovic sculpture; ethnic art; contemporary crafts; modern sculpture, graphics, and drawings

New Orleans Museum of Art
No. 1 Lelong Avenue
City Park
New Orleans, LA 70179
504-488-2631
Admission: Adults $4.00; students $2.00
Collections: Kress Collection of Italian Renaissance and Baroque painting; Chapman H. Hyams Collection of Barbizon and Salon painting; works by Edgar Degas; The Matilda Geddy Gray Foundation Collection; works by Peter Carl Faberge

The R.W. Norton Art Gallery
4747 Creswell Avenue
Shreveport, LA 71106
318-865-4201
Admission: No charge; donations accepted
Collections: Works by Western artists Charles M. Russell and Frederic Remington; Wedgewood collection; European paintings, sculpture, miniatures, and tapestries

MAINE

Portland Museum of Art
Seven Congress Square
Portland, ME 04101
207-775-6148
Admission: Adults $3.50; students $2.50
Collections: Charles Shipman Payson Collection of paintings by Winslow Homer; American painting, works on paper and sculpture from 1800; Japanese prints

University of Maine Museum of Art
109 Carnegie Hall
Orono, ME 04469
207-581-3255
Admission: No charge
Collections: 18th- to 20th-century American and European graphics and painting; modern and historic Maine art; contemporary art

William A. Farnsworth Library and Art Museum
19 Elm Street
Rockland, ME 04841
207-596-6457
Admission: Adults $3.00; students $2.00
Collections: Works by Jonathan Fisher; Wyeth family; Louise Nevelson; 18th- to 20th-century American art

MARYLAND

The Baltimore Museum of Art
Art Museum Drive
Baltimore, MD 21218
410-396-7100
Admission: Adults $4.50; students $3.50
Collections: The Cone Collection, featuring the works of Matisse; 20th-century American and European sculpture; 1st- to 3rd-century mosaics from Antioch, Syria

Elizabeth Myers Mitchell Art Gallery at St. John's College
60 College Avenue
Annapolis, MD 21404
410-626-2556
Admission: No charge
Collections: 16th-century Italian art; 14th-century Chinese art; 17th-century Dutch art; 20th-century Japanese art

Walters Art Gallery*
600 N. Charles
Baltimore, MD 21201
410-527-9000
Admission: Adults $4.00; children under 18 free
Collections: Arts from antiquity to 19th-century; decorative arts, paintings, and sculpture

Washington County Museum of Fine Arts
City Park
Hagerstown, MD 21741
301-739-5727
Admission: No charge; donations accepted
Collections: 19th-century European paintings; Oriental and African art collection; regional artists

MASSACHUSETTS

Arthur M. Sackler Museum*
485 Broadway
Cambridge, MA 02138
617-495-9400
Admission: Adults $5.00; students $3.00; children free
Collections: Ancient Asian, Islamic, and Indian art

Boston Museum of Fine Arts*
465 Huntington Ave.
Boston, MA 02115
617-267-9300
Admission: Adults $7.00; students under 17 $3.50
Collections: Asiatic, Egyptian, Greek, Roman, and Near
 Eastern art; American and European art; Chinese por-
 celain; pre-Columbian art

Boston Public Library
Copley Square
Boston, MA 02117
617-536-5400
Admission: No charge
Collections: Murals by Edwin A. Abbey; John Elliott,
 Pierre Pavis de Chavannes and John Singer Sargent;
 sculpture; paintings by Copley and Duplessis; architec-
 tural drawings

Busch-Reisinger Museum*
32 Quincy St.
Cambridge, MA 02138
617-495-2317
Admission: Call for information
Collections: 20th-century German painting and sculpture;
 Scandinavian, German, Austrian and Swiss art from
 Middle Ages to present; European and American art

Museum of Fine Arts
49 Chestnut Street
Springfield, MA 01103
413-732-6092
Admission: Adults $3.00; students $1.00
Collections: European and American paintings; sculpture,
 graphics; Oriental arts

Museum of the National Center of Afro-American Artists
300 Walnut Avenue
Boston, MA 02119
716-442-8014
Admission: Adults $1.25; students $.50
Collections: Paintings, graphics, prints by African Ameri-
 can artists, African art

Sterling and Francine Clark Art Institute
225 South Street
Williamstown, MA 01267
413-458-9545
Admission: No charge; donations accepted
Collections: Italian, Flemish, Dutch, and French Old
 Master paintings (14th- to 18th-century); French
 19th-century painters, including the Impressionists;
 works of American painters Homer and Sargent

MICHIGAN

Detroit Institute of Art*
5200 Woodward Avenue
Detroit, MI 48202
313-833-7900
Admission: Suggested donation, adults $4.00; students
 $1.00
Collections: European, 20th-century, Islamic, American,
 Asian, African, Oceanic, and New World Cultures
 art; Theatre arts

Grand Rapids Art Museum
155 Division North
Grand Rapids, MI 49503
616-459-4677
Admission: Adults $2.00
Collections: Renaissance paintings; German Expressionist
 paintings; 19th- and 20th-century American paintings

Muskegon Museum of Art*
430 W. Clay
Muskegon, MI
616-722-0278
Admission: No charge; donations accepted
Collections: American and European paintings and
 graphic arts; photography, sculpture, Tiffany glass

Saginaw Art Museum
1126 N. Michigan Avenue
Saginaw, MI 48602
517-754-2491
Admission: No charge; donations accepted
Collections: 14th-century through present day European
 and American paintings; John Rogers sculpture; Japa-
 nese prints

MINNESOTA

Minneapolis Institute of Arts*
2400 Third Ave., S
Minneapolis, MN 55404
612-870-3000
Admission: No charge; donations accepted
Collections: European and American painting and deco-
 rative art; Oriental, pre-Columbian, African, Oceanic,
 Islamic, and ancient art

Plains Art Museum
521 Main Avenue
Moorehead, MN 56560
218-236-7383
Admission: No charge; donations accepted

Collections: Contemporary regional art; contemporary and traditional Native American art; African carvings; bronzes and textiles

Tweed Museum of Art
10 University Drive
University of Minnesota
Duluth, MN 55812
218-726-8222
Admission: No charge; donations accepted
Collections: Old Master-19th-century European painting; modern and contemporary painting, drawing, graphics, and photography; 19th- and 20th-century American art

Walker Art Center*
Vineland Place
Minneapolis, MN 55403
612-375-7600
Admission: Adults $3.00; students $2.00
Collections: Contemporary art collection including paintings, sculpture, drawings, prints; Minneapolis Sculpture Garden (7½ acre urban garden featuring 40 sculptures)

MISSISSIPPI

Lauren Rogers Museum of Art
5th Avenue at 7th Street
Laurel, MS 39440
601-649-6374
Admission: No charge; donations accepted
Collections: 19th- and 20th-century American and European paintings and drawings; 18th-century Japanese Ukiyo-e woodblock prints

Meridian Museum of Art
25th Avenue and 7th Street
Meridian, MS 39301
601-693-1501
Admission: No charge; donations accepted
Collections: Caroline Durieux lithographs; 18th-century British portraits; works by Will Barnet, Marie Hull, George Ault, and Alice Neel

Mississippi Museum of Art
201 Pascagoula Street
Jackson, MS 39201
601-960-1515
Admission: Adults $3.00
Collections: 19th- and 20th-century American and Mississippi art; Oriental and ethnographic art; mid 18th-to 19th-century European painting

MISSOURI

Kemper Museum of Contemporary Art and Design of Kansas City Art Institute
4415 Warwick Blvd.
Kansas City, MO 64111
816-561-4852
Admission: No charge; donations accepted
Collections: Contemporary art in all media, American painting, sculpture, and photographs; works by Jesse Howard, Missouri folk artist

Nelson Atkins Museum of Art*
4525 Oak Street
Kansas City, MO 64111-1873
816-561-4000
Admission: Adults $4.00; students $1.00
Collections: European, American, and ancient art; Henry Moore Sculpture Garden; Asiatic, Native American, Oceanic and pre-Columbian art

Museum of Art and Archeology, University of Missouri
Packard Hall
Columbia, MO 65211
314-883-3591
Admission: No charge; donations accepted
Collections: Early Christian and Byzantine art; 15th- to 20th-century drawings and prints; African, Pre-Columbian, Chinese, Japanese, South, and Southwest Asian art

The Saint Louis Art Museum
1 Fine Arts Drive
St. Louis, MO 63110
314-721-0072
Admission: Regular exhibits: No charge; Special Exhibitions: Adults $3.50; students $2.50; special educational rates
Collections: Classical, medieval, Renaissance, 18th- and 19th-century, and contemporary painting, sculpture; Egyptian, Chinese, Japanese, Indian, Near Eastern, and Western art

MONTANA

C. M. Russell Museum
400 13th St., North
Great Falls, MT 59401
406-727-8787
Admission: Adults $4.00; students $2.00
Collections: Art of the American West with emphasis on C. M. Russell; western artists' paintings and bronzes; contemporary art

Museum of Fine Arts
School of Fine Arts, University of Montana

Missoula, MT 59812
406-243-4970
Admission: No charge; donations accepted
Collections: Collection of western painters: Sharp, Paxson, Mauer, Chase; Krasner & Motherwell contemporary print collection; Autio, Voulkos ceramic sculpture

Yellowstone Art Center
401 N. 27th Street
Billings, MT 59101
406-256-6804
Admission: No charge; donations accepted
Collections: Contemporary, regional collection; paintings, sculpture, ceramics, photography; L. A. Huffman photographs, Poindexter Collection of New York Abstract Expressionists

NEBRASKA

Joslyn Art Museum
2200 Dodge Street
Omaha, NE 68102
402-342-3300
Admission: Adults $3.00; students $1.50; Sat. mornings–no charge
Collections: European and American paintings, sculpture, graphics; Native American art; art of the Western frontier

Museum of Nebraska Art
24th and Central
Kearney, NE 68848
308-234-8559
Admission: No charge; donations accepted
Collections: Nebraska art and artists from early 19th-century to present

University of Nebraska Art Galleries—Sheldon Memorial Art Gallery
12th and R Streets
Lincoln, NE 68588-0300
402-472-2461
Admission: No charge
Collections: 19th- and 20th-century American painting with emphasis on 20th-century; sculpture from Rodin to David Smith

NEVADA

Donna Beam Fine Arts Gallery, UNLV
4505 Maryland Parkway
Las Vegas, NV 89154
702-739-3893

Admission: No charge
Collections: Contemporary American art

Las Vegas Art Museum
3333 W. Washington
Las Vegas, NV 89107
702-647-4300
Admission: No charge; donations accepted
Collections: Contemporary fine art; early Las Vegas area collection

Nevada Museum of Art
160 W. Liberty
Reno, NV 89501
702-329-3333
Admission: Adults $3.00; students $1.50; Fridays no charge
Collections: 19th- and 20th-century American paintings and prints; Native American art; art of the Great Basin region

NEW HAMPSHIRE

The Art Gallery, University of New Hampshire
Paul Creative Arts Center
University of New Hampshire
Durham, NH 03824-3538
603-862-3712
Admission: No charge; donations accepted
Collections: 20th-century works on paper; 19th-century American landscape and Japanese woodblock prints

The Currier Gallery of Art
192 Orange Street
Manchester, NH 03104
603-669-6144
Admission: Adults $5.00; students $3.00
Collections: European and American paintings and sculpture; 15th-century Tournei tapestry; Zimmerman house, a Usonian house designed by Frank Lloyd Wright

Hood Museum of Art
Dartmouth College
Hanover, NH 03755
603-646-2808
Admission: No charge; donations accepted
Collections: American and European paintings, sculpture, drawings, photographs and prints; African, Asian, Melanesian, and Native American art

NEW JERSEY

The Newark Museum*
49 Washington Street

Newark, NJ 07101-0540
201-596-6550
Admission: Adults $4.00; students $2.00
Collections: American painting and sculpture; Asian art, especially Tibetan; decorative arts; textiles

New Jersey Center for Visual Arts
68 Elm Street
Summit, NJ 07901
908-273-9121
Admission: No charge
Collections: Contemporary art

Stedman Art Gallery
Rutgers, The State University of New Jersey
Camden, NJ 08102
609-757-6245
Admission: No charge
Collections: Contemporary American works on paper; paintings; sculpture; 20th-century European works on paper

NEW MEXICO

Museum of International Folk Art
706 Camino Lejo
Santa Fe, NM 87501
505-827-6350
Admission: Adults $3.50; students 16 and under no charge
Collections: International folk art including ceramics, textiles, costumes, dolls, and toys, Spanish Colonial religious art; ceremonial objects

Roswell Museum and Art Center
100 West 11th
Roswell, NM 88201
505-624-7644
Admission: No charge; donations accepted
Collections: 20th-century American painting and sculpture; paintings and prints by Peter Hurd and Henriette Wyeth; Southwestern paintings

University Art Museum, The University of New Mexico Fine Arts Center
Albuquerque, NM 87131
505-277-4001
Admission: No charge; donations accepted
Collections: 19th- and 20th-century graphics; paintings; photography; sculpture; Spanish Colonial art

NEW YORK

Albany Institute of History and Art
125 Washington Avenue

Albany, NY 12210
518-463-4478
Admission: No charge; donations accepted
Collections: 18th-century Hudson Valley portraits and scripture paintings; Hudson River School landscapes; 17th- to 20th century portraits

Albright-Knox Art Gallery*
1285 Elmwood Ave
Buffalo, NY 14222
716-882-8700
Admission: Call for information
Collections: 18th-century English paintings; 19th-century French and American painting; 3000 B.C. through present day sculpture

The Bronx Museum of the Arts
1040 Grand Concourse
Bronx, NY 10456
212-681-6000
Admission: Adults $3.00; students $2.00
Collections: 20th-century works on paper by African, Latin American, and Southern Asian artists and American descendents from those regions

Memorial Art Gallery of the University of Rochester
500 University Avenue
Rochester, NY 14607
716-473-7720
Admission: Adults $4.00; students $2.50
Collections: Ancient-20th-century art of France, America, Africa and the Orient; including painting, sculpture, prints, drawings, and decorative arts

Metropolitan Museum of Art*
1000 Fifth Ave.
New York, NY 10028
212-879-5500
Admission: Suggested donations: adults $6.00; students $3.00
Collections: Ancient and modern art of Egypt, Greece, Rome, the Near and Far East, Europe, Africa, Oceania, pre-Columbian cultures, and the United States

Museum of American Folk Art*
61 W. 62nd St.
New York, NY 10023-7015
212-977-7170
Admission: No charge; donations accepted
Collections: American 18- to 20th-century folk sculpture, painting, textiles, and decorative arts

Museum of Modern Art*
11 W. 53rd St.
New York, NY 10019

212-708-4480
Admission: Adults $7.00; student group rates by
appointment
Collections: Modern art from 1880 to present

Pierpont Morgan Library*
29 E. 36th St.
New York, NY 10016
212-685-0008
Admission: suggested donations: adults $5.00; students
$3.00
Collections: Paintings; Near Eastern seals and tablets;
Old Master drawings

Solomon R. Guggenheim Museum*
1071 Fifth Ave.
New York, NY 10128
212-360-3500
Admission: Adults $7.00; students $4.00
Collections: Paintings; sculpture, works on paper; concen-
tration on Picasso, Mondrian, Kandinsky, Miro, and
others; post-WWII painting and sculpture

Whitney Museum of American Art*
945 Madison Ave.
New York, NY 10021
212-570-3600
Admission: $5.00
Collections: Paintings, sculpture, drawings, prints, and
photography

NORTH CAROLINA

The Mint Museum
2730 Randolph Rd.
Charlotte, NC 28207
704-337-2000
Admission: Adults $4.00; students $2.00
Collections: European and American painting; ancient
Chinese, 18th-century Continental and English ce-
ramics; decorative art

St. John's Museum of Art
114 Orange Street
Wilmington, NC 28401
919-763-0281
Admission: No charge; donations accepted
Collections: Mary Cassatt color prints; regional American
paintings, sculptures, and prints

North Carolina Museum of Art
2110 Blue Ridge Rd.
Raleigh, NC 27607-6494
919-833-1935
Admission: No charge

Collections: European and American art; African, Oce-
anic, and Pre-Columbian art; North Carolina art

Weatherspoon Art Gallery
University of N.C. at Greensboro
Spring Garden and State Street
Greensboro, NC 27412
919-334-5907
Admission: No charge
Collections: American modern and contemporary paint-
ing; sculpture; drawings; graphic arts; Asian art

NORTH DAKOTA

North Dakota Museum of Art
Centennial Drive
Grand Forks, ND 58202
701-777-4195
Admission: No charge; donations accepted
Collections: Contemporary art (American and interna-
tional), Native American and northern plains artists

North Dakota State University Art Gallery
Memorial Union—North Dakota State University
Fargo, ND 58105
701-237-8241
Admission: No charge; donations accepted
Collections: Contemporary works by American artists

OHIO

The Butler Institute of American Art*
524 Wick Ave.
Youngstown, OH 44502
216-743-1711
Admission: No charge; donations accepted
Collections: American art from Colonial period to pres-
ent; Americana ceramics; sculpture; contemporary
photography

Cincinnati Art Museum
Eden Park
Cincinnati, OH 45202-1596
513-721-5204
Admission: Adults $3.00; students under 18 free
Collections: Egyptian, Greek, Roman sculpture, painting,
ceramics; 15th- to 20th-century European and Ameri-
can art; primitive art of the South Pacific and Africa

Cleveland Museum of Art*
11150 East Boulevard
Cleveland, OH 44106
216-421-7340
Admission: No charge

Collections: Art from all cultures and periods; paintings, sculpture, decorative arts, textiles photography

Columbus Museum of Art*
480 E. Broad St.
Columbus, OH 43215
614-221-6801
Admission: No charge to permanent collection
Collections: 15th- to 20th-century European art; Western decorative art; 19th- and 20th-century American art

Dayton Art Institute*
Forest and Riverview Avenues
Dayton, OH 45401
513-223-5277
Admission: Adults $3.00; students $1.00
Collections: European and American painting and sculpture; Asian art; Art of Our Time collection

Ohio Historical Society*
1982 Velma Ave.
Columbus, OH 43211
614-297-2300
Admission: $2.00
Collections: Pre-Columbian Indian art objects and artifacts; decorative arts and textiles of Ohio

The Toledo Museum of Art*
2445 Monroe Street
Toledo, OH 43620
419-255-8000
Admission: No charge; donations accepted
Collections: European and American painting, sculpture, decorative arts; ancient and medieval art

OKLAHOMA

Grace Phillips Johnson Art Gallery
Phillips University, University Station
Enid, OK 73702
405-237-4433
Admission: No charge
Collections: Paintings, sculptures, graphics, decorative arts

Oklahoma City Art Museum at The Fairgrounds
3113 Pershing Avenue
Oklahoma City, OK 73107
405-946-4477
Admission: Adults $3.50; students $2.50
Collections: 19th- and 20th-century painting, sculpture, prints, drawings, and photographs; Eason collection of graphic arts

The Philbrook Museum of Art
2727 Rockford Rd.
Tulsa, OK 74114
918-749-7941
Admission: Adults $3.00; students free
Collections: Samuel H. Kress collection of Italian Renaissance painting; Philbrook Collection of American Indian painting; Shinenken Collection of Japanese screens and scrolls

Thomas Gilcrease Institute of American History and Art*
1400 Gilcrease Museum Rd.
Tulsa, OK 74127
918-582-3122
Admission: Suggested donations: adults $3.00; children free
Collections: American sculpture and painting; Native American artifacts from Arctic to Mexico

OREGON

University of Oregon Museum of Art*
1430 Johnson Lane
Eugene, OR 97403
503-346-3027
Admission: No charge; donations accepted
Collections: Oriental, contemporary American and Northwest art; works of Morris Graves; Ghandarian and Indian sculpture

Portland Art Museum
1219 S.W. Park Avenue
Portland, OR 97205
503-226-2811
Admission: Adults $3.00; students $1.50
Collections: 16th- to 20th-century European and American paintings and sculpture; West African art; Kress Collection of Renaissance art; Asian and pre-Columbian art

Coos Art Museum
235 Anderson
Coos Bay, OR 97420
503-267-3901
Admission: No charge; donations accepted
Collections: Contemporary American prints; Northwest art in various medias

PENNSYLVANIA

The Carnegie Museum of Art
4400 Forbes Avenue
Pittsburgh, PA 15213
412-622-1975
Admission: Adults $4.00; students $2.00
Collections: European and American painting; French

Impressionist and Postimpressionist art; African art; Oriental art; photography

Erie Art Museum
411 State Street
Erie, PA 16501
814-459-5477
Admission: $1.00
Collections: Paintings, sculpture, graphics, decorative art; Indian bronze and stone sculpture

Fallingwater
P.O. Box R
Mill Run, PA 15464
Admission: $6.00; discount for students
Collections: Decorative arts, including furniture by Frank Lloyd Wright; sculpture by Lipschitz, Arp, and Voulkos; paintings and graphic work by Picasso and Diego Rivera

Pennsylvania Academy of the Fine Arts
1301 Cherry Street
Philadelphia, PA 19102
215-972-7600
Admission: Adults $5.00; students $2.00
Collections: 18th- to 20th-century American paintings, drawings, sculpture and prints; collection includes works by Winslow Homer, Edward Hopper, William Bailey, Alex Katz, and others

Philadelphia Museum of Art*
26th St and Benjamin Franklin Parkway
Philadelphia, PA 19030
215-763-8100
Admission: Adults $6.00; students $3.00
Collections: American and European art; Indian, Far and Near Eastern art; regional art

The University Museum of Archeology and Anthropology*
University of Pennsylvania
33rd and Spruce Streets
Philadelphia, PA 19104-6324
215-898-4000
Admission: Call for information
Collections: Egyptian, Mediterranean, Near Eastern, African, South Asian, Oceanic, and Australian, and North, Middle, and South American artifacts

RHODE ISLAND

David Winton Bell Gallery
List Art Center, Brown University
64 College Street
Providence, RI 02905
401-785-9451

Admission: No charge; donations accepted
Collections: 5,000 prints, drawings, and photographs from 1500 to present; 200 paintings and sculptures, including works by Olitski, Stella, Noland, Gottlieb, and others

Museum of Art, Rhode Island School of Design*
224 Benefit Street
Providence, RI 02903
401-831-7106
Admission: Adults $2.00; students $.50
Collections: Classical art; medieval art; Latin American art; Japanese prints; 20th-century American art, Oriental textiles and art

Newport Art Museum
76 Bellevue Avenue
Newport, RI 02840
401-847-0179
Admission: Adults $2.00; students $1.00
Collections: Works by Howard Gardener Cushing

SOUTH CAROLINA

Brookgreen Gardens*
U.S. 17 South
Murrells Inlet, SC 29576
803-237-1014
Admission: Adults $5.00; children $2.00
Collections: Sculpture, botany, native fauna

Columbia Museum of Art
1112 Bull Street
Columbia, SC 29201
803-799-2810
Admission: No charge; donations accepted
Collections: Kress Collection of Renaissance paintings; Spanish Colonial collection; European and American paintings and decorative arts

Gibbes Museum of Art
135 Meeting Street
Charleston, SC 29401
803-722-2706
Admission: Adults $2.00; students $.50
Collections: American portraits; prints and miniatures; Oriental art objects; Japanese prints; contemporary art

Greenville County Museum of Art
420 College Street
Greenville, SC 29601
803-271-7570
Admission: No charge; donations accepted
Collections: American paintings, sculpture, and graphics,

including works by Andrew Wyeth (on loan from the Maggill Collection)

SOUTH DAKOTA

Dahl Fine Arts Center
713 Seventh Avenue
Rapid City, SD 57701
605-394-4101
Admission: No charge; donations accepted
Collections: 200 cycloramic murals depicting the history of the United States; early Oscar Howe tempera; regional Black Hills art

Oscar Howe Art Center
119 W. Third
Mitchell, SD
605-996-4111
Admission: No charge; donations accepted
Collections: Original paintings and lithographs by Sioux artist Oscar Howe; collection of works by upper midwest artists in various media

South Dakota Art Museum
Medary Avenue at Harvey Dunn Street
Brookings, SD 57007
605-688-5423
Admission: No charge; donations accepted
Collections: Paintings; sculpture; graphic arts; decorative arts

TENNESSEE

The Dixon Gallery and Gardens
4339 Park Avenue
Memphis, TN 38117
901-761-5250
Admission: Adults $3.50; students $2.50
Collections: German porcelain; 18th-, 19th-, and 20th-century paintings, prints, and sculpture; with emphasis on French and American Impressionists and Postimpressionists including Cassatt, Cesanne, Degas, Matisse, Monet, Renoir, and others

Hunter Museum of Art
10 Bluff View
Chattanooga, TN 37403
615-267-0968
Admission: No charge; donations requested
Collections: American paintings, graphics, and sculpture 18th-, 19th-, and 20th-centuries; Oriental decorative objects

Tennessee Botanical Gardens and Fine Arts Center, Inc.
Forrest Park

Nashville, TN 37205
615-356-8000
Admission: Adults $4.00; students $1.00
Collections: Japanese woodblock prints; 17-to 20th-century American and European art; sculpture; Japanese gardens

TEXAS

Amon Carter Museum*
3501 Camp Bowie Blvd.
Ft. Worth, TX 76113-2365
817-738-1933
Admission: No charge
Collections: American art; Carter Collection of Remington and Russell works; photography

Amarillo Art Center
2200 S. Van Buren
Amarillo, TX 79178
806-371-5050
Admission: No charge
Collections: 20th-century American paintings; prints; drawings; photographs; sculpture

Archer M. Huntington Art Gallery
University of Texas at Austin
Art Building
23rd and San Jacinto Streets
Austin, TX 78712-1205
Admission: No charge
Collections: Greek and Roman art; 19th- and 20th-century American art; 15th- to 17th-century European art; contemporary Latin American art

Dallas Museum of Art*
1717 Hardwood
Dallas, TX 75201
214-922-1200
Admission: No charge, except to special exhibits
Collections: European and American art; ancient, Mediterranean, pre-Columbian, African, Oceanic, and Japanese art; photography

El Paso Museum of Art
1211 Montana Avenue
El Paso, TX 79902
915-541-4040
Admission: No charge; donations accepted
Collections: 14th- to 17th-century European art; American art; 19th-century western U.S. and Mexico art; post-Columbian decorative art; pre-Columbian art of the Americas

Kimbell Art Museum*
3333 Camp Bowie Blvd.

Fort Worth, TX 76104-2744
817-332-8451
Admission: No charge
Collections: Western European paintings; sculpture from antiquity to 20th-century; pre-Columbian objects; Asian sculpture, screens, scrolls and ceramics; African sculpture

Museum of Fine Arts, Houston
1001 Bissonnet
Houston, TX 77005
713-639-7300
Admission: Adults $2.00
Collections: European and American paintings, American Indian art; African and Oceanic primitive art; decorative arts; sculpture

San Antonio Museum Association*
3801 Broadway
San Antonio, TX 78229
512-978-8100
Admission: Call for information
Collections: American and European art; Latin American art; regional art; Western antiquities

UTAH

Braithwaite Fine Arts Gallery
351 West Center Street
Cedar City, UT 84720
801-586-5432
Admission: No charge; donations accepted
Collections: 19th- and 20th-century American art

Springville Museum of Art
126 E. 400 Street
Springville, UT 84663
801-489-9434
Admission: No charge; donations accepted
Collections: 19th- and 20th-century Utah art; collection of Cyrus E. Dallin, sculptor and John Hafen, painter; Utah and American art

Utah Museum of Fine Arts
101 AAC
University of Utah
Salt Lake City, UT 84112
801-581-7332
Admission: No charge; donations accepted
Collections: 19th-century American and French landscape paintings; contemporary graphic arts; African, pre-Columbian, and Indonesian art; Japanese screens

VERMONT

Robert Hull Fleming Museum
University of Vermont
Colchester Avenue
Burlington, VT 05405
802-656-0750
Admission: No charge
Collections: American and European paintings; sculpture, prints, and drawings, medieval to modern; African, Oceanic, Oriental, and pre-Columbian decorative arts.

St. Johnsburg Athenaeum
30 Main Street
St. Johnsburg, VT 05819
802-748-8291
Admission: No charge; donations accepted
Collections: Permanent exhibit of 100 works of art, primarily 19th-century American

Shelburne Museum*
U.S. Rte. 7
Shelburne, VT 05842
802-985-3346
Admission: Adults $15.00; children $6.00; special group rates
Collections: American fine, folk, and decorative arts; Old Master and Impressionist painting, drawings and sculpture

Southern Vermont Art Center
West Road
Manchester, VT 05254
802-362-1405
Admission: Adults $3.00; students $.50
Collections: Paintings, sculpture, graphics, photographs

VIRGINIA

Abby Aldrich Rockefeller Folk Art Center*
P.O. Box C
Williamsburg, VA 23187
804-220-7670
Admission: Call for information
Collections: American folk art, paintings, sculpture, and needlework

Hampton University Museum
Hampton University
Hampton, VA 23668
804-727-5308
Admission: No charge
Collections: Traditional African, Oceanic and American-Indian art; contemporary art; 20th-century African American art

Roanoke Museum of Fine Arts
One Market Square
Roanoke, VA 24011
703-342-5760
Admission: Adults $2.00; students $.50
Collections: Contemporary American paintings, sculpture and graphics; Folk art; 19th-century American painting; African sculpture; Japanese decorative arts

Virginia Museum of Fine Arts*
2800 Grove Avenue
Richmond, VA 23221-2466
804-367-0844
Admission: Suggested donations: Adults $2.00
Collections: Ancient Greek and Roman; Coptic, Byzantine; African; Asian; Russian Imperial jewels, including Fabergé Easter Eggs; contemporary art.

WASHINGTON

Donald Sheehan Art Gallery
900 Isaacs-Olin Hall
Walla Walla, WA 99362
509-527-5249
Admission: No charge
Collections: Thomas P. Davis Asian Art Collection; Pacific Northwest art

Henry Art Gallery
15th Avenue N.E. and N.E. 41st Street
University of Washington
Seattle, WA 98195
206-543-2281
Admission: No charge; donations accepted
Collections: 19th- and 20th-century American and European painting, drawings, and photographs; Japanese mengei ceramics; textiles from over 130 countries

Maryhill Museum of Art
35 Maryhill Museum Drive
Goldendale, WA 98620
509-773-3733
Admission: Adults $2.50; students $1.50
Collections: European and American art; Rodin drawings and sculpture; paintings and sculpture

Seattle Art Museum*
Volunteer Park
Seattle, WA 98112
206-443-4763
Admission: Suggested donation: adults $6.00; students $4.00; first Tuesday of every month—free admission
Collections: Asian and Indian art; African art; modern and contemporary European and American art; Renaissance and Baroque paintings

WEST VIRGINIA

Huntington Museum of Art, Inc.
2033 McCoy Road
Huntington, WV 25701
304-529-2701
Admission: Adults $2.00; students $1.00
Collections: 19th- and 20th-century American paintings and sculpture; 19th-century English and French painting; Pre-Columbian ceramics; Junior Art Museum Collection

Parkersburg Art Center
220 Eighth Street
Parkersburg, WV 26101
304-485-3859
Admission: No charge; donations accepted
Collections: Rotating art exhibits

Sunrise Museums, Inc.
746 Myrtle Road
Charleston, WV 25314
304-344-8035
Admission: Adults $2.00; students $1.00
Collections: American painting, sculpture, graphics, decorative arts; Native American, African, and Oceanic artifacts

WISCONSIN

Madison Art Center
211 State Street
Madison, WI 53715
608-257-0158
Admission: No charge; donations accepted
Collections: Japanese, Mexican, European and American paintings, sculpture, prints; photography gallery collection

Milwaukee Art Museum
750 N. Lincoln Memorial Drive
Milwaukee, WI 53202
414-271-9508
Admission: Adults $4.00; students $2.00
Collections: 18th- to 20th-century American and European painting, sculpture, graphics, photography, decorative arts, prints and drawings

Rahr West Art Museum
Park Street at N. 8th Street
Manitowac, WI 54220
414-683-4501
Admission: No charge; donations accepted
Collections: 19th- and 20th-century American paintings; 19th-century American decorative arts; Chinese ivory carvings

WYOMING

Bradford Brinton Memorial Museum

239 Brinton Road
Big Horn, WY 82833
307-672-3173
Admission: No charge (Open mid-May–Labor Day)
Collections: Western art by Remington Russell, Boreen, Johnson, Russ, Gollings, and Kleiber; Native American arts and weavings

University of Wyoming Art Museum

Fine Arts Building
N. 19th Street
Laramie, WY 82071
307-766-6622
Admission: No charge; donations accepted
Collections: Paintings, graphics, sculpture, drawings, decorative art; emphasis on 19th- and 20th-century American art

Wildlife of the American West Art Museum

110 N. Center Street
Jackson, WY 83001
307-733-5771
Admission: Adults $2.00; students $1.50 (open Memorial Day–Labor Day)
Collections: 19th- and 20th-century North American Wildlife art

Glossary

A

aborigines the native people of Australia

abstract purposefully invented, distorted, or rearranged forms and colors presented in contrast to reality

abstract art *adj.* art in which the subject matter has been simplified or distorted to the point that it may or may not be easily discerned; *v.* the process of creating art work from real objects that are then altered or changed

Abstract Expressionism an art movement that was the product of Expressionism, in which artists used a spontaneous method for creating their art; main artists: Hans Hofmann, Jackson Pollock, David Smith, and Franz Kline

academies schools of art

acetate sheets of thin, clear plastic used to cover artwork

acrylic paint pigment mixed with synthetic or plastic binders

actual textures textures that can be felt when touched

additive with light, the process of mixing colors

admissions portfolio a collection of twelve to twenty works of art that best represent an artist's talent

advertising artist an artist who creates visual images that will persuade the public to purchase a product or patronize a business

aerial drawings plans for the placement of a building in the landscape as one looks down at it

aesthetics an area of study aimed at understanding the nature of art—its essential characteristics, why it is made, what forms it takes, and how people respond to it

aesthetic value the impact of a work of art on our senses, intellect, and emotions

album quilt fabric bedcovering of individually designed and stitched squares assembled into an overall pattern

allegiance loyalty to a cause, a nation, or an individual

allegory a story in which characters, things, and events have hidden meanings

American Abstractionism an art movement characterized by the artist reducing the subject matter to its main features; main artists: John Marin, Stuart Davis, and Mark Toby

Anno Domini (A.D.) in the year of our Lord

anthropology the study of people and the culture in which they live

anthropomorphism the process of attributing human characteristics, movements, and behavior to an animal

appraise to determine the monetary worth of a work of art

apprentice someone who works closely with an experienced artist in order to learn the techniques of that person's trade

aquatint a printmaking process that includes etching and that permits broad areas of black and gray tones

aqueduct a masonry channel used to convey water; invented and widely used by the Romans

arch a curved replacement for a lintel

archaeology study of the physical remains of a culture

architecture the art and profession of designing and constructing buildings; also, the resulting buildings themselves

architect an artist who designs the interior and exterior structures of homes and public buildings

area of concentration the subject area in which a student completes beginning, intermediate, and advanced courses

armature a supporting structure, usually made of wire or wood, that eventually become covered with the modeling medium

art the special expression of ideas, feelings, and values in visual form

Art Brut an art movement that shunned all works of art made by professional artists and embraced the art of children, developmentally handicapped individuals, and people not professionally trained as artists

art criticism a special, concentrated way of looking at

a piece of art with a purpose to receive maximum enjoyment and meaning from it

art director the person who coordinates the activities of set and costume designers, graphic artists, and lighting technicians

art education the learning of art history and about how art is created, talking and writing about art, and learning how to make works of art in a teacher/student environment

art historian the people who assemble accounts of how, why, and when people around the world have created art

art history an account of how, why, and when people around the world have created art

artists people who apply their knowledge, feelings, imaginations, values, and skills to create extraordinary objects or events that we call art

art theory attempts to explain why certain objects or events are called art; attempts to identify important features or characteristics shared by a work of art

Ash Can School a group of American artists who used the images of the American city—with its slums, back alleys, and night spots—as their subject matter; main artists: John Sloan, George Bellows, and Edward Hopper

assemblage the bonding together of shapes or objects by gluing, soldering, pasting, or nailing

atmospheric perspective the effects of the layers of atmosphere and light, between artist and object, that influence the artist's perception of distance and result in the illusion of distance to the viewer

avant-garde very original, experimental art

B

balance the equal or unequal distribution or arrangement of the elements within a work of art

baren rounded, smooth, flat pad used in printmaking

barrel vault a series of arches joined together to enclose a space, as in a tunnel

bird's eye view view you have if looking down on a scene from an elevated position

books of hours calendar-like books depicting labors or events associated with each month of the year

Buddha the "enlightened one," Siddhārtha Gautama, the spiritual leader of India during the sixth century B.C.

burnished highly polished in certain areas

bustle a framework or padding worn by women to puff out a skirt at the back

buttress a large support built against a wall to counteract the pressure exerted on the wall from the weight of an arch, vault, or roof

C

cadastres slabs of clay and papyrus into which land boundaries and fertile areas for crop planting were drawn with a sharp tool

calligraphy beautiful handwriting

canvas a cotton or linen cloth stretched over a wood or cardboard frame

capital the top of a column

caricature a drawing of a person in which certain features have been distorted to achieve a humorous or satirical effect

carving the removal of portions of sculpting material in order to create a form

casting the pouring of liquid materials, such as clay, bronze, metal or plaster, into a mold designed by an artist

catacombs underground tunnels built by fourth century Christians outside of Rome

ceramics the process of creating containers, dishware, or decorative and functional objects from clay

chartography the science of drawing land or sea maps

chiaroscuro dramatic contrasts in light and shadow

chronology a timeline which tells the story of the development of art according to dates

closure the process by which the "mind's eye" forms the lines connecting the points even though no lines actually exist

codex a folding-screen book, up to twenty-one feet long, made from paper of bark or pounded deerskin

colonades long rows of similar columns set equal distances apart

color what is perceived when waves of light strike the retina of the eye

Color Field art a group of artists who expressed visual statements about color; main artists: Mark Rothko, Helen Frankenthaler, and Frank Stella

commission when an artist is asked by a customer to

create a work of art with a particular style or subject matter for which the customer will pay the artist

contextual criticism to focus on understanding a work of art in relationship to personal, social, or historical information that cannot be gathered simply from observing the work of art itself

contour drawing rendering of an object's edges and interior lines through a continuous movement of a drawing tool; does not include shading or proportion

contour lines lines that show the edge of a shape

Corinthian column column that is tall and slim with a very ornate capital

critical method a means of organizing or structuring certain questions so that goals may be met and the dialogue kept relevant

cross-hatching using two sets of hatching lines (parallel lines) that cross one another to create dark and light areas

Cubism art movement in which the subject matter is visually fragmented to reveal multiple viewpoints

curator a caretaker of a portion of a museum collection

D

Dada an art movement whose silly name was used to express the artists' personal attitudes toward art in society

docent a museum guide who conducts individual and group tours of a museum's collections

dome a continuous series of rounded arches with a common center

donor portraits paintings or murals commissioned by wealthy persons and donated to their churches as visible signs of their devotion

doric column columns with no decoration on the capital

draftsman's net a wooden frame with a net of black threads stretched across the opening, and a movable eyepiece to help the artist fix a line of sight

drawing the process of creating an image on a surface with a tool that leaves a mark or impression

dynamics the rhythm and movement in art that expresses great action, energy, and force

dynasty a succession of rulers who are members of a family line

E

earthworks a work of art that is designed for a particular place, utilizes the environment, and depends on the natural environment for its existence, impact, and meaning

effigy an image or a representation of a person or part of nature

element a basic component or essential "part" of a work of art

elevational drawing architectural drawings that show the height dimensions of a building

embrasures the low segments of a castle or town wall. They provided larger openings from which a variety of weaponry could be launched

embroidery intricate needle work used to decorate fabric

emphasis technique used by an artist to place special importance on an element, subject, or other aspect of a work of art

encaustic an art technique in which hot wax and pigment are applied to a canvas with a brush

enigmatic puzzling or hard to understand

ephemeral lasting only a short time

etching the process of engraving a design into a metal plate with acid and a pointed tool called a stylus for the purpose of creating a plate for printing

excavation the act of digging through layers of earth to locate the physical remains of a culture

expression a visual representation of our ideas, feelings, and values

Expressionism art movement with the main goal of expression of deeply felt emotions through art; main artists: Max Ernst, Wassily Kandinsky, Franz Marc, and Emil Nolde; or, a theory that relates the emotional life of the artist to the emotional impact of the work of art

expressive to be able to effectively communicate feelings and ideas in visual form

eye level the point of view held by the viewer of a work

F

Fauves French term for "wild beasts," a group of artists around the turn of the twentieth century with the main goals of experimentation and shocking the public

Fauvism an art movement characterized by the arbitrary use of color

Femmage art a term coined by Miriam Schapiro that is a combination of "female" and "collage" used to give a name to an artistic method of creating collages through the use of traditional sewing and craft techniques

figurative painter painter who specializes in the portrayal of the human figure

finial the decorative top or fancy, uppermost tip of the spire of a structure

firing a process of heating clay at very high temperatures and then allowing it to cool in order to make it hard and resistant to water

fluted columns columns with a decorative pattern of grooves running from top to bottom on each column

Fluxus movement art movement in which the artists presented live events involving music, literary readings, and spontaneous art; main artist: Nam June Piak

flying buttress an arch projecting over the side aisle of a cathedral, which helps direct the outward thrust downward, creating the illusion of a floating, unsupported roof

folk art artistic work by individuals who have not been trained as artists

foreshortening reducing or distorting shapes to give the illusion of three-dimensional space as it is actually seen by the human eye

Formal Academies a group of learned members who establish very strict rules about what the subject of a work of art may be and how it may be created

forms three-dimensional shapes

frescoes a style of painting in which tempera is applied to the wet plaster surface of building walls

Futurism a small group of Italian artists whose art is the marriage of the qualities of modern technology with the expressive images of art; main artists: Umberto Boccioni, Giacomo Balla, and Joseph Stella

G

geometric shapes circles, squares, rectangles and triangles—mathematical in proportion

gesso a white, chalky paint used on bare canvas as a foundation for painting

gesture drawings loose, quick renderings of a person, animal, or object that captures them in the act of moving

glaze a semi-transparent coating used to give an art object a glossy finish

gold leaf a very thin sheet of gold applied to a surface with adhesive

Gothic a term referring to the Goths, a fearsome Germanic people who destroyed a great deal of classical art during the 400s; used to describe the architecture of the 1400 and 1500s

Gothic arch a pointed arch

gouache an opaque paint used with watercolor techniques

Graffiti art art that consists of images and words applied to subway walls and trains, buildings, and public fixtures

graphic designer an artist who solves visual problems by using the elements and principles of art

griot a storyteller

groined vault a Roman structure formed by intersecting two barrel vaults at right angles

H

hardware the monitor, keyboard, disk drive, mouse or joystick, and printer of a computer

Harlem Renaissance art movement that illustrated the African American themes about life; main artists: Palmer Hayden, Jacob Lawrence, and Horace Pippin

hatching drawing a series of parallel lines that are placed close together for dark areas and farther apart for light shading

hieroglyphics Egyptian sacred writings

high relief sculptural forms in a relief sculpture that protrude significantly

horizon line a line drawn across the picture plane where the earth appears to meet the sky

I

iconography the interpreting of an artifact or work of art through studying its subject matter, theme, or symbols

icons the signs of a particular culture found in its artifacts and works of art

illuminated manuscripts richly illustrated books

implied forms forms that give the illusion of being

three-dimensional, but are represented on a flat, two-dimensional surface, like drawing paper or canvas

implied lines lines that are recognized by the brain and the eye but are not really present

industrial designer an artist who designs functional products for public and private use

industrial engineers artists who design functional products for public and private use

Installation art a work of art that is built temporarily or permanently into a museum or gallery space; main artists are Lucas Samaras and Sandy Skoglund

internship a period of time in which a graduating student works with a professional artist in a studio environment

interpretation an informed explanation of the meaning of a work of art

intrinsic to come from within

invented texture texture made up by the artist using lines and shapes; referred to as pattern

ionic column column with short, fluted shafts and scroll-like decorations on the capital

itinerant artist an artist who travels from place to place, making a living by seeking and fulfilling commissions to make art

J

jali a type of Indian carving; literally means "net," but compares much better with the delicacy of lace

jewelry designer an artist who produces models for mass-produced jewelry, or creates a commissioned piece of jewelry for a client

K

Kabuki a form of theater that developed in Japan during the seventeenth century in which both male and female roles were played by men and stories were told through pantomime, dance, and song

kachina a representation of the spirit of an earthly object in the Hopi religious system

kachina-manas female kachinas

keystone a wedge-shaped piece of stone at the top of an arch that locks all of the other stones in place

kiln a special oven used to fire ceramics

Kinetic art a type of sculpture that moves; main artists were George Warren Rickey and Len Lye

kiosks small covered pavilions

L

life studies drawings of objects in their environment

Light art art using electric light to create a special visual effect; main artist was Dan Flavin

line a moving point on the surface of a canvas, paper, slab of clay, or metal printing plate that forms shapes, gives direction, and creates rhythm and movement within a work of art

lintel the horizontal beam that lays across two posts with the function of supporting the load placed upon it; also called beam, rafter, or girder

logo the graphic design that identifies the product of a specific manufacturer

low relief sculptural forms in a relief sculpture that protrude only a little

M

manifesto a proclamation of ideas or intentions

mastaba rectangular burial mound with sloping sides

matte having a smooth, even surface free of gloss or highlights

matting to frame artwork with mat board or poster board

mechanical or architectural drawing detailed renderings of a plan for the assembling of an object, building, or environment

media art materials such as paint, clay, wood, drawing tools, and fibers

medical illustrator artists who produce renderings of the external and internal parts of humans and animals, such as tissues, organs, skeletal systems, and cells

merlons the high segments of a castle or town wall that contained an arrow loop from which arrows could be shot

method the way in which an artist uses the media

Mexican muralist art a group of Mexican artists who painted images of the Mexican people, revolution and oppression, native traditions, industrialization and hope for the people of Mexico; main artist: Diego Rivera

minaret a tower with projecting balconies from which the Islamic faithful can be called to prayer

Minimal art a twentieth-century art movement that sought to present ideas in the simplest forms possible

modeling the shaping of a sculpture by an artist into a desired form

Modernism art and ideas that stress individuality, originality, universal meaning, and "art for art's sake"

Mogul the dynasty that flourished India from the mid-1500s to the early 1700s, marked by an interest in architecture, poetry and many other art forms

monochromatic the use of only one color and its different values in a work of art

monoprint a process in which only one image can be lifted from a flat printing plate, such as a sheet of plastic or linoleum

monument a visual reminder of an important person, event, or idea in history

mosaic a work of art that is constructed of many small pieces of colored tile

mother-of-pearl the hard, opalescent layer found inside certain sea shells

motif a visual theme or repeated pattern in a design

mouse a hand-held device that artist may use to help them create images on a computer screen, used to select commands or options visible on the screen

movement the visual suggestion of action created by the placement of the elements in a work of art

Mudras hand gestures with specific meanings in Buddhism

mural a work of art, usually large in scale, painted on or attached to a wall or ceiling

N

naturalistic style an artistic style that attempts to make a work of art as lifelike and true to nature as possible

negative space the unused area between, within, and surrounding shapes and forms in an artistic composition

netsuke tiny, lifelike, ivory sculptures tied to the cord of a kimono

nib the point of a marker or pen

O

oil paint pigment mixed with linseed oil

one-point perspective a work in which the artist has used only one vanishing point

Op art an art movement whose artists were interested in how the careful arrangement of lines, colors, and geometric shapes to produce an optical effect; main artists: Victor Vasarely and Bridget Riley

oral history the passing of information from generation to generation through the spoken word

organic shapes shapes that are irregular, curvilinear, and not measurable

P

pagoda a temple of several stories, each story having its own projecting roof

Paleolithic referring to the second stage of the Stone Age, in which people fashioned their tools from stone

panorama a view of what can be seen in many directions

pantheon all of the gods of a culture or religion

pastels sticks of ground pigment

patron a wealthy or influential person who supports an artist by providing opportunities and funds that make it possible for the artist to do his or her work

perceive to be aware of things through our senses—seeing, hearing, tasting, smelling, and touching; the ability to recognize and understand things we experience in our environment

perspective a system for representing the illusion of three-dimensional space on a flat or two-dimensional surface

Photo-realism an art movement in which the artists painted with such precision and detail that their work resembled a photograph of the image; main artists: Richard Estes and Chuck Close

photography the making of fine art, commercial, and educational pictures by capturing the light of an object with a camera

photoscreen a stencil of an image produced in a printing shop

picture plane the flat surface on which a work of art is made

pigment matter that gives color to materials such as paints, dyes, crayons, and inks

pointillism a painting style that consists of the application of small dots, or points, of color

Pop art an art movement that was a reflection of the popular culture, the media, and advertising images; main artists: Andy Warhol, Roy Lichtenstein, Claus Oldenburg, and Robert Rauschenberg

porcelain a white fine clay used in the production of high-quality dishware or decorated objects

portrait bust a three dimensional, usually life-size, sculpture of someone showing his or her likeness from the shoulders up

positive space the space taken up by the shapes and forms themselves

post the upright vertical stones or pieces of wood used to support the lintel; also called a column or pier

Postimpressionism a late nineteenth-century French art movement that expanded ideas advanced by the Impressionists; main artists: van Gogh, Cézanne, and Gauguin

Postmodern art artworks and ideas that are rich and diverse in terms of meanings, materials, cultural traditions, and historical references

powwow a special gathering of Native Americans marked by ceremonial music and dance

primary colors colors that cannot be made by the artist: red, yellow, and blue

prime to prepare

printmaking the process of creating one or more images from a single prepared surface

Process art art movement in which the art would undergo a performance or transformation; main artist: Hans Haacke

proof the initial print in the printing run of a work of art

proportion the relationship in size of one component of a work of art to another

pure painting the artistic style of abstracting and simplifying images until only color, line, and shape remain

R

radiocarbon dating a scientific process used to determine the age of an object by the object's radiocarbon content

ready-mades functional objects, such as bicycle wheels and hat racks, that the artist proclaimed to be works of art

real forms three-dimensional forms that actually exist in space, such as trees, mountains, or buildings

real lines lines that exist within a work of art

Regionalism art movement in which artists returned to the realistic representation of subject matter characteristic of the part of the country in which they lived; main artists: Grant Wood and John Steuart Curry

relief sculptural forms that protrude from a flat surface

relief sculpture a type of carving in which material is removed from only one side of the sculpture, leaving the back of the sculpture flat

reliquaries ornate receptacles of different sizes and shapes used to contain church relics

Renaissance a French word meaning "rebirth"; the time period that followed the Middle Ages

representational or realistic drawing a rendering that looks like the object or image the artist is viewing or imagining, often uses perspective, shading, and modeling techniques

rhythm the regular repetition of elements, patterns, or movements in a work of art

ribbed vault a skeleton of pointed arches to which light masonry could be applied, allowing rectangular area to be covered

rock art ancient images painted or carved on rock

rock cut temple temple carved from solid rock, a process more similar to carving a stone sculpture than constructing a building

rose windows round stained-glass windows with a symmetrical design around the center

S

scarification the custom of scarring one's skin in patterns to signify family and cultural ties

scenario a short summary of a real or imagined series of events

screen a fine mesh fabric stretched across a wooden frame; used for silkscreen printmaking

scroll a length of paper with a wooden rod attached at each end that is used for rolling the ends toward the middle

sculpture the making of works of art that possess height, width, and depth

scumbling using the side in a back and forth motion of the tool to create a solid area of shading

secondary color the result of mixing two primary colors in equal amounts: orange, green, and violet

self-portrait a work of art in which an artist uses his/her own image as the subject

serigraph a silkscreen print

serpentine a long, thin shape that curves or coils like the body of snake

shades colors to which a darker color or black has been added

shape a two-dimensional area defined by a boundary

sikhara spire found on Indian temple

simulated texture the recreations of a manufactured or natural texture

sketchbook a visual diary of artistic thoughts

smudging using a finger or blending stick (compressed paper) to spread the medium on the surface

Social Realists a group of artists who dealt with themes such as poverty, oppression, and social injustice

software contains information (programs) and instructions that help the computer operators meet their computing needs

Soho an art movement famous for the short-lived art that emerged on the walls, windows, and doorways of the public buildings in a twenty-block area of New York City

spectrum the colors that make up light

step pyramid a pyramid that was shaped like several mastabas of diminishing size stacked one on top of the other

stippling using the point of the drawing tool to make small dots to create an area of dark or light

stone pictures Japanese art form in which pictures are "discovered" in stones

storyboard frame by frame sequence of events for a commercial, television show, or movie

striations incised line

studio production the processes people engage in to make art

style a characteristic manner of presenting ideas and feelings in visual form

stylized an artistic style in which the body parts of the figure have been simplified and reduced to their most basic form, or an artistic form in which an object has been changed or abstracted from nature in order to fit the artistic rules and traditions of a culture

subtractive a type of sculpture in which the artist removes selected portions of the sculpting material (stone, marble, etc.) to create the work of art

Superrealism an artistic style with the intent to produce works so realistic that the viewer is unable to distinguish between illusion and reality

Suprematism an art movement founded by a small group of Russian artists that consisted of making geometric shapes of color that interact subtly with the backgrounds of similar intensities; main artist: Kasimir Malevich

Surrealism an art movement in which artists combined naturally unrelated events, images, objects, or situations in a dreamlike scene; main artist: Salvador Dali

syndicated cartoons cartoons that are published nationally, usually in newspapers

T

tag a special signature specific to a Graffiti artist

television graphic artist an artist who may design promotions for advertising campaigns, create sets for game or talk shows, and invent new logos for the television station

tertiary colors the result of mixing varying amounts of a primary and a secondary color

texture the surface qualities of a particular object or work of art

The Eight a gathering of eight artists brought together by Robert Henri who broke with the tradition of the European art academies to explore new styles and subjects

thesis an exhibition of an artist's work that demonstrates proficiency in his or her area of concentration

three-dimensional having width, height, and depth

three-point perspective the use of three vanishing points in a work

tints colors to which a lighter shade white has been added

tooled leather leather that has been hand decorated

tooth slightly rough surface of paper

topiary the practice of training and clipping shrubs to grow in shapes they wouldn't take on their own

totem poles wooden poles that were carved and painted with symbolic designs, and that stood upright in front of native houses

trompe l'oeil a type of painting that is so realistic that viewers are not sure whether they are looking at a painting of objects or the objects themselves

tumulus a mound over a burial site

two-dimensional having width and height

two-point perspective the use of two vanishing points in a work

U

ukiyo-e an art form of the Edo-Tokugawa period of Japan which means literally "pictures of the floating world"

unity a principle that helps us see the components of a work of art as a whole

V

value the amount of lightness or darkness a color possesses

vanishing point point to which all objects seem to recede

variety a principle that focuses on differences and diversities in a work of art

vault an arched structure, usually forming a ceiling or doorway, or a combination of arches

vellum paper made from calfskin that was used for illuminated manuscripts

Venuses name given to female images found carved during the Stone Age

W

wall installation a work of art that has been permanently installed into a wall in a museum, or another public or private building

warp threads threads that run vertically in a woven cloth

weaving the process of making fabric by passing threads over and under each other in a given pattern

weft threads threads that run horizontally in a woven cloth

whirligigs wind toys with moving parts that are propelled by the force of the wind

worm's eye view the view you would have if you were lying on the ground looking up; object lies above the horizon line

Z

ziggurat massive tiered temples constructed of mud bricks

Glossary/Glosario

A

Aborigines/aborígenes: la gente nativa de Australia

Abstract/abstracto: formas y colores intencionalmente inventados, distorsionados, o dispuestos de otro modo, presentados a diferencia de la realidad

Abstract art/arte abstracto: adj. arte el cuàl el tema (de que se trata) ha sido simplificado o torcido hasta el punto que sea o no sea fácilmente discernido; v. el proceso de crear obras de arte de objetos reales que luego son alterados o cambiados

Abstract Expressionism/expresionismo abstracto: un movimiento de arte que fue el producto del expresionismo donde los artistas usaron un método espontáneo para crear su arte, sin la menor idea de como parecería cuando terminaron; artistas principales fueron Hans Hofmann, Jackson Pollock, David Smith, y Franz Kline

Acetate/acetato: hojas de plástico delgado y lúcido usadas para cubrir obras de arte

Acrylic paint/pintura acrílica: pigmento mezclado con aglutinantes sintéticos o plásticos

Actual textures/texturas actuales: texturas que se puede sentir cuando se las toca

Additive/aditivo: con luz, es el proceso de mezclar colores

Admissions portfolio/obras de admisión: una colección de doce a veinte obras de arte que mejor representan el talento de un artista

Advertising artist/artista de publicidad: un artista que crea imágenes visuales que persuadirán al público para comprar un producto o frecuentar un negocio

Aerial drawings/diseños aéreos: planes para la colocación de un edificio en el paisaje según como uno lo ve mirando hacia abajo (a él)

Aesthetics/estética: un área de estudio con el objetivo de entender la naturaleza del arte—sus características esenciales, por qué está hecho, qué forma toma, y cómo la gente responde a ella

Aesthetic value/valor estético: el impacto de una obra de arte sobre nuestros sentidos, intelecto, y emociones

Album quilt/álbum colcha: cubrecama tejida de cuadrados individualmente designados y cosidos, ensamblados en un diseño en conjunto

Allegiance/fidelidad: lealtad a una causa, una nación, o a un individuo

Allegory/alegoría: un cuento en que los personajes, las cosas, y los eventos tienen sentidos ocultos

American abstractionism/arte abstracto americano: un movimiento de arte caracterizado por la reducción de la materia de sus características principales por el artista; artistas principales fueron John Mavin, Stuart Davis y Mark Toby

Anno Domini (a.d.)/Anno Domini (a.c.): en el año de nuestro Señor

Anthropology/antropología: el estudio de personas y la cultura en que viven

Anthropomorphism/antropomorfismo: el proceso de atribuir características, movimientos, y conducta humanos a un animal

Appraise/evaluar; valorar: determinar el valor monetario de una obra de arte

Apprentice/novicio: alguien que trabaja contiguamente con un artista experto para poder aprender las técnicas de su oficio

Aqueduct/acueducto: un canal albañilería usado para transportar agua; inventado y excesivamente usado por los romanos

Aquatint/acuatinta: un proceso de grabado al agua-afuerte que permite anchas áreas de tonos negros y grises

Area of concentration/área de concentración: el área de estudios en la cual un estudiante completa cursos principios, intermedios, y avanzados

Arch/arco: un reemplazo encorvado por un dintel

Archeology/arqueología: el estudio de los restos físicos de una cultura

Architect/arquitecto: un artista que concibe las estructuras interiores y exteriores de residencias y edificios públicos

Architecture/arquitectura: el arte y la profesión de proyectar y construir edificios; tambien, los edificios resultantes mismos

Armature/armazón: una estructura para sostener, usualmente hecha de alambre o madera, que eventualmente se cubre con el medio para modelar

Art/arte: la expresión especial de ideas, sensaciones, y valores en forma visual

Art Brut/arte brut: un movimiento de arte que rehuyó todas las obras de arte hechas por artistas profesionales y abrazó el arte hecho por niños, individuos con impedimentos del desarrollo, y personas no profesionalmente entrenadas como artistas

Art criticism/crítica del arte: una manera concentrada especial de mirar una obra de arte con el propósito de recibir el placer y significado máximo de ella

Art director/director de arte: la persona que coordina las actividades de diseñadores de platóes y vestuarios, artistas gráficas, y técnicos de iluminación

Art education/educación de arte: el aprendizaje de la historia de arte y sobre como el arte está creado, el hablar y escribir sobre el arte, y el aprendizaje de como hacer obras de arte en un ambiente de maestro estudiante

Art history/historia del arte: los contextos generales sociales, culturales, e históricos para entender y apreciar artesanías como un paso al estudio de arte

Art historian/historiador del arte: la gente que ensambla informes de cómo, por qué, y cuándo la gente alrededor del mundo ha creado el arte

Artists/artistas: personas que aplican su conocimiento, sentimientos, imaginaciones, valores, y habilidades para crear objetos o eventos extraordinarios que nosotros llamamos arte

Ash Can School/grupo de artistas de crudo realismo: un grupo de artistas americanos que usó las imágenes de la ciudad americana—con sus barrios pobres, callejones posteriores, y lugares nocturnos de pasatiempo—como sus temas; artistas principales fueron John Sloan, George Bellows, y Edward Hopper

Assemblage/ensamblaje (collage): uniendo formas u objetos usando cola, soldadura, goma, o claves

Atmospheric perspective/perspectiva atmosférica: los efectos de las capas de atmósfera y luz, entre el artista y el objeto, que influyen la percepción de distancia del artista y resultan en la ilusión de distancia para el veedor

Avant-garde/vanguardia: arte experimental muy original

B

Balance/balanza: la distribución o el arreglo igual de los elementos dentro de una obra de arte

Balance/balanza: la distribución o el arreglo igual o desigual de los elementos dentro de una obra de arte

Baren/baren: una almohadilla suave, lisa, y redonda usada en estampación

Barrel vault/bóveda cilíndrica: una serie de arcos juntados para encerrar un espacio, como en un túnel

Bird's eye view/a vista de pájaro: la vista que uno tiene mirando hacia abajo a una escena desde una posición elevada

Books of hours/libros de horas: libros parecidos a calendarios retratando labores o eventos asociados con cada mes del año

Buddha/Buda: el "esclarecido," Siddhartha Guatama, el líder espiritual de la India durante el siglo sexto a. de J.C.

Burnished/bruñido: sumamente pulido en ciertas áreas

Bustle/almohadilla: una estructura o atestadura usada por las mujeres para abultar las faldas por detrás

Buttress/contrafuerte: un apoyo grande construido contra una muralla para contrariar la presión ejercida en la muralla del peso de un arco, bóveda, o techo

C

Cadastres/catastros: trozos de arcilla y papiro en donde los límites de terrenos y las áreas fértiles para plantar cosechas fueron trazados con una herramienta aguda

Calligraphy/caligrafía: escritura bella

Canvas/lienzo: una tela de algodón o lino extendida sobre un marco hecho de madera o cartulina

Capital/capitel de columna: la cima de una columna

Caricature/caricatura: un dibujo de una persona donde ciertas características han sido distorsionadas para resultar con un efecto chistoso o satírico

Carving/entalladura (tallando): quitando porciones de materia de escultura para crear una forma

Casting/fundición: vaciar materias derretidas, como arcilla, bronce, metal o plaste, en un molde diseñado por un artista

Catacombs/catacumbas: túneles subterráneos construidos por los cristianos del cuarto siglo fuera de Roma

Ceramics/cerámica: el proceso de crear envases, vajilla, u objetos decorativos y funcionales de arcilla

Chartography/cartografía: la ciencia de dibujar mapas de la tierra o mar

Chiaroscuro/claroscuro: contrastes dramáticos en luz y sombra

Chronology/cronología: una línea de tiempo que relata el desarrollo del arte conforme a fechas

Closure/cierre: el proceso por el cual la imaginación forma las líneas conectando los puntos aunque ningunas líneas actualmente existen

Codex/códice: un libro biombo, hasta veintiún pies de largo, hecho de papel de corteza o de cuero de venado machacado

Colonades/colonades: filas largas de columnas similares puestas a distancia igual

Color/color: lo que se percibe cuando ondas de luz caen sobre la retina del ojo

Color field art/campo arte de color: un grupo de artistas que expresó exposiciones visuales sobre color; artistas principales fueron Mark Rothko, Helen Frankenthaler, y Frank Stella

Commission/comisión: cuando un cliente pide que un artista cree una obra de arte con un estilo o tema en particular por la cual el cliente pagará al artista

Contextual criticism/crítica del contexto: enfocar en el entendimiento de una obra de arte con relación a información personal, social, o histórica que no se puede juntar sólo por la observación de la obra de arte misma

Contour drawing/dibujo contorno: representación de los lindes y líneas interiores de un objeto a través de un movimiento continuo de una herramienta para dibujar. No incluye degradación o proporción

Contour lines/líneas contornas: líneas que muestran el borde de una forma

Corinthian column/columna corintia: una columna que es alta y delgada con un capitel muy ornado

Critical method/método crítico: una manera de organizar o estructurar ciertas preguntas para poder lograr metas y mantener pertinente el diálogo

Criticism/crítica: un proceso de hacer preguntas sobre una obra de arte

Cross-hatching/sombrear; rayar: usando dos juegos de líneas sombreadas (líneas paralelas) que cruzan una con otra para crear áreas oscuras y claras

Cubism/cubismo: un movimiento de arte donde la materia es visualmente fragmentacia para revelar puntos de vista multiples

Curator/encargudo: un guardián de una porción de una colección en un museo

D

Dada/dada: un movimiento de arte cuyo nombre ridículo fue usado para expresar las actitudes personales del artista hacia el arte en la sociedad

Docent/docente: una guía de un museo que conducta visitas individuales y en grupos de las colecciones de un museo

Dome/domo (cúpula): una serie continua de arcos curvados con un centro común

Donor portraits/retratos donadores: cuadros o murales comisionados por personas ricas y donados a sus iglesias como símbolos visibles de su devoción

Doric column/columna dórica: columnas sin decoración en el capitel

Drawing/dibujando (dibujar): el proceso de crear una imagen en una superficie con una herramienta que deja una marca o impresión

Dynamics/dinámica: el ritmo y movimiento en arte que expresa acción, energía y fuerza grande

Dynasty/dinastía: una sucesión de gobernantes que son miembros de una línea familiar

E

earthworks/obras de tierra: una obra de arte que está designada por un lugar en particular; utiliza el ambiente; y depende del ambiente natural para su existencia, impacto, y significado

Effigy/efigie: una imagen o representación de una persona o de parte de la naturaleza

Element/elemento: un componente básico o parte esencial de una obra de arte

Elevational drawing/dibujo elevacional: dibujos arquitecturales que muestran las dimensiones de la altura de un edificio

Embrasures/aspilleras: los segmentos bajos de un castillo o de una muralla alrededor de un pueblo. Proveyeron aberturas más grandes por donde se podía lanzar una variedad de armería.

Embroidery/bordado: costura intricada usada para decorar tela

Emphasis/énfasis: técnica usada por un artista para poner importancia especial sobre un elemento, sujeto, u otro aspecto de una obra de arte

Encaustic/encausto: una técnica del arte donde se aplica cera caliente y pigmento a un lienzo con una brocha

Enigmatic/enigmático: confundido o difícil para entender

Ephemeral/efímero: durando sólo un tiempo corto

Etching/grabado: el proceso de grabar o cortar un diseño en una plancha de metal con una herramienta puntiaguda llamada punzón

Etching/grabado: el proceso de grabar una plancha de metal con ácido para crear una plancha para imprimir

Excavation/excavación: el acto de cavar por acodos de tierra para localizar los restos físicos de una cultura

Expression/expresión (expresar): una representación visual de nuestras ideas, sentimientos, y valores

Expressionism/expresionismo: un movimiento de arte con la meta principal de expresar emociones profundamente sentidas a través del arte; artistas principales fueron Max Ernst, Wassily Kandinsky, Franz Marc, y Emile Nolde

Expressive/expresivo: ser capaz de efectivamente comunicar sentidos e ideas en forma visual

F

Fauves/fauves: términos franceses para "bestias salvajes"; un movimiento de arte cerca del final del siglo pasado con las metas principales de experimentación y escandalizando el público

Fauvism/fauvismo: un movimiento de arte caracterizado por el uso arbitrario de color

Femmage Art/arte femmage: un término creado por Miriam Shapiro que es una combinación de "hembra" y "collage" usado para dar un nombre a un método artístico de crear collages por el uso de técnicas tradicionales de costura y arte

Figurative painter/pintor figurado: un pintor que especializa en el retrato de la figura humana

Finial/florón: la parte decorativa de arriba, o la extremidad ornamental más elevada de la aguja de una estructura

Firing/cocción: un proceso de calentar arcilla en temperaturas muy altas y luego dejar que se enfríe para que sea dura e impermeable al agua

Fluted columns/columnas estriadas: columnas con un diseño decorativo de acanaladuras extendiéndose de arriba abajo en cada columna

Fluxus movement/movimiento flujo: un movimiento de arte en el cual los artistas presentaron eventos vivos involucrando música, lecturas literarias, y arte espontáneo; artista principal fue Nam June Piak

Flying buttress/arco botarete: un arco proyectando sobre el pasillo ladero de una catedral, que ayuda dirigir la fuerza propulsora de fuera hacia abajo. El efecto es la ilusión de un techo flotante sin apoyo.

Folk art/arte popular: obras artísticas hechas por individuos que no han sido entrenados como artistas

Foreshortening/escorzo: la reducción o distorsión de formas para dar la ilusión de espacio tridimensional, como el ojo humano actualmente lo ve

Formal Academies/Academias Formales: un grupo de miembros eruditos que establece reglas muy estrictas sobre lo que un tema de una obra de arte puede ser y como se puede crearlo

Forms/formas: configuraciones tridimensionales

Frescoes/pintar al fresco: un estilo de pintar donde se aplica la pintura al temple a la superficie del yeso mojado de las murallas de edificios

Futurism/futurismo: un grupo pequeño de artistas italianos cuyo arte es el matrimonio de las cualidades de tecnología moderna con las imágenes expresivas de arte; artistas principales son Umberto Boccioni, Giacomo Balla, y Joseph Stella

G

Gargoyles/gárgolas: criaturas extrañas, y frecuentemente espantosas, talladas en piedra que se colocan en un sitio elevado en los rincones de los tejados catedrales

Geometric shapes/formas geométricas: círculos, cuadrados, rectángulos y triángulos—matemáticamente proporcionados

Gesso/yeso: pintura blanca gredosa usada en un lienzo sin pintura como un fundamento para pintar

Gesture drawings/dibujos de gestos: representaciones indefinidas y rápidas de una persona, animal u objeto que los captura en el acto de moverse

Glaze/barniz: vidrio líquido (derretido)

Glaze/capa transparente: una capa semi-transparente usada para dar a un objeto un acabado en brillo

Gold leaf/hoja de oro: una plancha de oro sumamente delgada aplicada a una superficie con adhesivo

Gothic/gótico: un término que se refiere a los godos, una gente germánica terrible que destruyó una cantidad grande de arte clásico durante los años del 400; el término fue usado para describir la arquitectura del los años de 1400 y 1500

Gothic arch/arco gótico: un arco puntiagudo

Gouache/aguazo: una pintura opaca usada con técnicas de acuarela

Graffiti Art/arte hecho por grafiti: arte que consiste de imágenes y palabras aplicadas a murallas y trenes subterráneos, edificios, y cosas fijas públicas

Graphic designer/diseñador de artes gráficas: un artista que resuelve problemas visuales usando los elementos y principios del arte

Griot/griot: un narrador

Groined vault/bóveda vaída: Una estructura romana formada por la intersección de dos bóvedas cilíndricas en ángulos rectos

H

Hardware/maquinaria: el monitor, el teclado, el mecanismo para discos, el "ratón" o la palanca de mando, y la impresora de un computador

Harlem Renaissance/Renacimiento de Harlem: un movimiento de arte que ilustró los temas africanos-americanos sobre la vida como su materia; artista principales fueron Palmer Hayden, Jacob Lawrence, y Horace Pippin

Hatching/sombreado: dibujando una serie de líneas paralelas que están puestas muy cercas para las áreas oscuras y más apartes para la degradación clara

Hieroglyphics/jeroglíficos: escritos sagrados egipcios

High relief/alto relieve: formas esculturales en una escultura relieve que resaltan significativamente

I

Iconography/iconografía: la interpretación de un artefacto u obra de arte a través del estudio de su materia, tema, o símbolo

Icons/iconos: los símbolos de una cultura en particular

encontrados en sus artefactos y obras de arte

Illuminated manuscripts/manuscritos iluminados: libros bien ilustrados

Implied forms/formas implicadas: formas que dan la ilusión de ser tridimensionales, pero están representadas en una superficie bidimensional llana, como en papel de dibujo o lienzo

Implied lines/líneas implicadas: líneas que el cerebro y el ojo reconocen pero que realmente no están presentes

Industrial designer/diseñador industrial: un artista que diseña productos funcionales para el uso público y privado

Industrial engineers/ingenieros industriales: artistas que diseñan productos funcionales para el uso público y privado

Installation art/arte por instalación: una obra de arte que está erigida temporalmente o permanentemente en un espacio de un museo o galería; los artistas principales fueron Lucas Samaras y Sandy Skoglund

Internship/práctica como interno: un período de tiempo en que un estudiante graduando trabaja con un artista profesional en un ambiente de un estudio

Interpretation/interpretación: una explicación formada del significado de una obra de arte

Intrinsic/intrínseco: venir de adentro

Invented texture/textura inventada: textura hecha por el artista usando líneas y formas; que se refiere a configuración

Ionic column/columna jónica: una columna con fustes cortos y estriados y con decoraciones como volutas en el capitel

Itinerant artist/artista ambulante: un artista que viaja de un lugar a otro, ganándose la vida por medio de buscar y cumplir con encargos para hacer arte

J

Jali/jali: un tipo de talla india; el nombre literalmente significa "red", pero compara mucho mejor con la delicadeza de encaje

Jewelry designer/diseñador de joyas: un artista que produce modelos para joyas fabricadas en gran escala, o que crea una prenda de joyas encargada para un cliente

K

Kabuki/Kabuki: una forma de teatro que desarrolló en Japón durante el siglo diecisiete donde los papeles de ambos los hombres y las mujeres fueron desempeñados por los hombres. Contaron cuentos a través de pantomima, baile, y canción.

Kachina/Kachina: una representación del espíritu de un objeto mundano en el sistema religioso Hopi

Kachina-manas/Kachina-manas: kachinas hembras

Keystone/clave: un pedazo de piedra en forma de calce a la cabeza de un arco que encierra todas las otras piedras en su propio lugar

Kiln/horno (de ladrillo): un horno especial usado para cocer cerámica

Kinetic art/arte cinético: un tipo de escultura que mueve

Kinetic art/arte cinético: escultura en moción; artistas principales fueron George Warren Ricky y Len Lye

Kiosks/quioscos: pequeños pabellones a cubiertos

L

Life studies/bosquejos de la vida: dibujos de objetos en su ambiente

Light art/arte luminoso: arte usando luz eléctrica para crear un efecto visual especial; el artista principal fue Dan Flavin

Line/línea: un punto que mueve en la superficie de un lienzo, papel, trozo de arcilla, o plancha de impresa metal. Hace formas, da dirección, y crea ritmo y movimiento dentro de una obra de arte.

Lintel/dintel: la viga horizontal que está puesta sobre dos postes con la función de soportar el peso puesto sobre ella

Logo/logo: el diseño gráfico que identifica el producto de un fabricante específico

Low relief/bajo relieve: formas esculturales en una escultura relieve que resaltan sólo un poco

M

Manifesto/manifiesto: una proclamación de ideas o intenciones

Mastaba/mastaba: entierro rectangular con lados inclinados

Matte/mate: que tiene una superficie plana y lisa sin brillo o toques de luz

Matting/material para enmarcar dibujos, acuarelas, etc.: enmarcar obras de arte con un marco de cartón o cartel

Mechanical or architectural drawing/dibujo mecánico o arquitectónico: representaciones detalladas de un plan para la ensamblación de un objeto, edificio, o ambiente

Media/medios: materiales de arte como pintura, arcilla, madera, herramientas para dibujar, y fibras

Medical illustrator/ilustrador médica: artistas que producen representaciones de las partes externas e internas de humanos y animales, como los tejidos, órganos, sistemas esqueléticos, y las células

Merlons/merlones: los segmentos altos de un castillo o de una muralla alrededor de un pueblo que contuvieron un lazo para flechas por donde se podía lanzar flechas

Method/método: la manera en que una artista usa los medios

Mexican Muralist art/arte de pintor muralista mexicano: un grupo de artistas mexicanos que pintó imágenes de la gente mexicana, la revolución y la opresión, las tradiciones nativas, las costumbres y festivales, las leyendas, la industrialización, y la esperanza para el futuro de la gente de México; artistas principales fueron Diego Rivera, José Clemente Orozco, y David Siquerios

Minaret/torre de una mezquita: una torre con balcones sobresaliendo de donde se puede llamar a rezar a los fieles islámicos

Minimal art/arte mínimo: un movimiento de arte del siglo veinte que trató de presentar ideas en las formas más simples posibles

Modeling/modelar: la configuración de una escultura por un artista en una forma deseada

Modern art/arte moderno: un término usado para describir las obras de artistas de los siglos diecinueve y veinte que exploraron nuevas maneras de la expresión creativa otra cosa que el método tradicional del pasado

Modernism/modernismo: arte e ideas que dan énfasis en individualidad, originalidad, significado universal, y "arte por amor al arte"

Mogul/Mogol: la dinastía que floreció en la India desde mediados de los años 1500 hasta el principio de los años 1700. Fue marcada por un interés en arquitectura, poesía y muchas otras formas de arte.

Monochromatic/monocromático: el uso de un solo

color y sus diferentes valores en una obra de arte

Monoprint/monoimpreso: el proceso en el cual sólo se puede levantar una imagen de una plancha de impresa llana, como una hoja de plástico o linóleo

Monument/monumento: un recuerdo visual de una persona, un evento, o una idea importante en la historia

Mosaic/mosaico: una obra de arte que está construida de muchos pedacitos de tejas coloradas

Mother-of-pearl/madreperla: la capa dura, opalescente encontrada adentro de ciertas conchas marinas

Motif/motivo: un tema visual o modelo repetido en un diseño

Mouse/"ratón": un aparato controlado por la mano que los artistas pueden usar para ayudarles crear imágenes en una pantalla de computador. Se usa para elegir mandos u opciones visibles en la pantalla.

Movement/movimiento: la sugerencia de acción visual creada por la colocación de los elementos en una obra de arte

Mudras/Mudras: gestos hechos con las manos con significados específicos en el budismo

Mural/pintura mural: una obra de arte, usualmente en escala grande, pintada en o pegada a una pared o cielo raso

N

Naturalistic style/estilo naturalístico: un estilo artístico que intenta hacer una obra de arte lo más parecida como viva y parecida a la naturaleza posible

Negative space/espacio negativo: el área no usada entre, dentro de, y rodeando las configuraciones y formas en una composición artística

Netsuke/netsuke: pequeñas esculturas marfileñas, que parecen vivas, amarradas al cordel de un kimono

Nib/punta: la punta de un marcador o pluma

O

Oil paint/pintura de óleo: pigmento mezclado con aceite de linaza

Op art/arte op (óptico): un movimiento de arte cuyos artistas estaban interesados en el arreglo cuidadoso de líneas, colores, y formas geométricas para producir un efecto óptico; artistas principales fueron Victor Vasarely y Bridget Riley

Oral history/historia oral: pasando información de generación a generación por medio de la palabra hablada

Organic shapes/formas orgánicas: formas que son irregulares, curvilíneas, y no mensurables

P

Pagoda/pagoda: un templo de varios pisos, cada uno con su propio techo saliente

Paleolithic/paleolítico: refiriéndose al segundo período de la Edad de Piedra, donde las herramientas fueron talladas de piedra

Panorama/panorama: una vista de lo que se puede ver en muchas direcciones

Pantheon/panteón: todos los dioses de una cultura o religión

Pastels/pasteles: palos de pigmento pulverizado

Patron/patrocinador: una persona rica o influyente que mantiene a un artista por medio de proveer oportunidades y fondos que posibilite que el artista haga su trabajo

Perceive/percibir: tener conciencia de cosas por medio de nuestros sentidos—ver, oír, saborear, oler y tocar; la habilidad de reconocer y entender las cosas que experimentamos en nuestro ambiente

Photography/fotografía: la formación de fotos de arte fino, comerciales, y educacionales capturando la luz de un objeto con una cámara

Photo-Realism/foto realismo: un movimiento de arte en el cual el artista pintó con tanta precisión y detalle que sus obras parecieron una fotografía de la imagen; artistas principales: Richard Estes y Chuck Close

Photoscreen/fotofiltro: una plantilla/estarcido de una imagen producida/o en un taller de imprenta

Pigment/pigmento: materia que da color a materiales como pinturas, tinturas, creyones, y tintas

Pointillism/puntillismo: un estilo de pintar que consiste de la aplicación de puntos pequeños de color

Pop art/arte realista que utiliza técnicas y temas populares como tiras cómicas, afiches, etc.: un movimiento de arte que fue una reflección de la cultura popular, los medios, y las imágenes de publicidad; artistas principales fueron Roy Lichtenstein, Claus Oldenburg, y Robert Rauschenberg

Porcelain/porcelana: una arcilla fina y blanca usada en la producción de vajilla de calidad alta u objetos decorados

Portrait bust/retrato de busto (escultura): una escultura tridimensional, usualmente de tamaño natural, de alguien mostrando su semejanza desde los hombros hacia arriba

Positive space/espacio positivo: el espacio tomado por las configuraciones y formas mismas

Post/poste: las piedras o pedazos de madera verticales y rectos usados para soportar el dintel; también se llama una columna o pilar

Postimpressionism/Postimpresionismo: un movimiento de arte francés del fin del siglo diecinueve que extendió ideas adelantadas por los impresionistas; artistas principales: van Gogh, Cézanne, y Gauguin

Postmodern/postmoderno: arte que fue hecho después de fines de los años de 1960; también se llama "contemporáneo"

Postmodern art/arte postmoderno: obras de arte e ideas que son ricas y diversas en términos de significados, materias, tradiciones culturales, y referencias historicas

Powwow/ceremonia hechicera propia de los indios de Norteamérica: una reunión especial de americanos nativos marcada por música y baile ceremonial

Primary colors/colores primarios: colores que el artista no puede hacer. Estos colores son el rojo, el amarillo, y el azul.

Prime/imprimar: preparar

Printmaking/estampando: el proceso de reproducir crear una o más imágenes de una superficie simplemente preparada

Process Art/arte por proceso: un movimiento de arte en el cual el arte pasaría por una ejecución o transformación; artista principal fue Hans Haacke

Proof/prueba: la salida impresa inicial en la impresión de una obra de arte

Proportion/proporción: la relación en el tamaño de un componente de una obra de arte a otro

Pure painting/pintura (pintar) pura: el estilo artístico de abstraer y simplificar imágenes hasta que sólo el color, la línea, y la forma quedan

R

Radiocarbon dating/método del carbono 14 para determinar la edad de vestigios orgánicos: un proceso científico para determinar la edad de un objeto por el contenido de su radiocarbono

Ready-mades/(ya) hechos: objetos funcionales, como ruedas de una bicicleta y perchas para sombreros, que el artista proclamó ser obras de arte

Real forms/formas reales (verdaderas): formas tridimensionales que actualmente existen en el espacio como los árboles, las montañas, y los edificios

Real lines/líneas reales: líneas que existen dentro de una obra de arte

Regionalism/regionalismo: un movimiento de arte en el cual los artistas volvieron a la representación realista de la materia, característica de la parte del país en que vivieron; artistas principales fueron Grant Wood y John Steuart Curry

Relief/relieve: formas esculturales que resaltan desde una superficie llana

Relief sculpture/escultura de relieve: un tipo de talla donde se quita materia de un solo lado de la escultura, dejándola plana por detrás

Reliquaries/relicarios: receptáculos ornados de diferentes tamaños y formas usados para contener reliquias de iglesias

Renaissance/Renacimiento: una palabra francesa que significa "renacimiento"; el período que siguió la Edad Media

Representational or realistic drawing/dibujo representacional o realista: una representación que parece el objeto o imagen que la artista ve o imagina. Técnicas de perspectiva, degradación, y modelar se usan frecuentemente.

Rhythm/ritmo: la repetición regular de elementos, configuraciones, o movimientos en una obra de arte

Ribbed vault/bóveda acanalada: un esqueleto de arcos puntiagudos al cual se podría aplicar albañilería ligera, dejando que un área rectangular sea cubierta

Rock art/arte de piedra: imágenes antiguas pintadas o talladas en piedra

Rock cut temple/templo cortada de piedra: templo tallado de piedra sólida, un proceso más similar a la tallación de una escultura de piedra que a la construcción de un edificio

Rose windows/rosetones (ventanas): vitrales redondos con un diseño simétrico alrededor del centro

S

Scarification/escarificación: la costumbre de marcar la

piel de una persona con una cicatriz en diseños para significar ataduras familiares y culturales

Scenario/argumento: un sumario corto de una serie de eventos verdadera o imaginada

Screen/trama: tejido de malla fina tendida sobre un bastidor de madera usado para estampación de estarcido de seda

Scroll/rollo de papiro: una largura de papel con una barra de madera ligada en cada extremo que se usa para enrollar los extremos hacia el medio

Sculpture/escultura: obras de arte que tienen altura, anchura, y profundidad

Scumbling/dar glacis: usando el lado, en un movimiento de un lado a otro, de la herramienta para crear un área sólida de degradación

Secondary color/color secundario: el resultado de mezclar dos colores (primarios) en cantidades iguales. Estos colores son el naranja, el verde, y el violeta.

Self-portrait/autorretrato: una obra de arte donde el artista usa su propia imagen como el sujeto

Serigraph/serígrafo: impresión con estarcido de seda

Serpentine/serpentina: una forma larga y delgada que curvea o serpentea como el cuerpo de una culebra

Shades/sombras: colores a cuales se ha agregado un color más oscuro o negro

Shape/forma: un área bidimensional definida por un límite

Sikhara/sikhara: aguja encontrada en un templo indio

Simulated texture/textura simulada: las recreaciones de una textura fabricada o natural

Sketchbook/bloc de dibujo; libro de bosquejo: un diario visual de pensamientos artísticos

Smudging/tiznar: usando el dedo o un palo para mezclar (papel comprimido) para extender el medio en la superficie

Social Realists/Realistas Sociales: un grupo de artistas que trató con temas como la pobreza, la opresión, y la injusticia social

Software/software: contiene información (programas) e instrucciones que ayuda a los operadores del computador satisfacer sus necesidades computadores

Soho/Soho: un movimiento de arte famoso por el arte de breve duración que emergió en las murallas, ventanas, y entradas de edificios públicos en un área de veinte cuadras en la ciudad de Nueva York

Spectrum/espectro: los colores que componen luz blanca

Step pyramid/pirámide de pisos: una pirámide que fue formada como varias mastabas de tamaño disminuyendo, amontonadas una encima de la otra

Stippling/puntear: usando el punto de la herramienta para dibujar para hacer puntos pequeños para crear un área de oscuridad o luz

Stone pictures/dibujos en piedra: formas de arte japonés donde "se descubre" dibujos en piedras

Storyboard/tabla de cuento: secuencia de eventos cuadro por cuadro para un comercial, programa de televisión, o película

Striations/estrías: línea cortada

Studio production/producción de estudio: los procesos en los cuales personas toman parte para hacer arte

Style/estilo: una manera característica de presentar ideas y sentimientos en forma visual

Stylized/estilizar: un estilo artístico en el cual partes del cuerpo de la figura han estado simplificadas y reducidas a su forma más básica

Stylized/estilizar: una forma artística donde un objeto ha sido cambiado o abstraído de la naturaleza para poder adaptar a las reglas y tradiciones artísticas de una cultura

Subtractive/sustractivo: un tipo de escultura en donde el artista remueve porciones escogidas de la materia para esculpir (piedra, mármol, etcétera) para crear la obra de arte

Superrealism/superrealismo: un estilo artístico con la intención de producir obras tan realistas que el veedor no puede distinguir entre ilusión y realidad

Suprematism/suprematismo: un movimiento de arte fundado por un grupo pequeño de artistas rusos que consistió de hacer formas geométricas de color que obran recíprocamente sutilmente con los fondos de intensidades similares; artista principal: Kasimir Malevich

Surrealism/surrealismo: un movimiento de arte donde los artistas combinaron eventos, imágenes, objetos, o situaciones naturalmente no relacionados en una escena como un sueño (irreal); artista principal fue Salvador Dali

Syndicated cartoons/tiras cómicas sindicadas: tiras cómicas que están publicadas nacionalmente, usualmente en periódicos

T

Tag/rúbrica: una firma especial específica a un artista de grafiti

Television graphic artist/artista de artes gráficas para la televisión: un artista que puede concebir promociones para campañas de publicidad, crear platóes para concursos y discursos televisivos, e inventar logos nuevos para la estación de televisión

Tertiary colors/colores terciarios (colores en tríos): el resultado de mezclar variantes cantidades de un color primario y secundario

Texture/textura: las características de la superficie de un objeto u obra de arte en particular

The Eight/Los Ocho: una asamblea de ocho artistas reunida por Robert Henri quien cortó con la tradición de las academias de arte europeas para explorar nuevos estilos y sujetos

Theory of art/teoría de arte: intenta explicar por que ciertos objetos o eventos se llaman arte; intenta identificar aspectos o características importantes en común con una obra de arte

Thesis/tesis: una exhibición de las obras de un artista que demuestra su habilidad en su área de concentración

Three-dimensional/tridimensional: que tiene anchura, altura, y profundidad

Tints/tintas: colores a cuales se ha agregado un tono de blanco más claro

Tooled leather/cuero labrado: cuero que ha sido decorado a mano

Tooth/diente: superficie de papel un poco áspera

Topiary/arte de jardinería: la práctica de poner en espaldera y mondar arbustos para crecer en formas que no tomarían independientemente

Totem poles/postes totémicos: postes de madera que fueron tallados y pintados con diseños simbólicos, y que fueron colocados rectos en frente de casas nativas

Trompe l'oeil/ilusión óptica: un tipo de pintura que es tan realista que los espectadores no están seguros si están mirando una pintura de objetos o si son los objetos mismos

Tumulus/túmulo: un montecillo encima de una sepultura

Two-dimensional/bidimensional: que tiene anchura y altura

U

Ukiyo-e/ukiyo-e: una forma de arte del período Edo-

Tokugawa de Japón que literalmente significa "pinturas (imágenes) del mundo flotante"

Unity/unidad: un principio que nos ayuda ver los componentes de una obra de arte en conjunto

#

Value/valor: la cantidad de claridad u obscuridad que un color posee

Variety/variedad: un principio que enfoca en las diferencias y diversidades en una obra de arte

Vault/bóveda: una estructura arqueada, usualmente formando un cielo raso o entrada

Vault/bóveda: una combinación de arcos

Vellum/papel pergamino: papel hecho de piel de becerro que fue usado para manuscritos iluminados

Venuses/Vénuses: el nombre dado a imágenes hembras encontradas esculpidas durante la Edad de Piedra

w

Wall installation/instalación en una pared: una obra de arte que ha sido permanentemente instalada en una pared en un museo, o otro edificio público o privado

Warp threads/hilos urdimbres: hilos verticales en una tela

Weaving/tejido: el proceso de hacer tela cruzando hilos por encima y por debajo entre sí en un diseño

Weft threads/hilos tramas: hilos horizontales en una tela

Whirligigs/molinetes: juguetes que enrollan con partes móviles que son propulsados por la fuerza del viento

z

Ziggurat/zigurat: templos monumentales arreglados en filas construidos de ladrillos de barro

Index

Titles in italic indicate titles of artwork. Page numbers in bold indicate illustrations of artwork.